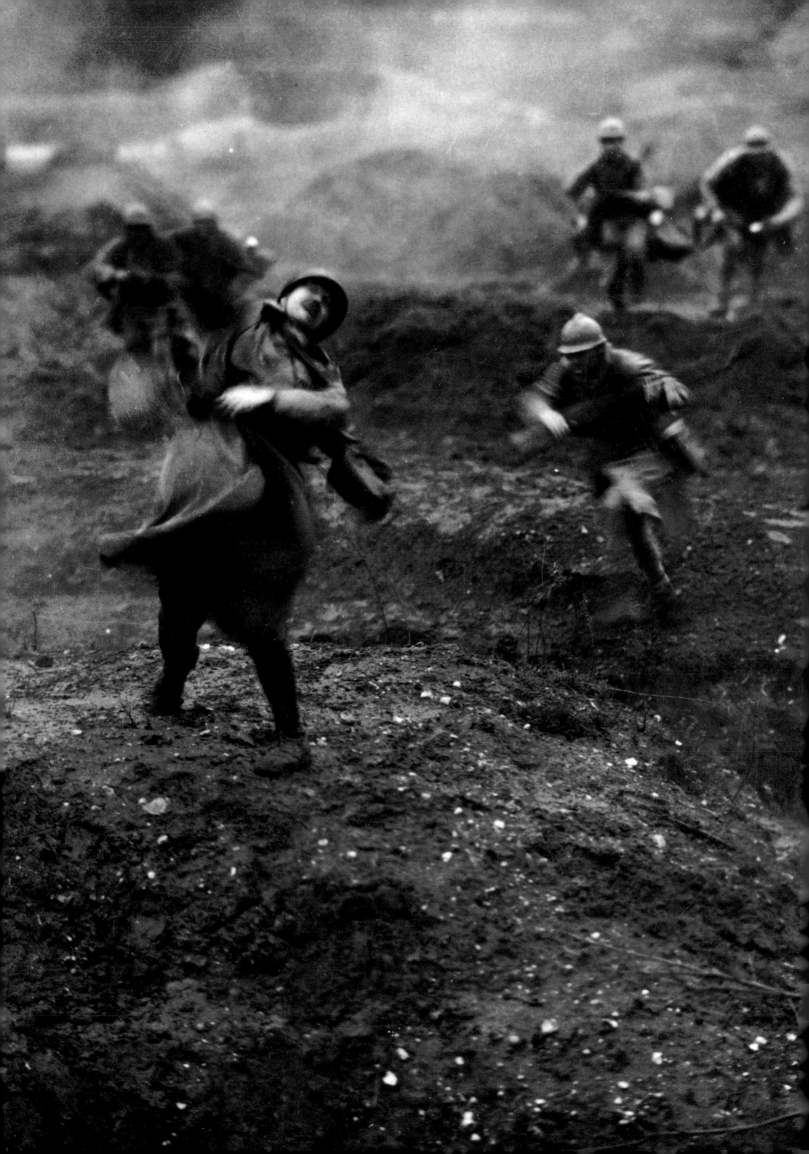

The Hulton Getty Picture Collection

CAMERA IN CONFLICT

Armed Conflict

Bewaffnete Konflikte

Conflits armés

Robert Fox

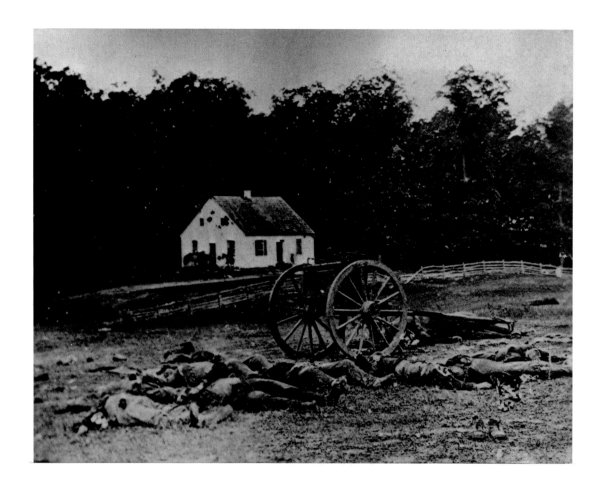

First published in 1996 by Könemann Verlagsgesellschaft mbH, Bonner Strasse 126, D-50968 Köln

© 1996 Könemann Verlagsgesellschaft mbH. Photographs © 1996 Hulton Getty Picture Collection Limited

All photographs from the Hulton Getty Picture Collection, London, with grateful acknowledgement to: Agence France Presse; The Associated Press; Link Picture Library; Mirror Syndication International; The Observer; Reuters; Slava Katamidze; Kevin Weaver

This book was produced by The Hulton Getty Picture Collection Limited, Unique House, 21-31 Woodfield Road, London W9 2BA

For Könemann:
Production manager: Detlev Schaper
Managing editors: Kristina Meier and Sally Bald
Typesetting: Oliver Hessmann
German translation: Manfred Allié,
Gabriele Kempf-Allié, Franca Fritz, Heinrich Koop
French translation: Annie Berthold, Joëlle Marelli, Francine Rey

For Hulton Getty:
Art director: Michael Rand
Design: Ian Denning
Picture research: Leon Meyer with Dawn Wyman, Roger Syring
Project editor: Elisabeth Ingles
Production coordinator: Elisabeth Ihre

Colour separation: Imago. Printed and bound in France by Partenaires Fabrications

ISBN 3-89508-217-1

(Above) American dead await burial in front of Dunker Church Antietam, Maryland, September 1862.
The battle was the single bloodiest day in American history with over 20,000 casualties.
(Frontispiece) French soldiers attacking at 'H' hour at Verdun in 1916.
(Oben) Gefallene Amerikaner liegen bis zur Bestattung vor der Dunker Church in Antietam, Maryland, September 1862.
Die Schlacht gilt mit über 20000 Opfern als die blutigste in der amerikanischen Geschichte.
(Frontispiz) Französische Soldaten greifen zur Stunde »H« in Verdun an, 1916.
(Au-dessus) Dépouilles d'Américains avant les funérailles, en face de la Dunker Church, Antietam, Maryland, en septembre 1862.
Ce fut la plus sanglante des batailles de l'histoire américaine, avec plus de 20000 morts.
(Frontispice) Attaque des soldats français à l'heure H, Verdun, 1916.

Contents

Introduction *8*

1. New Wars for Old *20*

2. Dreams of Empire *48*

3. Global Warfare *68*

4. The Restless Peace *124*

5. The World at War *168*

6. The Cold War *248*

7. Local Wars *270*

8. The New World Disorder *372*

Back to the Future *410*

Index *416*

Inhalt

Einführung *12*

1. Neues an allen Fronten *20*

2. Der Traum vom Weltreich *48*

3. Weltweiter Krieg *68*

4. Der ruhelose Frieden *124*

5. Die Welt im Krieg *168*

6. Der Kalte Krieg *248*

7. Örtlich begrenzte Kriege *270*

8. Eine neue Weltunordnung *372*

Zurück in die Zukunft *412*

Index *416*

Sommaire

Introduction *16*

1. Avènement des guerres modernes *20*

2. Rêves d'empire *48*

3. Guerre mondiale *68*

4. Une paix fragile *124*

5. Le monde en guerre *168*

6. La guerre froide *248*

7. Guerres locales *270*

8. Le nouveau désordre mondial *372*

Retour au futur *414*

Index *416*

Introduction

When photographers began appearing on the battlefield for the first time, warfare itself was entering a new, ironclad, industrialized age. The armies captured through the lens in the Crimea and the American Civil War were delivered to the theatre of operations by iron steamships and a network of railways. Soon the armies themselves became almost mass-produced, turned out in huge numbers and then tested to destruction. The time of the great war photographers was that of the making and breaking of great armies, in Europe, America, Asia and India.

In the American Civil War, the first conflict in which the photographer superseded the engraver, or the sketcher for the popular press, the Union under President Lincoln had to produce four armies, mostly from the industrialised north-east, before the southern Confederacy was beaten. The British deployed four armies in the First World War (1914-18), more than five million men, nearly a quarter of the male population of the British Isles.

In the era of mass warfare, it was the photographer and the reporter who provided the individual view, the arresting image

and phrase to bring home the pathos of battle and its consequences. The first British war photographer, Roger Fenton, went to the Crimea after reading the despatches in *The Times* by William Howard Russell – the first modern war correspondent to make public impact. Russell had many characteristics that were to mark his successors to this day: a sharp eye, physical courage, and a huge ego.

His 1854 account of the futile Charge of the Light Brigade at Balaclava, a mixture of poetry and good reporting, still reads as fresh as the day it was penned. 'They swept proudly past, glittering in the morning sun in all the pride and glory of war', he wrote in purple Victorian prose. The end of the despatch abandons poetry and gives the exact count of men and beasts in the charge, with the numbers returned, wounded and slain: 'Our loss, as far as it could be ascertained in killed, wounded and missing, at two o'clock today, was as follows: – Went into Action 607, Returned from Action 198, Loss 409.' This is straight reporting at its best, a legacy which echoes down the centuries.

Witnessing the British Harriers taking off from the aircraft carriers for the first air battles of the Falklands in 1982, the BBC's Brian Hanrahan echoed Russell with the famous phrase, 'I counted them all out, and I counted them all back.' But unlike Russell, Hanrahan was prevented by military censors from mentioning the precise number of aircraft he saw taking off to battle in the South Atlantic.

For photographer and reporter the relationship with military and political authority was nearly always fractious and difficult. Close relationships are often formed in the heat of combat itself, but military command and governments have always wanted to reach for the blue pencil and the chinagraph crayon to cancel the upsetting line and the disturbing picture. Russell himself became controversial, and Field Marshal Herbert Kitchener summed up a general military contempt for the early war reporters when he swept out of his tent on one African expedition shouting, 'out of my way, you drunken swabs!'

For the early photographers such as Fenton in the Crimea and the Brady photographers in the American Civil War, their business was a cottage industry. Both took their darkrooms on special covered waggons; they won fame and notoriety but hardly made fortunes. Brady died in poverty, though his photographs sold across Europe as well as in America. So laborious was Fenton's process of actually taking the pictures that most of his portfolio from the Crimea is of landscapes and groups of men and civilians away from the combat itself. Nonetheless he gave his viewers an astonishing sense of immediacy, of being at the scene of action.

A few years later Felice Beato, an Italian who worked with the British Army, took some powerful photographs of the

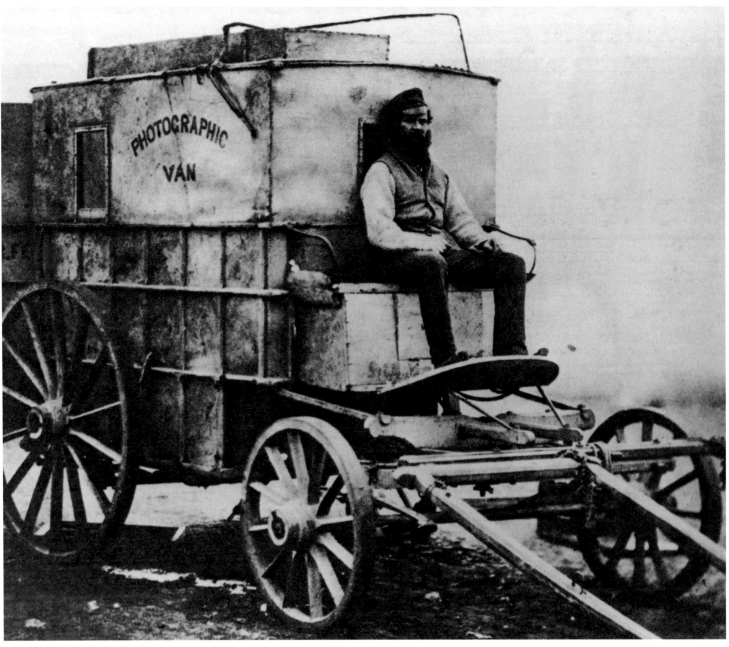

(1) William Howard Russell of *The Times* in the Crimea, 1855. The first of the modern war correspondents, brave, accurate and proud. (2) Early war photography was laborious. Roger Fenton took his mobile darkroom to the Crimea. He could develop negatives within ten minutes.

(1) William Howard Russell von der *Times* auf der Krim, 1855. Er war der erste moderne Kriegsberichterstatter, mutig, genau und stolz. (2) In der Frühzeit der Fotografie war die Arbeit des Kriegsfotografen mühselig. Roger Fenton nahm diese mobile Dunkelkammer mit auf die Krim. Er konnte Negative in zehn Minuten entwickeln.

(1) William Howard Russell, envoyé spécial du *Times* en Crimée, 1855. Russell est le premier correspondant de guerre moderne, courageux, précis et fier. (2) A ses débuts, la photographie de guerre est une laborieuse entreprise. Roger Fenton a emmené cette chambre noire mobile jusqu'en Crimée; il pouvait développer ses clichés en dix minutes.

destruction and reprisals in the Indian Mutiny (1857). More remarkable is the set of his photographs of the dead and debris in the immediate aftermath of the attack on the Taku Forts in the Opium War in China of 1860.

The war that marked the turning-point for photography, and has been catalogued indelibly by the camera, is the American Civil War (1861-65). The entrepreneurial talents of Mathew B. Brady put combat photography on a new footing. He organised a team of photographers, who captured some of the most famous images. Though he delegated much of the work, he himself was a lion of industry and courage. At the First Battle of Bull Run (July 1861), where Russell of *The Times* was

also present, he got caught up in the helter-skelter retreat of the Northern Yankee army. 'Brady has shown more pluck than many of the officers who were in the fight', wrote an eyewitness; 'he went … with his sleeves tucked up and his big camera directed upon every point of interest on the field.'

The Brady photographers and their kind were on the battlefield at Antietam on 17 September 1862, the bloodiest day in the story of American arms. They photographed the dead where they lay in rows and heaps, down the sunken 'bloody lane', and the wrecked Confederate batteries by Dunker church. More than 20,000 American soldiers were killed or wounded, more than twice the number of casualties on the day

of the Normandy landings, D-Day, the Sixth of June 1944. The slaughter at Antietam and a score and more of similar battles would be etched on the nation's consciousness, sharpened often by the images of the war photographer.

For the British and the Commonwealth the indelible memory is 1 July 1916, the first day of the Somme, when more than 57,740 allied troops were killed or wounded in a single day. The Australians and New Zealanders gained a sense of nationhood through the gruelling experience of the Gallipoli campaign, while for the Canadians it was the battle of Beaumont Hamel on the Somme, when the Newfoundland Regiment was wiped out all but for a hundred or so men, and the more successful attack on Vimy Ridge a year later. For the French the baptism of blood was Verdun in 1916, and for the Germans and the Russians it was the sustained sacrifice of millions of lives in central Europe's Eastern Fronts in two world wars.

In later challenges, such as the grindingly difficult battles for the islands in the Pacific War (1941-45) culminating in Iwo Jima and Okinawa, and in the recapture of Hue in 1968, the shades of Antietam would continue to haunt generations of American citizen armies. In the American popular experience of war, photography was the essential medium, particularly through photo-journalism magazines like *Life*. In Britain *Picture Post*, the creation of Edward Hulton, was to play a unique role. The German magazine *Signal* displayed some of the best war photography, as did the propaganda publications of the Soviet Union, whose photographers were in the front line from Stalingrad to the capitulation of Berlin in 1945.

In the huge confrontation of mass armies on the Western Front in the First World War, the authorities tried to give photography a minor role. British military censors would not at first allow accredited photographers into the front line, and they first went forward – for a major offensive on the Somme – only in 1916. Much of the modern memory of the First World War is shaped by the paintings and writings of the period. Wilfred Owen's *Anthem for Doomed Youth*: 'The shrill demented choirs of wailing shells;/And bugles calling for them from sad shires' and Sassoon's *General*: '"He's a cheery old card," grunted Harry to Jack/As they slogged up to Arras with rifle and pack.../But he did for them both with his plan of attack' are now lines as familiar as the best of Shakespeare.

Paintings by the likes of Otto Dix, Paul Nash, Vassily Kandinsky even, enforce the sensation of Europe in its machine-made apocalypse. In one famous instance, art followed the photographer. The series of photographs taken of the gas victims at Béthune in 1918 were the inspiration for John Singer Sargent's huge, bleak canvas *Gassed*.

Photography was to be a vital ingredient in the development of new tactics to break the blind stalemate of trench warfare. From about 1916 aircraft could provide accurate photographs for artillery fire-plans. Getting the photographs seemed at first an amateur, casual affair. 'We were out taking photos. A perfect summer evening made the work go quickly. Archie (anti-aircraft fire) was poor, the front quiet, it seemed a

pity to go home,' recalls one innocent young pilot, Cecil Lewis, in his memoir *Sagittarius Rising*. Photography and radio were to enable reconnaissance aircraft to pinpoint fire accurately, and lend their own support in ground attack, one of the big innovations of 1917.

Looking closely at the photo-reportage of 1917, the myths of modern memory begin to fail – for, as the pictures in this book show, it was the year which shook the century, the year which anticipated the social, political and military struggles for a half-century and more, to the end of the era of mass war in Europe, 1989. The realisation of this has been one of the biggest surprises in preparing this book. In the east we have the birth of Soviet Communism with the October Revolution, in the south the shattering defeat of the Italians at Caporetto, which would lead to the rise of Fascism. On the Western Front the Germans and their opponents started developing the tactic of the combined arms battles, infantry, artillery and air, the basis of *Blitzkrieg*, and the later American 'air/land' doctrines still current today. In Palestine Allenby and irregulars like Colonel T. E. Lawrence were developing a modern guerrilla war with commando raids deep behind enemy lines, aided later by armoured cars and fighter-bombers. Lawrence himself was a passionate amateur photographer.

Action photography came of age in the era of the Second World War, the citizens' war on a global scale. The imagery of the photographers has given us icons of our own visual era, from Robert Capa's picture of the soldier being shot in the Spanish Civil War to the raising of the standard, Old Glory, on Iwo Jima by Joe Rosenthal. These pictures were complemented by the mass deployment of the relatively new medium of radio, which relayed some masterly paintings in words from the battlefront though the voices of America's Ed Murrow giving a running commentary on the Blitz in London, the BBC's Richard Dimbleby accompanying a bombing raid over Germany, and the prose-poetry of Wynford Vaughan Thomas evoking the song of the nightingales in the trenches at Anzio.

The moments the great war photographers froze for eternity still have the ability to surprise and shock – the Russians, 'the Ivans', retreating and advancing in a ghostly *danse macabre* through the snows of Stalingrad and Kharkov, the fright of the child surrendering to the SS in the Warsaw ghetto, the astonishing shot of hundreds of US 'doughboys' leaping down the side of the aircraft carrier USS *Lexington* in the battle of the Coral Sea.

The last of the photographers' wars, conflicts in which they were a dominant force, was the chaotic battle for South Vietnam from 1963 to 1975. Here the photographers were still the best and brightest of their trade; they were heroes in the mould of William Howard Russell and Mathew Brady, and behaved like it. The exploits of such men as Larry Burrows, Terry Fincher and Don McCullin were legends of bravery. Holed up in positions like Hill Timothy, Burrows (who was later killed in an aircraft over Cambodia) and Fincher were as exposed to fire as any GI or Marine. Their images did as much

Photography was to have as much of an impact on the way the First World War was fought as how it was reported. Aerial photography from aircraft and balloons like this German one could provide very precise information on artillery fire plans.

Die Fotografie sollte auf die Kriegführung im Ersten Weltkrieg ebenso große Auswirkungen zeigen wie auf die Art der Berichterstattung. Luftaufnahmen aus Flugzeugen und Ballons wie diesem deutschen Ballon konnten sehr präzise Aufklärung über die Aufstellung der Artillerie geben.

La photographie aura autant de répercussions sur le déroulement de la Première Guerre mondiale que sur la manière de la relater. La photographie aérienne qui se faisait par avion ou ballon, tel ce dirigeable allemand, donnait exactement les plans de feu de l'artillerie ennemie.

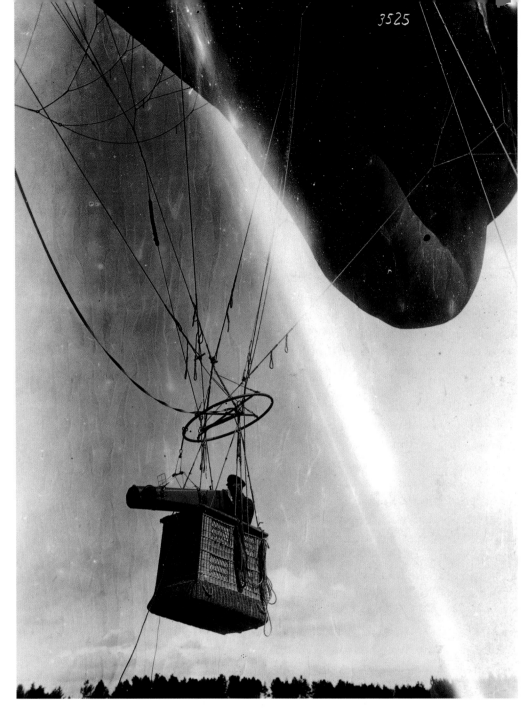

as anything on television to bring home the poignancy of the savagery wrought on the civilian population by napalm, fire and poison defoliants.

In an earlier war, in Korea (1950-53), one of the outstanding photographers, Bert Hardy, and the writer James Cameron showed as much courage at home as they did under fire at the front. On assignment for *Picture Post* they witnessed the round-ups and mistreatment of prisoners at Pusan. The autocratic Edward Hulton refused to publish the damning photographs (see pages 282-84); the row that followed eventually led to the closure of *Picture Post*, the most outstanding photo-journalism magazine of its time. Hardy and Cameron stuck to their principles, and the story and photographs of the Pusan prisoners were published and distributed by other journals.

By the end of the Vietnam conflict, war had become a television story – up to a point. In the Gulf battle for Kuwait, television networks such as CNN could show air attacks as they happened – they even showed allied aircraft taking off,

warning the recipients at the other end. In Bosnia some of the television reporting slid towards polemic, where television journalists, isolated in their own intellectual no-man's-land in the Balkans, became advocates almost before they were reporters. Bosnia, like Somalia, Angola, Afghanistan and East Timor, is a conflict of a new age and order – the long war, where the conflict becomes an end in itself. Television will be only an occasional visitor in these dangerous, difficult and mundane communal conflicts.

This means the action photographer is far from an endangered species. He or she will still be the provider of the arresting image that sums up the terror and pity of a whole world in convulsion. This is what we see in this book. A single image tells a story worth a volume. In 1961 the photographer Peter Leibing caught the split second when the East German border soldier made his leap to freedom across the barbed wire protecting the construction of the Berlin Wall: in an instant a figure sums up the pathos of a world divided by war and the prospect of war.

Einführung

Als die ersten Fotografen auf den Schlachtfeldern der Welt erschienen, war auch das Kriegshandwerk im Umbruch begriffen – ein neues, durch die Industrialisierung geprägtes Zeitalter begann. Die Armeen, deren Bilder im Krimkrieg und im Amerikanischen Bürgerkrieg auf fotografische Platten gebannt wurden, kamen mit Dampfschiffen aus Stahl und über ein gut ausgebautes Eisenbahnnetz an die Front. Wenige Jahre später ähnelten die Armeen einem Industrieprodukt, das massenhaft hergestellt werden konnte und so lange im Einsatz war, wie es hielt. Die große Zeit der Kriegsfotografie war zugleich auch die Zeit, in der in Europa, Amerika, Asien und Indien die großen Armeen entstanden – und untergingen.

Im amerikanischen Bürgerkrieg, dem ersten, in dem der Fotograf den bis dahin dominierenden Kupferstecher (oder den Zeichner der frühen Massenpresse) ablöste, mußte die Union unter Präsident Lincoln vier Armeen aufstellen – größtenteils aus dem industrialisierten Nordosten –, bevor sie die Konföderierten des Südens bezwingen konnte. Die Briten schickten im Ersten Weltkrieg vier Armeen in die Schlacht, über fünf Millionen Mann, was ein Viertel der männlichen Bevölkerung ihres Landes ausmachte.

Im Zeitalter des Massenkrieges konnten nur Fotograf und Reporter einen persönlichen Eindruck vom Kampfgeschehen vermitteln. Ihre Bilder und Sätze blieben im Gedächtnis und machten die gewaltigen Emotionen der Schlacht und ihrer Folgen greifbar. Roger Fenton, der erste britische Kriegsfotograf, reiste auf die Krim, weil ihn die Berichte von William Howard Russell in der *Times* beeindruckt hatten. Russell war der erste Kriegsberichterstatter, der wirklich die Öffentlichkeit ansprach, er hatte bereits viele der Eigenschaften, die für seine Nachfolger bis heute typisch geblieben sind: ein scharfes Auge, großen Mut und gewaltiges Selbstvertrauen.

Der Bericht, mit dem er 1854 den sinnlosen »Todesritt von Balaklawa« (Charge of the Light Brigade) beschrieb, ist eine Mischung aus Poesie und guter Beobachtung; er liest sich heute noch so frisch wie an dem Tag, an dem Russell ihn zu Papier brachte. »Sie schwebten vorüber, glitzerten in der Morgensonne in aller Pracht und allem Stolz des Krieges«, schrieb er in der überschwenglichen Art der Viktorianer. Am Ende seines Berichts ist die Poesie verflogen, und er führt nüchtern die Zahl der Männer und Pferde auf, die auszogen, und die Zahl der Zurückgekehrten, Gefallenen und Verwundeten: »Unsere Verluste, soweit sich um zwei Uhr heute nachmittag die Zahlen bestimmen ließen, waren wie folgt: ausgerückt 607, aus dem Felde zurückgekehrt 198, Tote und Verwundete 409.« Das ist sachlicher Bericht, wie er sein sollte, und den Nachhall davon hören wir in den Kriegsberichten bis in die Gegenwart.

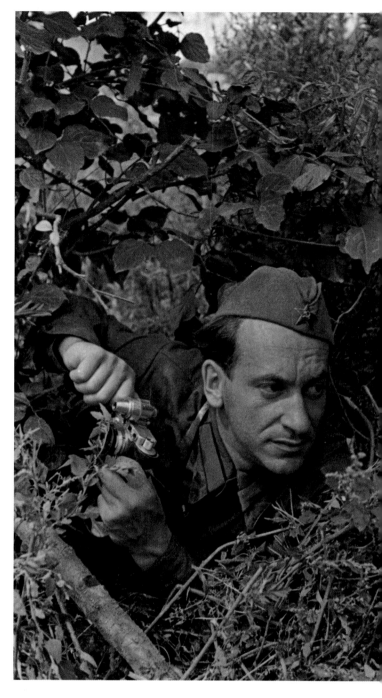

The Russian war photographer Victor Temin in a well camouflaged position in Manchuria in the 1930s. He is using a version of the German 35-mm Leica, which revolutionized combat photography.

Der russische Fotograf Victor Temin in den dreißiger Jahren in einem gut getarnten Unterstand in der Mandschurei. Er benutzt eine Version der deutschen 35-mm-Leica, die die Feldfotografie revolutionierte.

Victor Temin, reporter photographe russe, en action dans une position bien camouflée en Mandchourie dans les années 30. Il utilise une version du Leica 35mm allemand qui a révolutionné la photographie de guerre.

Als der BBC-Reporter Brian Hanrahan im Falklandkrieg von 1982 die britischen Harrier zum ersten Lufteinsatz von den Flugzeugträgern abheben sah, prägte er – als Echo Russells – den berühmten Satz: »Ich habe mitgezählt, als sie abflogen, und ich habe mitgezählt, als sie wiederkamen, und es war dieselbe Zahl.« Allerdings durfte Hanrahan aus taktischen Gründen nicht verraten, wieviele Maschinen er beim Südatlantikeinsatz gesehen hatte.

Das Verhältnis der Fotografen und Reporter zu den Militärs und zur politischen Führung war fast immer spannungsgeladen. Beim Einsatz an der Front werden oft enge Freundschaften geschlossen, doch Militärkommando und Regierung greifen gern zu schwarzer Farbe und Korrekturstift, um eine störende Zeile oder ein beunruhigendes Bild zu tilgen. Auch Russell machte sich später unbeliebt, und Feldmarschall Herbert Kitchener sprach wohl das aus, was man in Militärkreisen allgemein über die frühen Kriegsreporter dachte. Als er einmal bei einem seiner Afrikafeldzüge aus dem Zelt gestürmt kam, brüllte er: »Aus dem Weg, ihr Säufer und Waschlappen!«

Die frühen Fotografen wie Fenton auf der Krim sowie Brady und seine Männer im amerikanischen Bürgerkrieg betrieben ihre Arbeit kommerziell. Beide zogen mit speziell eingerichteten Wagen, in denen sie ihre Dunkelkammern hatten, in den Krieg; sie wurden berühmt oder machten sich Feinde – reich wurde allerdings keiner von beiden. Brady starb als armer Mann, obwohl seine Bilder sich in Amerika und ganz Europa gut verkauft hatten. Die Verfahren, nach denen Fenton seine Aufnahmen auf der Krim machte, waren so umständlich, daß nur wenige wirklich während der Schlacht entstanden; seine Mappe enthält größtenteils Landschaftsbilder und Gruppenaufnahmen von Soldaten und Zivilisten. Trotzdem hatten alle, die seine Bilder sahen, das Gefühl, daß sie unmittelbar am Ort des Geschehens dabeiwaren.

Ein paar Jahre später machte Felice Beato, ein Italiener in Diensten der britischen Armee, eine Reihe eindrucksvoller Aufnahmen von den Zerstörungen des indischen Aufstands von 1857 und den darauf folgenden Strafmaßnahmen. Noch bemerkenswerter sind seine Bilder von Opfern und Verwüstungen während des Sturms auf die Taku-Festungen im Opiumkrieg, China 1860.

Der Krieg, der für die Fotografie den Durchbruch bedeutete, da er erstmals umfassend dokumentiert wurde, war der Amerikanische Bürgerkrieg (1861-65). Mathew B. Brady schuf mit unternehmerischem Geschick eine Kriegsfotografie, wie die Welt sie zuvor nicht gesehen hatte. Er hatte ein ganzes Team von Fotografen angestellt, und einige der berühmtesten Bilder stammen von seinen Mitarbeitern. Auch wenn Brady viel von seiner Arbeit delegierte, arbeitete er doch unentwegt und mit größtem Mut. In der ersten Schlacht von Bull Run (Juli 1861), bei der Russell von der *Times* ebenfalls dabei war, geriet er zwischen die sich Hals über Kopf zurückziehende Yankee-Armee. »Brady hatte mehr Mumm als viele Offiziere, die als Soldaten ins Feld zogen«, schrieb ein Augenzeuge; »mit hochgerollten Hemdsärmeln ... schleppte er seine große Kamera überallhin auf dem Schlachtfeld, wo es etwas zu sehen gab.«

Brady stand mit seinen Leuten, zusammen mit anderen Fotografen, am 17. September 1862 auf dem Feld von Antietam, wo die blutigste Schlacht in der Geschichte des amerikanischen Militärs geschlagen wurde. Sie nahmen die Toten auf, wie sie entlang einer Senke, der »bloody lane«, in langen Reihen oder zu Bergen aufgetürmt lagen, und fotografierten die zerstörten konföderierten Stellungen bei der Kirche von Dunker. Die Schlacht forderte über 20 000 Tote und Verwundete, mehr als doppelt so viele amerikanische Soldaten, wie die Landung in der Normandie am 6. Juni 1944, der »D-Day«, kostete. Das Gemetzel von Antietam und ein gutes Dutzend ähnlicher Schlachten sind im Gedächtnis der Nation verankert, oft genug geschärft von den Bildern der Kriegsfotografen.

Für Briten und die Bewohner des Commonwealth ist der Inbegriff des Krieges der 1. Juli 1916, der erste Tag der Schlacht an der Somme, als mindestens 57 740 alliierte Soldaten an einem einzigen Tag fielen oder verwundet wurden. Die Australier und Neuseeländer fanden im Grauen des Gallipoli-Feldzugs ihre nationale Identität, die Kanadier in der Schlacht von Beaumont an der Somme, wo das Neufundland-Regiment bis auf etwa 100 Männer vernichtet wurde, und im erfolgreicheren Sturm auf die Höhen von Vimy im Jahr darauf. Für die Franzosen war Verdun im Jahr 1916 die Bluttaufe, für die Deutschen und Russen bedeutet Krieg die Millionen von Leben, die sie in zwei Weltkriegen an den Ostfronten Mitteleuropas verloren.

Bei späteren Herausforderungen, etwa den aufreibenden Kämpfen um die Inseln im Pazifikkrieg (1941-45) mit ihren Höhepunkten Iwo Jima und Okinawa oder der Rückeroberung von Hue, 1968, verfolgten die Schatten von Antietam die amerikanischen Bürgerarmeen Generation um Generation. Für den Begriff, den Amerikaner sich vom Krieg machten, waren Fotografien entscheidend, im Fotojournalismus vor allem Zeitschriften wie *Life*. In Großbritannien kam diese Rolle der von Edward Hulton gegründeten *Picture Post* zu. Einige der besten Kriegsfotos erschienen in der deutschen Illustrierten *Signal;* vorbildlich waren auch die Propagandaschriften der Sowjetunion, deren Fotografen von Stalingrad bis zum Fall Berlins im Jahre 1945 stets an vorderster Front dabeiwaren.

Bei den Stellungskriegen der riesigen Armeen an der Westfront des Ersten Weltkriegs waren Fotografen nicht gern gesehen. Die britische Zensur ließ zunächst keine akkreditierten Fotografen an die Front; erst 1916, bei einer größeren Initiative an der Somme, bekamen die Fotografen zum ersten Mal eine Schlacht zu sehen. Was wir heute vom Ersten Weltkrieg wissen, ist weitgehend von den Malern und Dichtern jener Zeit geprägt. Verse von Kriegsdichtern wie Wilfred Owen oder Siegfried Sassoon sind in England Gemeingut geworden wie die bekanntesten Zeilen Shakespeares.

Bilder von Malern wie Otto Dix, Paul Nash und sogar Wassily Kandinsky verstärken den Eindruck noch, daß Europa

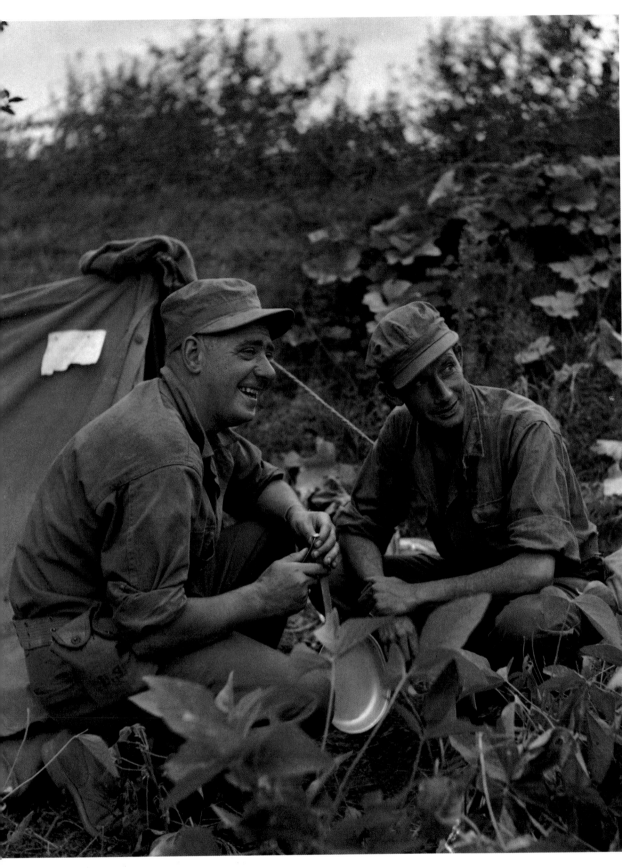

durch seine eigenen Maschinen untergeht. Einen berühmten Fall gibt es, wo ein Fotograf die Vorlage zu einem solchen Bild lieferte – John Singer Sargent ließ sich zu seiner schwarzen Leinwand *Gaskrieg* von einer Serie von Aufnahmen inspirieren, die 1918 von Gasopfern in Béthune entstand.

Die Fotografie trug auch entscheidend zur Entwicklung neuer Taktiken bei, die einen Weg aus der Sackgasse des Grabenkriegs versprachen. Von etwa 1916 an war es möglich, vom Flugzeug aus Aufnahmen zu machen, die genau genug

für einen Feuerplan der Artillerie waren. Die Flieger nahmen die Sache anfangs nicht allzu ernst: »Wir haben eine Runde gedreht, um Fotos zu machen. Ein wunderschöner Sommerabend, da ging die Arbeit wie von selbst. Kaum Flugabwehrfeuer, an der Front alles ruhig – es tat uns fast leid, daß wir gleich zurückfliegen mußten«, schreibt ein unschuldiger junger Pilot namens Cecil Lewis in seinen Memoiren *Sagittarius Rising*. Mit Hilfe von Fotografien und Funk konnten Aufklärungsflugzeuge Geschütze genauer auf ihr Ziel ausrich-

ten, sie konnten auch bei einem Angriff den Bodentruppen Geleitschutz geben – eine der großen Neuerungen des Jahres 1917.

Bei genauer Betrachtung der Fotoreportagen von 1917 erweist sich manches, was wir über den Krieg wissen, als Mythos – denn wie die Bilder dieses Buches beweisen, war 1917 das große Umbruchsjahr, das Jahr, in dem der Grundstein zu den sozialen, politischen und militärischen Auseinandersetzungen eines halben Jahrhunderts gelegt wurde, bis zum Ende der Epoche der Massenkriege in Europa im Jahre 1989. Diese Erkenntnis ist für den Autor die größte Überraschung bei den Vorarbeiten zu diesem Buch gewesen. Im Osten schlug mit der Oktoberrevolution die Geburtsstunde des Sowjetkommunismus, im Süden förderte die verheerende Niederlage der Italiener in Caporetto die Entstehung des Faschismus. An der Westfront entwickelten die Deutschen und ihre Verbündeten die Taktiken des gemeinschaftlichen Infanterie-, Artillerie- und Luftangriffs, die Grundbegriffe des Blitzkriegs und der späteren amerikanischen »Air/Land«-Doktrin, die bis heute das strategische Denken beherrschen. In Palästina entwickelten Allenby und Außenseiter wie Colonel T. E. Lawrence den modernen Guerillakrieg mit Kommandoüberfällen weit hinter den feindlichen Linien, später mit der Hilfe von Panzerwagen und Kampfbombern. Lawrence war übrigens ein begeisterter Amateurfotograf.

Zur vollen Blüte kam die Schlachtenfotografie im Zweiten Weltkrieg, dem Krieg, der weltweit zu einem Krieg auch gegen die Zivilbevölkerung werden sollte. Die Bilder der Fotografen haben uns Sinnbilder unserer Zeit gegeben, von Robert Capas Aufnahme des Soldaten, der im Spanischen Bürgerkrieg erschossen wird, bis zu Joe Rosenthals Bild vom Hissen der Flagge auf Iwo Jima. Außerdem hatten erstmals weite Bevölkerungskreise Zugang zum Rundfunk, damals noch ein neues Medium, in dem Männer wie der Amerikaner Ed Murrow, der laufend über den Londoner *Blitz* berichtete, oder Richard Dimbleby von der BBC, der die Bombenangriffe auf Deutschland kommentierte, meisterhafte Schlachtgemälde in Worten lieferten. Wynford Vaughan Thomas beschwor in Prosagedichten den Gesang der Nachtigallen in den Schützengräben von Anzio.

Die Augenblicke, die die großen Kriegsfotografen für die Ewigkeit festhielten, schockieren und überraschen bis heute – die »Iwans«, die in gespenstisch wirkenden Bewegungen durch den Schnee von Stalingrad und Charkow anrücken, die Angst des Kindes, das sich im Warschauer Ghetto der SS ergibt; das verblüffende Bild von Hunderten amerikanischer Landser, die in der Schlacht vom Korallenmeer von Bord des Flugzeugträgers USS *Lexington* springen.

Der letzte Krieg der Fotografen, der letzte, für dessen Berichterstattung sie eine entscheidende Rolle spielten, wurde zwischen 1963 und 1975 in der Schlacht um Südvietnam geführt. Dort waren die besten und scharfsinnigsten Fotografen im Einsatz, die es damals gab; sie waren Helden vom gleichen Schlage wie William Howard Russell und Mathew Brady und traten mit dem gleichen Anspruch auf. Die

Tapferkeit von Männern wie Larry Burrows, Terry Fincher und Don McCullin war legendär. In Stellungen wie Hill Timothy waren Burrows (der später bei einem Flug über Kambodscha umkam) und Fincher denselben Gefahren ausgesetzt wie jeder GI oder Marineinfanterist. Ihre Bilder leisteten einen ebenso großen Beitrag wie alles, was es im Fernsehen zu sehen gab, um den Menschen weltweit zu Bewußtsein zu bringen, wie schwer die Bevölkerung unter Napalm, Bränden und giftigen Entlaubungsmitteln zu leiden hatte.

In einem früheren Krieg, dem Koreakrieg (1950-53), zeigten einer der führenden Fotografen, Bert Hardy, und der Reporter James Cameron zu Hause ebensoviel Mut, wie sie es im Gewehrfeuer der Front getan hatten. Sie waren im Auftrag der *Picture Post* nach Pusan gereist und hatten dort mit angesehen, wie die Gefangenen zusammengetrieben und mißhandelt wurden. Der autokratische Edward Hulton weigerte sich, das belastende Material zu veröffentlichen (s. S. 282-284), und als die Auseinandersetzung darum anhielt, stellte er die *Picture Post,* die führende fotojournalistische Zeitschrift ihrer Epoche, kurzerhand ein. Hardy und Cameron ließen sich nicht beirren, und der Bericht und die Bilder über die Gefangenen von Pusan erschienen anderswo.

Als der Vietnamkrieg zu Ende ging, waren Kriegsberichte längst Sache des Fernsehens geworden – doch ganz verdrängen konnten die Fernsehreporter den Fotojournalismus nicht. Im Zweiten Golfkrieg brachten Sender wie CNN Liveberichte von Luftangriffen – sie zeigten sogar den Start alliierter Maschinen, so daß der Feind am anderen Ende gewarnt war. In Bosnien verkamen die Fernsehberichte vielfach zu Polemik, denn die Journalisten, isoliert in ihrem eigenen intellektuellen Niemandsland auf dem Balkan, wurden schon Parteigänger, bevor sie überhaupt mit ihren Berichten begannen. In Bosnien, Somalia, Angola, Afghanistan und Osttimor lernen wir eine neue Art von Krieg kennen – Kriege, die keinen Anfang und kein Ende haben und in denen die Auseinandersetzungen zum Selbstzweck werden. Bei diesen schwierigen, gefährlichen und öden Bürgerkriegen wird das Fernsehen nie mehr als bloß ein Zaungast sein.

Diese neue Ära macht den Kriegsfotografen aber nicht überflüssig. Auch weiterhin werden Fotografen für uns die eindrucksvolle Bilder aufnehmen, die das Elend und Entsetzen einer aus den Fugen geratenen Welt auf den Punkt bringen. Solche Bilder führt dieses Buch vor. Ein einziges Bild erzählt eine Geschichte, die zu beschreiben man einen ganzen Band bräuchte. 1961 konnte der Fotograf Peter Leibing den Sekundenbruchteil festhalten, in dem ein ostdeutscher Grenzsoldat den Sprung in die Freiheit machte, über den Stacheldrahtzaun, der die im Bau befindliche Berliner Mauer abschirmte: In einem Augenblick zeigt eine Gestalt die Summe des Leidens einer Welt auf, die zweigeteilt ist vom Krieg und von der Aussicht auf weiteren Krieg.

Introduction

Quand les photographes apparaissent sur les champs de bataille, la guerre, elle-même, subit de profondes transformations, issues de la révolution industrielle. L'objectif saisit, dans la guerre de Crimée et la guerre de Sécession, des armées qui ont été transportées sur le théâtre des opérations par paquebots cuirassés ou à travers le réseau ferroviaire. Bientôt, ce sont des armées massives, rassemblant des quantités énormes de soldats, qui sont soumises à l'épreuve de la destruction. L'époque des grands photographes de guerre est celui où, en Europe, en Amérique, en Extrême-Orient et en Inde, se font et se défont des armées gigantesques.

C'est pendant la guerre de Sécession que, pour la première fois, la photographie prend le pas sur la gravure ou le croquis dans la presse populaire. Sous la présidence de Lincoln, les Etats-Unis auront à rassembler quatre armées, provenant surtout du nord-est, plus industrialisé, avant de vaincre la Confédération sudiste. Pendant la Première Guerre mondiale (1914-18), les Britanniques déploieront quatre armées, plus de cinq millions d'hommes, près d'un quart de la population masculine de la Grande-Bretagne.

A l'ère de la guerre de masse, le photographe et le reporter trouvent les images et les mots qu'il faut pour porter dans les foyers la passion et la compréhension de la bataille, en en offrant une vision individuelle. Le premier photographe britannique, Roger Fenton, part en Crimée après avoir lu dans le *Times* des dépêches de William Howard Russell – le premier correspondant de guerre moderne à trouver une audience publique. Les caractéristiques de Russell marqueront des générations de grands reporters: acuité du regard, courage physique et un immense ego.

Son récit, fait en 1854, de la vaine charge de la Brigade légère à Balaclava, mêlant poésie et un sens remarquable du reportage, garde aujourd'hui toute sa fraîcheur. «Il passaient fièrement, étincelant dans le soleil matinal, dans l'orgueil et la gloire de la guerre», écrit-il dans une prose victorienne pleine d'éclat. La fin du texte laisse la poésie pour donner le décompte exact des hommes et des bêtes engagés dans la charge, ceux qui reviennent indemnes, les blessés et les morts: «Nos pertes, pour autant qu'on puisse en être sûr, morts, blessés et disparus confondus, sont à deux heures, ce jour, les suivants: participants à l'opération, 607; rentrés: 198; pertes: 409». Voilà du reportage brut. Un héritage qui se transmettra de génération en génération.

Contemplant les Harriers britanniques qui décollent des porte-avions, pour la première bataille aérienne des Malouines en 1982, Brian Hanrahan, de la BBC, a cette phrase russellienne: «Je les ai tous comptés au départ et je les ai tous comptés au retour. C'était le même nombre». Mais à la différence de

The Vietnam War was the last occasion where photography led the reporting of the war. Here Terry Fincher of the *Daily Express* and Larry Burrows of *Life* magazine pose during a lull in the bombardment of Hill Timothy, South Vietnam, April 1968.

Der Vietnamkrieg war der letzte Krieg, in dem die Berichterstattung von der Fotografie geprägt war. Hier Terry Fincher vom *Daily Express* und Larry Burrows von *Life* während einer Feuerpause bei der Bombardierung von Hill Timothy, Südvietnam, April 1968.

La guerre du Vietnam est le dernier conflit où la photographie a constitué la base du reportage. Terry Fincher du *Daily Express* et Larry Burrows du magazine *Life* posent pendant une accalmie, lors du bombardement de Hill Timothy, Vietnam du Sud, avril 1968.

Russell, Hanrahan est empêché par la censure militaire de donner le nombre précis d'avions qu'il voit partir pour l'Atlantique Sud.

Pour les photographes et les journalistes en général, les rapports avec les autorités militaires et policières ont toujours été empoisonnés. Souvent, des relations étroites se forment au cœur de la bataille, mais les états-majors et les gouvernements résistent mal à la tentation de barrer d'un trait rouge une phrase critique ou une image dérangeante. Russell, lui-même, n'a pas manqué de soulever des controverses et le maréchal Herbert Kitchener résume le mépris généralisé des militaires envers les premiers grands reporters, quand, lors d'une expédition africaine, il sort furieux de sa tente en criant: «Hors de ma vue, bande d'éponges!»

Pour les premiers photographes – Fenton dans la guerre de Crimée ou les photographes de Brady pendant la guerre de Sécession – le métier est une industrie artisanale. Ils transpor-

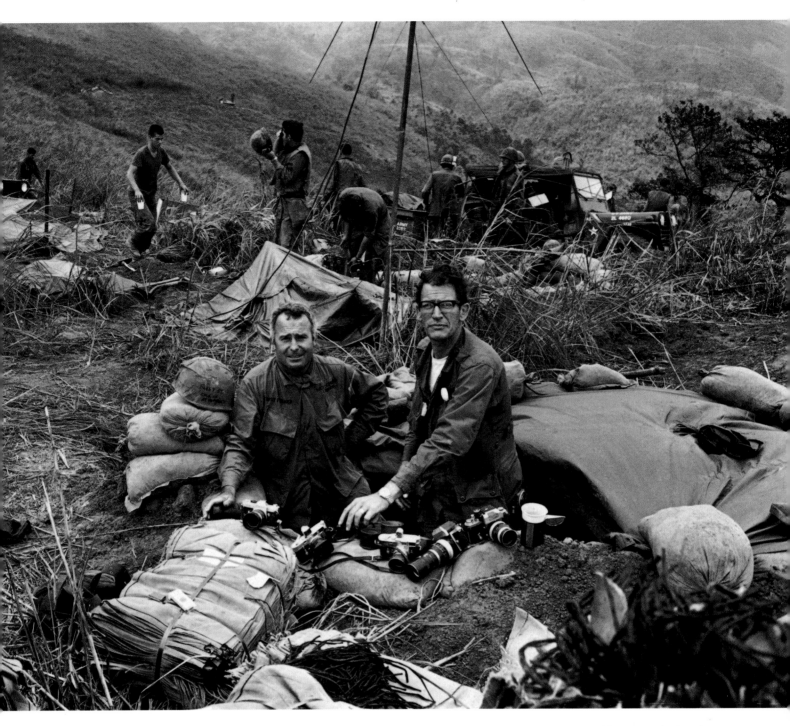

tent avec eux leur chambre noire, dans des wagons spécialement isolés; ils obtiennent la notoriété ou se font des ennemis mais ne font pas fortune. Brady mourra dans la misère, bien que ses photos soient vendues tant en Europe qu'en Amérique. Quant à Fenton, la technique de prise de vue qu'il utilise est si lourde que la plupart de ses images de Crimée consistent en paysages et en groupes de soldats ou de civils à l'écart des combats. Malgré cela, il offre à ses contemporains le sentiment d'une réalité palpable, d'une proximité avec le théâtre où se jouaient les choses.

Quelques années plus tard, Felice Beato, un Italien qui travaille avec l'armée britannique, prend des clichés saisissants des destructions et représailles qui font suite à la mutinerie indienne de 1857. Plus remarquable encore est la série qu'il fait sur les morts et les ruines qui suivent immédiatement l'attaque du fort de Taku dans la guerre de l'Opium en Chine, en 1860.

Mais la guerre qui fait date dans l'histoire de la photographie, celle qui est enregistrée pour l'éternité par la chambre obscure, c'est la guerre de Sécession (1861-65). L'esprit d'entreprise de Mathew B. Brady marque un nouveau tournant dans la photographie de guerre. Il réunit une équipe de photographes qui produiront des images célèbres. S'il délègue une grande partie du travail, il n'en est pas moins doté d'une incroyable puissance de travail et de courage. Lors de la première bataille de Bull Run (juillet 1861), également couverte par Russell pour le *Times,* il est pris dans la retraite désordonnée de l'armée des Etats du Nord. «Brady a montré plus de cran que beaucoup d'officiers engagés dans les combats», écrit un témoin occulaire, «il retournait ses manches et dirigeait son objectif directement sur chaque foyer d'intensité sur le terrain».

Les photographes de Brady et leurs semblables sont sur le terrain à Antietam le 17 septembre 1862, le jour le plus

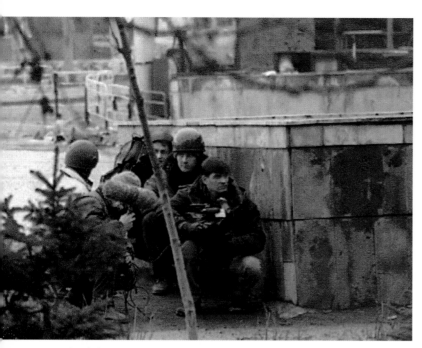

The fighting in Chechenya was the most dangerous for modern war reporting. Camera teams and reporters had to work under intense and indiscriminate bombardment from both sides. A news team take shelter from a heavy rocket bombardment, Grozny, January 1995.

Die Kämpfe in Tschetschenien waren für die moderne Kriegsbericht-erstattung äußerst gefährlich. Kamerateams mußten unter intensivem und blindem Beschuß beider Seiten arbeiten. Ein Nachrichtenteam sucht Schutz vor einem schweren Raketenangriff, Grosny, Januar 1995.

La guerre de Tchétchénie est la plus dangeureuse de toutes pour le reportage de guerre. Les caméramen et les reporters sont obligés de travailler sous les bombardements intenses et aveugles des deux camps. Une équipe de journalistes s'est mise à l'abri lors d'un bombardement à la roquette lourde à Grozny, janvier 1995.

sanglant de l'histoire militaire américaine. Ils photographient les morts qui gisent par rangées et par tas le long du « chemin sanglant », ainsi que l'artillerie sudiste détruite près de Dunker Church. Plus de 20 000 soldats américains sont tués ou blessés, plus du double des morts du débarquement de Normandie, le 6 juin 1944. Le carnage d'Antietam et de plus de vingt batailles simi-laires est resté gravé dans la conscience nationale américaine, souvent grâce à la photographie de guerre.

Pour les Britanniques et le Commonwealth, c'est le souvenir indélébile du 1er juillet 1916, le premier jour de la bataille de la Somme, où plus de 57 740 soldats alliés sont tués en un seul jour. Le sentiment national des Australiens et des Néo-Zélandais se renforce dans l'expérience éprouvante de la campagne de Gallipolli, tandis que pour les Canadiens, c'est la bataille de Beaumont-Hammel qui joue ce rôle. Le régiment de Terre-Neuve y est balayé, à une centaine d'hommes près. Mais c'est aussi, un an plus tard, l'offensive, plus réussie, de la crête de Vimy. Pour les Français, le baptême du feu moderne se déroule à Verdun en 1916; pour les Allemands et les Russes enfin, c'est le sacrifice prolongé de millions de vies sur les fronts orientaux d'Europe centrale au cours des deux guerres mondiales.

D'autres conflits, comme les longues et pénibles batailles des îles, dans la guerre du Pacifique (1941-45) qui culmine à Iwo Jima et à Okinawa, ou la reprise de Huê en 1968, conti-nueront à projeter l'ombre d'Antietam sur des générations de conscrits américains. La photo est le moyen principal par lequel la guerre arrive dans les foyers américains, principale-ment dans des magazines comme *Life*. En Grande-Bretagne, le *Picture Post*, créé par Edward Hulton, joue un rôle essentiel. Le magazine allemand *Signal* publie quelques-unes des meil-leures photos de guerre, de même que les journaux de propagande soviétiques. Leurs photographes sont aux pre-mières lignes, de la bataille de Stalingrad à la capitulation de Berlin en 1945.

Avec le choc massif des armées sur le front occidental de la Première Guerre mondiale, les autorités tentent de réduire le rôle des photographes. La censure militaire britannique commence par leur refuser l'accès du front. Ce n'est qu'en 1916, au moment de la bataille de la Somme, qu'ils pourront faire leur travail. Notre mémoire de cette guerre a été largement façonnée par les tableaux et les écrits de cette période. Ainsi, *Hymne à une jeunesse condamnée,* de Wilfred Owen: « Le chœur strident et dément, la plainte des obus; / Et le clairon qui les appelle du fond des tristes comtés » ou encore *Le Général*, de Siegfried Sassoon: « ‹ C'est un joyeux luron ›, grogna Harry à Jack / Tandis qu'ils avançaient péniblement vers Arras avec fusils et paquetages / Mais il leur régla leur compte à tous deux avec son plan d'attaque. » Ces lignes sont pour les Britanniques aussi familières aujourd'hui que les plus célèbres passages de Shakespeare.

Les tableaux d'Otto Dix, de Paul Nash, de Wassily Kandinsky, véhiculent le sentiment d'une Europe prise dans une machine apocalyptique. Dans un cas au moins, l'art suit la photographie. Une série de photos montrant les victimes du gaz à Béthune, en 1918, inspire à John Singer Sargent une immense et lugubre toile intitulée *Gazés*.

La photo jouera un rôle déterminant dans l'élaboration de nouvelles tactiques permettant de franchir l'impasse où s'enlise la guerre de tranchées. Vers 1916, les prises de vues aériennes sont suffisamment précises pour que soient établis sur leur base des plans de tirs d'artillerie. Obtenir les clichés semble d'abord une affaire d'amateurs. « Nous sortîmes prendre des photos. Cette magnifique soirée d'été rendait le travail rapide. Archie (les tirs anti-aériens) était faible, le front tranquille, il nous semblait dommage de rentrer. » se souvient un jeune pilote, Cecil Lewis, dans ses mémoires, *Sagittarius Rising*. La photographie et la radio permettent aux avions de reconnaissance de diriger précisément leurs tirs et apportent leurs contributions pour les attaques au sol, l'une des innovations de 1917.

Si l'on regarde de près les reportages phototographiques de 1917, les mythes de la mémoire moderne vacillent car, comme le montre ce livre, c'est l'année qui ébranle le monde, l'année où s'anticipent les luttes sociales, politiques et militaires qui dureront plus d'un demi-siècle, jusqu'à la fin des guerres de masse en Europe, en 1989. Ce fut notre plus grande surprise,

en préparant ce livre. En 1917, on a, à l'Est, la naissance du communisme soviétique avec la révolution d'Octobre, et au Sud, la défaite écrasante des Italiens à Caporetto, à l'origine de la montée du fascisme. Sur le front occidental, les Allemands et leurs adversaires commencent à élaborer des tactiques faisant intervenir tous les corps d'armées – infanterie, artillerie et aviation – base de la *Blitzkrieg* et des doctrines américaines ultérieures de frappes air-sol, toujours en usage aujourd'hui. En Palestine, Allenby et des irréguliers comme le colonel T.E. Lawrence inventent la guérilla moderne, des attaques de commandos très en avant des lignes ennemies, avec plus tard le soutien de véhicules blindés et de chasseurs bombardiers. Il se trouve que Lawrence est lui-même un amateur passionné de photo...

La photographie de guerre atteint sa majorité pendant la Deuxième Guerre mondiale, celle des citoyens à l'échelle du globe. Les visions des photographes ont marqué l'univers visuel de toute une époque, du soldat tué de la guerre d'Espagne, saisi par Robert Capa, au hissement du drapeau américain sur Iwo Jima, immortalisé par Joe Rosenthal. A la photo s'ajoute le rayonnement de ce médium relativement nouveau qu'était la radio, qui transmet depuis le front de magistrales épopées, composées pour les Américains par Ed Murrow, commentant en direct les attaques aériennes sur Londres, et pour les Britanniques par Richard Dimbleby, de la BBC, décrivant un bombardement aérien sur l'Allemagne, ou encore, par Wynford Vaughan Thomas et sa prose poétique, évoquant le chant des rossignols dans les tranchées d'Anzio.

Les moments des grandes guerres, qui ont été fixés pour l'éternité par les photographes, gardent tout leur pouvoir de surprise, de saisissement: les Russes reculant et avançant dans une danse macabre et fantomatique dans les neiges de Stalingrad et de Kharkhov; la peur d'un enfant devant les SS dans le ghetto de Varsovie; l'étonnante vision de centaines de soldats américains sautant du porte-avion *Lexington* lors de la bataille de la mer de Corail.

Le dernier conflit où les photographes jouent un rôle prépondérant est celui du Sud-Viêtnam, de 1963 à 1975. Là encore, c'est la pointe de la profession qui se retrouve sur le front: des héros fidèles aux modèles de William Howard Russel et de Matthew Brady. Le courage de Larry Burrows, Terry Fincher ou Don McCullin est devenu légendaire. Cachés sur des postes comme Hill Timothy, Burrows (qui mourra en vol au-dessus du Cambodge) et Fincher n'exposent pas moins leur vie que les GI's ou les marines. Les images qu'ils laissent ne sont pas moins poignantes, ne témoignent pas moins de la brutalité exercée sur les populations civiles par le napalm, les tirs et les défoliants, que celles que l'on peut voir aujourd'hui à la télévision.

Auparavant, en Corée (1950-53), le remarquable photographe Bert Hardy et l'écrivain James Cameron montrent autant de courage chez eux, en Angleterre, que sur le front. Envoyés en mission par le *Picture Post*, ils sont témoins des rassemblements de prisonniers et des mauvais traitements qui leur sont infligés à Pusan. Edward Hulton, l'autocratique directeur de la publication, refuse de publier ces images accablantes. Dans la polémique qui s'ensuit, il décide de fermer le *Picture Post*, le meilleur magazine de reportage photographique de son temps. Hardy et Cameron s'obstinent et l'article et les photos des prisonniers de Pusan seront publiés par d'autres journaux.

A la fin du conflit du Viêtnam, la guerre est devenue, dans une certaine mesure, télévisuelle. Dans la guerre du Golfe, des chaînes de télévision comme CNN sont en mesure de transmettre les attaques aériennes en direct – ils montrent même les avions occidentaux au décollage, instruisant ainsi les cibles des attaques. En Bosnie, le reportage télévisé dérive vers la polémique. Les journalistes, regroupés dans le no man's land du Holiday Inn, ont du mal à se soustraire aux pressions locales. La Bosnie, comme la Somalie, l'Angola, l'Afghanistan ou le Timor oriental, est le lieu d'un nouveau genre de conflits: des guerres interminables qui sont des fins en elles-mêmes. La télévision ne se rend que ponctuellement sur le terrain de ces conflits communautaires.

Tout ceci tend à indiquer que le photographe de guerre est loin d'être en voie de disparition. Il, ou elle, sera toujours le passeur d'une image saisissante qui rassemble en elle toute la terreur et la pitié d'un monde en convulsions. C'est ce que nous essayons de montrer dans ce livre. Une simple image peut en dire aussi long qu'un volume entier. En 1961, Peter Leibing capte l'instant où un soldat est-allemand fait le saut vers la liberté en passant les barbelés qui protègent la construction du mur de Berlin. En un instant, cette photo concentre la passion d'un monde divisé par la guerre et par la hantise de la guerre.

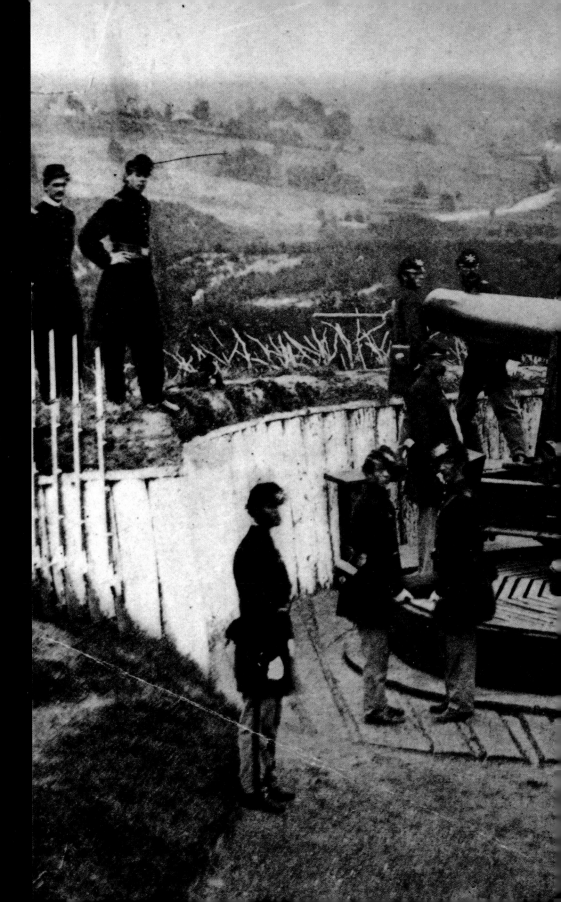

The American Civil War was the bloodiest in the story of American arms. Weapons made by modern industry were used by both sides: heavy artillery, ironclad battleships, torpedoes. But much of the fighting was at close range. More American soldiers were killed in the four years of fighting than in any war since. Here Union troops man a heavy gun at Fort Totten, on the defensive ring of Washington.

Der Amerikanische Bürgerkrieg war der blutigste Krieg in der Geschichte des Landes. Auf beiden Seiten kamen moderne, industriell gefertigte Waffen, schwere Artillerie, gepanzerte Schlachtschiffe und Torpedos zum Einsatz. Ein Großteil der Kämpfe wurde jedoch im Nahkampf geführt. In den vier Jahren dieses Krieges kamen mehr amerikanische Soldaten ums Leben als in jedem anderen Krieg danach. Hier sieht man Soldaten der Unionstruppen neben einem schweren Geschütz in Fort Totten, einem Teil des Befestigungsrings der Hauptstadt Washington.

La guerre de Sécession fut la plus meurtrière de toute l'histoire américaine. Si des deux côtés, on utilisa des armes modernes – artillerie lourde, cuirassés, torpilles – nombreux encore furent les combats livrés à courte portée. Ces quatre années de conflit firent plus de victimes parmi les soldats qu'aucune autre guerre par la suite. Nous voyons ici les troupes de l'Union servant un canon lourd à Fort Totten, sur la ligne de défense de Washington.

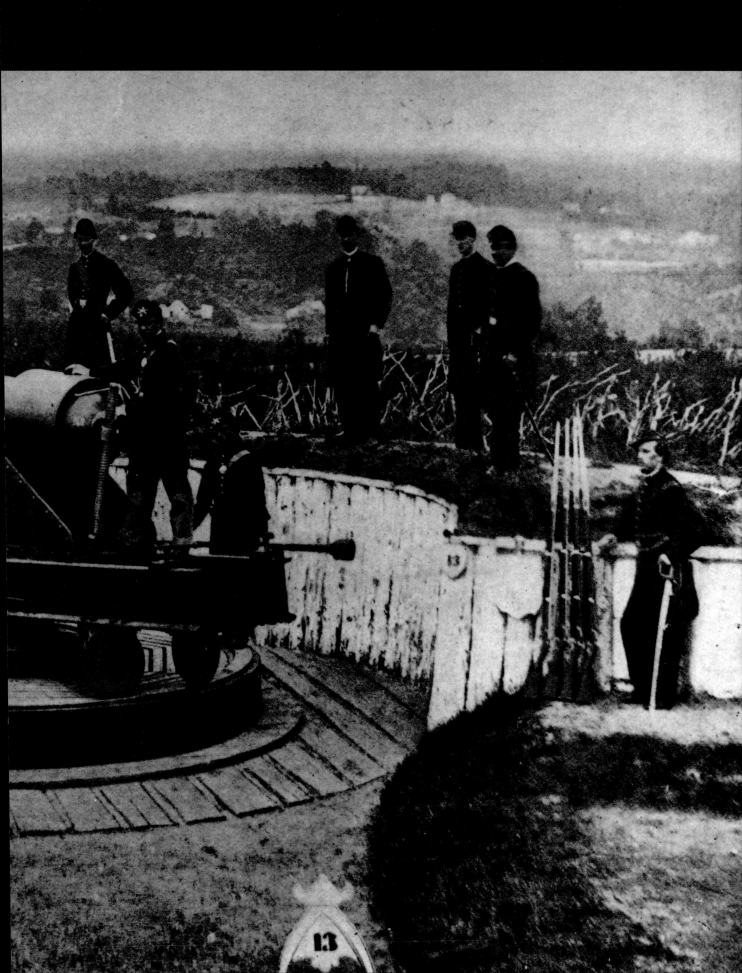

Machines, Management and Men

From the Crimea to Sedan

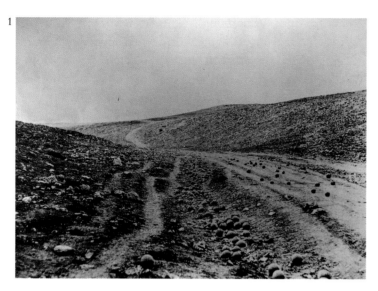

The Crimean War (1853-57) was the first of the new wars and the last of the old for the European powers. For the first time European forces used ironclad steamships, infantry fired bullets from rifled muskets, and armies in the field were in contact with their capitals by telegraph. Telegraph communication also meant that a correspondent like William Howard Russell of the London *Times* could get back inside a fortnight despatches such as the gripping account of the glorious folly of the Charge of the Light Brigade at Balaclava in October 1854. The era of the modern war correspondent had begun.

Turkey declared war on Imperial Russia in 1853 after the Russians threatened to attack through Turkey's possessions in the eastern Balkans. The French and British, anxious to guard Europe's flank with Asia, then joined Turkey's cause and declared war in 1854. An expeditionary force of British, French and Turks set out to attack the Black Sea Fleet at Sevastopol in the Crimea, and fought two battles at the Alma River and Balaclava. In November the Russians counter-attacked at Inkerman. Sevastopol did not fall until 9 September 1855. In one of the last successful attacks on the city, French field officers synchronized watches for the first time in battle.

The war effort on all sides, the British particularly, was marked by incompetence and weak command. Supply ships anchored offshore were wrecked by winter storms. Soldiers and horses starved; more died of infected wounds and disease than in battle. (Allied losses came to 253,000 while the Russians lost 256,000 – mostly from malnutrition and disease.) At the height of the war Florence Nightingale set out with 38 assistants to try to improve the squalid conditions in the British field hospital at Scutari on the Bosphorus. The plight of the troops reported in *The Times* became a public scandal in London, and the government fell.

In the Second Opium War (1856-60), French and British forces took Canton and marched on Peking. After they took the Taku forts at the entrance to Tientsin, the Chinese agreed to talk. The Treaties of Tientsin regulated the trade in opium and gave concessions to foreign powers, Austria and America as well as Britain and France, over access to the interior, allowing trading ports on the rivers and stations for missionaries.

The most innovative war of the 19th century, and the bloodiest, was the American Civil War (1861-65). Initially the secessionist rebel Southern Confederacy had the edge, with an army of some 112,000. The North, fighting to keep the Union of the United States intact, had superior numbers of about 150,000, but many were untrained conscripts. The South had the ablest generals in Robert E. Lee, James Longstreet and Thomas Stonewall Jackson but the North had a president of genius, Abraham Lincoln, who proved to be an untutored but instinctive master strategist. The North was eventually able to mobilize a fully industrialized society for war, and this proved decisive; it could draw on a population of 25 million against the nine million of the rural South.

The use of railways and river navigation, steamships and iron warships, breech-loading rifles and artillery pieces became commonplace in this conflict – a pattern of war was being set for nearly 100 years to come. Telegraphy and aerial surveillance from balloons were widespread. News photography was possible at the scene of battle – very different from the stagey, posed pictures of the Crimean War. In 1862 Richard Gatling introduced the first effective machine gun; eleven of his models were to be used during the Civil War. The machine gun was to lengthen the odds greatly against attackers across open ground against fixed positions.

In 1865 Lee was finally trapped and surrounded, and surrendered at Appomattox Court House. Lee and Ulysses S. Grant, the North's most successful general, between them showed the importance of manoeuvre; moving round objectives, feinting and deceiving, was vital when enveloping well prepared defensive positions armed with modern weaponry, rifles, machine guns and artillery. It was a lesson the military academies of Europe were slow to learn.

The lessons might have been learned, too, from the Franco-Prussian War (1870-71). An ill-organised French army under Napoleon III set out to check the ambitions of Bismarck's Prussia, which had fought two small wars against Austria and Denmark to weld together the modern German state. The French cheerfully sang that they would capture Berlin. The Germans were better organised under General Helmuth von Moltke, a genius in modern logistics. Having nearly beaten the Germans at Saint-Privet, the French were shattered at Sedan and Napoleon III himself was among the prisoners of war.

The Germans advanced on Paris, and in early 1871 occupied the city. An armistice gave Alsace-Lorraine to Germany. Napoleon was deposed and the Third Republic proclaimed; and in 1871 the Parisians manned the barricades to fight for their own egalitarian, independent Commune.

The Franco-German war brought Germany's military position into focus as the dominant issue in Europe's future stability. It was to remain so for 120 years to come.

Der Krimkrieg (1853-57) war der erste neue und der letzte alte Krieg der europäischen Mächte. Erstmals setzte das europäische Militär gepanzerte Dampfschiffe ein; die Kugeln der Infanterie kamen aus Gewehren mit gezogenem Lauf, und die Armeen an der Front standen in telegrafischem Kontakt zu ihren Hauptstädten. Dank der Telegrafie war es auch möglich, daß ein Kriegsberichterstatter wie William Howard Russell der Londoner *Times* in weniger als 14 Tagen Berichte zukommen lassen konnte, etwa die packende Schilderung des ebenso sinnlosen wie berühmten »Totenritts von Balaklawa« (Charge of the Light Brigade) im Oktober 1854. Das Zeitalter der modernen Kriegsberichterstattung war geboren.

1853 erklärte die Türkei dem zaristischen Rußland den Krieg, nachdem die Russen damit gedroht hatten, die türkischen Besitzungen auf dem östlichen Balkan anzugreifen. Da Frankreich und England dadurch die europäische Südostflanke bedroht sahen, schlugen sie sich auf die Seite der Türken und erklärten 1854 Rußland den Krieg. Ein britisch-französisch-türkisches Expeditionskorps schickte sich an, die russische Schwarzmeerflotte bei Sewastopol auf der Krim anzugreifen; an der Alma und bei Balaklawa kam es daraufhin zu zwei Schlachten. Im November erfolgte der russische Gegenangriff bei Inkerman. Sewastopol fiel erst am 9. September 1855. Bei einem der letzten erfolgreichen Angriffe auf die belagerte Stadt verglichen französische Frontoffiziere erstmals in einer Schlacht ihre Uhren.

Auf allen Seiten, vor allem auf der britischen, war die Kriegführung durch Inkompetenz und Führungsschwäche gekennzeichnet. Versorgungsschiffe lagen vor der Küste vor Anker und sanken in Winterstürmen. Truppen und Pferde litten Hunger; es starben mehr Soldaten an infizierten Wunden und Krankheiten als im Kampf. (Die Verluste der Westmächte beliefen sich insgesamt auf 253 000. Auf russischer Seite kamen 256 000 Soldaten ums Leben, überwiegend durch Unterernährung und Krankheiten.) Mitten im Schlachtgetümmel zog Florence Nightingale mit 38 Mitstreiterinnen in das britische Feldlazarett Scutari am Bosporus, um das Elend der dortigen Verwundeten zu lindern. Die Berichterstattung der *Times* über die Qualen der Soldaten löste in London einen öffentlichen Skandal aus, der die Regierung zu Fall brachte.

Im Zweiten Opiumkrieg (1856-60) eroberten französische und britische Truppen die Stadt Kanton und marschierten auf Peking. Nach der Einnahme der Takuforts bei Tientsin zeigten sich die Chinesen verhandlungsbereit. Die Verträge von Tientsin und Peking regelten den Opiumhandel und eröffneten ausländischen Mächten – Österreich und Amerika ebenso wie England und Frankreich – den Zugang zum Landesinneren; ihnen war es fortan gestattet, Missionsstationen und Handelsposten entlang der Flüsse einzurichten.

Der modernste und blutigste Krieg des 19. Jahrhunderts war der Amerikanische Bürgerkrieg (1861-65), auch Sezes-

The Crimean War
Here the old tactics of the Napoleonic wars lagged behind military technology. (1) The 'valley of death' down which the Light Brigade charged. (2) General Bosquet, the French commander, surveys the battle at Balaclava.

Der Krimkrieg
Hier zeigte moderne Militärtechnik ihre Überlegenheit gegenüber den alten Taktiken der Napoleonischen Kriege. (1) Das »Tal des Todes«, Schauplatz des »Totenritts von Balaklawa«. (2) General Bosquet, der französische Befehlshaber, beobachtet die Schlacht bei Balaklawa.

La guerre de Crimée
La vieille tactique des guerres napoléoniennes retardait par rapport à la nouvelle technologie militaire. (1) La « vallée de la mort » où se produisit la Charge de la Brigade légère. (2) Bosquet, le général français, surveille la bataille de Balaklava.

sionskrieg genannt. Anfangs hatten die Konföderierten, die von der Union abgefallenen Südstaaten, mit einer Armee von rund 112 000 Mann die Oberhand. Der Norden, der für den Erhalt der Union der Vereinigten Staaten eintrat, war mit 150 000 Mann zwar zahlenmäßig überlegen, doch viele der Soldaten waren gänzlich unerfahren. Mit Robert E. Lee, James Longstreet und Thomas Stonewall Jackson verfügte der Süden über die fähigsten Generäle, doch an der Spitze der Nordstaaten stand mit Abraham Lincoln ein genialer Präsident, der sich ohne einschlägige Vorbildung als meisterhafter Stratege entpuppte. Am Ende war der Norden in der Lage, seine inzwischen industrialisierte Gesellschaft für den Krieg zu mobilisieren. Dieser Faktor erwies sich als ausschlaggebend, denn der Norden konnte sich auf eine Bevölkerung von 25 Millionen stützen, während im ländlichen Süden nur neun Millionen lebten.

Der Einsatz von Eisenbahn und Flußschiffahrt (mit Dampfschiffen und gepanzerten Kriegsschiffen), von Hinterladern und Artilleriegeschützen wurde in diesem Krieg zur alltäglichen Erscheinung – der Amerikanische Bürgerkrieg war wegweisend für die folgenden 100 Jahre. Vielfach gab es bereits Telegrafie sowie Luftaufklärung vom Ballon aus. Fotoreporter konnten am Kriegsschauplatz Aufnahmen machen, die authentischen wirkten als die inszenierten, gestellten Bilder aus dem Krimkrieg. Im Jahr 1862 stellte Richard Gatling das erste funktionstüchtige Maschinengewehr vor; elf verschiedene Modelle dieser Waffe sollten im Sezessionskrieg zum Einsatz kommen. Das Maschinengewehr als Verteidigungswaffe verminderte die Erfolgsaussichten bei einem Angriff auf feste Stellungen in offenem Gelände erheblich.

1865 kapitulierte General Lee bei Appomattox in Virginia, nachdem man ihn in eine Falle gelockt und eingekreist hatte. Sowohl Lee als auch Ulysses S. Grant, der erfolgreichste General des Nordens, zeigten, wie wichtig das Manövrieren war: Wer gegen gut vorbereitete, mit modernen Gewehren, Maschinengewehren und Artilleriegeschützen ausgerüstete Verteidigungsstellungen vorgehen wollte, war darauf angewiesen, sein Ziel zu umgehen und mit Schein- und Täuschungsmanövern zu operieren. Dies war eine Lektion, die die Militärakademien in Europa erst nach und nach begriffen.

Man hätte diese Lehren auch aus dem Deutsch-Französischen Krieg (1870-71) ziehen können, in dem eine schlecht organisierte französische Armee unter Napoleon III. den Versuch unternahm, Bismarcks ehrgeiziges Preußen in seine Schranken zu verweisen, nachdem dieses um der nationalen Einigung Deutschlands willen bereits zwei kleinere Kriege gegen Österreich und Dänemark geführt hatte. Die Franzosen sangen frohgemut davon, wie sie Berlin einnehmen würden, doch die Deutschen unter Helmuth Graf von Moltke, einem Genie der modernen Logistik, waren besser organisiert. Nachdem sie die Deutschen bei Saint-Privat beinahe geschlagen hätten, erlitten die Franzosen bei Sedan eine vernichtende Niederlage, und Napoleon III. geriet selbst in Gefangenschaft.

Die Deutschen rückten gegen Paris vor und beschossen Anfang 1871 die Stadt. Im Vorfrieden von Versailles fiel Elsaß-Lothringen an Deutschland. Napoleon wurde abgesetzt und die Dritte Republik ausgerufen; 1871 stiegen die Pariser auf die Barrikaden und kämpften für die egalitäre, unabhängige Pariser Kommune.

Der Krieg von 1870/71 machte zum ersten Mal bewußt, daß die militärische Stellung Deutschlands der beherrschende Faktor in der Frage der künftigen Stabilität Europas war. Daran sollte sich 120 Jahre lang nichts ändern.

Les puissances européennes inaugurèrent un nouveau type de conflit armé avec la guerre de Crimée (1853-57). Pour la première fois, la marine était équipée de cuirassés à vapeur, l'infanterie de cartouches à balles de fusils, et les armées en campagne étaient reliées à leurs capitales par le télégraphe. C'est cette nouvelle forme de communication qui permit à un correspondant du *Times,* William Howard Russell, de faire parvenir à son journal, en moins de deux semaines, un reportage passionnant sur la fameuse Charge de la Brigade légère à Balaklava en octobre 1854. Avec Russell était née l'ère du correspondant de guerre moderne.

La Turquie avait déclaré la guerre à la Russie en 1853, à la suite des menaces tsaristes d'envahir les possessions ottomanes dans les Balkans. Français et Anglais, soucieux de préserver l'accès de l'Europe à l'Asie, prirent fait et cause pour la Turquie et, à leur tour, déclarèrent la guerre à la Russie en 1854. Un corps expéditionnaire composé de Britanniques, de Français et de Turcs se lança à l'assaut de Sébastopol, base de la flotte russe en mer Noire, puis livra deux batailles sur les rives de l'Alma et à Balaklava. Les Russes contre-attaquèrent en novembre à Inkerman, un faubourg de Sébastopol. La ville ne tomba que le 9 septembre 1855. Juste avant l'un des derniers assauts sur la ville, les officiers français accordèrent leurs montres – une première dans un conflit armé.

La guerre pratiquée par les belligérants, en particulier les Anglais, était marquée par l'incompétence et l'insuffisance du commandement. Les navires de ravitaillement qui avaient mouillé non loin des côtes s'étaient échoués au cours des tempêtes hivernales. Les soldats et les chevaux souffraient de la faim. Les blessures infectées ou les maladies faisaient plus de ravages que les combats (les Alliés perdirent 253 000 hommes, les Russes 256 000 – la plupart morts de sous-alimentation et de maladie). Au plus fort de la guerre, Florence Nightingale, aidée de 38 assistantes, tenta d'améliorer les conditions misérables de l'hôpital de campagne britannique se trouvant à Scutari sur le Bosphore. La situation critique des troupes dont le *Times* de Londres avait rendu compte déclencha un tel scandale que le gouvernement dut démissionner.

Durant la seconde guerre de l'Opium (1856-60), les troupes franco-anglaises s'emparèrent de Canton puis marchèrent sur Pékin. Elles prirent les forts de Taku qui protégeaient T'ien-Tsin, obligeant ainsi les Chinois à traiter avec eux. Les traités de T'ien-Tsin réglèrent le commerce de l'opium et autorisèrent des puissances étrangères – Autriche,

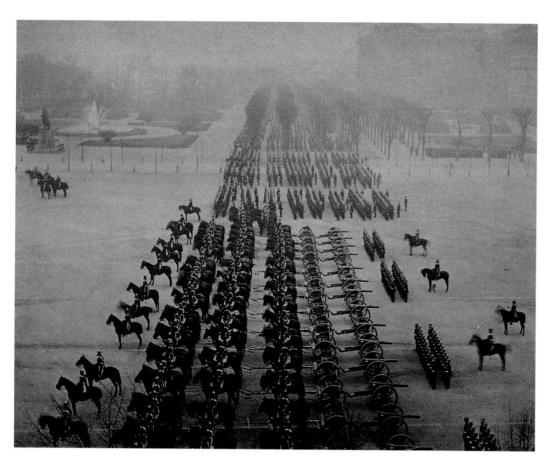

The Franco-Prussian War
Prussian horse artillery and infantry parade in Paris, 1871. Images like this were later to fuel the outbreak of Europe's two biggest wars.

Der Deutsch-Französische Krieg
Parade der preußischen reitenden Artillerie und Infanterie in Paris, 1871. Bilder wie dieses sollten später Zündstoff für den Ausbruch der beiden größten Kriege in Europa liefern.

La guerre franco-allemande
Parade de l'infanterie et de l'artillerie montée prussiennes à Paris en 1871. De telles images devaient contribuer plus tard à allumer les deux plus grandes guerres que connut l'Europe.

Amérique, France et Grande-Bretagne – à installer des concessions en Chine, à pénétrer à l'intérieur du pays pour y ouvrir des comptoirs le long des fleuves et établir des missions religieuses.

La guerre la plus innovatrice et la plus meurtrière du 19e siècle fut la guerre de Sécession (1861-65). Au début, la Confédération sudiste eut un léger avantage avec son armée de quelque 112 000 hommes. Le Nord qui luttait pour préserver l'Union avait plus de soldats à sa disposition, 150 000 environ, mais la plupart étaient des conscrits inexpérimentés. Les Etats du Sud avaient en Robert E. Lee, James Longstreet et Thomas Stonewall Jackson les meilleurs des généraux, mais le Nord avait un président de génie, Abraham Lincoln, qui s'affirma être un stratège à l'instinct infaillible, à défaut de formation militaire. Le Nord était en mesure de mobiliser une société entièrement industrialisée, un facteur qui s'avérerait décisif. Il pouvait faire appel à 25 millions d'habitants, le Sud, plus rural, à neuf millions seulement.

L'utilisation du chemin de fer, de la navigation fluviale, du navire et du cuirassé à vapeur, du fusil chargé par la culasse et de pièces d'artillerie devint courante au cours de cette guerre, un modèle de guerre qui devait s'imposer pendant près d'un siècle. Le télégraphe et la surveillance aérienne par ballon s'étaient répandus. Le reportage photographique pouvait se faire dorénavant sur le théâtre même des opérations. On est loin des poses théâtrales des photographies de la guerre de Crimée. En 1862, Richard Gatling avait mis au point la première mitrailleuse automatique dont onze exemplaires furent utilisés pendant la guerre de Sécession. La mitrailleuse augmentait considérablement les chances de parer les attaques ennemies en terrain découvert contre des positions défensives.

En 1865, Lee et son armée furent encerclés et capitulèrent à Appomattox en Virginie. Lee et Ulysses S. Grant, le plus grand des généraux nordistes, montrèrent tous deux l'importance de la manœuvre: se déplacer autour d'objectifs en feintant l'ennemi pour prendre des positions bien préparées et défendues par un armement moderne – fusils, mitrailleuses et artillerie – était devenu capital. Une leçon que les écoles militaires européennes seront longues à apprendre.

La guerre franco-allemande de 1870-71 aurait pu être aussi un bon enseignement. Une armée française mal organisée et équipée sous les ordres de Napoléon III entreprit de contenir les ambitions de la Prusse qui venait de faire la guerre à l'Autriche et au Danemark, sous la pression d'un Bismarck voulant mener à bien sa politique d'unité allemande. Les Français optimistes chantaient qu'ils allaient s'emparer de Berlin. Les Allemands commandés par le général Helmuth von Moltke, un génie de la stratégie moderne, étaient mieux organisés. L'armée française, après en avoir fait presque découdre aux Allemands à Saint-Privet, fut défaite à Sedan. Parmi les prisonniers de guerre se trouvait Napoléon III lui-même.

L'armée allemande se dirigea sur Paris et investit la ville au début de l'année 1871. L'armistice enlevait l'Alsace-Lorraine à la France. L'empereur Napoléon III fut déchu et la Troisième République proclamée. Cependant, en 1871, les Parisiens élevèrent des barricades puis constituèrent un gouvernement révolutionnaire, la Commune.

Cette guerre avait mis en lumière un fait nouveau: la force militaire de l'Allemagne. Celle-ci resterait un enjeu pour la stabilité en Europe pendant 120 ans.

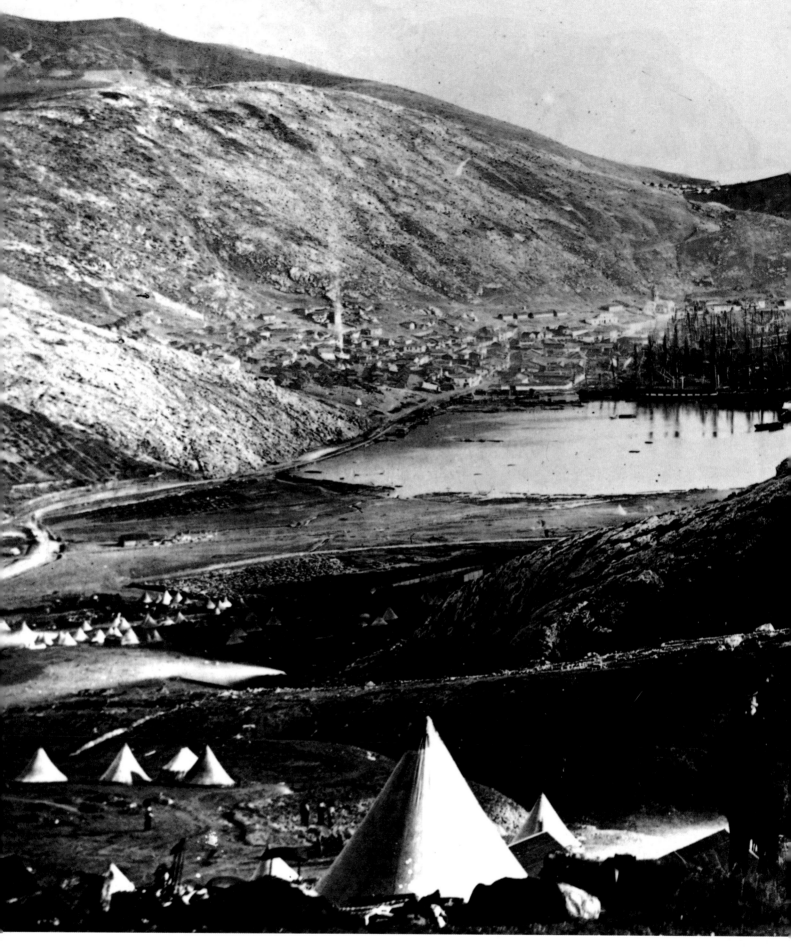

Conditions in the Crimea

The camp of the British Foot Guards at Balaclava in the winter of 1854-55. Conditions were squalid, and food and fodder so short that more men and horses died from disease and malnutrition than from bullets. A report in 1857 said that the incidence of disease in the army was twice that of the civilian population in Britain.

Die Zustände auf der Krim

Das Lager der britischen Garderegimenter in Balaklawa im Winter 1854-55. Überall herrschte Schmutz; Lebensmittel und Tierfutter waren so knapp, daß mehr Männer und Pferde an Krankheiten und Unterernährung starben als an Schußwunden. Nach einem Bericht von 1857 war der Krankenstand in der Armee doppelt so hoch wie bei der britischen Zivilbevölkerung.

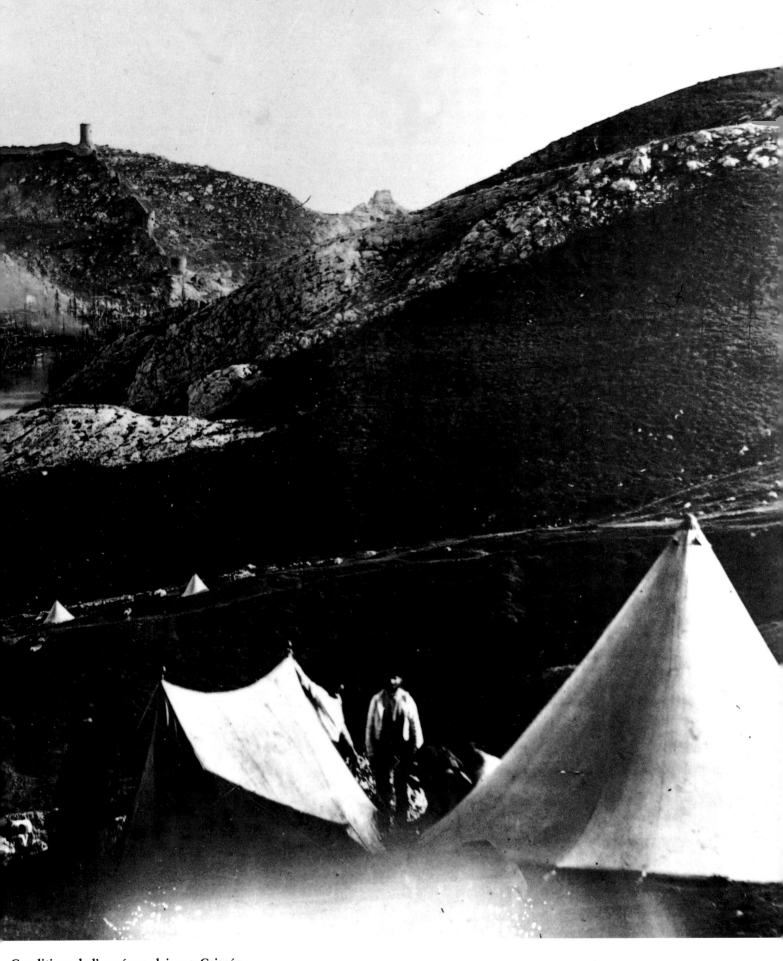

Conditions de l'armée anglaise en Crimée
Le cantonnement des fantassins à Balaklava pendant l'hiver 1954-55.
Les conditions étaient catastrophiques, la nourriture et le fourrage si
rares que les soldats et les chevaux mouraient plus de maladie et de
sous-alimentation que de balles. Un rapport de 1857 révéla que la
fréquence des maladies chez les soldats était deux fois supérieure à
celle de la population civile britannique.

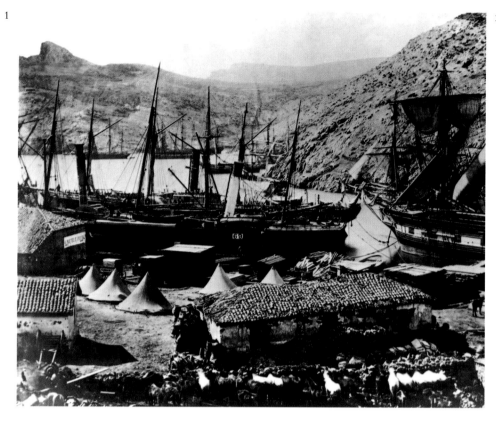

Logistics

Crimean logistics proved a nightmare for all armies. Clothes and boots came in the wrong shapes and sizes; one infamous consignment was of left boots only. (1) Ships at Cossack Bay, Balaclava. (2) Mortar teams rest easy during the siege of Sevastopol. (3) French and British soldiers fraternise in the lines before Sevastopol. (4) Camp of the 97th Infantry before the last attacks on Sevastopol.

Logistik

entwickelte sich im Krimkrieg zum Alptraum. Kleidung und Schuhe kamen in den falschen Formen und Größen an; eine besonders berüchtigte Lieferung bestand nur aus linken Stiefeln. (1) Schiffe in der Kosakenbucht vor Balaklawa. (2) Mörserbesatzungen legen während der Belagerung von Sewastopol eine Pause ein. (3) Französische und britische Soldaten verbrüdern sich vor Sewastopol. (4) Das Lager des 97. Infanteriebataillons vor dem letzten Angriff auf Sewastopol.

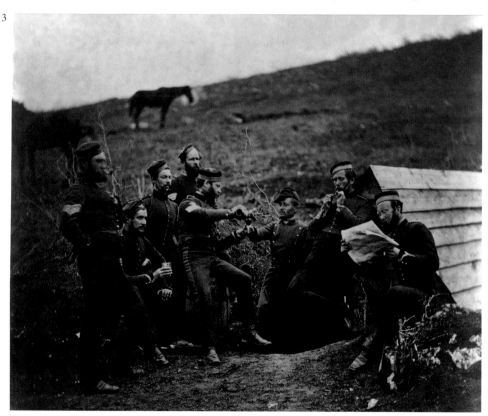

Logistique

En Crimée, le cauchemar des belligérants fut la logistique. Vêtements et bateaux étaient livrés dans des tailles et des formes inadéquates; l'exemple le plus honteux fut l'envoi de bottes pour le seul pied gauche. (1) Navires dans la baie de Cossack à Balaklava. (2) Des artilleurs dorment sur leurs deux oreilles pendant le siège de Sébastopol. (3) Soldats français et anglais fraternisant sur les lignes de Sébastopol. (4) Camp du 97ᵉ bataillon d'infanterie avant les derniers assauts sur la ville.

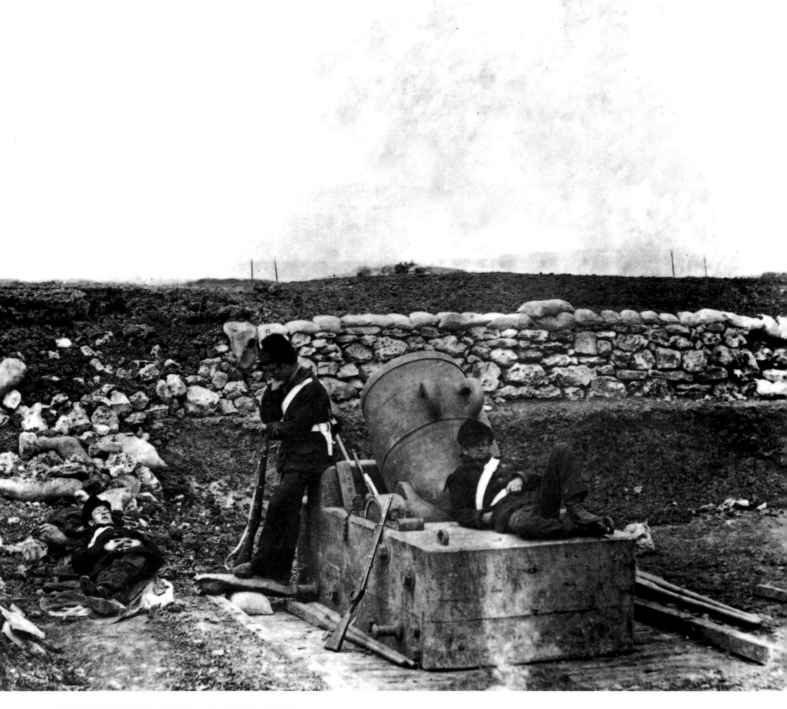

4

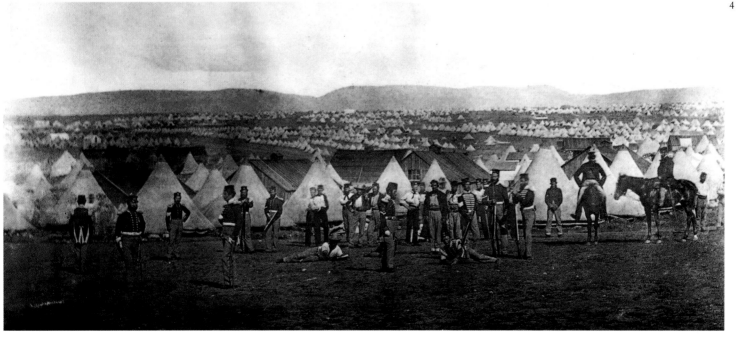

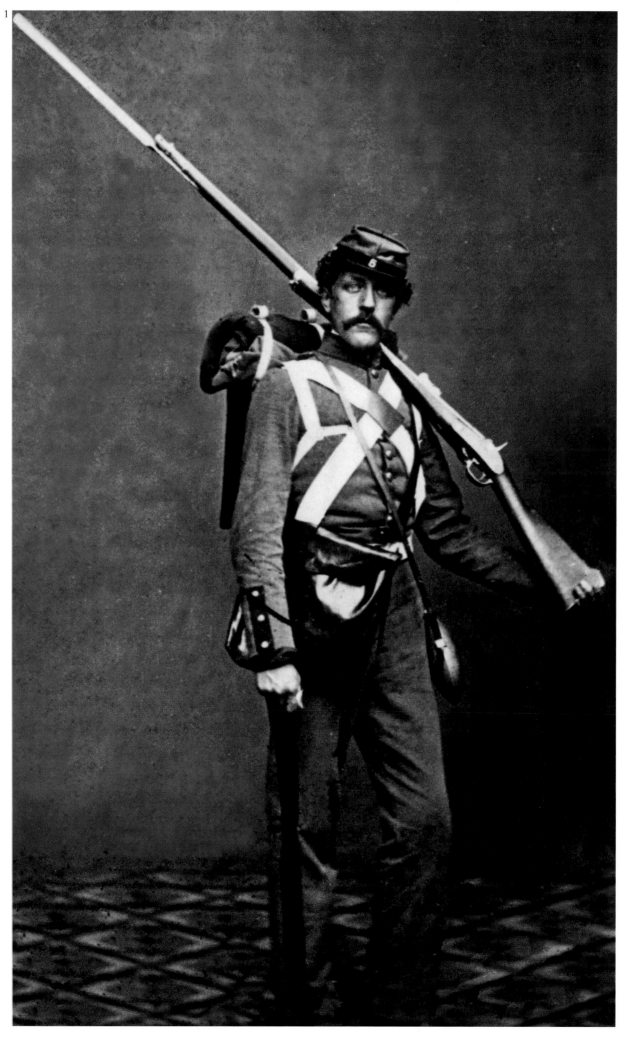

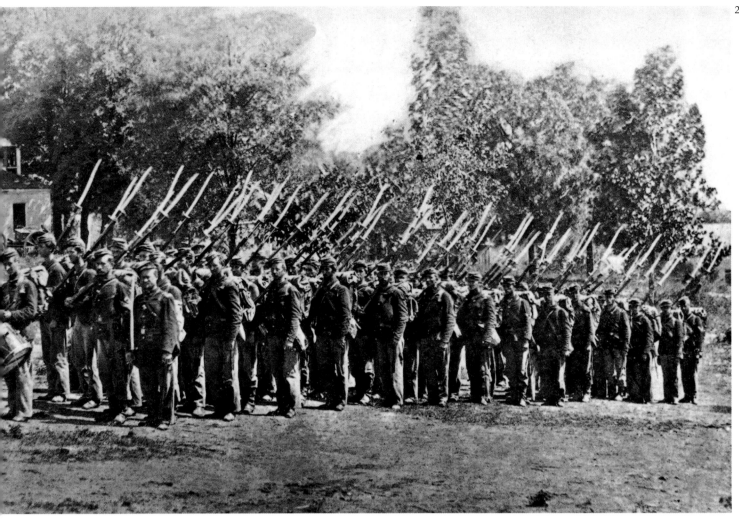

The American Civil War

Nearly all the soldiers of both sides were called up from civilian life – there were few professionals – and went into battle with a modicum of training. (1) A 'reb' Confederate infantryman. Note the enormous length of his bayonet, which was often used for the murderous fighting in the trenches at Gettysburg, Antietam and Vicksburg. (2) A Company of Infantry parades at Harper's Ferry, which Stonewall Jackson took on 15 September 1862. (3) A Confederate sniper killed at Gettysburg, July 1863.

Der Amerikanische Bürgerkrieg

Fast alle Soldaten auf beiden Seiten waren von Hause aus Zivilisten – es gab kaum Berufssoldaten –, die nur ein Minimum an Ausbildung erhielten, ehe sie in die Schlacht zogen. (1) Ein Infanterist aus den Reihen der konföderierten »Rebellen«. Auffällig ist die gewaltige Länge der Bajonetts, einer Waffe, die bei den blutigen Kämpfen in den Schützengräben von Gettysburg, Antietam und Vicksburg häufig zum Einsatz kam. (2) Siegreiche Infanteristen ziehen durch Harpers Ferry, das Stonewall Jackson am 15. September 1862 einnahm. (3) Ein konföderierter Scharfschütze, der im Juli 1863 bei Gettysburg ums Leben kam.

La guerre de Sécession

L'armée était constituée – il y avait peu de soldats de métier – de civils mobilisés partant à la guerre après une sommaire instruction militaire. (1) Un fantassin de l'armée confédérée. Remarquez la longueur de sa baïonnette souvent utilisée dans les combats meurtriers de Gettysburg, d'Antietam et de Vicksburg. (2) Une compagnie d'infanterie défilant à Harper's Ferry, pris par Stonewall Jackson le 15 septembre 1862. (3) Un tireur isolé confédéré tué à Gettysburg en juillet 1863.

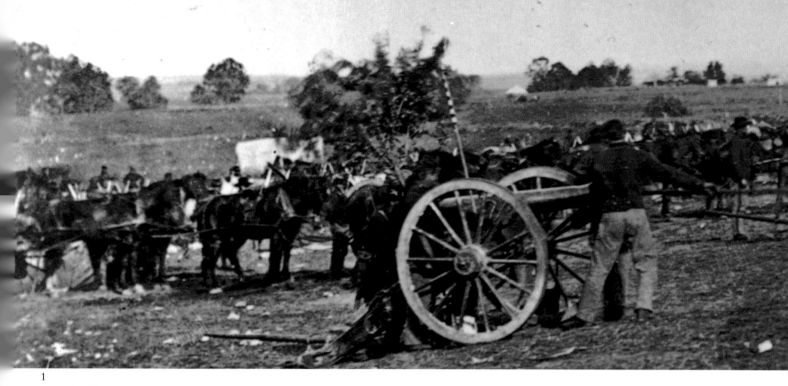

1

Artillery

Artillery helped lend superiority to the defenders in static warfare. (1) The guns of Battery D, 5th US (Federal) Artillery, being laid for action. (2) Guns and crews of the 1st Connecticut Artillery parading at Fort Richardson, Arlington, Virginia. The Arlington home of Robert E. Lee was to become the nation's war memorial. (3) The Dictator, the heaviest gun of the war, used by federal forces in the closing stages in 1865.

Artillerie

verschaffte den Verteidigern im Stellungskrieg entscheidende Vorteile. (1) Die Geschütze der Batterie D der 5. US-(Bundes-)Artillerie werden in Gefechtsstellung gebracht. (2) Parade der Geschütze und Mannschaften der 1. Connecticut-Artillerie in Fort Richardson, Arlington, Virginia. Auf dem Anwesen von Robert E. Lee in Arlington entstand später die nationale Gedenkstätte für Kriegsopfer. (3) Der »Diktator«, das schwerste Geschütz des Krieges, wurde von Bundestruppen 1865 in der letzten Phase des Krieges eingesetzt.

Artillerie

L'artillerie permettait aux défenseurs de s'assurer la supériorité dans la guerre de positions. (1) Canons de la batterie D, 5e bataillon d'artillerie fédéral, mis en action. (2) Armes et hommes du 1er bataillon d'artillerie du Connecticut déployés au Fort Richardson à Arlington, Virginie. La maison de Robert E. Lee à Arlington allait devenir le monument aux morts national. (3) Le « Dictateur », le plus gros canon de la guerre, fut utilisé par les fédéraux au cours des dernières phases du conflit, en 1865.

2

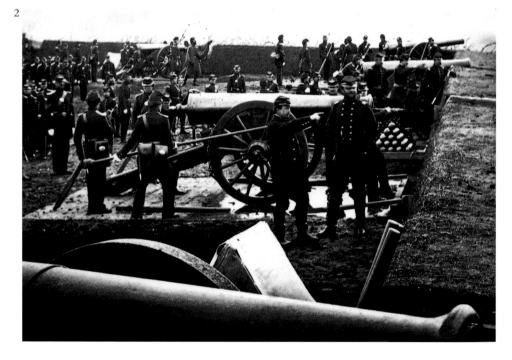

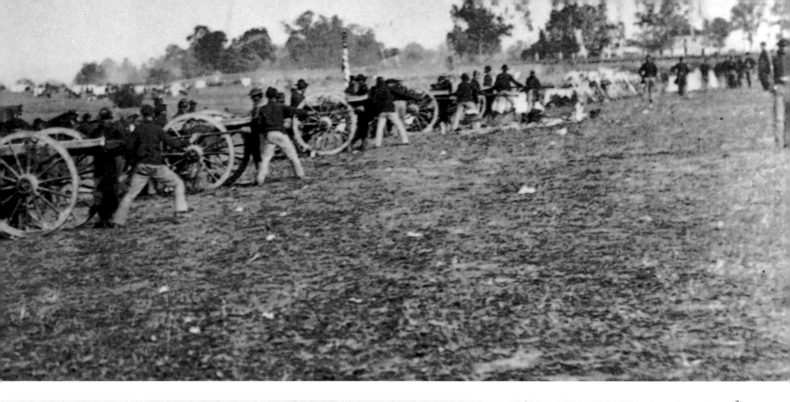

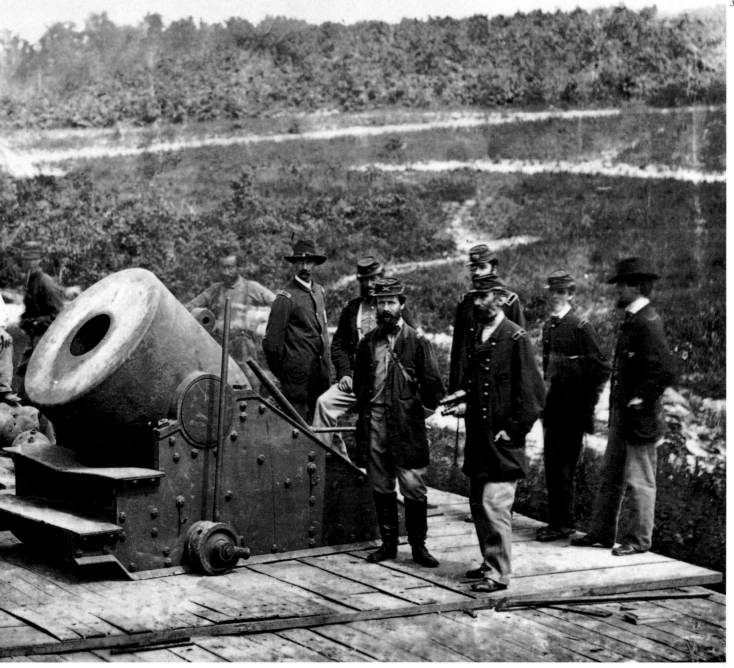

1

2

3

The Second Chinese Opium War
(1) British troops celebrate after taking the Taku Forts, Tientsin. (2) Chinese militia from up-country, armed with clubs and wicker shields. (3) The scene at the entrance of the Taku Forts on the Peiho River just after they were stormed. The treaties signed in 1860 after the campaign opened up the Chinese interior to western trade and missionaries.

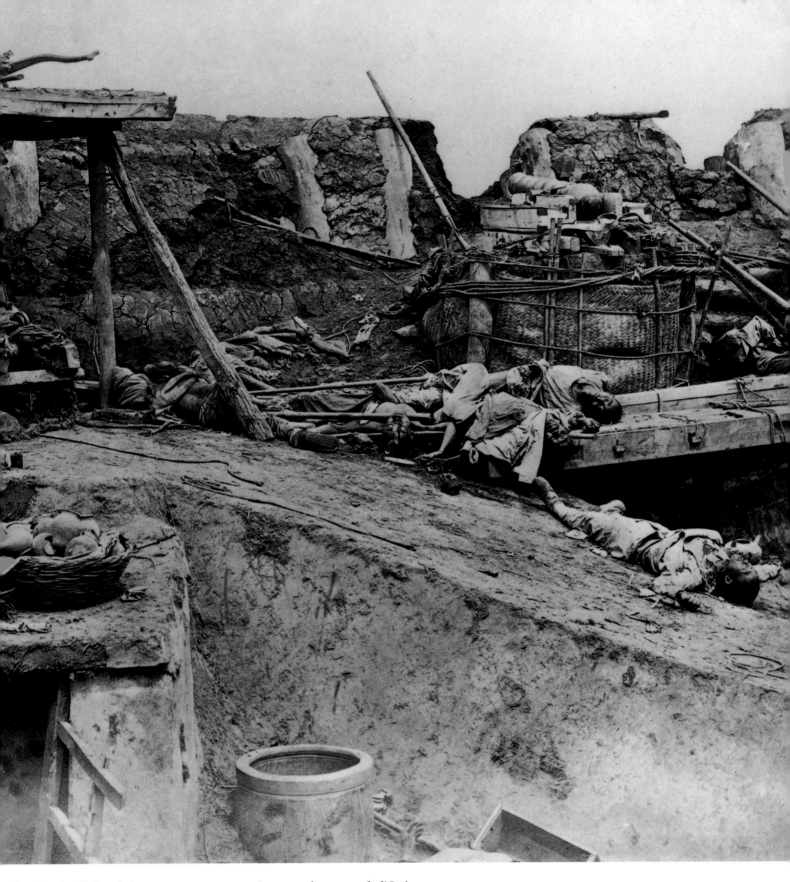

Der Zweite Opiumkrieg

(1) Britische Soldaten feiern die Einnahme der Takuforts bei Tientsin. (2) Chinesische Soldaten aus dem Landesinneren, bewaffnet mit Keulen und geflochtenen Schilden. (3) Der Zugang zu den Takuforts am Fluß Haiho unmittelbar nach ihrer Erstürmung. Die Verträge, die nach Beendigung des Feldzugs 1860 unterzeichnet wurden, öffneten das Landesinnere Chinas für westliche Händler und Missionare.

La seconde guerre de l'Opium

(1) Les troupes britanniques fêtent la prise des forts de Taku à T'ien-Tsin. (2) Milices chinoises de l'intérieur armées de massues et de boucliers d'osier. (3) Scène à l'entrée des forts Taku sur la rivière Peiho juste après leur prise. Les traités signés en 1860 ouvraient l'intérieur de la Chine au commerce et aux missionnaires occidentaux.

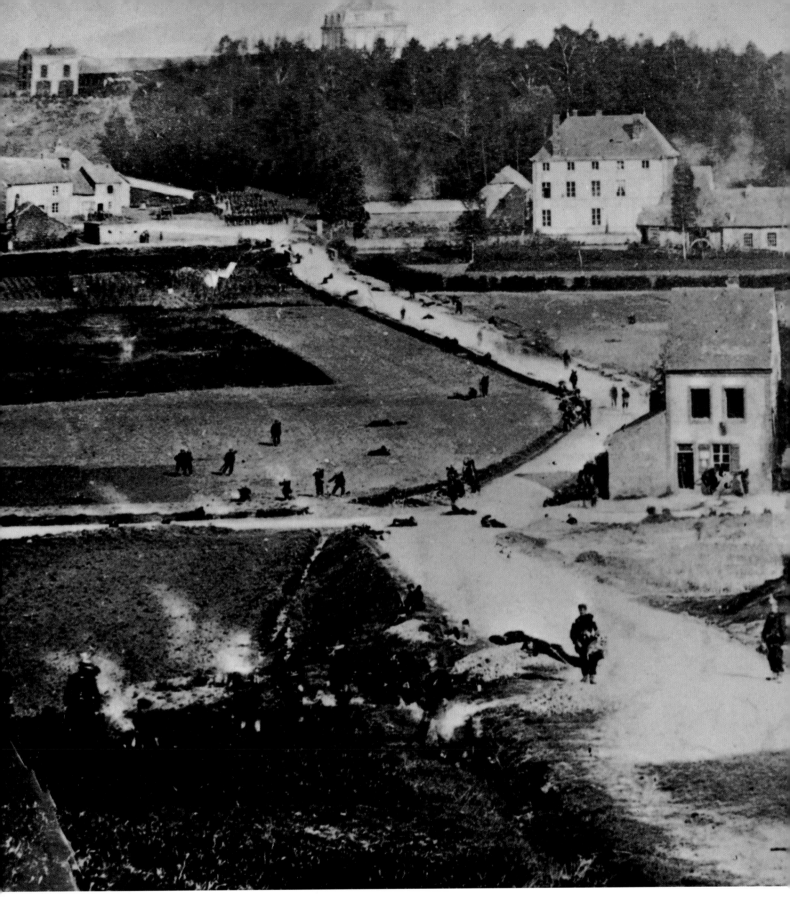

The Franco-Prussian War

Prussian infantry advancing in the battle of Sedan (1870). This is one of the first great action shots of war photography. The picture appears to be taken from the French positions. Sedan was to open up the advance.

Der Deutsch-Französische Krieg

Das Vorrücken der preußischen Infanterie in der Schlacht von Sedan (1870). Dies ist eine der ersten großen Schlachtaufnahmen in der Geschichte der Kriegsfotografie. Das Bild wurde vermutlich von den französischen Stellungen aus aufgenommen. Der Sieg bei Sedan machte den Weg frei für den deutschen Vormarsch auf Paris.

La guerre franco-allemande

Progression de l'infanterie prussienne pendant la bataille de Sedan (1870). Ceci est l'une des premières grandes photographies de guerre. Le cliché semble avoir été pris depuis les positions françaises. Sedan devait permettre l'avancée des Allemands.

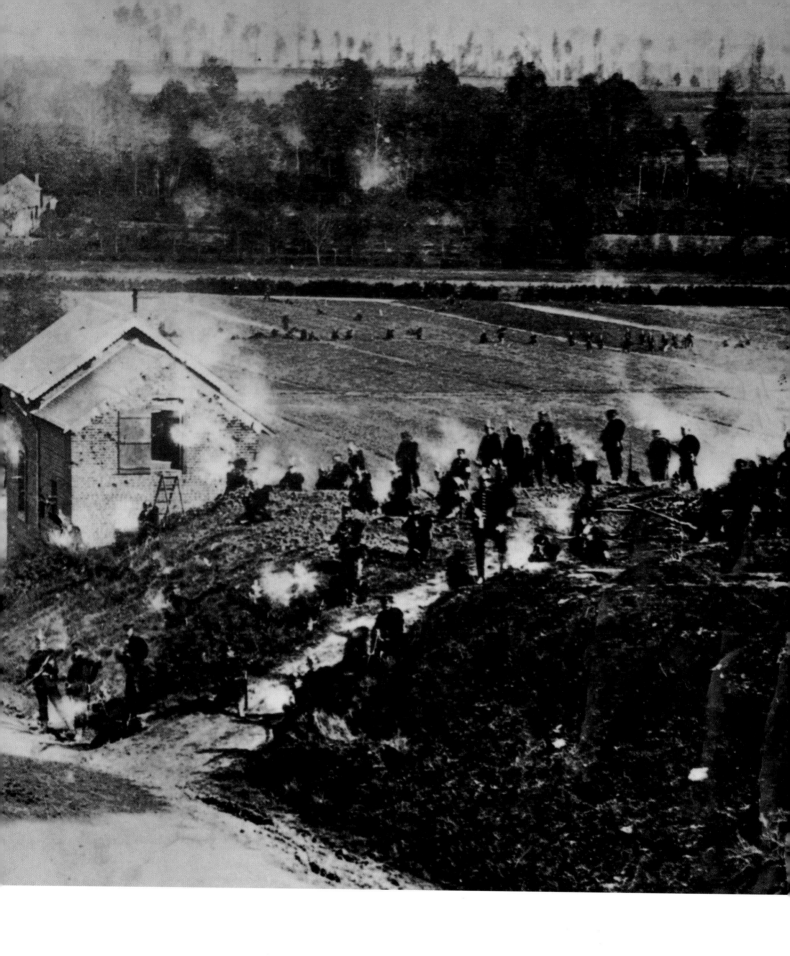

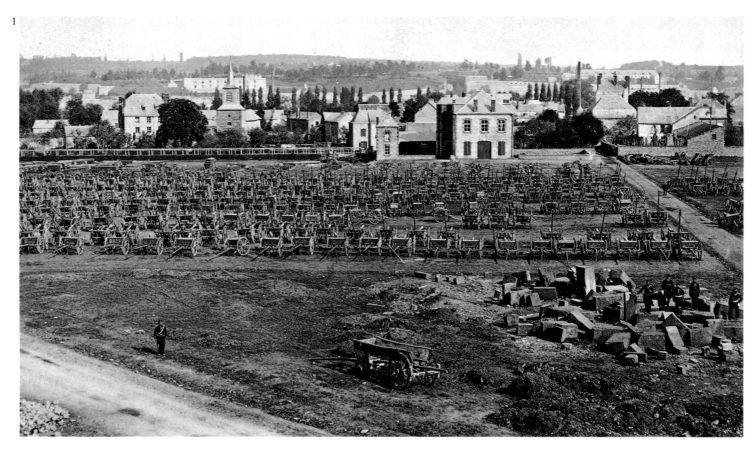

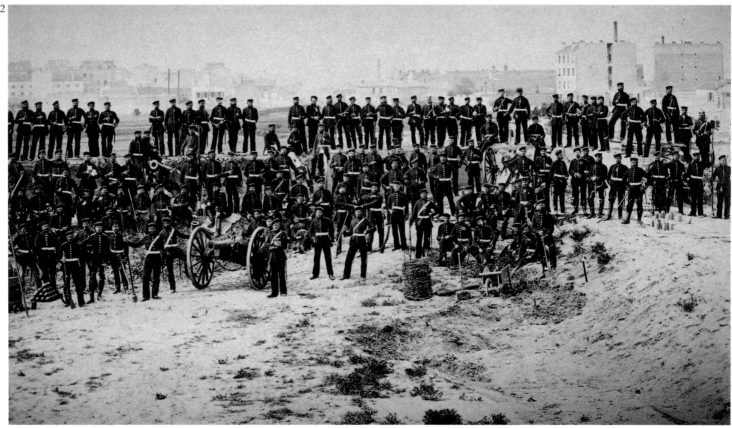

Prussia Victorious

(1) The French, later German, encampment before Sedan. (2) Prussian artillery at the fort of d'Aubervilles. Though superior in artillery, the Germans took heavier casualties in the war. (3) German gunners with the ammunition resupply on the day Sedan fell, 2 September 1870. (4) The victorious parade before the Palace of St-Cloud. Note the waggon trains before the building – horses were still the vital element of logistics and manoeuvre in war.

Das siegreiche Preußen

(1) Das französische, später deutsche Truppenlager vor Sedan. (2) Preußische Artillerie am Fort von Aubervilles. Trotz ihrer überlegenen Artillerie erlitten die Deutschen schwerere Verluste. (3) Deutsche Kanoniere mit Munitionsnachschub, fotografiert am 2. September 1870, dem Tag als Sedan fiel. (4) Die Siegesparade vor dem Schloß von Saint-Cloud. Die Ansammlung von Pferdewagen vor dem Gebäude macht deutlich, daß Pferde nach wie vor unverzichtbar für den Nachschub und die Manövrierfähigkeit der Truppen waren.

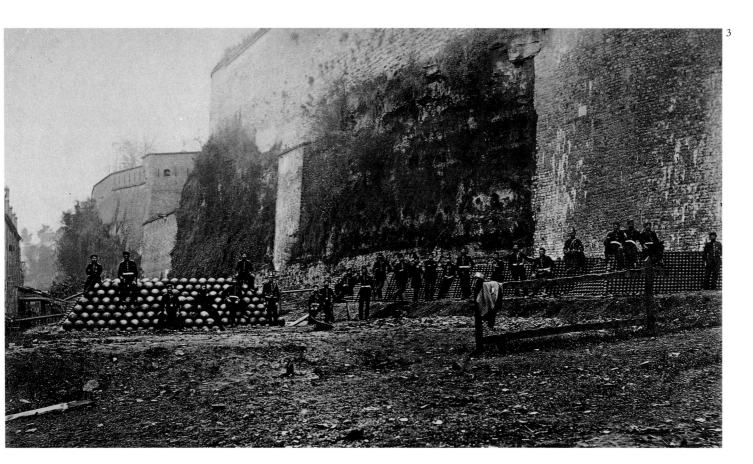

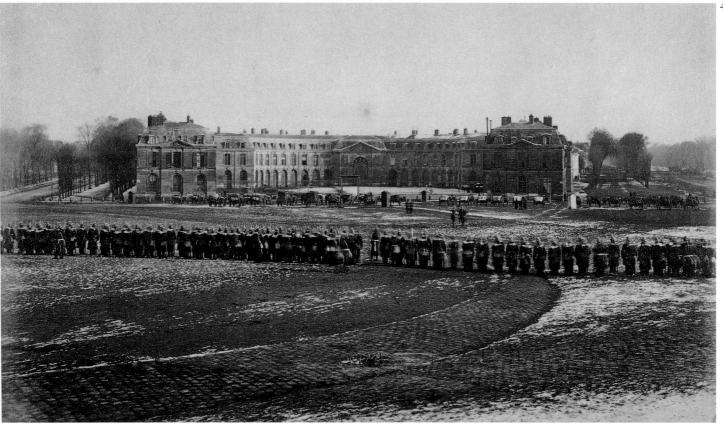

Victoire de la Prusse

(1) Le campement français, plus tard allemand, devant Sedan. (2) Artillerie prussienne au fort d'Aubervilles. Bien que supérieurs par leur artillerie, les Allemands accusèrent de plus lourdes pertes. (3) Artilleurs allemands avec leur stock de munitions le jour de la chute de Sedan (2 septembre 1870). (4) Vainqueurs paradant devant le château de Saint-Cloud. A remarquer le convoi de chariots devant l'édifice – à l'époque, les chevaux jouent encore un rôle capital dans la logistique et la manœuvre de guerre.

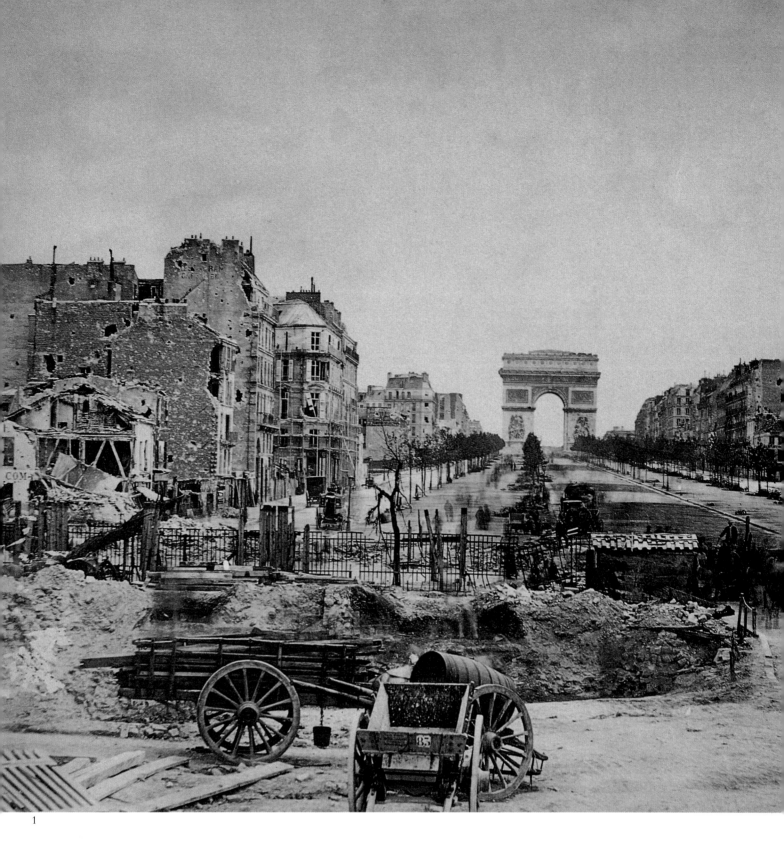

1

War in the City

After coming under siege from the Prussians, and surrendering in January 1871, the Paris authorities suffered the spontaneous revolt of radicals declaring the Paris Commune. (1) A barricade at the Porte Maillot, 23-29 May 1871. (2) A gun before the barricade at the Rue Castiglione. (3) The photographer and aeronaut Gaspard-Félix Nadar supervising the inflation of his balloons; they were used extensively during the war. Léon Michel Gambetta, founder of the Third Republic, escaped the siege of Paris in one to organise French resistance outside the capital.

Krieg in der Stadt

Nach der Belagerung durch die Preußen und der Kapitulation im Januar 1871 sahen sich die Pariser Behörden mit einem spontanen Aufstand radikaler Kräfte konfrontiert, die die Pariser Kommune ausriefen. (1) Eine Barrikade an der Porte Maillot, 23.-29. Mai 1871. (2) Ein Geschütz vor der Barrikade an der Rue Castiglione. (3) Der Fotograf und Ballonfahrer Gaspard-Félix Nadar überwacht das Aufblasen seiner Ballons; solche Ballons kamen während des Krieges häufig zum Einsatz. Léon Michel Gambetta, der Begründer der Dritten Republik, floh per Ballon aus dem belagerten Paris, um außerhalb der Hauptstadt den französischen Widerstand zu organisieren.

La ville en guerre

Après le siège et la reddition de Paris en janvier 1871, le gouvernement dut faire face à une insurrection populaire spontanée et à la proclamation de la Commune. (1) Barricade porte Maillot, 23-29 mai 1871. (2) Canon devant la barricade de la rue Castiglione. (3) Gaspard-Félix Nadar, photographe et aéronaute, surveillant le gonflement de ses ballons qui serviront beaucoup pendant la

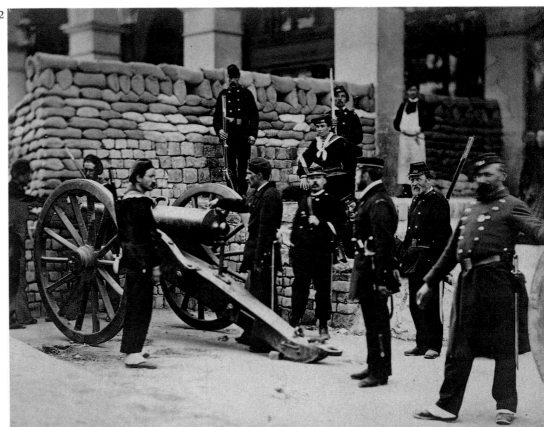

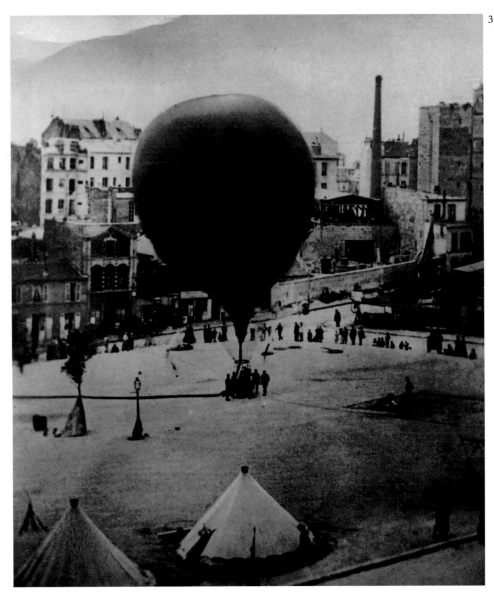

guerre. C'est dans l'un de ces ballons que
Gambetta, fondateur de la Troisième
République, fuit la capitale assiégée pour
organiser la résistance à l'ennemi depuis la
province.

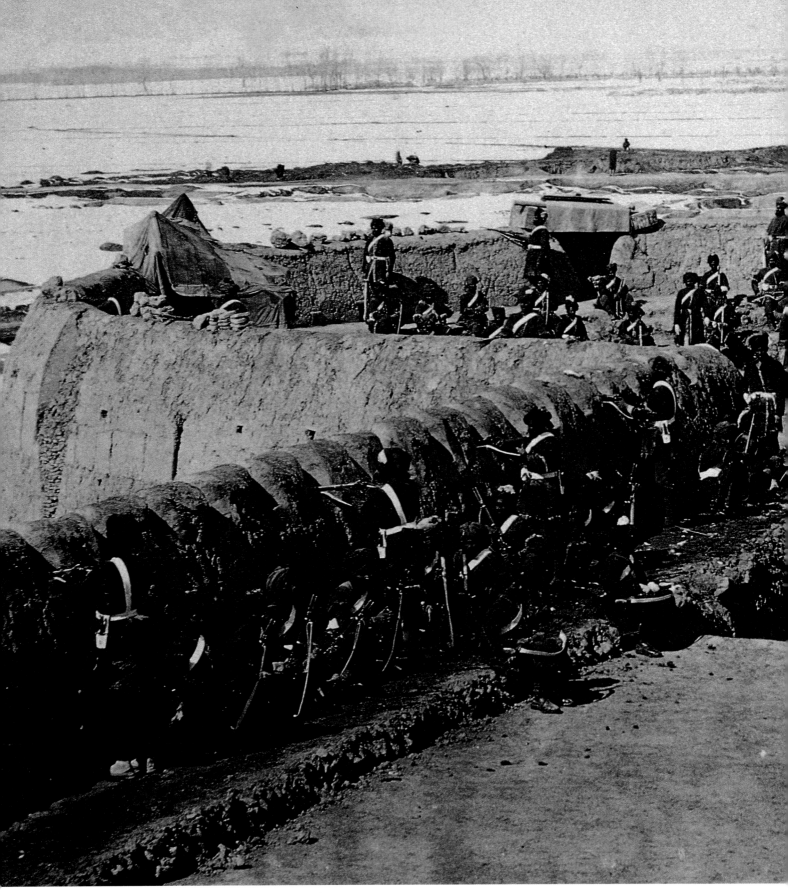

The Second Afghan War, 1

Afghanistan in the 19th century was sandwiched between the Russian and British Empires, competing for control of the North-West Frontier. In the First Afghan War (1839-42), the British succeeded in capturing Kabul, but virtually the whole brigade was lost in an ambush by local tribesmen. No outside power was able to control this violent cocktail of a dozen nations and hundreds of tribes, as the Russians were to discover 100 years later. (Above) In the Second Afghan War (1878-80) General Sir Frederick Roberts occupied Kabul, with well prepared fortifications to withstand a siege.

Der Zweite anglo-afghanische Krieg, 1

Afghanistan lag im 19. Jahrhundert im Spannungsfeld zwischen den russischen und britischen Interessensphären, die um die Kontrolle der Nordwestgrenze Britisch-Indiens rangen. Im Ersten anglo-afghanischen Krieg (1839-42) gelang es den Briten, Kabul einzunehmen, doch beim Rückzug wurde fast die gesamte Brigade in einem Hinterhalt von einheimischen Stammeskämpfern aufgerie-

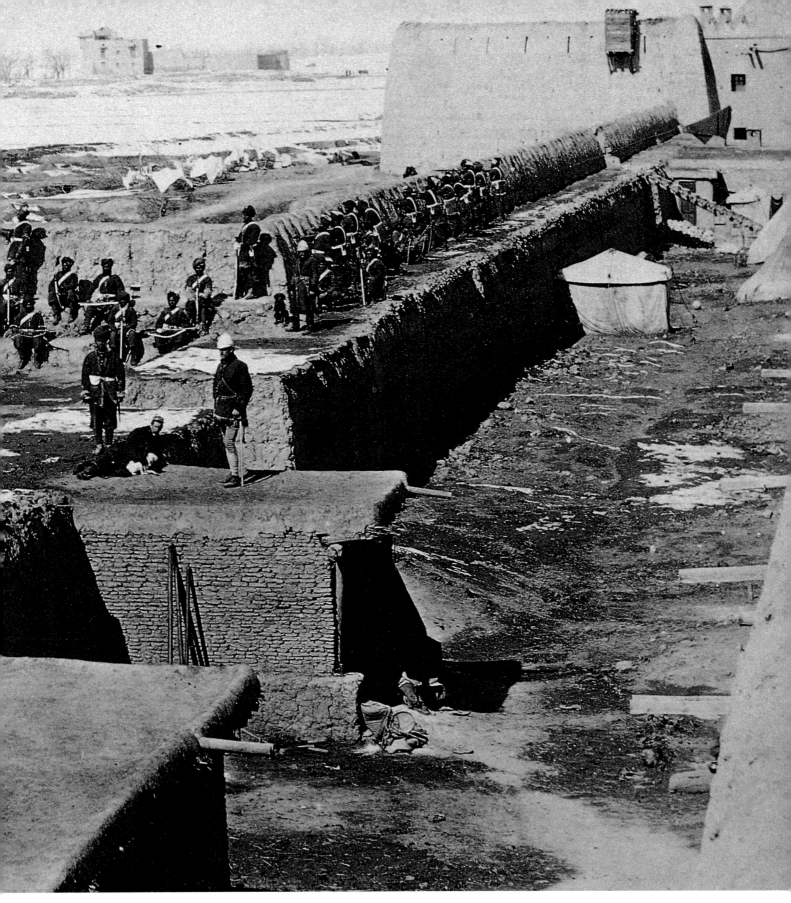

ben. Keine auswärtige Macht war in der Lage, diese explosive Mischung, die aus einem Dutzend verschiedener Nationen und Hunderten von Stämmen bestand, unter Kontrolle zu halten – das mußten auch die Russen 100 Jahre später erneut feststellen. (Oben) Im Zweiten anglo-afghanischen Krieg (1878-80) eroberte General Frederick Roberts Kabul; dank gut vorbereiteter Befestigungsanlagen hielt er einer Belagerung stand.

La seconde guerre afghane, 1
Au 19ᵉ siècle, l'Afghanistan était pris en étau entre l'Empire russe et l'Empire britannique qui se disputaient le contrôle de la frontière du Nord-Ouest. Lors de la première guerre afghane (1839-42), les Anglais réussirent à prendre Kaboul, mais presque toute la garnison qui se retira en janvier 1842 fut massacrée dans une embuscade tendue par une tribu locale. Aucune puissance étrangère

ne put jamais prendre le contrôle d'une douzaine de nations et d'une centaine de tribus composant un cocktail explosif; les Soviétiques en feront l'expérience un siècle après. (Ci-dessus) Pendant la seconde guerre afghane (1878-80), le général Frederick Roberts occupa Kaboul ceinte de fortifications capables de résister à un siège.

The Second Afghan War, 2

(1) A group of Roberts' officers. (2) Local tribesmen were a law unto themselves. (3) Roberts had to consult frequently with the leadership, or *Sirdars,* in Kabul. (Overleaf) The Bala Bug near Kabul. The terrain of high passes and narrow river valleys tipped the odds heavily against outsiders. When Roberts' force withdrew he needed 120 camels to move his personal effects alone.

Der Zweite anglo-afghanische Krieg, 2

(1) Eine Gruppe von Roberts' Offizieren. (2) Die Angehörigen der einheimischen Stämme lebten nach ihren eigenen Gesetzen. (3) In Kabul mußte Roberts sich oft mit den lokalen Anführern, den *Sirdars,* beraten. (Folgende Doppelseite) Bala Bagh in der Nähe von Kabul. Mit seinen hohen Pässen und engen Flußtälern war Afghanistan für Ortsfremde ein außerordentlich schwieriges Terrain. Als seine Truppen sich zurückzogen, benötigte Roberts allein für den Transport seiner persönlichen Besitztümer 120 Kamele.

La seconde guerre afghane, 2

(1) Groupe d'officiers de Roberts. (2) Les tribus locales ne connaissaient d'autre loi que la leur. (3) Roberts devait souvent consulter les chefs, les *Sirdars.* (Page suivante) Le Bala Bug près de Kaboul. Le terrain accidenté – cols élevés et vallées encaissées – laissait peu de chances aux envahisseurs étrangers. Quand son armée se retira, il fallut à Roberts 120 chameaux pour transporter ses seuls effets personnels.

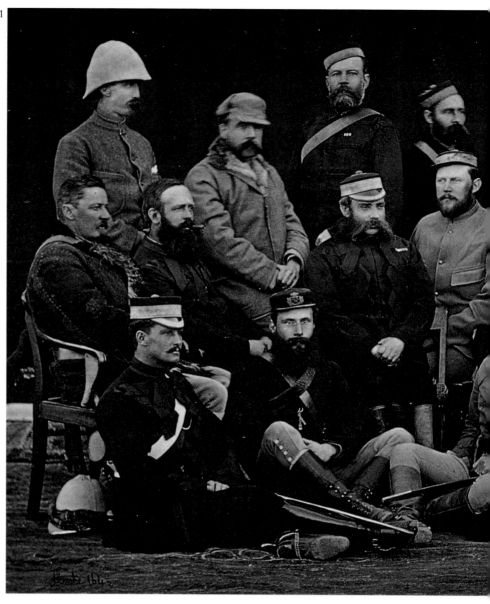

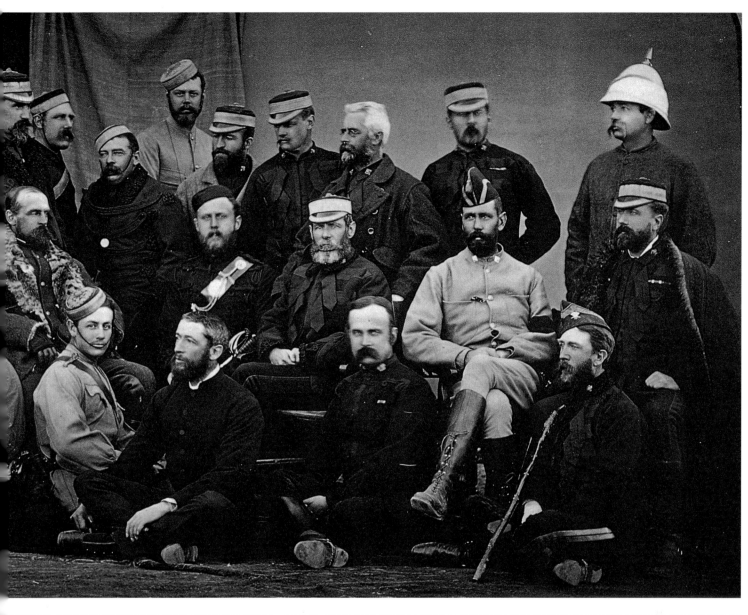

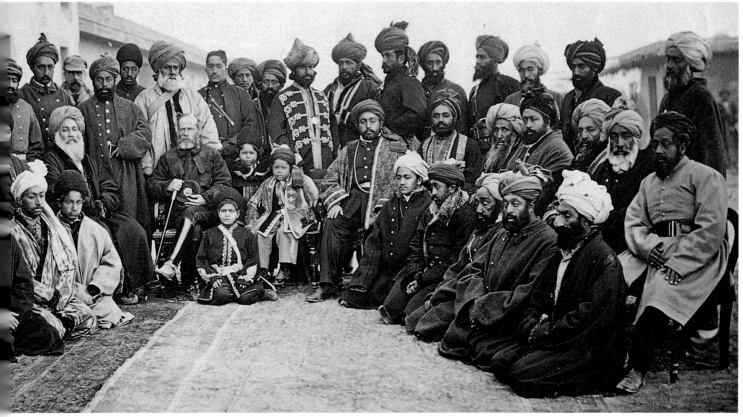

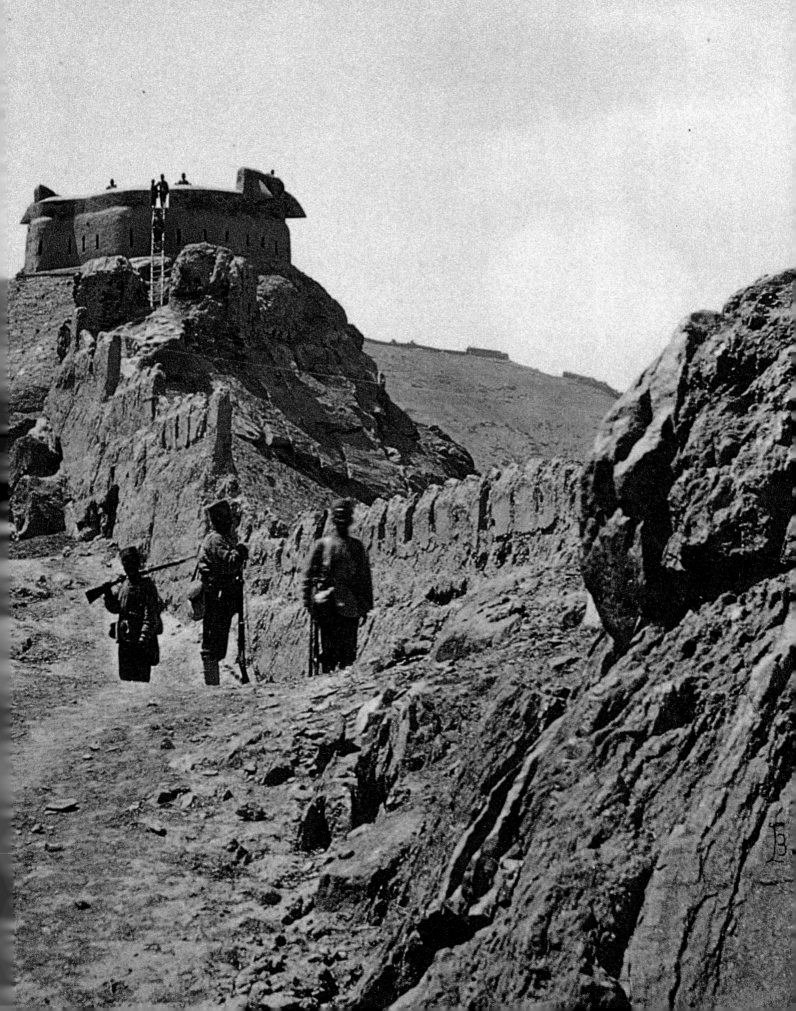

Britain and France led the powers in the huge expansion of empires at the close of the 19th century, and they competed fiercely in the scramble for African dependencies. Here Scottish soldiers show off at the Sphinx of Giza after they had won the battle of Tel-el-Kebir in 1882, which strengthened Britain's grip on Egypt in 'the veiled protectorate'.

England und Frankreich führten den Reigen der Mächte an, die Ende des 19. Jahrhunderts gewaltige Expansionsbestrebungen unternahmen und verbissen um den Erwerb von Kolonien in Afrika wetteiferten. Hier posieren schottische Soldaten vor der Sphinx von Giseh, nachdem sie durch ihren Sieg in der Schlacht von et-Tell el-Kebir (1882) die englische Herrschaft über Ägypten im »verschleierten Protektorat« gefestigt hatten.

A la fin du 19ᵉ siècle, la Grande-Bretagne et la France, rêvant de grands empires, se firent une concurrence effrénée pour mettre la main sur le continent africain. Nous voyons ici des soldats écossais poser devant le Sphinx de Gizeh après leur victoire à Tel el Kébir en 1882, victoire qui scella la mainmise de l'Angleterre sur l'Egypte dans le « protectorat voilé ».

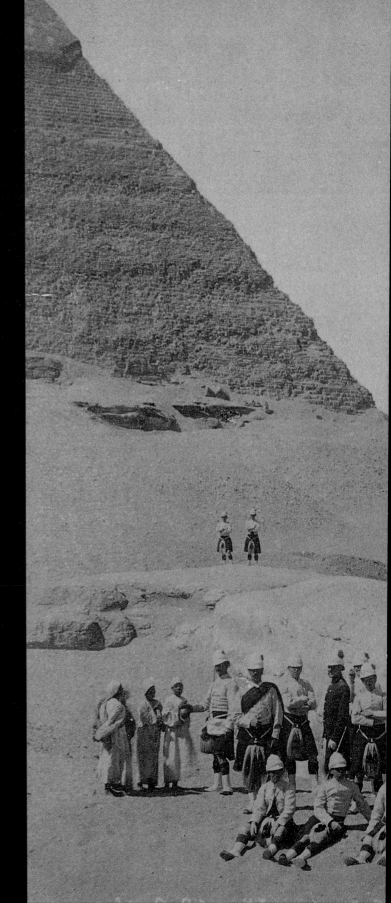

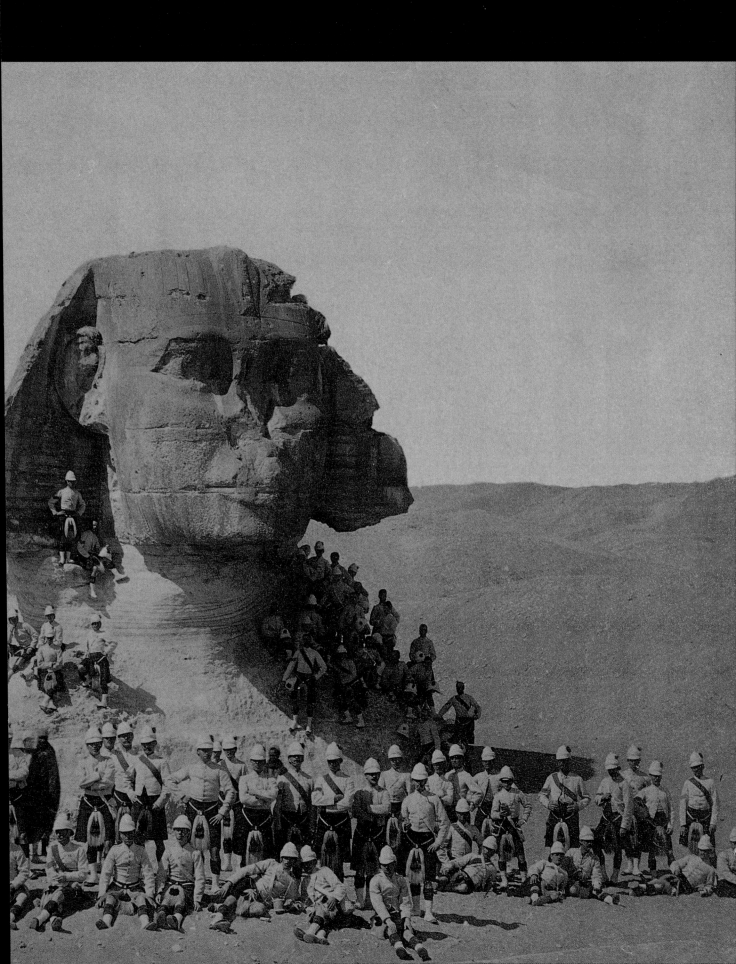

The Colonial Grab

From Egypt to the Balkan Wars

The race for overseas colonies and possessions accelerated in the closing decades of the 19th century; it was to contribute to the global clash of the First World War. The British Army had learned many of the lessons of the Crimean War, and though it suffered severe reverses, it succeeded in maintaining the Empire.

British control of Egypt was secured at the battle of Tel-el-Kebir in 1882, one of the few occasions in this era where they were up against a well-organised enemy. The Mahdi – or Islamic Saviour – was finally defeated at Omdurman on the upper Nile by General Sir Herbert Kitchener in 1898, where a mixed British, Sudanese and Egyptian force of 25,800 overwhelmed a force of 60,000 Dervishes. In the battle the greatly superior firepower of the 40 Maxim light machine guns, mounted on land and on river barges, was decisive.

Maxim guns were to save the day in the Zulu wars of 1879, which opened with the defeat of the British by the highly disciplined formations of Zulu warriors, *impis*, at Isandhlwana in Zululand – where the British had to withdraw after losing 1329 out of a force of 1500. That same night a garrison of 139 men, some of them sick, at the fort at Rorke's Drift held out against an attack by 4000 Zulus. Eleven men won the Victoria Cross, Britain's highest gallantry decoration, 15 were killed and the fort was relieved in the morning.

In 1899 the Boers sent a force into Natal, fearing they were about to be cut off in the Transvaal and Orange Free State from access to the sea. Within weeks the British were under siege in Kimberley, Mafeking and Ladysmith, and in 'black week', 10-15 December, suffered three defeats at Stormberg, Magersfontein and Colenso, with another at Spion Kop the following January. With Lord Roberts in command they forced the Boer army under Cronje to surrender in February 1900, and took Bloemfontein and Pretoria. In 1902 the Boers accepted British sovereignty.

New empires were won, but old ones were lost. When the US battleship *Maine* was sunk by a mine in Havana harbour, with a loss of 266 lives, the Americans demanded Spain leave Cuba. In the Spanish-American war of 1898 the Americans freed the Philippines and Cuba from Spanish imperial control. In the entire war the Americans lost one naval officer, 17 sailors, and 29 officers and 449 men in the army. The Spanish War was the vindication of the modern US navy, not least in its health care, as most of the fighting was in the worst tropical heat.

The most spectacular display of modern naval power came in the Russo-Japanese War (1904-5). The Japanese were bent on capturing Port Arthur, which they had ceded to the Russians in 1894, and with it large parts of Manchuria. After a series of defeats on land and sea, the Russians decided to despatch their Baltic Fleet on a 20,000-mile voyage to Japanese waters. As Admiral Rozhdestvensky's ships emerged from the fog off Tsushima on 27 May 1905, Admiral Togo's battle-cruisers, torpedo boats and destroyers opened fire. The Japanese line then 'crossed the T', cutting into the Russian fleet, which hardly managed to bring its battleships to bear: all were sunk. At the end of the day the Japanese lost only three torpedo boats and 117 men; only three Russian ships made it to Vladivostok, the rest being sunk or captured, with 4830 men killed and 5917 captured.

War photographers were systematically deployed for the first time in the wars that shook the Balkans from 1912 to 1913. The new Balkan nations had worked steadily to undermine their former imperial masters, Ottoman Turkey. The cosmopolitan Austro-Hungarian Empire was also vulnerable to the demands for autonomy from its national minorities, such as the Czechs, Hungarians, Slovaks and Croats. In 1912 the Balkan League, comprising Bulgaria, Serbia, Montenegro and Greece, demanded autonomy for Macedonia from Turkey. Hostilities broke out in October 1912 (the First Balkan War), with the Ottoman forces being pushed back from Macedonia. At Lule Burgas in Thrace the Turks lost 40,000 men, a mortal blow to their power in Europe. At the London conference in January 1913 Turkey gave up all lands in the Balkans except a small enclave west of Constantinople, and the emergence of a new Albanian state was confirmed.

Bulgaria lost most of her gains from the Turks in a disastrous war of August 1913 (the Second Balkan War), in which she turned on her former allies but was heavily beaten by Serbia and Greece. Turkey hung on to Adrianople, and the Serbs occupied Skopje, the present capital of the former Yugoslav Macedonia. Serbia had resented the Austrian hold on neighbouring Bosnia-Hercegovina since the Congress of Berlin in 1878; in 1908 the Serbs formally annexed Bosnia. On the Serbian national day, Vidovdan (St Vitus' Day), 28 June 1914, Gavrilo Princip, a member of the nationalist Young Bosnia movement, shot and killed the highly unpopular heir to the Austrian throne, Archduke Franz Ferdinand, in Sarajevo, the Bosnian capital. By then Europe's powers were caught in a set of interlocking alliances and pacts that made war all but inevitable once mobilisation started – particularly by the increasingly edgy imperial Germany, which felt more and more hemmed in by foes on land, France and Russia, and at sea by the might of the British Royal Navy.

Vienna blamed Serbia as the inspiration for the assassination, and issued an ultimatum, demanding the right to hold its own investigations in Serbia itself. The ultimatum was finally refused on 28 July, by telegram. Wireless telegraphy

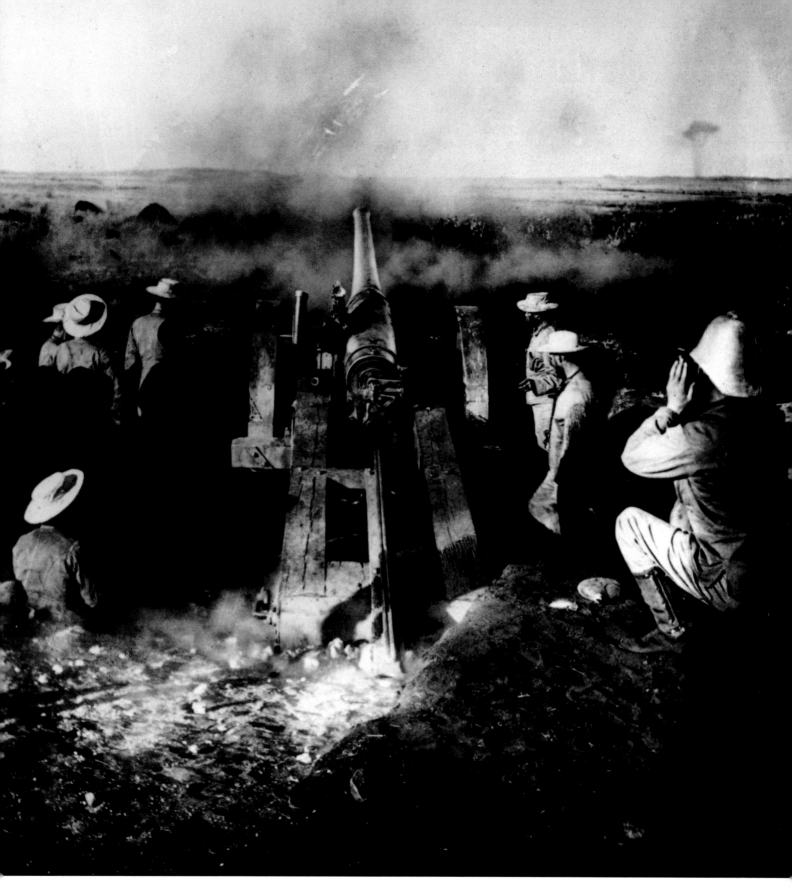

The Boer War
A 4.7-inch gun, 'Joe Chamberlain' of the Naval Brigade, giving covering fire at Magersfontein – scene of one of the 'black week' defeats of the British by the Boers in 1899.

Der Burenkrieg
Ein 4,7-Zoll-Geschütz der Marinebrigade mit dem Spitznamen »Joe Chamberlain« gibt Feuerschutz bei Magersfontein – Schauplatz einer der britischen Niederlagen gegen die Buren in der »Schwarzen Woche« des Jahres 1899.

La guerre des Boers
Le « Joe Chamberlain », un canon de 4.7 de la brigade navale, tirant un feu de couverture à Magersfontein – scène photographiée lors d'une des défaites britanniques de la « semaine noire », 1899.

1

Rebellion in Africa

Cecil Rhodes (1853–1902) was one of the architects of British policy in southern Africa, and the territory administered by his British South Africa Company became colonial Rhodesia. A raid into Transvaal by his friend Dr Jameson led to his resignation as Prime Minister of Cape Colony. (1) Here he poses (centre right) with his brother during the 1896 Matabele rebellion, which he ended by negotiating with tribal chiefs. (2) Survivors of B Company the 2nd/24th South Wales Borderers after their heroic defence of Rorke's Drift against 4000 Zulu warriors on 22 January 1879. Of the 139 men in the garrison, 35 were already sick or injured. The defence was commanded by two young officers, Lt. John Chard, Royal Engineers, and Lt. Gonville Bromhead. Descendants of Bromhead still serve in the British Army.

Aufstand in Afrika

Cecil Rhodes (1853-1902) war einer der Baumeister der britischen Südafrikapolitik; aus dem Gebiet, das die von ihm gegründete British South Africa Company verwaltete, wurde später die englische Kolonie Rhodesien. Der Überfall seines Freundes Dr. Jameson auf Transvaal (»Jameson Raid«) veranlaßte Rhodes zum Rücktritt vom Amt des Premierministers der Kap-Kolonie. (1) Hier posiert er (Mitte rechts) zusammen mit seinem Bruder während des Matabele-Aufstands von 1896, den er durch Verhandlungen mit den Stammeshäuptlingen beilegen konnte. (2) Überlebende vom Regiment der B-Kompanie der 2./24. South Wales Borderers nach der heroischen Verteidigung von Rorke's Drift gegen 4000 Zulukrieger am 22. Januar 1879. Unter der 139 Mann starken Besatzung der Garnison befanden sich 35 Kranke und Verwundete. Das Kommando bei der Verteidigung des Forts hatten zwei junge Offiziere, Lieutenant John Chard von den Royal Engineers und Lieutenant Gonville Bromhead. Nachkommen von Bromhead dienen noch heute in der britischen Armee.

Rébellion en Afrique

Cecil Rhodes (1853-1902) fut l'un des artisans de la politique britannique en Afrique australe; le territoire administré par la British South Africa Company, dont il était le fondateur, devint la colonie de Rhodésie. Le raid mené au Transvaal par son ami Jameson l'obligea à démissionner de son poste de Premier ministre de la colonie du Cap. (1) Il pose ici (au milieu à droite) à côté de son frère pendant la rébellion des Matabélé en 1896; il négocia avec les chefs tribaux pour y mettre fin. (2) Survivants de la compagnie B du 2ᵉ/24ᵉ South Wales Borderers après leur résistance héroïque au fort de Rorke's Drift assiégé par 4000 Zoulous, janvier 1879. Sur les 139 hommes de la garnison, 35 étaient malades ou blessés. Ils étaient commandés par deux jeunes officiers, le lieutenant John Chard du Génie royal et le lieutenant Gonville Bromhead. Des descendants de Bromhead servent toujours dans l'armée britannique.

was also used to mobilize the forces of Tsarist Russia, Serbia's ally, on the evening of 30 July – calling more than two million men to arms. When Germany marched into Belgium, Britain invoked a treaty of 1839 and declared war on 4 August.

'The summer of 1914 will remain in the memory of those who lived through it as the most beautiful summer they ever remembered,' wrote Ivo Andric in *The Bridge over the Drina,* the epic Balkan novel, 'for in their consciousness it shone and flamed over a gigantic and dark horizon of suffering and misfortune which stretched into infinity.'

Der Wettlauf um überseeische Kolonien und Besitzungen nahm in den letzten Jahrzehnten des 19. Jahrhunderts an Intensität zu; imperialistische Bestrebungen waren mitverantwortlich für den Ausbruch globaler Spannungen im Ersten Weltkrieg. Die britische Armee hatte viel aus den Erfahrungen des Krimkriegs gelernt, und obwohl sie schwere Rückschläge einstecken mußte, gelang es ihr doch, das britische Weltreich zusammenzuhalten.

Die Schlacht von et-Tell el-Kebir (1882) sicherte die Herrschaft der Briten über Ägypten. Es gehörte zu den Ausnahmen in jener Zeit, daß ihnen eine wohlorganisierte feindliche Armee gegenübertrat. Die Anhänger des Mahdi – des islamischen Messias – wurden erst 1898 in Omdurman am Oberlauf des Nils von General Herbert Kitchener besiegt, wo eine bunt zusammengewürfelte britisch-sudanesisch-ägyptische Truppe von 25 800 Mann eine Armee von 60 000 Derwischen überwältigte. Entscheidend für den Sieg war die überlegene Schußkraft von 40 sogenannten »Maxim-Gewehr-Kugelspritzen«, die an Land und auf Flußkähnen postiert waren.

Maxim-Maschinengewehre sollten auch in den Zulu-Kriegen von 1879 den Ausschlag geben. Am Anfang der Auseinandersetzungen stand eine vernichtende Niederlage der Engländer gegen die disziplinierten Kampfeinheiten von Zulukriegern *(impis)* bei Isandlwana in Zululand, wo die Briten den Rückzug antreten mußten, nachdem sie 1329 von 1500 Mann verloren hatten. In der gleichen Nacht hielt eine Garnison von 139 teilweise kranken Soldaten im Fort von Rorke's Drift dem Angriff von 4000 Zulukriegern stand. Das Fort wurde erst am Morgen besetzt. Elf Soldaten erhielten das Victoria Cross, die höchste Tapferkeitsauszeichnung des britischen Empire; 15 Soldaten fielen.

1899 schickten die Buren Truppen nach Natal, weil sie befürchteten, daß Transvaal und der Oranje-Freistaat ihren Zugang zum Meer verlieren könnten. Schon nach einigen Wochen wurden die Briten in Kimberley, Mafeking und Ladysmith belagert; in der »schwarzen Woche« vom 10. bis 15. Dezember erlitten sie drei Niederlagen: am Stormberg, bei Magersfontein und Colenso, gefolgt von einer weiteren, am Spion Kop, im darauffolgenden Januar. Unter dem Kommando von General Roberts zwangen die Briten die Burenarmee unter Cronje im Februar 1900 zur Kapitulation und nahmen Bloemfontein und Pretoria ein. 1902 erkannten die Buren die britische Herrschaft an.

Während neue Reiche erobert wurden, gingen alte verloren. Als das amerikanische Schlachtschiff *Maine* im Hafen von Havanna von einer Mine versenkt wurde und die Explosion 266 Todesopfer forderte, verlangten die Amerikaner, daß die Spanier Kuba verlassen sollten. Im Spanisch-Amerikanischen Krieg von 1898 befreiten die Amerikaner die Philippinen und Kuba aus spanischer Herrschaft. In dem ganzen Krieg verloren die USA »nur« einen Marineoffizier und 17 Matrosen sowie 29 Armee-offiziere und 449 Soldaten. Der Spanisch-Amerikanische Krieg stellte die Leistungsfähigkeit der modernen amerikanischen Marine unter Beweis, insbesondere auch ihrer medizinischen Versorgung, denn ein Großteil der Kämpfe fand in schlimmer tropischer Hitze statt.

Die wohl spektakulärste Demonstration moderner Seekriegsführung war der Russisch-Japanische Krieg (1904-05). Die Japaner wollten neben großen Teilen der Mandschurei Port Arthur einnehmen, das sie 1894 den Russen hatten überlassen müssen. Nach einer Reihe von Niederlagen zu Wasser und zu Land beschlossen die Russen, ihre Ostseeflotte auf die Reise in japanische Gewässer zu schicken. Als Admiral Roschdestwenskijs Schiffe am 27. Mai 1905 vor Tsushima aus dem Nebel auftauchten, eröffneten Admiral Togos Schlachtkreuzer, Torpedoboote und Zerstörer das Feuer. Durch geschicktes Manövrieren setzten die Japaner die russischen Schlachtschiffe außer Gefecht. Insgesamt verloren die Japaner nur drei Torpedoboote und 117 Mann; von den

russischen Schiffen erreichten lediglich drei den Hafen von Wladiwostok, der Rest wurde versenkt oder aufgebracht; auf russischer Seite gab es 4830 Tote und 5917 Gefangene.

In den Kriegen, die 1912/13 den Balkan erschütterten, kamen erstmals Kriegsfotografen systematisch zum Einsatz. Die jungen Nationen auf dem Balkan waren unablässig bemüht, den Einfluß ihrer ehemaligen Herren, der osmanischen Türken, zu untergraben. Auch der Vielvölkerstaat Österreich-Ungarn sah sich durch die Autonomieforderungen nationaler Minderheiten (wie zum Beispiel der Tschechen, Ungarn, Slowaken und Kroaten) in seiner Existenz bedroht. 1912 forderte der aus Bulgarien, Serbien, Griechenland und Montenegro bestehende Balkanbund die Unabhängigkeit Makedoniens von der Türkei. Im Oktober 1912 kam es zum Ausbruch von Feindseligkeiten (dem Ersten Balkankrieg), in deren Verlauf die osmanischen Truppen aus Makedonien zurückgedrängt wurden. Bei Lüle Burgas in Thrakien verloren die Türken 40 000 Mann, ein vernichtender Schlag für ihre Macht in Europa. Im Frieden von London im Januar 1913 verzichtete die Türkei auf sämtliche Besitzungen auf dem Balkan bis auf einen kleinen Gebietsstreifen westlich von Konstantinopel; im gleichen Jahr wurde die Entstehung eines neuen albanischen Staates bestätigt.

In einem neuerlichen Krieg im August 1913 (dem Zweiten Balkankrieg), in dem Bulgarien sich gegen seine früheren Verbündeten wandte und von Serbien und Griechenland

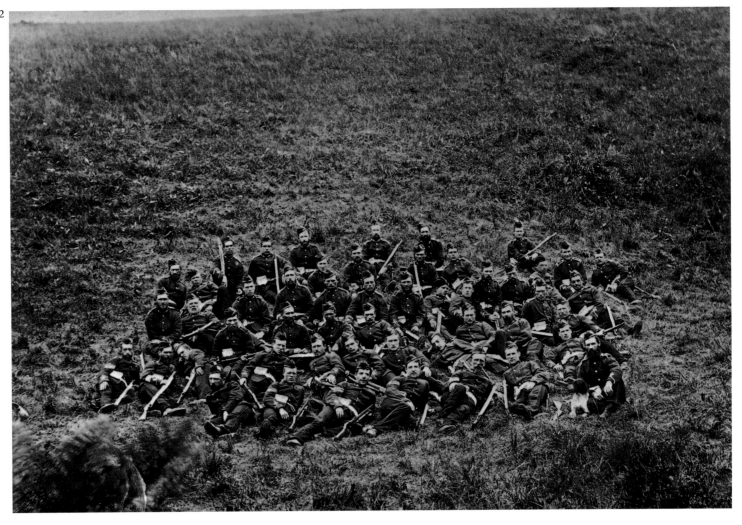

vernichtend geschlagen wurde, verlor es einen Großteil der Gewinne aus dem Ersten Balkankrieg. Die Türkei behielt Adrianopel, und die Serben besetzten Skopje, die heutige Hauptstadt des vormals jugoslawischen Makedonien. Schon seit dem Berliner Kongreß von 1878 grollten die Serben wegen der österreichischen Verwaltung des benachbarten Bosnien-Herzegowina; 1908 annektierten die Österreicher Bosnien und die Herzegowina in aller Form. Am 28. Juni 1914, dem serbischen Nationalfeiertag Vidovdan – dem Tag des Heiligen Vitus – erschoß Gavrilo Princip, ein Mitglied der nationalistischen Bewegung »Jung-Bosnien«, in der bosnischen Hauptstadt Sarajevo den verhaßten österreichischen Thronfolger, Erzherzog Franz Ferdinand. Zu diesem Zeitpunkt waren die europäischen Mächte in ein hochkompliziertes Bündnissystem einbezogen, das einen Krieg praktisch unvermeidlich machte, wenn man erst einmal mit der Mobilmachung begann. Dies war eine Gefahr, die ganz besonders auf das zunehmend nervös reagierende kaiserliche Deutschland zutraf, das sich zu Lande immer stärker von Frankreich und Rußland und zur See von der Schlagkraft der britischen Marine bedrängt fühlte.

In Wien beschuldigte man die Serben der Anstiftung zu dem Attentat vom 28. Juni 1914 und forderte in einem Ultimatum, daß die Österreicher selbst in Serbien Ermittlungen anstellen durften. Das Ultimatum wurde am 28. Juli telegrafisch abgelehnt. Das Mittel der drahtlosen Telegrafie kam auch zum Einsatz, als das mit Serbien verbündete zaristische Rußland am Abend des 30. Juli den Befehl zur Generalmobilmachung gab und mehr als zwei Millionen Mann zu den Waffen rief. Als die Deutschen in Belgien einmarschierten, berief sich England auf einen Vertrag von 1839 und erklärte am 4. August 1914 Deutschland den Krieg.

»Alle, die ihn erlebt haben, werden den Sommer des Jahres 1914 als den schönsten Sommer im Gedächtnis behalten, an den sie sich je erinnert haben«, schreibt Ivo Andric in seinem epischen Balkanroman *Die Brücke über die Drina,* »denn in ihrem Bewußtsein leuchtete und loderte er vor einem gigantischen finsteren Horizont des Leids und Unglücks, der sich endlos erstreckte.«

L a course aux possessions et aux colonies d'outremer s'accéléra dans les dernières décennies du 19ᵉ siècle, ce qui devait contribuer au conflit global de la Première Guerre mondiale.

L'armée britannique avait tiré les leçons de la guerre de Crimée, et bien qu'enregistrant de sérieux revers, elle réussit à maintenir la cohésion de l'empire.

La Grande-Bretagne s'assura le contrôle de l'Egypte à la bataille de Tel el Kébir en 1882, l'une des rares occasions dans cette région où l'armée avait affaire à un ennemi bien organisé. Le Mahdi (le Sauveur pour les shi'ites) fut vaincu finalement en 1898 à Omdourman sur le Nil supérieur par le général Herbert Kitchener. Une armée de 25 800 hommes composée

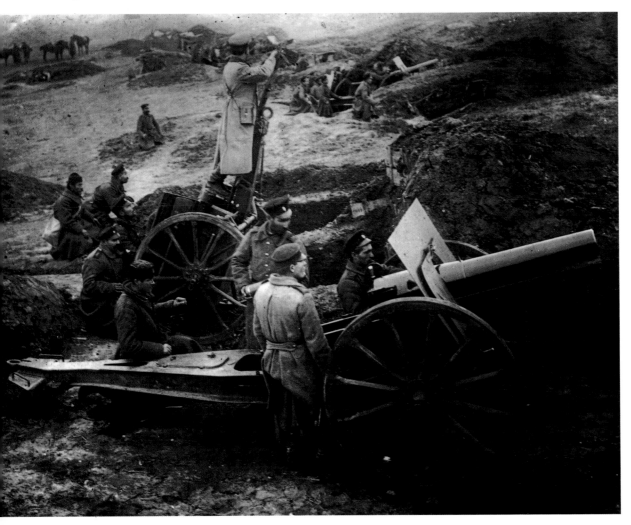

War in the Balkans
A Bulgarian field gun being laid for the siege of the Turkish defences of Adrianople in the Second Balkan War, 1913.

Krieg auf dem Balkan
Ein bulgarisches Feldgeschütz wird für die Belagerung der türkischen Befestigungen von Adrianopel im Zweiten Balkankrieg (1913) in Stellung gebracht.

Guerre dans les Balkans
Canon de campagne bulgare installé pour le siège d'Andrinople, occupée par les Turcs pendant la seconde guerre balkanique, 1913.

de Britanniques, de Soudanais et d'Egyptiens écrasa 60 000 derviches. La puissance de feu des 40 mitrailleuses Maxim, légères et montées sur le sol ou sur des barques, se révéla décisive.

Pendant les guerres zouloues de 1879, ces mitrailleuses devaient sauver la journée qui débuta par la défaite des Britanniques face à des guerriers zoulous parfaitement disciplinés, les *impis,* à Isandhlwana en pays zoulou. Les Britanniques battirent en retraite en ayant perdu 1329 hommes sur 1500. La même nuit, enfermée au fort de Rorke's Drift, une garnison de 139 soldats, dont certains étaient malades, résistèrent à l'assaut de 4000 Zoulous. Onze hommes furent décorés pour leur bravoure de la Croix de Victoria, la plus haute distinction militaire britannique; 15 y payèrent de leur vie et le siège fut levé au matin.

En 1899, les Boers expédièrent une force armée dans le Natal, dans la crainte d'être privés de leur accès à la mer dans le Transvaal et l'Etat libre d'Orange. En quelques semaines, les Anglais se retrouvèrent assiégés à Kimberley, Mafeking et Ladysmith, et durant la «semaine noire», du 10 au 15 décembre, ils furent sévèrement battus à Stormberg, Magersfontein et Colenso, subissant une autre défaite à Spion Kop le mois suivant. En février 1900, les soldats placés sous les ordres de Lord Roberts vainquirent l'armée boer de Cronje, et prirent Bloemfontein et Pretoria. Les Boers acceptèrent finalement la souveraineté britannique en 1902.

De nouveaux empires étaient conquis, les anciens perdus. Lorsqu'une mine coula le cuirassé américain *Maine* en rade de La Havane, faisant 266 morts, les Américains sommèrent l'Espagne de se retirer de Cuba. Pendant la guerre hispano-américaine de 1898, les Américains libérèrent les Philippines et Cuba de la domination espagnole. Les pertes américaines s'élevèrent en tout et pour tout à un officier de marine et 17 marins, à 29 officiers et 449 hommes de l'armée de terre. La guerre avec l'Espagne donna une justification à la marine américaine moderne, en particulier dans ses services de santé, car les combats avaient été livrés dans la pire chaleur tropicale.

La guerre russo-japonaise (1904-05) fut la démonstration la plus éclatante d'une puissance navale moderne. Les Japonais tenaient à reprendre Port Arthur qu'ils avaient cédé aux Russes en 1894, ainsi qu'une grande partie de la Mandchourie. Après une série de défaites sur terre et sur mer, les Russes dépêchèrent leur flotte de la Baltique dans les eaux japonaises, à quelque 12 000 kilomètres de là. Lorsque, le 27 mai 1905, les navires de l'amiral Rozhdestvenski émergèrent du brouillard au large de Tsushima, les croiseurs, torpilleurs et destroyers de l'amiral Togo ouvrirent le feu. La flotte japonaise traversa les lignes russes. Les bateaux russes qui ne faisaient pas le poids furent coulés. A la fin de la journée, les pertes japonaises ne s'élevaient qu'à trois torpilleurs et 117 marins. Trois navires russes seulement purent rejoindre Vladivostok, le reste avait été coulé ou capturé. Les pertes russes s'élevaient à 4830 soldats tués et 5917 prisonniers.

Les photographes de guerre entrèrent pour la première fois en action pendant les guerres qui secouèrent les Balkans de 1912 à 1913. Les nouvelles nations balkaniques avaient tout fait pour saper la puissance de leur ancien dominateur, l'Empire ottoman. L'Empire austro-hongrois était en butte lui aussi aux revendications autonomistes de ses minorités nationales: Tchèques, Hongrois, Slovaques et Croates. L'entente balkanique composée de la Bulgarie, de la Serbie, du Monténégro et de la Grèce, réclama en 1912 l'indépendance de la Macédoine. Les hostilités éclatèrent en octobre 1912 (première guerre balkanique). L'armée ottomane fut chassée de Macédoine. Pendant la bataille de Lule Burgas en Thrace, elle perdit 40 000 soldats, un coup mortel porté à la domination turque en Europe. Le traité de Londres signé en janvier 1913 acheva le démembrement de la Turquie d'Europe (celle-ci ne conservait plus qu'une enclave à l'ouest de Constantinople) et confirma l'émergence d'une nouvel Etat albanais.

La Bulgarie perdit ce qu'elle avait pris aux Turcs dans sa désastreuse campagne d'août 1913 (seconde guerre balkanique) contre ses anciens alliés, la Serbie et la Grèce. La Turquie gardait Andrinople, les Serbes occupaient Skopje, la nouvelle capitale de l'ancienne Macédoine yougoslave. Depuis le congrès de Berlin en 1878, la Serbie n'avait jamais accepté que les Autrichiens conservent la Bosnie-Herzégovine voisine. La Serbie avait annexé de fait la Bosnie en 1908. A Sarajevo, le 28 juin 1914, jour de la Saint-Guy, fête nationale serbe, Gavrilo Princip, membre du mouvement nationaliste Jeune Serbie, assassina le très impopulaire héritier des Habsbourg, l'archiduc François-Ferdinand. A l'époque, les puissances européennes étaient liées par un tel lacis d'alliances et de pactes que la guerre était pratiquement inévitable, une fois décrétée la mobilisation, comme le fit l'Allemagne impériale dont la nervosité allait croissant. Celle-ci se sentait en effet de plus en plus prise en tenaille entre la France et la Russie, ses ennemis continentaux, et la Royal Navy, son ennemi naval.

Vienne condamna la Serbie pour cet assassinat et lui lança un ultimatum, exigeant de faire sa propre enquête en Serbie. L'ultimatum fut refusé par télégramme le 28 juillet 1914. Le télégraphe sans fil fut également utilisé le 30 juillet pour mobiliser les forces armées de la Russie tsariste, alliée de la Serbie – 2 millions d'hommes en tout. Quand l'Allemagne envahit la Belgique, la Grande-Bretagne invoqua un vieux traité de 1839 pour lui déclarer la guerre le 4 août.

«L'été de 1914 restera gravé dans la mémoire de ceux qui l'ont vécu comme le plus beau qu'ils aient jamais eu», écrit Ivo Andric dans *Le pont de la Drina,* une nouvelle épique balkanique, «car, pour eux, il brillait et flambait au-dessus d'un immense et sombre horizon, un infini de souffrances et de malheur.»

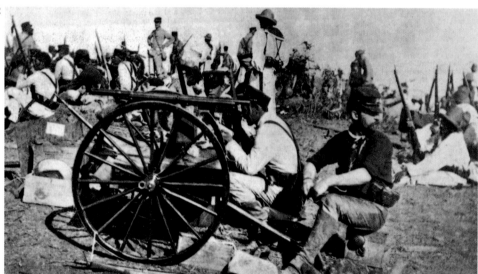

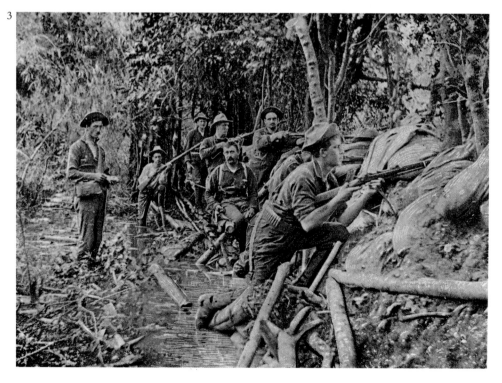

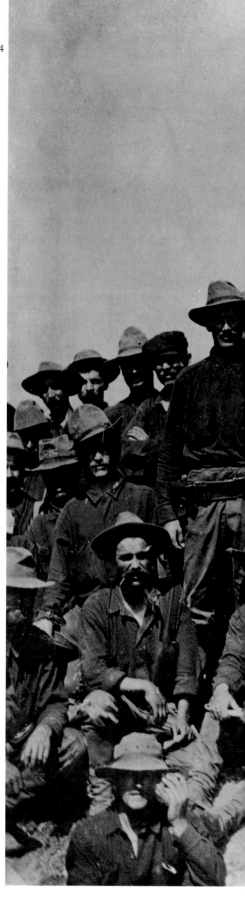

The Great Adventure
The Spanish-American War of 1898.
(1) A gun being loaded aboard a Spanish
cruiser. (2) The Spanish defenders in camp
in Cuba. (3) US soldiers prepare their
positions in trenches before Manila, 1898.
(4) The future president, Lt.-Col. Theodore
Roosevelt, and his men of the 1st Cavalry
Volunteers – the Rough Riders – on San Juan
hill which they won on 1 July 1898.

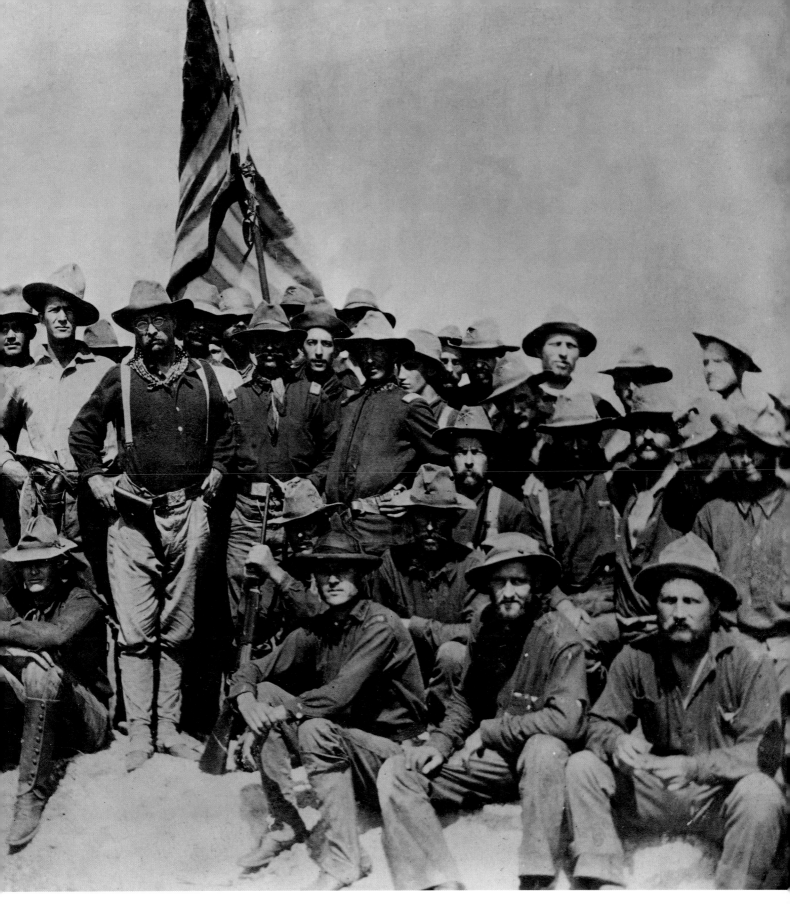

Das große Abenteuer
Der Spanisch-Amerikanische Krieg von 1898.
(1) Ein Geschütz wird auf einen spanischen Kreuzer geladen. (2) Das Lager der spanischen Verteidiger in Kuba. (3) Amerikanische Soldaten richten im Jahr 1898 ihre Stellungen in den Schützengräben vor Manila ein.
(4) Der spätere Präsident Theodore Roosevelt und seine Männer vom Freiwilligenregiment der 1st Cavalry Volunteers – den berühmten »Rough Riders« – auf dem Hügel von San Juan, den sie am 1. Juli 1898 eroberten.

La grande aventure
La guerre hispano-américaine de 1898.
(1) Un canon chargé à bord d'un croiseur espagnol. (2) Cantonnement espagnol à Cuba.
(3) Des soldats américains en position dans leurs retranchements devant Manille, 1898.
(4) Le lieutenant-colonel Theodore Roosevelt, futur président américain, et ses hommes de la 1ère cavalerie de volontaires – les Rough Riders – sur la montagne San Juan qu'ils ont conquise le 1er juillet 1898.

BOERS IN BATTLE
BURGHERS SLAAGS.

VAN HOEPEN.

Masters of the Veldt

In the Boer War (1899-1902) the Afrikaners' fire was effective at 500 metres – here (1) they set up the siege trenches before Mafeking in 1899. (2) A schoolmaster and his pupil as commando scouts at Mafeking. (3) The Afrikaners were masters of the open uplands of the veldt. They were excellent shots, with their up-to-date bolt-action rifles, which used smokeless powder.

Die Herren des Veldt

Im Burenkrieg (1899–1902) betrug die Reichweite des burischen Feuers 500 Meter. Hier (1) sieht man burische Truppen beim Ausheben von Schützengräben vor der Belagerung von Mafeking im Jahr 1899. (2) Ein Lehrer und sein Schüler als Kundschafter bei Mafeking. (3) Die Buren kannten das offene Hochland des Veldt wie ihre Westentasche. Sie waren ausgezeichnete Schützen und benutzten moderne Schlagbolzengewehre mit rauchschwachem Pulver.

Les maîtres du veldt

Pendant la guerre des Boers (1899-1902), le tir des Afrikaners portait à 500 mètres. (1) Soldats afrikaaners en position devant Mafeking, 1899. (2) Un maître d'école et son élève envoyés en éclaireurs à Makefing. (3) Les Afrikaaners étaient les maîtres du veldt. Excellents tireurs, ils étaient équipés de fusils à culasse mobile ultramodernes et de poudre non fumigène.

EEN SCHOOLMEESTER MET
ZIJN LEERLING OP
COMMANDO OF
MAFEKING

VAN HOEPEN
PHOTO.
PRETORIA

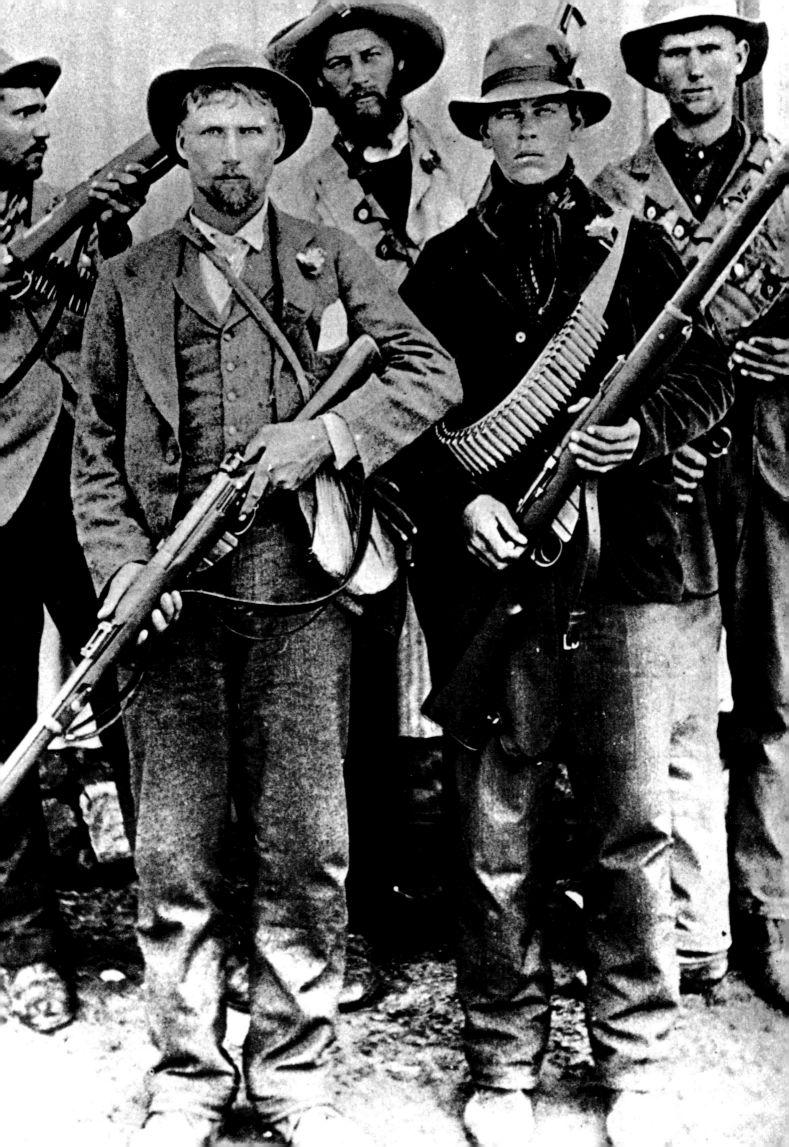

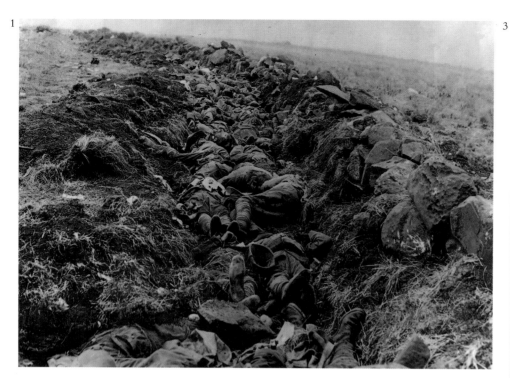

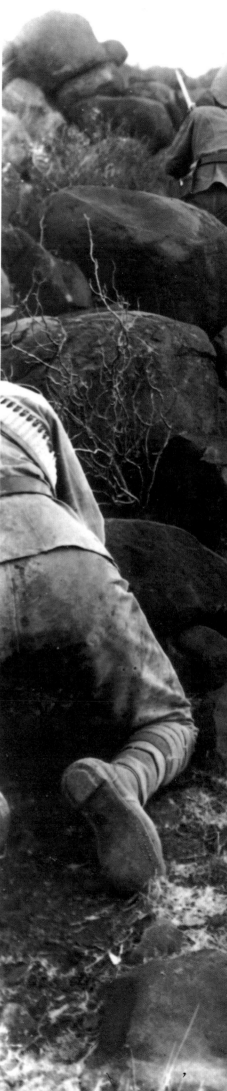

Masters of Camouflage

The Boers blended into the rocky outcrops, or *kopje*, tempting the British attackers across the killing zone of the open ground before them. (1) The battlefield at Spion Kop, January 1900. (2) A supply column crossing the Koffie Spuit, December 1901. (3) Soldiers of the Royal Canadian Regiment attacking a *kopje* in the battle for Sunnyside Farm, 1900.

Meister der Tarnung

Die Buren agierten nahezu unsichtbar zwischen den Felsen, den sogenannten *kopjes,* und verleiteten die britischen Angreifer so dazu, sich in gefährliches offenes Gelände vorzuwagen. (1) Das Schlachtfeld am Spion Kop im Januar 1900. (2) Ein Nachschub-konvoi beim Überqueren des Koffie Spuit im Dezember 1901. (3) Soldaten des Royal Canadian Regiment beim Angriff auf ein *kopje* im Kampf um die Sunnyside Farm (1900).

Les champions du camouflage

Les Boers s'évanouissaient dans les *kopje,* élévations faites d'amas de roches, poussant les attaquants anglais à s'aventurer en terrain découvert, dans une zone dangereuse pour eux. (1) Le champ de bataille de Spion Kop, janvier 1900. (2) Une colonne de ravitaillement traversant le Koffie Spuit, décembre 1901. (3) Soldats du régiment royal canadien attaquant un *kopje* dans la bataille de Sunnyside Farm, 1900.

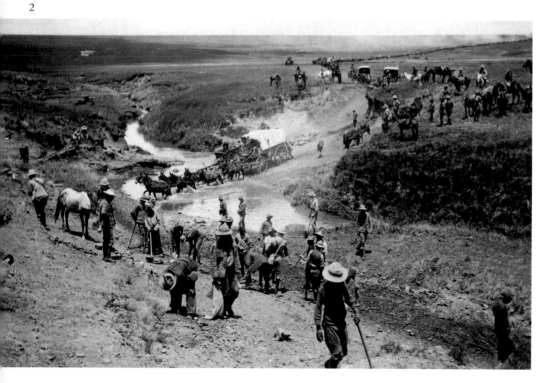

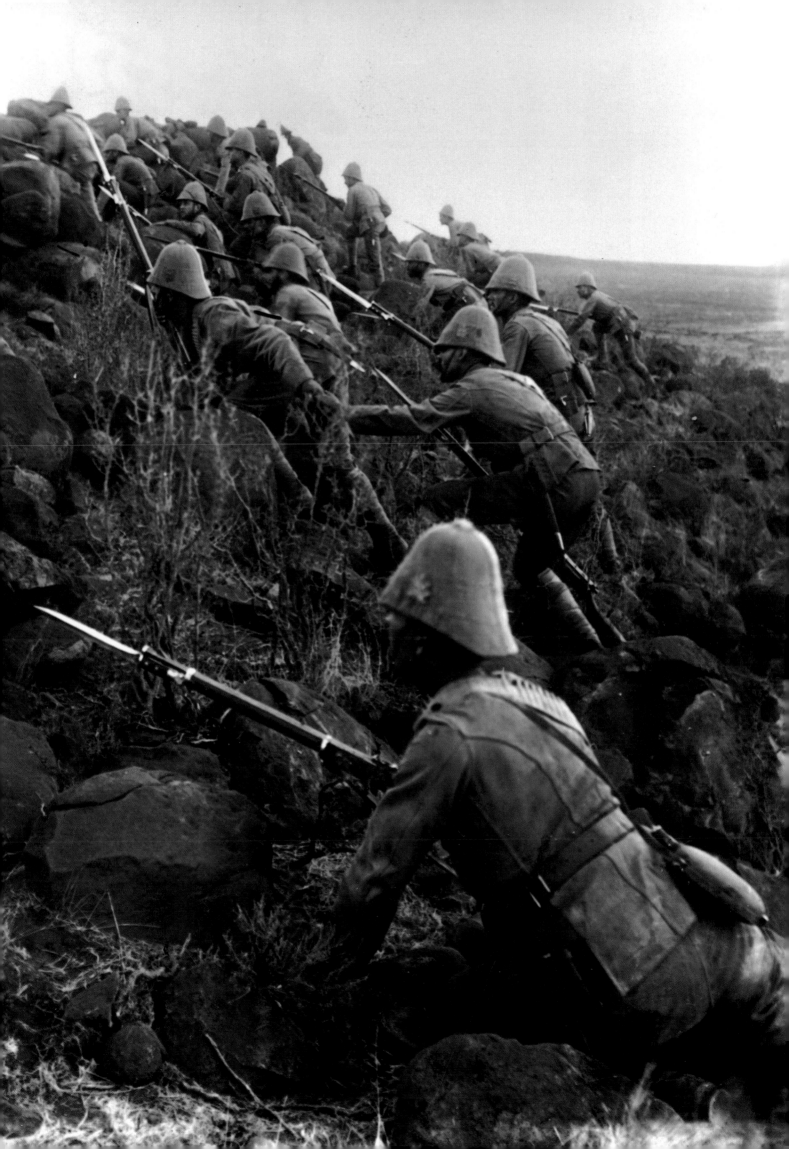

Prisoners of War

The British treatment of prisoners and civilians drew international criticism in the Boer War. (1) A German intermediary is brought in to negotiate a surrender. (2) Wounded Afrikaners being treated at the Wijnberg Hospital, Pretoria. (3) More than 120,000 Boer civilians, women and children mostly, were detained in concentration camps. Many suffered malnutrition and disease.

Kriegsgefangene

Die Art und Weise, wie die Briten gefangene Soldaten und Zivilisten behandelten, machte sie im Burenkrieg zur Zielscheibe internationaler Kritik. (1) Ein deutscher Unterhändler wird im Jahr 1900 zu Kapitulationsverhandlungen gebracht. (2) Verwundete Buren werden im Wijnberg-Krankenhaus in Pretoria behandelt. (3) Mehr als 120 000 burische Zivilisten – überwiegend Frauen und Kinder – wurden in Konzentrationslagern interniert. Viele waren unterernährt und krank.

Prisonniers de guerre

Pour leur traitement des prisonniers et des civils boers, les Britanniques s'attirèrent les plus vives critiques. (1) Un médiateur allemand est envoyé pour négocier une reddition. (2) Blessés afrikaaners soignés à l'hôpital Wijnberg de Pretoria. (3) Plus de 120 000 civils boers, en majeure partie des femmes et des enfants, furent internés dans des camps de concentration. Beaucoup souffrirent de sous-alimentation et de maladie.

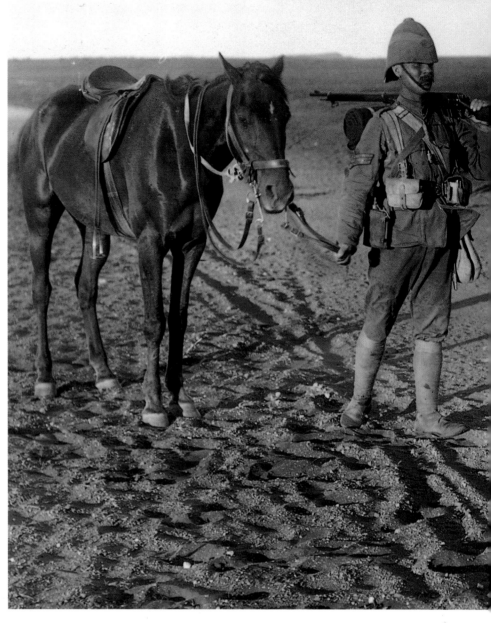

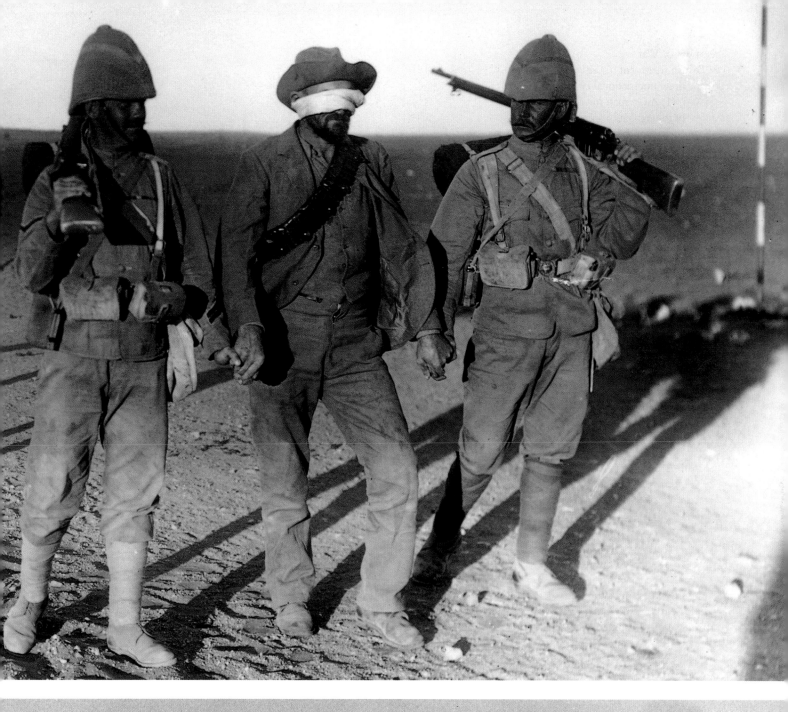

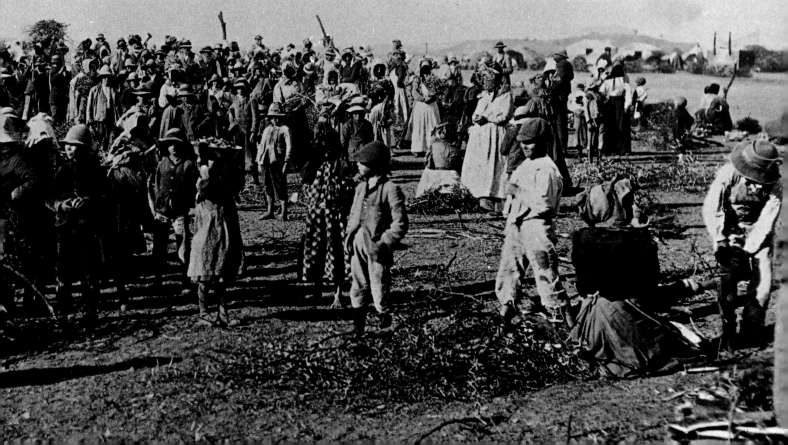

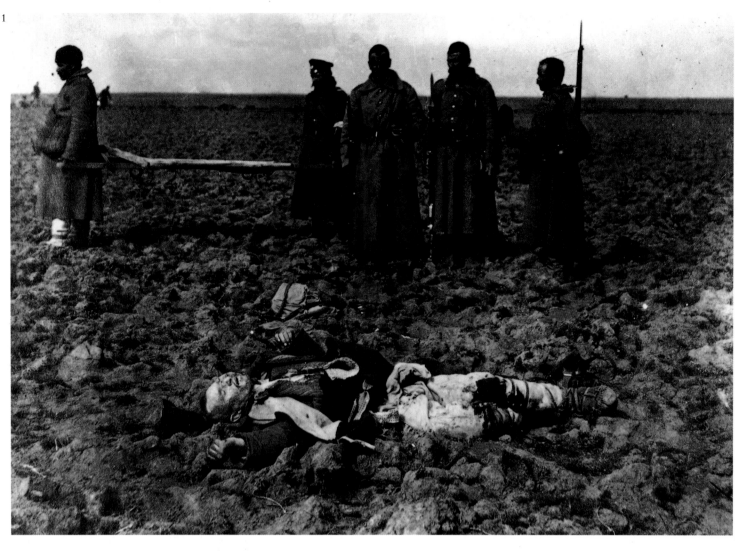

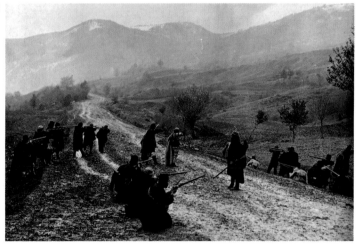

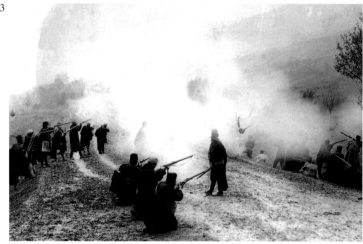

Vendetta and Liberation

The Balkan Wars (1912-13) were marked by their peculiar savagery – vendetta was rife, and life was cheap. (1) Removal of the dead from the battlefield at Adrianople in 1913. (2, 3) An unknown victim faces summary execution in 1913. (4) The heroic pose of a fighter, probably from Montenegro. Note the standard service revolver (a similar one fired the fatal shots that killed the Archduke Franz Ferdinand) and the ancient rifle, a flintlock of Turkish design.

Blutrache und Befreiung

Die Balkankriege (1912-13) waren gekennzeichnet durch ihre besondere Grausamkeit. Blutrache grassierte, und ein Menschenleben war nicht viel wert. (1) Abtransport der Gefallenen auf dem Schlachtfeld von Adrianopel (1913). (2, 3) Ein unbekanntes Opfer bei einer Massenexekution im Jahr 1913. (4) Ein vermutlich montenegrinischer Kämpfer in Siegerpose. Beachtenswert ist sein Armeerevolver (aus einer Waffe dieses Typs wurden die tödlichen Schüsse auf Erzherzog Franz Ferdinand abgegeben) und das antiquierte türkische Steinschloßgewehr.

Vendetta et libération

Les guerres balkaniques (1912-13) furent d'une sauvagerie extrême. La vendetta était courante et une vie ne comptait pas. (1) Les morts sont enlevés du champ de bataille à Adrianople, 1913. (2, 3) Victime anonyme d'une exécution sommaire, 1913. (4) Pose théâtrale d'un combattant, probablement monténégrin. A noter le revolver de guerre standard (c'est un revolver du même type qui tua l'archiduc François-Ferdinand) et le vieux fusil à silex de modèle turc.

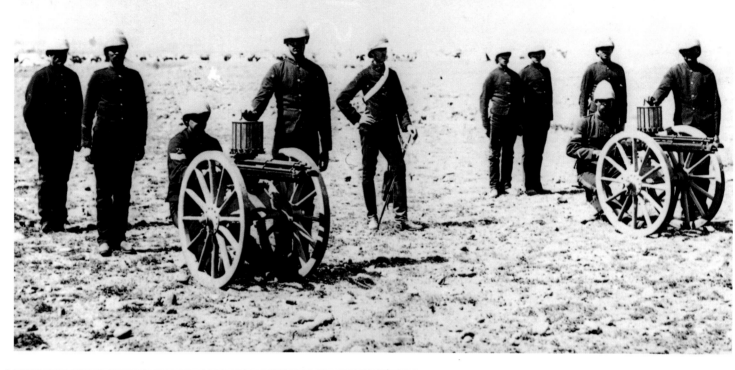

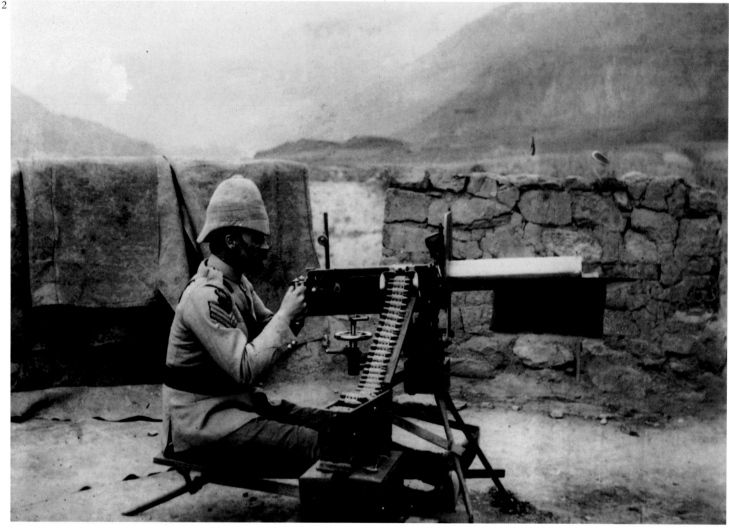

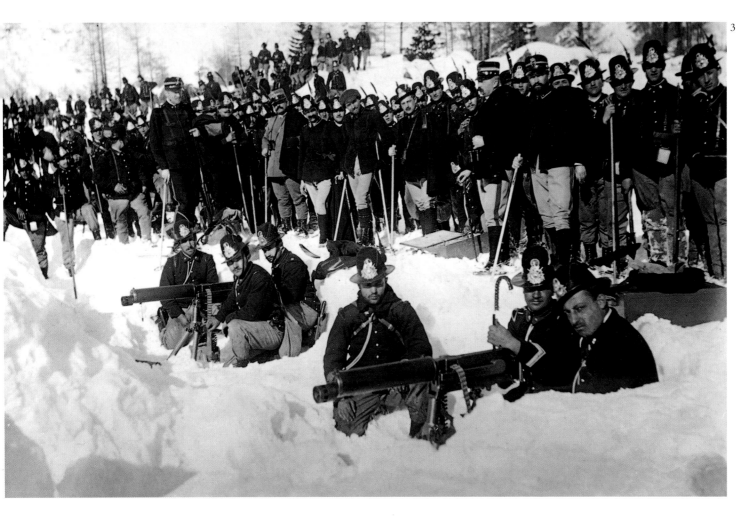

The Machine Gun Era

The machine gun was a main armament from the time of the Zulu wars on.
(1) Revolving chamber guns, first invented by Richard Gatling in the American Civil War, are paraded by the British Indian Army.
(2) A light Maxim gun is set up at Chilas Fort, North-West Frontier, India, 1898.
(3) Austrian Alpine troops with their machine guns, First World War. (4) German machine gunners masked up during a gas attack. (5) Members of the British Machine Gun Corps similarly masked with a Vickers machine gun on the Somme, 1916.

Das Zeitalter des Maschinengewehrs

Das Maschinengewehr war seit der Zeit der Zulu-Kriege eine der wichtigsten Waffen.
(1) Maschinengewehre des Typs, wie sie von Richard Gatling im Amerikanischen Bürgerkrieg entwickelt wurden, bei einer Parade der britischen Indienarmee. (2) Ein leichtes Maxim-Maschinengewehr im Fort von Chilas an der Nordwestgrenze Britisch-Indiens, 1898. (3) Österreichische Gebirgs-jäger mit Maschinengewehren im Ersten Weltkrieg. (4) Deutsche Maschinengewehr-schützen mit Masken während eines Gasangriffs. (5) Maskierte Mitglieder des britischen Maschinengewehrkorps mit einem Vickers-Maschinengewehr in der Schlacht an der Somme, 1916.

L'avènement de la mitrailleuse

La mitrailleuse constitua l'armement de base à partir des guerres zouloues. (1) Soldats de l'armée des Indes présentant fièrement leurs fusils-mitrailleurs à tambour inventés par Richard Gatling pendant la guerre de Sécession. (2) Une mitrailleuse Maxim en position de tir au fort de Chilas, frontière nord-ouest de l'Inde. (3) Chasseurs alpins autrichiens avec leurs mitrailleuses pendant la Première Guerre mondiale. (4) Mitrailleurs allemands équipés de masques lors d'un combat au gaz toxique. (5) Mitrailleurs britanniques masqués eux aussi, avec leur mitrailleuses Vickers, bataille de la Somme, 1916.

5

The First World War was to involve mass society on an unprecedented scale. It was also the first truly global war. In four years 37 million soldiers would be killed or injured, and ten million civilians. Commanders had to develop revolutionary tactics to deal with new technology in war. The innovation of the Armoured Fighting Vehicle was encouraged by Churchill. The first six British tanks appeared at the Somme in August 1916, but were first used in a mass attack at Cambrai in 1917, where up to 400 achieved a spectacular breakthrough, though the British lacked the reserves to exploit it.

Der Erste Weltkrieg sollte die moderne Massengesellschaft in bislang beispielloser Weise in seinen Sog ziehen. Zugleich war er der erste wirklich globale Krieg. In vier Jahren wurden 37 Millionen Soldaten und zehn Millionen Zivilisten getötet oder verwundet. Der Einsatz neuer Technologien verlangte völlig neue Taktiken. Die neuartigen Panzerfahrzeuge fanden in Churchill einen Fürsprecher. Im August 1916 tauchen erstmals sechs britische Panzer an der Somme auf, aber erst 1917 verhalfen sie den Briten bei Cambrai in einem Massenangriff mit fast 400 Tanks zu einem spektakulären Durchbruch. Die Briten hatten jedoch nicht genügend Reserven, um diesen Erfolg auszubauen.

La Première Guerre mondiale mobilisa les populations sur une échelle sans précédent. Ce fut aussi le premier grand conflit mondial. En quatre ans, 37 millions de soldats et 10 millions de civils furent tués ou blessés. Les commandements durent mettre au point des tactiques révolutionnaires pour répondre à la nouvelle technologie de guerre. Winston Churchill encouragea l'utilisation d'un véhicule de guerre inédit: le char d'assaut. Les six premiers blindés firent leur apparition sur la Somme en 1916, mais c'est à Cambrai en 1917 qu'ils furent utilisés pour la première fois en grand nombre: 400 chars environ réussirent une percée spectaculaire dont l'armée britannique ne put tirer profit par manque de réserves.

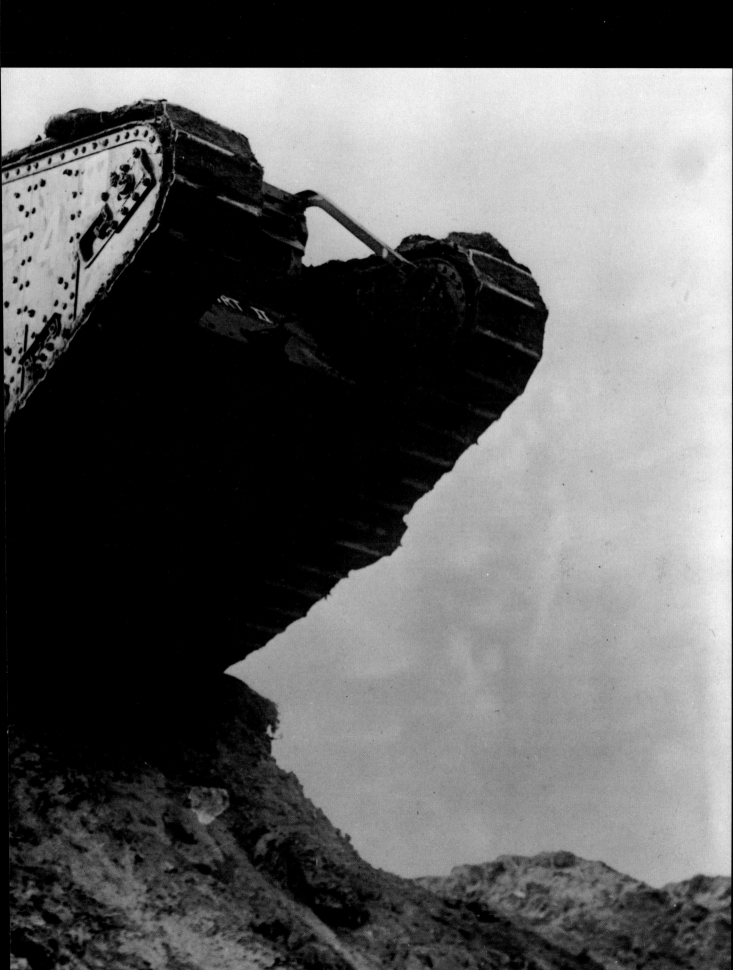

The Clash of Great Armies

1914–18

The First World War or Great War was a watershed because it involved the wholesale conscription of civil society into four years of brutal warfare. Some historians see it as the beginning of an era in which international politics focused on the balance of power in central Europe, and which came to an end with the collapse of Communism in Europe and the end of the Cold War in 1989.

When the great armies mobilized for war in the summer of 1914, most of their general staff believed the conflict would be brief, a few months at most, as they had not the financial or industrial resources to sustain their forces in the field for longer. The main German strategy, developed by General Alfred von Schlieffen, was to deal a swift knock-out blow to France first in order to avoid fighting a war on two fronts. The Germans believed they had time to strike through Belgium and round Paris before the Russians could prepare fully for an offensive in the east. They were wrong on both counts: the French fell back on Paris and held, and the Russians mobilised more quickly than expected.

The French held the line of the river Marne between 5 and 10 September, in a battle involving more than two million soldiers, probably the biggest ever fought to date. The Germans retreated to the Aisne, and the new commander, Erich von Falkenhayn, ordered the race to the Channel ports. In the last four months of 1914, half a million French, German and British soldiers were killed in the fighting in France and Flanders; by then their armies had gone firm on a line, the Western Front, which would hardly move for the next three years.

1

In 1915 the line was static – barbed wire, machine guns, mortars, mines and heavy artillery made manoeuvre seemingly impossible. The French forces tried offensives in the Champagne region in March and May, and the British attacked successfully at Loos. Despite the lack of movement the French lost a million soldiers in 1915 alone.

In 1916 Falkenhayn resolved to break the French by attacking their garrison at Verdun. In the initial attack in February, the Germans nearly took the city, but in the subsequent months of fighting both armies were mauled terribly. After the initial German success in taking Fort Douaumont, the French hurriedly replaced their commander, Joseph Joffre, with General Philippe Pétain, who managed to calm mutinous troops and conduct a successful defence, largely by using motor vehicles to ferry supplies. By the end of the year nearly a million German and French soldiers had fallen at Verdun.

To relieve pressure on Verdun, the British were urged to attack further up the line, on the Somme. After a seven-day barrage, the British and French forces advanced on 1 July 1916. On that first day alone, the British sustained 57,740 casualties, of which 19,240 were killed – the worst day in the history of the British army. Most of the 120,000 British infantry did not make their first objective, the front line of the German trenches – though at the southern end of the battle the French and British fared better. The battle ended on 13 November at the cost of 420,000 British, 195,000 French and 650,000 German casualties. The British introduced tanks for the first time, and more than 400 aircraft were used for reconnaissance.

Hard lessons were drawn from the experience of 1916 on all sides. The German commander Erich von Ludendorff developed a manual, *Conduct of the Defensive Battle*, one of the foundations of modern tactical thinking in high-intensity warfare. Ludendorff recommended that massed infantry should stand back from the line, out of artillery range, while forward positions would be held by a screen of machine guns supported by strong points in depth. In both his offensive and defensive tactics, he recommended that responsibility should be given to the lowest level of command, so that each NCO would know his mission; this is the essence of mission-orientated orders.

The Western allies also evolved new tactics to break the stranglehold of strong defences backed by artillery, barbed wire, machine guns and mortars from well-dug-in positions. A mass attack by 476 tanks and 1003 guns supporting six British divisions achieved a dramatic breakthrough at Cambrai in October but the British lacked the reserves to exploit the attack to the full. Cambrai marked a turning point, with the successful use of tanks, the first modern artillery fire-plan and

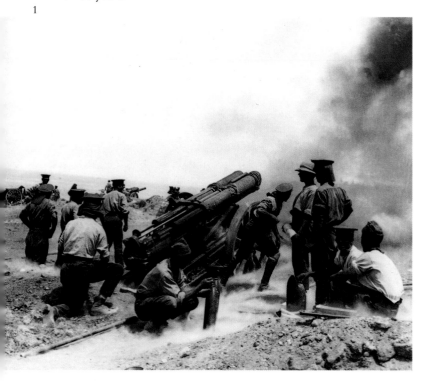

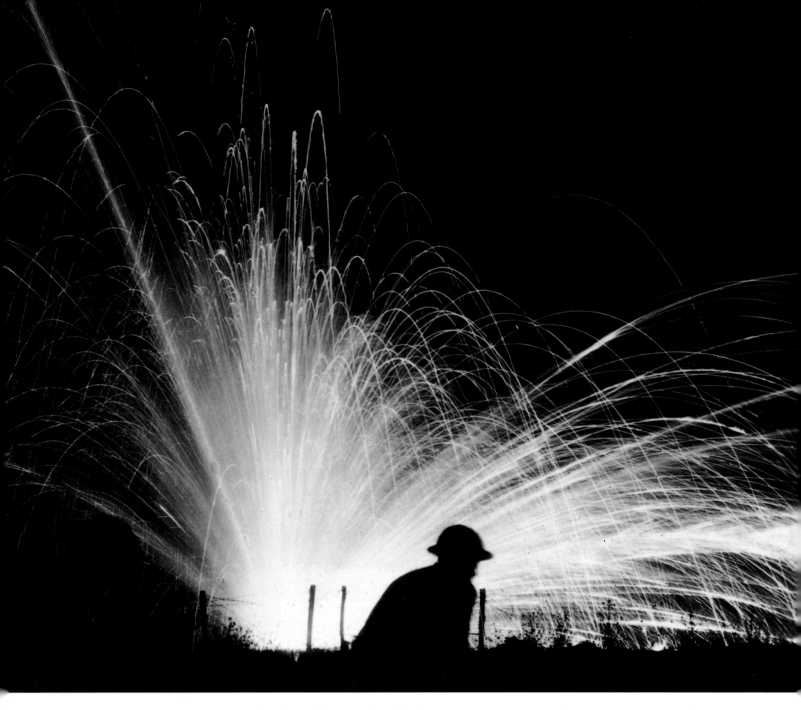

(1) A 60-pounder heavy field gun in action at Helles Bay, Gallipoli, summer 1915. (2) Illumination flares and shells in No Man's Land, Western Front, 1917.

(1) Ein schwerer Sechzigpfünder im Einsatz an der Helles-Bucht auf Gallipoli, Sommer 1915. (2) Leuchtkugeln und Granaten im Niemandsland an der Westfront, 1917.

(1) Pièce de soixante en action à Helles Bay, Gallipoli, été 1915. (2) Embrasement d'obus et de mortiers dans le no man's land du front occidental, 1917.

the integration of aircraft with armour, artillery and infantry action – the essence of the modern all-arms battle. In September and October the British fought the battle of Passchendæle, a ghastly struggle, often in mud, for a few hundred yards of front in Flanders, in which the Western allies lost 400,000 men.

In 1918 Ludendorff applied his new tactical thinking to attack, forming 40 divisions of 'storm troopers' to break through the weakest point of the enemy line, with the support of fully coordinated artillery. On 21 March the 'Michael Offensive' began, involving a million German soldiers. By the end of May the Germans were back on the Marne, 40 miles from Paris, and the French government was preparing to move out. The German offensive, the fourth of this campaign, failed

at Reims and on 8 August a mixed allied force counter-attacked at Amiens. Covered by highly accurate British artillery and 324 Mark V tanks, the infantry broke through to a depth of seven miles. Ludendorff declared 8 August 'the black day for the German army' and advised the Kaiser that Germany could no longer win the war.

In the south the American forces under General John Pershing, who had arrived in 1917, pushed back the Germans in the Saint-Mihiel salient, backed by 1000 allied aircraft. After a loss of nearly a million men in 1918, half a million deserters, and with starvation threatening at home, the Germans sought a cease-fire in November.

The war on the Eastern Front was more complex and mobile than that in the West. In August the Russians began

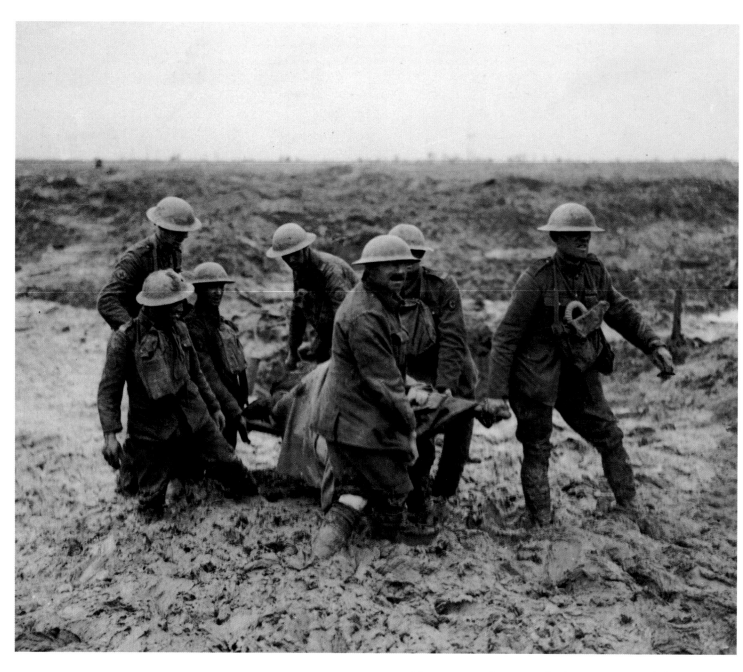

Stretcher party in the mud, Belgium, 1917. The allied artillery barrage of more than 3,500,000 shells before Passchendæle burst the drains in the flat marshland of the salient. It warned the enemy of the offensive, and meant that much of the fighting was in mud; thousands of men and horses drowned.

Verwundetentransport im tiefen Schlamm, Belgien, 1917. Das alliierte Sperrfeuer vor Passchendæle, bei dem über dreieinhalb Millionen Artilleriegranaten abgefeuert wurden, zerstörte die Entwässerungsgräben im flachen Marschland bei Ypern. Es war die Eröffnung der Offensive, doch mußte nun ein Großteil der Kämpfe im Schlamm geführt werden; Tausende von Soldaten und Pferden ertranken.

Brancardiers dans la boue, Belgique, 1917. Les 3 500 000 obus du barrage d'artillerie allié devant Passchendæle détruisirent le système de drainage de la région marécageuse du saillant, avertissant les ennemis de l'offensive et obligeant les belligérants à combattre dans la boue. Des milliers d'hommes et de chevaux périrent dans ce bourbier.

marching two armies towards East Prussia, and four towards Galicia in Austria, despite the fact that the Tsarist forces took weeks to mobilize. By mid-September the Russians had lost a quarter of a million men.

At the end of August the Germans caught the Russians at Tannenberg. The Germans managed to overhear the plans of the Russian command under General Pavel Rennenkampf (1st Army) and General Alexander Samsunov (2nd Army). The Germans realized that Rennenkampf had virtually halted and Samsunov's forces were isolated. With the use of railways they quickly moved their own forces forward, enveloped Samsunov's army, and destroyed two out of his five corps. The battle itself was directed by the command of General Paul von Hindenburg with General Ludendorff as chief of staff, but much of the planning was done before they arrived. The Germans sustained 15,000 casualties, and the Russians 120,000, including 90,000 prisoners; the Russians had more than 300 guns captured.

The German 8th Army then turned and caught the Russian 1st Army at the Masurian Lakes (9-14 September 1914).

Though severely mauled, and with the loss of 45,000 casualties and 150 guns to the German losses of 10,000 men, Rennenkampf managed to pull his forces back to Russia. The Russian commander of the North-West Front, General Yakov Zhilinsky, was sacked.

The Russians were to suffer shortage of equipment, arms of all kinds, and ammunition, and were inferior in artillery forces. But they managed to sustain fighting along a line far longer than the Western Front; the Eastern Front ran from the Baltic into the Balkans in the south. In 1915 and 1916 the Russian armies mounted repeated offensives into Galicia. In 1915 the success of the limited Russian advance persuaded Romania to join the war. On 2 May 1915 General August von Mackensen attacked and surprised the Russians between Gorlice and Tarnow. The Czar wrote, 'With its infantry and artillery dumb, our army is drowning in its own blood.' In a month the Germans moved 100 miles forward, capturing more than 400,000 Russian prisoners.

In October, with Bulgaria now involved in alliance with the Central Powers (see below), Mackensen led an advance into Serbia. Despite reinforcement by French and British troops, the Serb army was driven out and beat a retreat in the first blast of winter through Albania and Montenegro to the coast and Corfu.

In 1916 the Tsarist forces were reorganized, and managed successes against the Austrians and the Turks in the Caucasus. General Alexei Brussilov's army advanced 40 miles into Austria in two weeks in June 1916, taking more than 200,000 prisoners. Brussilov was a meticulous planner and revolutionized the use of indirect fire, artillery precisely registered and coordinated with infantry attacks. Despite the privations of Russian units, the planning of the central staff, the STAVKA, and the use of artillery were to provide examples for the Russians and their allies in future wars.

In April 1915, British troops began a diversionary operation by landing on the Gallipoli Peninsula, south-west of the Bosphorus, while the French moved in on the Asian shore opposite. The Dardanelles campaign had been inspired by Winston Churchill, First Lord of the Admiralty in the British government. Realizing that the allies were bogged down in western Europe, he aimed to produce movement by hitting the Central Powers in the south, in addition giving help to Russia through the Black Sea. An attempt to force the narrows of the Dardanelles failed in February and March when three battleships were sunk by mines.

The landings were badly planned and executed. The Turkish forces under their German adviser General Liman von Sanders were ready. In one of the few places where Australian and New Zealand troops landed unopposed – now called Anzac Cove – Colonel Mustafa Kemal moved his troops swiftly to plug the gap, and the allies failed to move inland. For the rest of 1915, the allies held only four unconnected points round the peninsula, which they had aimed to cut off at the neck within a day of landing. More than half a million allied troops were involved in the campaign; half became casualties of disease and battle. The expeditionary forces were withdrawn by the end of January 1916. Paradoxically, the experience contributed to the birth of three modern nations – the ANZACs (Australian-New Zealand Army Corps) are seen as the founding spirits of their respective countries, while Kemal Ataturk was to be the founder of the modern, secular, and still increasingly powerful modern Turkish state.

The debacle helped bring Bulgaria into the war, giving the Central Powers dominance in the Balkans until 1918. Italy entered the war in the summer of 1915, taking up a line in the north-east along the river Piave and on the Carso mountains. Fighting in the Carso and in the 12 battles of the Isonzo was as bitter as on any front in the war. The Italians threw illiterate peasants as young as 16 and 17 into futile attacks on the rocky face of the mountains held by Austrian machine gunners and artillery. The Sassari Brigade from Sardinia received casualties as high as those of any major unit on the allied side. In the 12th battle of Isonzo, Caporetto (24 October-7 November 1917), the Italians under General Cadorna broke and fell back to the line of the river Piave. The Italians lost 45,000 killed and 250,000 captured, and 2500 guns, but Cadorna, later replaced by General Armando Diaz, stabilized the line at the Piave and did not surrender.

British, French and American units were moved to reinforce the Italians. In the autumn of 1918 the Italians, with 57 divisions, including three British, two French and one Czech, attacked 58 Austro-Hungarian divisions near Vittorio Veneto, which was captured on 30 October. The Austrian army was broken, and an armistice was signed on 4 November 1918. Effectively it was the end of the Austro-Hungarian Empire.

In March 1917 another Imperial regime ended when the government of Czar Nicholas II was forced to abdicate. The Germans allowed the revolutionary Vladimir Ilyich Lenin to travel in a sealed train from Switzerland to Russia to foment revolution under the slogan 'peace and bread'. On 7 November his Bolsheviks seized power, and on 20 November sued for peace. The Russian armies had been exhausted by the war; they suffered 9,150,000 casualties – 76.3 per cent of their fighting strength of 12,000,000 men under arms. The Germans were given the Ukraine, Poland and the Baltic states of Russia under the Treaty of Brest-Litovsk (March 1918).

More than 70 million men had been mobilized for the war; 700,000 British soldiers died, 1.1 million Austrians, 1.3 million French, 2 million Germans. The Austrians suffered 90 per cent casualties of the 7,800,000 men they mobilized.

Among the technical innovations on the battlefield, the most important were the introduction of poison gas, the tank, and the fighter aircraft. Despite its ban by the Hague Convention of 1899, the Germans experimented with tear gas against the French and the Russians in the opening stages of the war. On 22 April 1915, the Germans released 150 tonnes of chlorine in support of an attack. The gas had very little effect on the British opposite. The British and French formed gas units – the British eventually favouring the use of gas in

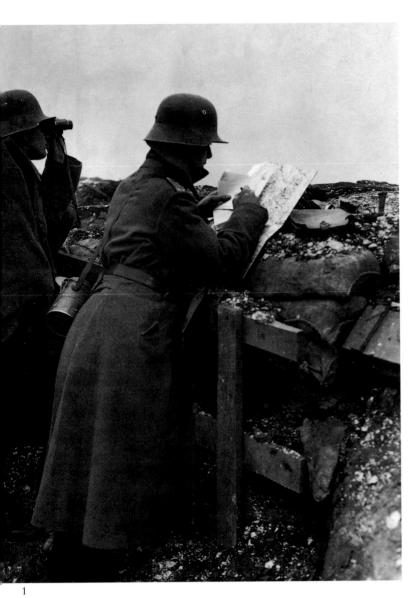

1

artillery shells and mortars, rather than release from industrial cylinders. Both the Germans and the allies had quantities of mustard gas by 1918, which caused unpleasant blistering of the skin and lungs, and the Germans used this to the end of the war.

Though gas was rigorously banned by international law, chemical weapons have become commonplace in the arsenals of many armies and in the hands of terrorists. The Italians used it comprehensively, and on Mussolini's express orders, in Abyssinia in 1936. In the Iran-Iraq War of 1979-88 chemical weapons were used, particularly by the Iraqi forces of Saddam Hussein. In 1988 the Iraqis attacked the Kurdish community in Halabja with mustard gas, which they are accused of having used in March 1991 to suppress the Kurdish revolt round Mosul.

The major battlefield innovation was in tactics: the use of indirect fire support from artillery and mortars, planned to combine with an all-arms attack involving infantry, armour, artillery and air power. The Germans, French, British and Russians evolved concepts that were the basis of tactics of manoeuvre warfare in the Second World War, and in high-intensity conventional warfare today; these were the seeds of German *Auftragstaktik*, *Blitzkrieg*, the Soviet shock attack, and the American land/air 2000.

Der Erste Weltkrieg war anders als alle vorherigen Kriege, denn in den vier Jahren seiner erbitterten Kämpfe wurde erstmals auch die zivile Bevölkerung in all ihren Bereichen mobilisiert. Manche Historiker sehen im Ersten Weltkrieg den Beginn einer Ära, in der das Hauptinteresse der internationalen Politik dem Gleichgewicht der Kräfte in Mitteleuropa galt, einer Ära, die 1989 mit dem Zusammenbruch der kommunistischen Staaten und dem Ende des Kalten Krieges ihren Abschluß fand.

Als sich die großen Armeen im Sommer 1914 zum Kampf rüsteten, ging man in den Generalstäben davon aus, daß der Krieg nicht lange dauern würde, allenfalls ein paar Monate, denn man hatte weder die finanziellen noch die industriellen Ressourcen, um die gewaltigen Streitkräfte länger unter Waffen zu halten. Die von General Alfred von Schlieffen entwickelte deutsche Strategie sah vor, daß zunächst Frankreich durch einen schnellen Schlag ausgeschaltet werden sollte, um einem Zweifrontenkrieg zuvorzukommen. Die Deutschen glaubten, sie hätten ausreichend Zeit, um durch Belgien vorzudringen und Paris im großen Bogen zu umgehen, ehe die Russen im Osten angriffsbereit waren. Doch beide Rechnungen gingen nicht auf: Die Franzosen sammelten sich vor Paris und hielten dem Ansturm stand, und die Russen mobilisierten schneller als erwartet.

Vom 5. bis 10. September 1914 brachten die Franzosen den deutschen Vormarsch an der Marne zum Stehen. Mit über zwei Millionen beteiligten Soldaten war diese Schlacht die wohl größte, die je geschlagen wurde. Die Deutschen zogen sich bis zur Aisne zurück, und der neue Generalstabschef Erich von Falkenhayn befahl den sogenannten »Wettlauf zum Meer«, um vor dem Gegner die Kanalhäfen zu erreichen. In den letzten vier Monaten des Jahres 1914 fiel eine halbe Million französischer, deutscher und englischer Soldaten in den Kämpfen in Frankreich und Flandern; ihre Armeen standen sich mittlerweile an der Westfront in einem Stellungskrieg gegenüber, in den in den nächsten drei Jahren nur wenig Bewegung kommen sollte.

1915 war die Front auf der ganzen Linie erstarrt – Stacheldrahtverhaue, Maschinengewehre, Mörser, Minen und schwere Artillerie machten ein Manövrieren so gut wie unmöglich. Im März und Mai unternahmen die Franzosen Durchbruchsversuche in der Champagne, und die Briten attackierten erfolgreich in Loos. Doch selbst im Stellungskrieg verloren die Franzosen allein 1915 eine Million Soldaten.

Im Jahr 1916 beschloß Falkenhayn, die Franzosen durch einen Angriff auf Verdun zu zermürben. Bei der ersten Offensive hätten die Deutschen die Stadt beinahe eingenommen, doch in den Kämpfen der folgenden Monate erlitten beide Armeen schwere Verluste. Nach dem deutschen Anfangserfolg mit der Erstürmung des Forts Douaumont lösten die Franzosen eiligst ihren Befehlshaber Joseph Joffre durch General Philippe Pétain ab, dem es gelang, die meuternden Truppen zu beschwichtigen und Verdun erfolgreich zu verteidigen, vor allem durch den Einsatz von motorisierten Fahrzeugen zum Transport von Versorgungs-

gütern. Bis zum Jahresende waren fast eine Million deutscher und französischer Soldaten bei Verdun gefallen.

Um den Druck auf Verdun zu mindern, sahen sich die Briten genötigt, weiter nördlich, an der Somme, anzugreifen. Nach siebentägigem Sperrfeuer unternahmen britische und französische Truppen am 1. Juli 1916 einen Durchbruchsversuch. Allein an diesem ersten Tag gab es auf britischer Seite 38 500 Verwundete und 19 240 Tote – es war der schwärzeste Tag in der Geschichte der britischen Armee. Die meisten der 120 000 britischen Infanteristen erreichten nicht einmal ihr erstes Operationsziel, die vorderste Linie der deutschen Schützengräben. Im südlichen Kampfabschnitt waren die Franzosen und Engländer allerdings erfolgreicher. Als die Kämpfe am 13. November 1916 endeten, belief sich die Zahl der Toten und Verwundeten bei den Briten auf 420 000, bei den Franzosen auf 195 000 und bei den Deutschen auf 650 000. Erstmals brachten die Briten Panzer (»Tanks«) zum Einsatz, und mehr als 400 Flugzeuge unternahmen Aufklärungsflüge.

Aus den bitteren Erfahrungen des Jahres 1916 zogen beide Seiten ihre Lehren. Der deutsche General Erich von Ludendorff verfaßte ein Handbuch mit taktischen Überlegungen zum Stellungskrieg, eine der Grundlagen moderner Kriegführung. Ludendorff empfahl, die Infanterie hinter der Front, außerhalb der Reichweite des gegnerischen Artilleriefeuers, zusammenzuziehen, während die vordersten Stellungen von Maschinengewehr-Vorposten gehalten wurden, die von nach hinten verlagerten Stützpunkten aus versorgt werden sollten. Sowohl für den Angriff als auch für die Verteidigung empfahl er, der untersten Kommandoebene Verantwortung zu übertragen, so daß jeder Unteroffizier seinen Kampfauftrag kannte; das ist der Kern einer einsatzorientierten Befehlsstruktur.

Auch die Westalliierten entwickelten neue Taktiken, um sich aus dem Würgegriff uneinnehmbarer, tief eingegrabener Verteidigungsstellungen mit Artilleriedeckung, Stacheldrahtverhauen, Maschinengewehren und Mörsern zu befreien. Im Oktober gelang sechs britischen Divisionen, unterstützt von 476 Tanks und 1003 Geschützen, ein dramatischer Durchbruch bei Cambrai, aber die Briten hatten nicht genügend Reserven, um diesen Erfolg auszubauen. Durch den ersten erfolgreichen Einsatz von Panzern, den ersten modernen Artillerie-Feuerplan und das für die moderne Kriegführung mit allen Kampfmitteln typische gemeinschaftliche Vorgehen von Flugzeugen, Panzern, Artillerie und Infanterie markierte Cambrai einen Wendepunkt. Im September und Oktober kämpften die Briten bei Passchendæle in Flandern um ein paar hundert Meter Boden; es war eine mörderische Schlacht, oftmals im Schlamm, bei der die Westalliierten 400 000 Mann verloren.

1918 wandte Ludendorff seine neuen taktischen Prinzipien auch auf den Angriffskrieg an: Er formierte eine 40 Divisionen starke Sturmtruppe, die, unterstützt von einer perfekt koordinierten Artillerie, die feindlichen Linien an der schwächsten Stelle durchbrechen sollte. Am 21. März

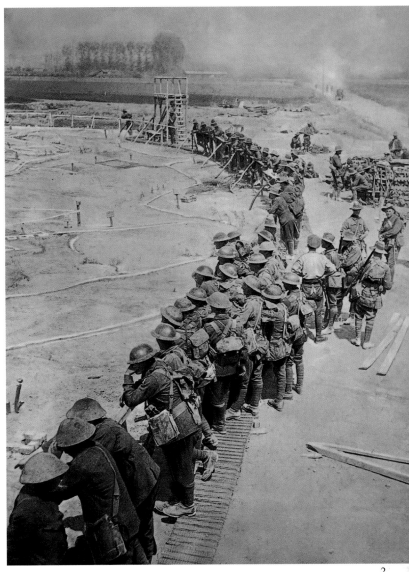

2

(1) German officers surveying and mapping British positions captured on the Western Front. (2) Australian soldiers studying a sand model of the terrain before the attack on Messines Ridge, 7 June 1917, one of the best-planned allied attacks on the Western Front. It started with huge mine explosions, which could be heard in London.

(1) Deutsche Offiziere beobachten und verzeichnen britische Stellungen, die sie an der Westfront eingenommen haben.
(2) Australische Soldaten machen sich vor dem Angriff auf Messines am 7. Juni 1917 – einer der am besten geplanten alliierten Operationen an der Westfront – anhand eines Sandmodells mit dem Gelände vertraut. Der Angriff begann mit gewaltigen Minenexplosionen, die bis nach London zu hören waren.

(1) Officiers allemands surveillant et dressant le plan des positions anglaises prises sur le front Ouest. (2) Soldats australiens étudiant un modèle en sable de la crête de Messine avant l'attaque du 7 juin 1917, l'une des attaques alliées les mieux préparées sur le front Ouest. Elle commença avec d'énormes explosions de mines qui s'entendirent jusqu'à Londres.

1

(1) French aviators loading up bombs on the Western Front, summer 1915. Bombs were dropped by hand in the early days; later, aircraft carried out highly risky but effective ground attacks with machine guns and bombs. (2) French troops marching to positions on the Salonika Front, 1915, watched by resting British troops.

(1) Französische Flieger nehmen im Sommer 1915 an der Westfront Bomben an Bord. Anfangs wurden Bomben von Hand abgeworfen; später unterstützten Erdkampfflugzeuge die Bodentruppen durch gewagte, aber erfolgreiche Manöver mit Maschinengewehren und Bomben. (2) Rastende britische Soldaten beobachten französische Truppen auf dem Weg an die Front bei Saloniki, 1915.

(1) Aviateurs français chargeant des bombes, front occidental, été 1915. Au début, les bombes étaient larguées à la main; plus tard, les avions équipés de mitrailleuses et des bombes furent utilisés pour des attaques au sol efficaces bien que très risquées. (2) Troupes françaises marchant vers des positions sur le front de Salonique en 1915, des soldats anglais au repos les regardent passer.

begann die deutsche Offensive, die Operation »Michael«, an der eine Million deutsche Soldaten beteiligt waren. Ende Mai standen die Deutschen wieder an der Marne, 60 Kilometer vor Paris, und die französische Regierung traf Vorbereitungen zur Flucht. Doch schließlich scheiterte bei Reims der vierte deutsche Vorstoß dieses Feldzugs, und am 8. August erfolgte der alliierte Gegenangriff bei Amiens. Unterstützt von der überaus effektiven britischen Artillerie und 324 Tanks des Typs Mark V gelang es der Infanterie, mehr als zehn Kilometer tief in gegnerisches Gebiet vorzudringen. Ludendorff erklärte den 8. August zum »schwarzen Tag des deutschen Heeres«, und teilte dem Kaiser mit, daß er nicht mehr mit einem deutschen Sieg rechne.

Im südlichen Frontabschnitt drängten die 1917 eingetroffenen amerikanischen Truppen unter General John Pershing, unterstützt von 1000 alliierten Flugzeugen, die Deutschen am Saint-Mihiel-Bogen zurück. Angesichts von fast einer Million Toten und Verwundeten und einer halben Million Deserteuren sowie einer drohenden Hungersnot in

der Heimat unterzeichneten die Deutschen im November 1918 ein Waffenstillstandsabkommen.

Der Krieg im Osten war komplexer, und es gab mehr Bewegung als im Westen. Obwohl das zaristische Rußland Wochen für die Mobilmachung seiner Truppen brauchte, entsandte es bereits im August 1914 zwei Armeen nach Ostpreußen und vier in das zu Österreich gehörende Galizien. Bis Mitte September hatten die russischen Streitkräfte schon über 250 000 Mann verloren.

Ende August trafen Deutsche und Russen bei Tannenberg aufeinander. Es war den Deutschen gelungen, die Pläne des russischen Oberkommandos unter General Pavel Rennenkampf von der 1. Armee und General Alexander Samsonow von der 2. Armee abzuhören. Als ihnen klar wurde, daß Rennenkampfs Vormarsch praktisch zum Stillstand gekommen und Samsonows Truppe isoliert war, schafften sie ihre eigenen Truppen per Eisenbahn eiligst an die Front, umfaßten Samsonows Armee und schlugen sie vernichtend. Den Oberbefehl bei der eigentlichen Schlacht hatten General Paul von Hindenburg und sein Stabschef Ludendorff, aber ein Großteil der Planungen hatte bereits vor ihrer Ankunft stattgefunden. Die Deutschen verloren in der Schlacht 15 000 Mann, die Russen 120 000 – 30 000 Tote und Verwundete, dazu 90 000 Gefangene; außerdem fielen mehr als 300 russische Geschütze in die Hand des Feindes.

Anschließend wandte sich die deutsche 8. Armee nach Osten und stellte die russische 1. Armee an den Masurischen Seen (9.-14. September 1914). Trotz schwerer Verluste – 45 000 Tote und Verwundete und 150 Geschütze auf russischer im Vergleich zu 10 000 Mann auf deutscher Seite – gelang es Rennenkampf, seine Truppen nach Rußland zurückzuführen. Der russische Oberbefehlshaber der Nordwestfront, General Jakow Schilinski, verlor seinen Posten.

Die Russen hatten mit Engpässen bei Ausrüstung, Waffen und Munition zu kämpfen und waren auch auf dem Gebiet der Artillerie ihrem Gegner unterlegen. Trotzdem gelang es ihnen, sich entlang einer Frontlinie, die wesentlich länger war als die Westfront, zu behaupten: die Ostfront erstreckte sich von der Ostsee bis auf den Balkan. In den Jahren 1915 und 1916 griffen russische Armeen mehrfach Galizien an. Der Erfolg des begrenzten russischen Vorstoßes von 1915 veranlaßte Rumänien zum Kriegseintritt auf seiten der Entente. Am 2. Mai 1915 erzwang General August von Mackensen durch einen Überraschungsangriff auf die Russen bei Gorlice-Tarnow den Durchbruch. Der Zar schrieb: »Infanterie und Artillerie sind verstummt, und unsere Armee ertrinkt im eigenen Blut.« Binnen eines Monats rückten die Deutschen 150 Kilometer vor und nahmen mehr als 400 000 russische Gefangene.

Nachdem Bulgarien im Oktober 1915 auf seiten der Mittelmächte in den Krieg eingetreten war (s.u.), unternahm Mackensen einen Vorstoß gegen Serbien. Trotz der Unterstützung durch französische und britische Truppen wurde die serbische Armee vertrieben und zog sich in den ersten

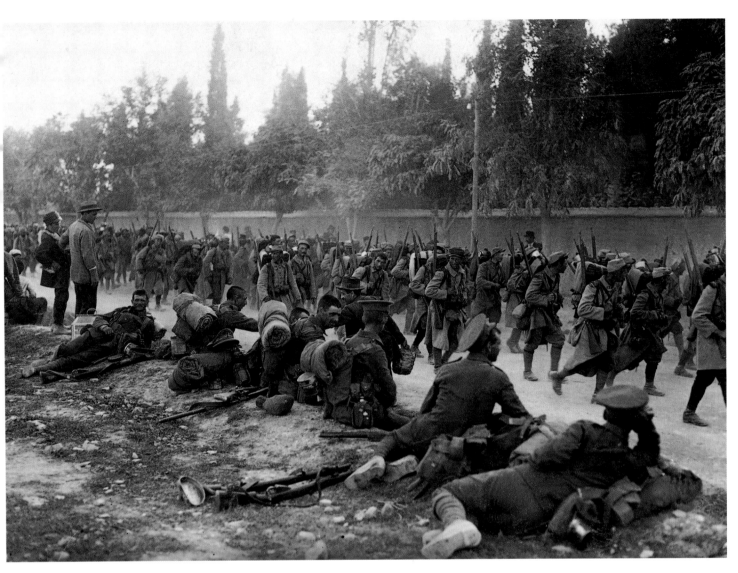

Winterstürmen durch Albanien und Montenegro an die Küste und nach Korfu zurück.

1916 war die Kampfkraft der zaristischen Truppen wiederhergestellt; sie errangen Erfolge gegen die Österreicher und gegen die Türken im Kaukasus. Innerhalb von nur zwei Wochen drang die russische Armee unter General Alexej Brussilow im Juni 1916 60 Kilometer tief in österreichisches Gebiet vor und nahm über 200 000 Gefangene. Brussiolow war ein penibler Planer und großer Neuerer auf dem Gebiet des indirekten Artilleriebeschusses, bei dem die Artillerieoperationen exakt mit Attacken der Infanterie koordiniert wurden. Trotz der Entbehrungen, unter denen die russischen Einheiten litten, war die Planungsarbeit des zentralen Stabs (STAVKA) und der Einsatz der Artillerie wegweisend für die Russen und ihre Alliierten in künftigen Kriegen.

Im April 1915 begannen britische Truppen ein Ablenkungsmanöver, bei dem sie auf der Halbinsel Gallipoli, südwestlich des Bosporus, landeten, während die Franzosen die gegenüberliegende asiatische Küste besetzten. Der Dardanellenfeldzug ging auf eine Idee Winston Churchills, des Ersten Lords der Admiralität in der britischen Regierung, zurück. Als er erkannte, daß die Alliierten in Westeuropa festsaßen, wollte er durch einen Angriff auf die Mittelmächte im Süden Bewegung in die verfahrene Situation bringen; außerdem wollte man Rußland vom Schwarzen Meer aus

Unterstützung zukommen lassen. Bei dem vergeblichen Versuch, die Meerenge der Dardanellen einzunehmen, waren bereits im Februar und März 1915 drei Schlachtschiffe durch Minen versenkt worden.

Die Landeoperation war schlecht geplant und mangelhaft in der Durchführung. Die türkischen Streitkräfte unter ihrem deutschen Befehlshaber Otto Liman von Sanders waren auf den Angriff vorbereitet. An einer der wenigen Stellen, wo die australischen und neuseeländischen Truppen ungehindert hatten landen können – einer Bucht, die nach den beteiligten Einheiten des Australian-New Zealand Army Corps noch heute den Namen Anzac-Bucht trägt –, zog Oberst Mustafa Kemal rasch Truppen zusammen, um die Lücke in der Verteidigung zu schließen. Den Alliierten gelang es dadurch nicht, ins Innere der Halbinsel vorzustoßen. Im weiteren Verlauf des Jahres 1915 behaupteten die Alliierten lediglich vier isolierte Stützpunkte rings um die Halbinsel, die sie eigentlich binnen eines Tages nach der Landung vom Hinterland hatten abriegeln wollen. An der Unternehmung waren mehr als eine halbe Million alliierte Soldaten beteiligt; die Hälfte von ihnen erkrankte oder wurde im Kampf verwundet oder getötet. Ende Januar 1916 zogen die Expeditionstruppen wieder ab. Paradoxerweise leistete diese glücklose Unternehmung Geburtshilfe für gleich drei moderne Nationen: Die Soldaten des ANZAC gelten

gemeinhin als die ersten treibenden Kräfte für die Unabhängigkeit Australiens und Neuseelands, und Kemal Atatürk sollte zum Begründer des modernen, säkularisierten und zunehmend an Macht gewinnenden türkischen Staates werden.

Das Debakel des Dardanellenfeldzugs trug dazu bei, Bulgarien zum Kriegseintritt auf seiten der Mittelmächte zu bewegen, was diesen bis 1918 zu einem Übergewicht auf dem Balkan verhalf. Im Sommer 1915 trat auch Italien – auf alliierter Seite – in den Krieg ein und errichtete eine Front im Nordosten des Landes entlang der Piave und im Karst-Gebirge. Dort und in den zwölf Isonzoschlachten wurde mit der gleichen Erbitterung gekämpft wie an den anderen Fronten des Ersten Weltkriegs. Die Italiener schickten Sechzehnjährige ohne jede Ausbildung in aussichtslose Gefechte ins Gelände, das von österreichischen Maschinen-gewehrstellungen und Artillerie beherrscht wurde. Die Sassari-Brigade aus Sardinien erlitt ebenso hohe Verluste wie jede größere Einheit auf alliierter Seite. In der zwölften Isonzoschlacht, der Schlacht von Caporetto (24. Oktober-7. November 1917), brach die italienische Front unter General Luigi Cadorna zusammen, und die Italiener wichen zurück bis an die Piave. Die Niederlage kostete die Italiener 45 000 Tote, 250 000 Gefangene und 2500 Geschütze, aber Cadorna, der später durch General Armando Diaz abgelöst wurde, stabilisierte die Front an der Piave und kapitulierte nicht.

Unterstützt wurden die Italiener durch britische, französische und amerikanische Verbände. Am 30. Oktober 1918 siegten die Italiener mit 57 Divisionen – darunter drei britische, zwei französische und eine tschechische – über 58 österreichisch-ungarische Divisionen bei Vittorio Veneto. Der Kampfgeist der österreichischen Armee war gebrochen, und am 4. Novermber 1918 wurde der Waffenstillstand unter-zeichnet. Damit war das Schicksal des Vielvölkerstaats Österreich-Ungarn praktisch besiegelt.

Bereits im März 1917 hatte, als Zar Nikolaus II. zur Abdankung gezwungen wurde, einem anderen Kaiserreich die letzte Stunde geschlagen. Die Deutschen gestatteten dem Revolutionär Wladimir Iljitsch Lenin in einem plombierten Eisenbahnwaggon die Durchreise aus der Schweiz nach Rußland, wo er unter dem Motto »Friede und Brot« die Revolution vorantreiben sollte. Am 7. November ergriffen Lenins Bolschewiki die Macht und leiteten am 20. November Friedensverhandlungen ein. Die russischen Armeen waren vom Krieg erschöpft; 9 150 000 Soldaten – drei Viertel ihrer zwölf Millionen Mann starken Streitkräfte – waren getötet oder verwundet worden. Im Frieden von Brest-Litowsk (März 1918) verlor Rußland die Ukraine, Polen und die baltischen Staaten.

Am Ersten Weltkrieg hatten mehr als 70 Millionen Soldaten teilgenommen; unter den Gefallenen waren 700 000 Briten, 1,1 Millionen Österreicher, 1,3 Millionen Franzosen und zwei Millionen Deutsche. Bei den Österreichern wurden 90 Prozent des Gesamtaufgebots von 7 800 000 Mann getötet oder verwundet.

Zu den wichtigsten technischen Neuerungen, die auf dem Schlachtfeld Einzug gehalten hatten, zählten Giftgas, Panzer und Jagdflugzeuge. Trotz des Verbots durch die Haager Landkriegsordnung von 1899 und 1907 experimentierten die Deutschen im Anfangsstadium des Krieges in Frankreich und Rußland mit Tränengas. Am 22. April 1915 setzten sie zur Unterstützung eines Angriffs 150 Tonnen Chlorgas ein. Das Gas blieb jedoch ohne große Wirkung auf den britischen Gegner. Briten und Franzosen bildeten spezielle Gaseinheiten; die Briten entwickelten Gasgranaten, die aus Artilleriegeschützen abgefeuert wurden – zuvor war das Gas einfach aus industriellen Gasflaschen abgelassen worden. Sowohl die Deutschen als auch die Alliierten waren 1918 im Besitz von Senfgas, das auf der Haut und in den Lungen schwer heilende Wunden erzeugte.

Obwohl das internationale Recht den Einsatz von Giftgas strikt untersagt, gehören chemische Kampfstoffe heute zum Standardarsenal vieler Armeen und Terrororganisationen. Die Italiener setzten es 1936 in großem Stil und auf ausdrücklichen Befehl Mussolinis in Abessinien ein. Im iranisch-irakischen Krieg von 1979-88 kamen chemische Waffen zum Einsatz – vor allem durch die irakischen Truppen Saddam Husseins. 1988 gingen die Irakis mit Senfgas gegen die Kurden in Halabjah vor und werden auch beschuldigt, es im März 1991 zur Unterdrückung des kurdischen Aufstands in Mosul eingesetzt zu haben.

Die wichtigste strategische Neuerung vollzog sich auf dem Gebiet der Kampftaktik: im genau koordinierten Einsatz indirekter Feuerunterstützung durch Artilleriegeschütze und Mörser bei einem kombinierten Angriff aller Waffengattungen – Infanterie, Panzertruppen, Artillerie und Luftwaffe – zugleich. Deutsche, Franzosen, Briten und Russen entwickelten taktische Konzepte, die wegweisend für die Kriegführung im Zweiten Weltkrieg und für die intensive konventionelle Kriegführung in unserer Zeit wurden; hier liegen die Wurzeln zu taktischen Konzepten wie der »Auftragstaktik« und dem »Blitzkrieg« der Deutschen, zum sowjetischen Überraschungsangriff und zur amerikanischen »Land-Air-2000«-Strategie.

La Première Guerre mondiale fut un événement décisif car elle mobilisa l'ensemble de la société civile pendant les quatre années de ce conflit sanglant. Certains historiens la considèrent comme l'avènement d'une époque de politique internationale basée sur l'équilibre des forces en Europe centrale, époque s'achevant avec l'effondrement du communisme en Europe et la fin de la guerre froide en 1989.

Lorsque les armées furent mobilisées au cours de l'été 1914, la plupart des états-majors pensaient que le conflit serait de courte durée, quelques mois en tout, car aucun belligérant n'avait la capacité financière et industrielle d'entretenir plus longtemps une armée en campagne. La stratégie des Allemands, mise au point par le général Alfred von Schlieffen, consista à lancer une attaque éclair contre la France pour la mettre à genoux et éviter ainsi d'avoir à combattre sur deux fronts. Les Allemands croyaient avoir le temps d'envahir la Belgique et d'atteindre les environs de Paris avant que les Russes ne lancent une offensive à l'Est. Ils se trompaient: les Français qui s'étaient repliés sur Paris tinrent bon, et les Russes mobilisèrent plus vite que prévu.

L'armée française tint sur le front de la Marne entre le 5 et le 10 septembre; cette bataille est certainement de par le nombre de soldats engagés – plus de 2 millions – la plus grande de toute l'Histoire. Les Allemands se retirèrent jusqu'à l'Aisne, puis leur nouveau commandant en chef, Erich von Falkenhayn, lança ses troupes dans la course à la mer. Durant les quatre derniers mois de l'année 1914, un demi-million de soldats français, allemands et britanniques furent tués en France et en Flandres; à ce moment-là, les armées tenaient ferme sur une ligne, le front Ouest, qui devait peu bouger pendant les trois années suivantes.

En 1915, le front était «fixé»: les fils de fer barbelé, les mitrailleuses, les mortiers, les mines et l'artillerie lourde rendaient apparemment impossible toute manœuvre. L'armée française tenta une offensive en Champagne en mars et en mai, et les Britanniques attaquèrent les troupes allemandes à Loos, avec succès. Malgré l'absence de mouvement, les Français perdirent un million d'hommes pendant la seule année 1915.

En 1916, Falkenhayn décida de briser la défense française en attaquant Verdun. Peu s'en fallut que les Allemands ne prennent la ville en février, lors du premier assaut, mais les mois suivants, les deux armées se livrèrent une sanglante bataille. Après la prise du fort de Douaumont par les Allemands, l'état-major français se dépêcha de remplacer Joffre, commandant de corps d'armée, par le général Pétain. Celui-ci réussit à calmer les troupes qui se mutinaient et à organiser une défense en réquisitionnant des véhicules automobiles pour transporter les approvisionnements. A la fin de l'année, le bilan était lourd: presqu'un million d'Allemands et de Français étaient tombés à Verdun.

Pour relâcher la pression sur Verdun, les Britanniques furent chargés de lancer une offensive sur la Somme. Après un tir de barrage de sept jours, les troupes franco-anglaises avancèrent enfin le 1er juillet 1916. Pour le seul premier jour,

les pertes britanniques s'élevèrent à 57 740 hommes dont 19 240 tués. Le jour le plus sombre de l'histoire de l'armée britannique. La majeure partie des 120 000 fantassins anglais n'atteignirent pas leur objectif, la première ligne de tranchées allemandes, alors que sur le front sud, les troupes franco-anglaises avaient réussi une percée. La bataille s'acheva le 13 novembre avec des pertes énormes: 420 000 du côté britannique, 195 000 du côté français et 650 000 chez les Allemands. Les premiers chars anglais et plus de 400 avions de reconnaissance avaient participé à l'offensive.

Les belligérants tirèrent les leçons de l'année 1916. Le commandant en chef de l'armée allemande Erich von Ludendorff, auteur d'un ouvrage intitulé *Conduite de la guerre défensive*, fut un des fondateurs de la tactique de la guerre intensive moderne. Il recommandait que l'infanterie soit placée en retrait des lignes, hors de portée de l'artillerie, tandis que les premières positions seraient défendues par un écran de mitrailleuses soutenu par une ligne de tir en profondeur. Aussi bien dans la tactique défensive que la tactique offensive, la responsabilité devait être partagée jusqu'au plus bas niveau de commande, de sorte que chaque sous-officier connaisse sa mission. C'était l'essence de l'ordre coordonné à la mission.

Les forces alliées recoururent elles aussi à une nouvelle tactique pour percer de puissantes défenses basées sur l'artillerie, le fil de fer barbelé, les mitrailleuses et les mortiers. Six divisions anglaises soutenues par 476 tanks et 1003 canons réussirent une percée à Cambrai en octobre 1916, mais les Anglais manquaient alors de réserves pour exploiter entièrement leur offensive. Cambrai marqua un tournant dans la guerre avec l'apparition des chars d'assaut, le premier plan de tir moderne et l'intégration d'avions à l'action conjuguée des blindés, de l'artillerie et de l'infanterie. C'était la première opération toutes armes. En septembre et en octobre, l'armée britannique combattit à Passchendæle, une bataille épouvantable, livrée en partie dans la boue, pour gagner une centaine de mètres sur le front des Flandres, où les forces alliées perdirent 400 000 hommes.

En 1918, Ludendorff appliqua sa nouvelle théorie tactique à l'attaque: il forma 40 divisions de «troupes d'assaut» chargées de briser le point le plus vulnérable des lignes ennemies avec le soutien de l'artillerie entièrement coordonnée. Le 21 mars, un million de soldats allemands lancèrent l'«offensive Michael». Fin mai, les Allemands étaient revenus à la Marne, à 60 km de Paris, et le gouvernement français s'apprêtait à quitter la capitale. L'offensive allemande, la quatrième de cette campagne, échoua à Reims, et le 8 août, une armée alliée lança une contre-offensive à Amiens. Couverte par une artillerie britannique d'une grande précision et 324 chars Mark V, l'infanterie ouvrit une brèche de 11 km à l'intérieur des positions ennemies. Ludendorff déclara que le 8 août avait été «un jour sombre pour l'armée allemande» et avisa l'Empereur que l'Allemagne ne pouvait plus gagner la guerre.

Au sud, les forces américaines du général John Pershing, arrivées en 1917, repoussèrent les Allemands dans le saillant de Saint-Michel, appuyées par 1000 avions alliés. Affaiblis par la

perte de près d'un million d'hommes en 1918, d'un demi-million de déserteurs, et par une population menacée de famine, les Allemands sollicitèrent un cessez-le-feu en novembre.

La guerre sur le front de l'Est était plus complexe et mobile que sur le front de l'Ouest. En août, deux armées russes marchèrent sur la Prusse orientale et quatre sur la Galicie, en Autriche, bien que les forces tsaristes aient eu besoin de deux semaines pour être mobilisées. A la mi-septembre, les Russes avaient perdu 250 000 hommes.

Fin août, l'armée allemande surprit les Russes à Tannenberg. Les Allemands avaient eu vent des plans du commandement russe constitué du général Pavel Rennenkampf (1ère armée) et du général Alexandre Samsounov (2e armée). Ils avaient compris que l'armée de Rennenkampf s'était quasiment arrêtée et que celle de Samsounov était isolée. Dépêchant leurs troupes par chemin de fer, ils encerclèrent Samsounov et mirent hors de combat deux de ses cinq corps d'armée. C'est le général Paul von Hindenburg, secondé par le général Ludendorff, chef d'état-major, qui dirigea la bataille mais une bonne partie des plans étaient antérieurs à leur arrivée. Les Allemands subirent 15 000 pertes, les Russes 120 000, dont 90 000 prisonniers; plus de 300 canons russes furent capturés par l'ennemi.

La 8e armée allemande fit demi-tour et surprit la 1ère armée russe dans la région des lacs mazures (9-14 septembre 1914). Bien que sévèrement battue, affaiblie par la perte de 45.000 hommes et de 150 canons, contre 10 000 pertes pour l'armée allemande, Rennenkampf réussit à se replier en Russie avec ses troupes. Le commandant russe du front nord-ouest, le général Yakov Zhilinsky, fut relevé de ses fonctions.

Les Russes qui souffraient du manque d'équipement, d'armes en tous genres et de munitions, étaient inférieurs par leur artillerie. Ils réussirent pourtant à tenir sur une ligne bien plus longue que le front Ouest, qui s'étendait de la Baltique aux Balkans. En 1915 et 1916, les armées russes lancèrent plusieurs offensives en Galicie. Devant le succès de la timide avance russe, la Roumanie entra en guerre elle aussi en 1915. Le 2 mai 1915, le général August von Mackensen attaqua les Russes par surprise entre Gorlice et Tarnów. «Par la bêtise de son infanterie et de son artillerie, notre armée se noie dans son propre sang», écrivit le Tsar. Les Allemands progressèrent de 170 km en un mois, faisant plus de 400 000 prisonniers russes.

En octobre, Mackensen, fort du soutien de la Bulgarie, alliée des Empires centraux (voir plus bas), envahit la Serbie. Au début de l'hiver, malgré les renforts français et anglais, l'armée serbe dut battre en retraite à travers l'Albanie et le Monténégro jusqu'à la côte et l'île de Corfou.

Les forces tsaristes se réorganisèrent en 1916 et remportèrent des victoires contre les Autrichiens et les Turcs dans le Caucase. En Autriche, en juin 1916, l'armée du général Alexeï Broussilov progressa de 65 km en deux semaines, faisant plus de 200 000 prisonniers. Broussilov était un organisateur méticuleux et il révolutionna l'emploi du tir indirect en faisant exactement coïncider l'artillerie avec les

attaques de l'infanterie. Malgré les privations endurées par les unités russes, on peut dire que les plans de l'état-major, le Stavka, et l'emploi de l'artillerie serviront de modèles aux Russes et à leurs alliés au cours des prochaines guerres.

Les troupes britanniques montèrent une opération de diversion en avril 1915 en débarquant dans la péninsule de Gallipoli, au sud-ouest du Bosphore, tandis que les Français débarquaient sur la rive asiatique. Winston Churchill, alors premier lord de l'Amirauté, fut l'instigateur de cette campagne des Dardanelles. Les Alliés étant enlisés en Europe de l'Ouest, il pensait faire bouger les choses en frappant les Empires centraux sur leur flanc sud et, en plus, aider la Russie en mer Noire. En février et en mars, la tentative franco-anglaise d'ouvrir les Détroits échoua avec le coulage par mines de trois de leurs navires de guerre.

Les débarquements étaient mal conçus et mal exécutés. Les forces turques placées sous les ordres du général allemand Liman von Sanders étaient bien préparées. Les troupes du colonel Mustafa Kemal s'étaient déplacées rapidement pour arrêter le corps d'armée australo-néo-zélandais (ANZAC) à l'un des rares endroits – appelé depuis l'anse de l'Anzac – où les Alliés avaient débarqué sans rencontrer de résistance. Ceux-ci ne purent aller plus loin. Pendant le reste de l'année 1915, les Alliés ne tinrent que quatre points disséminés autour de la péninsule alors qu'ils avaient imaginé occuper celle-ci en une journée. La moitié des 500 000 soldats alliés participant à l'expédition mourut de maladie ou pendant les débarquements. Les forces expéditionnaires se retirèrent à la fin de janvier 1916. Paradoxalement, cette expédition contribua à la naissance de trois nations. L'Anzac est considéré comme l'esprit fondateur de deux pays: l'Australie et la Nouvelle-Zélande; Mustafa Kemal est le créateur de l'Etat turc moderne et laïc, dont la puissance ne cessera de s'affirmer.

La débâcle alliée poussa la Bulgarie à entrer en guerre, donnant ainsi aux Empires centraux la supériorité dans les Balkans jusqu'en 1918. L'Italie, entrée en lice pendant l'été 1915, occupa une ligne s'étirant du nord-est de la rivière Piave aux monts du Karst. Les combats dans le Karst et l'Isonzo furent aussi durs que sur tout autre front de la guerre. Les Italiens lancèrent de jeunes paysans illettrés de 16 ou 17 ans dans de vaines offensives sur le versant rocheux du Karst tenu par les mitrailleurs et les artilleurs autrichiens. La brigade Sassari de Sardaigne perdit autant d'hommes que n'importe quelle grosse unité du camp allié. Le front italien rompit à Caparetto, lors de la 12e bataille de l'Isonzo (24 octobre-7 novembre 1917). Les soldats commandés par le général Cadorna reculèrent jusqu'à la rivière Piave. Les Italiens perdirent 45 000 hommes et 2500 canons; 250 000 soldats furent faits prisonniers. Mais Cadorna, remplacé plus tard par le général Armando Diaz, stabilisa le front à Piave et ne se rendit pas.

Des unités britanniques, françaises et américaines furent envoyées pour aider les Italiens. A l'automne 1918, l'armée italienne composée de 57 divisions, dont trois britanniques, deux françaises et une tchèque, attaquèrent les Austro-

A nurse serves tea to British walking wounded. Nurses on the Western Front were to give the most vivid accounts of the terrible slaughter there. Many were unpaid volunteers.

Eine Krankenschwester versorgt britische Verwundete mit Tee. Krankenschwestern – zumeist waren es ehrenamtliche Freiwillige – lieferten besonders eindrucksvolle Berichte von dem Gemetzel an der Westfront.

Une infirmière sert du thé à des blessés anglais. Les infirmières témoigneront du monstrueux carnage se produisant sur le front occidental. Beaucoup étaient des bénévoles non rémunérées.

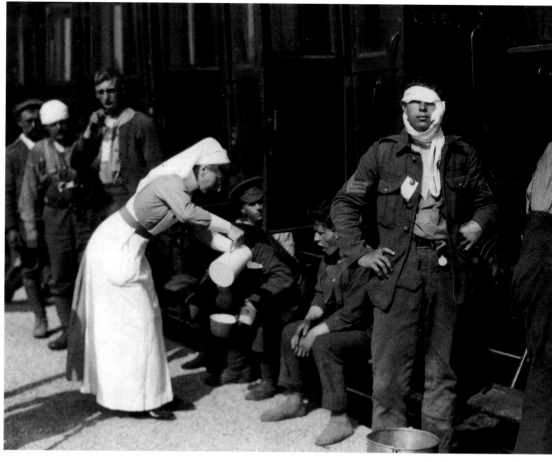

Hongrois près de Vittorio Veneto, qui fut pris le 30 octobre. Le front austro-hongrois rompu, l'Autriche signa un armistice le 4 novembre, ce qui allait précipiter la fin de l'Empire.

En mars 1917, un autre empire s'effondra: celui du tsar Nicolas II, forcé d'abdiquer. Les Allemands avait permis le passage du révolutionnaire Vladimir Ilitch Lénine à travers son territoire dans ce qu'on a appelé le «train plombé»: de retour en Russie, celui-ci fomenta la révolution en lançant son slogan «Paix et Pain». Les bolcheviks prirent le pouvoir le 7 novembre et sollicitèrent la paix le 20 novembre. Les armées russes, épuisées par la guerre, avaient perdu 9 150 000 soldats, en tout 76,3 % des 12 000 000 d'hommes en armes. La Russie dut abandonner à l'Allemagne l'Ukraine, la Pologne et les pays Baltes par le traité de Brest-Litovsk (mars 1918).

Plus de 70 millions d'hommes avaient été mobilisés. 700 000 soldats britanniques, 1,1 million d'Autrichiens, 1,3 de Français et 2 millions d'Allemands étaient morts. Les Austro-Hongrois accusèrent 90 % de pertes sur les 7 800 000 soldats qu'ils avaient mobilisés.

Le gaz asphyxiant, le char d'assaut et l'avion de combat comptent parmi les innovations techniques les plus importantes de cette guerre. Malgré l'interdiction prononcée par la Convention de La Haye en 1899, les Allemands expérimentèrent le gaz lacrymogène sur les Français et les Russes pendant les premières phases de la guerre. Le 22 avril 1915, ils lâchèrent 150 tonnes de chloropicrine sur les soldats britanniques, avec un résultat minimal. A leur tour, les armées française et britannique s'équipèrent en gaz, les Britanniques préférant employer à cette fin les obus et les mortiers au lieu des gros diffuseurs cylindriques. Les Allemands comme les

Alliés disposaient en 1918 de grandes quantités de gaz moutarde, un gaz vésicant douloureux pour la peau et les poumons. Les Allemands l'employèrent jusqu'à la fin de la guerre.

Bien que les gaz de combat aient été formellement interdits par la législation internationale, les armes chimiques font partie des arsenaux de nombreux pays et se trouvent entre les mains de terroristes. Les Italiens s'en servirent largement, en 1936 par exemple, en Abyssinie, sur l'ordre de Mussolini. Durant la guerre irano-irakienne de 1979-88, les belligérants, en particulier les Irakiens, employèrent des armes chimiques. A Halabja, en 1988, l'armée de Saddam Hussein attaqua les Kurdes avec du gaz moutarde; elle fut accusée d'en avoir utilisé également en mars 1991 pour réprimer la révolte kurde dans la province de Mossoul.

La plus grande nouveauté de la guerre résidait dans la tactique: celle de l'emploi d'un feu indirect à l'artillerie et au mortier pour soutenir une attaque toutes armes, basée sur l'action conjuguée de l'infanterie, des blindés, de l'artillerie et de l'aviation. Allemands, Français, Britanniques et Russes développèrent leurs propres théories, bases de la tactique de la guerre de mouvement durant la Seconde Guerre mondiale et la guerre conventionnelle intensive de notre époque. Elles contenaient en germe le *Blitzkrieg* et l'*Auftragstaktik* de l'armée allemande, l'attaque choc soviétique et le terre-air 2000 des Américains.

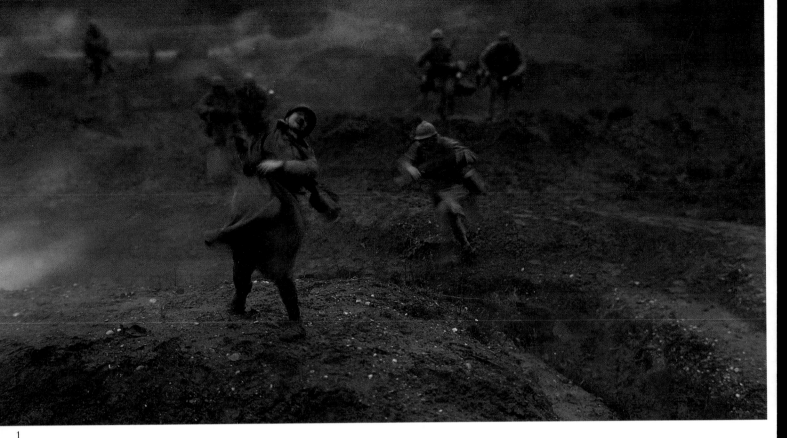

1

Trench Warfare

(1) French soldiers attacking at 'H' hour at Verdun in 1916. (2) An open British trench on the Western Front. (3) The Germans learnt to keep most of their infantry and reserves well back, out of range of forward artillery. German positions were formidably fortified.

Grabenkrieg

(1) Französischer Angriff in der Stunde »H« vor Verdun, 1916. (2) Ein offener britischer Schützengraben an der Westfront. (3) Die Deutschen lernten, einen Großteil ihrer Infanterie und Reserven hinter der Front zu postieren, außerhalb der Reichweite der vorgeschobenen Artillerie. Deutsche Stellungen waren schwer befestigt.

La guerre de tranchées

(1) Attaque de soldats français à l'heure H à Verdun en 1916. (2) Tranchée britannique sur le front occidental. (3) Les Allemands avaient appris à placer la majeure partie de leur infanterie et de leurs réserves hors de portée de l'artillerie de première ligne. Leurs positions étaient protégées par des ouvrages défensifs blindés.

2

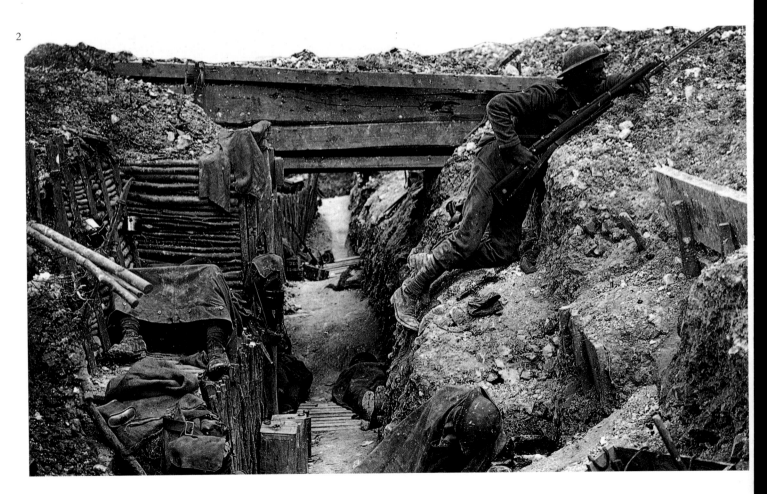

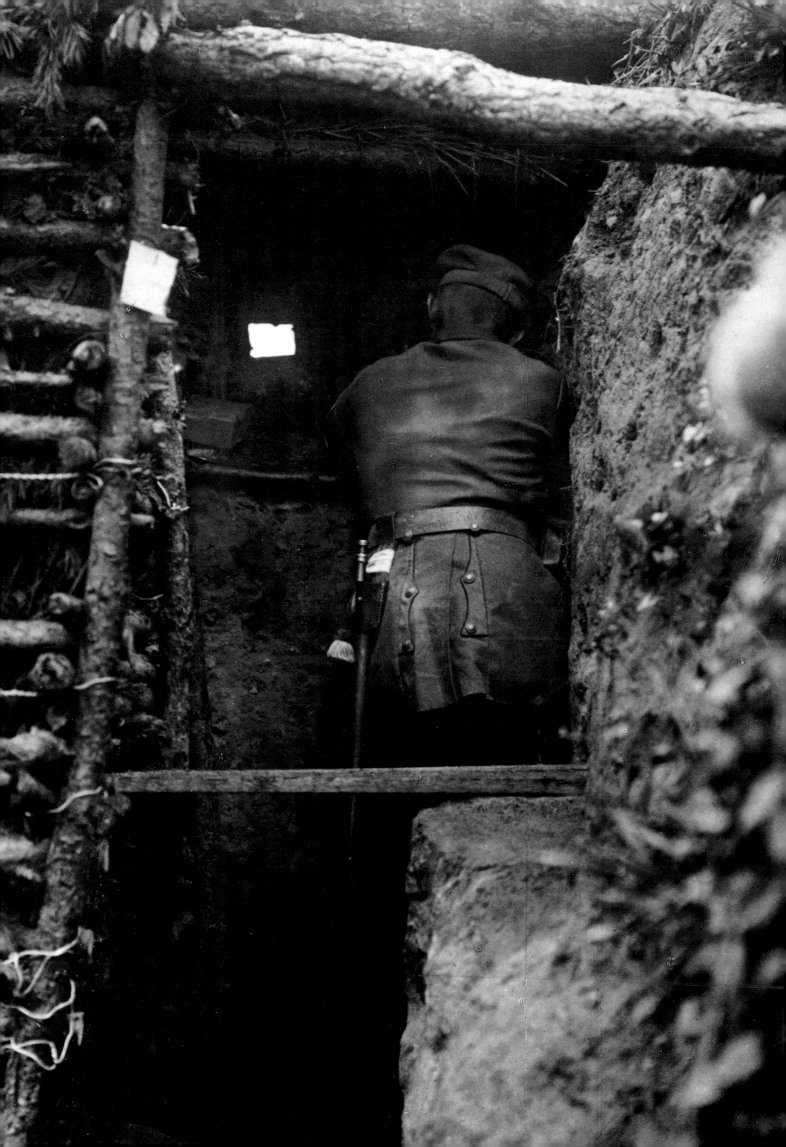

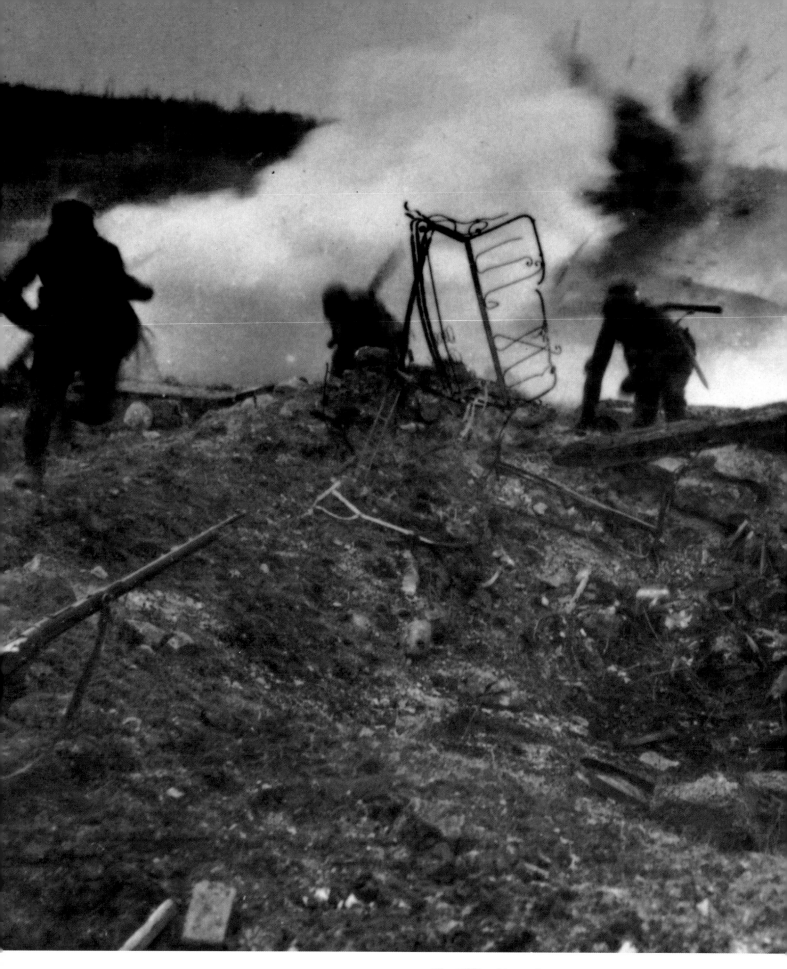

The Killing Zone, 1
The Germans' specially trained storm-trooper infantry units made big advances in 1918, but still had to face the problem of crossing the 'killing zone', the open ground in front of dug-in snipers, machine gunners, and increasingly better directed artillery.

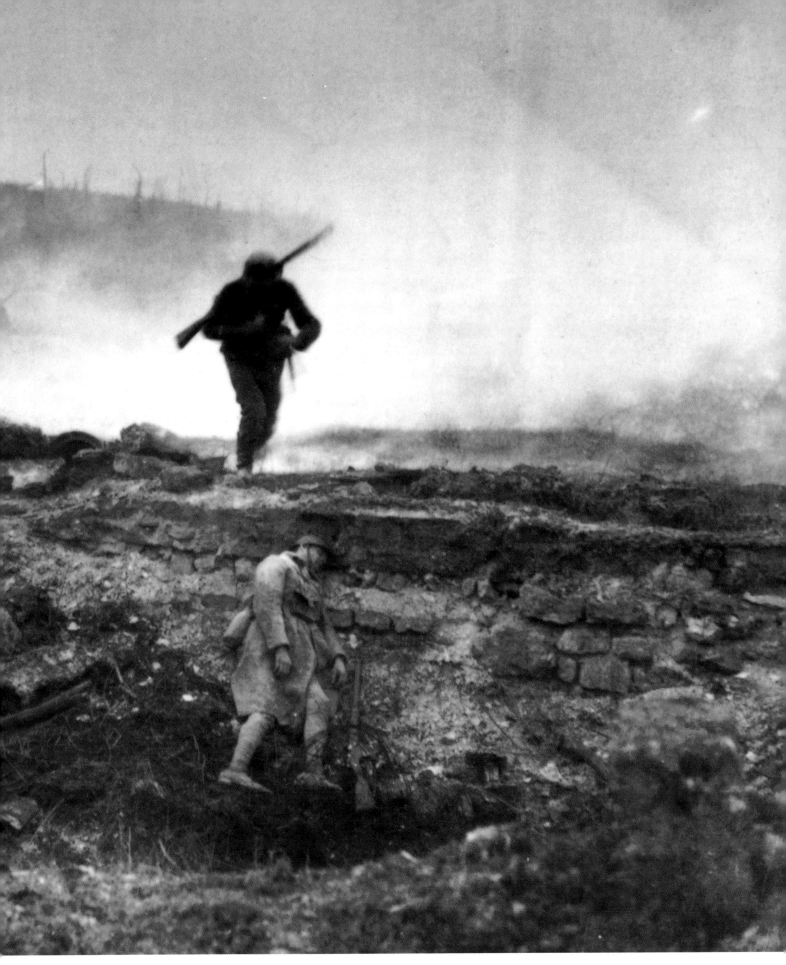

Die Todeszone, 1

Die speziell ausgebildeten deutschen Infanterie-Sturmtruppen verzeichneten 1918 große Erfolge, doch auch sie mußten die »Todeszone« überwinden, das offene Gelände vor den feindlichen Linien, in dem sie schutzlos feindlichen Scharfschützen, Maschinengewehren und zunehmend treffsichereren Artilleriegeschützen ausgeliefert waren.

Zone de la mort, 1

Les troupes d'assaut allemandes, très bien entraînées, réussirent des percées en 1918, mais le problème pour elles était encore de franchir à découvert la « zone de la mort », cible de tireurs embusqués, de mitrailleurs et d'une artillerie de plus en plus précise.

1

The Killing Zone, 2

The infantry charge across open ground was both costly and hazardous. At the Somme, the British command believed soldiers should advance at a walk, to give them confidence. (1) Scottish soldiers at the charge at Passchendæle, 1917. (2) Canadian soldiers use craters for makeshift defences in the Flanders mud, November 1917. (3) Often troops would be pinned down for days: a German rifleman beside his slain French foe.

Die Todeszone, 2

Infanterieangriffe in offenem Gelände waren riskant und verlustreich. An der Somme rückten die Briten in kleinen Schritten vor, damit die Soldaten nicht den Mut verloren. (1) Schottische Soldaten beim Sturmangriff vor Passchendæle. (2) Im November 1917

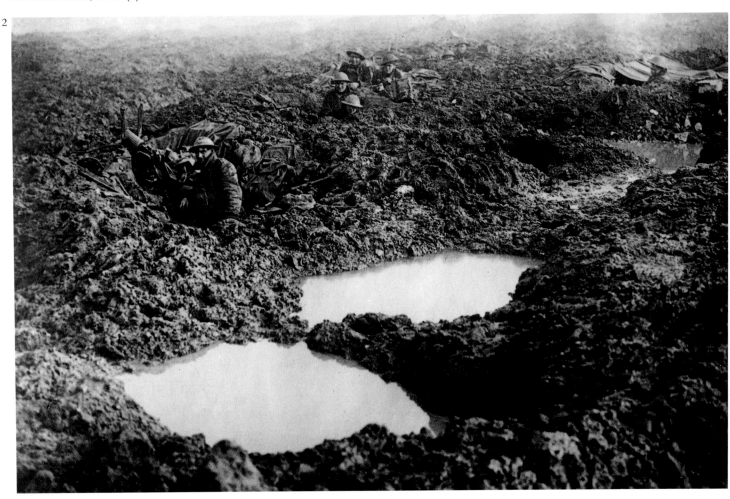

2

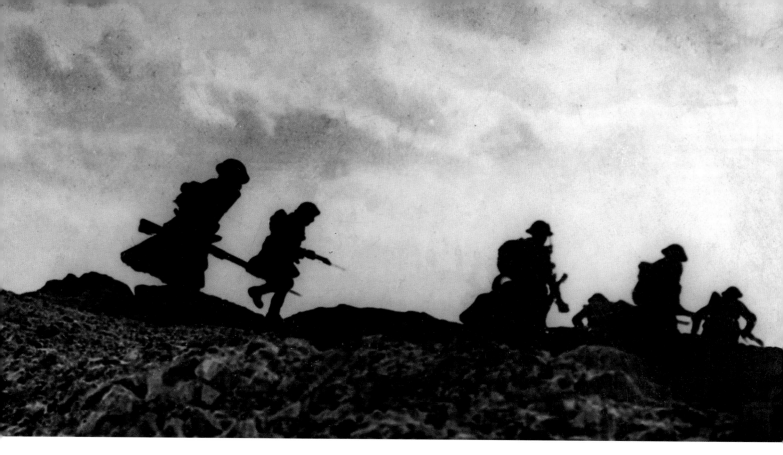

benutzten kanadische Soldaten Granattrichter im Schlamm von Flandern als provisorische Unterstände. (3) Oftmals saßen Soldaten tagelang an einer Stelle fest: Hier ein deutscher Schütze neben seinem toten französischen Feind.

Zone de la mort, 2

Charger en terrain découvert était une entreprise dangereuse et coûteuse en hommes. Sur la Somme, le commandement anglais pensait que les soldats devaient avancer au pas pour se donner confiance. (1) Charge de soldats écossais à

Passchendæle, 1917. (2) Des soldats canadiens se servent de cratères d'obus comme protection de fortune dans la boue des Flandres, novembre 1917. (3) Les troupes étaient souvent immobilisées des jours durant: un fusilier allemand à côté d'un ennemi français tombé au champ d'honneur.

3

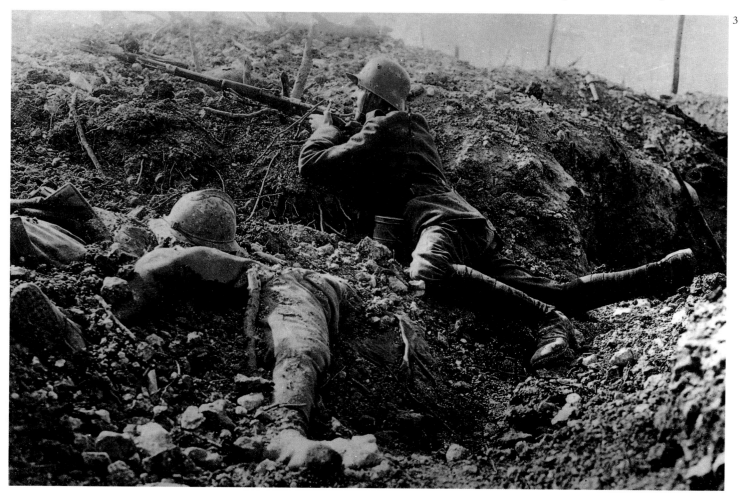

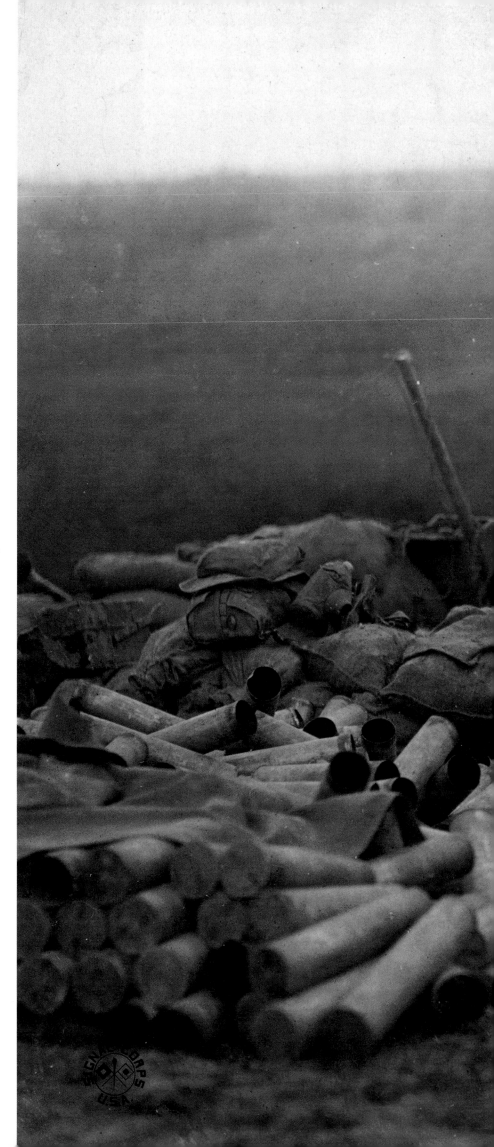

Artillery

Artillery was to be the dominant weapon of
defence throughout the land war in Europe.
More than any technical invention, it was the
innovation of new tactics which made
artillery so deadly. All sides, the Russians,
Germans and British particularly, evolved
new concepts of fire support and indirect
fire, which hold good today. In 1917, at
Cambrai, Vimy Ridge and Messines, detailed
fire plans were drawn up, with the guns
registered according to map reference, aided
by aerial photography. Nearly a third of the
British forces were made up of artillery units
by the end of the war. Here an American
team serves a field howitzer at top speed in
the counter-offensive of 1918.

Artillerie

Die Artillerie sollte während des Landkriegs
in Europa zur dominierenden Verteidigungs-
waffe werden. Mehr als alle technischen
Errungenschaften war es die Entwicklung
neuer Strategien, die die Artillerie zu einer so
tödlichen Waffe werden ließ. Alle Beteiligten
– vor allem Russen, Deutsche und Briten –
entwarfen neue strategische Konzepte zur
Feuerunterstützung und zum indirekten
Artilleriebeschuß, die noch heute Gültigkeit
besitzen. Bei Cambrai, Vimy und Messines
wurden 1917 detaillierte Feuerpläne erstellt,
für die man die genaue Position der Geschüt-
ze mit Hilfe von Luftaufnahmen bestimmte.
Bei Kriegsende machte die Artillerie fast ein
Drittel der britischen Streitkräfte aus. Hier
laden amerikanische Kanoniere bei der
Gegenoffensive des Jahres 1918 im Eiltempo
eine Feldhaubitze.

Artillerie

L'artillerie fut la principale arme défensive de
la guerre terrestre en Europe. Plus que toute
invention technique, c'est la mise au point de
nouvelles tactiques qui la rendirent si
meurtrière. Les belligérants, en particulier les
Russes, les Allemands et les Britanniques,
développèrent les notions d'appui d'artillerie
et de tir indirect, toujours en vigueur. En
1917, à Cambrai, à la crête de Vimy et de
Messine, on dressa des plans de tir précis
avec les canons disposés selon les données
fournies par le lever aérien. A la fin des
hostilités, presque le tiers des forces anglaises
étaient des unités d'artillerie. On peut voir ici
des soldats américains servant un obusier à tir
rapide pendant la contre-offensive de 1918.

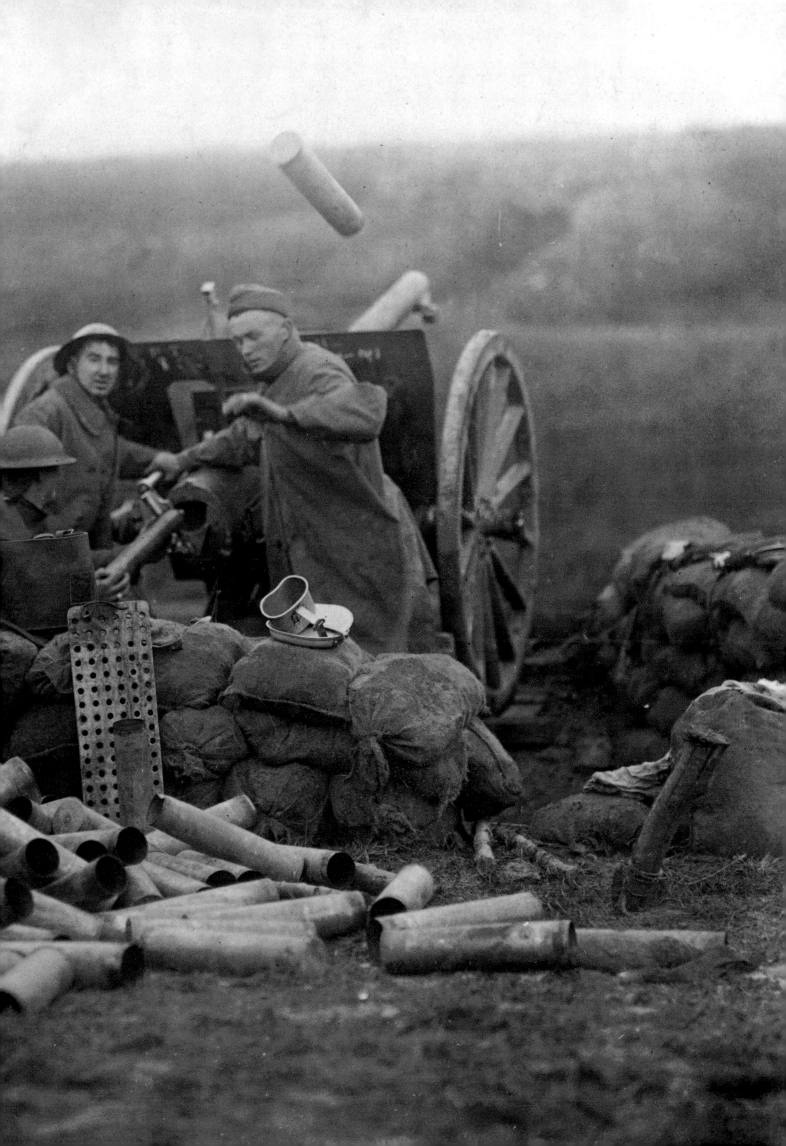

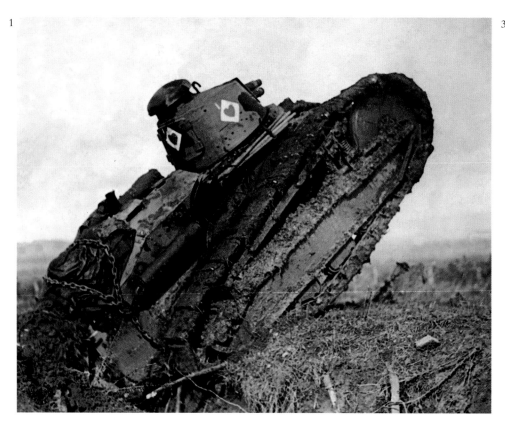

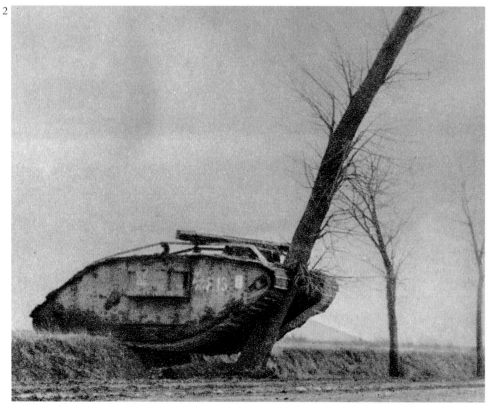

The Tank

Tanks were most effective when their offensive was coordinated with aircraft and artillery. (1) A light tank in action, 1917. (2) A British tank comes to an abrupt halt – the crew of eight endured cramped, noisy conditions. (3) A British Mark IV carrying soldiers on a jaunt, 1918 – none is wearing a helmet or battle webbing.

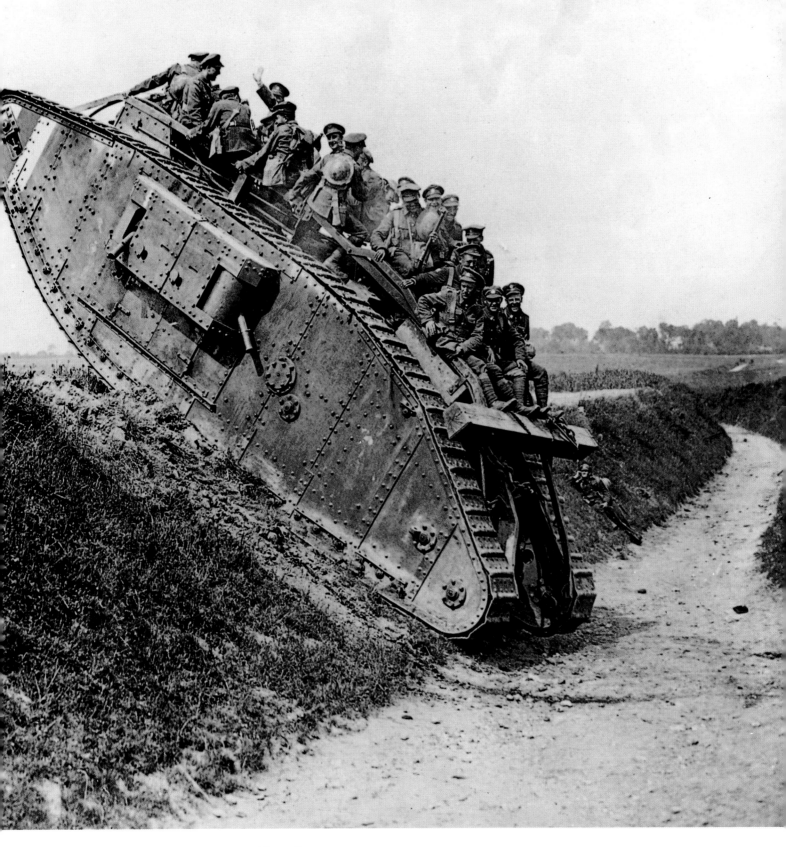

Panzer

Panzerangriffe waren dann am wirksamsten, wenn sie von Artillerie und Luftwaffe unterstützt wurden. (1) Ein leichter Panzer in Aktion, 1917. (2) Ein britischer Panzer macht eine plötzliche Vollbremsung – die Panzerbesatzung von acht Mann litt unter großer Enge und beträchtlichem Lärm. (3) Soldaten unternehmen eine Spritztour mit einem britischen Tank vom Typ Mark IV – sie tragen weder Helme noch Kampfausrüstung.

Chars d'assaut

Les chars atteignaient leur efficacité maximum lorsque leur offensive était coordonnée à celle de l'aviation et de l'artillerie. (1) Un char léger en action, 1917. (2) Blindé anglais stoppé brutalement – les huit hommes s'y trouvaient à l'étroit et dans un bruit infernal. (3) Des soldats en balade sur un char Mark IV, 1918 – aucun n'est protégé par un casque ou des sangles.

Gas Warfare

Phosgene and mustard gas were used. (1) The Germans brought the gas to the front in cylinders; it sometimes blew back on friendly forces. (2) A German soldier sounds the alarm on a frying pan. (3) The Russians equipped their forces with full breathing apparatus. (4) British troops blinded by mustard gas, Béthune, 10 April 1918. This photograph was used for Sargent's famous painting. (5) A French resupply team, March 1918 – even the horses wear gas masks.

Gaskrieg

Bei Gasangriffen kamen unter anderem Phosgen und Senfgas zum Einsatz. (1) Die Deutschen ließen das Gas aus Gaszylindern ab, und dabei wurde es oft in die eigenen Reihen geweht. (2) Ein deutscher Soldat schlägt Alarm auf einer Bratpfanne. (3) Die Russen rüsteten ihre Truppen mit kompletten Atemgeräten aus. (4) Britische Soldaten mit Augenverletzungen nach einem Senfgasangriff bei Béthune am 10. April 1918. Dieses Foto diente als Vorlage für ein berühmtes Gemälde von John Singer Sargent. (5) Ein französischer Versorgungstrupp im März 1918 – sogar die Pferde tragen Gasmasken.

Guerre de gazage

Les gaz à l'ypérite et au phosgène comptaient parmi les armes employées. (1) Les Allemands les apportaient dans des cylindres; le vent renvoyait parfois ces gaz sur leurs positions. (2) Soldat allemand sonnant l'alarme sur une poêle. (3) Les Russes avaient équipé leurs soldats d'appareils respiratoires complets. (4) Les troupes anglaises aveuglées par du gaz moutarde, Béthune, 10 avril 1918. Sargent se servit de cette photographie pour peindre son célèbre tableau. (5) Soldats français chargés du ravitaillement, mars 1918 – même les chevaux sont masqués.

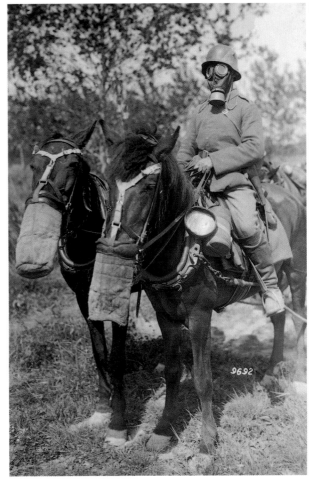

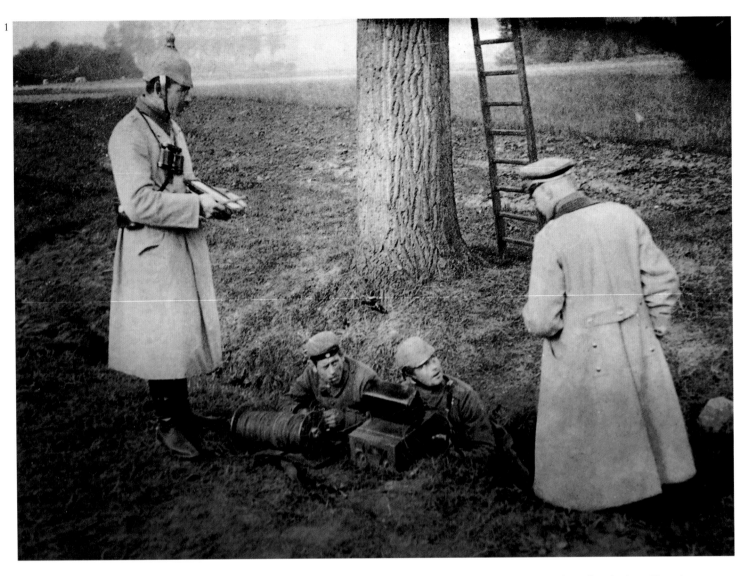

Communications War

Battlefield communications improved hugely during the war, with Fleidl telephones allowing contact with the front. (1) German signallers with a primitive field telephone set. Later, aircraft would help the targeting of artillery by wireless communication with the ground. (2) A portable Marconi wireless station operated in the field by Russian soldiers. (3) An underground telephone exchange, 1915; note the bearded engineer's less than military appearance.

Fernmeldewesen

Die Kommunikation im Felde verbesserte sich während der Kriegsjahre beträchtlich, als Fleidl-Telefone den direkten Kontakt zur Front ermöglichten. (1) Deutsche Fernmelder mit einem der ersten Feldtelefone. Später halfen Flugzeuge, die in Funkverbindung mit dem Boden standen, beim Einrichten der Artillerie. (2) Russische Soldaten im Feld mit einer tragbaren Marconi-Funkstation. (3) Eine unterirdische Telefonvermittlung, 1915 – der bärtige Techniker sieht nicht gerade militärisch aus.

Guerre de transmission

Les transmissions sur le champ de bataille se perfectionnèrent pendant cette guerre grâce aux téléphones Fleidl qui reliaient directement au front. (1) Opérateurs allemands avec leur téléphone de campagne primitif. Plus tard, l'aviation aidera l'artillerie en communiquant par radio avec le sol. (2) Poste de radiotélégraphie Marconi de l'armée russe. (3) Installation téléphonique souterraine, 1915; à noter l'apparence peu militaire de l'opérateur barbu.

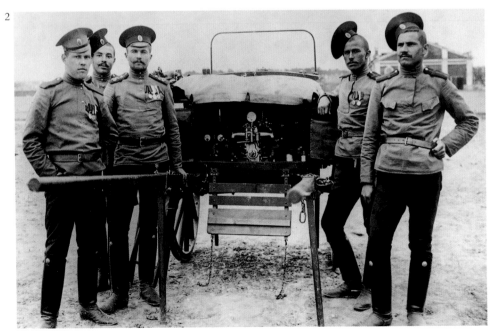

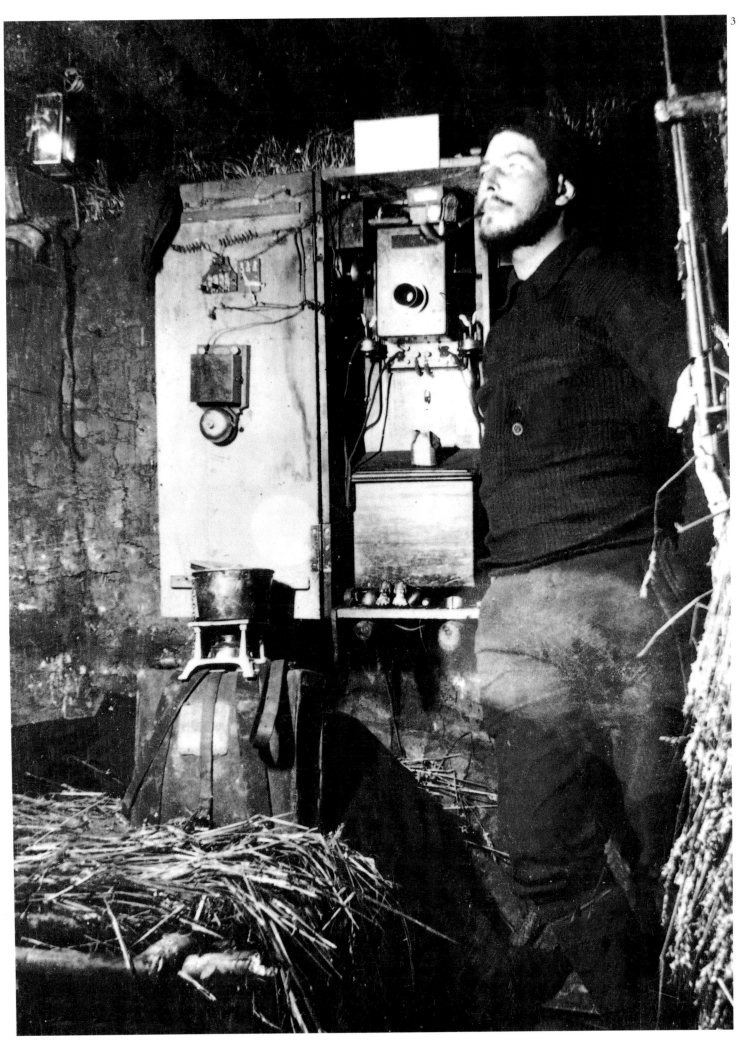

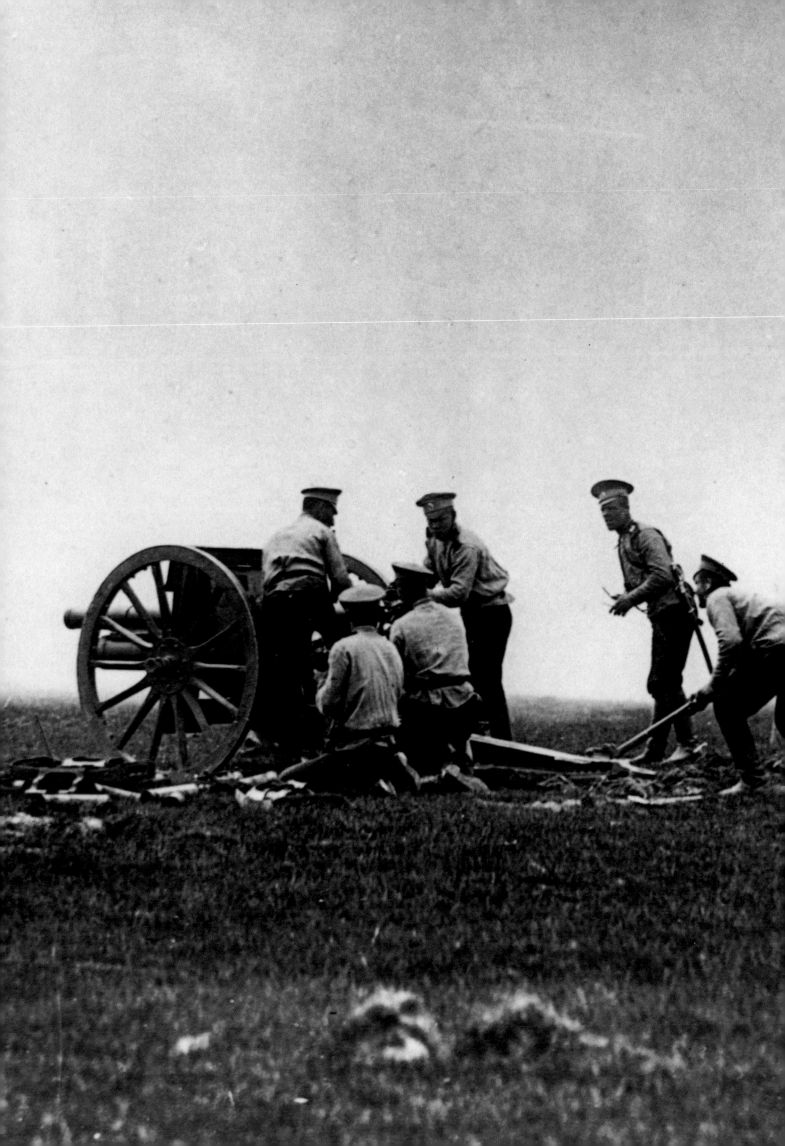

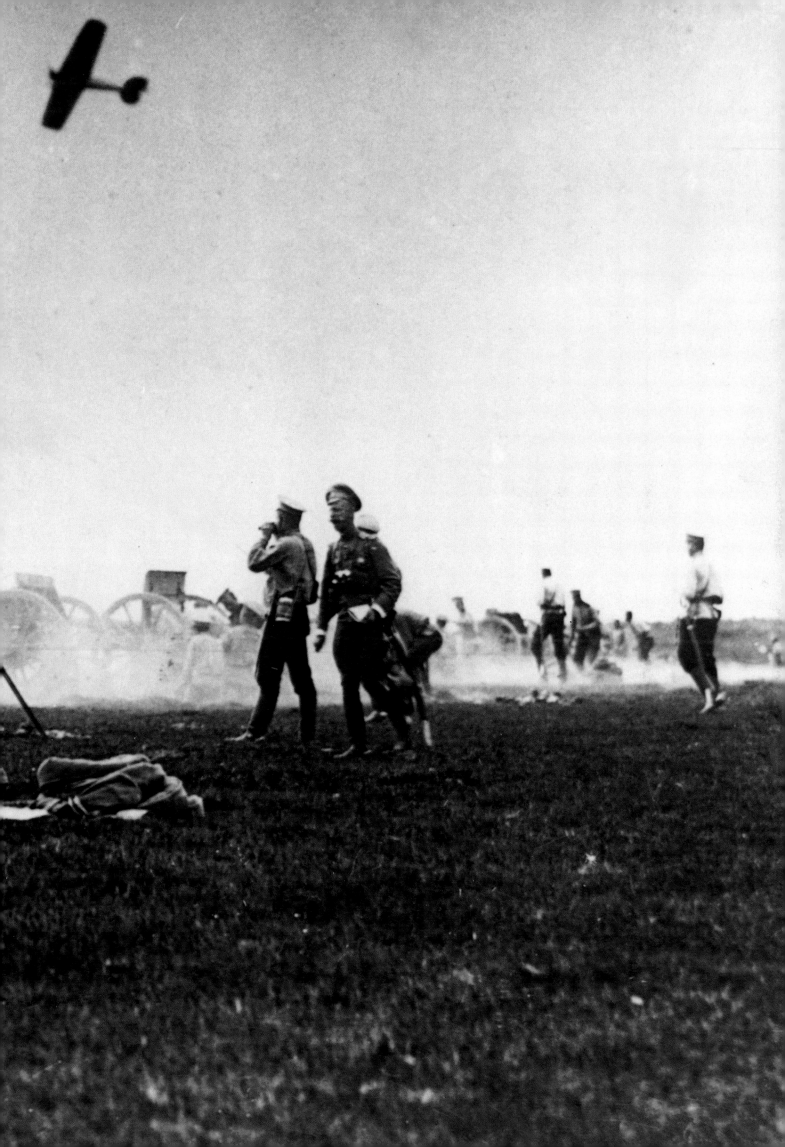

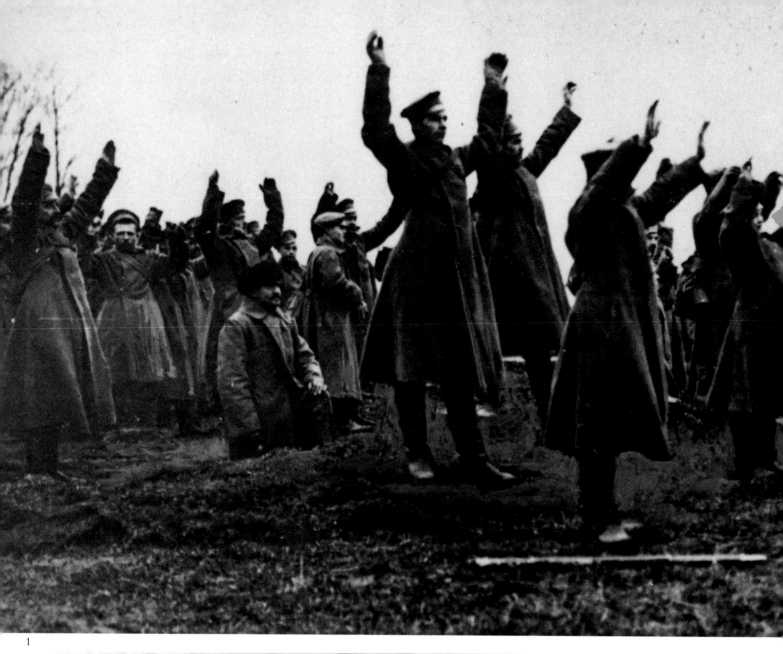

1

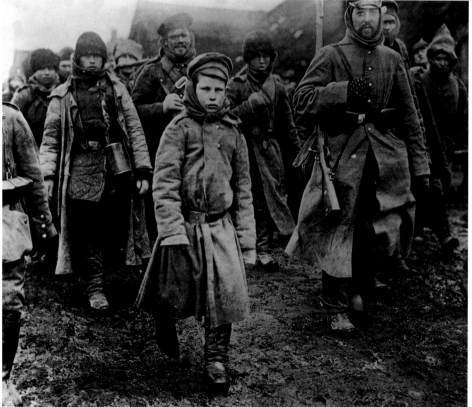

2

The Russian Front

In the opening stages of the war the Russians sustained over half a million casualties. (Previous page) Russian gunners with light field guns, 1914. They are in direct line-of-sight mode: the later development of indirect fire by artillery in well co-ordinated plans of attack was to be a major advance in battlefield tactics. (1) More than two million Russians surrendered in 1917 when their armies collapsed. (2) Russian prisoners after the defeat at the Masurian Lakes in East Prussia in 1914. (3) A Russian soldier takes his rifle butt and bayonet to two deserters.

Die Ostfront

Im Anfangsstadium des Krieges wurden auf russischer Seite über eine halbe Million Soldaten getötet oder verwundet. (Vorhergehende Seite) Russische Kanoniere mit leichten Feldgeschützen im ersten Kriegsjahr. Wie man deutlich sieht, stehen sie deckungslos unter direktem Beschuß. Die Entwicklung des indirekten Artilleriefeuers nach sorgsam ausgeklügelten Angriffsplänen war eine der wichtigsten kampftaktischen

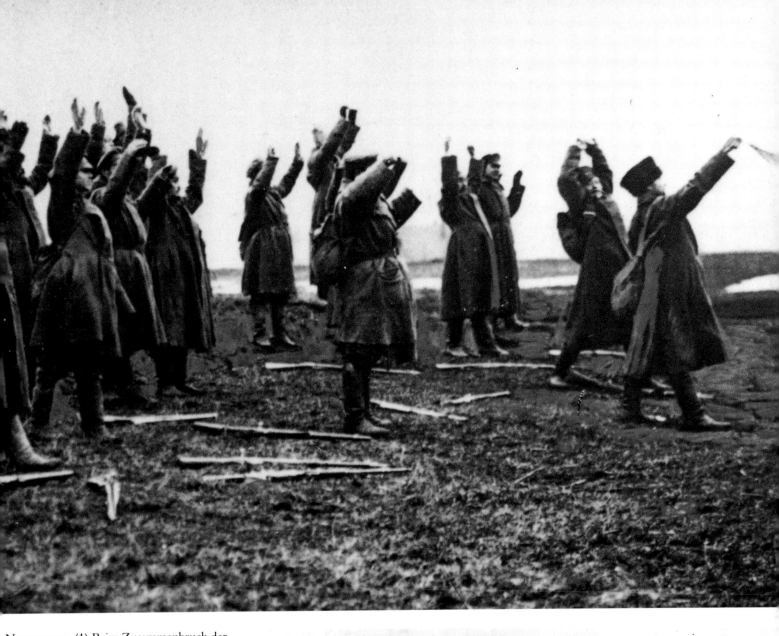

Neuerungen. (1) Beim Zusammenbruch der russischen Armeen im Jahr 1917 kapitulierten über zwei Millionen Soldaten. (2) Russische Gefangene nach der Niederlage an den Masurischen Seen in Ostpreußen (1914). (3) Ein russischer Soldat bedroht zwei Deserteure mit Gewehrkolben und Bajonett.

Sur le front russe

Les pertes russes se montèrent à plus d'un demi-million dès le début de la guerre. (Page précédente) Artilleurs russes servant des mitrailleuses légères, 1914. Ils se trouvent en pleine ligne de visée: le futur tir d'artillerie indirect associé à des plans d'attaques coordonnés sera une innovation majeure de la tactique militaire. (1) Plus de deux millions de Russes durent se rendre en 1917 après l'effondrement de leurs armées.
(2) Prisonniers de guerre russes après leur défaite aux lacs mazures en 1914.
(3) Un soldat russe lève sa crosse de fusil et sa baïonnette sur deux déserteurs.

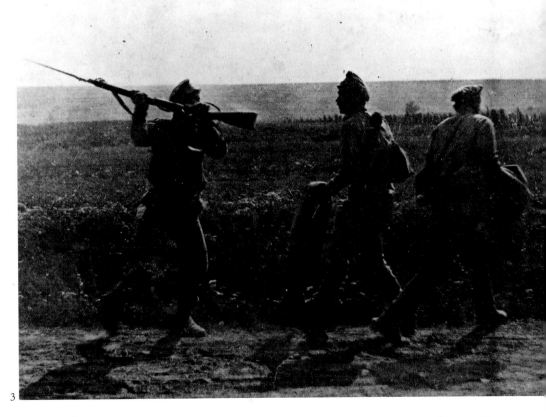

3

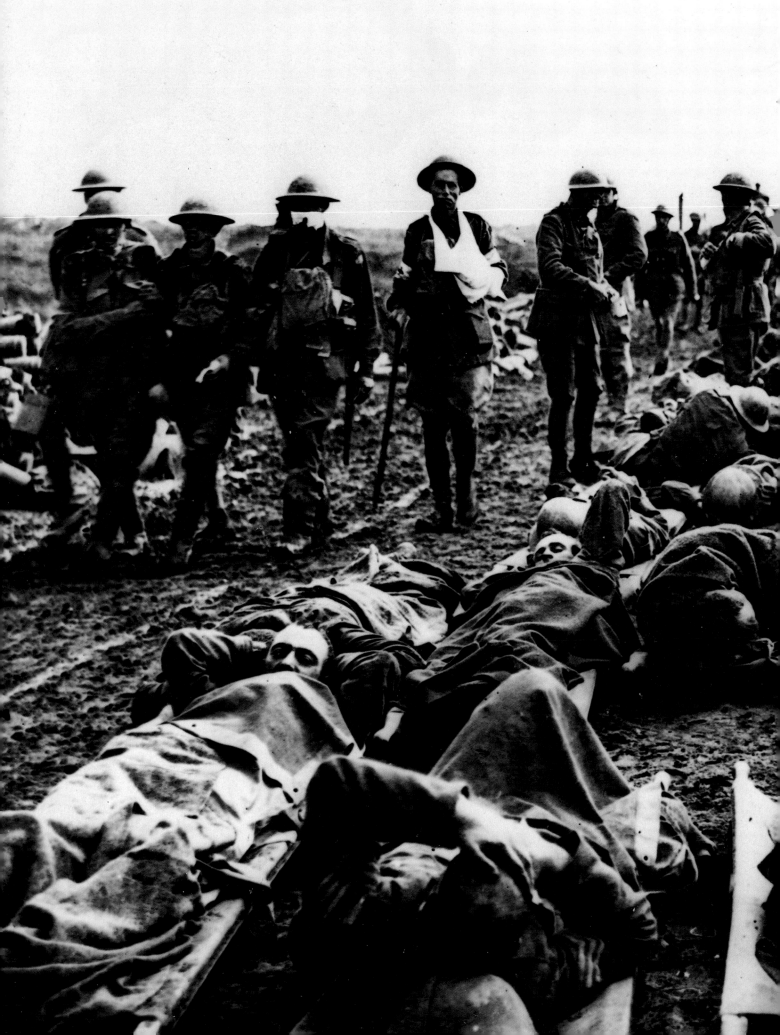

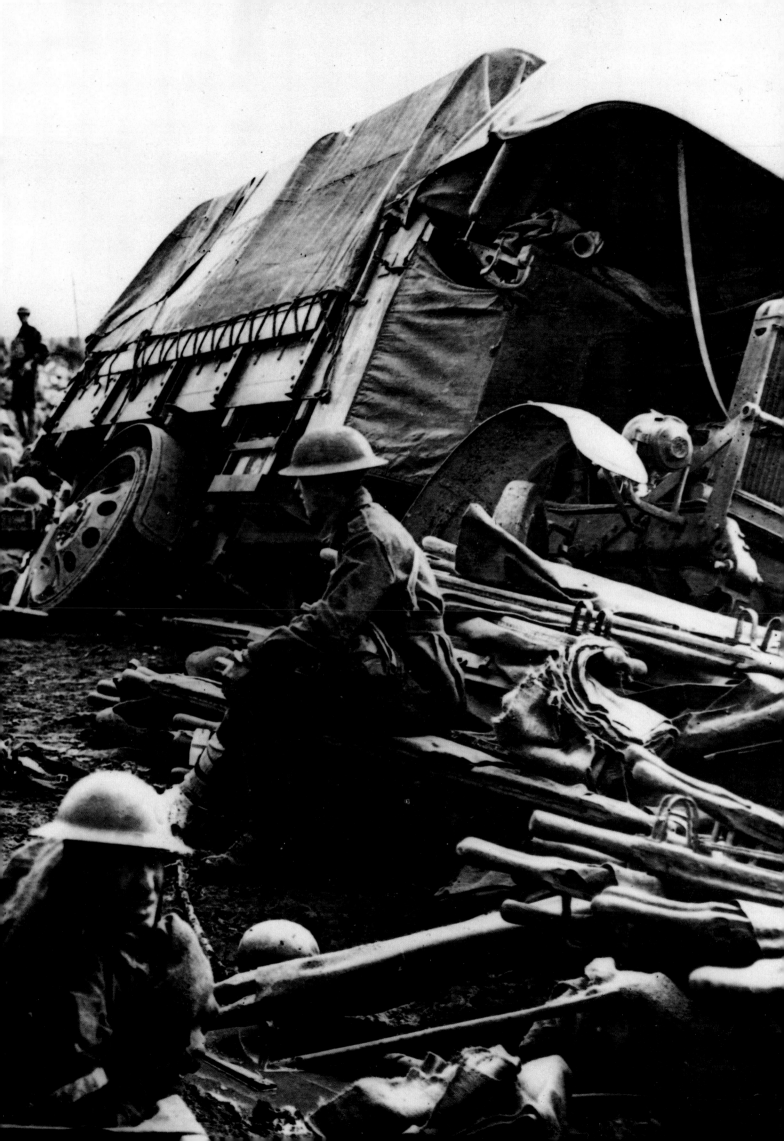

Wounded and Captured

One of the most murderous main supply routes in the Ypres Salient was the Menin Road. (Previous page) Australian walking wounded return from the front in 1917. (1) British walking wounded being brought in as prisoners by an equally weary German. Relations were relatively civil between captors and prisoners on the Western Front. (2) Often the prisoners had to go through gruesome tasks, as here, where they search the dead for valuables while the German guard makes an official list. (3) Wounded in a forward underground dressing station by the Menin Road.

Verwundete und Gefangene

Eine der wichtigsten und zugleich gefährlichsten Nachschubrouten an die Front bei Ypern war die Straße nach Menen. (Vorhergehende Seite) Australische Verwundete bei der Rückkehr vom Fronteinsatz, 1917. (1) Britische Verwundete sind von einem ebenso erschöpften Deutschen gefangengenommen worden. Gefangene wurden an der Westfront relativ human behandelt. (2) Oft wurde den Gefangenen einiges zugemutet, so wie hier, wo sie die Toten nach Wertsachen durchsuchen, während ein deutscher Bewacher alles genau registriert. (3) Verwundete in einem vorgeschobenen unterirdischen Sanitätsposten an der Straße nach Menen.

Blessés et prisonniers

La route de Menin fut l'une des voies de ravitaillement les plus meurtrières du saillant d'Ypres. (Page précédente) Blessés australiens revenant à pied du front, 1917. (1) Des soldats britanniques blessés faits prisonniers par des Allemands tout autant épuisés. Sur le front occidental, les relations entre vainqueurs et vaincus restaient polies. (2) Les prisonniers étaient souvent délégués à des tâches épouvantables comme celle de fouiller les morts pour récupérer des objets de valeur, devant un soldat allemand en train d'en dresser une liste officielle. (3) Blessés dans un poste de secours souterrain sur la route de Menin.

1

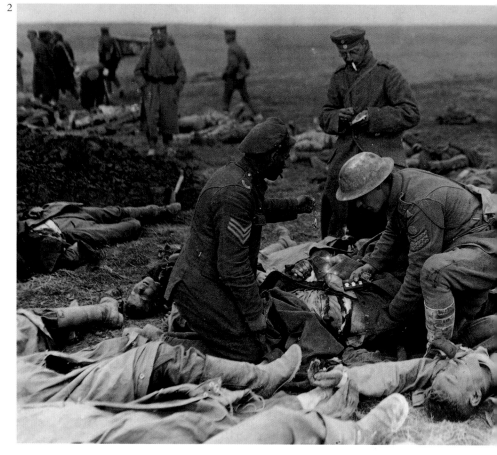

2

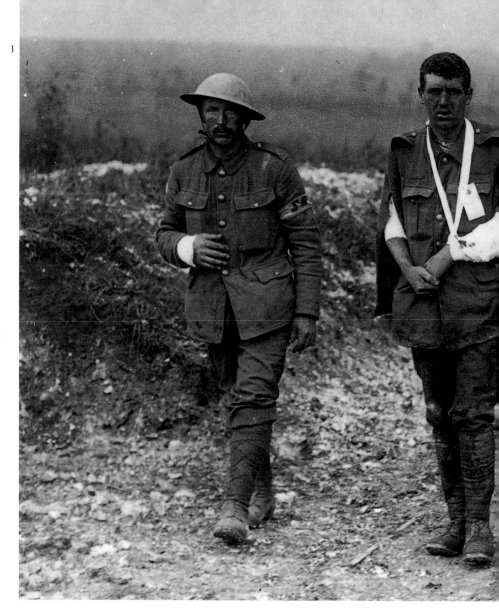

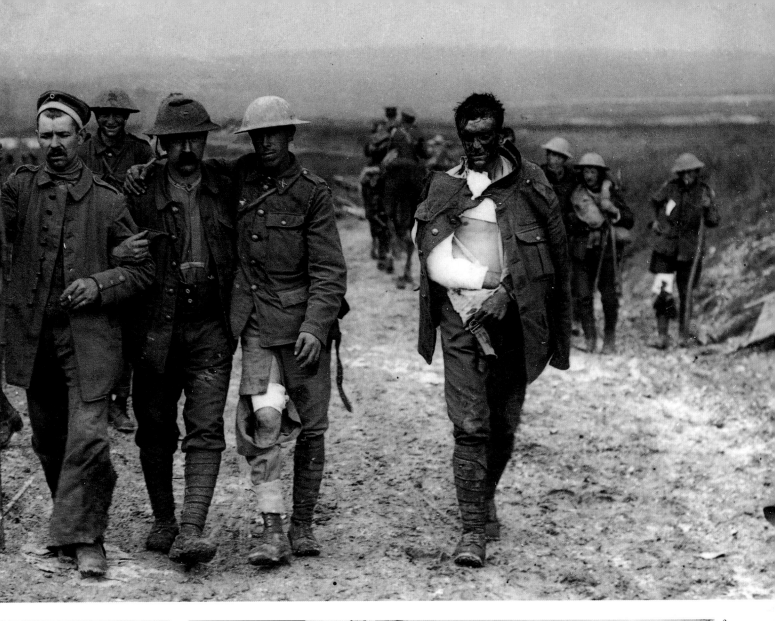

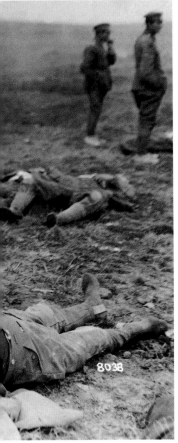

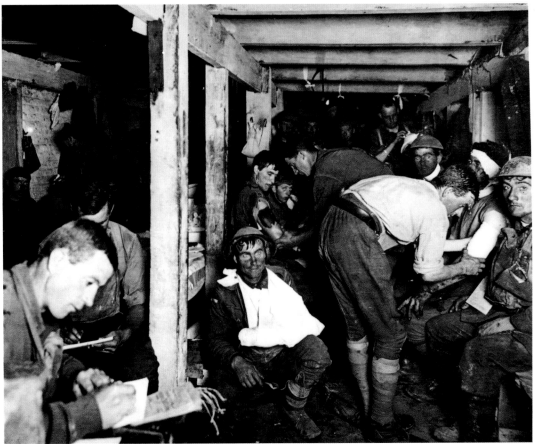

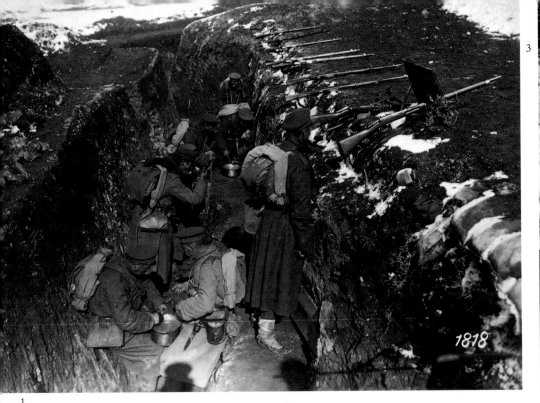

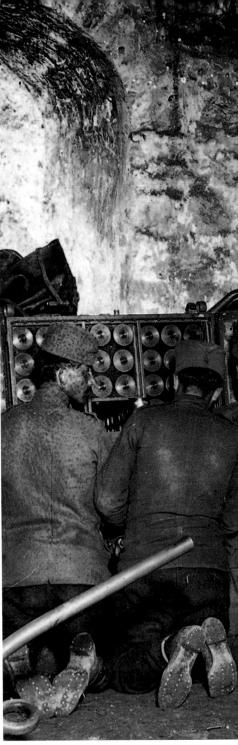

The Balkan Front

Bulgaria entered the war as an ally of the Central Powers, to avenge her defeat at the hand of the Serbs in 1913. (1) Bulgarian troops brewing up a meal in their trenches on the Dorian Front. (2) General Kovess taking a salute from his German allies as he and his colleagues pass in limousines captured on the Southern European Front. (3) Serb artillery firing on Semlin against the advance of the Austrians and Bulgarians under General Mackensen, 1915. (4) Serbian soldiers rest up in Belgrade, 1915, the year in which the Royal Serb Army was forced out of the country, to retreat through Albania and Bulgaria to the Adriatic coast.

Der Krieg auf dem Balkan

Bulgarien trat auf seiten der Mittelmächte in den Krieg ein, um sich für die Niederlage, die es 1913 im Kampf gegen Serbien erlitten hatte, zu rächen. (1) Bulgarische Soldaten bei der Essenszubereitung im Schützengraben an der Front bei Dojran. (2) Deutsche Verbündete salutieren General Kovess, als er mit seinen Kollegen in erbeuteten Limousinen vorbeifährt. (3) Die serbische Artillerie beschießt Semlin, um die österreichisch-bulgarische Offensive unter General Mackensen im Jahr 1915 aufzuhalten. (4) Serbische Soldaten bei einer Verschnaufpause in Belgrad im Jahr 1915, dem Jahr, in dem die Armee des Königreichs Serbien aus ihrem Land vertrieben wurde und sich durch Albanien und Bulgarien an die Adriaküste zurückzog.

Le front balkanique

La Bulgarie, alliée des Empires centraux, entra en guerre pour se venger de sa défaite contre les Serbes en 1913. (1) Soldats bulgares se préparant un repas dans les tranchées du front dorien. (2) Le général Kovess salué par ses alliés allemands au moment où il passe avec ses officiers dans des limousines récupérées sur le front de l'Europe méridionale. (3) Artilleurs serbes tirant sur Semlin pour stopper l'avance des Autrichiens et des Bulgares commandés par le général Mackensen, 1915. (4) Soldats serbes se reposant à Belgrade en 1915, l'année où l'armée serbe fut contrainte de battre en retraite à travers l'Albanie et la Bulgarie jusqu'à la côte adriatique.

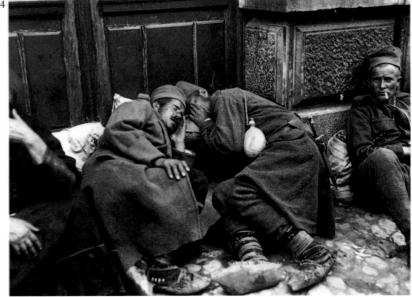

4

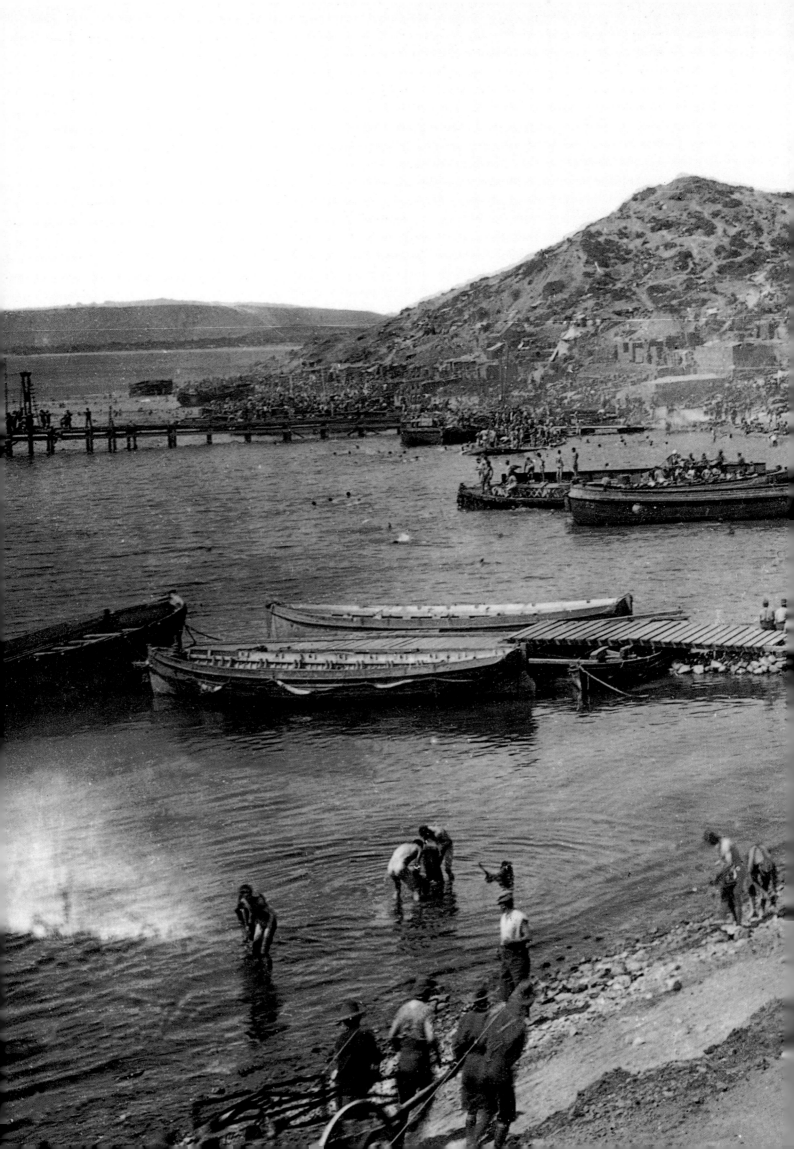

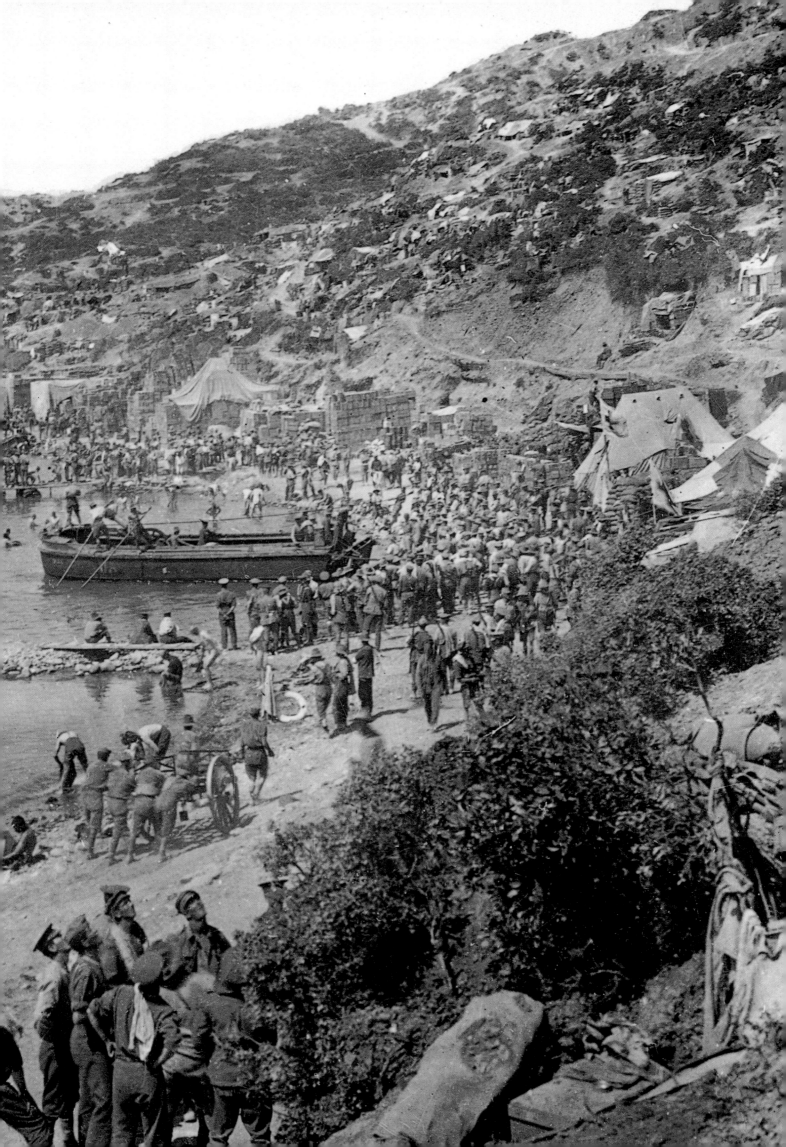

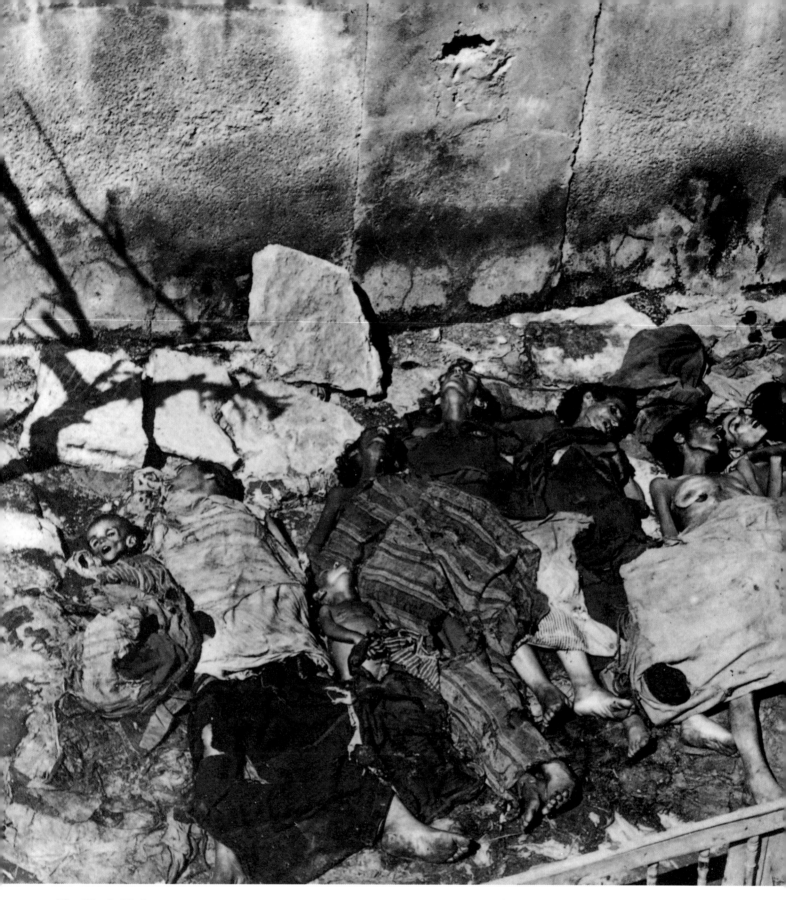

The War in Turkey

(Previous page) Anzac Cove, Gallipoli Peninsula, summer 1915. The British troops rapidly lost the initiative in the Dardanelles, by delaying deployment inland from the first landings in April. Mustafa Kemal moved his forces to oppose the Australians and New Zealanders when they landed here. (Above) Civilian victims in Turkey, 1914, thought to be Armenians: a hugely controversial episode, which still reverberates today. The Armenians had murdered several prominent Turks whom they believed responsible for their oppression.

Der Krieg in der Türkei

(Vorhergehende Seite) Die Anzac-Bucht auf der Halbinsel Gallipoli im Sommer 1915. Die Briten verloren rasch ihre Stoßkraft an den Dardanellen, als es ihnen nach der Landung im April nicht gelang, landeinwärts vorzudringen. Mustafa Kemal zog Truppen zusammen und leistete den Australiern und Neuseeländern Widerstand, als sie hier landeten. (Oben) Getötete Zivilisten in der Türkei, 1914. Vermutlich Opfer des Massakers an den Armeniern, einer viel-diskutierten Episode, deren Nachwirkungen noch heute zu spüren sind. Die Armenier hatten mehrere prominente Türken ermordet, die sie für die Unterdrückung ihres Volkes verantwortlich machten.

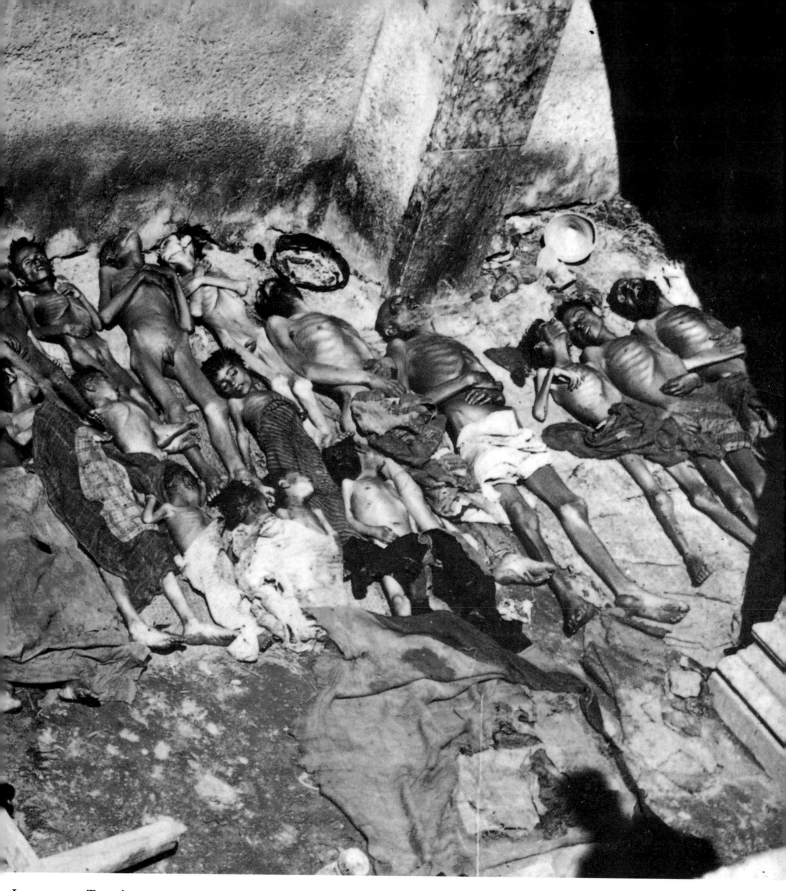

La guerre en Turquie

(Page précédente) L'anse de l'Anzac, péninsule de Gallipoli, en été
1915. Les troupes anglaises perdirent rapidement l'initiative dans les
Dardanelles en différant leur déploiement à l'intérieur des terres après
leur débarquement en avril. Mustafa Kemal déplaça ses troupes pour
combattre les Australiens et les Néo-Zélandais qui venaient de
débarquer. (Ci-dessus) Victimes civiles en Turquie, 1914, supposées
être arméniennes: un épisode tragique très critiqué dont les
conséquences se font sentir encore de nos jours. Des Arméniens
avaient assassiné plusieurs personnalités turques responsables, selon
eux, de leur oppression.

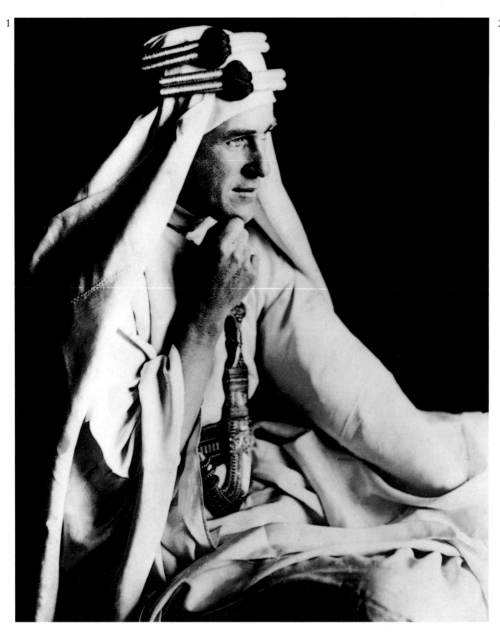

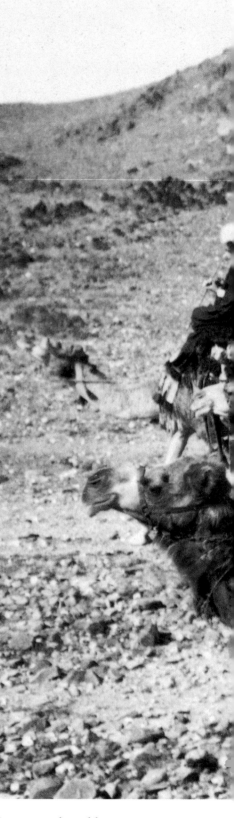

War in the Sand

The Turkish leadership under the influence of Enver Bey, Minister of War, wanted to use the war to regain territories lost by the Ottoman Empire in the previous 50 years, in Egypt and Libya, Cyprus, Macedonia and Thrace, and to liberate the Turkish peoples of the Caucasus. Though the Turkish forces were to acquit themselves well on several fronts, the war was to bring the end of the empire – which was to lead to the creation of the modern Middle East, and provide a powerful ingredient in the present conflicts of the region. (1) T. E. Lawrence, the scholar who became an inspirational adviser to the Arab Army in the 1915 revolt against the Turks. (2) The Arabs carried out a successful guerrilla campaign along the Hejaz railway, including the capture of the port of Aqaba in July 1917 after an 800-mile approach march through the desert.

Krieg in der Wüste

Die türkische Regierung wollte unter Einfluß des Kriegsministers Enver Pascha den Krieg nutzen, um Gebiete in Ägypten, Libyen, Zypern, Makedonien und Thrakien zurückzuerobern, die dem Osmanischen Reich in den letzten 50 Jahren verloren-gegangen waren, und die türkischen Völker des Kaukasus zu befreien. Doch obwohl die türkischen Truppen sich an mehreren Fronten tapfer schlugen, sollte der Krieg das Ende des Reiches besiegeln. So entstand der heutige Nahe Osten; viele der gegenwärtigen Auseinandersetzungen in der Region haben ihren Ursprung in dieser Zeit. (1) T. E. Lawrence, der Gelehrte, der 1915 zum inspirierten Berater der Araber bei ihrem Aufstand gegen die Türken wurde. (2) Die Araber führten einen erfolgreichen Guerilla-krieg entlang der Hidjasbahn, in dem sie unter anderem nach einem 1200 Kilometer langen Marsch durch die Wüste im Juli1917 die Hafenstadt Akaba eroberten.

La guerre des sables

Sous l'influence de son ministre de la guerre, Enver Bey, la Turquie voulut profiter de la guerre pour reconquérir les territoires qu'elle avait perdus au cours des 50 dernières années (Egypte, Libye, Chypre, Macédoine et Thrace) et libérer les populations turques du

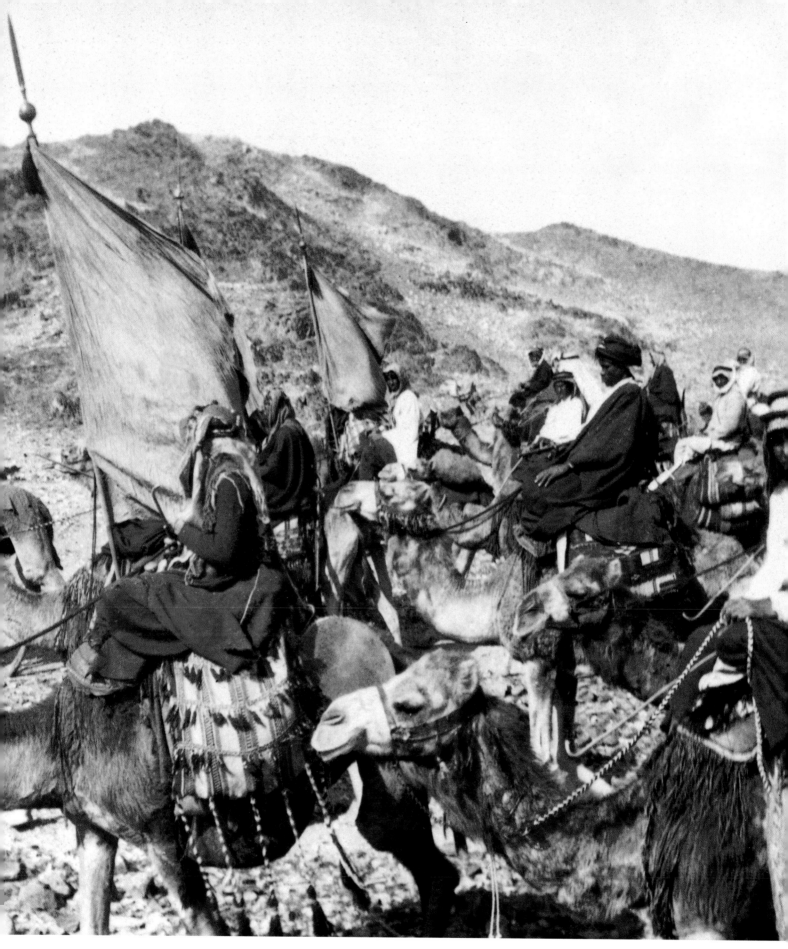

Caucase. Même si l'armée turque se comporta vaillamment sur plusieurs fronts, la guerre allait achever le démembrement de l'Empire. Ceci devait conduire à la création du Moyen-Orient moderne et être à la source des conflits actuels dans la région. (1) T. E. Lawrence, homme de lettres et personnage légendaire devenu conseiller de l'armée arabe lors du soulèvement de 1915 contre les Turcs. (2) Les Arabes menèrent victorieusement leur guerre de guérillas le long de la ligne de chemin de fer de Hejaz, puis, en juillet 1917, prirent le port d'Akaba après une marche de 1200 km dans le désert.

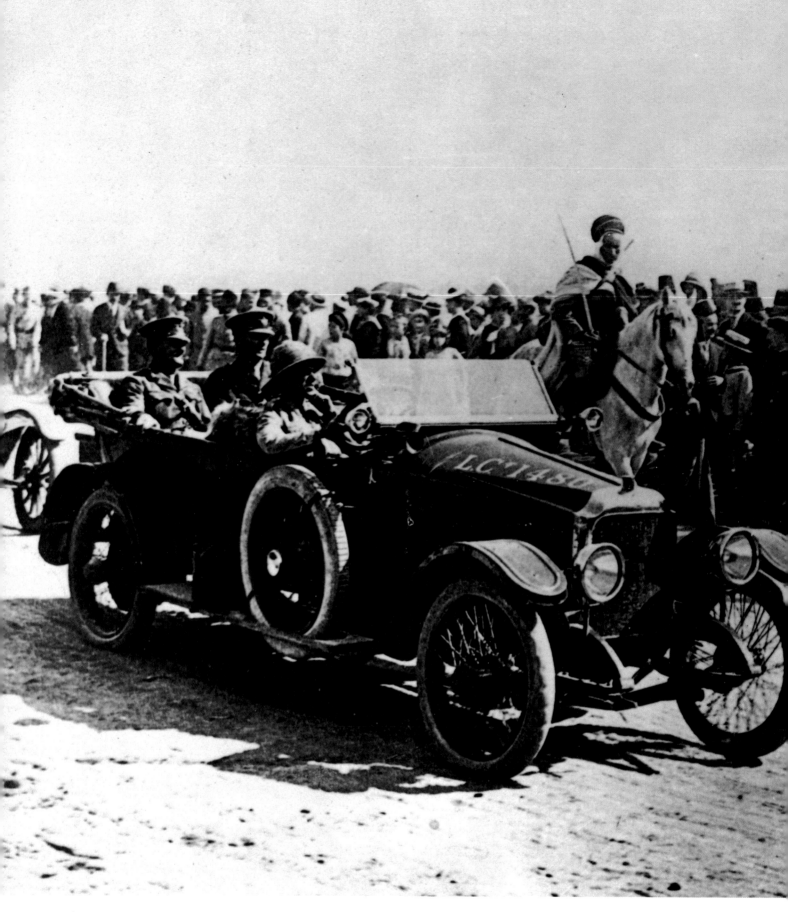

Palestine 1917

General Sir Edmund Allenby enters Jerusalem in a Vauxhall staff car, 7 December 1917. He had to wait until September 1918 to mount his knock-out blow in the Megiddo offensive. The newly formed RAF provided close air support, destroying Kemal's field telephone system. Megiddo was, perhaps, the most complete victory of the war – 80,000 Turks, Austrians and Germans surrendered to the allies, who had lost only 782 killed and 4179 wounded in the offensive. The Ottoman Empire was in disintegration.

Palästina 1917

General Edmund Allenby fährt am 7. Dezember 1917 in einem Vauxhall-Stabswagen in Jerusalem ein. Auf seinen großen Triumph, die Megiddo-Offensive, mußte er noch bis zum September 1918 warten. Die kurz zuvor eingerichtete Royal Air Force leistete ihm dabei entscheidende

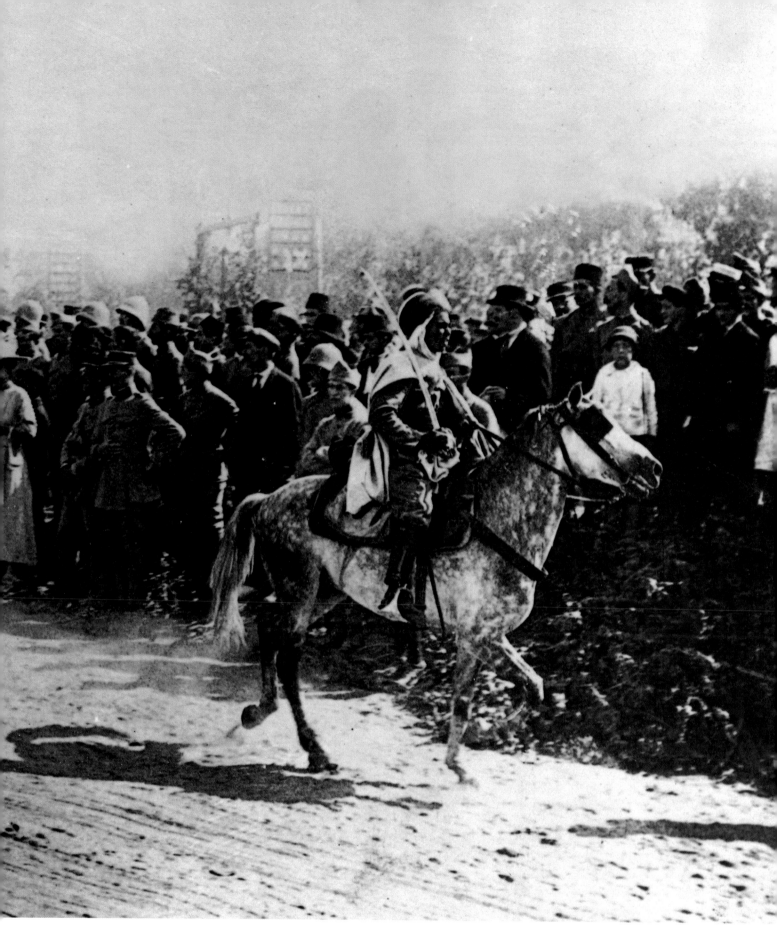

Hilfe – sie zerstörte Kemals Telefonverbindung zur Front. Megiddo war vielleicht der vollkommenste Sieg des ganzen Krieges – 80 000 Türken, Österreicher und Deutsche ergaben sich den Alliierten, die selbst nur 782 Tote und 4179 Verwundete zu beklagen hatten. Das Ende des osmanischen Reiches war besiegelt.

La Palestine, 1917
Le général Edmund Allenby fait son entrée à Jérusalem dans une Vauxhall de service, 7 décembre 1917. Il dut attendre septembre 1918 pour lancer une offensive décisive à Meggido. La RAF nouvellement créée lui fournit l'appui aérien, détruisant tout le système de transmission du général Kemal.

Meggido représente peut-être la victoire la plus complète de la guerre: 80 000 Turcs, Autrichiens et Allemands capitulèrent devant les Alliés dont les pertes se résumèrent à 782 tués et 4179 blessés. Cette victoire précipita l'éclatement de l'Empire ottoman.

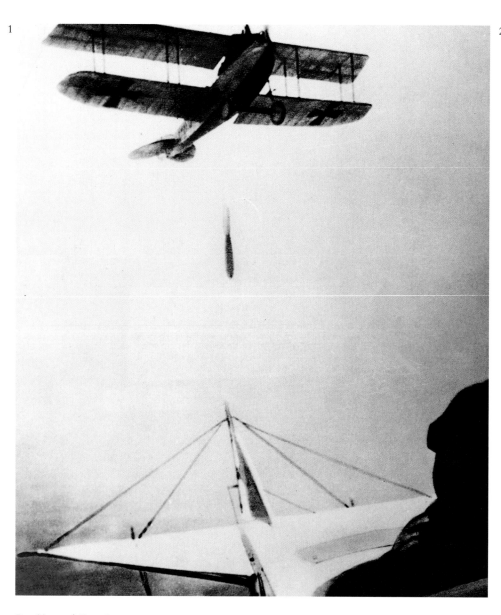

By Air and Sea, 1

Aircraft were used primarily for reconnaissance in 1914, but by 1918 had become a major arm of battle as fighters and bombers, for close air support and strafing in the battle itself, attacking forces in the rear and strategic bombing; the pattern of 20th-century airpower, with independent air forces, was established by 1917.
(1) A German biplane drops a bomb. The bomb would be released by hand.
(2) A mine explodes during a German mine-laying operation.

Zu Wasser und in den Lüften, 1

1914 wurden Flugzeuge noch hauptsächlich zur Aufklärung eingesetzt, doch 1918 trugen sie als Jäger und Bomber bereits einen entscheidenden Teil zu den Kämpfen bei; sie begleiteten Einsätze aus der Luft und beharkten die feindlichen Truppen, griffen die Nachhut an und bombardierten strategisch. 1917 hatte sich das Grundmuster für den Rest des Jahrhunderts mit eigenständig operierenden Luftstreitkräften bereits herausgebildet. (1) Ein deutscher Doppeldecker beim Abwerfen einer Bombe. Solche Bomben wurden von Hand abgeworfen.
(2) Deutsche legen Minen; eine davon explodiert gerade.

Guerre dans les airs et sur mer, 1

En 1914, l'avion était destiné à des opérations de reconnaissance mais en 1918, il était devenu une arme à part entière, à la fois chasseur et bombardier, fournissant un appui aérien direct et mitraillant en rase-mottes, attaquant à l'arrière et bombardant les points stratégiques. Le modèle de la puissance aérienne du 20ᵉ siècle avec ses forces autonomes remonte à 1917. (1) Un biplan allemand larguant une bombe. Les bombes étaient lancées à la main. (2) Une mine explose pendant une opération de minage menée par les Allemands.

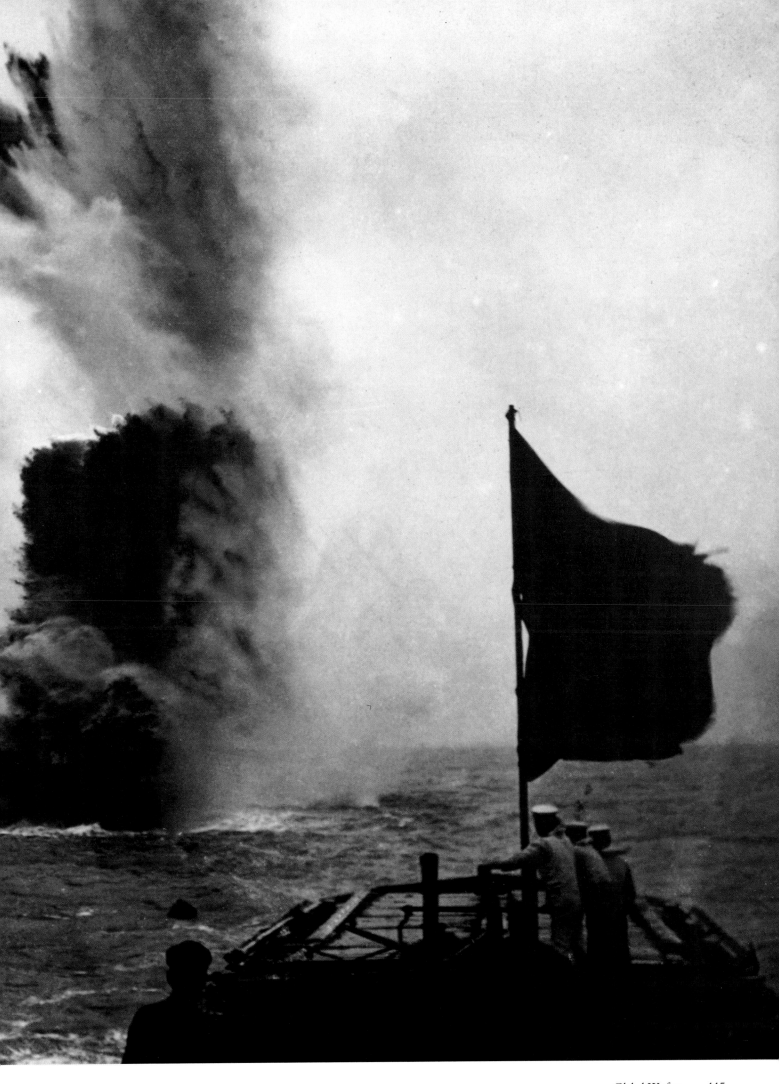

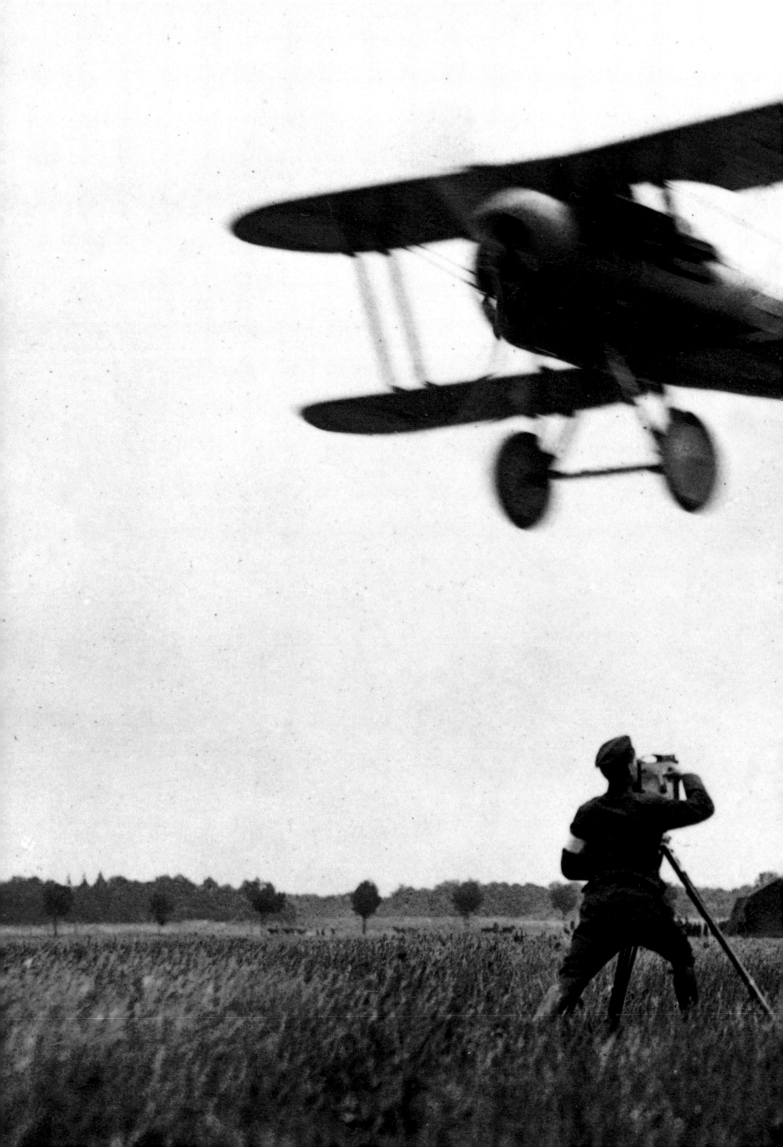

By Air and Sea, 2
(Previous page) An American Army cinematographer tries to film
an American taking off during the summer counter-offensive in
France, 1918, when General Pershing's American troops could call
on the support of 1500 aircraft. (1) The US gun crew closes up for
action on a German commerce raider. The ghostly appearance is
created by anti-flash masks, tunics and gloves, designed to protect
from cordite burns and poisonous fumes during battle.
(2) A British battle squadron at sea, line ahead, in an Atlantic swell
in September 1914, viewed from the bridge of HMS *Audacious*.

Zu Wasser und in den Lüften, 2
(Vorige Seite) Ein Kameramann der US-Armee hält während der
Gegenoffensive in Frankreich im Sommer 1918 den Start eines
amerikanischen Flugzeuges im Bild fest; damals unterstützten
1500 Maschinen General Pershings Truppen. (1) Amerikanische
Kanoniere nehmen einen deutschen Zerstörer ins Visier, der Jagd
auf Handelsschiffe macht. Ihre gespenstische Erscheinung erklärt
sich durch Masken, Überhemden und Handschuhe, die sie im
Gefecht vor Korditverbrennungen und giftigen Dämpfen schützen
sollen. (2) Eine britische Kampfschwadron auf hoher See im
Atlantik, September 1914. Das Bild ist von der Brücke der HMS
Audacious aufgenommen.

Guerre dans les airs et sur mer, 2
(Page précédente) Un cinéaste de l'armée américaine filme un
décollage d'avion américain en France pendant la contre-offensive
de l'été 1918; les troupes du général Pershing purent compter à ce
moment-là sur l'appui de 1500 avions. (1) Marins américains se
serrant pour tirer sur un raider de commerce allemand. Ils ont l'air
de fantômes avec leurs masques, leurs tuniques et leurs gants de
protection contre les brûlures de cordite et les émanations
toxiques. (2) Une escadrille britannique, vue depuis le pont de
l'*Audacieux,* avance en colonne sur la mer houleuse de l'Atlantique,
septembre 1914.

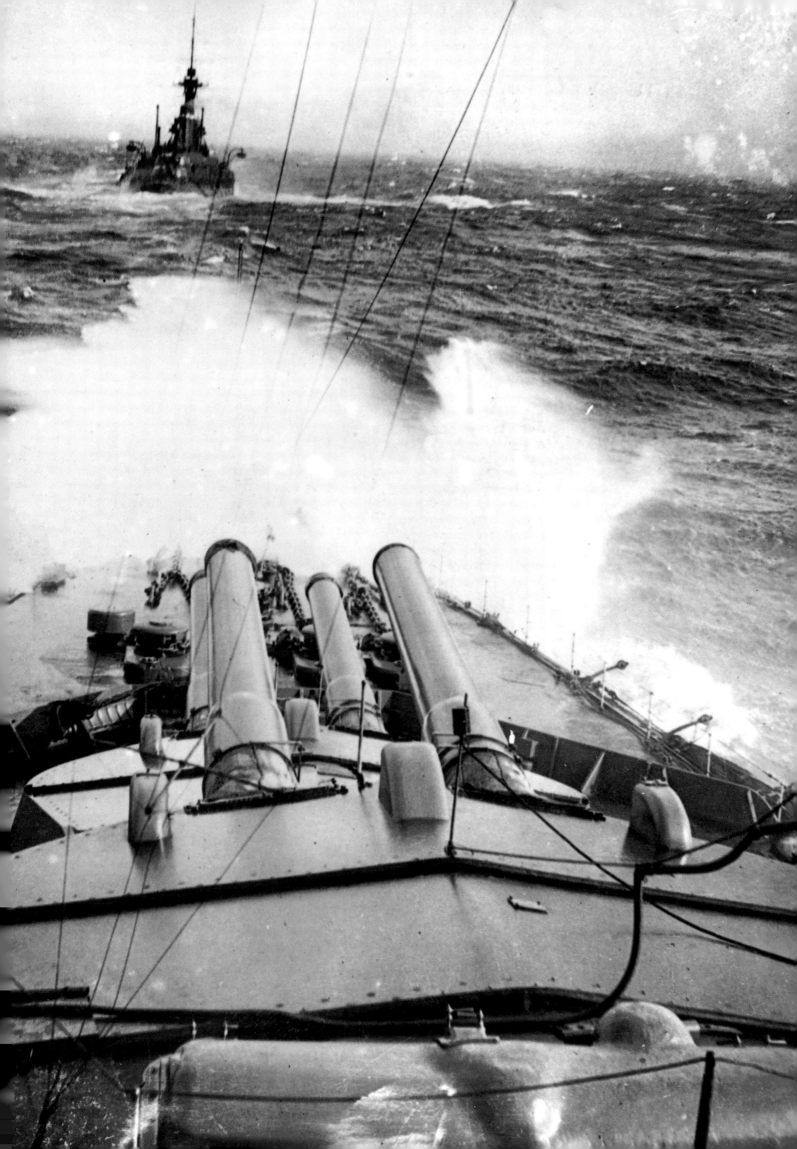

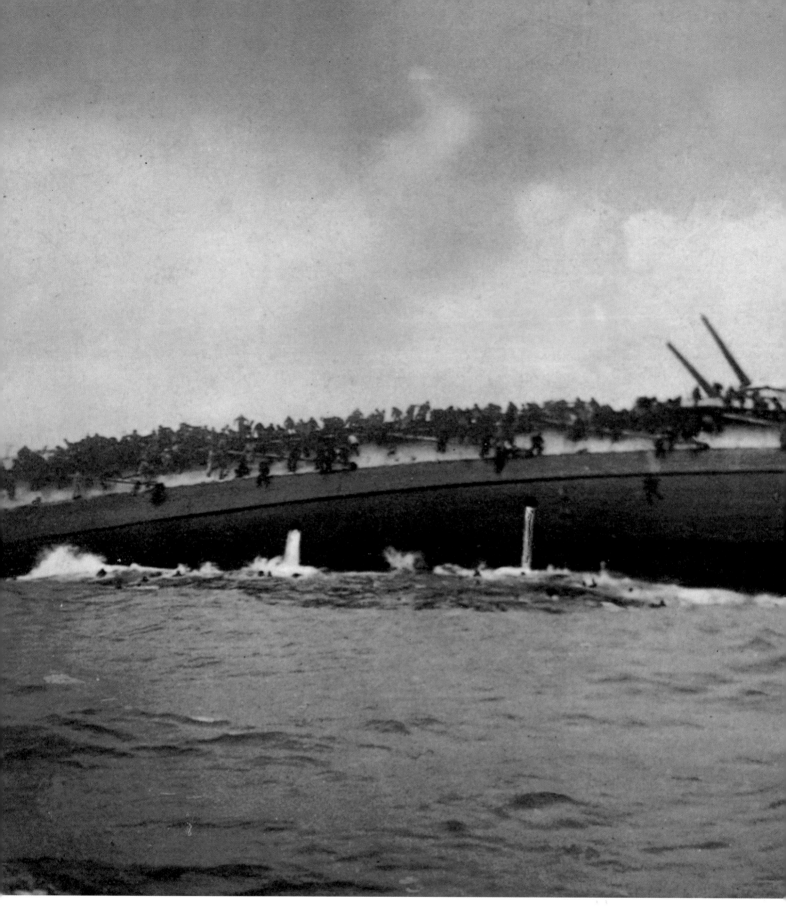

Sea Battle

The war at sea at first followed a predictable pattern, with the Royal Navy endeavouring to keep the German High Seas Fleet confined to ports round the Baltic. Here, the German battle-cruiser *Blücher* in her final moments after being hit off the Dogger bank in January 1915. More than 700 of the ship's company were drowned after she capsized. Misinterpretation of Admiral Beatty's battle orders allowed the rest of Admiral Hipper's raiding squadron to escape.

Seeschlacht

Der Krieg auf See verlief zunächst ganz nach dem vorhersehbaren Muster, wonach die Royal Navy versuchte, die deutsche Hochsee-flotte am Auslaufen aus den Ostseehäfen zu hindern. Das Bild zeigt die letzten Augenblicke des deutschen Panzerkreuzers *Blücher,* der im Januar 1915 vor der Doggerbank versenkt wurde. Das Schiff kenterte, und über 700 Mann Besatzung ertranken. Der Rest der deutschen Überfallflotte unter Admiral Hipper konnte entkommen, weil ein Kommando des britischen Admirals Beatty falsch gedeutet wurde.

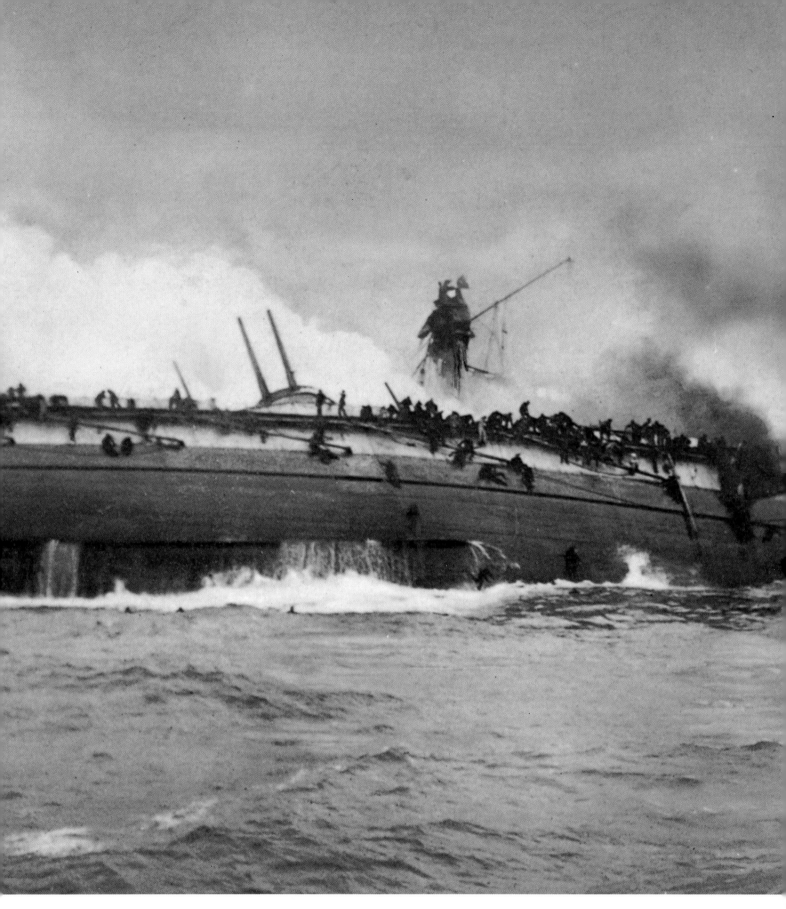

La guerre sur mer
La guerre navale prit un tour prévisible lorsque la Royal Navy
s'efforça d'enfermer la flotte allemande dans les ports de la Baltique.
Derniers instants du croiseur cuirassé allemand *Blücher* qui vient d'être
touché à la hauteur du Dogger Bank, janvier 1915. Plus de 700
hommes d'équipage se noyèrent quand le navire chavira. Les ordres de
l'amiral Beatty ayant été mal interprétés, le reste de l'escadre
commandée par l'amiral Hipper put s'enfuir.

1

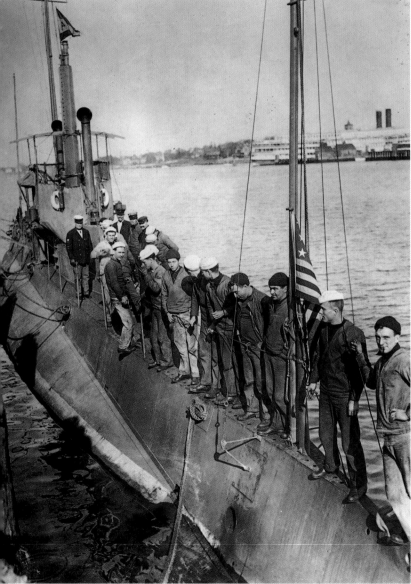

Submarine Warfare

The Germans quickly deployed a powerful submarine force. In 1915 German U-boats sank more than one million tons of allied shipping, including the liner *Lusitania* off Ireland, with the loss of more than 1000 lives, 120 of them Americans. The toll of allied commercial shipping due to the gunfire as much as the torpedoes of the German submarine force began dropping only in the latter half of 1917, when the allies began using armed convoys. (1) One of Germany's largest ocean-going submarines about to set off on patrol in the North Sea, 1916. (2) An American submarine ship's company in an informal deck muster in March 1917. (3) A U-boat captain and officer of the watch manning the conning tower on surface patrol; these vessels could spend only a limited time, a few hours at most, under water. (4) A coaster triggers a mine; these were as much a hazard as the torpedoes and gunfire of marauding U-boats.

U-Boot-Krieg

Die Deutschen stellten rasch eine starke Unterseeflotte auf. 1915 versenkten deutsche U-Boote mehr als eine Million Tonnen alliierte Schiffe, unter anderem das Passagierschiff *Lusitania,* bei dessen Untergang vor der irischen Küste über 1000 Menschen – davon 120 Amerikaner – ums Leben kamen. Die Verluste an alliierten Handels-schiffen durch deutsche U-Boot-Geschütze und Torpedos nahmen erst in der zweiten Hälfte des Jahres 1917 ab, als die Alliierten dazu übergingen, bewaffnete Konvois einzusetzen. (1) Eines der größten deutschen Hochsee-U-Boote auf dem Weg zu einer Patrouillenfahrt in der Nordsee (1916). (2) Die Besatzung eines amerikanischen Unterseeboots ist im März 1917 zwanglos an Deck angetreten. (3) Der Kapitän und ein Wachoffizier auf dem Kommandoturm eines aufgetauchten U-Boots; die damaligen U-Boote konnten nur wenige Stunden unter Wasser verbringen. (4) Ein Küstenfahrzeug löst eine Minenexplosion aus; Minen waren ebenso gefährlich wie die Torpedos und Geschütze marodierender U-Boote.

2

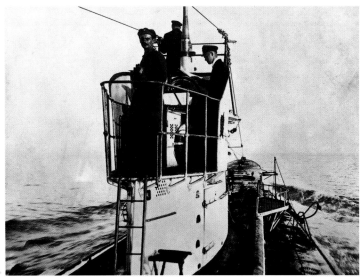

La guerre sous-marine

Les Allemands déployèrent très vite une force sous-marine puissante. En 1915, les submersibles allemands coulèrent plus d'un million de tonnes de bateaux alliés, dont le paquebot *Lusitania* au large de l'Irlande, qui coûta la vie à 1000 personnes dont 120 Américains. Le nombre de navires de commerce alliés coulés par les canons ou les torpilles des sous-marins allemands commença à diminuer dans la seconde moitié de 1917. (1) Un des plus gros sous-marins de haute mer de la marine allemande partant en patrouille en mer du Nord. (2) Equipage de sous-marin américain rassemblé sur le pont, mars 1917. (3) Un capitaine et un officier de quart surveillant la surface depuis le kiosque; le temps de plongée de ces bâtiments était limité, quelques heures au plus. (4) Navire caboteur faisant exploser une mine, un des hasards de la guerre au même titre que les torpilles et les canonnades des sous-marins en maraude.

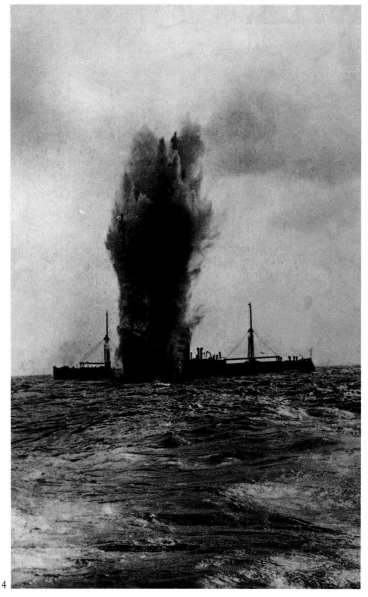

4

In the years of restless peace, Europe
was soon divided into armed camps,
and new leaders arose, formed by the
experience of the Great War. Hitler
had been decorated on the Western
Front, and Mussolini was deeply
affected by the slaughter of the Italian
armies on the Carso and the Isonzo.
Here Hitler receives the salute and
greeting of thousands of his youth
movement at Nuremberg in 1938.

In den Jahren des ruhelosen Friedens
war Europa schnell in mehrere
bewaffnete Lager gespalten. Neue
Führer tauchten auf, die von den
Erfahrungen des Ersten Weltkriegs
geprägt worden waren: Hitler hatte
sich an der Westfront bewährt, und
Mussolini stand tief unter dem
Eindruck der Massaker an der
italienischen Armee am Carso und
Isonzo. Auf dem nebenstehenden
Foto nimmt Hitler 1938 in Nürnberg
die Parade und den Gruß der
Hitlerjugend ab.

Au lendemain de la Première Guerre
mondiale, la paix reste fragile.
L'Europe est bientôt divisée en deux
camps et de nouveaux dirigeants,
issus de la Grande Guerre,
s'imposent. Hitler a été décoré sur le
front occidental et Mussolini reste
profondément marqué par le
massacre des armées italiennes dans le
Karst et l'Isonzo. En 1938, à
Nuremberg, Hitler est acclamé par
des milliers de jeunes du mouvement
hitlérien.

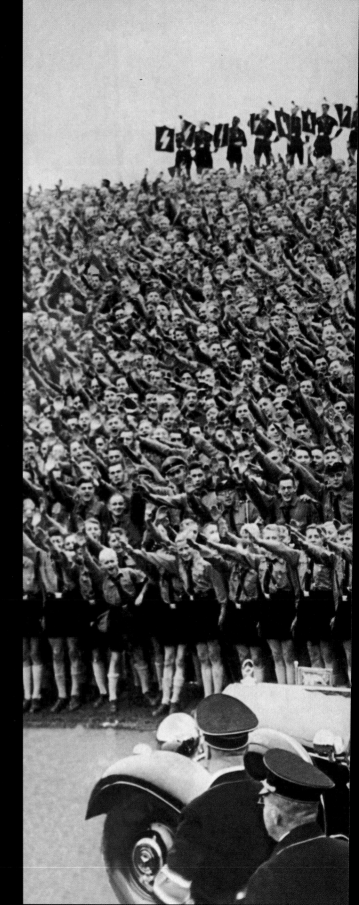

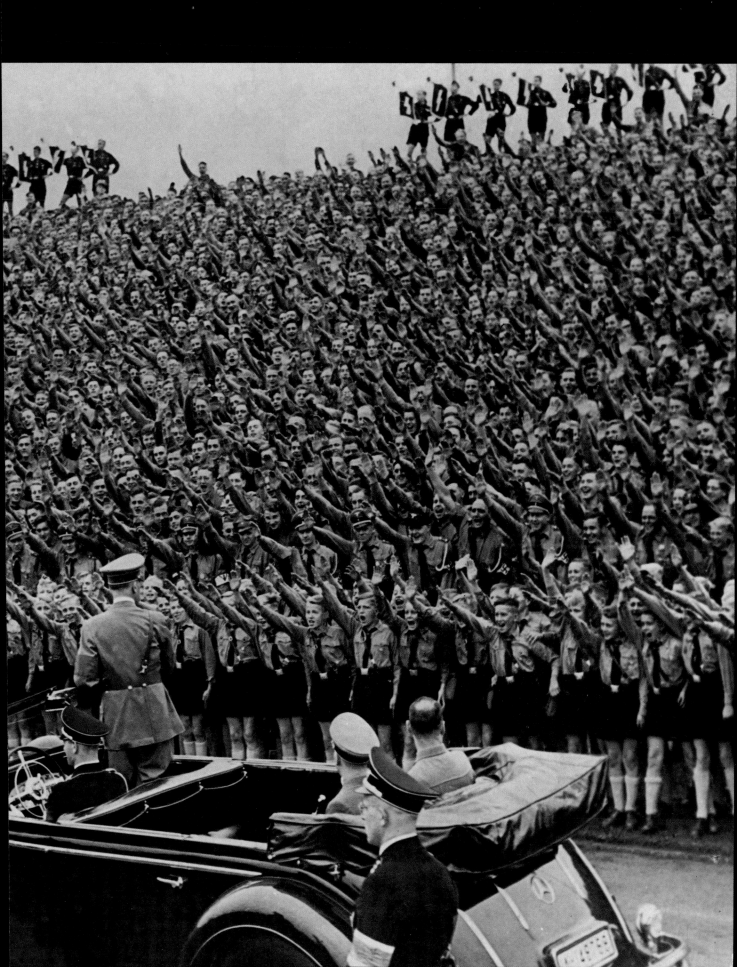

New Empires

1918–1939 between the wars

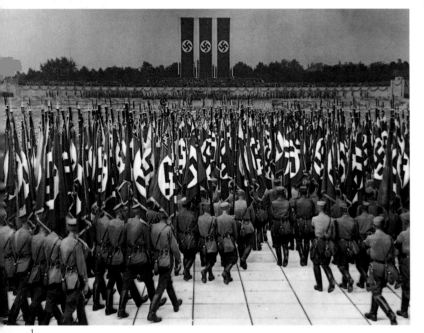

1

The years from 1918 to 1939 were a period of no war and no peace. At the Versailles Treaty negotiations concluding the First World War, a young British officer, Archibald Wavell, spoke of 'a peace to end all peace'. President Woodrow Wilson hoped that the world would live up to the high-minded principles of his 14 points. The League of Nations was formed, to sit in Geneva, but was fatally weakened by the absence of the United States and the Soviet Union.

While the talking went on at Versailles, unfinished business from the Great War continued, particularly in the Middle East and Russia. From two defeated powers new regimes were born, in Soviet Russia where the civil war raged until 1922, and in Turkey where General Mustafa (Ataturk) raised the standard against the Western allies – Britain and France joined by Greece and Italy – occupying part of his country. War broke out between the new Soviet regime and the newly independent Poland in 1920. The Poles defeated the Russians, but the Red Army survived; it began to evolve new tactics and a staff system which survived Stalin's vindictive purges of the officer corps in 1936 and was crucial to organising the response to Hitler's invasion of Russia in 1941.

Britain aimed at the rapid demobilization of its wartime armies, but, ironically, Versailles added to British overseas responsibilities with mandates over territories in the Middle East, with growing unrest in Iraq, India, and the new mandate in Palestine, where they tried to manage the hopeless task of reconciling the aspirations of the local Arab nationalist leadership and the Zionist Jewish movement – both of whose causes Britain had backed in the First World War.

In Germany more than 50 committees were devoted to the study of the lessons of the First World War. Meanwhile resentment at the peace terms, punitive reparations and occupation of the Ruhr and Saar, and the world-wide Depression fuelled the rise of Hitler's Nazi Party, which took power in 1933. The Nazis played on the idea that Germany had lost in 1918 due to betrayal at home, particularly by the Jews. Against Hitler's steady expansion of power, from the occupation of the Rhineland to union with Austria and the dismemberment of Czechoslovakia in 1939, the Western community wanted to do little. Diplomatic minds were distracted by events in Abyssinia, in Manchuria, and the collapse of credibility of the League of Nations.

In 1922, after the 'march on Rome' by his Black Shirt supporters, Benito Mussolini seized power in Italy. Mussolini was keen on expanding Italy's empire, and in 1935 moved to annex Abyssinia from Italian Somalia. At his personal instruction, it is now known, the Italians used large amounts of gas to break the poorly armed forces of the Emperor Haile Selassie, who went into exile. The League of Nations imposed sanctions against Italy, but they were ineffectual. Despite the military rhetoric, and alliance with Nazi Germany, Italy under the fascist regime, much of which was show rather than substance, was woefully unprepared to be dragged into a total war in Europe in 1940.

The Japanese regarded control over Manchuria as a primary strategic interest, and in 1931 used the alleged bombing of the railway near Mukden as a pretext to invade. As well as this threat, China was in the grip of civil war. In 1921 Mao Tse-Tung became secretary of the Communist party of China. He was opposed, successfully at first, by General Chiang Kai-Shek, who became the leader of the Kwomintang army in 1925. In 1934 Mao's Communist forces were in such difficulty that he undertook a 5000-mile retreat into Yenan in the interior; in the 'long march', which lasted more than a year, under a third of the 100,000 who set out were to survive. In 1937 Mao decided that the main enemy was Japan; that year saw all-out war erupt, with Japan securing Nanking and Shanghai with great ferocity. Japan incurred the outright condemnation of the League of Nations, from which she withdrew in 1933. However, the League could do nothing.

The Manchurian conflict was a combination of civil and international war, a pattern repeated in the Second World War – in Yugoslavia, Ukraine, Italy, Greece and in parts of France. The civil war which erupted in Spain in 1936 was a proxy war for the new European powers to try out their new weapons and tactics. In July 1936 the Commander of the Spanish Army in Morocco, General Francisco Franco, defied the republican government in Madrid and crossed the Straits of Gibraltar with his army. He received help in troops and aircraft from Mussolini, and the Messerschmitt Me109 fighters and the Junkers Ju87 dive-bombers of the volunteer German Condor Legion. The dive-bombers struck at the Basque town of Guernica on 26 April 1937, killing some 6000 civilians and razing half the buildings. Finally the republicans' resistance collapsed in Catalonia, after the bombing of Barcelona. Spain had been the final proof of the fecklessness of the League of

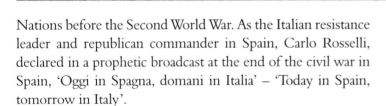

Nations before the Second World War. As the Italian resistance leader and republican commander in Spain, Carlo Rosselli, declared in a prophetic broadcast at the end of the civil war in Spain, 'Oggi in Spagna, domani in Italia' – 'Today in Spain, tomorrow in Italy'.

(1) The great Nazi Rally at Nuremberg in 1938: 'Honour to the Heroes', the flag parade of Hitler's militia, the SS and SA, in the Luitpold Stadium. (2) Mounted Carabinieri military police parading through a triumphal arch in Rome – a characteristic piece of Fascist architecture – to honour the founders of the Axis, Mussolini (*il Duce*) and Hitler.

Die Jahre zwischen 1918 und 1939 waren eine Zeit, die weder Krieg noch Frieden kannte. Während der Verhandlungen zum Versailler Vertrag im Anschluß an den Ersten Weltkrieg sprach ein junger britischer Offizier, Archibald Wavell, von »einem Frieden, der jedem Frieden ein Ende setzt«. Und der amerikanische Präsident Woodrow Wilson hoffte, daß die Welt gemäß den hehren Grundsätzen seines 14-Punkte-Programms leben könnte. Zur gleichen Zeit fand die Gründung des Völkerbundes mit Sitz in Genf statt, der jedoch durch die Abwesenheit der Vereinigten Staaten und der Sowjetunion gefährlich geschwächt war.

Während man in Versailles noch verhandelte, wurde an einigen Schauplätzen des Ersten Weltkriegs weitergekämpft, insbesondere im Nahen Osten und in Rußland. Aus den Trümmern zweier besiegter Mächte entstanden neue Reiche – in Rußland, wo der Bürgerkrieg bis 1922 weiter wütete, und in der Türkei, wo General Mustafa Atatürk den Kampf gegen die westlichen Alliierten – England und Frankreich sowie Griechenland und Italien – aufnahm, die einen Teil seines Landes besetzt hielten. 1920 entbrannte ein Krieg zwischen

(1) Der Reichsparteitag der Nazis in Nürnberg 1938: »Heldengedenken«, die Flaggenparade von SS und SA im Luitpold-Stadion. (2) Berittene Carabinieri paradieren in Rom durch einen Triumphbogen – ein typisches Bauwerk faschistischer Architektur – zu Ehren der Gründer der »Achse«, Mussolini (*il Duce*) und Hitler.

(1) 1938, grand rassemblement nazi à Nuremberg: « Honneur aux héros », défilé sous les drapeaux des milices hitlériennes, les SS et les SA, dans le stade Luitpold. (2) Défilé des carabinieri, police militaire montée, sous un immense arc de triomphe de Rome (un monument typique de l'architecture fasciste), en l'honneur des fondateurs de l'Axe, Mussolini (*il Duce*) et Hitler.

dem Sowjetregime und dem gerade unabhängig gewordenen Polen. Die polnische Armee besiegte die russischen Truppen, aber die Rote Armee überlebte. Sie entwickelte neue Taktiken und ein Stabssystem, das Stalins rachsüchtige Säuberungsaktion des Offizierkorps im Jahr 1936 überstand und bei der Organisation eines Gegenschlags auf Hitlers Einmarsch nach Rußland 1941 von entscheidender Bedeutung war.

Großbritannien strebte zwar eine rasche Abrüstung seiner Kriegsarmeen an, aber Versailles trug mit Mandaten über

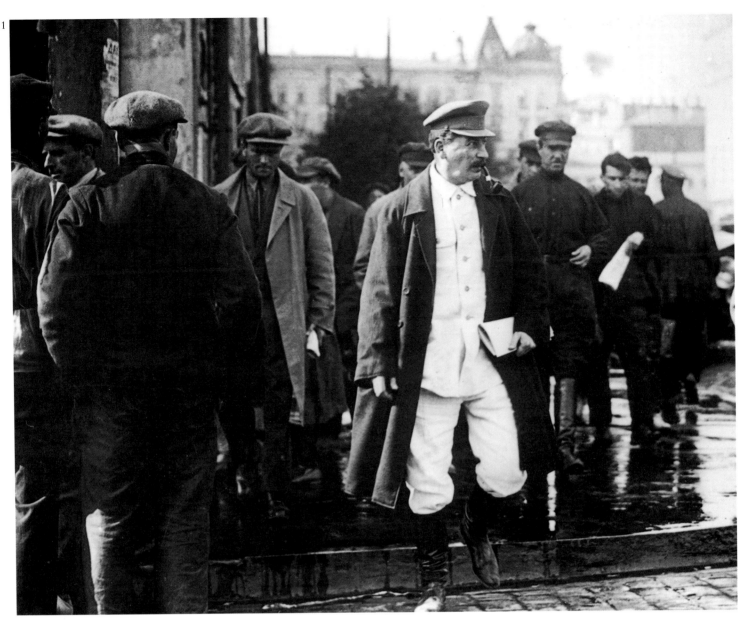

Territorien im Nahen Osten zu weiteren britischen Verpflichtungen bei. Die Briten mußten sich mit der wachsenden Unruhe im Irak und in Indien auseinandersetzen und sich um ihr neues Mandat in Palästina kümmern, wo sie die Versöhnung zwischen den Bestrebungen der örtlichen arabischen nationalen Führung und der zionistisch-jüdischen Bewegung beschäftigt hielt – deren beider Anliegen Großbritannien im Ersten Weltkrieg unterstützt hatte.

In Deutschland analysierten über 50 Ausschüsse den Ersten Weltkrieg. In der Zwischenzeit nährten Unmut gegen die Friedensbedingungen, extrem hohe Reparationszahlungen und die Besetzung von Ruhr und Saar sowie eine weltweite wirtschaftliche Depression den Aufstieg von Hitlers Nationalsozialistischer Partei, die 1933 die Macht übernahm. Die Nazis propagierten die These, daß Deutschland den Krieg 1918 aufgrund eines innerdeutschen Verrats, insbesondere der Juden, verloren hätte. Gegen Hitlers ständige Machterweiterung – von der Besetzung des Rheinlands bis zum Anschluß Österreichs und der Zerstückelung der Tschechoslowakei – gedachte die westliche Gemeinschaft jedoch kaum etwas zu unternehmen. Die diplomatischen Bemühungen konzentrierten sich auf die Ereignisse in Abessinien, in der Man-

dschurei und auf den Zusammenbruch der Glaubwürdigkeit des Völkerbundes.

Nach dem »Marsch auf Rom« der faschistischen Schwarzhemden ergriff Benito Mussolini 1922 in Italien die Macht. Mussolini strebte eine Erweiterung des italienischen Reichs an und marschierte 1935 aus dem ostafrikanischen Kolonialterritorium Italienisch-Somaliland nach Abessinien ein. Wie man heute weiß, setzten die italienischen Truppen auf seine persönliche Anweisung hin große Mengen Gas ein, um den Widerstand der kaum bewaffneten Armee des Kaisers Haile Selassie zu brechen, der sich ins Exil begab. Der Völkerbund verhängte Sanktionen gegen Italien, die jedoch völlig nutzlos waren. Trotz seines militaristischen Auftretens und der Allianz mit Nazi-Deutschland war das faschistische Italien – dem es vor allem um ein Schauspiel seiner Macht ging – sehr schlecht auf den Kriegseintritt im Jahre 1940 vorbereitet.

Die Japaner betrachteten die Machtübernahme in der Mandschurei als strategisch vorrangige Aufgabe und nutzen 1931 die angebliche Bombardierung der Eisenbahntrasse in der Nähe von Mukden als Vorwand für ihren Einmarsch. Aber China befand sich auch mitten in einem Bürgerkrieg. 1921 war Mao Tse-tung zum Sekretär der Kommunistischen

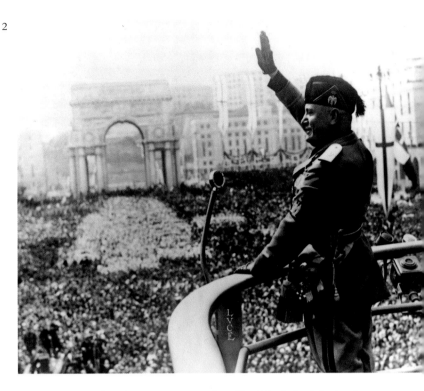

The Great Dictators
(1) Stalin, who ordered the liquidation of millions of Soviet citizens and the deportation of as many to labour camps in systematic purges during his 30-year rule. (2) Mussolini in characteristic pose. (3) General Franco with his wife Doña Carmen Pola and supporters.

Die großen Diktatoren
(1) Stalin, der während seiner 30jährigen Herrschaft in systematischen Säuberungen die Liquidation von Millionen sowjetischer Bürger und die Deportation ebensovieler in die Arbeitslager befahl. (2) Mussolini in charakteristischer Pose. (3) General Franco mit seiner Frau Doña Carmen Pola und Anhängern.

Les grands dictateurs
(1) Staline ordonnera la liquidation de millions de Soviétiques et la déportation de millions de personnes dans des camps de travail et pratiquera des purges systématiques pendant ses 30 ans de pouvoir. (2) Une des poses de Mussolini. (3) Le général Franco avec sa femme Doña Carmen Pola et des partisans.

Partei Chinas ernannt worden. Ihm gegenüber stand General Tschiang Kai-schek – seit 1925 Führer der Revolutionsarmee der Kuomintang –, der Mao in der ersten Zeit erfolgreich Widerstand bot. 1934 befand sich Maos kommunistische Rote Armee in so großen Schwierigkeiten, daß er seine Truppen auf einen 7500 Kilometer langen Rückzug nach Yenan ins Landesinnere führte. Dieser sogenannte »Lange Marsch« dauerte über ein Jahr und kostete zwei Drittel der ursprünglich 100 000 Mann starken Armee das Leben. 1937 entschied Mao, daß Japan der wichtigste Gegner sei. Im gleichen Jahr brach überall in China der Krieg aus, wobei Japan Nanking und Schanghai mit großer Entschlossenheit verteidigte. Japan hatte sich zwar einen scharfen Tadel des Völkerbundes eingehandelt, aus dem das Land 1933 austrat, aber der Völkerbund erreichte nichts.

Bei dem mandschurischen Zwischenfall handelte es sich um eine Mischung aus Bürgerkrieg und internationaler Auseinandersetzung – ein Muster, das sich im Zweiten Weltkrieg in Jugoslawien, Italien, Griechenland, in der Ukraine und in Teilen Frankreichs wiederholte. Der Bürgerkrieg, der 1936 in Spanien ausbrach, war ein Stellvertreterkrieg für die neuen europäischen Mächte, die dort ihre neuen Waffen und Strategien testeten. Im Juli des Jahres 1936 besiegte der Kommandant der Spanischen Armee in Marokko, General Francisco Franco, die republikanische Regierung in Madrid und überquerte mit seinen Truppen die Straße von Gibraltar. Dabei erhielt er Unterstützung von außen: Mussolini sandte Truppen und Flugzeuge, während ihn Deutschland mit den Messerschmitt Me-109-Jagdbombern und den Junkers Ju-87-Sturzkampfbombern der freiwilligen deutschen Legion Condor unterstützte. Die »Stukas« bombadierten am 26. April 1937 die baskische Stadt Guernica, wobei 6000 Zivilisten ums Leben kamen und die Hälfte der Stadt dem Erdboden gleichgemacht wurde. Nach der Bombardierung Barcelonas brach der Widerstand der Republikaner in Katalonien zusammen.

Spanien war der letzte Beweis für die Machtlosigkeit des Völkerbundes vor Beginn des Zweiten Weltkrieges – wie der Leiter des italienischen Widerstands und republikanische Kommandant in Spanien, Carlo Rosselli, in einem prophetischen Radiointerview gegen Ende des spanischen Bürgerkriegs erklärte: »Oggi in Spagna, domani in Italia« – »Heute in Spanien, morgen in Italien«.

L'entre-deux-guerres est une période sans guerre ni paix. A la signature du Traité de Versailles qui marque la fin de la Première Guerre Mondiale, un jeune officier britannique, Archibald Wavell, parle d'une «paix pour en finir avec toutes les paix». Le Président Woodrow Wilson espérait que le monde vivrait dans le respect de ses 14 points, inspirés par de grands principes. La Société des Nations est créée à Genève mais l'absence des Etats-Unis et de l'Union Soviétique lui seront fatales.

Les négociations de Versailles sont en cours mais la Grande Guerre n'est pas terminée pour autant, notamment au Moyen-

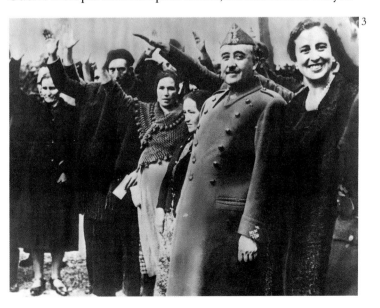

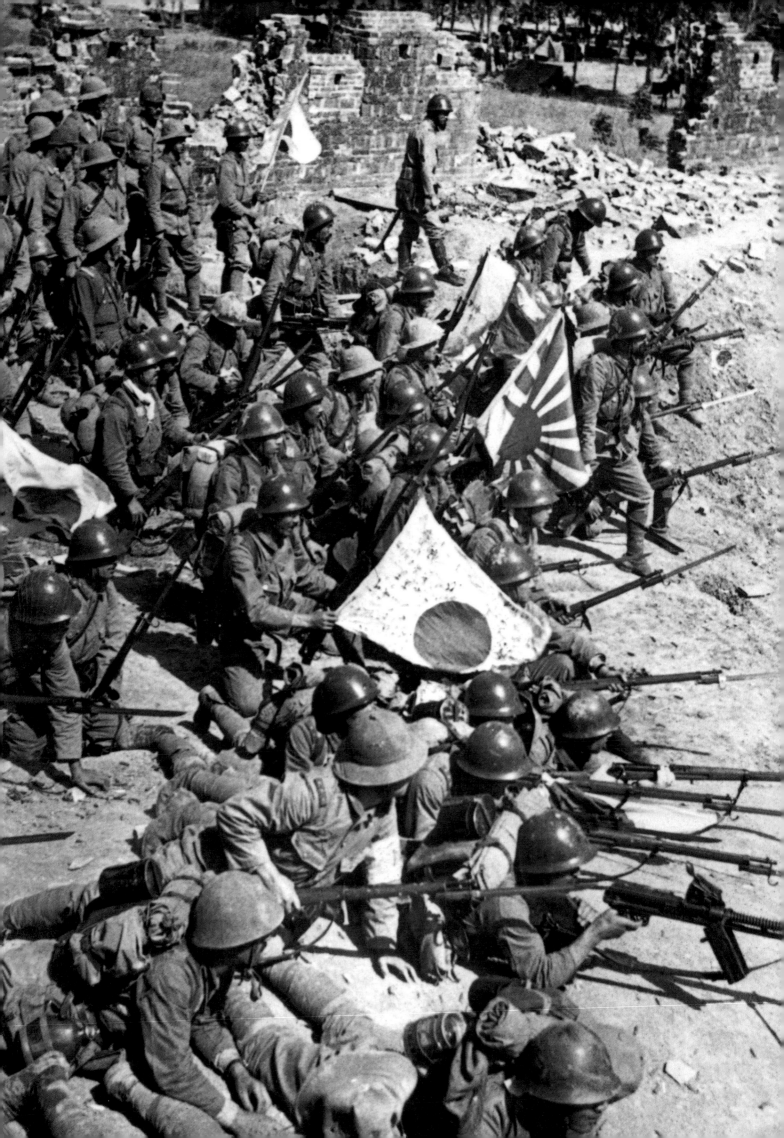

Orient et en Russie. Deux puissances vaincues donnent naissance à de nouveaux régimes en Russie soviétique où la guerre civile fera rage jusqu'en 1922 et en Turquie où le général Mustafa Kemal (Atatürk) soulève le peuple contre les Alliés occidentaux (la Grande-Bretagne, la France puis la Grèce et l'Italie) qui occupent une partie du pays. En 1920, la guerre éclate entre le nouveau régime soviétique et la Pologne, indépendante depuis peu. Les Polonais ont vaincu les Russes mais l'armée rouge survit. Elle développe de nouvelles tactiques et met en place un état-major qui survivra aux purges staliniennes de 1936 contre ses officiers. En 1941, elle joue un rôle crucial dans l'organisation de la riposte à l'invasion de la Russie par Hitler.

La Grande-Bretagne veut procéder à une rapide démobilisation de ses troupes mais se voit attribuer par Versailles de nouveaux engagements avec des mandats au Moyen-Orient. Les Britanniques doivent faire face à une agitation grandissante en Irak, en Inde et en Palestine, nouveau mandat, où le gouvernement entrepend la difficile tâche de réconcilier les aspirations du nationalisme arabe et du mouvement sioniste, deux causes que la Grande-Bretagne avaient soutenues pendant la Première Guerre mondiale.

En Allemagne, une cinquantaine de commissions se consacrent à une vaste étude pour tirer les enseignements de la guerre de 1914-18. Entre-temps, l'amertume face aux conditions de paix, aux réparations exigées et à l'occupation de la Ruhr et de la Sarre ainsi que la dépression mondiale contribuent à l'avènement du parti nazi de Hitler qui prend le pouvoir en 1933. Les Nazis imputent la défaite de l'Allemagne à une trahison qui serait venue de l'intérieur, plus particulièrement des Juifs. Face à l'ascension rapide de Hitler – de son occupation de la Rhénanie à l'*Anschluss* de l'Autriche et au démembrement de la Tchécoslovaquie en 1939 – les pays occidentaux n'interviendront pas ou si peu. Les diplomates s'intéressent davantage à ce qui se passe en Abyssinie, en Mandchourie et à la Société des Nations qui perd toute crédibilité.

En Italie, Benito Mussolini prend le pouvoir en 1922 après la «marche sur Rome» de ses Chemises Noires. Mussolini veut étendre l'empire italien et, en 1935, il entreprend d'annexer l'Abyssinie depuis la Somalie italienne. Sur ordre personnel de Mussolini – fait aujourd'hui reconnu – les Italiens ont recours à de grandes quantités de gaz pour vaincre les troupes faiblement armées de l'empereur Hailé Sélassié qui s'exile. La Société des Nations impose des sanctions à l'Italie, qui restent sans effet. Malgré sa réthorique militaire et son alliance avec l'Allemagne nazie, l'Italie fasciste, dont le régime est bien moins fort qu'il n'en paraît, manque cruellement de moyens quand, en 1940, elle se laisse entraîner dans une guerre totale en Europe.

Pour les Japonais, le contrôle de la Mandchourie constitue un atout stratégique essentiel. En 1931, ils envahissent le pays en réponse au prétendu bombardement de la ligne de chemin de fer près de Mukden. La Chine doit faire face à cette menace alors qu'elle est en proie à la guerre civile. En 1921, Mao Tsê-Tung devient le secrétaire du parti communiste chinois. Il a pour opposant le général Chiang Kai-Shek qui, dans un premier temps, gagne et devient le chef de l'armée du Kuo-min-tang en 1925. En 1934, les forces communistes sont en grande difficulté et Mao décide d'opérer une retraite de plus de 7000 kilomètres vers Yenan. Cette «Longue Marche» durera plus d'un an et seul un tiers des 100 000 soldats survivra. En 1937, Mao désigne le Japon comme ennemi principal. Cette année-là la guerre éclate sur tous les fronts. Le Japon défend Nanking et Shanghaï avec une grande férocité et se voit sévèrement condamné par la Société des Nations, dont il se retire en 1931. Cependant, quelle que soit la sévérité de ses critiques, la Société des Nations ne peut rien faire.

La guerre en Mandchourie est à la fois une guerre civile et une guerre internationale. Ce schéma se répétera au cours de la Deuxième Guerre mondiale, en Yougoslavie, en Ukraine, en Italie, en Grèce et dans certaines régions de la France. La guerre civile qui éclate en 1936 en Espagne est une guerre par nations interposées dans laquelle les nouveaux pouvoirs en place en Europe vont tester leurs armes et tactiques nouvelles. En 1936, le commandant de l'armée espagnole au Maroc, le général Francisco Franco, défie le gouvernement républicain à Madrid et traverse avec son armée le détroit de Gibraltar. Il reçoit le soutien en hommes et avions de Mussolini. Plus important encore est le soutien des volontaires allemands de la Légion Condor qui lui envoie des avions de chasse Messerschmitt Me109 et des bombardiers Junkers Ju-87. Les bombardiers opèrent un raid sur la ville basque de Guernica le 26 avril 1937, tuant 6000 civils et rasant la moitié des immeubles. Le bombardement de Barcelone marque la fin de la résistance républicaine en Catalogne. L'Espagne est le dernier exemple de l'inefficacité de la Société des Nations, à la veille de la Deuxième Guerre mondiale. Carlo Rosselli, chef de la résistance italienne et commandant républicain en Espagne, déclare dans un message diffusé à la radio à la fin de la guerre civile espagnole: «Oggi in Spagna, domani in Italia», «Aujourd'hui en Espagne, demain en Italie».

Japanese forces taking positions after seizing the village of Hsuchon, 1937.

Japanische Truppen beziehen nach der Eroberung des Dorfes Hsuchon ihre Stellungen, 1937.

Les forces japonaises prennent position après la conquête du village de Hsuchon, 1937.

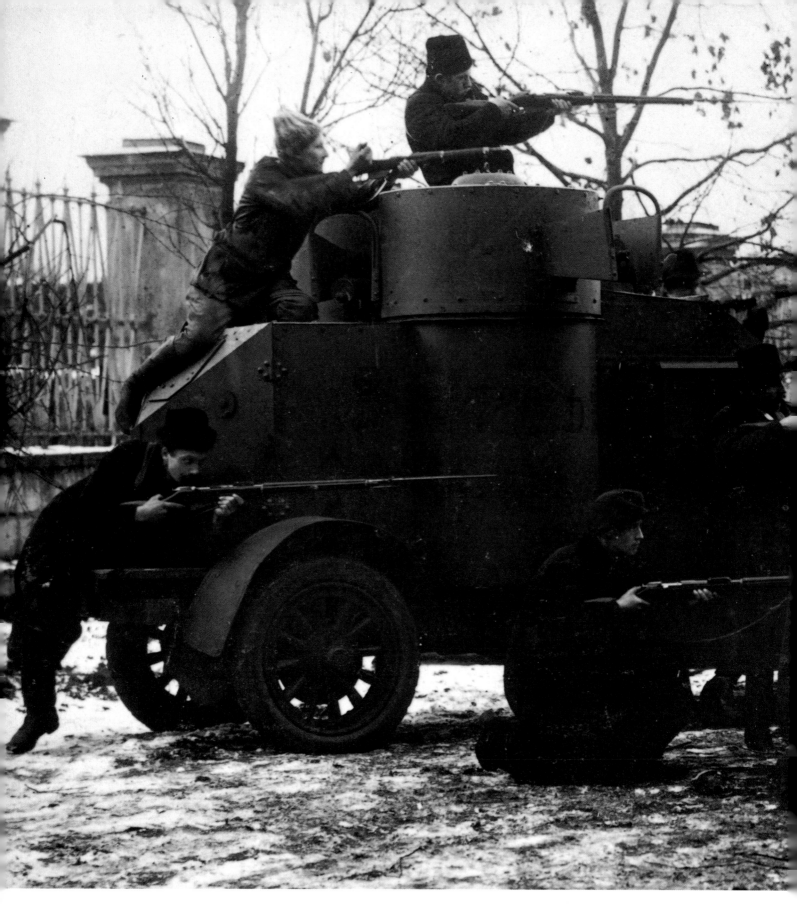

The Russian Revolution

Red Guards fire from an armoured car in Moscow in the October Revolution, 1917. The revolution brought a civil war and disturbances for another five years. But the forces of Lenin's Bolsheviks won, despite Western aid for their 'White Russian' opponents.

Die russische Revolution

Rotgardisten im Feuergefecht hinter einem Schützenpanzer während der Oktoberrevolution 1917 in Moskau. Die Revolution verursachte einen Bürgerkrieg und weitere fünf Jahre andauernde Unruhen. Aber trotz der westlichen Hilfe für die »weißrussische« Opposition siegten Lenins Bolschewisten.

La révolution russe

1917, à Moscou durant la révolution d'Octobre, des soldats de l'Armée Rouge font feu depuis un blindé. La révolution engendre la guerre civile et des troubles qui vont durer cinq ans. Mais les troupes bolchéviques de Lénine gagneront malgré l'aide apportée par les Occidentaux à leurs opposants, les « Russes blancs ».

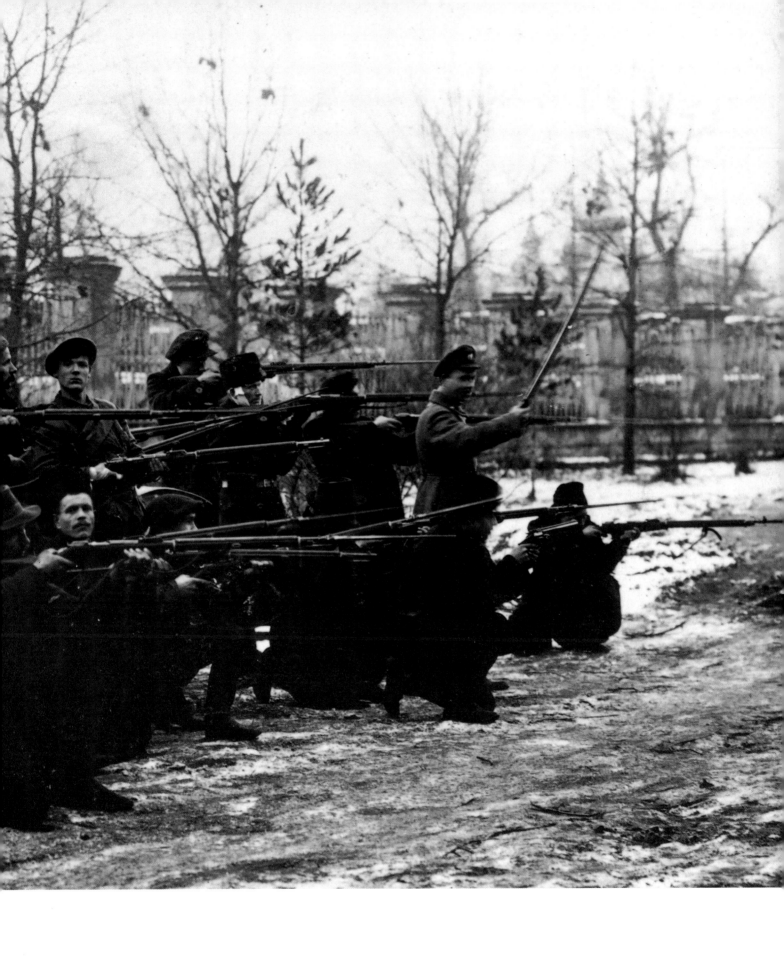

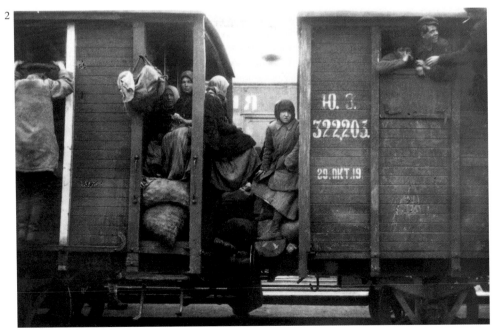

Civil War in Russia

(1) A women's death battalion, heads cropped, takes an oath of loyalty on the old Russian flag, June 1917, as the war with Germany is ending and civil war is about to begin. (2) Much of the transport in the civil war was by train. Here some beggar women ride the trains in desperate search of food and sustenance. (3) A young Bolshevik volunteer, grenades in his bandolier. This kind of bolt-action rifle would see service in several wars to come.

Bürgerkrieg in Rußland

(1) Ein Frauen-Todesbataillon mit kurzgeschorenen Haaren, das den Treueeid auf die alte russische Flagge leistet, Juni 1917, gegen Ende des Kriegs mit Deutschland und kurz vor Beginn des russischen Bürgerkriegs. (2) Während des Bürgerkriegs fanden die meisten Transporte auf dem Schienenweg statt. Das Foto zeigt Bettlerinnen bei der verzweifelten Suche nach Lebensmitteln. (3) Ein junger bolschewistischer Freiwilliger mit Granaten im Gürtel und einem Repetiergewehr, wie es später in diversen Kriegen verwendet wurde.

La guerre civile en Russie

(1) Juin 1917, un bataillon de la mort, des femmes à la tête rasée, prête serment devant l'ancien drapeau russe. La guerre avec l'Allemagne se termine et la guerre civile va commencer. (2) Durant la guerre civile, le train est le moyen de transport principal. Des mendiantes ont pris le train, à la recherche despérée de nourriture et de moyens de subsistance. (3) Un jeune volontaire bolchévique avec des grenades dans sa cartouchière. Ce type de fusil à culasse automatique servira dans bien des guerres à venir.

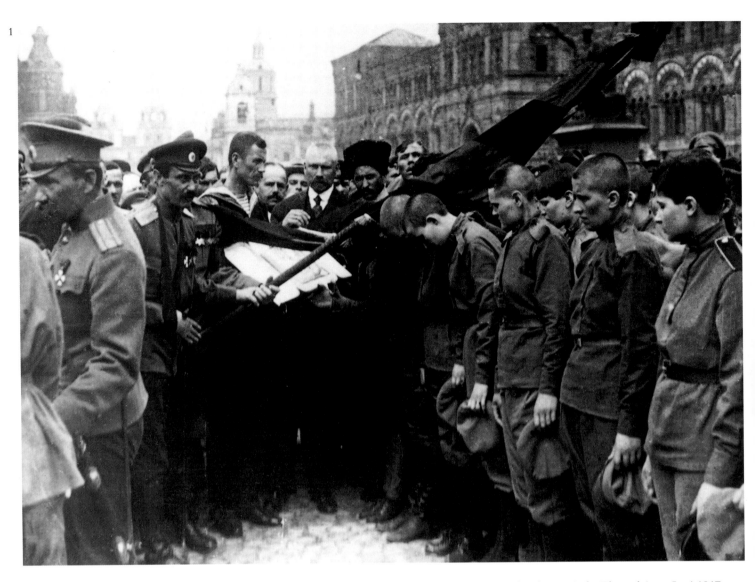

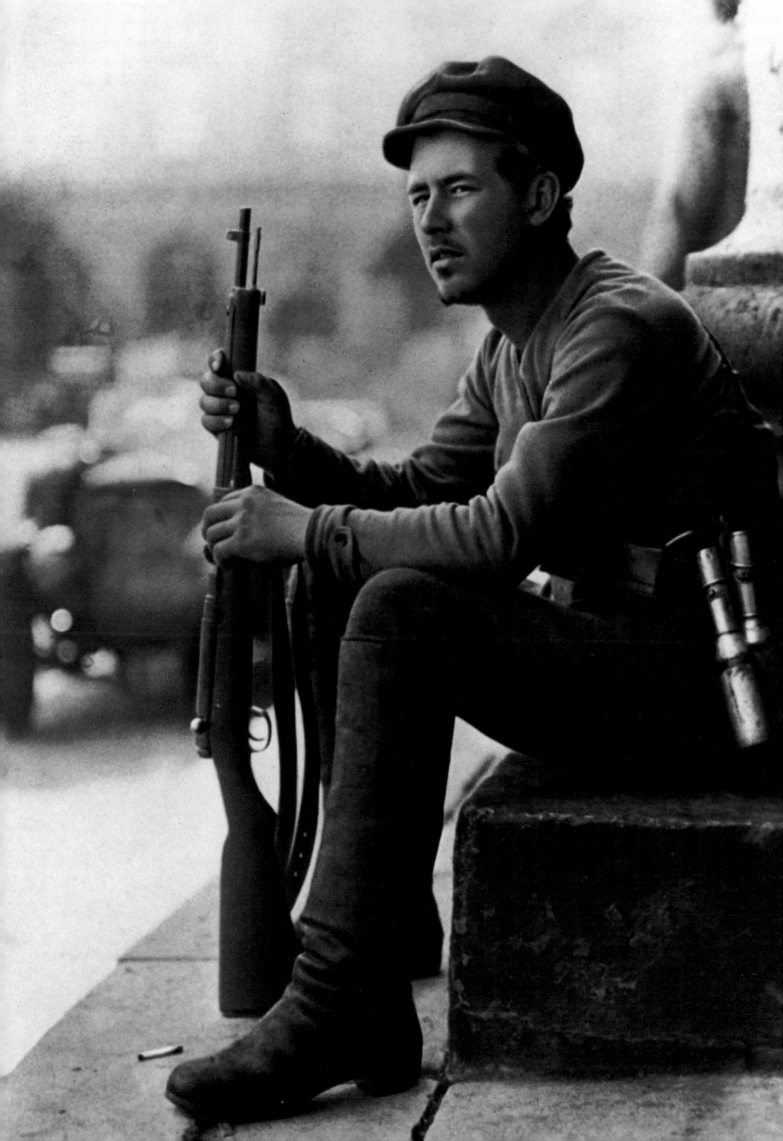

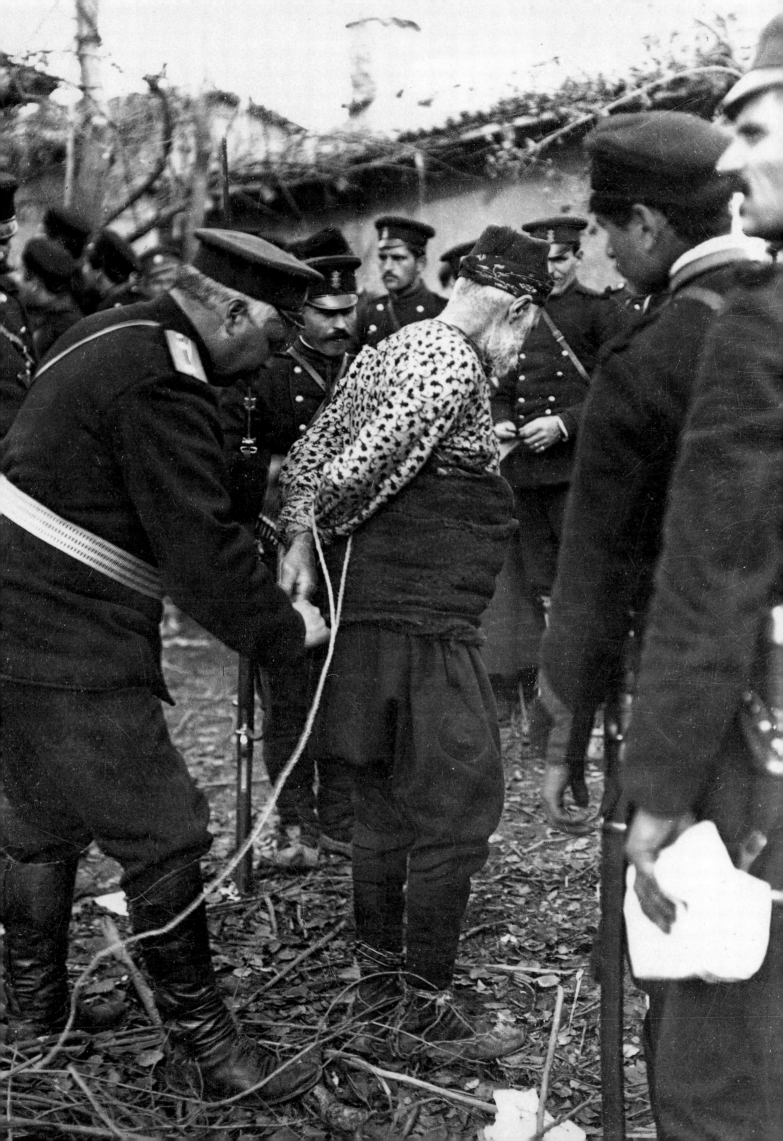

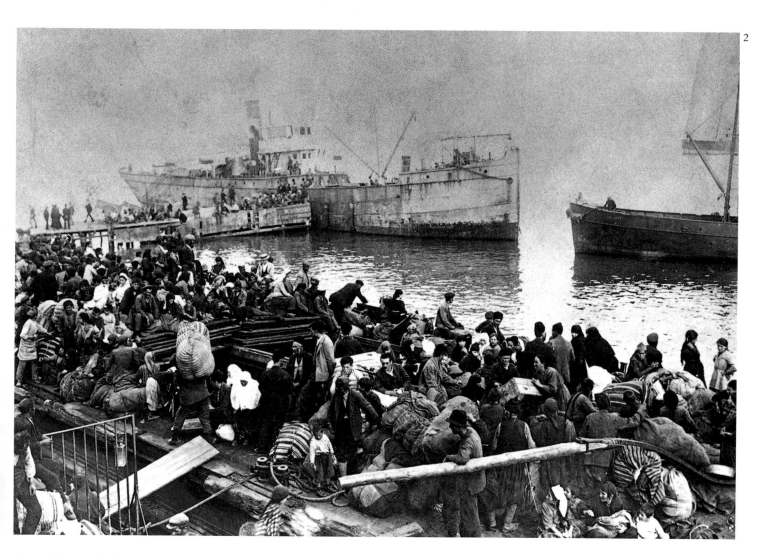

Ataturk's new Turkey

In September the armies of Mustafa Kemal (Ataturk) reached Smyrna (now Izmir) on the Aegean coast, and Turkey's independence was secured. (1) Turkish military police about to execute an old Turk for murdering Christians. (2) Thousands of local Greeks try to flee by sea, and half the town is burned down. (3) Ataturk, the 'Gazi' (warrior leader), reviews his troops in his remodelled army.

Atatürks neue Türkei

Im September erreichten Mustafa Kemal Atatürks Truppen Smyrna (das heutige Izmir) an der ägäischen Küste und sicherten die Unabhängigkeit der Türkei. (1) Türkische Militärpolizei kurz vor der Exekution eines alten türkischen Mannes, der des Mordes an Christen für schuldig befunden wurde. (2) Tausende von ortsansässigen Griechen versuchen, über das Meer zu fliehen; die Hälfte der Stadt ist bereits niedergebrannt. (3) Atatürk, der »Gazi« (Kriegsführer), bei der Abnahme seiner neugebildeten Truppen.

La nouvelle Turquie d'Atatürk

En septembre, les armées de Mustafa Kemal (Atatürk) atteignent Smyrne (aujourd'hui Izmir) sur la côte de la mer Egée, établissant l'indépendance de la Turquie. (1) La police militaire turque sur le point d'exécuter un vieux Turc qui a assassiné des Chrétiens. (2) Des milliers de Grecs de la région tentent de fuir par la mer et la moitié de la ville est brûlée. (3) Atatürk, dit le « Gazi » (chef de guerre) passe en revue les troupes de son armée réorganisée.

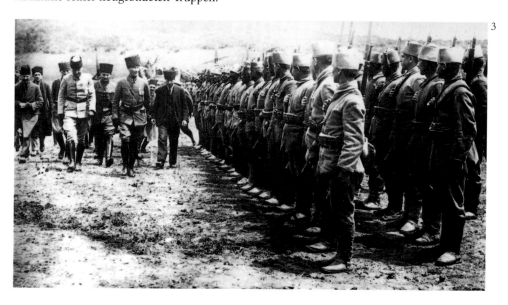

1

2

138 *The Restless Peace*

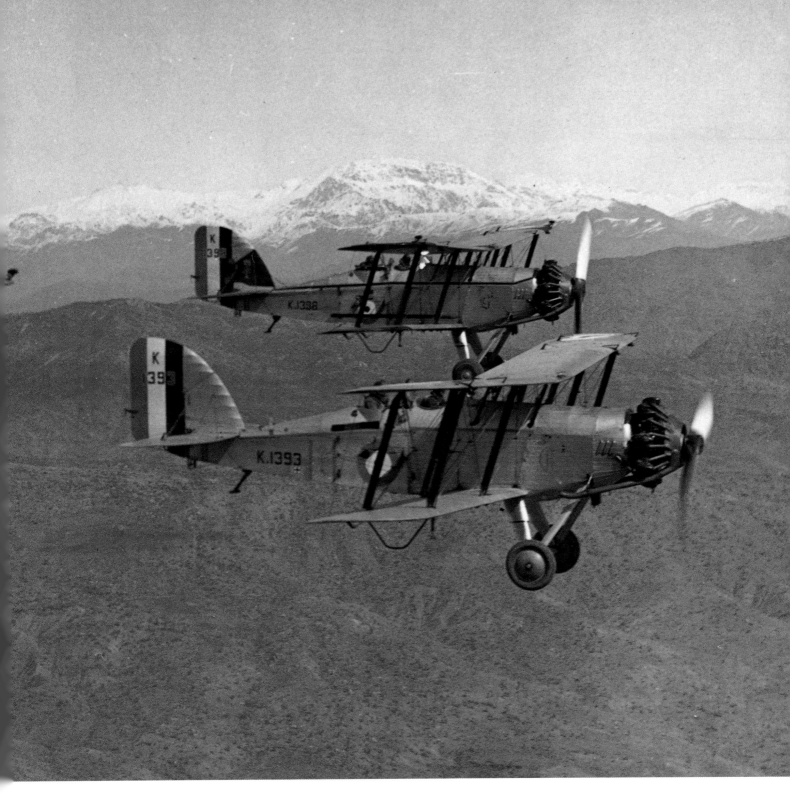

Air Power and Empire
The Royal Air Force was used extensively to guard the British Empire, which, with the addition of the mandates, was at its greatest extent between the World Wars. (1) A reconnaissance flight over the mountains of Kurdistan, northern Iraq. (2) Troops parading in front of a Vickers Vernon bomber for training in Egypt. Two squadrons of these bombers were based at Hinaidi in Iraq, and were used to suppress tribal rebellion.

Luftmächte und Großreiche
Die Royal Air Force trug erheblich zum Schutz des Britischen Empires bei, das – durch die Hinzufügung der Mandatsgebiete – zwischen den beiden Weltkriegen seine größte Ausdehnung erlebte. (1) Ein Erkundungsflug über Kurdistan, im Norden des Irak. (2) Truppenparade vor einem Vickers Vernon-Bomber, kurz vor dem Abflug nach Ägypten. Zwei dieser Bomberschwadronen waren in Hinaidi im Irak stationiert und wurden zur Unterdrückung von Volksaufständen eingesetzt.

La puissance aérienne et l'Empire
La Royal Air Force a pour mission principale de protéger l'Empire britannique qui, ayant à charge de nouveaux mandats, n'a jamais été aussi grand que pendant l'entre-deux-guerres. (1) Un vol de reconnaissance au dessus des montagnes du Kurdistan, au nord de l'Irak. (2) Revue des troupes devant un bombardier Vickers Vernon lors d'un entraînement en Egypte. Deux escadrilles de ces bombardiers sont basées à Hinaidi en Irak et sont utilisées pour réprimer les révoltes tribales.

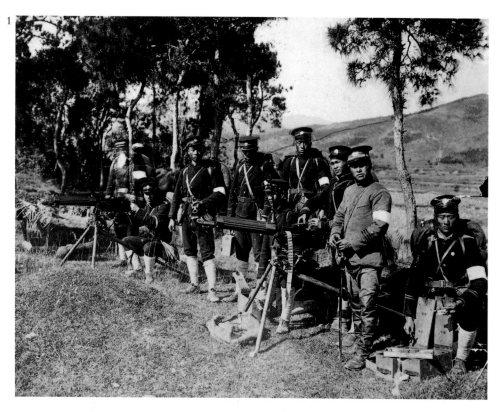

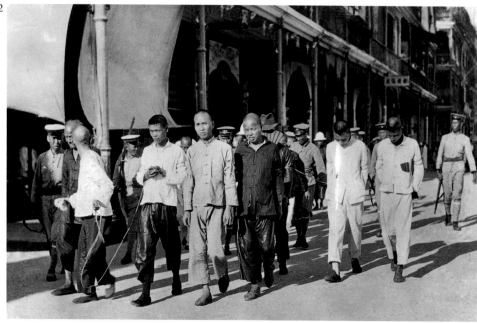

Chinese War Lords

Civil war raged in China in the 1920s and early 30s. (1) Armies led by Chiang Kai-Shek in Manchuria and General Woo in the southern provinces bolstered the government of Sun Yat-Sen, who died in 1925. Here the government soldiers train with modern machine guns. (2) Government troops round up bandit prisoners. (3) Sun Yat-Sen, China's president, visits the Ming tombs. (4) A squad of Marshal Sun's special shock troop units trains in Shanghai.

Chinesische Kriegsherren

Während der 20er und zu Beginn der 30er Jahre wurde China von Bürgerkriegen innerlich zerrissen. (1) Die von Tschiang Kai-schek geführten Truppen in der Mandschurei und General Wus Armee in den südlichen Provinzen stützten die Regierung Sun Yat-Sens, der 1925 starb. Hier trainieren die Regierungssoldaten mit modernen Maschinengewehren. (2) Regierungstruppen mit Gefangenen. (3) Sun Yat-Sen, Chinas Präsident, besucht die Ming-Gräber. (4) Eine Gruppe von Marschall Suns Spezialeinheiten beim Übungsschießen in Schanghai.

Les seigneurs de la guerre chinoise

En Chine, la guerre civile fait rage pendant les années 20 jusqu'au début des années 30. (1) Les armées dirigées par Chiang Kai-Shek en Mandchourie et le général Woo dans les provinces du Sud soutiennent le gouvernement de Sun Yat-Sen qui meurt en 1925. Soldats gouvernementaux s'entraînant au maniement de la mitrailleuse. (2) Des troupes gouvernementales ont arrêté des bandits. (3) Sun Yat-Sen, président de la République chinoise, en visite sur les tombes Ming. (4) A Shanghai, entraînement d'un escadron des troupes de choc spéciales du maréchal Sun.

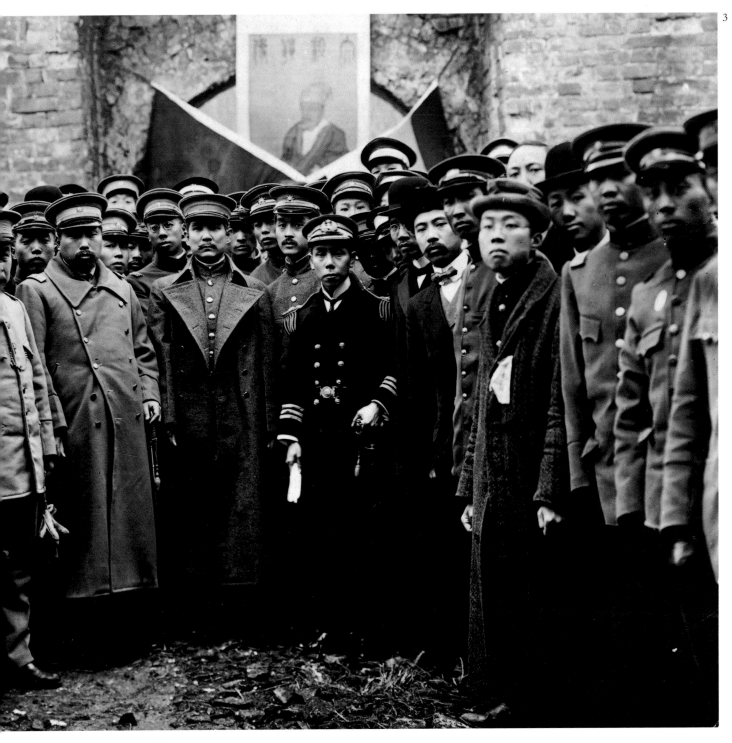

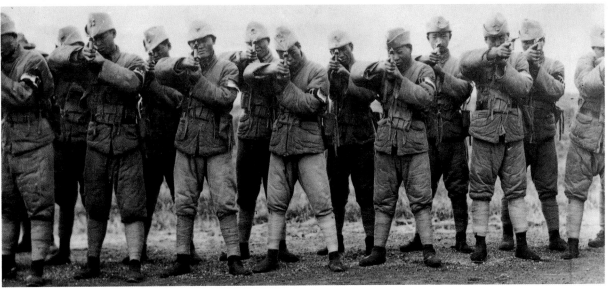

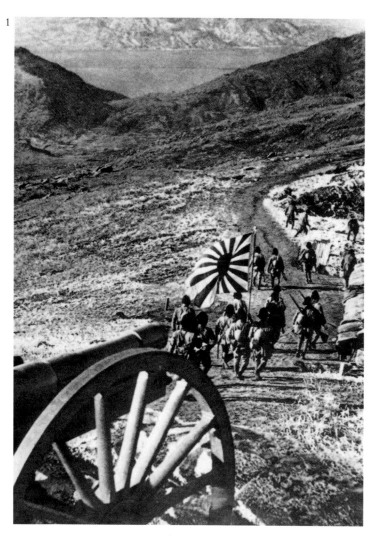

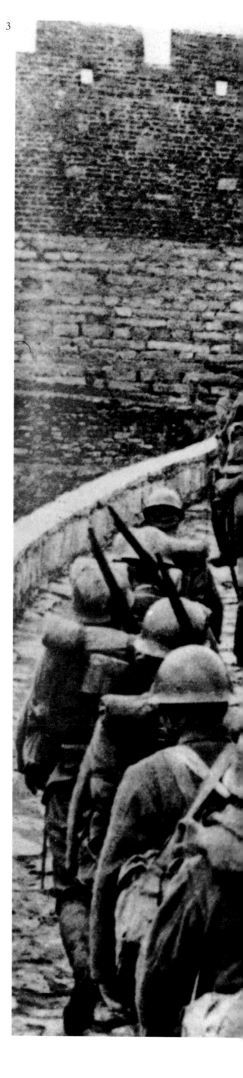

The Sino-Japanese War, 1

(1) The Japanese marched into Manchuria in 1931 after the so-called Mukden incident. The invasion was said to have been ordered by the Japanese command without sanction of the Imperial government. (2) The Japanese execute Chinese prisoners. The Japanese conduct was condemned by the League of Nations, but to no effect. (3) The seizure of Manchuria was to lead to all-out war in 1937.

Chinesisch-Japanischer Krieg, 1

(1) Die Japaner marschierten 1931 nach dem sogenannten Mukden-Zwischenfall in die Mandschurei ein. Die Invasion soll vom japanischen Oberkommando ohne Genehmigung der kaiserlichen Regierung befohlen worden sein. (2) Japanische Truppen bei der Exekution chinesischer Gefangener. Die japanische Führung wurde vom Völkerbund zwar schärfstens verurteilt, jedoch ohne Erfolg. (3) Der Einmarsch in die Mandschurei führte 1937 zu einem Krieg, der das ganze Land erfaßte.

La guerre sino-japonaise, 1

(1) 1931, les Japonais envahissent la Mandchourie suite au soi-disant incident de Mukden. L'invasion aurait été ordonnée par l'état-major japonais sans le consentement du gouvernement impérial. (2) Des Japonais exécutent des prisonniers chinois. L'attitude des Japonais est condamnée par la Société des Nations, en vain. (3) En 1937, la prise de la Mandchourie entraînera la guerre totale.

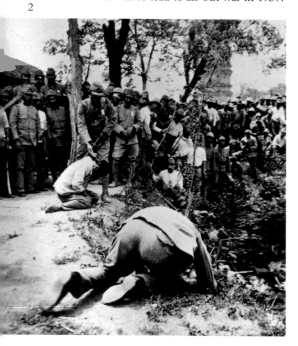

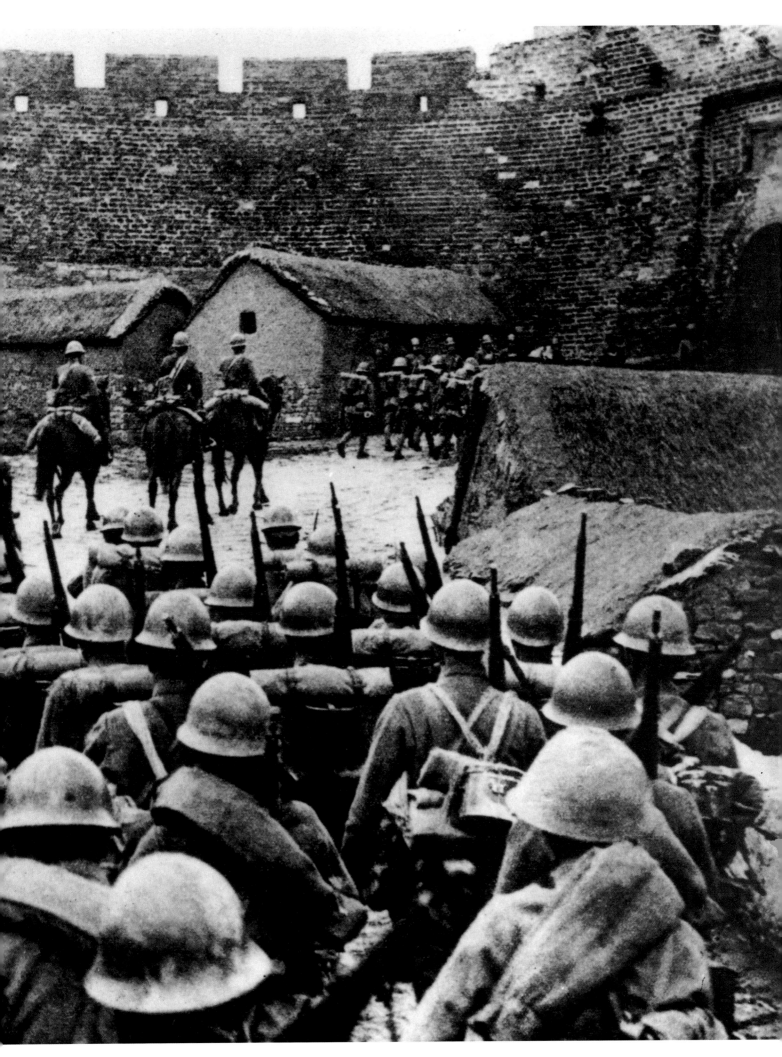

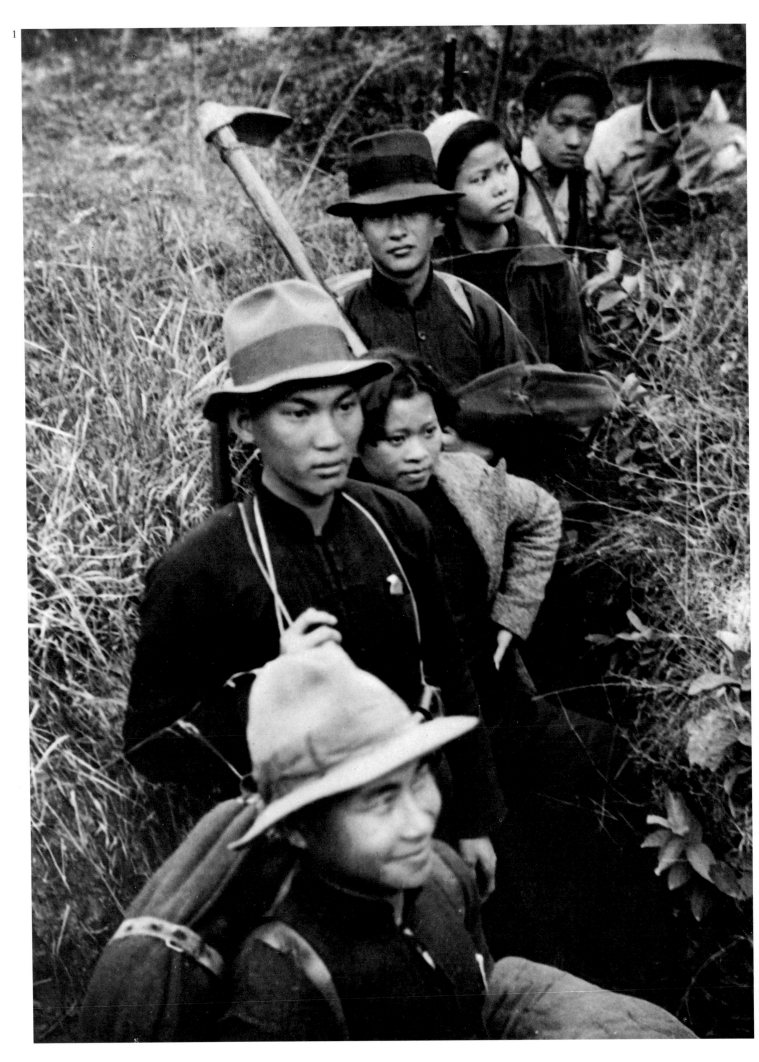

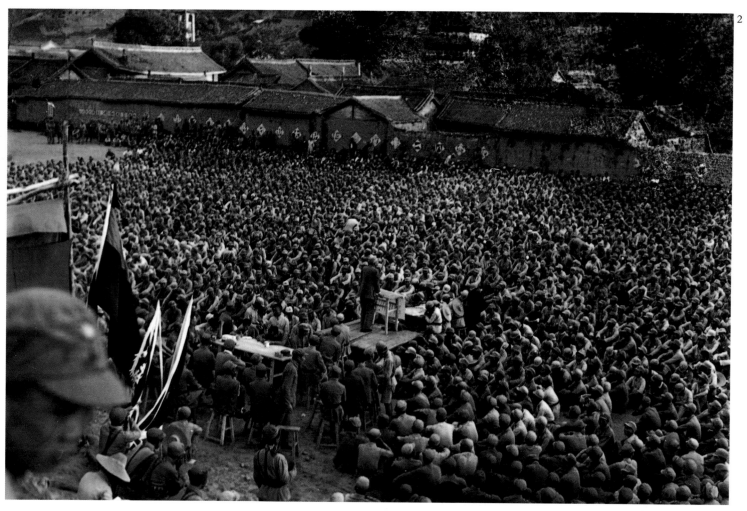

The Long March

In 1934, the Communist leader Mao Tse-Tung retreated with 100,000 of his followers from south to north China, a distance of 5000 miles. (1) Some of the 30,000 survivors in October 1935. (2) A Communist cadre leader addressing survivors. (3) Mao denouncing the Japanese, 1938.

Der lange Marsch

1934 zog der kommunistische Führer Mao Tse-tung mit 100 000 Anhängern von Süd- nach Nordchina, eine Strecke von 7500 Kilometern. (1) Einige der 30 000 Überlebenden im Oktober 1935. (2) Ein kommunistischer Kaderführer spricht zu Überlebenden. (3) Mao verurteilt die Japaner, 1938.

La Longue Marche

En 1934, Mao Tsê-Tung, chef des communistes, et 100 000 de ses hommes opèrent une retraite du sud au nord de la Chine, sur plus de 7000 kilomètres. (1) Octobre 1935, quelques-uns des 30 000 survivants. (2) Un des cadres du Parti communiste s'adresse aux survivants. (3) 1938, Mao s'en prend aux Japonais.

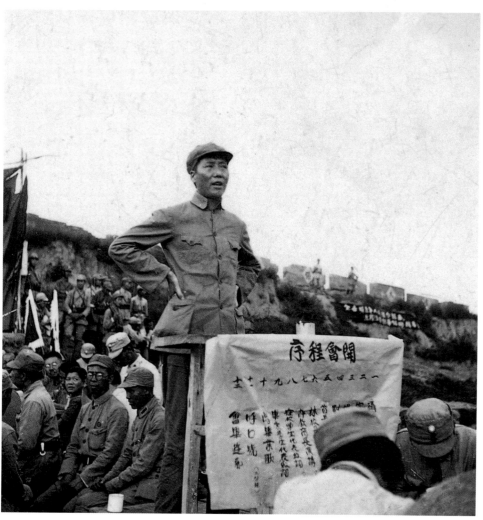

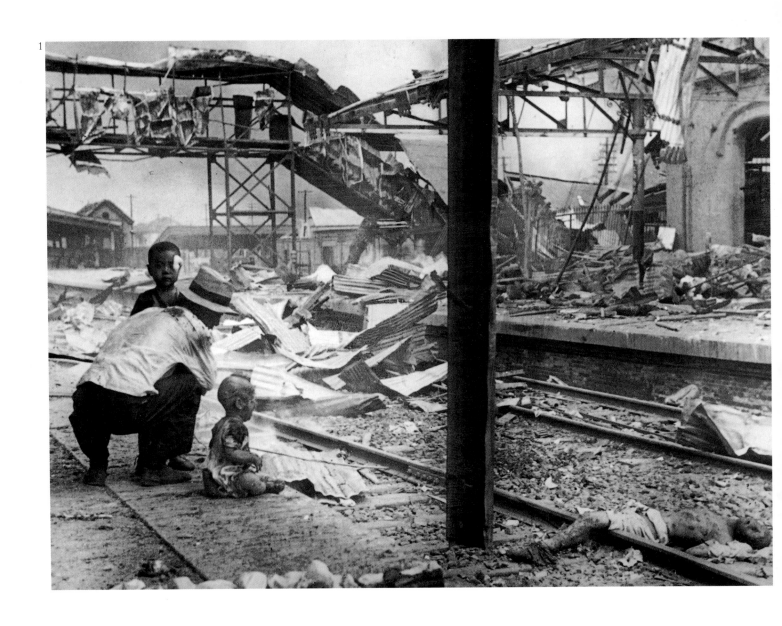

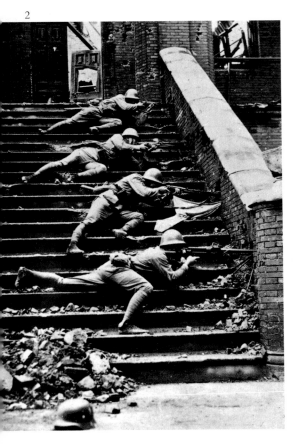

The Sino-Japanese War, 2

The Japanese mounted a ferocious assault on Shanghai and Nanking in 1937, with air and ground attacks. (1) The scene at Shanghai railway station after a bombardment in November 1937. (2) The Chinese put up strong resistance in Chapei, Shanghai. Here the Japanese infantry have broken holes in the wall to shoot at Chinese positions. (3) Japanese soldiers clearing the streets of Chapei of all signs of life after an artillery barrage.

Chinesisch-Japanischer Krieg, 2

Mit Luft- und Bodenangriffen begannen die Japaner 1937 einen wütenden Vorstoß auf Schanghai und Nanking. (1) Der Bahnhof von Schanghai nach einem Bombenangriff im November 1937. (2) Die Chinesen leisteten in Tschapei und Schanghai heftigen Widerstand. Auf diesem Foto hat die japanische Infanterie Löcher in eine Mauer gebrochen und schießt auf chinesische Stellungen. (3) Nach einem Artillerieangriff durchsuchen japanische Soldaten die Straßen von Tschapei nach Lebenszeichen.

La guerre sino-japonaise, 2

1937, les Japonais lancent une terrible offensive sur Shanghai et Nankin, avec des attaques aériennes et au sol. (1) Scène à la gare de Shangai après un bombardement en novembre 1937. (2) A Chapei et Shanghai, les Chinois opposent une résistance farouche. Des soldats de l'infanterie japonaise ont fait des trous dans le mur pour tirer sur les positions chinoises. (3) Après un tir barrage de l'artillerie, des soldats japonais font feu sur tout ce qui bouge dans les rues de Chapei.

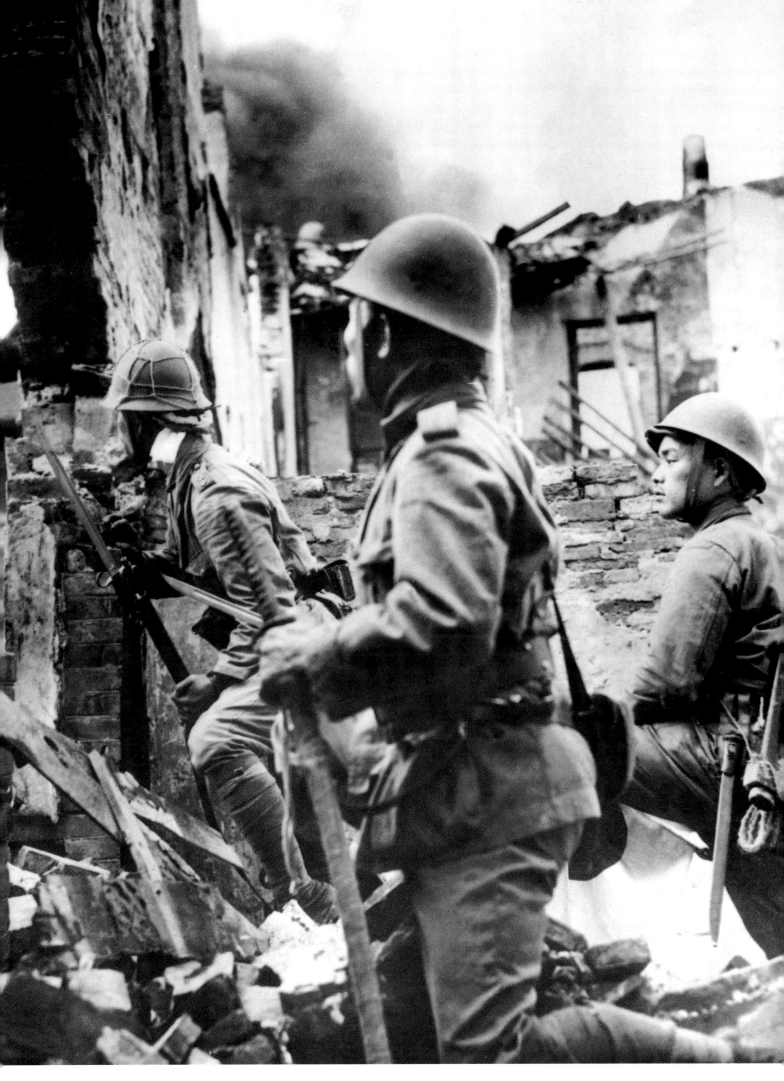

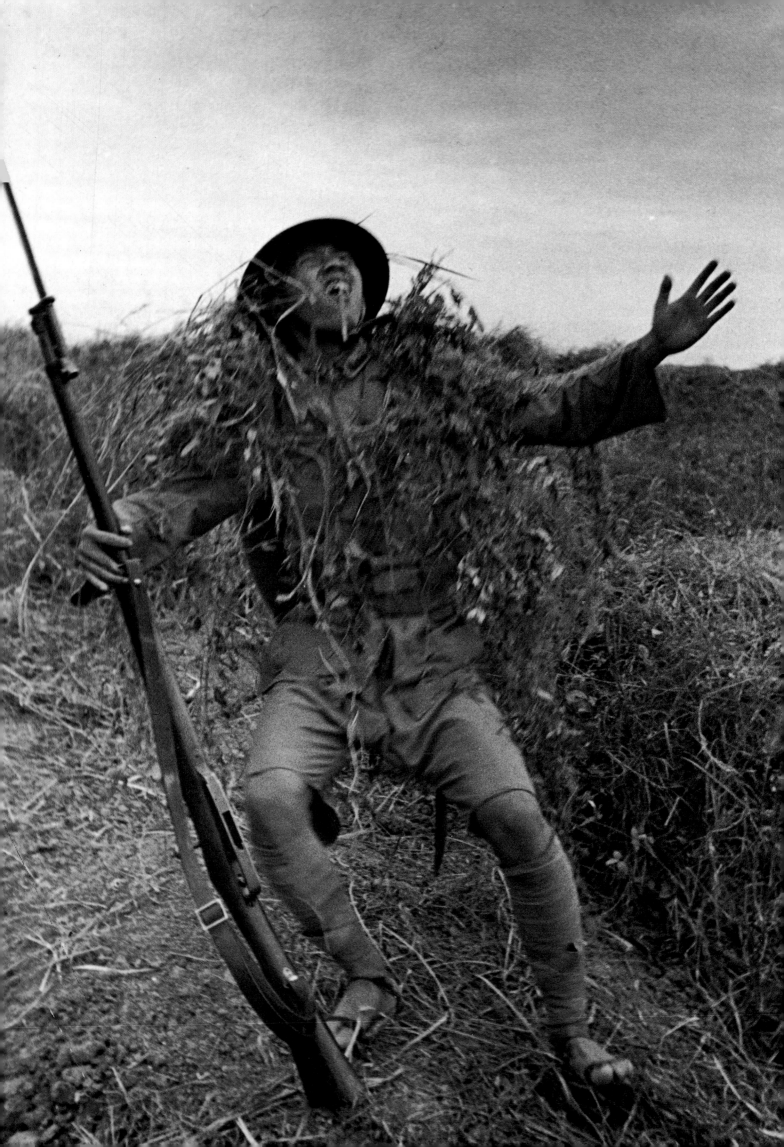

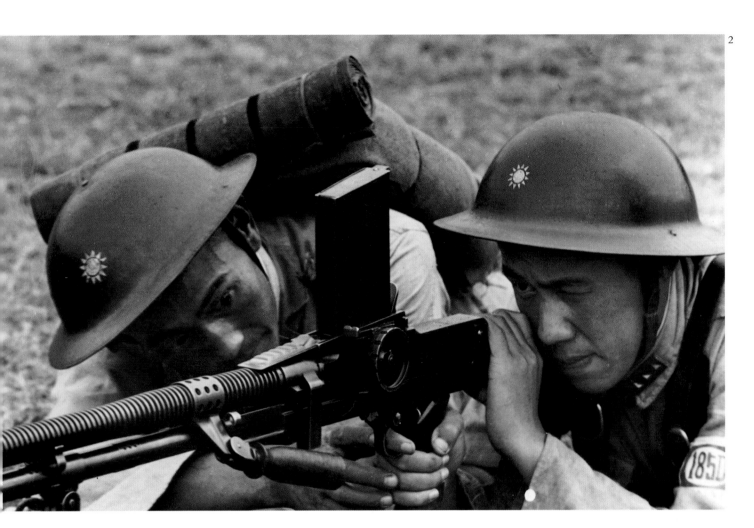

The Sino-Japanese War, 3

The armies of Chiang Kai-Shek learnt new guerrilla tactics from their former foes of the Communist cadres, who would fight them again after 1945. (1) A guerrilla, Private Chu Wen-hai, is wounded in action during skirmishing in 1939. (2) The Chinese guerrillas were trained on new light machine guns, which could be carried easily on foot across rough terrain. (3) Newly trained Chinese forces march to replace a division at the front, 1939.

Chinesisch-Japanischer Krieg, 3

Tschiang Kai-scheks Truppen lernten neue Guerrillataktiken von ihren ehemaligen Feinden, den kommunistischen Kadern, die sie nach 1945 wieder bekämpfen sollten. (1) Ein Guerrillakämpfer, Soldat Tschu Wen-hai, wird während eines Vorpostengefechts 1939 getroffen. (2) Die chinesischen Guerrillakämpfer wurden an neuen, leichten Maschinengewehren ausgebildet, die sich problemlos zu Fuß über unwegsames Gelände transportieren ließen. (3) Frisch ausgebildete chinesische Streitkräfte auf dem Marsch zu einer anderen Division, die sie an der Front ersetzen sollen, 1939.

La guerre sino-japonaise, 3

Les armées de Chiang Kai-Shek ont repris les nouvelles tactiques de leurs anciens ennemis, les cadres du Parti communiste, qu'ils combattront à nouveau en 1945. (1) Un franc-tireur, le soldat Chu Wen-hai, est blessé durant un accrochage en 1939. (2) Les francs-tireurs chinois apprennent à se servir de nouvelles mitrailleuses légères, facilement transportables à pied sur un terrain difficile. (3) En 1939, des forces armées chinoises nouvellement entraînées partent relever une division sur le front.

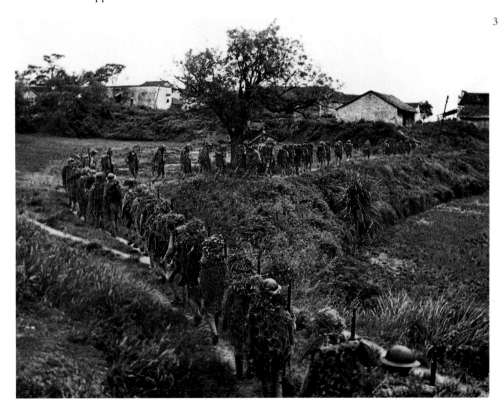

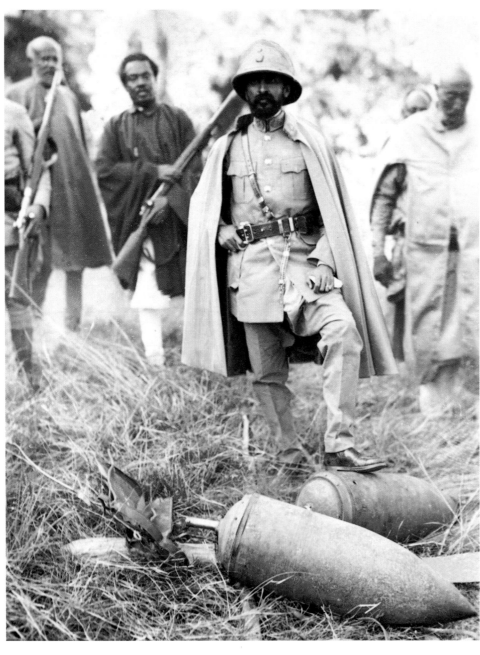

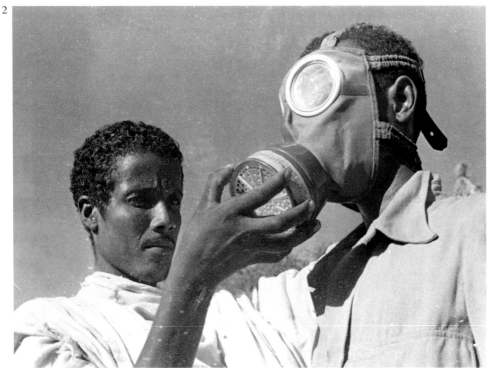

War in Abyssinia, 1

(1) The young Emperor Haile Selassie visits the battle front at Dessye, after it has been bombed by Italian aircraft. He puts one foot on an unexploded bomb. (2) It later transpired that the Italians used gas on a wider scale than had been thought. Here a gas mask is fitted – it took weeks to send these masks to the front, carried by camel caravan from the capital. (3) The arrival of Lessona Cobolli Gigli in Italian-occupied Addis Ababa. The banner proclaims 'To whom does the empire belong? Duce! Duce! To ourselves!'

Der Krieg in Abessinien, 1

(1) Der junge Kaiser Haile Selassie besucht die Front bei Dessye nach einer Bombardierung durch die italienische Luftwaffe. Das Foto zeigt ihn mit einem Fuß auf einem Blindgänger. (2) Später stellte sich heraus, daß die Italiener in großem Umfang Gas eingesetzt hatten. Auf dem Foto wird gerade eine Gasmaske angepaßt – es dauerte Wochen, bis die Masken mit Hilfe von Kamelkaravanen von der Hauptstadt an die Front gelangten. (3) Die Ankunft Lessona Cobolli Giglis im italienisch besetzten Addis Abeba. Die Inschrift des Spruchbandes lautet: »Wem gehört das Kaiserreich? Duce! Duce! Uns!«

La guerre en Abyssinie, 1

(1) Le jeune empereur Hailé Sélassié se rend sur le front à Dessye, bombardé par l'aviation italienne. Il pose un pied sur une bombe qui n'a pas explosé. (2) Il s'avèrera plus tard que les Italiens ont fait un emploi de gaz asphyxiants plus grand qu'on l'avait imaginé. Ajustement d'un masque à gaz. Il faut des semaines pour acheminer les masques, par chameaux, de la capitale au front. (3) Arrivée de Lessona Cobolli Gigli à Addis-Abeba, sous occupation italienne. La bannière proclame «A qui appartient l'empire? Duce! Duce! A nous!».

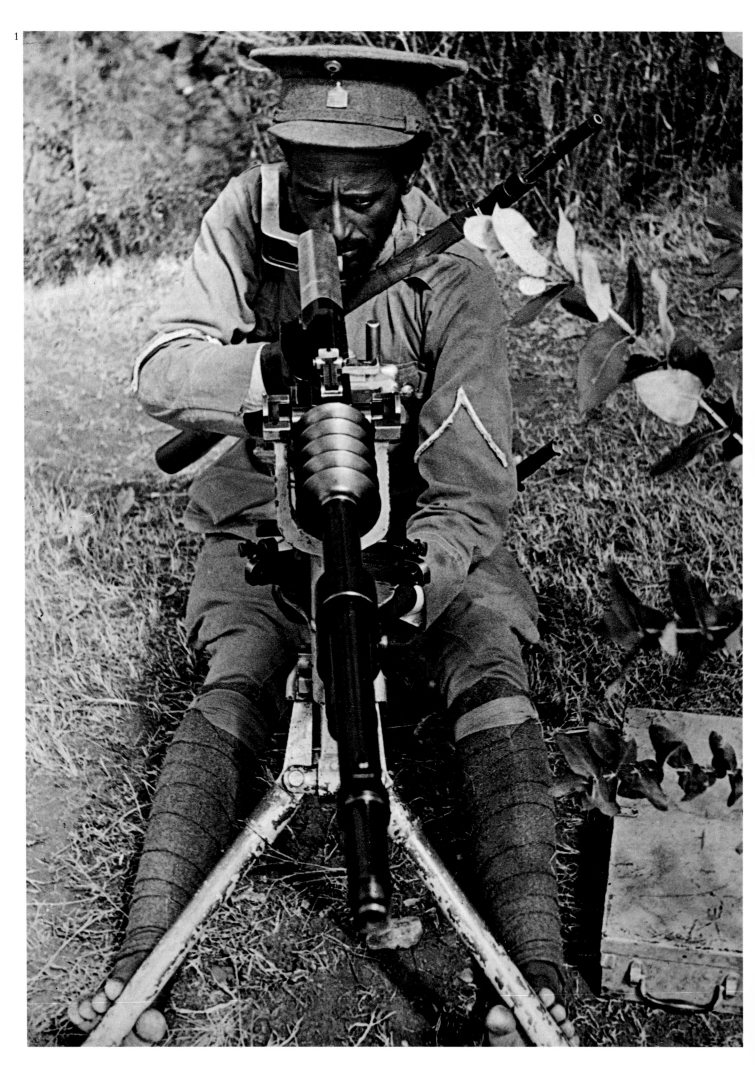

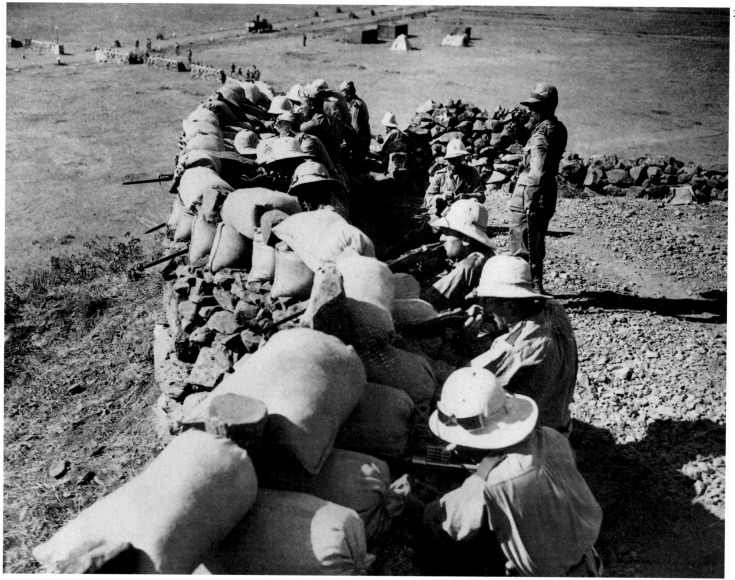

War in Abyssinia, 2

The Abyssinian forces did have a few modern weapons. (1) Here a government soldier trains on a heavy machine gun in manoeuvres round Addis Ababa. (2) The Italians prepare stone and sandbag fortifications before their attack on Makale in the north, November 1935. (3) A group of Haile Selassie's officers, with traditional dress and weapons, being given orders, March 1936.

Der Krieg in Abessinien, 2

Die abessinischen Streitkräfte besaßen nur wenige moderne Waffen. (1) Hier ein Regierungssoldat mit einem schweren Maschinengewehr bei Truppenübungen rund um Addis Abeba. (2) Italienische Soldaten bei der Errichtung von Stein- und Sandsackwällen vor dem Angriff auf Makale im Norden des Landes, November 1935. (3) Eine Gruppe von Haile Selassies Offizieren in traditioneller Kleidung und Ausrüstung erhält ihre Marschbefehle, März 1936.

La guerre en Abyssinie, 2

Les forces armées d'Abyssinie possèdent quelques armes modernes. (1) Un soldat du gouvernement apprend à se servir d'une mitrailleuse lourde lors de manœuvres autour d'Addis-Abeba. (2) Novembre 1935, les Italiens ont construit des fortifications avec des pierres et des sacs de sable avant d'attaquer Makale au nord du pays. (3) Mars 1936, des officiers de Hailé Sélassié, en habits et armes traditionnels, réunis pour recevoir des ordres.

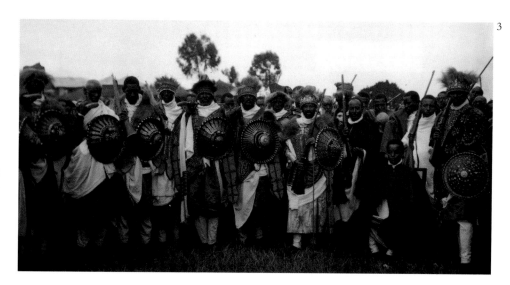

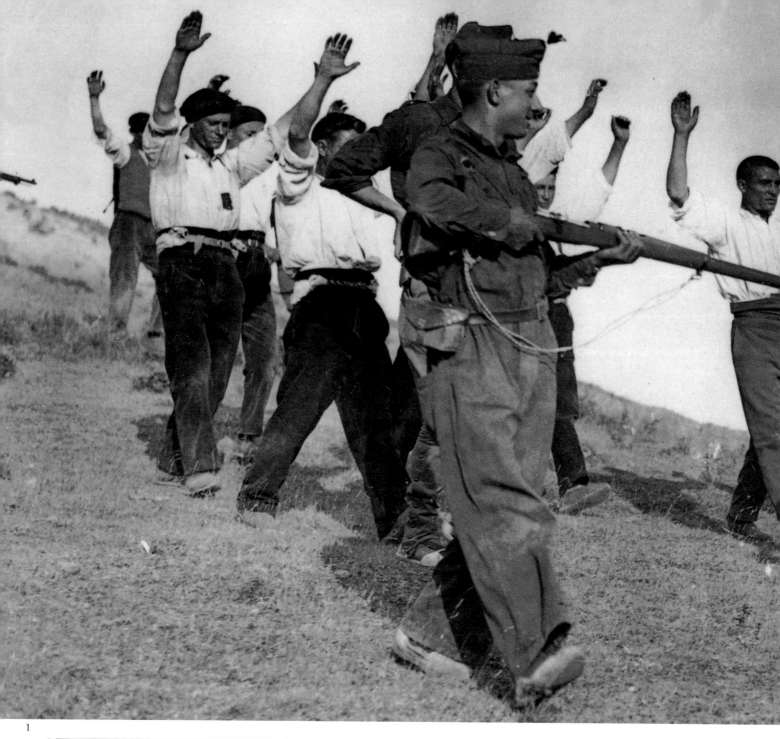

The Spanish Civil War, 1

More than a million people are said to have been killed in the Spanish war (1936-39). (1) Republicans surrender to nationalist troops on the Samosierra front. (2) Franco's well-equipped nationalist troops advance, bayonets fixed, through the debris of houses hit by air raids in Madrid, April 1937.
(3) Two months earlier, Republican government forces (in casual civilian dress) set an ambush in a village near Madrid. (Overleaf) Government and irregular loyal troops in Barcelona, August 1936, await the order to move to the Saragossa front.

Der spanische Bürgerkrieg, 1

Mehr als eine Million Menschen sollen im spanischen Bürgerkrieg (1936-39) ums Leben gekommen sein. (1) Republikaner ergeben sich den nationalistischen Truppen an der Samosierra-Front. (2) Francos gutausgerüstete nationalistische Truppen rücken nach einem Luftangriff mit aufgepflanztem Bajonett durch die Trümmer eines Hauses vor,

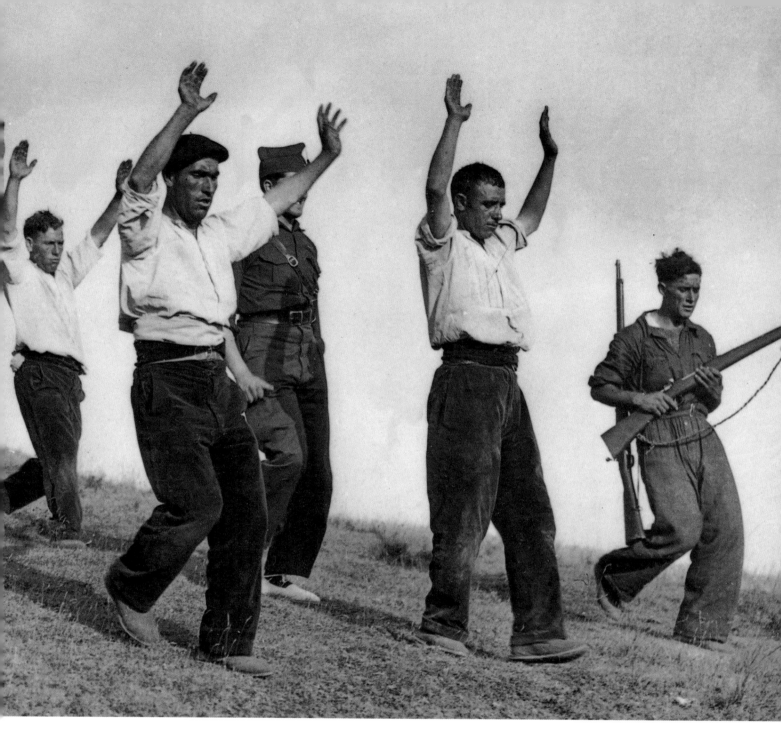

Madrid, April 1937. (3) Drei Monate zuvor legten republikanische Regierungstruppen in Zivilkleidung einen Hinterhalt in einem Dorf bei Madrid. (Folgende Doppelseite) Truppen der Regierung und der irregulären internationalen Brigade erwarten in Barcelona den Befehl zum Abrücken an die Saragossa-Front, August 1936.

La guerre civile espagnole, 1

On estime à plus d'un million le nombre de personnes tuées durant la guerre civile (1936-39). (1) Des Républicains se rendent aux troupes nationalistes sur le front de Samosierra. (2) Avril 1937 à Madrid, des soldats nationalistes de Franco, armés de baïonnettes, avancent parmi les ruines de maisons détruites par des raids aériens. (3) Deux mois plus tôt, des soldats républicains (en habits civils) préparent une embuscade dans un village près de Madrid. (Page suivante) A Barcelone, en août 1936, des soldats républicains et des volontaires attendent l'ordre de partir sur le front de Saragosse.

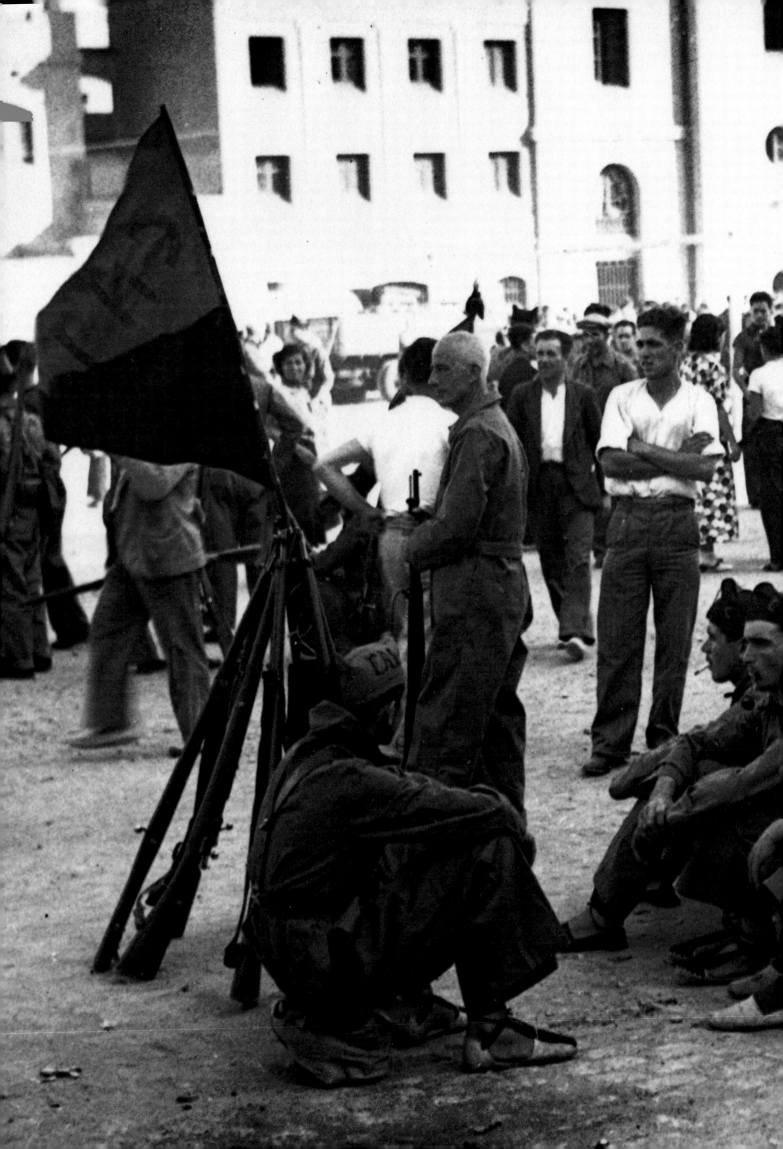

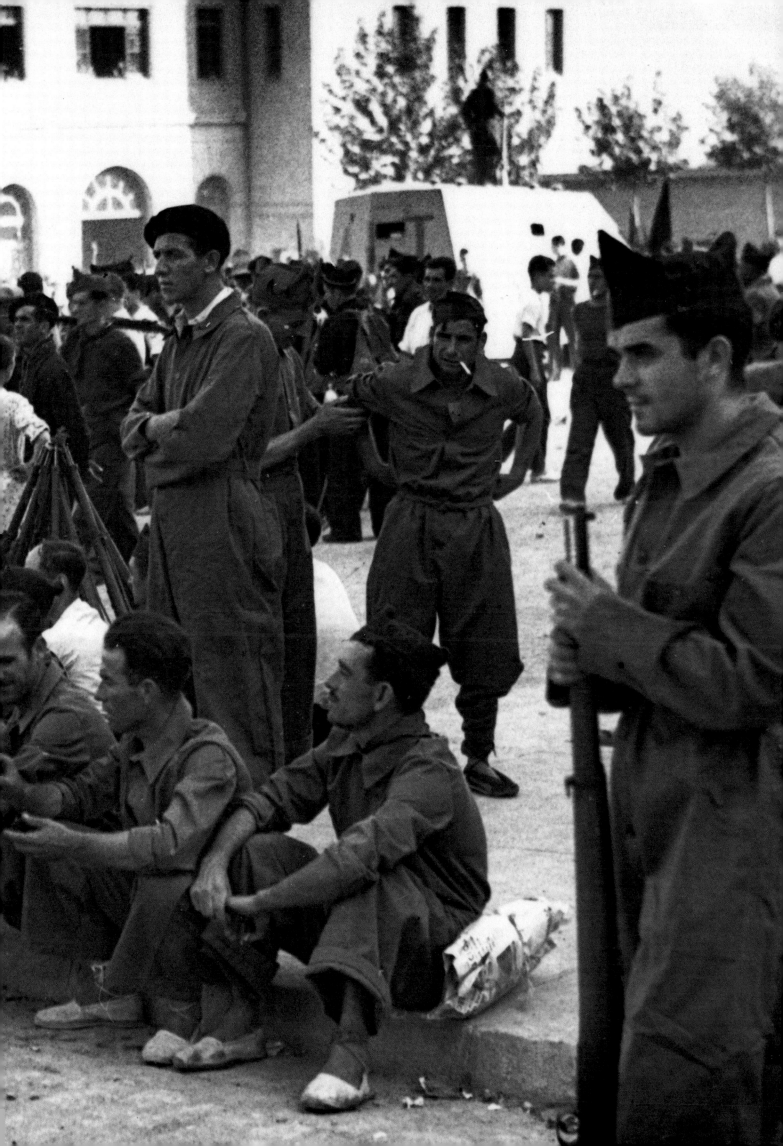

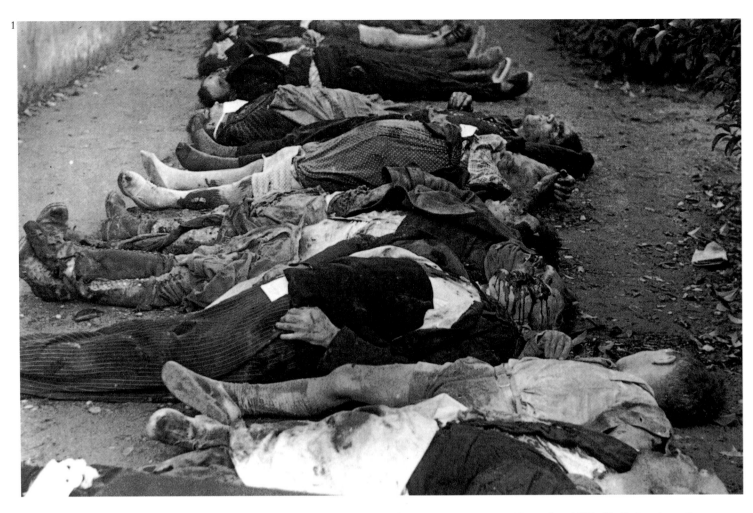

The Spanish Civil War, 2
Civilian victims. (1) Bodies of children awaiting burial after a nationalist air raid on their school in Barcelona, November 1937. The bodies of many of the victims in this war have never been found. (2) Victims of a sudden air raid. (3) By April 1939 Franco had secured his hold on Madrid, and many of the city's inhabitants, such as this woman, returned to find their homes pulverized by the last artillery and air attacks.

Der spanische Bürgerkrieg, 2
Zivilopfer. (1) Die Leichname getöteter Kinder nach einem nationalistischen Luftangriff auf eine Schule in Barcelona, November 1937. (2) Opfer eines überraschenden Luftangriffs. (3) Im April 1939 war Franco in Madrid einmarschiert, und viele Bewohner der Stadt, wie diese Frau, kehrten zu ihren Häusern zurück, die nach den letzten Luft- und Artillerieangriffen in Schutt und Asche lagen.

La guerre civile espagnole, 2
Victimes civiles. (1) Novembre 1937 à Barcelone, après un raid aérien de l'armée nationaliste sur une école, des corps d'enfants attendent d'être enterrés. Les corps d'un grand nombre de victimes de cette guerre ne seront jamais retrouvés. (2) Victime d'un raid aérien surprise. (3) Avril 1939, Franco est assuré de la prise de Madrid et beaucoup d'habitants, comme cette femme, reviennent et découvrent leurs maisons détruites après une dernière attaque d'artillerie et des raids aériens.

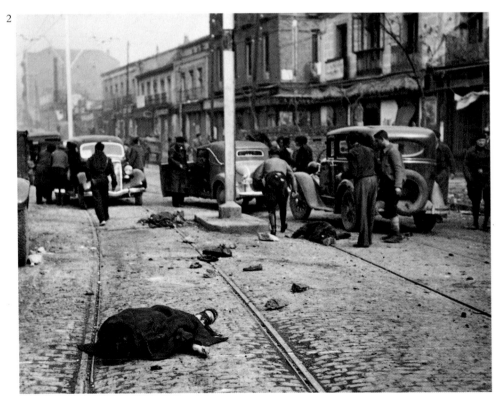

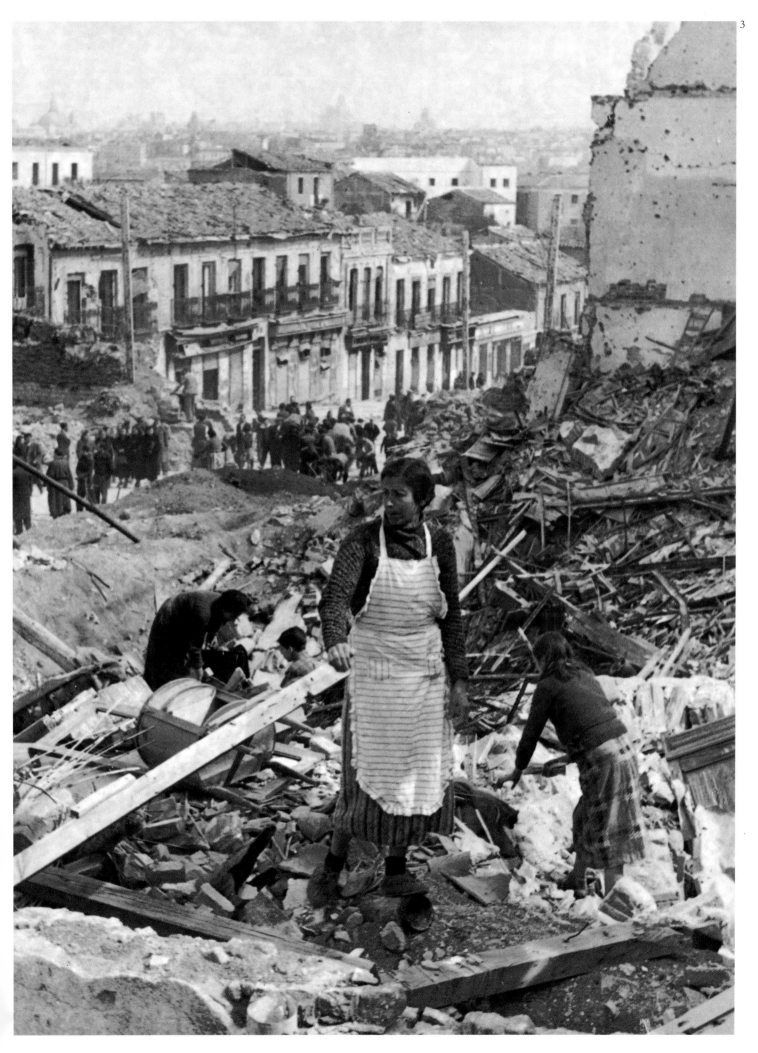

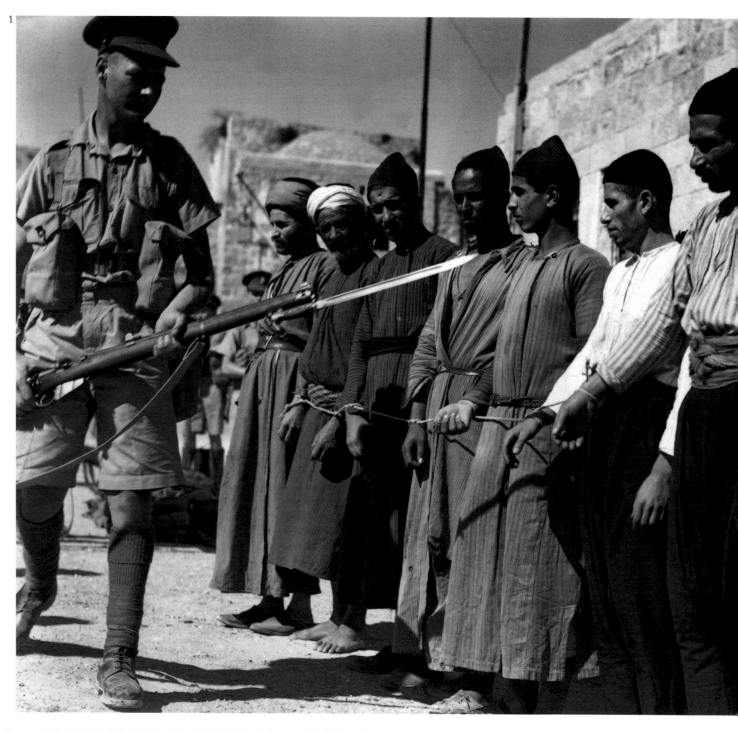

Unrest in Palestine

In the British mandate of Palestine Arab unrest twice burst into open revolt, requiring the services of 11 infantry battalions and a cavalry regiment to help keep order in 1938. (1) Arab prisoners rounded up in the Old City of Jerusalem, October 1938. (2) Arab guerrillas in 1940. (3) The beginnings of a full-scale riot at the Jaffa Gate, Jerusalem, 1933. (4) British forces blowing up the Arab village of Miar, near Haifa, as a punishment and warning to insurgents.

Unruhen in Palästina

Im britischen Mandat Palästina entwickelten sich aus Unruhen zweimal offene Aufstände. 1938 benötigte die britische Regierung elf Infantriebataillone und ein Kavallerieregiment, um Ruhe und Ordnung aufrecht-zuerhalten. (1) Arabische Gefangene werden in der Altstadt von Jerusalem zusammengetrieben, Oktober 1938. (2) Arabische Guerillas, 1940. (3) Der Beginn der

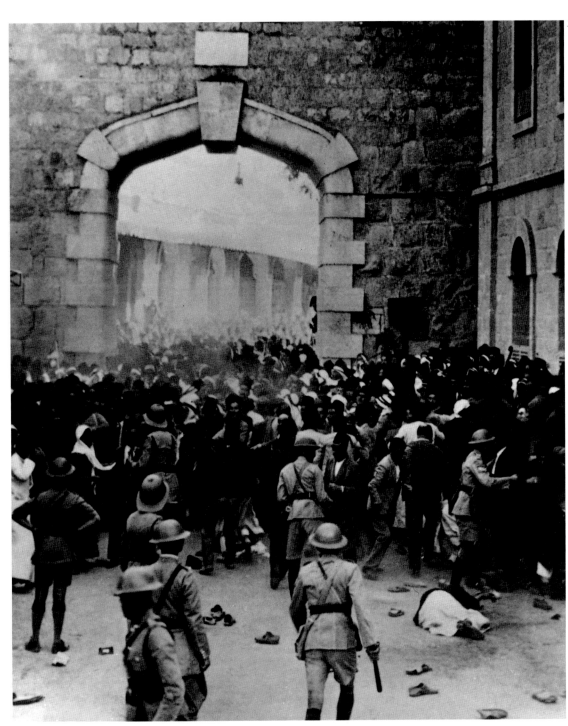

Aufstände am Jaffa-Tor, Jerusalem 1933. (4) Britische
Einheiten sprengen das arabische Dorf Miar bei Haifa –
als Strafe und Warnung an die Aufständischen.

Tensions en Palestine

1938, en Palestine arabe, sous mandat britannique, les
tensions à deux reprises éclatent en une révolte ouverte,
nécessitant l'intervention des bataillons de la 11ᵉ infanterie
et d'un régiment de cavalerie pour restaurer l'ordre.
(1) Octobre 1938, rassemblement de prisonniers arabes
dans la vieille ville de Jérusalem. (2) Des volontaires
arabes en 1940. (3) Le début des émeutes au portail Jaffa,
Jérusalem 1933. (4) L'armée britannique fait exploser
Miar, un village près de Haïfa, en guise de représailles et
d'avertissement aux insurgés.

Invaders' Welcome

Sudeten German children raise their arms in salute as Wehrmacht soldiers march across the border at Wald Haenst into Czechoslovakia, October 1938.

Begrüßung der Besatzer

Sudetendeutsche Kinder heben ihren Arm zum Hitlergruß, als die deutsche Wehrmacht bei Wald Haenst über die Grenze zur Tschechoslowakei marschiert, Oktober 1938.

L'accueil de bienvenue aux envahisseurs

Octobre 1938, des enfants allemands des Sudètes font le salut aux soldats de la Wehrmacht franchissant la frontière tchécoslovaque à Wald Haenst.

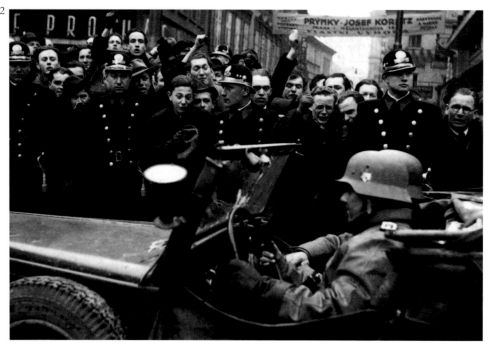

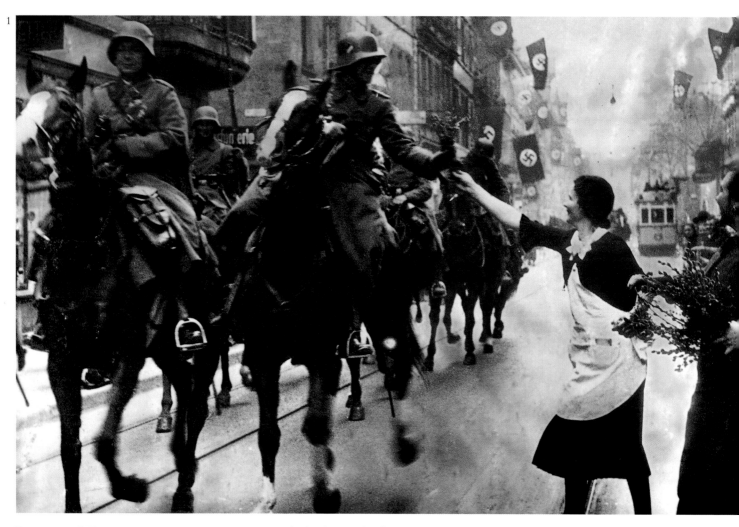

Rumours of War

(1) German cavalry being proffered flowers as they re-occupy the Rhineland in 1936. (2) In March 1939 Hitler's forces occupied Prague. Unlike their Sudeten German neighbours the Czechs are far less welcoming, and some in this crowd shake their fists at the troops. (3) In Austria, smiles all round from this group in Salzburg when the German troops arrive in the *Anschluss,* 13 March 1938.

(Overleaf) The people of Warsaw read Hitler's ultimatum the day before the Luftwaffe launches the first air raid on their city, August 1939.

Kriegslärm

(1) Deutsche Kavalleristen erhalten Blumen bei der Besetzung des Rheinlands 1936. (2) Im März 1939 besetzen Hitlers Armeen Prag. Im Gegensatz zu ihren sudetendeut-schen Nachbarn sind die Tschechen weit weniger begeistert; einige in der Gruppe schütteln den Soldaten ihre Fäuste entgegen. (3) Diese Gruppe freut sich, als die deutschen Truppen im Rahmen des »Anschlusses« in Salzburg einmarschieren, 13. März 1938. (Folgende Doppelseite) Die Bevölkerung von Warschau liest Hitlers Ultimatum, einen Tag, bevor die deutsche Luftwaffe ihre ersten Angriffe auf die Stadt fliegt. August 1939.

Rumeurs de guerre

(1) 1936, réoccupation de la Rhénanie : la cavalerie allemande est accueillie avec des fleurs. (2) Mars 1939, occupation de Prague par l'armée de Hitler. Contrairement à leurs voisins sudètes, d'origine allemande, les Tchèques se montrent bien moins accueillants. Dans la foule, des poings menaçants sont brandis contre les troupes. (3) 13 mars 1938, à Salzbourg en Autriche, un groupe de gens accueille avec de grands sourires l'entrée des troupes allemandes après l'*Anschluss.* (Page suivante) Août 1939, des habitants de Varsovie lisent l'ultimatum de Hitler à la veille du premier raid aérien de la Luftwaffe sur la ville.

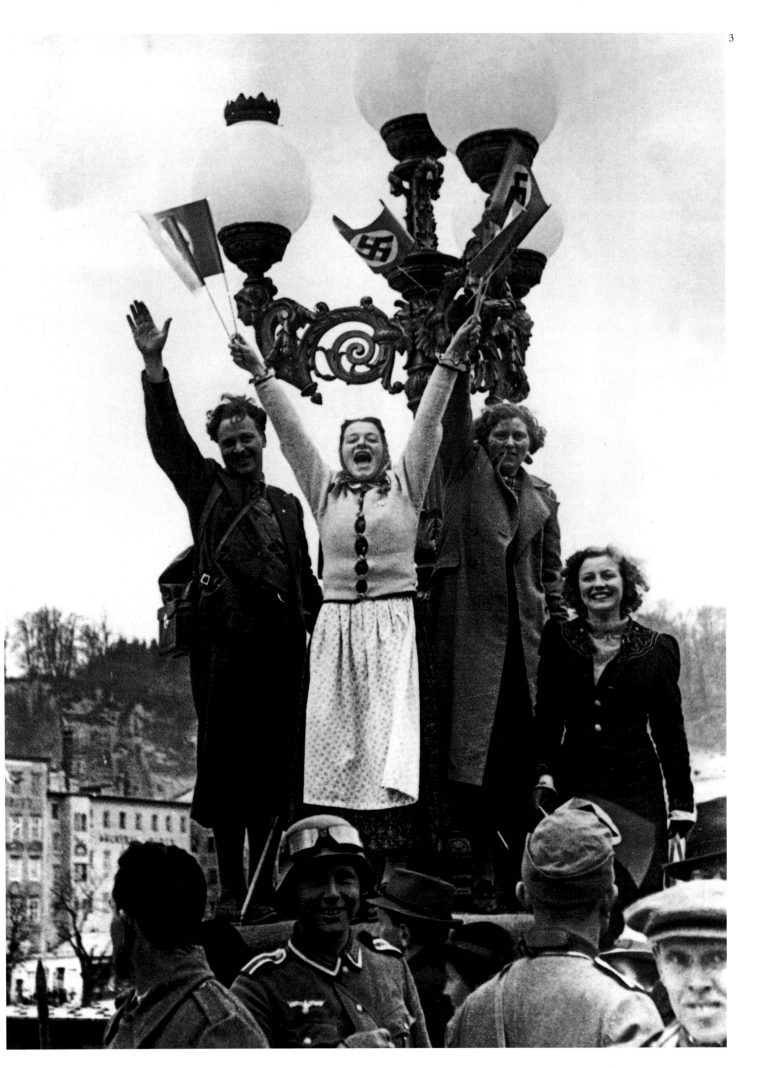

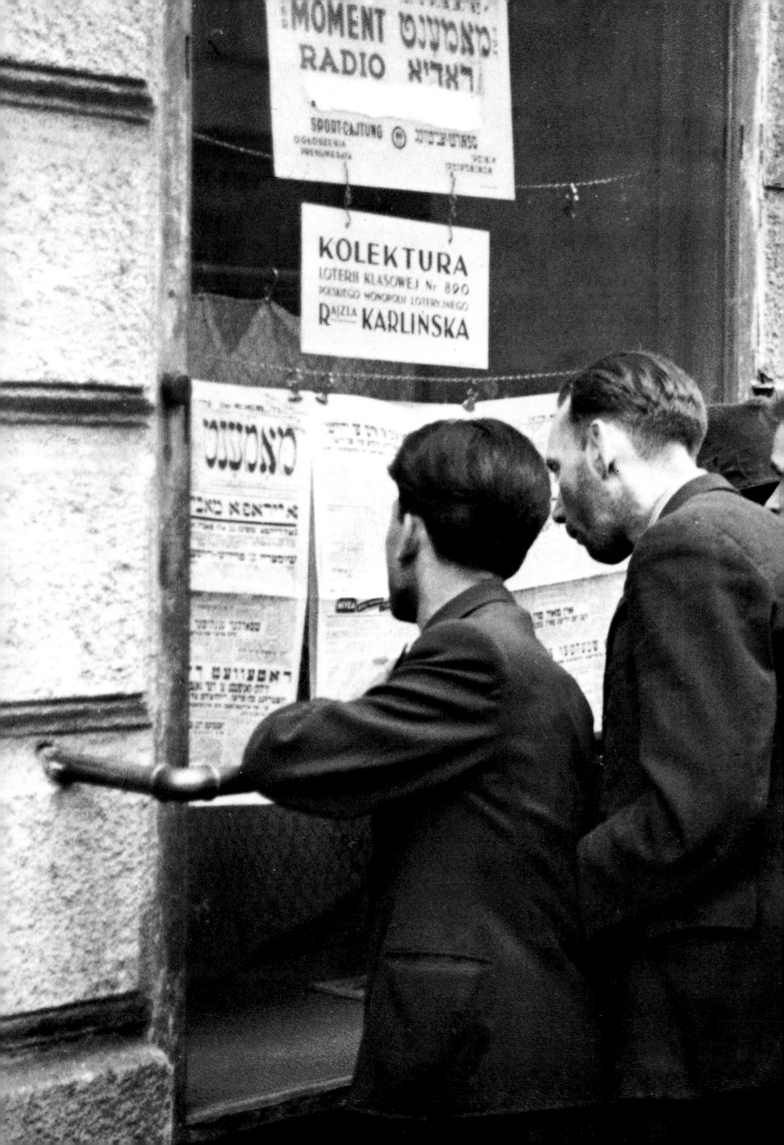

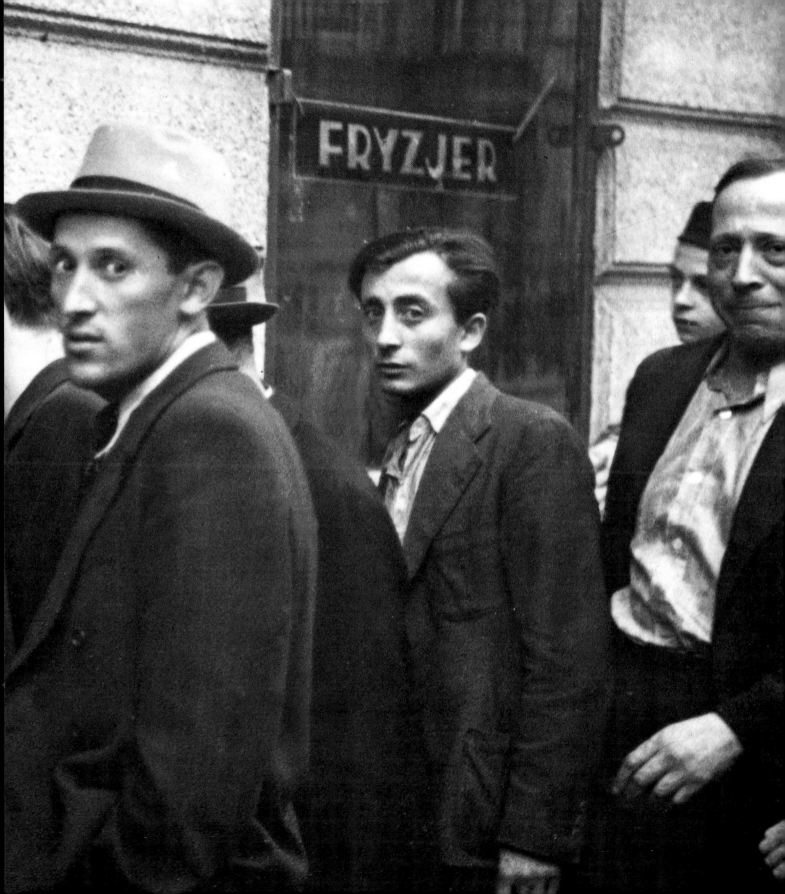

The Second World War was to be the largest global
conflict in history, affecting all continents and their
seas. More than 110 million men and women were
mobilized to fight, and some 55 million were killed.
Air forces developed a new and devastating power,
often striking against civilian targets. New weapons
such as flame-throwers, along with strafing from the
air, meant that the Germans could advance rapidly
through ill-defended towns and villages, and go
round or destroy strongly defended positions. Here
German troops advance through a village they have
torched in western France in May 1941.

Der Zweite Weltkrieg sollte der größte globale
Konflikt in der Geschichte werden; ein Krieg, der
alle Kontinente und Meere in Mitleidenschaft zog.
Mehr als 110 Millionen Männer und Frauen
nahmen an den Kämpfen teil, und etwa 55 Millionen
wurden getötet. Dabei entwickelten die Luftwaffen
neue und zerstörerische Kräfte, die sich mehr als
einmal gegen zivile Ziele richteten. Neue Waffen wie
Flammenwerfer, die in Kombination mit Luft-
angriffen eingesetzt wurden, ermöglichten es den
Deutschen, schnell durch schlecht verteidigte Städte
und Dörfer vorzustoßen und stark befestigte
Positionen zu umgehen oder sie zu zerstören. Das
Bild zeigt den Vormarsch deutscher Truppen durch
ein von ihnen in Brand gesetztes Dorf in West-
frankreich im Mai 1941.

La Deuxième Guerre mondiale, le plus grand conflit
de toute l'histoire, se déroulera sur les 5 continents et
toutes les mers. Plus de 110 millions d'hommes et de
femmes seront mobilisés et 55 millions seront tués.
L'aviation militaire, dotée d'une puissance nouvelle et
dévastatrice, sera souvent utilisée contre les civils.
Disposant de nouvelles armes comme les lance-
flammes et procédant à des bombardements aériens,
les Allemands peuvent traverser plus rapidement les
villes et villages mal défendus et encercler ou
détruire les positions plus résistantes. En mai 1941,
les troupes allemandes traversant un village de l'ouest
de la France après y avoir mis le feu.

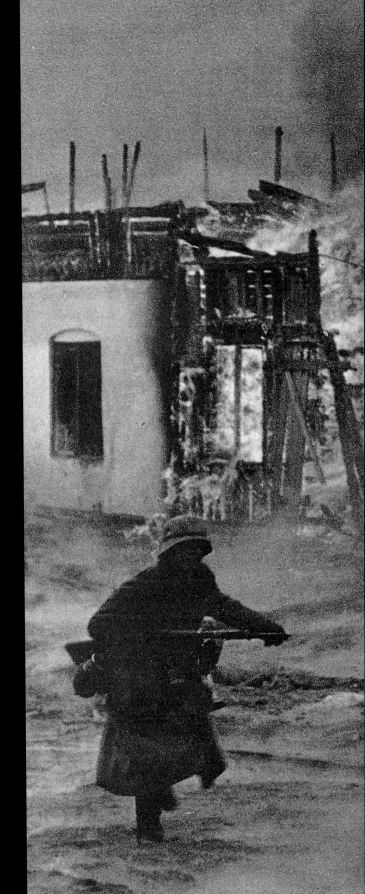

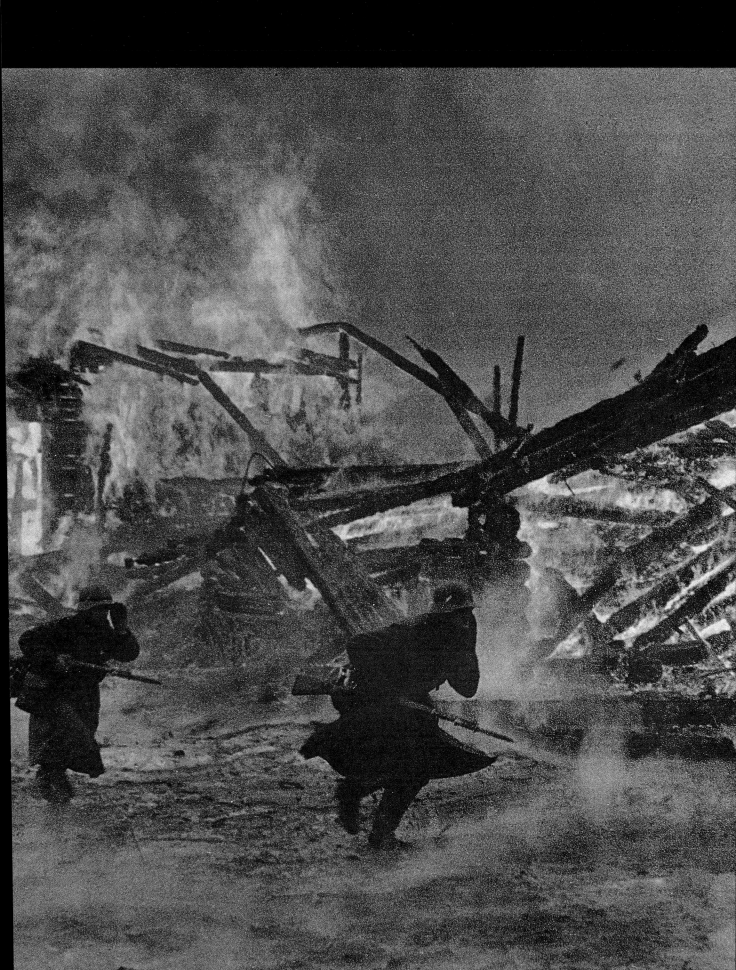

War in Europe

1939–45

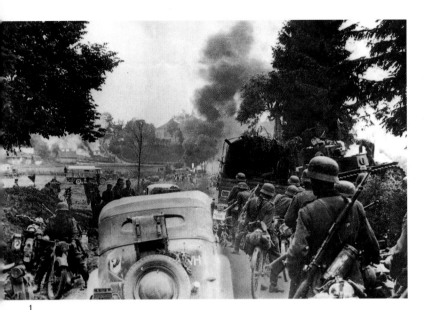

1

The long-anticipated war broke out in Europe on 1 September 1939 when Hitler's troops invaded Poland. The Poles had inadequate air and land forces against the six divisions of the Wehrmacht of about 1.4 million men. German tanks were opposed by troops on horseback, armed with lances and sabres: the invasion was to see the last cavalry charge in European warfare. Despite having their air force shot from the sky, the Poles put up stiff resistance, and Warsaw surrendered only on 29 September.

The attack on Poland brought Britain into the war. On 3 September Neville Chamberlain, the Prime Minister, declared in a broadcast, 'This country is now at war with Germany. We are ready.' For Britain it was to be the longest haul; she was the only major power to fight to the very finish, when the Japanese forces surrendered in August 1945. The effort was to drain the British and their Empire and Commonwealth of resources and treasure – and more than 452,000 military and 60,000 civilians dead. Germany was to lose 3,500,000 military dead and 3,800,000 civilians. France lost 250,000 soldiers and 360,000 civilians. After the war Britain, Germany and France would no longer be great military powers.

Within hours of war being declared on Germany, air-raid sirens sounded over London, setting the pattern for the war which was to involve civilians on a scale not seen before.

In the autumn of 1939 few could guess the shape of the forthcoming conflict. In Europe the battle lines were almost static – and the 'phoney war' would last six months. The French stood in their heavily fortified positions on the Maginot Line. Only the Finns fought a bitter winter campaign, which ended in defeat by the Russians in March 1940.

With the arrival of spring Hitler launched his offensive in western Europe, with the new tactic of *Blitzkrieg*. It was the opposite of the grinding static warfare of the Western Front in the First World War. By rapid thrusts and strikes by armoured infantry, tanks and artillery on the ground, and strafing and dive-bombing from the air, the attacking Germans broke and divided the opposing armies, who were impeded by the chaos of fleeing civilians.

On 9 April 1940, the German forces attacked Norway; on 10 May the Wehrmacht marched into Holland, Belgium, Luxembourg and France. On 4 June more than 330,000 British and allied troops were rescued by small boats from the beaches at Dunkirk. Ten days later German troops marched through the Arc de Triomphe, and for the second time in 70 years the German armed forces occupied and controlled Paris. On 18 June Fascist Italy entered the war, and four days later France surrendered.

By August Britain, too, faced invasion – from the air. The Battle of Britain was to run well into the winter, when the German Luftwaffe opted for night bombing raids. It gave rise to the legend of the Few, the fighter pilots of the RAF, and established Churchill, with his spellbinding oratory, as one of the most inspirational modern wartime leaders, and the saviour of his nation.

At sea the battle for survival was under way for Britain, with her allies, and the Axis powers of Germany and Italy. The Battle of the Atlantic, which brought warfare under the sea as well as on it across huge areas of ocean, was not to be decided until 1945. The use of airpower, fighters and bombers, the new manoeuvre warfare of tanks and the mechanised infantry of the *Blitzkrieg*, and submarines were to shape the destiny of the battle for Europe for nearly five years.

Almost every corner of Europe was to be encircled, attacked or occupied by the Axis Powers or their puppets. The struggle for liberation was to be a hard grind, not least because the Germans proved masters of the fighting withdrawal. The tide only turned with the entry of Russia into the war when Hitler invaded in 1941, and when America entered following the Japanese attack on Hawaii in December.

Though Italy sued for peace in September 1943, it would take the allies until April 1945 to liberate the peninsula, which was caught in its own domestic conflict between Fascist sympathisers and Communist-led partisans. In the Balkans, Yugoslavia was gripped by its own three-way civil conflict, which would re-ignite 50 years later.

The decisive push was in June 1944, when 850,000 American, British and Commonwealth forces landed in Normandy in Operation Overlord, the most complex amphibious assault in the history of arms. As late as January 1945 the Wehrmacht could still mount a massive counter-offensive which caught the allied armies off balance in the Ardennes. In the German cities civilians became the victims of allied strategic bombing, some raids involving hundreds of aircraft at a time. On 14 February 1945, more than 100,000 people, many of them refugees, perished in Dresden in a hurricane of fire set off by incendiary bombing. It was to take another two months for the Germans to surrender on their own soil, so ending the weary five-year war of Europe's liberation.

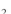

Am 1. September 1939, um 4.45 Uhr, brach mit dem Überfall auf Polen durch Hitlers Truppen der lange erwartete Krieg in Europa aus. Die Polen verfügten nur über unzureichende Luft- und Landstreitkräfte gegen die sechs Divisionen der Wehrmacht mit etwa 1,4 Millionen Mann. Deutschen Panzern standen Truppen zu Pferd gegenüber, die lediglich mit Lanzen und Säbeln ausgerüstet waren: Die Invasion erlebte den letzten Kavallerieeinsatz in der europäischen Kriegsgeschichte. Obwohl ihre Luftwaffe schnell außer Gefecht gesetzt wurde, leisteten die Polen erbitterten Widerstand; Warschau ergab sich erst am 29. September.

Der Überfall auf Polen verwickelte auch Großbritannien in den Krieg. Am 3. September erklärte Premierminister Neville Chamberlain in einer Radioansprache: »Unser Land befindet sich im Krieg mit Deutschland. Wir sind bereit.« Für Großbritannien sollte dieser Krieg am längsten dauern, denn das Land war die einzige Großmacht, die bis zum letzten Augenblick des Zweiten Weltkriegs, der Kapitulation der japanischen Streitkräfte im August 1945, kämpfen mußte. Die Kriegsanstrengungen sollten die Ressourcen und Reserven der Briten, des Empires und des Commonwealth erschöpfen – und mehr als 452 000 militärische und 60 000 zivile Todesopfer fordern. Deutschland verlor 3 500 000 Angehörige der Streitkräfte und 3 800 000 Zivilisten, Frankreich 250 000

(1) Wehrmacht motorised infantry, with motorbikes and tracked carriers, move into the Ukraine in the invasion of Russia in June 1941. They will be followed by the extermination squads of the SS. (2) Jews from the Warsaw ghetto surrender after their ill-fated uprising in April 1943. About 300,000 Jews were crammed into the ghetto; three years later only about 60,000 had survived.

(1) Motorisierte Infanterie der Wehrmacht mit Motorrädern und Kettenfahrzeugen dringt während der Invasion Rußlands im Juni 1941 in die Ukraine ein. Ihnen werden die Todesschwadronen der SS folgen. (2) Juden aus dem Warschauer Ghetto ergeben sich nach dem mißglückten Aufstand im April 1943. Etwa 300 000 Juden waren im Ghetto zusammengedrängt, von denen nur 60 000 die nächsten drei Jahre überlebten.

(1) Juin 1941, l'infanterie motorisée de la Wehrmacht, équipée de motocycles et de transporteurs, pénètrent en Ukraine lors de l'invasion de la Russie. Ils seront suivis des commandos d'extermination SS. (2) Des Juifs du ghetto de Varsovie se rendent après le soulèvement tragique d'avril 1943. Plus de 300 000 Juifs vivaient entassés dans le ghetto. Trois ans plus tard, seuls 60 000 auront survécu.

Soldaten und 360 000 Zivilisten. Nach dem Krieg würden Großbritannien, Deutschland und Frankreich als militärische Großmächte keine Rolle mehr spielen.

Innerhalb weniger Stunden nach der Kriegserklärung heulten die Luftschutzsirenen über London. Sie sollten zum Symbol für den Charakter dieses Krieges werden, der Zivilisten in bislang ungekanntem Ausmaß betraf.

Im Herbst 1939 konnten nur wenige das Ausmaß des sich entwickelnden Konfliktes erahnen. Die Frontlinien in Europa verliefen sechs Monate lang so gut wie statisch. Die Franzosen standen in ihren stark befestigten Positionen an der Maginot-Linie. Nur die Finnen kämpften einen bitteren Winterfeldzug, der im März 1940 mit ihrer Niederlage gegen die Russen endete.

Zu Beginn des Frühlings startete Hitler seine Offensive in Westeuropa mit einer neuen Strategie, dem sogenannten »Blitzkrieg«. Er war das Gegenteil des zermürbenden Stellungskriegs an der Westfront während des Ersten Weltkriegs. Durch schnelle Vorstöße und Angriffe von gepanzerter Infanterie, von Panzern und Bodenartillerie sowie durch Luftangriffe und Sturzkampfflieger rissen die angreifenden Deutschen die gegnerischen Armeen auseinander, die zudem durch Hunderttausende von fliehenden Zivilisten behindert wurden.

Am 9. April 1940 griffen die deutschen Streitkräfte Norwegen an, und am 10. Mai marschierte die Wehrmacht in Holland, Belgien, Luxemburg und Frankreich ein. Am 4. Juni wurden mehr als 330 000 britische und alliierte Truppen in kleinen Booten von der Küste bei Dünkirchen evakuiert. 10 Tage später marschierten deutsche Truppen durch den Arc de Triomphe, und zum zweiten Mal innerhalb von 70 Jahren besetzten und kontrollierten die deutschen Streitkräfte Paris. Am 18. Juni trat das faschistische Italien in den Krieg ein. Vier Tage später kapitulierte Frankreich.

Ab August war auch Großbritannien von der Invasion aus der Luft bedroht. Die Schlacht um England sollte bis tief in den Winter dauern, nachdem die deutsche Luftwaffe zu Nachtangriffen übergegangen war. Die Ereignisse legten den Grundstein für die »Legend of the Few« (Die Legende der Wenigen), der Kampfpiloten der RAF und ermöglichten den Aufstieg Winston Churchills, der sich aufgrund seiner Rhetorik zu einem der glänzendsten modernen Führer in Kriegszeiten und zum Retter seiner Nation entwickelte.

Auf See führten Großbritannien und seine Verbündeten gegen die Achsenmächte Deutschland und Italien einen Kampf auf Leben und Tod. Die Schlacht im Atlantik, die in weiten Teilen des Meeres sowohl oberhalb als auch unterhalb der Wasseroberfläche geschlagen wurde, sollte sich nicht vor 1945 entscheiden. Der Einsatz von Luftstreitkräften – Kampfflugzeugen und Bombern –, der neue taktische Panzerkrieg, die mechanisierte Infanterie des Blitzkriegs und die U-Boote bestimmten fast fünf Jahre lang das Geschick der Schlacht um Europa.

Fast jeder Winkel Europas sollte von den Achsenmächten oder ihren Marionetten eingekreist, angegriffen oder besetzt

werden. Der Befreiungskampf entwickelte sich zu einer mühsamen Angelegenheit, nicht zuletzt, weil sich die Deutschen als Meister des kämpfenden Rückzugs erwiesen. Das Blatt wendete sich erst mit den Kriegseintritten Rußlands – nach dem Überfall Hitlers 1941 – und Amerikas, nach dem japanischen Angriff auf Hawaii im Dezember 1941.

Obwohl Italien im September 1943 um Frieden bat, gelang es den Alliierten erst im April 1945, das vom Bürgerkrieg zwischen faschistischen Sympathisanten und kommunistisch geführten Partisanen zerrissene Land zu befreien. Auf dem Balkan war Jugoslawien in einen Dreiparteien-Bürgerkrieg verwickelt, der 50 Jahre später wieder aufflackern sollte.

Der entscheidende Vorstoß des Krieges gelang im Juni 1944, als 850 000 amerikanische, britische und Commonwealth-Soldaten während der Operation »Overlord«, dem umfangreichsten amphibischen Angriff der Kriegsgeschichte, in der Normandie landeten. Noch im Januar 1945 konnte die Wehrmacht eine massive Gegenoffensive durchführen, die die alliierten Armeen in den Ardennen aufrieb. In den deutschen Städten fielen Zivilisten den alliierten strategischen Bombardierungen zum Opfer, bei denen teilweise mehrere hundert Flugzeuge gleichzeitig eingesetzt wurden. Am 14. Februar 1945 starben mehr als 100 000 Menschen, darunter viele Flüchtlinge, in einem durch Brandbomben verursachten Feuersturm in Dresden.

Es sollte noch weitere zwei Monate dauern, ehe die Deutschen auf ihrem eigenen Territorium kapitulierten. Damit endete der zermürbende fünfjährige Krieg um die Befreiung Europas.

La guerre qui couvait depuis longtemps en Europe éclate le 1er septembre 1939 lorsque les troupes de Hitler envahissent la Pologne. L'aviation et l'armée de terre polonaises sont sous-équipées face aux six divisions près de 1,4 millions de soldat de la Wehrmacht. Les chars allemands combattent des troupes à cheval, armées de lances et de sabres. Ce sera la dernière charge de cavalerie dans une guerre européenne. En dépit d'une aviation anéantie, les Polonais opposent une forte résistance et Varsovie ne tombera que le 29 septembre 1939.

L'attaque de la Pologne entraîne la Grande-Bretagne dans la guerre. Le 3 septembre, le Premier ministre Chamberlain annonce à la radio que «le pays a déclaré la guerre à l'Allemagne. Nous sommes prêts.» Ce sera pour la Grande-Bretagne la route la plus longue. Elle sera la seule grande puissance à se battre jusqu'à la fin de la guerre quand les Japonais se rendent en août 1945. L'effort de guerre saignera les ressources et réserves du pays, de l'Empire et du Commonwealth. 452 000 soldats et 60 000 civils seront tués. L'Allemagne perdra 3 500 000 soldats et 3 800 000 civils. La France comptera 250 000 soldats et 360 000 civils de tués. Après cette guerre, l'Allemagne et la France ne retrouveront plus leur statut de grande puissance militaire.

Quelques heures après la déclaration de guerre à l'Allemagne, les sirènes retentissent dans Londres, marquant le

British and allied troops line up on the beaches for evacuation at Dunkirk, June 1940. Most men of the British Expeditionary Force were rescued, but many thousands were captured and held for the rest of the war.

Britische und alliierte Truppen formieren sich auf dem Strand für die Evakuierung von Dünkirchen, Juni 1940. Die meisten Männer der britischen Expeditionsarmee konnten sich retten; viele Tausende wurden jedoch gefangengenommen und für den Rest des Krieges interniert.

Juin 1940, colonnes de troupes britanniques et alliées pendant l'évacuation sur les plages de Dunkerque. La majorité du corps expéditionnaire britannique sera sauvée mais des milliers d'hommes seront faits prisonniers et retenus jusqu'à la fin de la guerre.

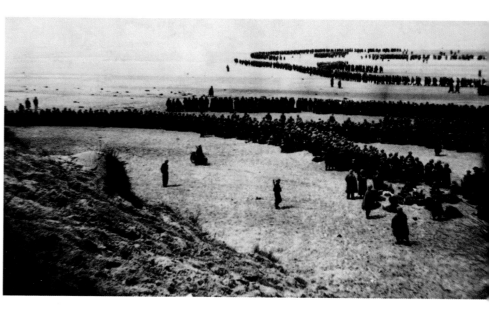

signal d'une guerre qui impliquera les civils comme jamais auparavant.

A l'automne 1939, peu était ceux qui pouvaient imaginer la tournure que prendrait cette guerre. En Europe, les fronts sont quasi immobiles. La «drôle de guerre» dure six mois. Les Français sont retranchés dans leurs positions très fortifiées sur la ligne Maginot. Seuls les Finlandais mènent une campagne difficile au cours de l'hiver avant d'être dominés par les Russes en mars 1940.

Au début du printemps, Hitler lance une offensive en Europe occidentale selon une nouvelle tactique, le Blitzkrieg. C'est le contraire de la guerre d'usure menée sur le front occidental durant la Première Guerre mondiale. Au sol, l'infanterie armée, les chars et l'artillerie mènent des offensives éclairs et avancent rapidement tandis que les bombardiers font des raids aériens et que les attaquants allemands anéantissent et divisent les forces armées opposées, plongées dans le chaos des civils en fuite.

Le 9 avril 1940, les forces allemandes attaquent la Norvège. Le 10 mai, la Wehrmacht envahit la Hollande, la Belgique, le Luxembourg et la France. Le 4 juin, plus de 330 000 Britanniques et soldats alliés sont évacués des plages de Dunkerque sur des petites embarcations. Dix jours plus tard, les troupes allemandes défilent sous l'Arc de triomphe. Pour la deuxième fois en 70 ans, les forces armées allemandes occupent et contrôlent Paris. Le 18 juin, l'Italie fasciste entre en guerre. Quatre jours plus tard, la France capitule.

En août, la Grande-Bretagne craint à son tour une invasion par les airs. La bataille de l'Angleterre dure tout l'hiver et la Luftwaffe allemande décide d'effectuer des raids aériens de nuit. Cette bataille donne naissance à la légende des Few, les pilotes de chasse de la RAF, et fait de Churchill, avec ses discours éloquents, l'un des dirigeants de la guerre moderne les plus inspirants. Il devient le sauveur de la nation.

En mer, la Grande-Bretagne et ses alliés mènent une bataille de survie face aux puissances de l'Axe, l'Allemagne et l'Italie. La bataille de l'Atlantique déclenche une guerre navale et sous-marine sur presque tous les océans qui ne s'achèvera qu'en 1945. L'emploi de forces aériennes, des chasseurs et des bombardiers, les nouvelles manœuvres des chars et de l'infanterie mécanisée du Blitzkrieg ainsi que les sous-marins marqueront la destinée de la bataille pour l'Europe pendant presque cinq ans.

Presque chaque parcelle de l'Europe est encerclée, attaquée ou occupée par les puissances de l'Axe ou ses marionnettes. La bataille pour la libération sera difficile et usante, les Allemands étant passés maîtres des offensives de retrait. En 1941, le vent tourne enfin quand la Russie entre en guerre après l'invasion de Hitler, suivie par les Américains après l'attaque japonaise sur Hawaï en décembre.

En proie à une guerre interieure entre sympathisants fascistes et partisans communistes, l'Italie réclame la paix en septembre 1943 mais il faudra attendre avril 1945 avant que les Alliés puissent libérer la Péninsule. Dans les Balkans, la Yougoslavie est en proie à une guerre civile sur trois fronts, qui resurgira 50 ans plus tard.

Le coup final sera porté en juin 1944 lorsque 850 000 Américains, Britanniques et soldats du Commonwealth débarquent en Normandie. C'est l'opération Overlord, l'attaque amphibie la plus complexe qu'ait jamais connue l'histoire militaire. Mais, en janvier 1945, la Wehrmacht est encore en mesure de lancer une contre-offensive massive dans les Ardennes qui déstabilise les armées alliées. Dans les villes allemandes, les civils sont les victimes des bombardements stratégiques des Alliés. Il arrive qu'un raid aérien soit effectué par des centaines d'avions en même temps. Le 14 février 1945 à Dresde, plus de 100 000 personnes, des réfugiés pour la plupart, périssent dans une tempête de feu causée par les bombes incendiaires. Il faudra attendre encore deux mois avant que les Allemands se rendent sur leur propre sol, mettant ainsi un terme à cinq ans d'une guerre sans répit pour libérer l'Europe.

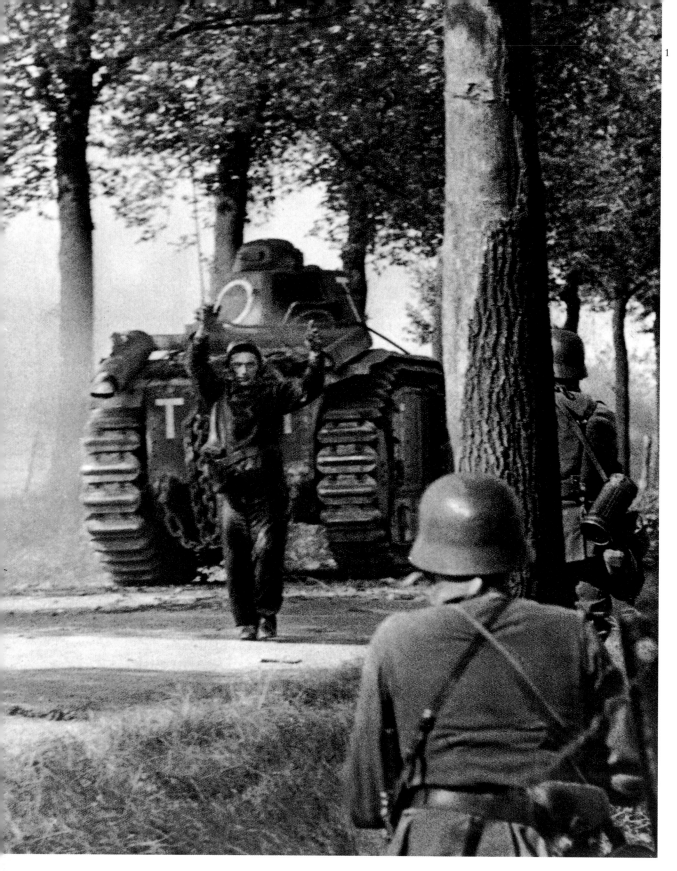

Blitzkrieg

The tactics of *Blitzkrieg* led to rapid advance by armoured ground forces with close support from fighters and divebombers. These tactics were to deliver much of western Europe to Hitler in eight weeks in the spring of 1940. (1) A French tank crewman surrenders. (2) Storm troopers seize their objective in Rotterdam.

Blitzkrieg

Die Taktik des »Blitzkriegs« ermöglichte den schnellen Vormarsch gepanzerter Bodentruppen mit direkter Unterstützung durch Kampfflugzeuge und Sturzkampfbomber. Dank dieser Taktik fiel im Frühling 1940 innerhalb von acht Wochen der Großteil Westeuropas in die Hände Hitlers. (1) Ein französischer Panzerfahrer ergibt sich. (2) Sturmtruppen in Rotterdam nehmen ihr Ziel in Angriff.

Le Blitzkrieg

La tactique du *Blitzkrieg* permet aux forces armées d'avancer rapidement sur le terrain, couvertes par les chasseurs et les bombardiers. Printemps 1940, cette tactique a permis, en huit semaines, de faire tomber la plus grande partie de l'Europe occidentale sous l'emprise de Hitler. (1) Un membre de l'équipage du char français se rend. (2) A Rotterdam, des troupes d'assaut visent leur cible.

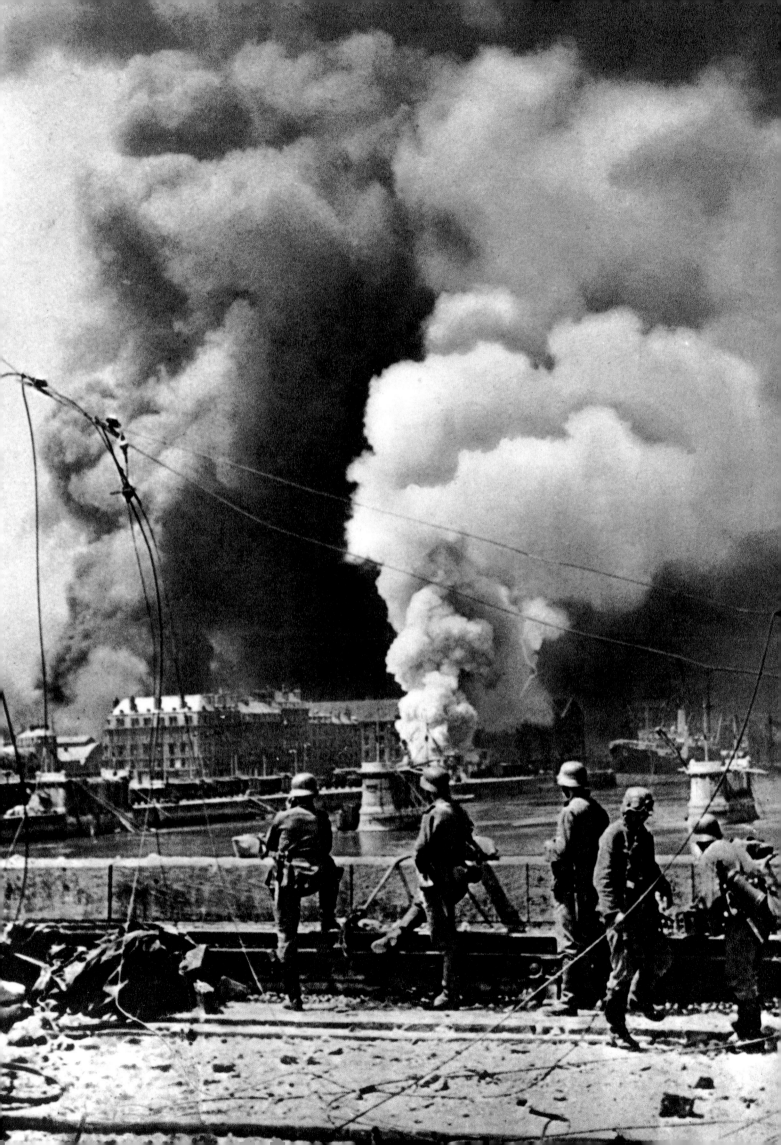

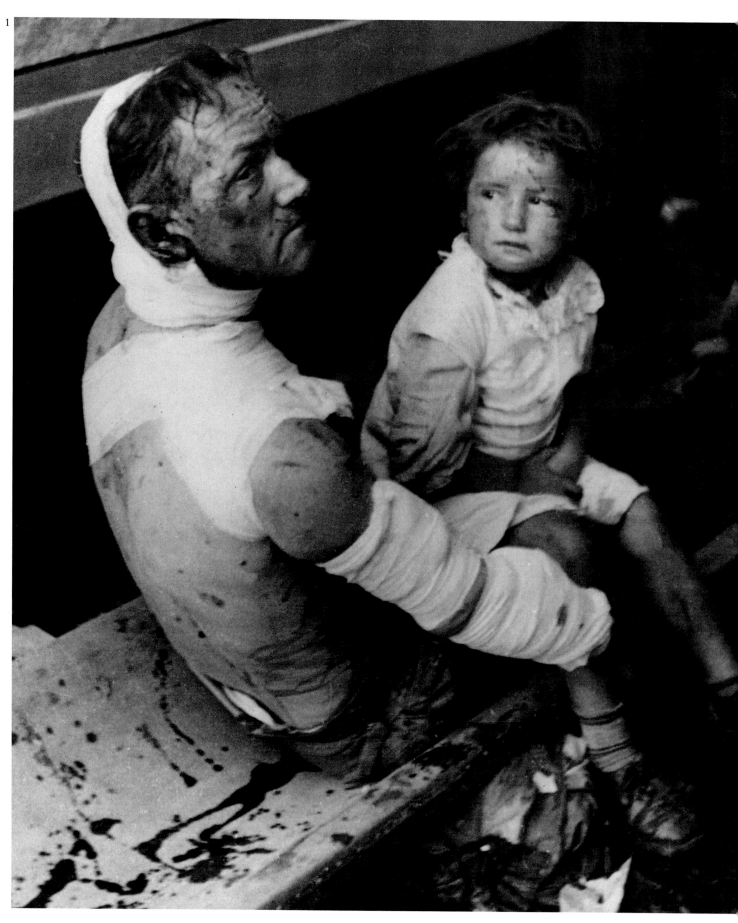

Poland Invaded

The capture of Poland was the beginning of the war in Europe. Warsaw capitulated only after a month of fierce fighting. (1) A father and his daughter injured in an air raid on a poor suburb of Warsaw. (2) A farmer despairs after bombers hit his home. (3) A medical orderly watches for new attacks, while the poster calls his fellow countrymen to arms.

Der Überfall auf Polen

Der Überfall auf Polen war der Beginn des Krieges in Europa. Warschau kapitulierte erst nach einem Monat heftiger Kämpfe. (1) Ein Vater und seine Tochter, die bei einem Luftangriff auf einen Vorort Warschaus verletzt wurden. (2) Ein verzweifelter Bauer, dessen Haus bei einem Bombenangriff getroffen wurde. (3) Ein Sanitäter hält nach neuen Angriffen Ausschau. Das Plakat im Hintergrund ruft seine Landsleute zu den Waffen.

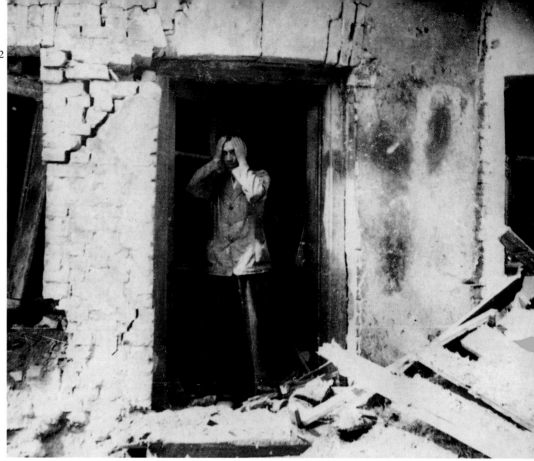

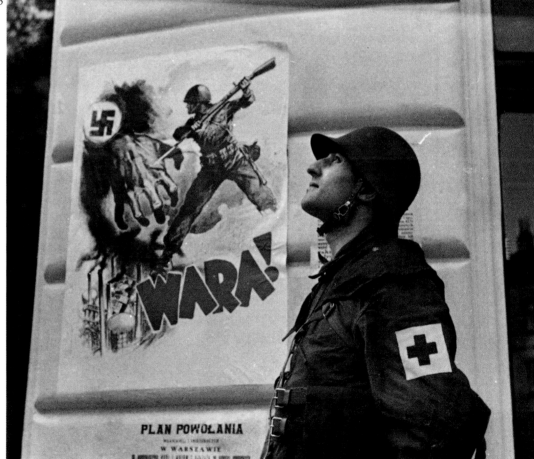

La Pologne envahie

La conquête de la Pologne marque le début de la guerre en Europe. Varsovie se rend, non sans avoir durement combattu pendant un mois. (1) Un père et sa fille blessés durant un raid aérien sur une banlieue pauvre de Varsovie. (2) Désespoir d'un fermier après le bombardement de sa maison. (3) Devant une affiche qui appelle aux armes, un secouriste scrute le ciel dans l'attente d'une nouvelle attaque.

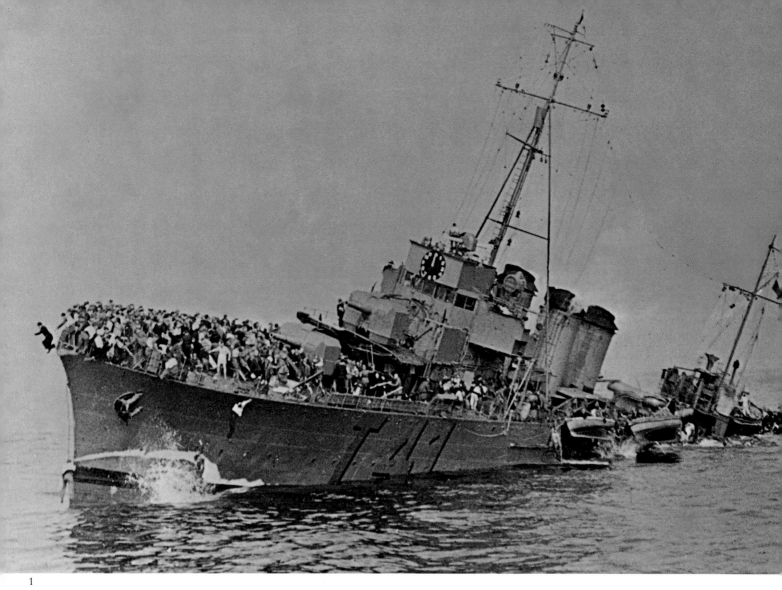

1

Dunkirk

The evacuation of the British Expeditionary Force from Dunkirk became a symbol of triumph-in-disaster. More than 330,000 troops escaped, including many who were to become the core of the Free French Forces. (1) The French destroyer *Bourrasque* is sunk by a mine. (2) British soldiers fight a desperate rearguard action, shooting rifles at attacking aircraft, while (3) sailors of her crew are hauled aboard a British vessel from their life-raft.

Dünkirchen

Die Evakuierung der britischen Expeditions-armee von Dünkirchen wurde zum Symbol des Sieges in der Niederlage. Mehr als 330 000 Soldaten entkamen; viele von ihnen bildeten später den Kern der Freien Französischen Armee. (1) Der französische Zerstörer *Bourrasque* sinkt nach einem Minentreffer. (2) Britische Soldaten in einem verzweifelten Rückzugsgefecht schießen mit Gewehren auf angreifende Flugzeuge, (3) während Matrosen ihrer Besatzung von ihren Rettungsbooten auf ein britisches Schiff geholt werden.

Dunkerque

L'évacuation du corps expéditionnaire britannique hors de Dunkerque devient le symbole d'une victoire-désastre. Plus de 330 000 soldats sont évacués. Parmi eux, un grand nombre formera les Forces françaises libres. (1) Le destroyer français *Bourrasque* est coulé par une mine. (2) A l'arrière, les soldats britanniques ripostent aux attaques aériennes tandis que (3) les matelots français sont hissés à bord d'un navire britannique.

2

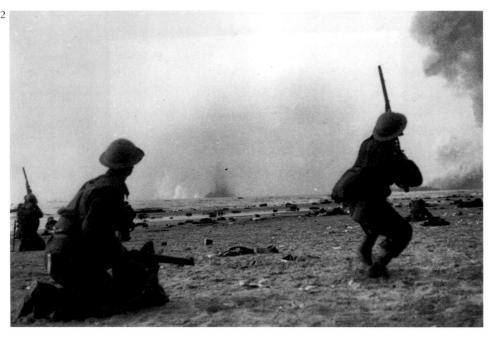

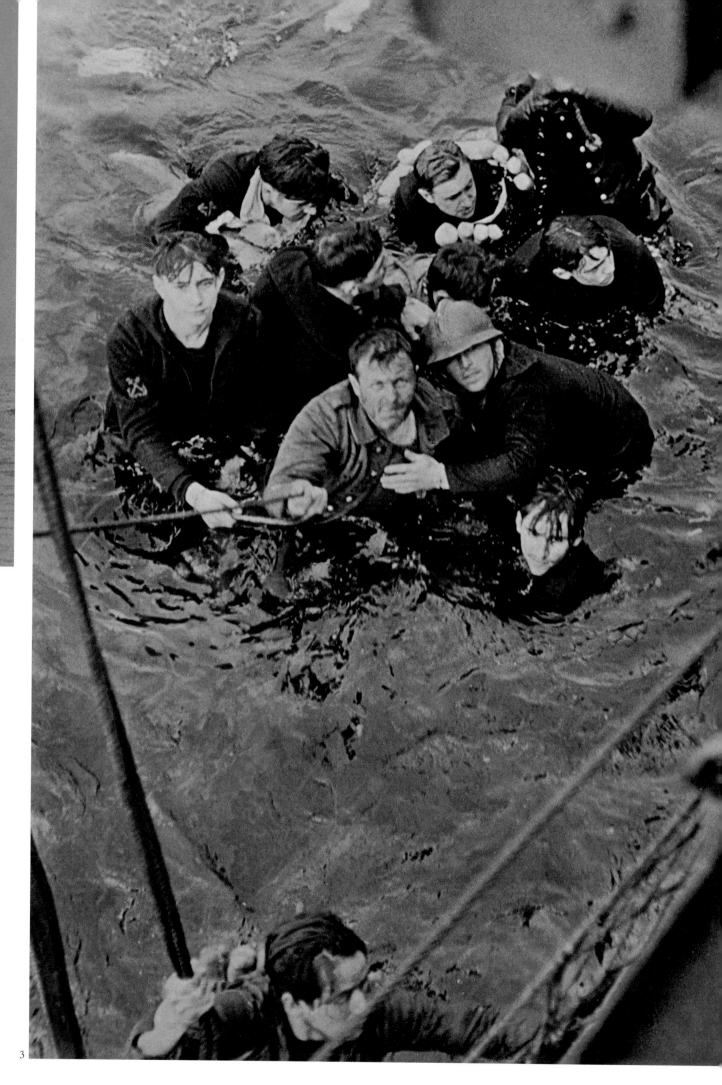

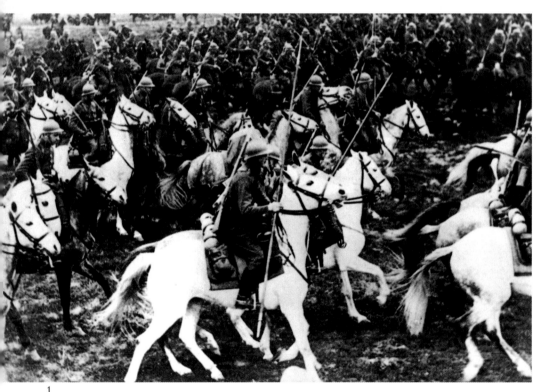

Horse Power

Cavalry saw its last big battle in Poland in 1939. (1) The famous Polish Mounted Brigade prepares for battle, with lances and swords. (2) Wehrmacht horse artillery in the invasion of Bulgaria in 1941. (3) Cossack cavalry in July 1942 kitted for modern guerrilla warfare with capes, steel helmets and sub-machine guns.

Pferdestärken

Die Kavallerie schlug ihre letzte große Schlacht 1939 in Polen. (1) Die berühmte Polnische Berittene Brigade bereitet sich mit Lanzen und Schwertern auf den Kampf vor. (2) Die berittene Artillerie der Wehrmacht während der Invasion Bulgariens 1941. (3) Kosakenkavallerie im Juli 1942, ausgestattet für den modernen Guerillakrieg mit Umhängen, Stahlhelmen und Maschinenpistolen.

Les ultimes batailles de la cavalerie

La dernière grande bataille montée se déroulera en Pologne en 1939. (1) La célèbre Brigade montée polonaise prête à l'attaque avec ses lances et épées. (2) L'artillerie de cavalerie de la Wehrmacht lors de l'invasion de la Bulgarie en 1941, (3) Juillet 1942, des cavaliers cosaques équipés d'armes modernes, capes, casques et mitraillettes.

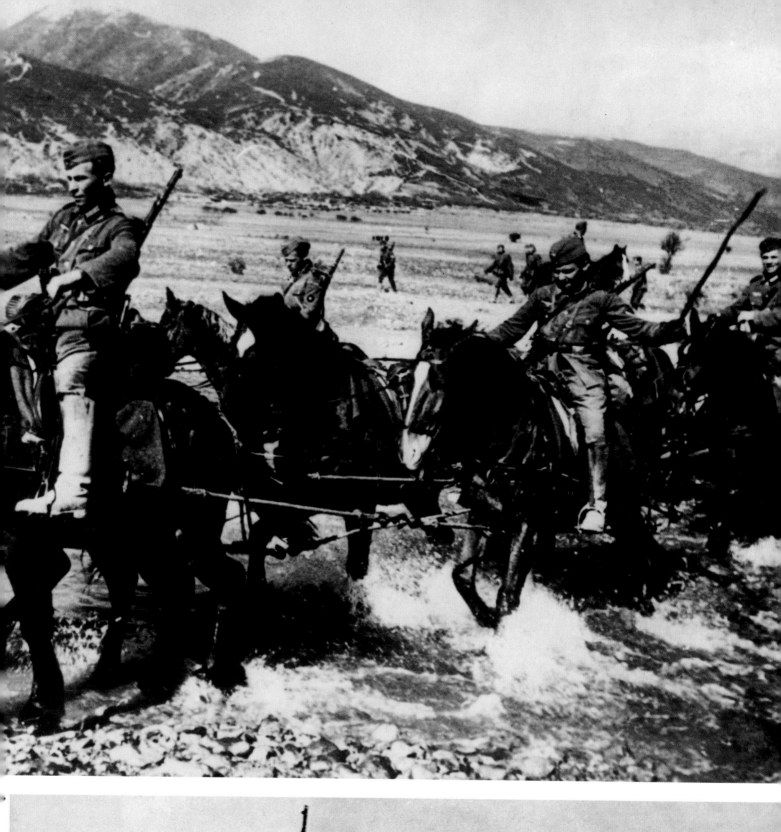
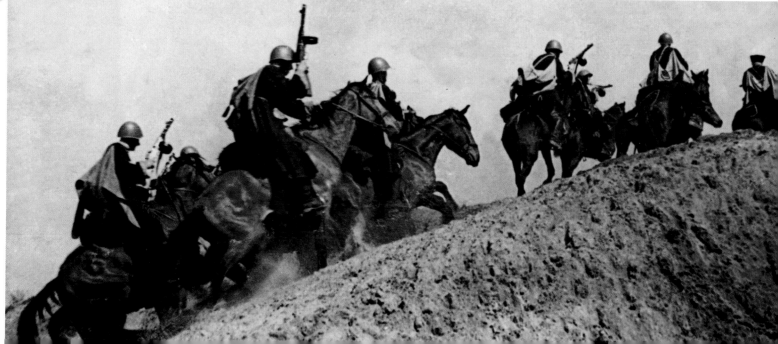

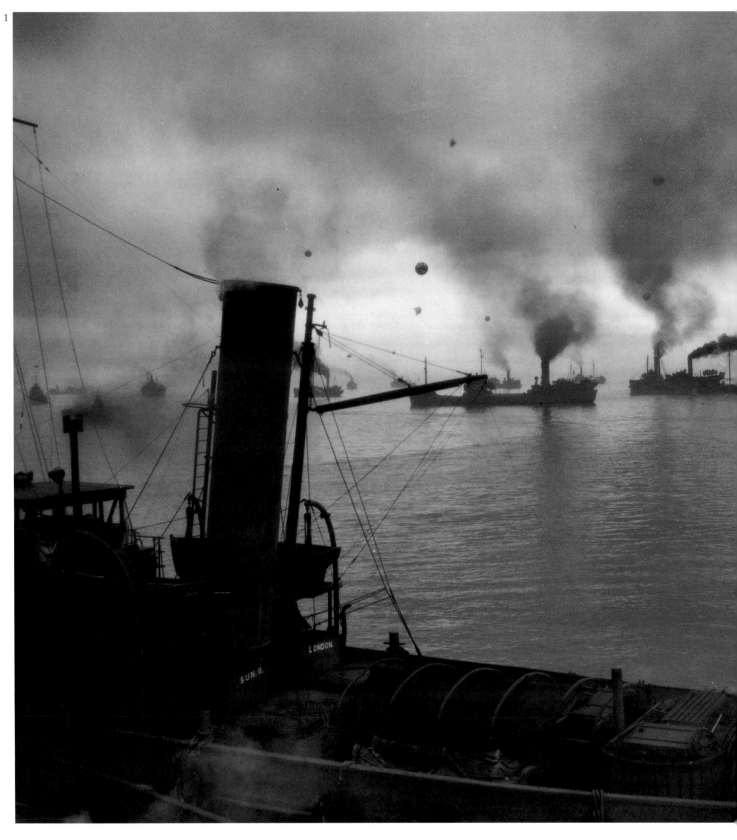

Battle in the Atlantic

The German Command said they had to sink 800,000 tons of allied shipping in the Atlantic each month to cripple their war effort. Their submarines achieved this only in July and October 1943. (1) A convoy of coasters sets out under the protection of balloons against air attacks. (2) Destroyer escorts fire depth charges against submarine raiders. (3) Rescue for survivors of a torpedoed merchantman, who have drifted for days on their upturned lifeboat.

Die Schlacht im Atlantik

Das deutsche Oberkommando gab den Befehl aus, pro Monat alliierte Schiffe im Umfang von 800 000 Tonnen im Atlantik zu versenken, um die feindlichen Kriegsan-strengungen lahmzulegen. Die deutschen U-Boote erreichten dieses Ziel nur im Juli und Oktober 1943. (1) Ein Konvoi sticht im Schutz von Ballons gegen Luftangriffe in See. (2) Begleitzerstörer feuern Wasserbomben auf angreifende U-Boote. (3) Rettung von Überlebenden eines torpedierten Handels-schiffs, die tagelang auf ihrem gekenterten Rettungsboot im Meer trieben.

La bataille de l'Atlantique

L'état-major allemand déclare qu'il faut couler 800 000 tonnes de matériels chaque mois pour entamer l'effort de guerre de la flotte alliée en Atlantique. Ses sous-marins n'atteindront cet objectif qu'en juillet et octobre 1943. (1) Un convoi de caboteurs quitte le port sous la protection de ballons anti-aériens. (2) Des escorteurs ripostent

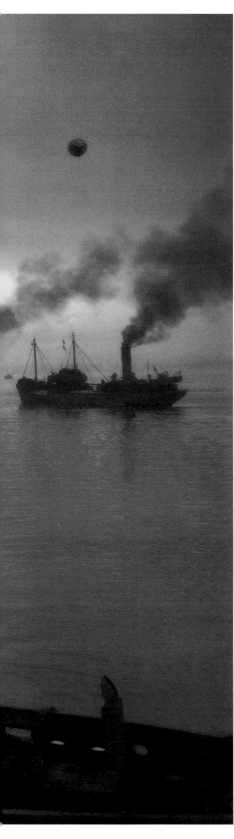

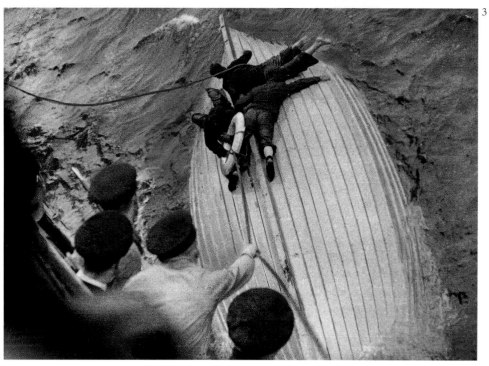

lourdement aux raids sous-marins.
(3) Sauvetage des survivants d'un navire marchand, à la dérive depuis plusieurs jours sur un bateau de sauvetage retourné.

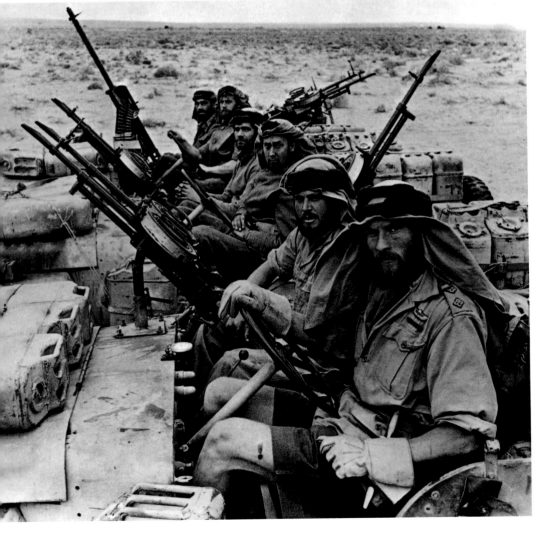

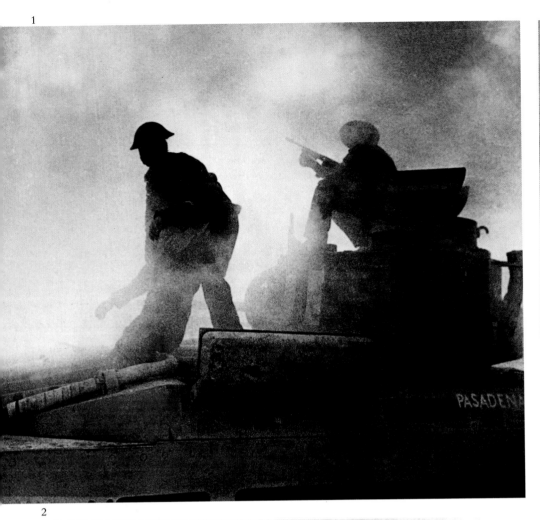

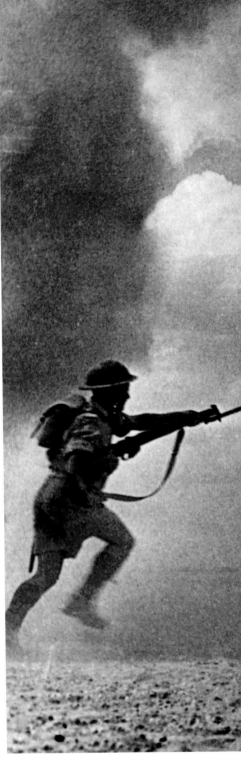

War in the Desert

Fighting in the Western Desert, North Africa, reached its climax in October and November when General Bernard Montgomery defeated Irwin Rommel at El-Alamein with overwhelming firepower. Desert warfare was a mixture of old and new weapons and tactics, artillery, tanks and new 'special forces' trained to fight deep behind enemy lines.
(1) Recovery of a British tank after it has 'brewed up' – been set alight – in battle.
(2) Troops of David Sterling's Long Range Desert Group – the SAS – return from a raid.
(3) Commonwealth soldiers, bayonets fixed, take the surrender of a German tank.

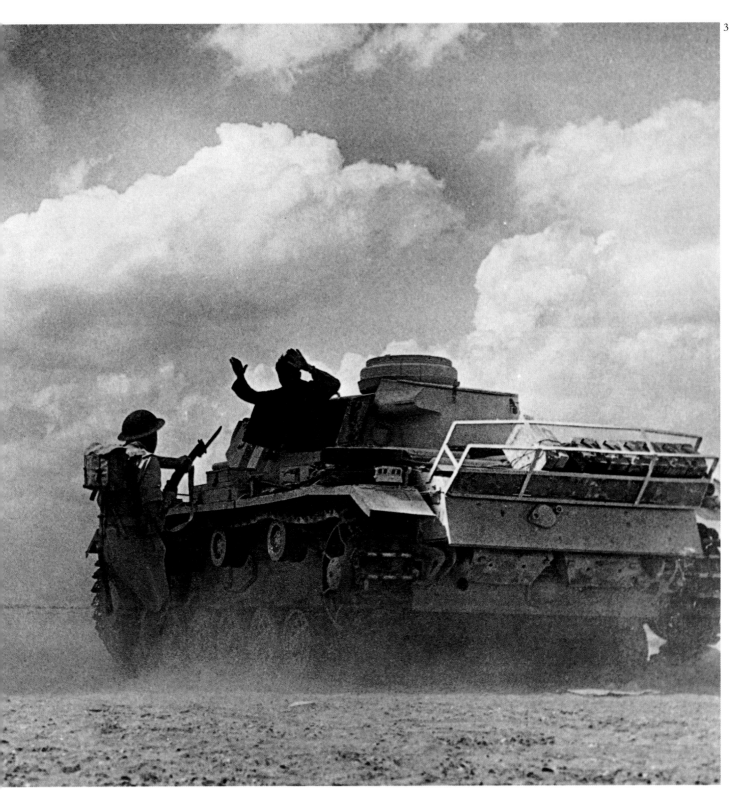

Wüstenkrieg

Die Kämpfe in Nordafrika erreichten ihren Höhepunkt im Oktober und November 1942, als General Bernard Montgomery Feldmarschall Erwin Rommel in El Alamein mit überlegener Feuerkraft besiegte. Der Wüstenkrieg war eine Mischung von alten und neuen Waffen, von Taktik, Artillerie, Panzern sowie neuen Spezialeinheiten, die für den Kampf hinter den feindlichen Linien ausgebildet wurden. (1) Bergung eines britischen Panzers, der während des Kampfes in Brand gesetzt wurde. (2) Truppen von David Sterlings *Long Range Desert Group* – dem SAS – kehren von einem Angriff zurück. (3) Soldaten des Commonwealth nehmen mit aufgepflanztem Bajonett die Kapitulation eines deutschen Panzers entgegen.

La guerre du désert

La bataille du Sahara occidental culmine en octobre et novembre. Montgomery, disposant d'une puissance de feu supérieure, écrase Rommel à El Alamein. Cette guerre mêle armes et tactiques anciennes et nouvelles, artillerie, chars et des « forces spéciales » qui combattent très en retrait des lignes ennemies. (1) Récupération d'un char britannique qui a pris feu durant la bataille. (2) Le *Long Range Desert Group* de David Sterling, les S.A.S., au retour d'un raid. (3) Reddition d'un char allemand devant des soldats du Commonwealth armés de baïonnettes.

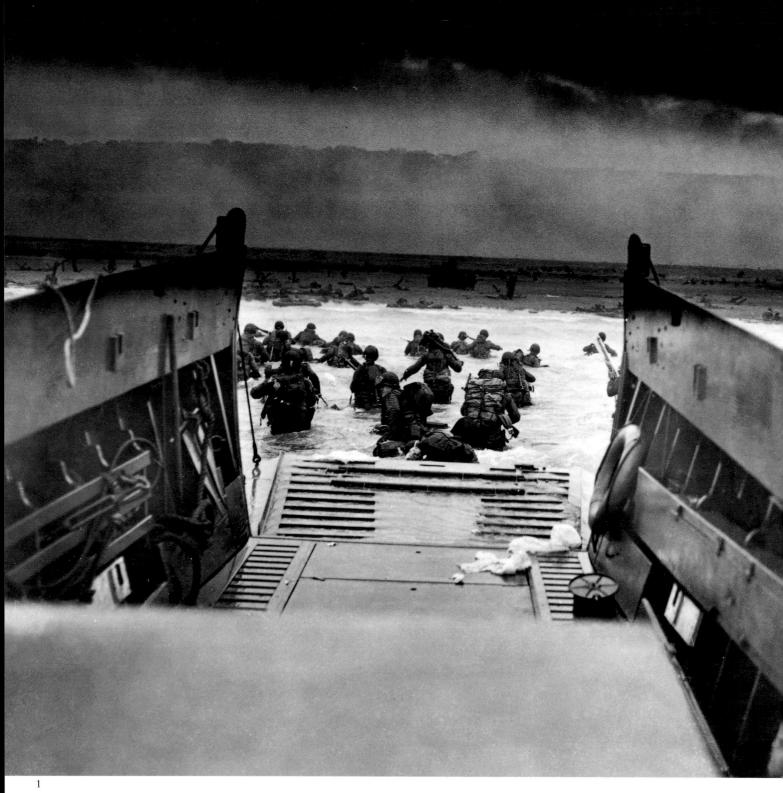

Amphibious Assault

The Western allies mounted major amphibious assaults in three different theatres: the Atlantic, the Mediterranean and the Pacific. The biggest was on D-Day, 6 June 1944, the beginning of Operation Overlord for the liberation of Europe.
(1) US infantry, part of six divisions going ashore at five beachheads. (2) The initial assault was backed up by 'Mulberry Harbour', a port built of ships and pontoons off the Normandy beaches. (3) Canadian troops return from the raid on Dieppe in August 1942, which failed, with half the attacking force lost.

Amphibischer Angriff

Die westlichen Alliierten starteten amphibische Großangriffe auf drei verschiedenen Schauplätzen: im Atlantik, im Mittelmeer und im Pazifik. Die größte Landung dieser Art fand am D-Day, dem »längsten Tag« am Beginn der Operation »Overlord« zur Befreiung Europas statt. (1) US-Infanterie, Teil der sechs Divisionen, die an fünf Brückenköpfen an Land gingen. (2) Der erste Angriff wurde von »Mulberry Harbour« aus unterstützt, einem künstlichen Hafen aus Schiffen und Pontons vor der Normandie-Küste.
(3) Kanadische Truppen kehren im August 1942 von einem fehlgeschlagenen Vorstoß auf Dieppe zurück, bei dem die Hälfte der Angriffstruppen getötet wurde.

Attaque amphibie

Les alliés occidentaux lancent des attaques amphibies décisives sur trois fronts: l'Atlantique, la Méditerranée et le Pacifique. La plus importante est celle du débarquement du 6 juin 1944 qui marque le début de l'opération Overlord pour la libération de l'Europe. (1) Une infanterie américaine, l'une des six divisions débarquant de cinq têtes de pont. (2) Le premier assaut est couvert par le « Mulberry Harbour », un port fait à partir de navires et de pontons au large des côtes normandes. (3) Août 1942, retour de troupes canadiennes après un raid manqué sur Dieppe, la moitié des soldats ont été tués.

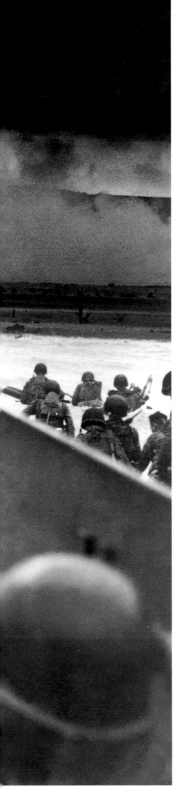

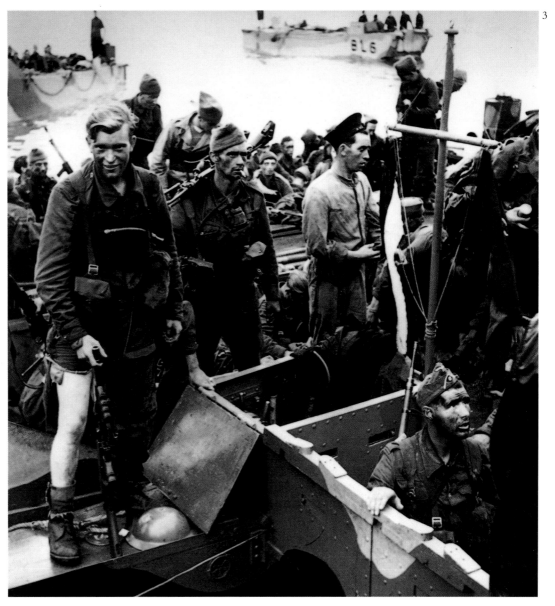

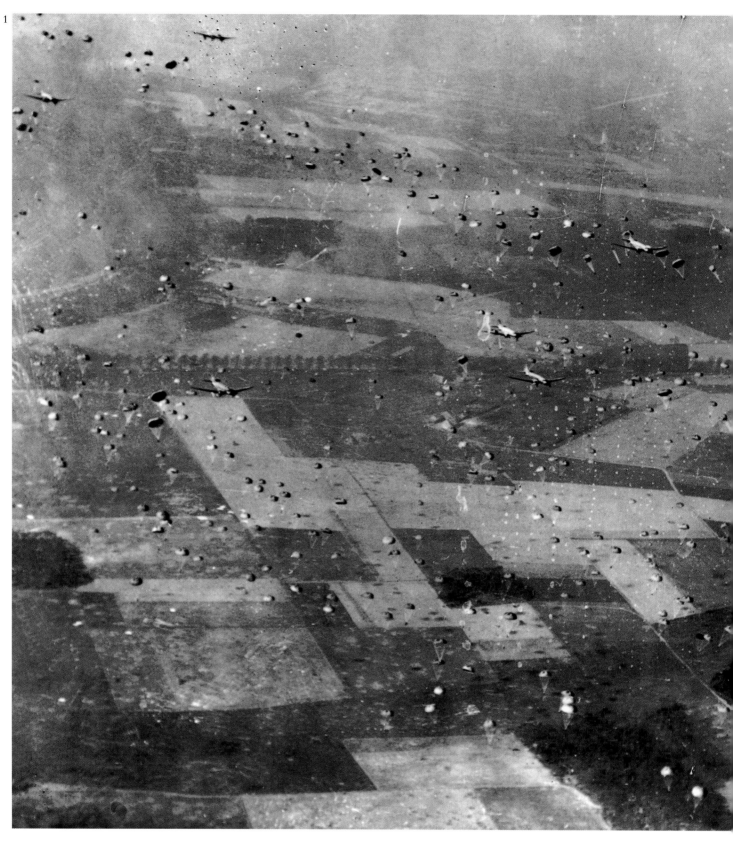

1

Jumping the Rhine

Parachute forces were deployed by both sides: paratroopers led the
German invasion of Crete in 1941, and were pathfinders for the allies
in Normandy in June 1944. The British airborne operation at Farnham
in 1944, however, was a heroic failure. (1) The biggest airborne assault
came in March 1945 when more than 40,000 American and
Commonwealth paratroopers secured the Rhine crossing. (2) Men of
the 17th US Airborne Division prepare to jump at Wesel on the Dutch
border – on the left (strap across face) is the photographer Robert
Capa. (3) A GI carries his buddy, injured in the drop.

Absprung über dem Rhein

Fallschirmspringer-Truppen wurden sowohl von den Alliierten als auch
von der Wehrmacht mit unterschiedlichem Erfolg eingesetzt. Mal führ-
ten sie die deutsche Invasion auf Kreta 1941 an, ein andermal dienten
sie als Vorhut für die Alliierten in der Normandie im Juni 1944. Die
britische Operation in Farnham 1944 mündete jedoch in eine Nieder-
lage. (1) Der größte Fallschirmspringer-Angriff erfolgte im März 1945,
als über 40 000 Springer aus amerikanischen und Commonwealth-
Einheiten den Übergang über den Rhein sicherten. (2) Männer der 17.
US Airborne Division bereiten ihren Absprung bei Wesel vor – links im
Bild (mit Gurt über dem Gesicht) steht der Fotograf Robert Capa.
(3) Ein GI trägt seinen beim Absprung verwundeten Kameraden.

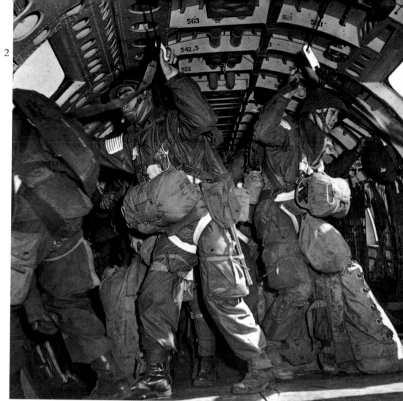

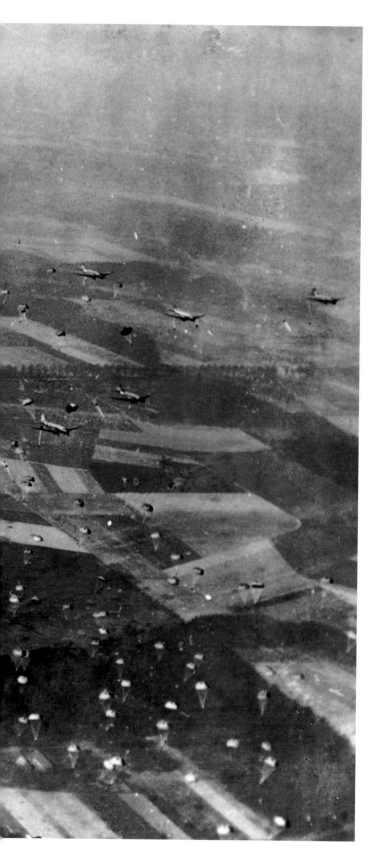

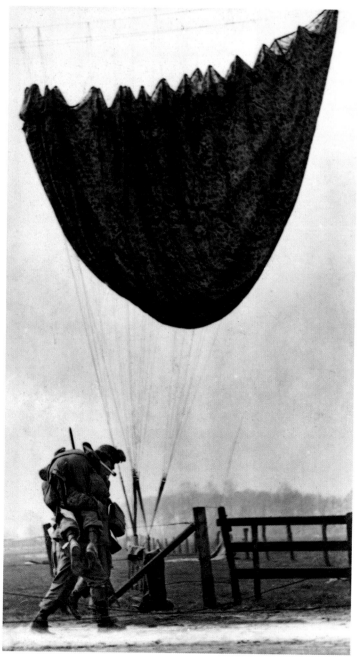

La traversée du Rhin

Des troupes de parachutistes sont déployées par les Alliés et la Wehrmacht, avec plus ou moins de succès. En 1941, les parachutistes sont en tête de l'invasion allemande de la Crète. Mais, en 1944, l'opération britannique aéroportée à Farnham est un échec héroïque. (1) La plus grande attaque aéroportée se déroule en mars 1945. Plus de 40 000 parachutistes américains et du Commonwealth couvrent la traversée du Rhin. (2) Des soldats de la 17ᵉ US Airborne Division se préparent à sauter au-dessus de Wesel à la frontière hollandaise – à gauche (visage caché par une courroie) se trouve le photographe Robert Capa. (3) Un GI porte un camarade, blessé pendant le saut.

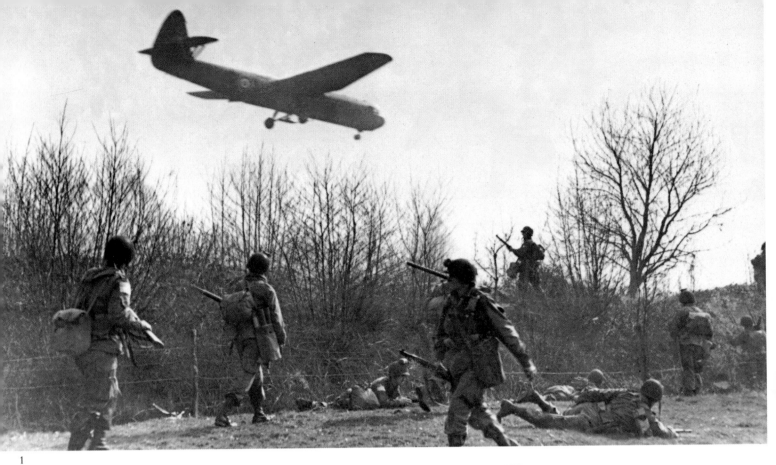

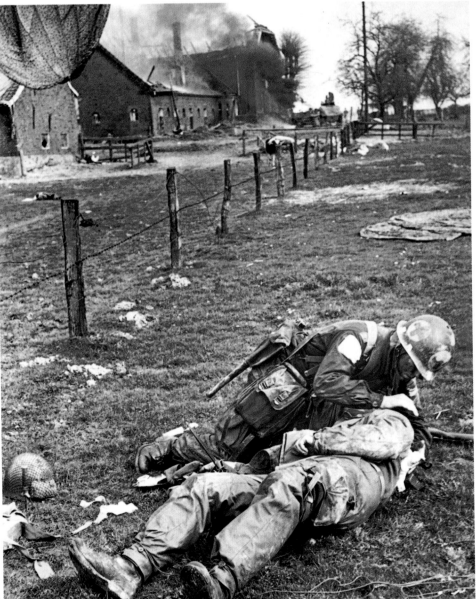

Paratroopers

Airborne forces in the assault across the Rhine, photographed by Robert Capa on 24 March 1945. (1) A British Horsa Glider brings in reinforcements. (2) A medical orderly helps an injured GI. (3) Normandy, June 1944: US Airborne troops with their plane, the DC-3 Dakota. (4) American paratroopers after liberating the village of Ste-Mère Eglise in Normandy.

Fallschirmspringer

Fallschirmspringer-Truppen beim Vorstoß über den Rhein, fotografiert von Robert Capa am 24. März 1945. (1) Ein britischer Horsa-Lastensegler bringt Nachschub. (2) Ein Sanitäter versorgt einen verletzten GI. (3) Normandie, Juni 1944: Fallschirm-springer der US-Armee marschieren zu ihrem Flugzeug, einer DC-3 Dakota. (4) Amerikanische Fallschirmspringer-Truppen nach der Befreiung des Dorfes Ste.-Mère-Eglise in der Normandie.

Les parachutistes

Troupes aéroportées photographiées par Robert Capa le 24 mars 1945 durant l'offensive sur le Rhin. (1) Un Horsa Glider britannique amène des renforts. (2) Un secouriste vient en aide à un GI blessé. (3) Juin 1944 en Normandie: des soldats de l'US Airborne et leur avion, un DC-3 Dakota. (4) Des parachutistes américains après la libération du village de Ste-Mère-Eglise en Normandie.

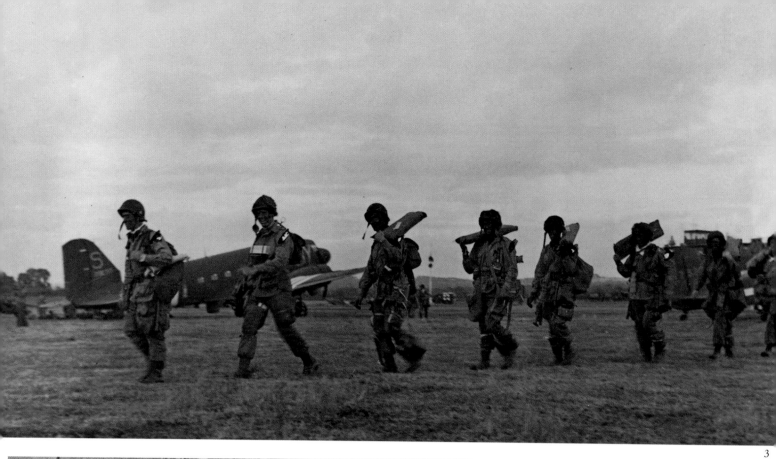

3

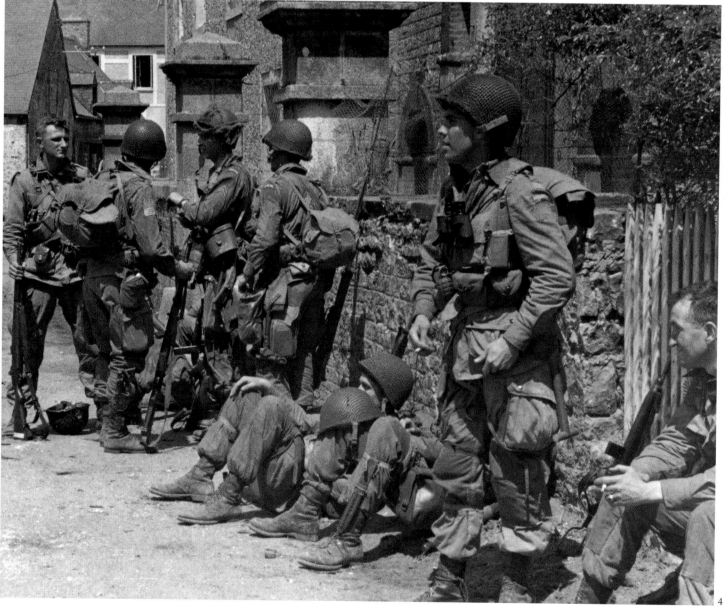

4

Firepower

The Germans and the allies experimented with highly mobile rocket systems. (1) An American M-4 opens fire at Beisdorf in Germany. (2) A jeep-mounted 4.5 multi-barrelled rocket fires at a German position in northern France in 1944. The American gunners could 'shoot and scoot', fire and then move to avoid counter-bombardment. (3) The bazooka was the first shoulder-launched anti-tank rocket, still in commission. Here the photographer records the moment of impact as a bazooka rocket knocks out a German Panzer in Normandy in July 1944.

Feuerkraft

Sowohl die Deutschen als auch die Alliierten experimentierten mit mobilen Raketen-systemen. (1) Eine amerikanische M-4 eröff-net das Feuer auf Beisdorf. (2) Eine auf einem Jeep montierte 4,5-Zoll-Rakete beschießt eine deutsche Stellung in Nord-frankreich 1944. Weil sie auf einem Jeep angebracht war, konnten die amerikanischen Schützen »feuern und fahren« – ihre Geschütze abfeuern und sofort weiterfahren, um Gegenangriffe zu vermeiden. (3) Die Bazooka war die erste einer erfolgreichen Serie von Panzerabwehrraketen, die von der Schulter abgefeuert werden konnten. Sie wird auch heute noch hergestellt. Auf diesem Bild hat der Fotograf den Moment des Auf-schlags festgehalten, bei dem eine Bazooka-Rakete einen deutschen Panzer in der Normandie außer Gefecht setzt. Juli 1944.

La puissance de feu

Allemands et Alliés ont expérimenté des systèmes de roquettes très mobiles. (1) Un M-4 américain ouvre le feu à Beisdorf en Allemagne. (2) 1944, une jeep équipée d'un lance-roquettes multitube ouvre le feu sur une position allemande au nord de la France. Les artilleurs américains savent « tirer et foncer », faire feu et avancer, pour éviter les ripostes. (3) Le *bazooka* est le premier lance-roquettes antichar portatif. Il est toujours en service. Juillet 1944 en Normandie, le photographe a saisi l'instant où la roquette du *bazooka* fait exploser un Panzer allemand.

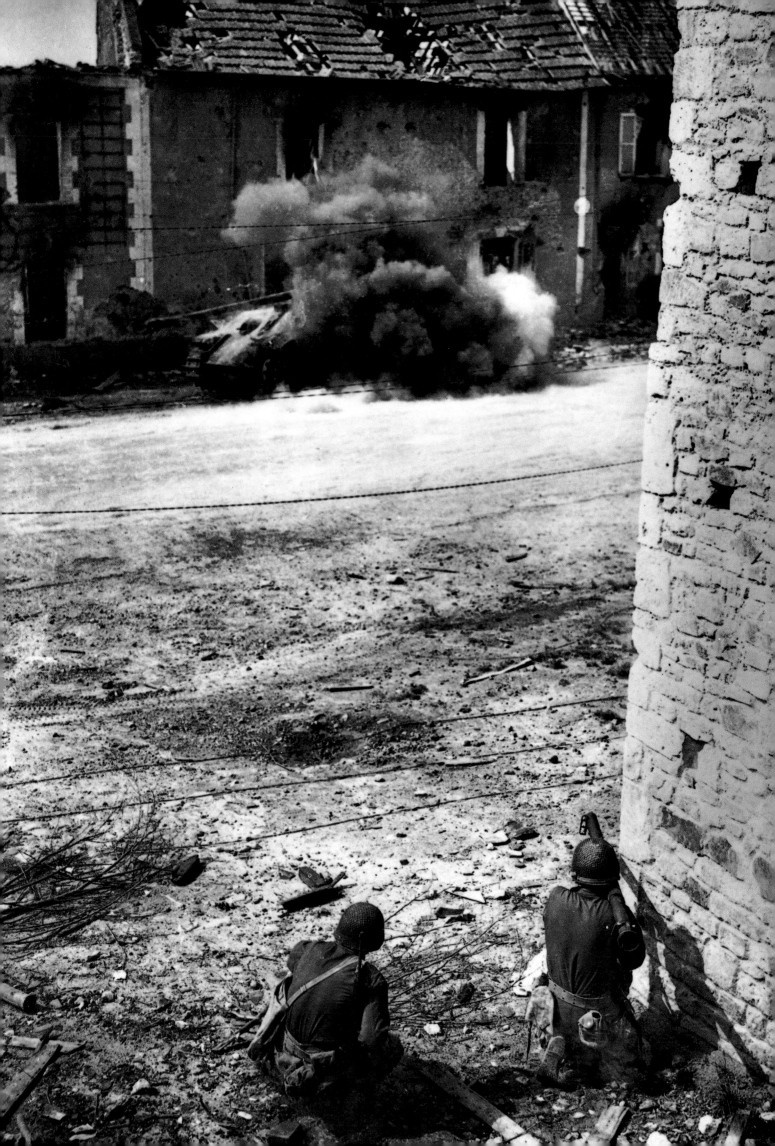

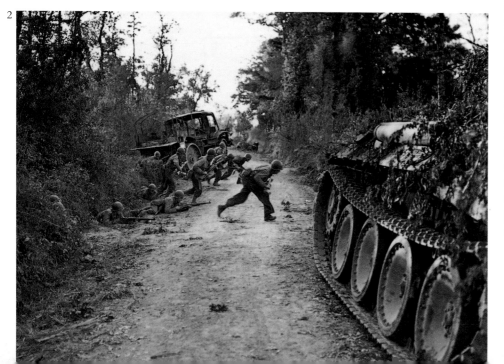

End-game

(1) American troops of the First Army reach out to shake hands with Russian soldiers across the smashed bridge at Torgau on the Elbe, 27 April 1945. (2) Fire and manoeuvre: American infantry pinned down by snipers and 88-mm shells in a lane in close country, the 'bocage' of Normandy. The soldiers had to crawl and rush to make the last 100 metres down the lane near Periers. (3) US Army tanks clearing the lanes near the Gothic cathedral in Cologne, come under fire – a crewman is flung free as the tank on the right is struck.

Endspiel

(1) Über die zerstörte Elbbrücke bei Torgau strecken sich amerikanische und russische Soldaten am 27. April 1945 die Hände entgegen. (2) Feuer und Manöver: Amerikanische Infanterie in der Normandie ist von Heckenschützen und 88-mm-Granaten auf einem Feldweg in unwegsamem Gelände eingeschlossen. Die Soldaten mußten kriechen und laufen, um die letzten 100 Meter des Weges in der Nähe von Periers zu überwinden. (3) Amerikanische Panzer, die die Gassen in der Nähe des Kölner Doms sichern sollten, geraten unter Feuer – ein Mitglied der Besatzung wird herausgeschleudert, als der Panzer rechts im Bild einen Treffer erhält.

Fin de partie

(1) Le 27 avril 1945 à Tourgau, des troupes américaines de la Première division tendent la main à des soldats russes sur un pont détruit de l'Elbe. (2) Feu et manœuvre dans le bocage de Normandie: des soldats de l'infanterie américaine contraints, par des francs-tireurs et des obus de 88 mm, d'avancer couchés. Ils doivent ramper et courir pour franchir les 100 derniers mètres de ce chemin près de Periers. (3) Des chars de l'armée américaine, qui dégagent les rues autour de la cathédrale gothique de Cologne, prennent feu. Un soldat parvient à s'échapper, le côté droit du char est touché.

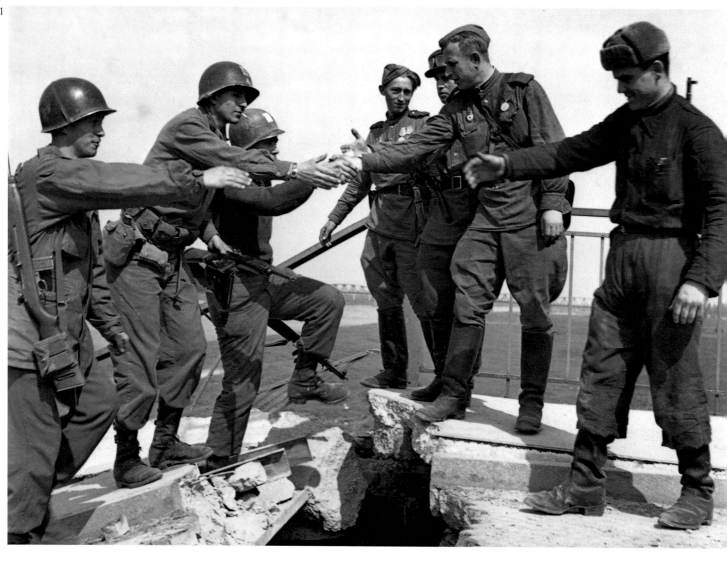

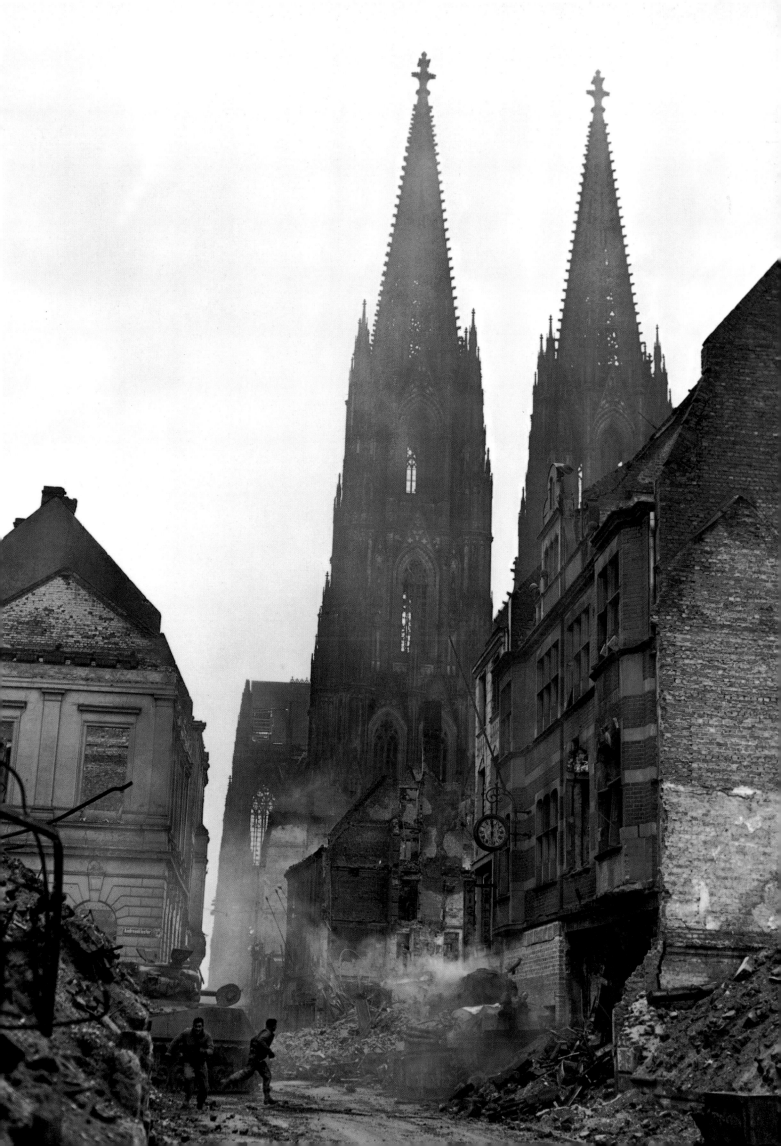

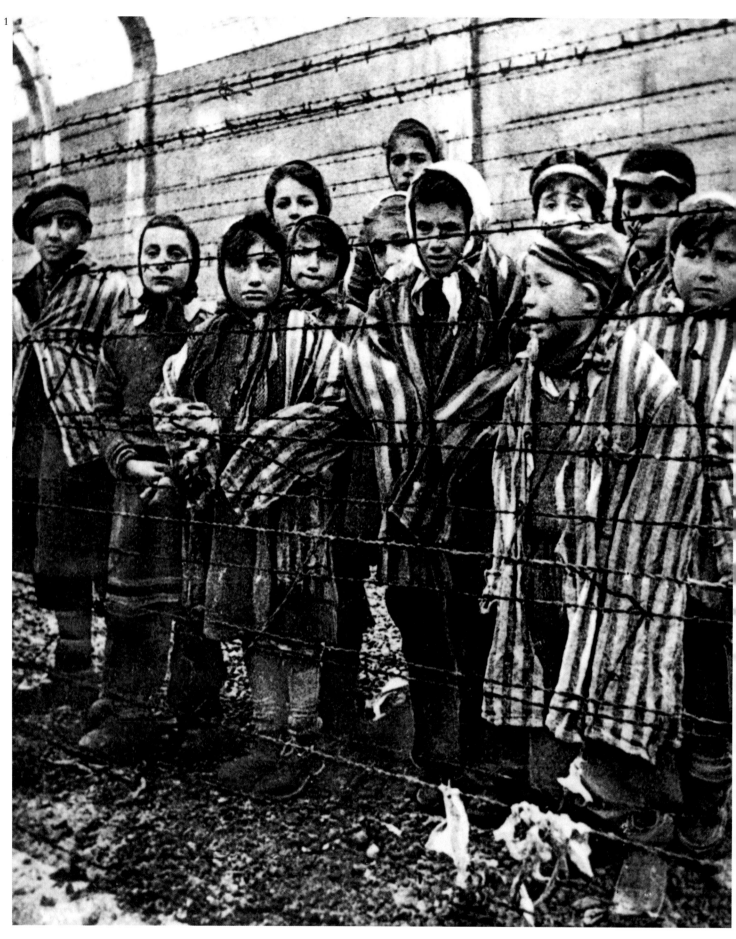

Oblivion: The Holocaust

In 1945 the horrors of the extermination camps administered by the Nazis stood revealed to the world. The numbers of people destroyed by Hitler's regime, and clients like the Ustashe dictatorship in Croatia, will never be known. At least six million Jews as well as gypsies and other ethnic and political undesirables were destroyed as a matter of policy – a policy of ruthless eradication on grounds of race and creed. (1) Children behind the wire in Auschwitz. (2) In Erla a Polish prisoner is discovered by allied troops in the last throes of starvation, his friend dead beside him. (3) Allied troops find truckloads of bodies at Buchenwald, ready for the last journey to the incinerator.

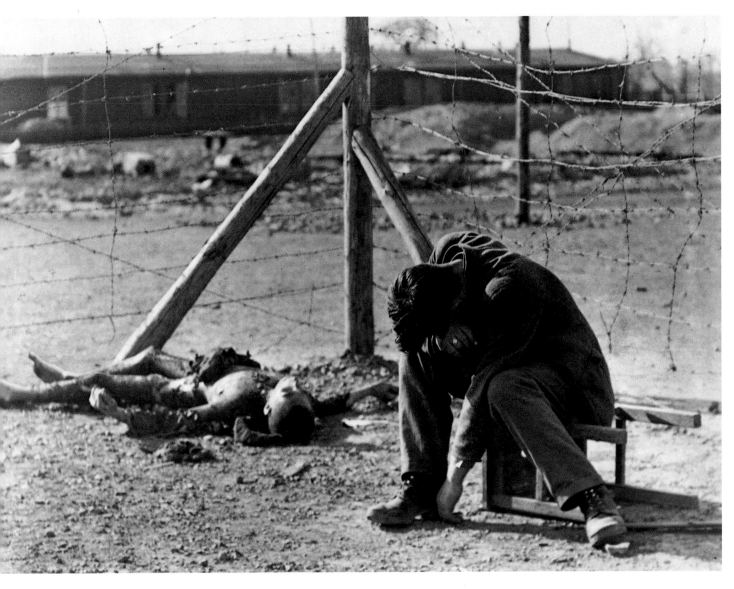

Vergessen: der Holocaust

1945 kamen die Greuel der von den Nazis verwalteten Vernichtungslager ans Licht der Weltöffentlichkeit. Die Zahlen der von Hitlers Regime und ähnlichen Diktatoren (etwa in Kroatien) ermordeten Menschen werden niemals genau bekannt werden. Mindestens sechs Millionen Juden sowie Sinti, Roma und andere ethnisch und politisch Unerwünschte wurden im Zuge einer politischen Strategie vernichtet – ein Handeln rücksichtsloser Ausmerzung aufgrund von Rasse und Überzeugung. (1) Kinder hinter dem Stacheldraht von Auschwitz. (2) In Erla wird ein polnischer Gefangener im letzten Stadium des Verhungerns von den alliierten Truppen gefunden, sein Freund liegt tot neben ihm. (3) Alliierte Truppen entdecken Lastwagen voller Leichen in Buchenwald, aufgeladen für ihre letzte Reise zu den Verbrennungsöfen.

L'horreur de l'holocauste

1945, les horreurs commises par les Nazis dans les camps de concentration sont révélées au monde. On ne connaîtra jamais le nombre exact de personnes qui ont péri sous le régime de Hitler et d'autres dictatures comme celle des Oustachis en Croatie. Plus de six millions de Juifs ainsi que des gitans et d'autres indésirables ethniques ou politiques ont été systématiquement exterminés, selon une politique d'élimination impitoyable fondée sur la race et les croyances religieuses. (1) Enfants à Auschwitz. (2) Erla, un prisonnier polonais mourant de faim. A côté de lui gît le corps de son ami. (3) A Buchenwald, des troupes alliées découvrent des camions chargés de corps qui allaient être conduits au four crématoire.

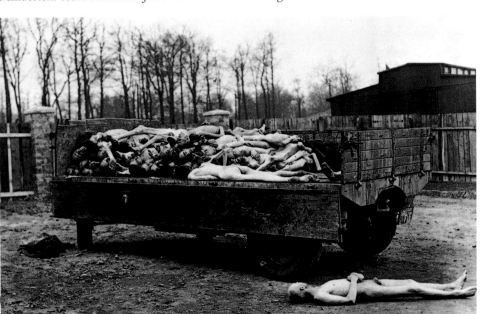

War at Home

Most civilians were to be directly involved in the war effort of the main combatants in the Second World War, producing supplies and support for the forces and in many cases becoming frontline targets to long-range aerial bombing. 'Keep the Home Fires Burning' and 'Dig for Victory' became slogans of an entirely new culture and way of life on the home front.

In the last week of August 1939, before Britain had declared war, children were moved out of the East End of London and other major cities which were thought likely to be targets for Germany's strategic bomber force. These children were the first war-time 'evacuees'. As night bombing intensified, some were packed off to the United States and Canada.

In continental Europe, children and other civilians were not so lucky, for they had little or no means of escape. The RAF began strategic bombing almost as soon as the Luftwaffe, which attacked southern England almost immediately after Chamberlain's declaration of war on 3 September. More than 100,000 tons of bombs were dropped on Germany by the RAF, which had a force of 1500 bombers, and the 8th and 5th US Air Forces, which had more than 2000 bombers in northern Europe by 1945. At least one million German civilians were killed by bombing, which made a surprisingly shallow dent in Germany's industrial output.

In Britain 100,000 women were conscripted by the Labour Minister, Ernest Bevin, to work in factories for war production. Initially 80,000 women were recruited for the 'Land Army' to work on farms. The work was arduous, long, and dangerous – but for many, it was a social liberation. In October 1943 the Archbishops of Canterbury and York warned that lax morals were posing 'a grave danger to the health of this nation'.

Following the evacuation of Dunkirk in 1940, the Home Guard was formed to defend Britain in the event of invasion, with 250,000 volunteers. Their enthusiasm and amateurishness – some had only pikes and staves – have become the stuff of legend.

By 1944 German industrial output reached its wartime peak under the direction of Albert Speer. Shortage of manpower, fuel and raw materials were growing problems; by late 1944 Germany relied on the enforced labour of more than seven million men and women, prisoners of war, slaves and residents of captured lands. Britain and the Commonwealth managed to produce more than 700 ships for the war, 135,000 aircraft and 160,000 armoured vehicles. But it was the manpower and industry of America and Soviet Russia which were to be decisive.

Along with the rest of Europe, Britain was subjected to severe food, fuel and clothing rationing; the delights of egg and milk powder and vegetarian sausages (8d. – 3p – a pound became features of the national diet. In December 1942 Sir William Beveridge's report recommended the peace-time establishment of the Welfare State, with free medical care, pensions and social security payments for the needy, producing in the depths of war one of the seeds of a reform which was to transform modern society.

Despite dissident voices, a new popular culture emerged through books and magazines such as *Picture Post* in Britain, *Signal* in Germany and *Life* in America. It was also the finest hour of the BBC domestic and overseas radio service – a medium peculiarly suited to Churchill's rich oratory.

The BBC became an invaluable link to the peoples of occupied Europe, and on occasion a crucial means of slipping coded messages to underground groups. Resistance in Europe took many different forms, from partisan armies in Yugoslavia, Albania and France to cells of saboteurs. In Yugoslavia the partisans in the civil war were led by Josip Broz, code-named Tito, secretary of the Communist Party and one of the most brilliant guerrilla generals of the century. In Italy the Communist-led partisans also became involved in a bloody civil war, after the formal surrender of the armed forces in 1943. In 1945 one group of partisans caught and killed the fleeing Mussolini and his mistress Clara Petacci, and with what many Italians regarded as unnecessary savagery hanged their bloody corpses in a Milan piazza.

Some agents showed astonishing bravery. Violette Szabo, an Anglo-Czech store worker, was parachuted into France as agent 'Louise', and was captured and shot in Ravensbrück in 1945. She was the first woman to be given the George Cross, Britain's highest gallantry award for civilians. The Lutheran pastor Dietrich Bonhoeffer showed astonishing moral as well as physical courage in the German Resistance, and in subsequent captivity, before he was hanged at Flossenbürg in 1945. His prison letters have inspired generations of Christians and liberals to this day.

Ein Großteil der Zivilisten war mehr oder weniger direkt am Kriegsgeschehen zwischen den Hauptgegnern des Zweiten Weltkriegs beteiligt. Sie produzierten Nachschub und Versorgungsmaterial für die Truppen und bildeten in vielen Fällen beliebte Angriffsziele für die Flächenbombardements aus großer Entfernung. »Halt den Ofen warm« und »Grabe für den Sieg« hießen die Slogans einer völlig neuen Kultur und Lebensweise an der Heimatfront.

In den letzten Augustwochen 1939 vor der Kriegserklärung Großbritanniens wurden Kinder aus dem Londoner East End und anderen Großstädten, von denen man vermutete, daß sie Ziele der deutschen Bombardierung darstellten, ausquartiert. Diese Kinder waren die ersten »Kriegsevakuierten«. Als die Nachtangriffe zunahmen, schickte man einige von ihnen in die Vereinigten Staaten und nach Kanada.

Im übrigen Europa hatten Kinder und andere Zivilisten nicht so viel Glück: Für sie gab es nur wenige oder keine Fluchtmöglichkeiten. Die britische Royal Air Force begann

A British observer watches as a searchlight hunts for incoming German bombers. The Luftwaffe switched to night attacks after the failure of its daytime Blitz of London in autumn 1940. Civilians were to be involved in home defence throughout Europe in a way not seen before in modern warfare.

Ein britischer Beobachter folgt den Suchscheinwerfern auf der Jagd nach anfliegenden deutschen Bombern. Die deutsche Luftwaffe ging zu Nachtangriffen über, nachdem sie mit den Tagangriffen auf London im Herbst 1940 keinen Erfolg gehabt hatte. In ganz Europa nahmen Zivilisten in bislang unbekanntem Ausmaß an der Heimatverteidigung teil.

Un observateur britannique scrute le ciel éclairé par un projecteur qui traque l'arrivée des bombardiers allemands. Automne 1940, la Luftwaffe lance des attaques nocturnes après l'échec du Blitz de Londres. Partout en Europe, les civils seront impliqués dans la défense de leur pays comme jamais auparavant dans une guerre moderne.

fast zur gleichen Zeit mit strategischen Bombardierungen wie die deutsche Luftwaffe, die Südengland fast unmittelbar nach Chamberlains Kriegserklärung am 3. September angriff. Mehr als 100 000 Tonnen Bomben wurden von 1500 Bombern der RAF und von der 5. und 8. US Air Force, die über 2000 Bomber in Westeuropa stationiert hatte, bis 1945 auf Deutschland abgeworfen. Mindestens eine Million deutsche Zivilisten kamen bei Bombardements ums Leben; ein Verlust, der erstaunlich geringe Auswirkungen auf die deutsche Industrieproduktion hatte.

In Großbritannien wurden 100 000 Frauen von Arbeitsminister Ernest Bevin zum Dienst in der Rüstungsindustrie verpflichtet. Ursprünglich waren 80 000 Frauen für die sogenannte »Landarmee« rekrutiert worden, um in der Landwirtschaft zu arbeiten. Die Arbeit war schwer, lang und

gefährlich, aber viele Frauen erlebten sie als soziale Befreiung. Im Oktober 1943 warnten die Erzbischöfe von Canterbury und York, daß die losen Sitten »eine schwerwiegende Gefahr für die Gesundheit unserer Nation« darstellten.

Nach der Evakuierung von Dünkirchen 1940 wurde die »Home Guard« mit 250 000 Freiwilligen zur Verteidigung Großbritanniens im Fall einer Invasion gegründet. Ihre Begeisterung und Improvisationsfähigkeit – einige hatten nur Piken und Knüppel – waren legendär.

1944 erreichte die deutsche Industrieproduktion unter der Leitung von Albert Speer ihren Höhepunkt. Knappheit bei Personal, Treibstoff und Rohmaterial stellten die Industrie vor ständig wachsende Probleme. Ende 1944 war Deutschland auf die Zwangsarbeit von mehr als sieben Millionen Männern und Frauen, Kriegsgefangenen und Bewohnern der besetzten

Länder angewiesen. Großbritannien und der Commonwealth produzierten mehr als 700 Kriegsschiffe, 135 000 Flugzeuge und 160 000 gepanzerte Fahrzeuge. Aber entscheidend für den Kriegsverlauf erwiesen sich die Arbeitskraft und die Industrie in Amerika und in der Sowjetunion.

Wie das übrige Europa war Großbritannien massiven Rationierungen bei Lebensmitteln, Treibstoff und Kleidung unterworfen. »Köstlichkeiten« wie Ei- und Milchpulver oder vegetarische Würstchen (8 Schilling, 3 Pence das Pfund) entwickelten sich zu festen Bestandteilen der englischen Küche. Im Dezember 1942 schlug Sir William Beveridge für die erhofften Friedenszeiten die Einrichtung des Wohlfahrtstaates mit freier Gesundheitsfürsorge, Pension und Sozialversorgung der in Not Geratenen vor. Damit wurde mitten im Krieg der Grundstein für eine Reform gelegt, die die englische Gesellschaft grundlegend verändern sollte.

Gegen einigen Widerstand entwickelte sich durch Bücher und Magazine wie *Picture Post* in Großbritannien, *Signal* in Deutschland und *Life* in den Vereinigten Staaten eine neue öffentliche Kultur. Für die nationalen und internationalen Radiosendungen der BBC schlug ebenfalls die große Stunde. Das neue Medium wurde vor allem ein Sprachrohr für die großartige Redekunst Winston Churchills.

Die BBC entwickelte sich zu einem wichtigen Verbindungsglied zu den Völkern des besetzten Europas, wobei gelegentlich auch kodierte Nachrichten an Partisanentruppen geschickt wurden. Der Widerstand in Europa nahm viele verschiedene Formen an, er reichte von Partisanenarmeen in Jugoslawien, Albanien und Frankreich bis zu kleinen Sabotagegruppen. In Jugoslawien wurden die Partisanen während des Bürgerkriegs von Josip Broz – Kodename Tito –, dem Sekretär der Kommunistischen Partei und einem der brilliantesten Guerillageneräle des 20. Jahrhunderts geführt. In Italien standen die Kommunisten nach der förmlichen Kapitulation der italienischen Streitkräfte 1943 ebenfalls in einem Bürgerkrieg. 1945 faßte und ermordete eine Partisanengruppe den flüchtigen Mussolini und seine Geliebte Clara Petacci. Ihre blutigen Leichen wurden auf einem Platz in Mailand aufgehängt – eine Geste, die von vielen Italienern für übertrieben grausam gehalten wurde.

Einige Geheimagenten bewiesen bemerkenswerte Tapferkeit. Violette Szabo, eine Anglo-tschechische Verkäuferin landete als Agentin »Louise« mit einem Fallschirm in Frankreich. 1945 wurde sie gefaßt und in Ravensbrück erschossen. Als erste Frau erhielt sie das Georgskreuz, den höchsten britischen Tapferkeitsorden für Zivilisten. Der Theologe Dietrich Bonhoeffer bewies während mehrerer Gefängnisaufenthalte große moralische Integrität und körperlichen Mut im deutschen Widerstand. Er wurde 1945 in Flossenbürg gehängt. Seine Briefe aus dem Gefängnis haben bis zum heutigen Tag Generationen von Christen und liberalen Denkern inspiriert.

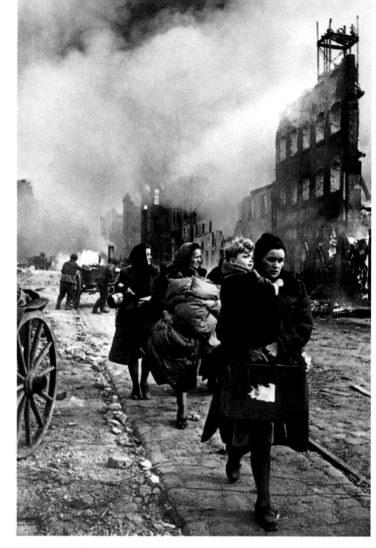

La société contribuera à l'effort de guerre des principaux belligérants de la Deuxième Guerre mondiale en participant à la production d'armes et au soutien des troupes. Les civils seront souvent les cibles d'une longue série de bombardements aériens. «Que la vie continue» et «En avant pour la victoire» deviendront les slogans d'une culture et d'un mode de vie nouveaux en Grande-Bretagne.

En août 1939, durant la semaine qui précède la déclaration de guerre de la Grande-Bretagne, les enfants de l'Est de Londres et d'autres grandes villes susceptibles d'être bombardées par les Allemands sont déplacés. Ce sont les premiers «évacués» de la guerre. Avec l'intensification du bombardement nocturne, certains seront expédiés aux Etats-Unis et au Canada.

Sur le continent, les enfants et les civils n'ont pas cette chance. Ils ont peu ou pas de moyens de fuir. La RAF riposte par des bombardements stratégiques à l'attaque lancée par la Luftwaffe sur le sud de l'Angleterre, après la déclaration de Chamberlain le 3 septembre. De 1939 à 1945, plus de 100 000 tonnes de bombes auront été lâchées sur l'Allemagne par la RAF et ses 1500 bombardiers et par les 8e et 5e flottes de l'US Air Force dont plus de 2000 appareils sont basés au nord de l'Europe. Au moins un million d'Allemands périront sous les bombardements qui, paradoxalement, n'anéantiront qu'à peine la production industrielle allemande.

En Grande-Bretagne, 100 000 femmes sont enrôlées par le ministre du Travail, Ernest Bevin, pour travailler en usine à la production d'armes. A l'origine, 80 000 femmes avaient été

(1) Millions had to abandon homes wrecked from bombing raids and the advance and retreat of armies in central Europe. (2) Food rations are issued to some young evacuees from London as they arrive in the village of Amersham – for some it was the first time they had seen the countryside.

(1) Millionen von Menschen in Mitteleuropa mußten ihre von Bombenangriffen und sich zurückziehenden Armeen zerstörten Häuser verlassen. (2) Nach ihrer Ankunft in der Ortschaft Amersham werden Lebensmittelrationen an einige junge Evakuierte aus London verteilt. Einige von ihnen kamen zum ersten Mal in ihrem Leben aufs Land.

(1) Europe centrale, des millions de personnes fuient leurs maisons détruites par les bombardements et les armées qui avancent ou font retraite. (2) Amersham, village anglais, des enfants évacués de Londres reçoivent des rations de nourriture. Certains voient la campagne la première fois.

2

recrutées par le «corps de travailleuses agricoles» pour travailler à la ferme. La tâche est dure, longue et dangereuse mais, pour beaucoup, c'est une libération sociale. En octobre 1943, les Archevêques de Canterbury et de York mettent en garde contre le relâchement des mœurs qui est «un danger grave pour la santé de la nation».

Après l'évacuation de Dunkerque en 1940, le Home Guard (défense civile) est créé pour défendre la Grande-Bretagne en cas d'invasion et comprend plus de 250 000 volontaires. Leur enthousiasme et leur amateurisme, certains n'ont pour seules armes que des piques et des douves, les rendront légendaires.

En 1944, dirigée par Albert Speer, la production industrielle allemande n'a jamais été aussi élevée. Le manque de main d'œuvre, de carburant et de matières premières est un problème grandissant. Fin 1944, l'Allemagne compte encore sur une main d'œuvre enrôlée de force de plus de sept millions d'hommes et de femmes, sur ses prisonniers de guerre, esclaves et sur les habitants des pays conquis. Durant la guerre, la Grande-Bretagne et le Commonwealth produiront plus de 700 navires, 135 000 avions et 160 000 véhicules blindés. Mais ce sont les effectifs et la production des Américains et des Russes qui seront déterminants.

Comme le reste de l'Europe, la Grande-Bretagne impose un rationnement strict de la nourriture, du carburant et des vêtements. L'œuf, le lait en poudre et les saucisses végétariennes sont des denrées de luxe au menu du régime national. En décembre 1942, le rapport de Sir Beveridge préconise l'instauration en temps de paix du Welfare State (l'État-providence): gratuité des soins médicaux, allocations de retraite et de sécurité sociale pour les nécessiteux. Au plus profond de la guerre, ce rapport met en place une réforme qui transformera la société moderne.

Malgré des voix dissidentes, une nouvelle culture populaire émerge à travers des livres et des revues comme le *Picture Post* en Grande-Bretagne, *Signal* en Allemagne et *Life* aux États-Unis. Ce sont aussi les plus grands moments de la BBC nationale et outre-mer, le moyen de communication idéal pour retransmettre les discours éloquents de Churchill.

La liaison avec la BBC est essentielle pour l'Europe occupée et jouera parfois un rôle crucial pour diffuser des messages codés aux organisations clandestines. En Europe, la résistance prend diverses formes, des armées partisanes en Yougoslavie, en Albanie et en France aux cellules de sabotage. En Yougoslavie, les partisans de la guerre civile sont menés par Josip Broz, nom de code Tito, secrétaire du Parti communiste et l'un des généraux de guérilla les plus brillants de ce siècle. En Italie, les partisans communistes sont impliqués dans une guerre civile meurtrière, après la reddition en forme des forces armées en 1943. En 1945, des partisans capturent et tuent Mussolini et sa maîtresse Clara Petacci alors en fuite et pendent leurs corps sur une place de Milan, un geste que beaucoup d'Italiens jugent sauvage et inutile.

Certains agents feront preuve d'un courage remarquable. Violette Szabo, une vendeuse anglo-tchèque, est parachutée en France sous son nom d'agent «Louise». Elle sera faite prisonnière et tuée à Ravensbrück en 1945. Elle est la première femme à recevoir la *George Cross,* la plus haute décoration civile britannique. Le pasteur luthérien, Dietrich Bonhoeffer, fera preuve d'une éthique infaillible et d'un grand courage physique dans la résistance allemande puis en captivité avant d'être pendu à Flossenbürg en 1945. Ses lettres de prisonnier ont inspiré des générations de chrétiens et de penseurs libres.

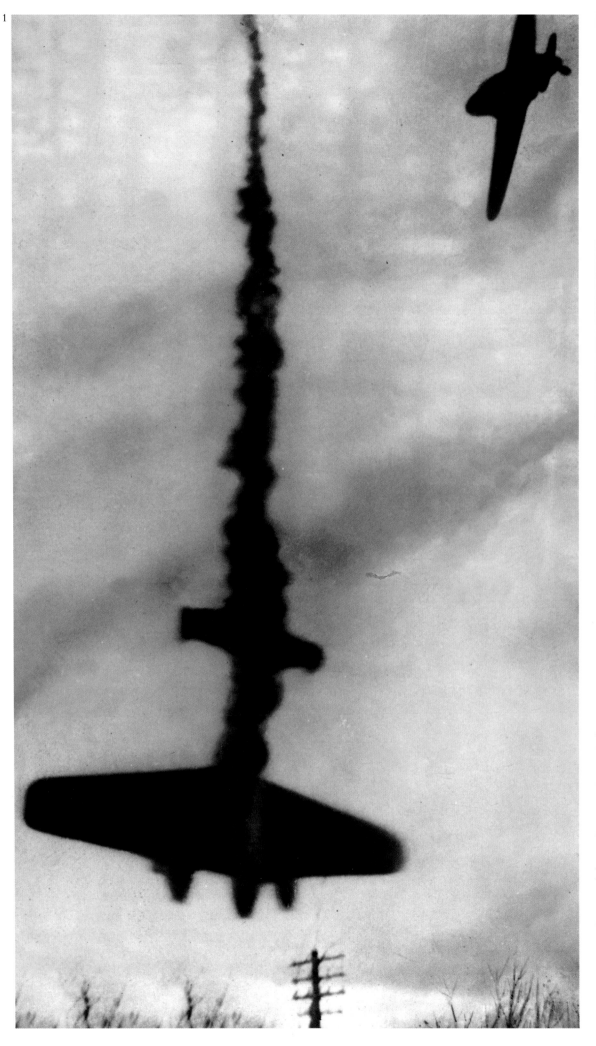

1

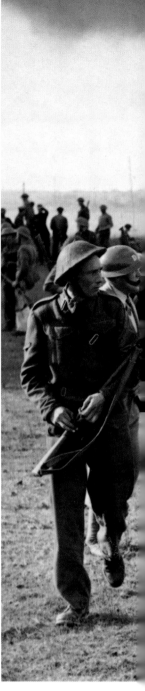

The Battle of Britain
In the late summer of 1940
German and RAF planes
fought duels over southern
and eastern England. (1) A
Heinkel III bomber is shot
down by a Hurricane over
Goodwood, Sussex, 10
August 1940. (2) The crew,
who parachuted, are taken
in by members of the
Home Guard as their plane
burns in the distance.
(3) The view of a passing
Spitfire from the rear turret
of a Heinkel III in a
dogfight, 19 May 1941.

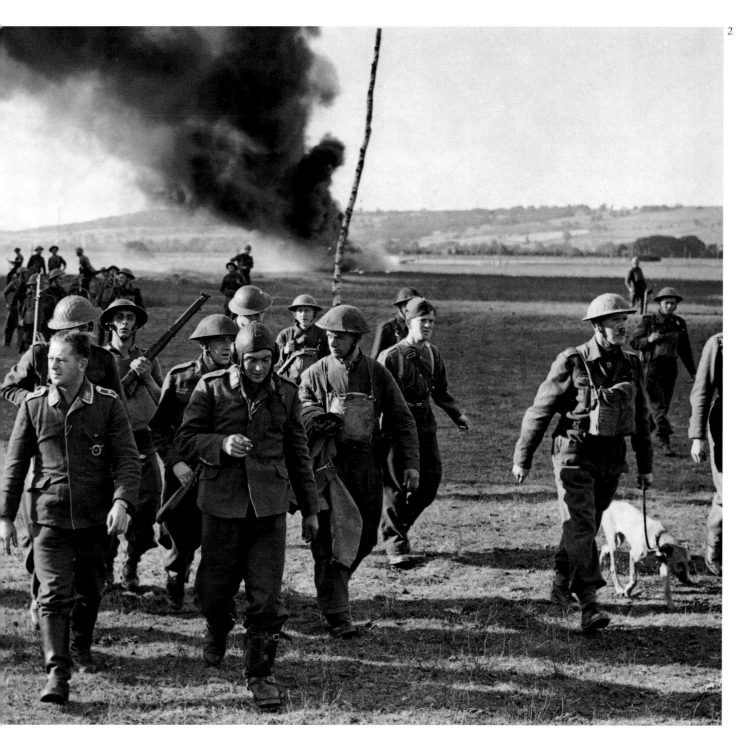

Die Schlacht um England

Im Spätsommer 1940 liefer-
en sich die deutsche Luft-
waffe und die RAF Gefechte
über dem Süden und Osten
Englands. (1) Ein von einer
Hurricane abgeschossener
Heinkel He-III-Bomber bei
Goodwood, Sussex, 10. Au-
gust 1940. (2) Die mit Fall-
schirmen abgesprungene Be-
atzung wird von Mitgliedern
der »Home Guard« gefangen-
genommen; im Hintergrund
das brennende Wrack.
(3) Eine vorbeifliegende Spit-
fire im Gefecht, gesehen vom
hinteren Geschützstand einer
He-III, 19. Mai 1941.

La bataille d'Angleterre

A la fin de l'été 1940, les
avions allemands et britanni-
ques se battent au-dessus du
sud-est de l'Angleterre. (1) 10
août 1940, un bombardier
Heinkel III est abattu par un
Hurricane au-dessus de
Goodwood, Sussex.
(2) L'équipage, qui s'est éjecté,
est emmené par des membres
du Home Guard. Leur avion
est encore en feu. (3) 19 mai
1941, lors d'un combat entre
avions de chasse, vue sur un
Spitfire de l'arrière d'une
tourelle de Heinkel III.

The Blitz

(1) Londoners stack their belongings and furniture in the road after their street is hit in a night bombing raid, 7 September 1940.
(2) Firemen bring their hoses to bear during a fire-bomb raid in the City of London.
(3) Coventry cathedral reduced to a shell after a heavy bombing raid on the night of 16 November 1940. Coventry was hit later in the 'Baedeker raids', so named because it was believed the targets were towns listed in the celebrated Baedeker guides to Britain.

Der »Blitz«

(1) Londoner Bürger bringen nach einem Nachtangriff auf ihren Straßenzug ihr Hab und Gut aus den Häusern, 7. September 1940. (2) Feuerwehrleute bringen ihre Schläuche während eines Brandbomben-angriffs auf die Londoner City in Position. (3) Die Kathedrale von Coventry ist nach einem massiven Bombardement in der Nacht des 16. November 1940 zu einer Ruine zusammengefallen. Coventry wurde später während der sogenannten »Baedeker-Angriffe« getroffen. Die Angriffe erhielten ihren Namen, weil man vermutete, daß die Ziele aus dem Baedeker-Reiseführer für Großbritannien ausgewählt worden waren.

Le Blitz

(1) 7 septembre 1940, des Londoniens rassemblent leurs affaires et meubles dans leur rue touchée pendant le bombardement de la nuit précédente. (2) Des pompiers déploient leurs tuyaux après un raid de bombes incendiaires sur la City de Londres. (3) La cathédrale de Coventry est presque entièrement détruite lors d'un bombardement massif dans la nuit du 16 novembre 1940. Coventry sera touchée lors des « raids Baedeker », nommés ainsi parce que les cibles étaient des villes citées dans le célèbre guide Baedeker de la Grande-Bretagne.

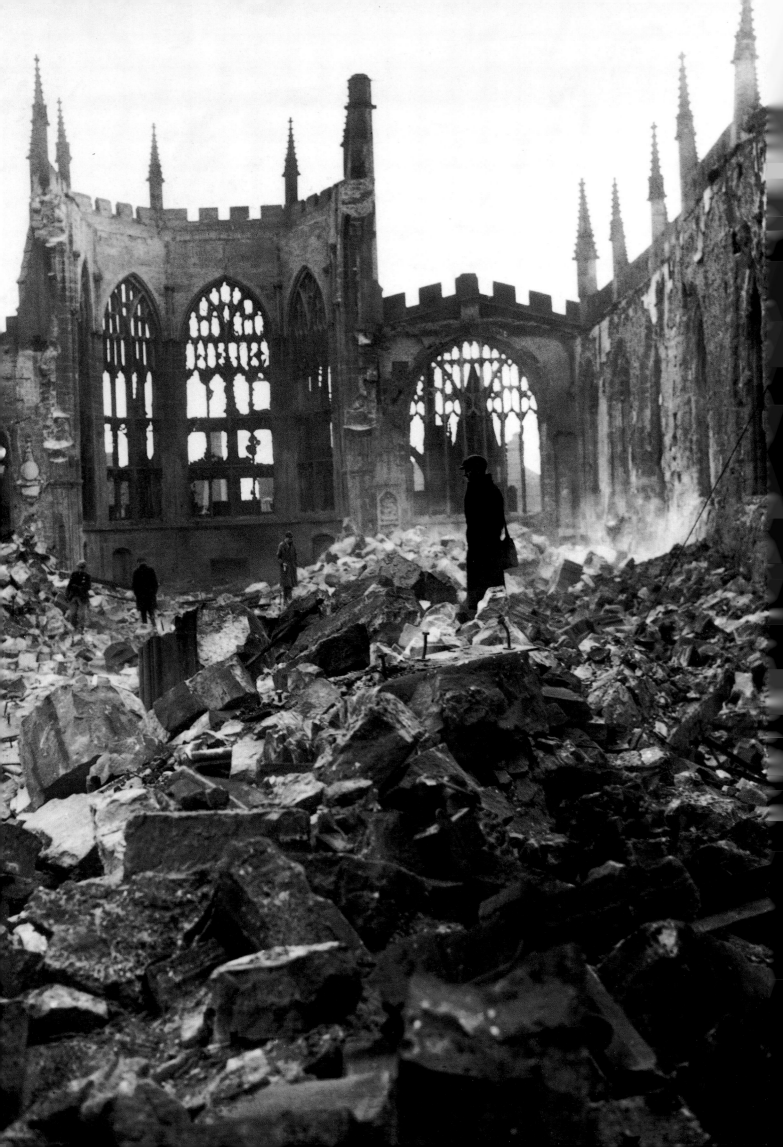

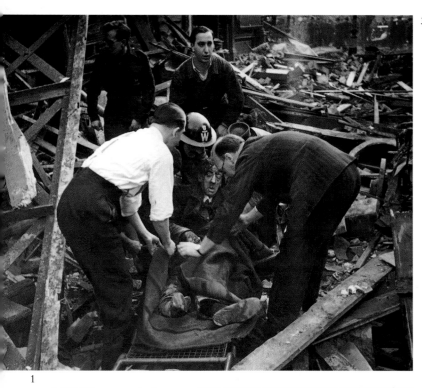

1

2

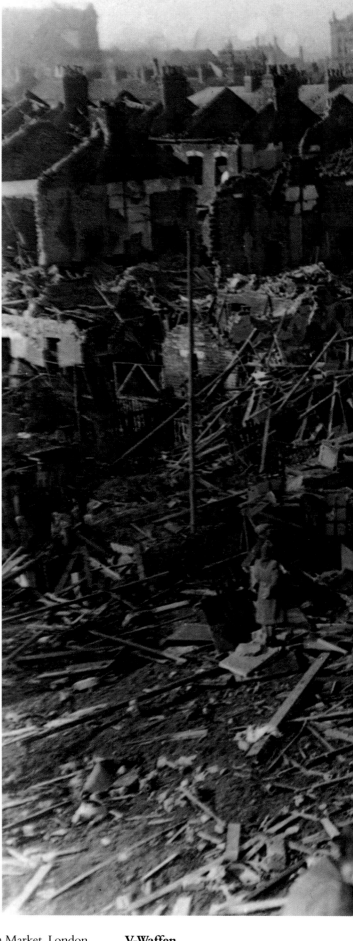

3

V-Bombs

In 1944 Hitler's forces launched their new secret weapons against Britain, the pilotless V-1 and more sophisticated V-2 bombs. The V-1s were inaccurate and noisy, hence the nickname 'doodlebugs'. The V-2 was almost impossible to bring down, and over 3000 were fired. (1) A victim being rescued from a V-2 attack on Farringdon Market, London, which killed 300. (2) A trainload of V-2 projectiles captured by the US Army at Bromskirchen, Germany, 1945. (3) The devastation of a V-bomb attack on Stratford, East London.

V-Waffen

1944 richteten Hitlers Streitkräfte ihre neue Geheimwaffe gegen Großbritannien: die unbemannte V1 und die verbesserte V2-Rakete. Die V1 waren wenig zielsicher und relativ laut, was ihnen den Spitznamen »Dudelkäfer« eintrug. Die V2 dagegen war so gut wie nicht abzuschießen; über 3000 dieser Bomben

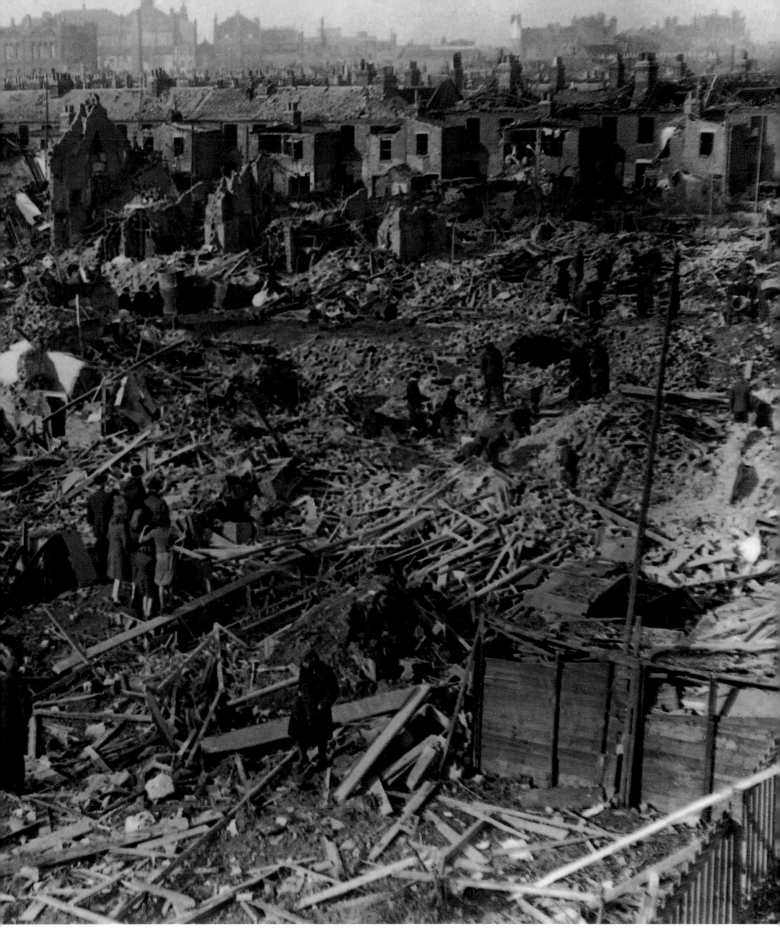

wurden abgefeuert. (1) Das Opfer einer V2-Rakete auf Farringdon Market, London, wird geborgen. Bei diesem Angriff kamen mehr als 300 Menschen ums Leben. (2) Eine Zugladung von V2-Projektilen, die 1945 von der US-Armee in Bromskirchen erobert wurden. (3) Zerstörungen durch einen V-Raketenangriff auf Stratford, im Osten Londons.

Les armes V

En 1944, les armées de Hitler utilisent leurs nouvelles armes secrètes contre la Grande-Bretagne, les V-1 sans pilote et les V-2, des bombes plus sophistiquées. Les V-1, surnommés les «bombes volantes», sont bruyants et peu précis. Par contre, il est presque impossible d'abattre les V-2 dont plus de 3000 seront lancés. (1) Sauvetage d'une victime après une attaque de V-2 sur le marché de Farrington, Londres, qui fait 300 victimes. (2) 1945, un train chargé de projectiles V-2, intercepté par l'armée américaine à Bromskirchen en Allemagne. (3) Stratford, un quartier extérieur de Londres, dévasté par des bombes V.

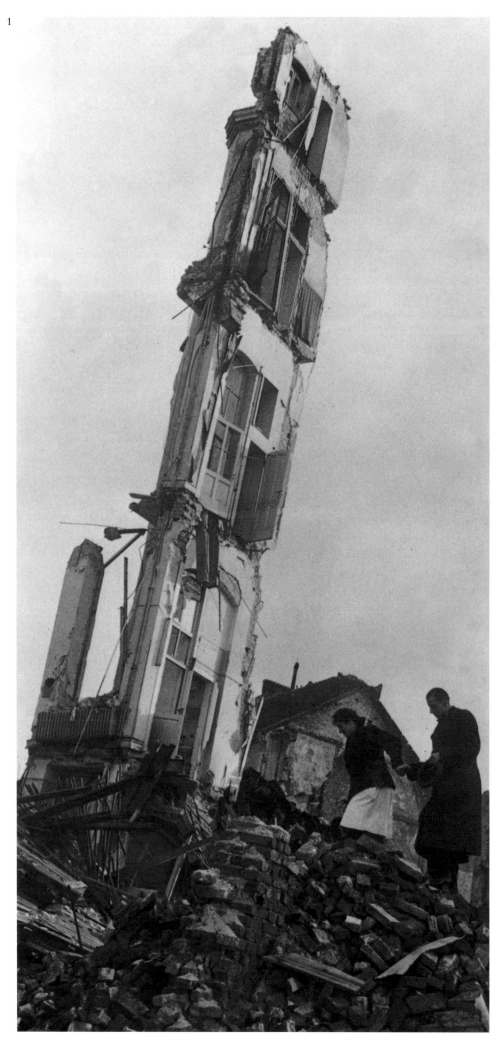

Strategic Bombing of Germany

The RAF, joined later by the 8th and 5th US Tactical Air Forces, carried out extensive strategic bombing raids on Germany. They did not stop the steady increase of industrial output until after 1943, however. Many of the victims were civilians, among them thousands of refugees killed in Dresden in February 1945. (1) The remains of an apartment house after a raid on Cologne. (2) The view through the bomb bay of an American bomber during a raid on the Bremen dockyards, 20 December 1943.

Strategische Bombardierungen in Deutschland

Die RAF, der sich später die 8. und 5. US Tactical Air Force anschloß, führte umfangreiche strategische Bombenangriffe auf Deutschland durch. Allerdings gelang es ihr erst ab Ende 1943, das ständige Ansteigen der Industrieproduktion zu stoppen. Viele der Opfer waren Zivilisten, unter ihnen Tausende von Flüchtlingen, die im Februar 1945 in Dresden getötet wurden. (1) Die Überreste eines Wohnhauses nach einem Angriff auf Köln. (2) Der Blick aus dem Bombenschacht eines amerikanischen Bombers während des Luftangriffs auf die Bremer Werften, 20. Dezember 1943.

Bombardements stratégiques de l'Allemagne

La RAF, bientôt rejointe par les 8ᶜ et 5ᶜ US Tactical Air Forces, effectue des bombardements stratégiques sur l'Allemagne mais ne parvient pas à freiner la production industrielle en constante augmentation jusqu'en 1943 et plus tard. La plupart des victimes sont des civils. Parmi eux, des milliers de réfugiés sont tués à Dresde en février 1945. (1) Vestiges d'un immeuble après un raid sur Cologne. (2) Vue de la soute à bombes d'un bombardier américain pendant le raid du 20 décembre 1943 sur les chantiers de constructions navales de Brême.

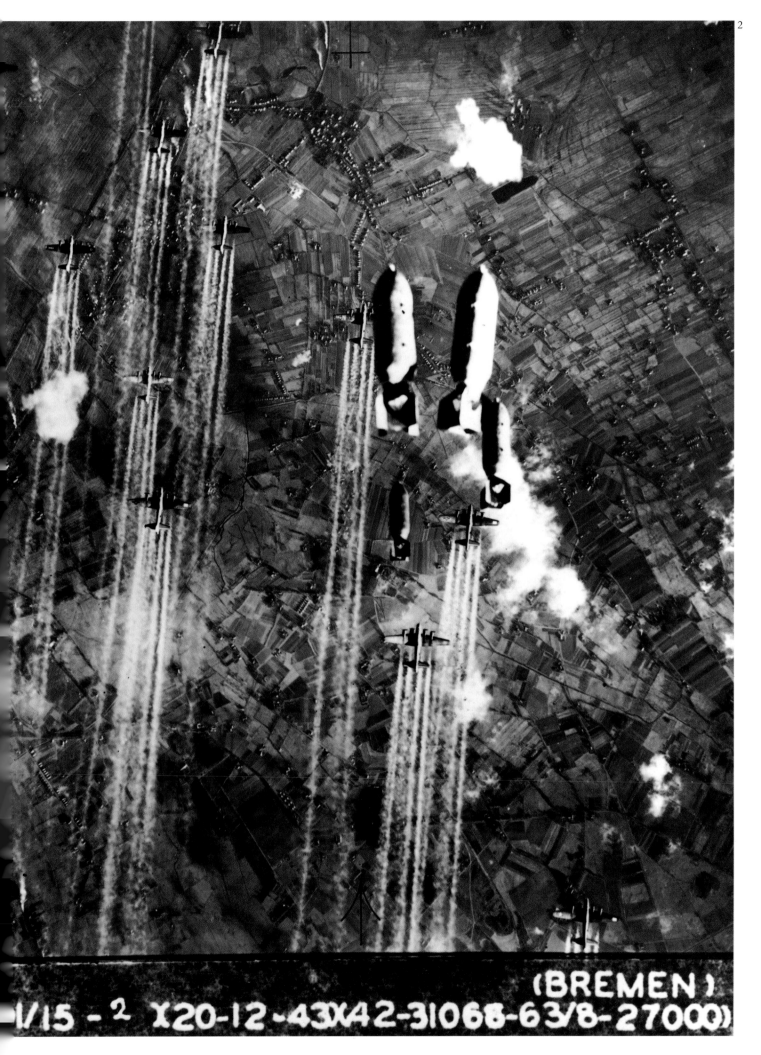

(BREMEN)

1/15 - 2 X20-12-43X42-31068-63/8-27000)

Women at Work

Thousands of women were recruited to work in armaments factories. (1) Miss Elsie Yates, a former waitress, works on the automatic pilot 'George' in the nose of an Avro Lancaster bomber. (2) The recruits to the Mechanised Transport Training Corps bought their own uniform. A recruit changes a wheel in Lambeth, London. (3) Fewer women were called to work in Germany, as they were needed at home to promote Aryan motherhood. This one became a welder for Messerschmitt. The original caption said 'Millions of women are hard at work fulfilling their duty, and we are proud they are doing their bit.'

Frauen bei der Arbeit

Tausende von Frauen wurden zur Arbeit in der Rüstungsindustrie eingezogen. (1) Elsie Yates, eine ehemalige Kellnerin, arbeitet im Cockpit eines Avro Lancaster-Bombers an dem Autopiloten »George«. (2) Die Rekruten des Mechanised Transport Training Corps kauften ihre eigenen Uniformen. Ein Rekrut beim Radwechsel in Lambeth, London. (3) In Deutschland zog man weniger Frauen zum Arbeitsdienst ein, da sie daheim zur Förderung der arischen Mutterschaft gebraucht wurden. Diese Frau war Schweißerin in den Messerschmitt-Flugzeugwerken. Die Originalunterschrift lautete: »Millionen von Frauen arbeiten hart, um ihre Pflicht zu erfüllen, und wir sind stolz, daß sie ihren Teil beitragen.«

Les femmes au travail

Des milliers de femmes sont appelées à travailler dans les usines d'armement. (1) Miss Elsie Yates, une ex-serveuse, à l'œuvre sur le pilotage automatique « George », se tient dans le nez d'un bombardier Avro Lancaster. (2) Les recrues du Mechanised Transport Training Corps ont leurs propres uniformes. Une recrue en train de changer une roue à Lambeth, Londres. (3) Peu de femmes seront enrôlées en Allemagne. Elles doivent rester à la maison pour promouvoir l'image de la mère aryenne. Cette femme travaille comme soudeuse chez Messerschmitt. La légende d'origine disait « Des millions de femmes travaillent dur et accomplissent leur devoir. Nous sommes fiers qu'elles participent à l'effort ».

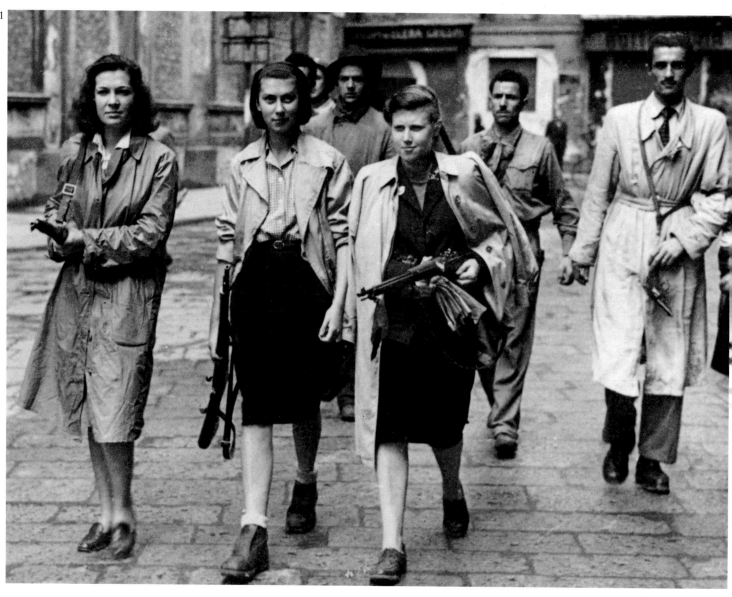

Partisans and Resistance

Under German occupation irregular resistance groups and partisan forces formed, and were to play an important political as much as military role in the liberation of Europe. (1) Partisans associated with the Partito d'Azione celebrating the liberation of Milan in the spring of 1945. (2) A *cheta* of Albanian partisans parade their home-made and British weaponry and the Albanian flag bearing the double eagle. (3) A beaming member of the French Forces of the Interior brandishes his British-supplied Bren gun before two admirers in the town of Châteaudun.

Partisanen und Widerstand

Unter der deutschen Besatzung bildeten sich Widerstandsgruppen und Partisanenarmeen. Sie spielten bei der Befreiung Europas eine entscheidende politische und militärische Rolle. (1) Partisanen, die dem Partito d'Azione zugerechnet wurden, feiern die Befreiung Mailands im Frühjahr 1945. (2) Eine Einheit albanischer Partisanen präsentiert selbstgebaute und britische Waffen sowie die albanische Flagge mit dem Doppeladler. (3) Ein strahlendes Mitglied der französischen Partisanenarmee schwingt in Châteaudun vor zwei Bewunderern sein von den Briten zur Verfügung gestelltes Bren-Gewehr.

Les partisans et la résistance

Sous l'occupation allemande, des groupements de résistants et des armées de partisans se forment. Ils joueront un rôle important, autant politique que militaire, dans la libération de l'Europe. (1) Printemps 1945, des partisans associés au Partito d'Azione célèbrent la libération de Milan. (2) Une cheta de partisans albanais posent avec leurs armes ou des armes anglaises avec le drapeau albanais et ses deux aigles. (3) A Châteaudun, un membre des Forces françaises de l'intérieur pose, radieux, devant deux admirateurs et brandit son fusil Bren, fourni par les Britanniques.

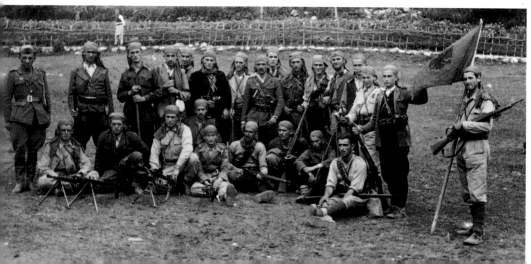

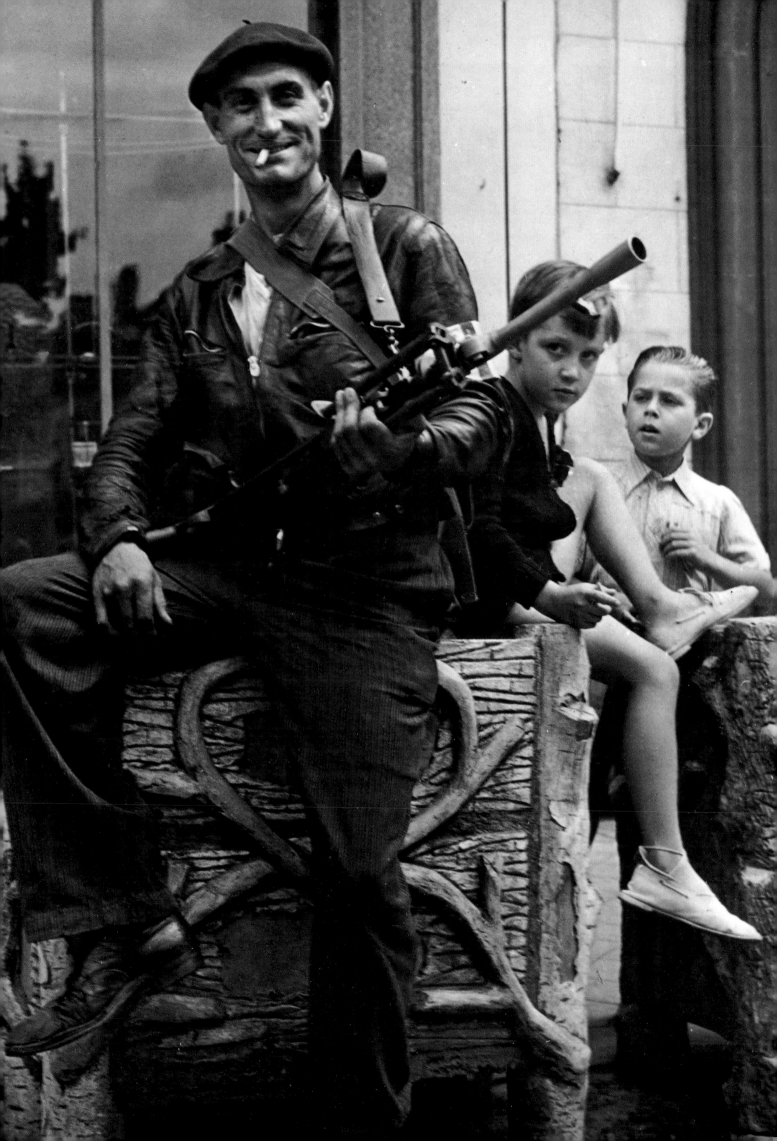

The Great Patriotic War

On the morning of 21 June 1941 more than three million men and more than 150 German and allied divisions crossed into Soviet Russia. Operation Barbarossa was Hitler's project to seize major cities such as Moscow and Kiev and destroy the Red Army, which he told his generals could be accomplished by winter.

At first the Russian forces were sent spinning. The armoured Panzer corps under Guderian and Von Manstein had rounded up more than 600,000 prisoners and destroyed 6000 tanks. But within a month the headlong offensive was flagging. The leading armoured units were in desperate need of replenishment with fuel and ammunition. The infantry divisions, which had moved almost entirely on foot, were up to a hundred miles in the rear; the already creaking logistical system was on the point of breaking. By mid-August the Germans had suffered 400,000 casualties, nearly a tenth of their total strength.

By autumn the German Army Group North had surrounded Leningrad, beginning a siege that was to last more than 900 days and in which one million Russians would lose their lives to hunger, cold or enemy bombardment. In September Operation Typhoon was launched to capture Moscow, the first turning point of the campaign in the east and the war in Europe. The Russians built defences in depth round the city, and in freezing conditions the German advance stopped 25 miles away. It was only then that Georgi Zhukov led a successful counter-attack, on 6 December, the day before the Japanese bombed Pearl Harbor. Hitler had failed to knock out the Red Army and conquer Russia by the end of 1941. The German armies were stuck in the snow and mud, but had inflicted terrible damage on their foe.

The appalling treatment of prisoners of both sides contributed to the ferocity of the war on the Eastern Front. It was ideological – Nazi against Communist; ethnic – German against Slav; and on the Russian side a fight for the homeland. For all the fear of Stalin's brutal regime, it was the Great Patriotic War.

Among the prisoners were millions of Jews of eastern Europe. Their large number led Reinhard Heydrich, the Nazi Governor of Bohemia, to advocate the extermination of the Jews – 'the final solution'. Heydrich was blown up in his car in Prague, the work of two Czech partisans flown in by the RAF for the purpose. As a reprisal 199 males of the village of Lidice near Prague were shot, the women and children sent to the camps, and the village razed to the ground in June 1942.

That year the Germans cut through the Caucasus, capturing Sevastopol, arriving at Stalingrad on the Volga in September. Within weeks they had taken most of the city and almost encircled the Russian defenders to its rear. In the depth of winter, however, the Russians slowly tightened the noose round the German pocket. Paulus was ordered to stand and fight rather than break out to link up with Von Manstein' Army Group South. A day after ordering his men to fight to the last, Paulus surrendered the Sixth Army. The whole Stalingrad offensive cost the Germans a million casualties.

Hitler then ordered the 'Citadel' offensive to squeeze the Soviet armies in the Kursk salient. The Russians had exact intelligence of when the attack would begin, on 5 July 1943 and put down the heaviest artillery barrage in modern conventional warfare. Kursk showed the Russians using their new concept of 'shock attack', still studied and used by armies east and west. At the moment of battle the artillery tries to punch a hole in the enemy, and infantry and airborne troops engage to clear a path for the tanks and guns moving forward. Tanks are allowed to charge forward until they run out of fuel and ammunition or break down. The Russian T 34 tank was ideally suited to these tactics; the other key weapon was the multi-barrelled Katyusha rocket launcher 'Stalin's Organ'.

In 1944 Marshal Zhukov feinted attacks north and south, but then hit Army Group Centre a crushing blow, destroying 17 divisions and beginning the advance into Poland and eventually to Berlin. By mid-April the Russians had a total force of more than 2.5 million closing in on the 1.25 million Germans round Berlin. At huge cost the Russians took the Reichstag by 2 May 1945, and the young Russian soldier sticking the Red Flag into the charred roof is one of the most powerful images of the war. The Russians had started the war as Hitler's allies. They finished by taking his ruined capital in a conflict that nearly cost them their own capital and homeland, and the lives of possibly 20 million of its soldiers and civilians.

To some the Russians of the Red Army were savages from the Steppe. For some, like the writer Primo Levi in Auschwitz they were his liberators, 'four men, armed but not against us, four messengers of peace, with rough and boyish faces beneath their fur hats' (*The Truce*).

Am Morgen des 21. Juni 1941 drangen über drei Millionen Soldaten und mehr als 150 deutsche und verbündete Divisionen in die Sowjetunion ein. Mit der Operation »Barbarossa« wollte Hitler die großen Städte wie Moskau und Kiew einnehmen und die Rote Armee zerstören; ein Ziel, so unterrichtete er seine Generäle, das bis zum Winter erreicht sein konnte.

Zunächst wurden die russischen Streitkräfte aufgerieben. Die bewaffneten Panzerdivisionen unter Guderian und von Manstein nahmen über 600 000 Menschen gefangen und zerstörten 6000 Panzer. Aber innerhalb eines Monats erlahmte die Offensive. Die führenden gepanzerten Einheiten benötigten dringend Nachschub an Treibstoff und Munition. Die Infanteriedivisionen, die fast ausschließlich zu Fuß marschierten, waren bis zu 160 Kilometer weit im Rückstand, und das bereits überstrapazierte logistische System stand kurz

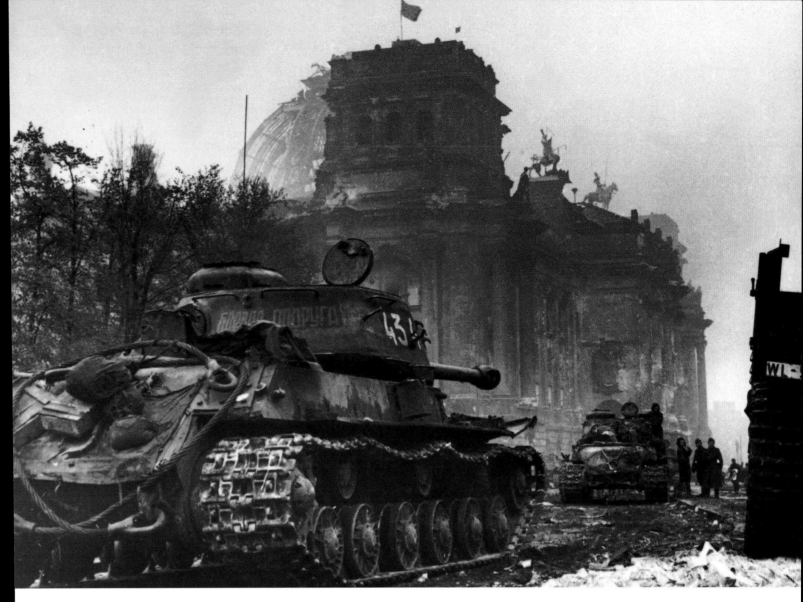

The ultimate goal for the Russians was Berlin. Here the Red Flag flies above the shattered Reichstag building, 2 May 1945. The battle for Berlin cost the Russians up to 60,000 lives, and it took four days to take the last few blocks in the heart of the city.

Das wichtigste Ziel der Russen war Berlin. Auf diesem Bild flattert die Rote Fahne über dem zerstörten Reichstagsgebäude, 2. Mai 1945. Die Schlacht um Berlin kostete die Russen 60 000 Mann. Sie benötigten vier Tage, um die letzten Häuserblocks im Herzen der Stadt zu erobern.

Pour les Russes, Berlin est le but ultime. Le 2 mai 1945, le drapeau rouge flotte sur le Reichstag en ruines. La bataille de Berlin entraînera la mort de 60 000 soldats russes. Il leur faudra quatre jours pour prendre les derniers immeubles du centre de la ville.

vor dem Zusammenbruch. Bis Mitte August verloren die Deutschen über 400 000 Soldaten, fast ein Zehntel ihrer Gesamtstärke.

Im Herbst hatte die Heeresgruppe Nord Leningrad eingekreist und begann eine Belagerung, die über 900 Tage dauerte und eine Million Russen durch Hunger, Kälte und Feindangriffe das Leben kostete. Im September begann die Operation »Taifun« zur Einnahme Moskaus. Sie wurde zu einem entscheidenden Wendepunkt des Feldzugs im Osten und des Krieges in Europa. Die Russen errichteten tiefe Verteidigungspositionen um die Stadt, und unter den Bedingungen des eisigen Winters kam der deutsche Vormarsch 40 Kilometer vor Moskau zum Stehen. Kurz danach, am 6. Dezember, einen Tag vor dem japanischen Angriff auf Pearl Harbour, führte Georgij Schukow eine erfolgreiche Gegenoffensive durch. Hitler verfehlte sein Ziel, die Rote Armee auszuschalten und Rußland bis Ende 1941 zu erobern. Die deutschen Armeen waren in Schnee und

Schlamm steckengeblieben, aber sie hatten unter ihren Feinden furchtbare Zerstörungen angerichtet.

Die Grausamkeit des Krieges an der Ostfront wurde durch die schockierende Behandlung der Gefangenen auf beiden Seiten noch verschärft. Es handelte sich um einen ideologischen (Nationalsozialismus gegen Kommunismus), ethnischen (Germanen gegen Slawen) und von russischer Seite gesehen um einen Kampf um die Heimat. Trotz aller Ängste vor Stalins brutalem Regime – es war der Große Vaterländische Krieg.

Unter den Gefangenen befanden sich Millionen von Juden aus Osteuropa. Wegen ihrer großen Anzahl unterstützte Reinhard Heydrich, stellvertretender Reichsprotektor der Nazis im Protektorat Böhmen, die Ausrottung der Juden – die sogenannte »Endlösung«. Im Juni 1942 wurde Heydrich in Prag von einer Autobombe getötet, die von zwei von der Royal Air Force eingeflogenen tschechischen Partisanen gelegt worden war. Zur Vergeltung erschossen die Deutschen noch

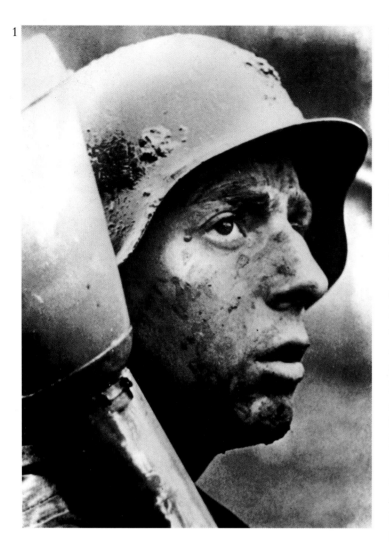

im selben Monat im Dorf Lidice, in der Nähe von Prag, 199 Männer. Die Frauen und Kinder wurden in Lager verschleppt, das Dorf wurde dem Erdboden gleichgemacht.

Im selben Jahr drangen die Deutschen bis zum Kaukasus vor, nahmen Sewastopol und erreichten im September Stalingrad an der Wolga. Innerhalb weniger Wochen hatten sie den größten Teil der Stadt eingenommen und die russischen Verteidiger in ihrem Rücken so gut wie eingeschlossen. Im tiefen Winter zogen die Russen jedoch langsam die Schlinge um den deutschen Kessel zusammen. Paulus bekam die Anordnung, die Stellung zu halten und zu kämpfen, anstatt auszubrechen und sich mit von Mansteins Heeresgruppe Süd zu verbinden. Einen Tag, nachdem Paulus seinen Soldaten befohlen hatte, bis zum letzten Mann zu kämpfen, kapitulierte er mit der Sechsten Armee. Die gesamte Stalingrad-Offensive führte auf deutscher Seite zu einer Million Toten, Verletzten und Verschollenen.

Danach ordnete Hitler die Offensive »Zitadelle« an, um die sowjetische Armee im Frontabschnitt Kursk einzukesseln. Die Russen waren über den Zeitpunkt des Angriffs, am 5. Juli 1943, genau informiert und antworteten mit dem stärksten Artillerie-Sperrfeuer in der modernen konventionellen Kriegsgeschichte. In Kursk nutzten die Russen ihr neues Konzept des »Überraschungsangriffs« – eine Taktik, die heute noch von Armeen in Ost und West angewandt wird: Im Gefecht versucht die Artillerie, ein Loch in die gegnerischen Reihen zu schlagen, während Infanterie und Lufttruppen den Weg für vorstoßende Panzer und Kanonen freihalten. Die Panzer dürfen vorrücken, bis ihnen der Treibstoff oder die Munition ausgeht oder sie eine Panne haben. Der russische T-34-Panzer war die ideale Waffe für diese Taktik; als zweite Hauptwaffe setzte die russische Armee den mehrrohrigen Katjuscha-Raketenwerfer ein, die auch als »Stalinorgel« bekannt wurde.

1944 täuschte Marschall Schukow Angriffe im Norden und im Süden vor, versetzte dann aber der Heeresgruppe Mitte einen vernichtenden Schlag, bei dem 17 Divisionen zerstört wurden. Damit begann der Vormarsch auf Polen und schließlich Berlin. Bis Mitte April hatten die Russen mit einer Gesamtstärke von 2,5 Millionen Soldaten 1,25 Millionen Deutsche um Berlin eingeschlossen. Unter großen Verlusten eroberten die Russen am 2. Mai 1945 das Reichstagsgebäude. Der junge russische Soldat, der die Rote Fahne durch das verkohlte Dach steckt, gehört zu den eindrucksvollsten Aufnahmen der Kriegsfotografie. Die Russen hatten den Krieg als Hitlers Verbündete begonnen. Sie beendeten ihn mit der Einnahme der zerstörten Hauptstadt nach einem Kampf, der sie beinahe ihre eigene Hauptstadt, ihre Heimat und das Leben von etwa 20 Millionen Soldaten und Zivilisten gekostet hatte.

Manche hielten die Russen der Roten Armee für Wilde aus der Steppe. Für einige, wie den Schriftsteller Primo Levi in Auschwitz, waren sie jedoch die Befreier: »Vier Männer, bewaffnet, aber nicht gegen uns: vier Botschafter des Friedens, mit rauhen und jungen Gesichtern unter ihren Pelzmützen« *(Die Atempause)*.

Le matin du 21 juin 1941, plus de trois millions d'hommes et plus de 150 divisions allemandes et coalisées envahissent la Russie soviétique. L'opération Barbarossa est le projet de Hitler pour s'emparer des villes importantes, comme Moscou et Kiev, et pour détruire l'Armée rouge. Hitler affirme à ses généraux que cette opération sera terminée avant l'hiver.

Les forces russes sont d'abord anéanties. Les divisions blindées des Panzers, commandées par Guderian et Von Manstein, ont fait plus de 600 000 prisonniers et détruit 6000 chars. Mais, en moins d'un mois, cette offensive rapide commence à faiblir et les unités blindées ont besoin d'être réapprovisionnées en carburant et munitions. Les divisions d'infanterie, qui s'étaient déplacées presque uniquement à pied, sont à quelques centaines de kilomètres à l'arrière. La logistique, déjà défaillante, est sur le point de s'effondrer. A la mi-août, les Allemands comptaient 400 000 pertes, presque le dixième de leur force totale.

A l'automne, le groupement nord de l'armée allemande encercle Leningrad. C'est le début d'un siège qui dura plus de 900 jours et durant lequel un million de Russes mourront de faim et de froid sous le bombardement ennemi. En septembre, l'opération Typhon est lancée pour prendre Moscou. C'est le premier tournant décisif de la campagne à l'Est et de la guerre en Europe. Les Russes construisent une solide défense autour de la ville et l'avancée allemande est arrêtée à moins de 50

(1) A weary Panzer-Grenadier with his Panzerfaust, an anti-tank grenade-launcher. A famous propaganda photograph from the Soviet Union: 'Know your enemy'. (2) A wounded Russian commissar directs the fighting.

(1) Ein erschöpfter Panzergrenadier mit seiner Panzerfaust. Ein berühmtes Propagandafoto aus der Sowjetunion: »Erkenne deinen Feind«. (2) Ein verwundeter russischer Kommissar gibt einen Feuerbefehl.

(1) Un grenadier fatigué avec son *Panzerfaust,* un lance-roquettes antichar. Une célèbre photo de la propagande soviétique « Sachez reconnaître votre ennemi ». (2) Un commissaire du peuple blessé dirige les tirs.

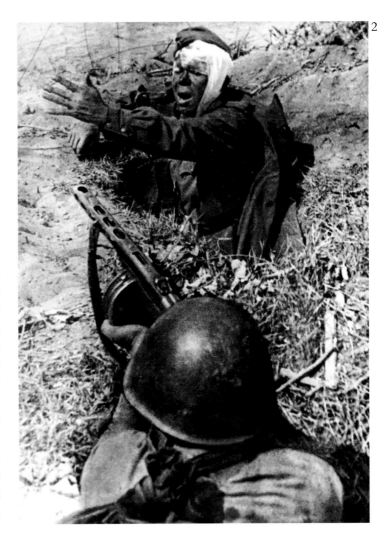

kilomètres de la ville. Les conditions sont glaciales. C'est seulement à ce moment-là que Georgi Zhukov lance une contre-attaque réussie, le 6 décembre, un jour avant le bombardement de Pearl Harbour par les Japonais. Fin 1941, Hitler a échoué dans sa tentative d'anéantir l'Armée rouge et de conquérir la Russie. Les armées allemandes sont bloquées dans la neige et la boue mais ont infligé de considérables dommages à leurs ennemis.

L'horrible traitement infligé aux prisonniers de chaque camp rend la guerre sur le front de l'Est encore plus féroce. Elle est idéologique, les nazis contre les communistes, et ethnique, les Allemands contre les Slaves. Du côté russe, c'est une lutte pour la patrie. Malgré toute la crainte qu'inspire la brutalité du régime de Staline, ce sera une grande guerre patriotique.

Parmi les prisonniers, on compte des millions de Juifs d'Europe de l'Est et Reinhard Heydrich, le gouverneur nazi en Bohème, décide alors d'engager la « solution finale », l'extermination des Juifs. Heydrich est tué dans l'explosion de sa voiture à Prague. Cet attentat est l'œuvre de deux partisans tchèques, acheminés sur place par la RAF. En représailles, 199 hommes du village de Lidice, près de Prague, sont fusillés. Les femmes et les enfants sont déportés et le village est totalement rasé en juin 1942.

Cette année-là, les Allemands traversent le Causase, prennent Sébastopol et, en septembre, atteignent Stalingrad. En quelques semaines, ils ont pris la plus grande partie de la ville et presque encerclé la défense russe à l'arrière. Durant l'hiver, les Russes resserrent progressivement l'étau sur la poche allemande. Paulus a l'ordre de résister et de se battre plutôt que de rejoindre le groupement sud de l'armée de Von Manstein. Un jour après avoir ordonné à ses hommes de se battre jusqu'au bout, Paulus se rend à la Sixième Armée. L'offensive sur Stalingrad aura coûté la mort d'un million d'Allemands.

Hitler lance alors l'offensive Citadelle pour presser les armées soviétiques dans le saillant de Koursk. Les Russes, informés par les services secrets, savent que l'offensive sera déclenchée le 5 juillet 1943 et mettent en place le plus grand barrage anti-blindés de la guerre moderne conventionnelle. A Koursk, les Russes développent le concept de l'« attaque de choc » que les armées de l'Est et de l'Ouest analysent et utilisent toujours. Quand la bataille est déclenchée, l'artillerie doit percer une poche chez l'ennemi pour permettre à l'infanterie et aux troupes aéroportées de dégager le terrain avant l'arrivée des chars et des canons. Les chars doivent avancer jusqu'à l'épuisement du carburant et des munitions ou la panne. Le char T-34 russe convient parfaitement à cette tactique. L'autre arme-clé est le lance-roquettes multitube Katioucha, appelé « orgues de Staline ».

En 1944, le Maréchal Zhukov feint des attaques au nord et au sud puis lance une puissante offensive sur le groupement du centre qui détruira 17 divisions et permettra l'entrée en Pologne puis la marche sur Berlin. A la mi-avril, plus de 2,5 millions de soldats russes encerclent 1,25 millions d'Allemands autour de Berlin. Au prix d'énormes pertes, les Russes s'emparent du Reichstag le 2 mai 1945. L'image du jeune soldat russe qui plante le drapeau rouge sur le toit brûlé du Reichstag est l'une des plus fortes images de la guerre. Les Russes ont commencé la guerre comme alliés de Hitler. Ils la terminent en prenant la capitale allemande après une guerre durant laquelle ils ont failli perdre leur capitale et leur pays. On estime à 20 millions le nombre de soldats et de civils soviétiques qui y auront laissé leur vie.

Pour certains, les Russes de l'Armée rouge sont des sauvages venus de la steppe. Pour d'autres, comme l'écrivain Primo Levi, déporté à Auschwitz, ils sont les libérateurs, « quatre hommes, armés mais pas contre nous, quatre messagers de la paix, aux visages rugueux et gamins, sous leurs toques en fourrure » *(La Trêve).*

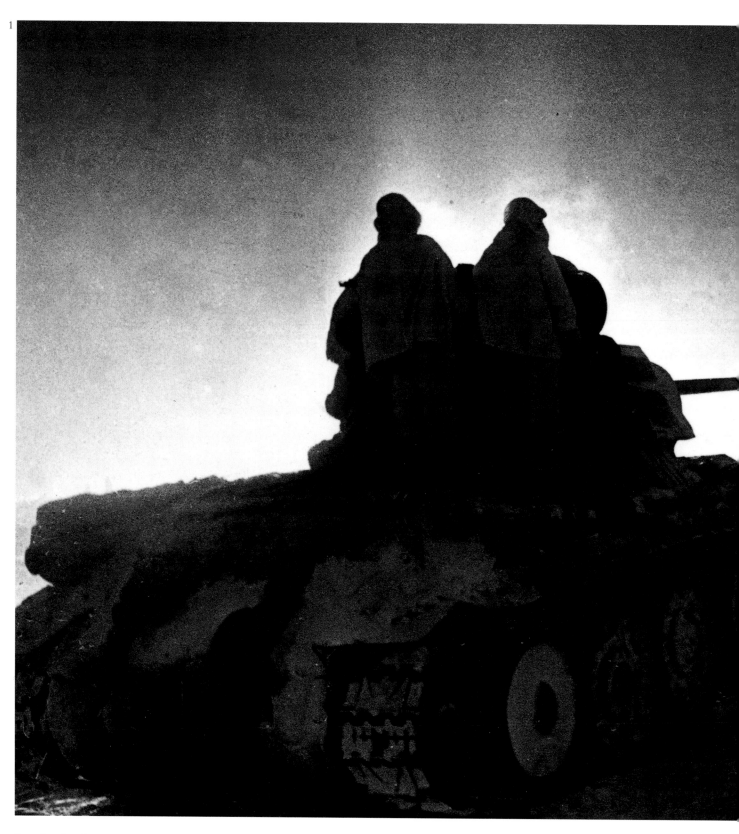

Russian Tanks

Guderian thought the Russian T-34 was the best tank in the war. It was highly mobile, could travel nearly 200 miles without refuelling, and its wide tracks allowed it to navigate marsh and mud where the German Panzers would get bogged down.
(1) A column of T-34s moving up to battle in 1942. (2) A Russian soldier is hit as a shell bursts nearby; action photograph by A. Garanin. (3) A German casualty in the snow, Kharkov.

Russische Panzer

Guderian hielt den russischen T-34 für den besten Panzer der Welt. Er war sehr beweglich und konnte gut 300 Kilometer fahren, ohne aufzutanken. Durch seine breite Fahrspur konnte er in Sumpf und Schlamm navigieren, während die deutschen Panzer darin steckenblieben. (1) Eine Kolonne T-34 fährt ins Gefecht, 1942. (2) Ein russischer Soldat, der von einer in der Nähe explodierten Granate verletzt wurde; Gefechtsfoto von A. Garanin. (3) Ein toter Deutscher im Schnee bei Charkow.

Les chars russes

Pour Guderian, le char russe T-34 est le meilleur char de cette guerre. Très mobile, il peut parcourir plus de 300 kilomètres sans avoir à faire le plein en carburant et ses grandes chenilles lui permettent d'avancer en terrain marécageux et boueux, là où les Panzers allemands s'enlisent. (1) 1942, une colonne de T-34 se dirige vers la bataille. (2) Un soldat russe est touché par un obus qui a explosé près de lui. (3) Un Allemand gît dans la neige à Kharkov.

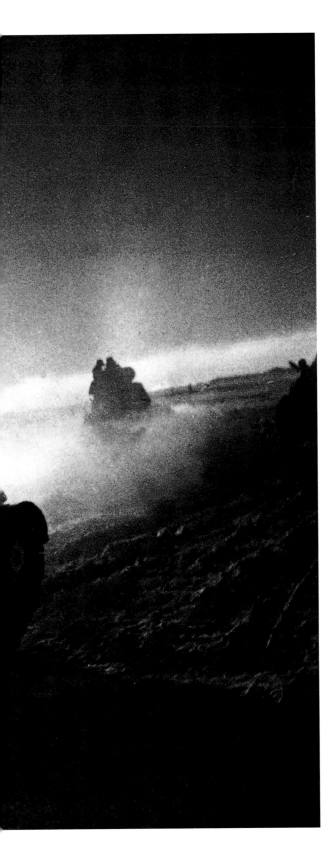

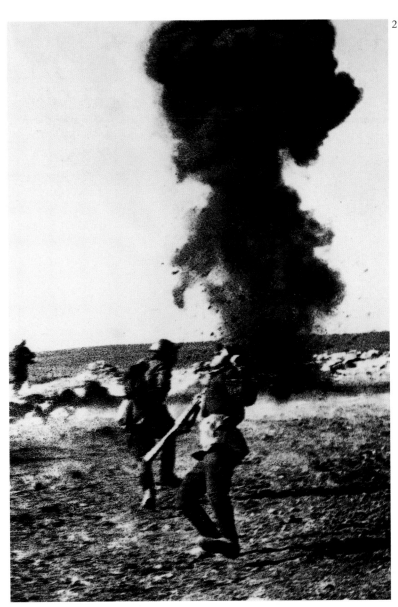

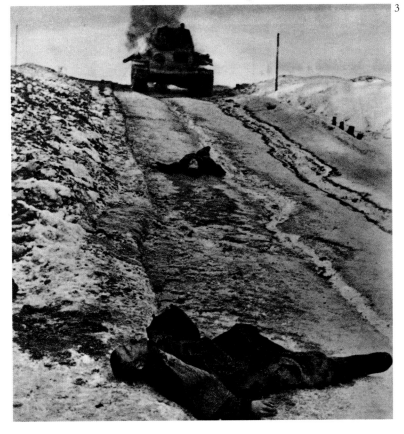

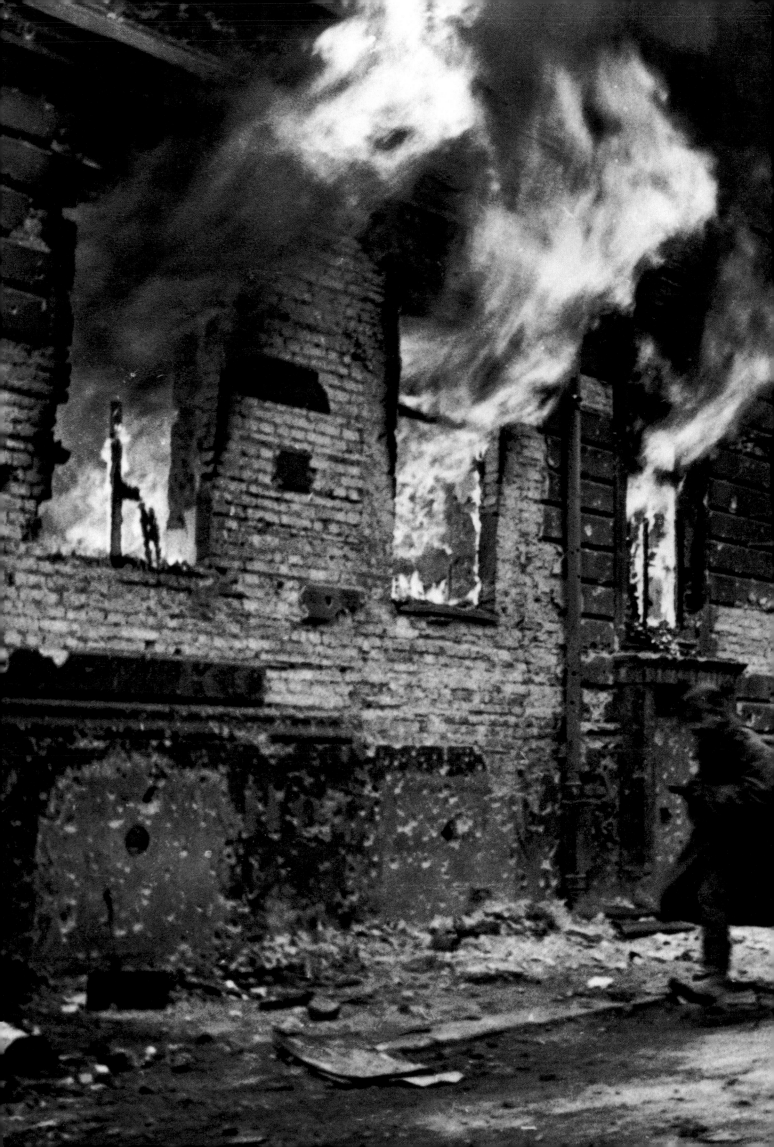

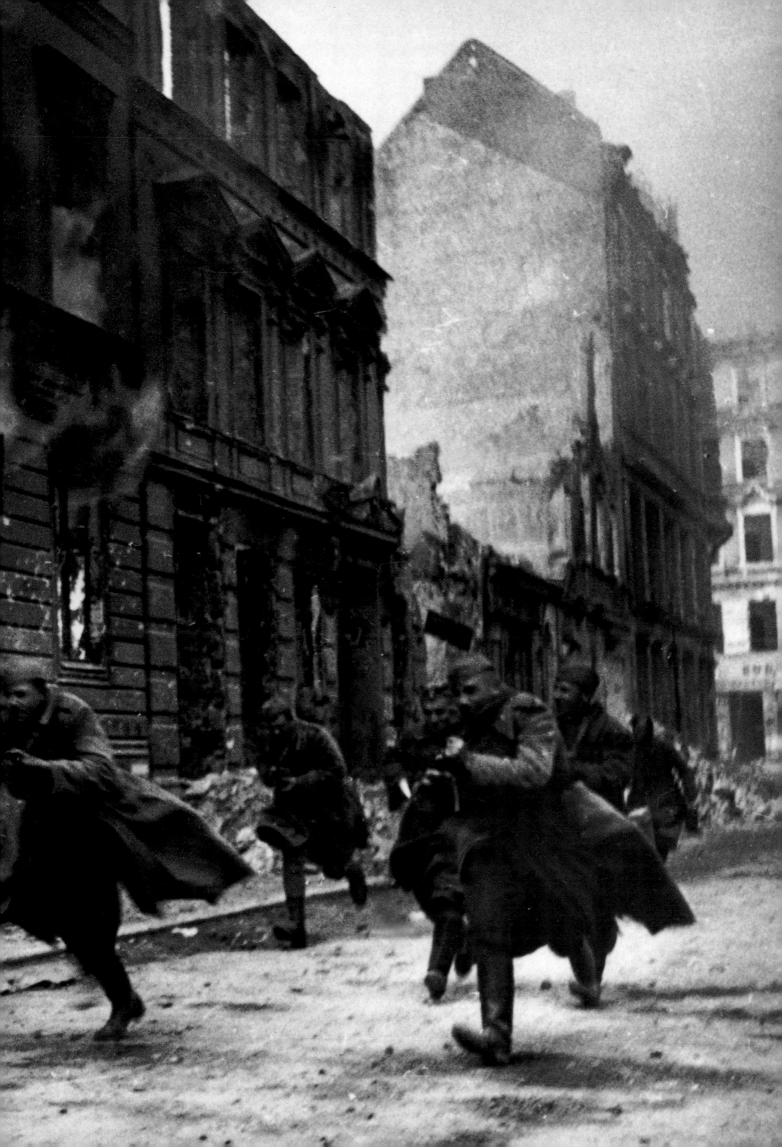

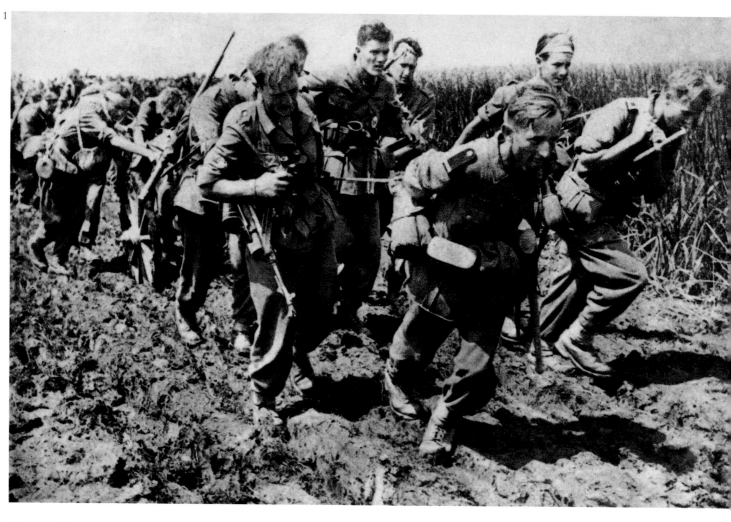

German Reverses

(Previous page) Russian assault troops charge down a street in the advance through Poland, 1944-45 – a dramatic action photograph by V. Temin. (1) As machines and horses got bogged down in the Russian mud, the German infantry had to manhandle guns and supply wagons. (2) German soldiers push their supply truck out of the way as a wooden farmhouse goes up in flames, fired on by Russian gunners. (3) A German casualty of the retreat from Moscow, 1941.

Deutscher Rückzug

(Vorige Doppelseite) Russische Angriffstruppen stürmen eine Straße auf dem Vormarsch durch Polen, 1944/45 – ein dramatisches Gefechtsfoto von V. Temin. (1) Nachdem Pferde und Maschinen in den russischen Sümpfen steckengeblieben waren, mußte die deutsche Infanterie die Kanonen und Nachschubwagen selbst ziehen. (2) Deutsche Soldaten schieben ihren Nachschubwagen in Sicherheit, nachdem ein hölzernes Bauernhaus von russischen Kanonen in Brand geschossen wurde. (3) Ein toter Deutscher auf dem Rückzug von Moskau, 1941.

Les revers de l'armée allemande

(Page précédente) 1944-45, durant la traversée de la Pologne, des troupes d'assaut russes foncent dans une rue – une photo prise dans le feu de l'action par V. Temin. (1) Machines et chevaux sont enlisés dans la boue russe et l'infanterie allemande doit tirer à la main canons et camions de ravitaillement. (2) Des soldats allemands poussent un camion de ravitaillement. A côté, une ferme en bois a pris feu après un tir des canons russes. (3) Un Allemand tué lors du retrait de Moscou en 1941.

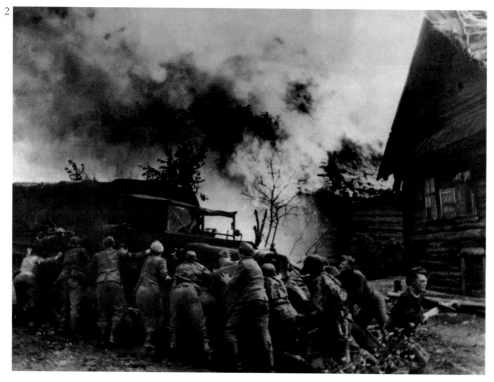

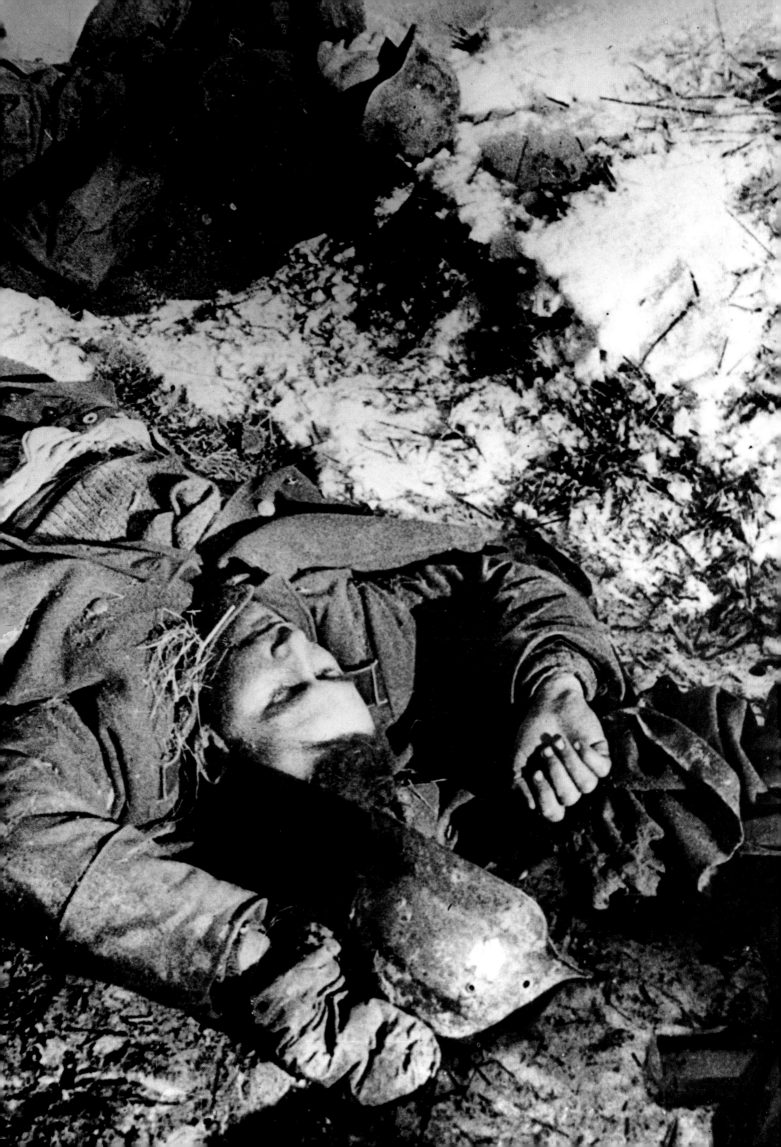

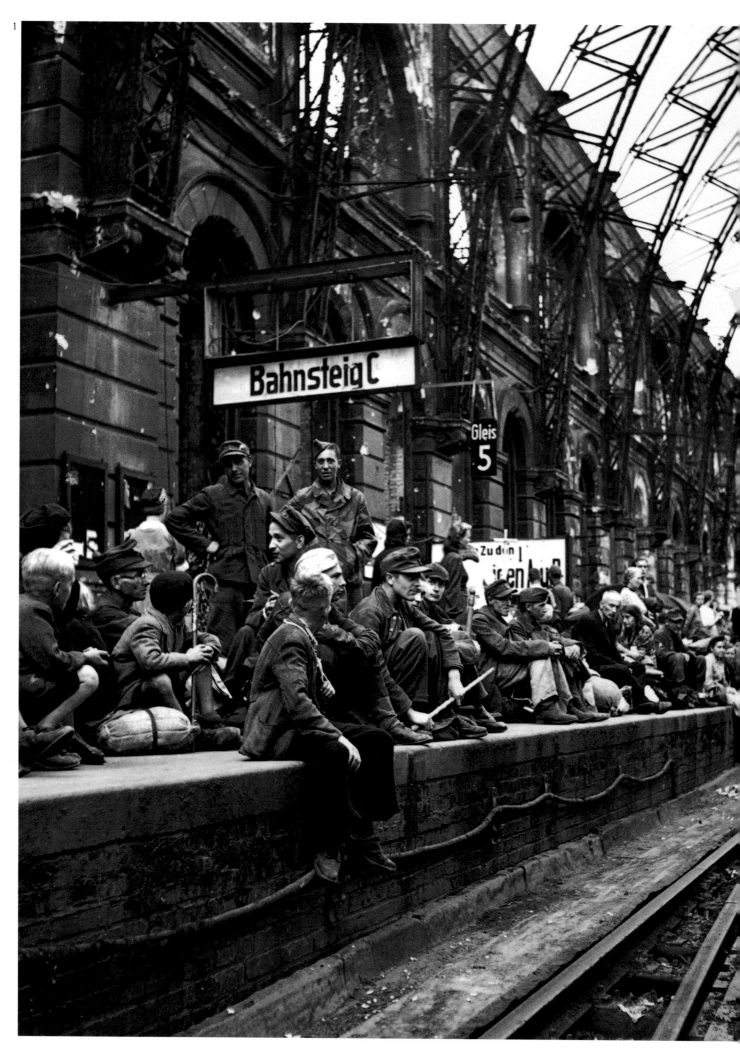

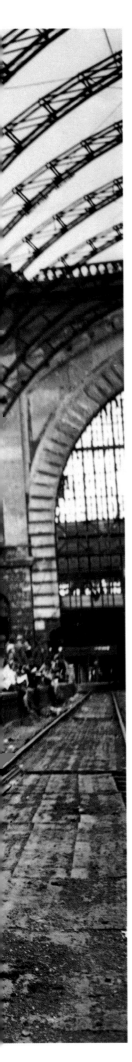

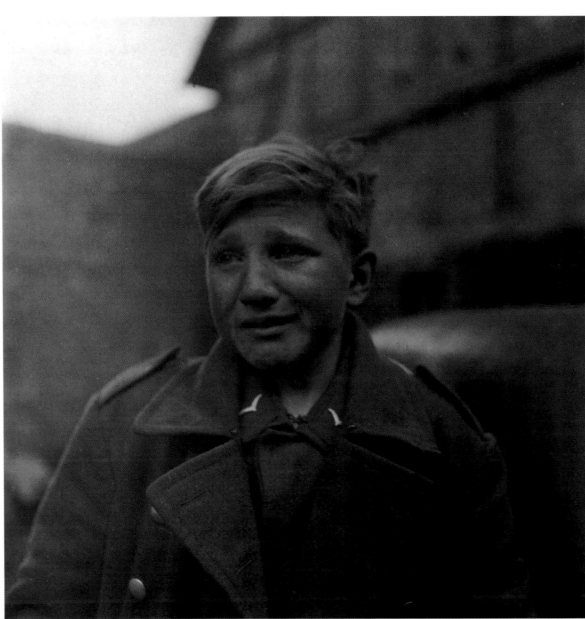

Casualties of Retreat

Millions of refugees were pushed across
Europe as the German armies were rolled
back, fighting one of the most dogged retreat
campaigns in history. It would take months,
if not years, to house all the refugees after the
war. (1) Soldiers and civilians crowd the
platform at a Berlin station, October 1945.
(2) Tears of defeat: a 15-year-old German
soldier breaks down in despair.

Opfer des Rückzugs

Millionen von Flüchtlingen wurden durch
Europa getrieben, als die deutsche Armee
einen Rückmarsch antreten mußte, der sich
zu einem der verbissensten Rückzugsgefechte
der Kriegsgeschichte entwickelte. Es dauerte
Monate, wenn nicht Jahre, bis alle Flücht-
linge nach dem Krieg ein Heim gefunden
hatten. (1) Soldaten und Zivilisten drängeln
sich auf dem Bahnsteig eines Berliner Bahn-
hofs, Oktober 1945. (2) Tränen der Nieder-
lage: Ein 15jähriger deutscher Soldat bricht in
Tränen aus.

Le rapatriement des blessés

Des millions de réfugiés déferlent à travers
l'Europe alors que les armées allemandes se
replient et livrent une des plus tenaces
campagnes de retraite de l'histoire. Après la
guerre, il faudra des mois, si ce n'est des
années, avant que tous les réfugiés retrouvent
un toit. (1) Octobre 1945, des soldats et des
civils envahissent le quai d'une gare de
Berlin. (2) Les larmes de la défaite.
Désespéré, un soldat allemand de 15 ans
éclate en sanglots.

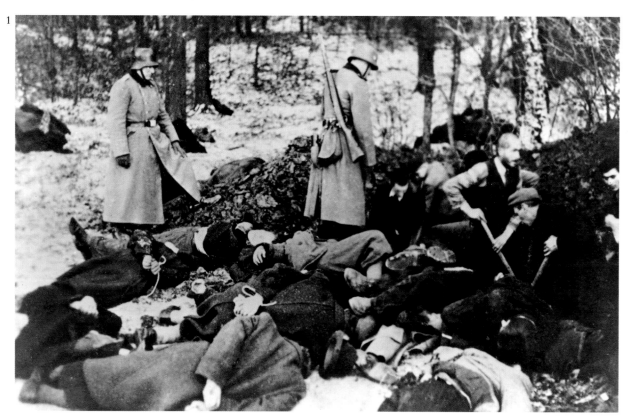

Reprisals and Atrocities
(1) Polish civilians being forced to dig graves for their compatriots. When they have finished, they too will be shot. (2) Russian villagers are forced to watch a flogging. This photograph was found on a dead German soldier. (3) A German officer, captured in the Netherlands, holds up photographs of Dutch civilians hanged and tortured in reprisals.

Vergeltung und Grausamkeiten
(1) Polnische Zivilisten werden gezwungen, Gräber für ihre Landsleute auszuheben. Wenn sie damit fertig sind, werden auch sie erschossen. (2) Russische Dorfbewohner müssen bei einer Auspeitschung zusehen. Dieses Bild wurde bei einem toten deutschen Soldaten gefunden. (3) Ein deutscher Offizier, der in den Niederlanden gefangengenommen wurde, zeigt Fotos von niederländischen Zivilisten, die man bei Vergeltungsmaßnahmen gehängt und gefoltert hat.

Représailles et atrocités
(1) Des civils polonais forcés de creuser des tombes pour leurs compatriotes. Quand ils auront terminé, ils seront eux aussi tués. (2) Des villageois russes obligés d'assister à une flagellation. Cette photo a été retrouvée sur un soldat allemand mort. (3) Un officier allemand, capturé en Hollande, montre une photo de civils hollandais pendus et torturés en représailles.

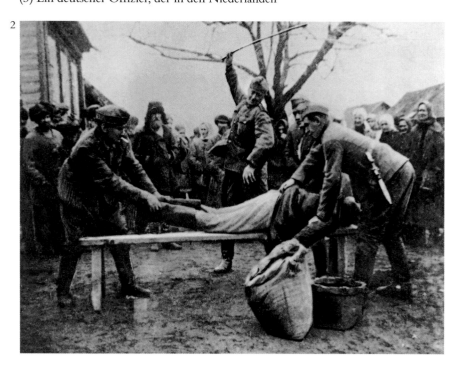

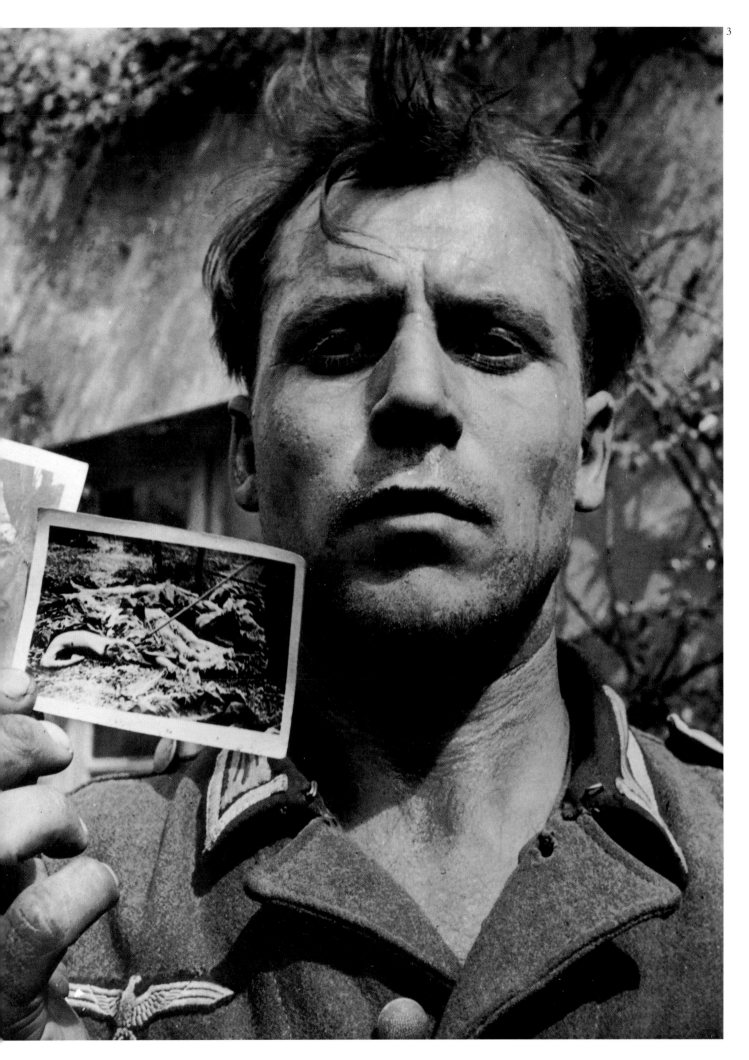

War in the Pacific

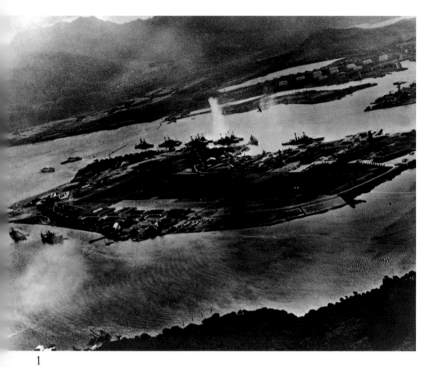

1

The Japanese attack on 7 December 1941 on Pearl Harbor, home of the American Pacific Fleet, came as no surprise – the Americans had ample intelligence warning, but were ill-prepared. Admiral Yamamoto, the genius of Japan's naval strategy, planned to destroy the American fleet in harbour. In a matter of hours eight battleships were sunk, with numerous escorts and tenders. But it was not the knock-out Japan had wanted; most of the American vessels were old, and the big fuel installations onshore were largely intact.

The attack finally brought America into the war, and was the first of a string of Japanese successes. The Americans were chased out of the Philippines by the spring of 1942. The Dutch were driven from Java, and the British lost Malaya and Burma; at Singapore on 15 February 1942, Lt-General Percival surrendered 130,000 British and Commonwealth troops. On 19 February a Japanese carrier force launched an air attack on Darwin in Australia, killing 500, destroying ships and hundreds of aircraft and knocking out the port for weeks. It was the furthest limit of Japanese expansion in the war.

Japan had a huge strategic area to control, needing huge resources. The battle for the Pacific was to be as no other in modern warfare, and in many aspects since. It would be fought with carriers, amphibious assault units, dive-bombers and suicide planes, and the new techniques of jungle warfare.

In early May 1942 the Japanese planned to take Port Moresby in New Guinea, to threaten and isolate Australia. An American fleet caught them and in the Coral Sea fought the first naval battle in which the main fleets did not sight each other. Exactly a month later the Japanese moved to attack the American airbase on the island of Midway. American Intelligence, through 'Magic', a decoding device similar to the British 'Ultra', pinpointed the main Japanese force of four carriers. The first wave of American Devastator Torpedo bombers was a failure, and costly. This was followed by a wave of Hellcat dive-bombers. As they arrived on target the decks of the Japanese carriers were crowded with aircraft being refuelled and bombed up; their guns were set at sea level expecting another torpedo bomber attack. Within minutes three carriers were in flames and had to be abandoned and the fourth sank later. The balance in the Pacific had swung to the Americans. In the Leyte Gulf, in the battle to regain the Philippines, the Americans eliminated the Japanese surface fleet in the biggest naval battle in history, while under the sea they put together a submarine operation which destroyed more than half of the entire Japanese merchant fleet.

For the Americans it was the era of the US Marine Corps who perfected the art of 'island hopping', assaults on islands where the Japanese were least expecting it. Though the fight for islands like Guadalcanal were long and gruelling, the American casualties were much lighter than the Japanese, who fought with blind fanaticism, and often committed suicide rather than surrender. At Tinian in the Marianas in July 1944 the entire Japanese garrison of 7000 fought to the death.

The bloodiest battles for the Americans were the last in 1945, the capture of Iwo Jima and Okinawa, where for the first time they encountered the Japanese in divisional strength, force of more than 70,000. Iwo Jima provided the most famous photographic icon of the war, the raising of Old Glory on Mount Surabachi. At Okinawa the Americans sustained more than 7000 killed and 30,000 wounded – many of them sailors. On one day alone, 6 April 1945, the Japanese launched 700 suicide dive-bomber attacks.

In Burma the British 'forgotten' 14th Army under Lt General Sir William Slim was turning defeat into victory with very limited resources. His armies outmanoeuvred the Japanese at Imphal and Kohima in Burma and then conducted one of the most successful pursuit battles of the entire war to take Mandalay, which was followed by the Japanese abandoning Rangoon on 23 April 1945.

On 8 August the Russians declared war on Japan and, with a most effective use of Blitzkrieg and shock attack, seized Manchuria and drove to the Korean border in a fortnight.

On 6 August a B-29 bomber, christened Enola Gay by her aircrew, dropped 'Little Boy', the atom bomb which killed 90,000 Japanese in Hiroshima in a flash 'brighter than a thousand suns'. Three days later 'Fat Boy' was dropped on Nagasaki, killing 25,000. On 14 August a delegation of Japanese ministers and officers signed the surrender of Japan on the deck of the battleship Missouri. The Second World War was at an end, though the Russians continued to fight in Manchuria.

The day that 'will live in infamy': (1) a photograph of Pearl Harbor during the attack taken from a Japanese aircraft, 7 December 1941. (2) The destroyer USS *Shaw* explodes during the air raids. Amazingly, the ship would be repaired and back in service within a year.

Der »Tag der Schande«: (1) Ein Foto von Pearl Harbour, das während eines Angriffs von einem japanischen Flugzeug aufgenommen wurde, 7. Dezember 1941. (2) Der Zerstörer USS *Shaw* explodiert während eines Luftangriffs. Erstaunlicherweise konnte das Schiff repariert werden und war innerhalb eines Jahres wieder im Einsatz.

Un jour « d'infamie qui restera dans les mémoires »: (1) Une photo de Pearl Harbour prise d'un avion japonais durant l'attaque du 7 décembre 1941. (2) Explosion du destroyeur USS *Shaw* pendant les raids aériens. Le bâtiment sera réparé et remis en service un an plus tard.

Der japanische Angriff auf Pearl Harbour, dem Heimathafen der amerikanischen Pazifikflotte, am 7. Dezember 1941 kam nicht überraschend – die Amerikaner waren durch ihr Spionagesystem hinreichend gewarnt. Dennoch waren sie schlecht vorbereitet. Admiral Yamamoto, ein Genie der japanischen Marinestrategie, plante die Zerstörung der amerikanischen Flotte im Hafen. In wenigen Stunden waren acht Schlachtschiffe sowie zahlreiche Begleitschiffe und Tender versenkt. Der alles entscheidende Schlag, den Japan angestrebt hatte, gelang jedoch nicht; die meisten der versenkten amerikanischen Schiffe waren alt, und die wichtigen Treibstoffanlagen an Land blieben größtenteils unbeschädigt.

Der Angriff auf Pearl Harbour führte zum Kriegseintritt der USA. Er stand am Anfang einer Reihe japanischer Siege:

Bis zum Frühling 1942 wurden die Amerikaner von den Philippinen vertrieben, die Niederländer mußten Java verlassen, und die Briten verloren Malaysia und Burma. Am 15. Februar 1942 ergab sich Generalleutnant Percival mit 130 000 britischen und Commonwealth-Soldaten in Singapur. Am 19. Februar fand von einem japanischen Flugzeugträger aus ein Luftangriff auf Darwin in Australien statt, bei dem 500 Menschen starben. Schiffe und Hunderte von Flugzeugen wurden zerstört; der Hafen war für Wochen lahmgelegt. Damit hatte die japanische Expansion im Krieg ihre größte Ausdehnung erreicht.

Japan mußte ein riesiges strategisches Gebiet kontrollieren und benötigte dafür große Ressourcen. Die Schlacht im Pazifik war und ist in vieler Hinsicht einzigartig in der modernen Kriegsgeschichte. Sie wurde mit Flugzeugträgern,

amphibischen Angriffseinheiten, Sturzkampfbombern, Selbstmordkommandos aus der Luft und den neuen Techniken des Dschungelkriegs geführt.

Um Australien einzuschüchtern und zu isolieren, planten die Japaner Anfang Mai 1942 einen Angriff auf Port Moresby auf Neuguinea. Die amerikanische Flotte stellte jedoch die Japaner und führte in der Korallensee die erste Seeschlacht, in der sich die Hauptgegner nicht zu Gesicht bekamen. Genau einen Monat später bereiteten die Japaner einen Angriff auf den amerikanischen Luftwaffenstützpunkt auf der Insel Midway vor. Mit Hilfe von »Magic«, einem Dekodierungssystem, das ähnlich wie das britische »Ultra«-System funktionierte, konnte der amerikanische Geheimdienst die Hauptstreitkraft der Japaner – vier Flugzeugträger – ausfindig machen. Die erste Angriffswelle amerikanischer Devastator-Torpedo-Bomber war ein kostspieliger Fehlschlag. Ihr folgte ein Angriff von Hellcat-Sturzkampffliegern. Als sie ihr Ziel anflogen, waren die japanischen Flugzeugträger vollbesetzt mit Flugzeugen, die aufgetankt und mit Bomben versehen werden mußten. Da man einen weiteren Torpedo-Bomberangriff vermutete, waren die Kanonen auf Wasserniveau gerichtet. Innerhalb weniger Minuten gingen drei Flugzeugträger in Flammen auf und mußten aufgegeben werden. Der vierte sank etwas später. Die Waagschale im Pazifik hatte sich zugunsten der Amerikaner geneigt. In der Schlacht um die Rückeroberung der Philippinen im Golf von Leyte konnten die Amerikaner in der größten Seeschlacht der Geschichte die japanische Überwasserflotte außer Gefecht setzen; unter Wasser wurden durch amerikanische U-Boot-Operationen mehr als die Hälfte der japanischen Handelsflotte zerstört.

Für die Amerikaner brach das Zeitalter des US Marine Corps an. Sie perfektionierten die Technik des »Inselspringens«, des Angriffs auf Inseln, auf denen die Japaner es am wenigsten erwarteten. Obwohl der Kampf um Inseln wie Guadalcanal lang und grausam war, hatten die Amerikaner geringere Verluste zu beklagen als die Japaner, die mit blindem Fanatismus kämpften und häufig den Selbstmord der Kapitulation vorzogen. In Tinian auf den Marianen kämpfte im Juli 1944 die gesamte japanische Garnison von 7000 Soldaten bis zum letzten Mann.

Die letzten Kämpfe des Jahres 1945 waren für die Amerikaner die verlustreichsten. Bei der Einnahme von Iwo Jima und Okinawa standen ihnen zum ersten Mal japanische Streitkräfte in Divisionsstärke gegenüber – mehr als 70 000 Soldaten. Auf Iwo Jima entstand auch das berühmteste Foto des Krieges: Soldaten pflanzen die amerikanische Flagge, Old Glory, auf dem Berg Surabachi. Auf Okinawa hatten die Amerikaner mehr als 7000 Tote und 30 000 Verwundete zu beklagen, darunter viele Matrosen. An einem einzigen Tag, dem 6. April 1945, flogen die Japaner 700 Selbstmordangriffe.

In Burma konnte die »vergessene« 14. britische Armee unter Generalleutnant Sir William Slim trotz geringer Reserven die Niederlage in einen Sieg verwandeln. Slim manövrierte die Japaner bei Imphal und bei Kohima in Burma aus und führte anschließend eines der erfolgreichsten Verfolgungsgefechte des gesamten Krieges, bei dem Mandalay und wenig später, am 23. April 1945, das von den Japanern aufgegebene Rangun erobert wurde.

Am 8. August erklärten die Russen Japan den Krieg, eroberten unter erfolgreichem Einsatz von Blitzkrieg und Überraschungsangriff die Mandschurei und drangen bis zur koreanischen Grenze vor.

Am 6. August warf ein B-29-Bomber, von seiner Crew auf den Namen Enola Gay getauft, die Atombombe »Little Boy« über Hiroshima ab. Mit einem Blitz, »heller als tausend Sonnen«, wurden 90 000 Japaner getötet. Drei Tage später warf man »Fat Boy« über Nagasaki ab. Hierbei starben 25 000 Menschen. Am 14. August unterzeichnete eine Delegation aus japanischen Ministern und Militärs an Deck des Kriegsschiffs *Missouri* die Kapitulation Japans. Der Zweite Weltkrieg war beendet, obwohl die Russen in der Mandschurei noch weiterkämpften.

L'attaque japonaise du 7 décembre 1941 sur Pearl Harbour, port d'attache de la flotte américaine du Pacifique, ne surprend pas. Mais les Américains, pourtant avertis par les services secrets, sont mal préparés. L'amiral Yamomoto, un génie de la stratégie navale japonaise, veut détruire la flotte américaine au port. En quelques heures, huit navires sont coulés ainsi que de nombreux escorteurs et ravitailleurs. Mais le coup porté n'est pas aussi important que prévu. La plupart des bâtiments américains sont vieux et les grands postes de ravitaillement en carburant au large des côtes sont intacts.

Cette attaque entraîne l'Amérique dans la guerre et marque le début d'une série de victoires japonaises. Au printemps 1942, les Américains sont chassés hors des Philippines. Les Hollandais doivent quitter Java, les Britanniques perdent la Malaisie et la Birmanie. Le 15 février 1942, à Singapour, le général de corps d'armée Percival se rend avec 130 000 soldats britanniques et du Commonwealth. Le 19 février, un porte avions japonais lance une attaque aérienne sur Darwin en Australie, tuant 500 personnes, détruisant des navires et des centaines d'avions et anéantissant le port pour plusieurs semaines. Les Japonais n'étaient jamais allés aussi loin dans la guerre.

Le Japon contrôle une zone stratégique immense et a besoin d'énormes ressources. La bataille du Pacifique est sans précédent dans la guerre moderne et, par bien des aspects, le reste encore. Elle sera livrée avec des porte-avions, des unités d'assaut amphibies, des bombardiers et des avions suicides et avec de nouvelles techniques de combat de jungle.

Début mai 1942, les Japonais veulent prendre le port de Moresby en Nouvelle-Guinée pour menacer et isoler l'Australie. Une flotte américaine les intercepte et livre en mer de Corail une première bataille navale à laquelle les flottes principales ne participent pas. Un mois plus tard, les Japonais lancent une offensive sur la base américaine de l'île Midway. Les services secrets américains localisent 4 porte-avions japonais sur leur récepteur-décodeur « Magic », semblable au décodeur anglais « Ultra ». La première sortie des bombardiers

américains Devastator Torpedo est un échec. Elle est suivie des bombardiers Hellcat qui arrivent en vue des porte-avions japonais alors qu'a lieu le ravitaillement en carburant et bombes de leurs avions. Les canons sont pointés sur la mer, en prévision d'attaques à la torpille. En quelques minutes, trois porte-avions sont en feu et abandonnés, le quatrième coulera plus tard. L'avantage dans le Pacifique bascule du côté américain. Dans le Golfe de Leyte où se jouera la reconquête des Philippines, et la plus grande bataille navale de l'histoire, les Américains éliminent la flotte japonaise en surface et lancent une opération sous-marine qui détruira plus de la moitié de la flotte marchande japonaise.

Du côté américain, c'est le règne des «marines». Ils perfectionnent l'art «d'avancer d'île en île» qui consiste à lancer des assauts là où les Japonais s'y attendent le moins. La conquête des îles, comme Guadalcanal, est longue et épuisante mais le nombre de victimes est bien moins élevé du côté américain que du côté japonais où les soldats se battent fanatiquement et se suicident plutôt que de se rendre. En juillet 1944 à Tinian, Iles Mariannes, la garnison japonaise qui compte 7000 hommes se bat jusqu'au dernier homme.

Pour les Américains, les batailles les plus sanglantes sont les dernières, en 1945, lors de la conquête de Iwo-Jima et d'Okinawa. Pour la première fois, ils font face à une force divisionnaire massive de plus de 70 000 Japonais. La photo la plus célèbre de la guerre, prise à Iwo-Jima, montre des soldats qui plantent le drapeau américain au sommet du Mont Surabachi. A Okinawa, les Américains comptent 7000 morts et 30 000 blessés, des matelots pour la plupart. Dans la seule journée du 6 avril 1945, les Japonais lancent 700 attaques-suicides.

En Birmanie, la 14ᵉ armée «oubliée» du général britannique Slim transforme la défaite en victoire avec des moyens très limités. Ses troupes dominent les Japonais à Imphal et Kohima en Birmanie puis lancent une offensive, l'une des plus belles victoires de toute la guerre, pour conquérir Mandalay, qui entraînera l'abandon de Rangoon par les Japonais le 23 avril 1945.

Le 8 août, les Russes déclarent la guerre au Japon. Utilisant avec efficacité les tactiques du *Blitzkrieg* et de l'attaque de choc, ils s'emparent de la Mandchourie et gagnent la frontière coréenne en deux semaines.

Le 6 août, le bombardier B-29, baptisé «Enola Gay» par l'équipage, lâche «Little Boy» sur Hiroshima. Cette bombe atomique, qui crée une lumière «plus éblouissante que mille soleils», tue 90 000 Japonais. Trois jours plus tard, «Fat Boy» est lâchée sur Nagasaki et fait 25 000 victimes. Le 14 août, une délégation de ministres et d'officiers japonais signent la reddition du Japon sur le pont du navire de guerre *Missouri*. C'est la fin de la Deuxième Guerre mondiale, même si les Russes se battent encore en Mandchourie.

The indignities of surrender: two American defenders after the fall of Corregidor and Bataan in the battle for the Philippines, which concluded in early 1942. The Japanese lost no time in showing their disdain for those who surrendered, part of their military code of *bushido* (chivalry). When they were defeated, many Japanese committed *hari kiri* (suicide) or preferred to fight to the last and be killed rather than give themselves up.

Die Schande der Niederlage: Zwei amerikanische Verteidiger nach dem Fall von Corregidor und Bataan in der Schlacht um die Philippinen, die Anfang 1942 beendet war. Die Japaner beeilten sich, den Unterlegenen ihre Verachtung zu zeigen, was zu ihrem Ehrenkodex des *bushido* (Ritterlichkeit) gehörte. Im Fall ihrer Niederlage begingen viele Japaner *harakiri* (Selbstmord) oder zogen es vor, bis zuletzt zu kämpfen und zu sterben anstatt aufzugeben.

L'affront de la reddition: Deux soldats américains après la chute de Corregidor et de Bataan durant la bataille des Philippines qui se terminera au début de 1942. Les Japonais affichent un mépris instantané à l'égard des soldats qui se rendent, comme le veut leur code militaire, le *bushido* (règle de chevalerie). Vaincus, les Japonais se font *hara kiri* (suicide) ou se battent jusqu'à la mort. Ils préfèrent être tués plutôt que d'avoir à se rendre.

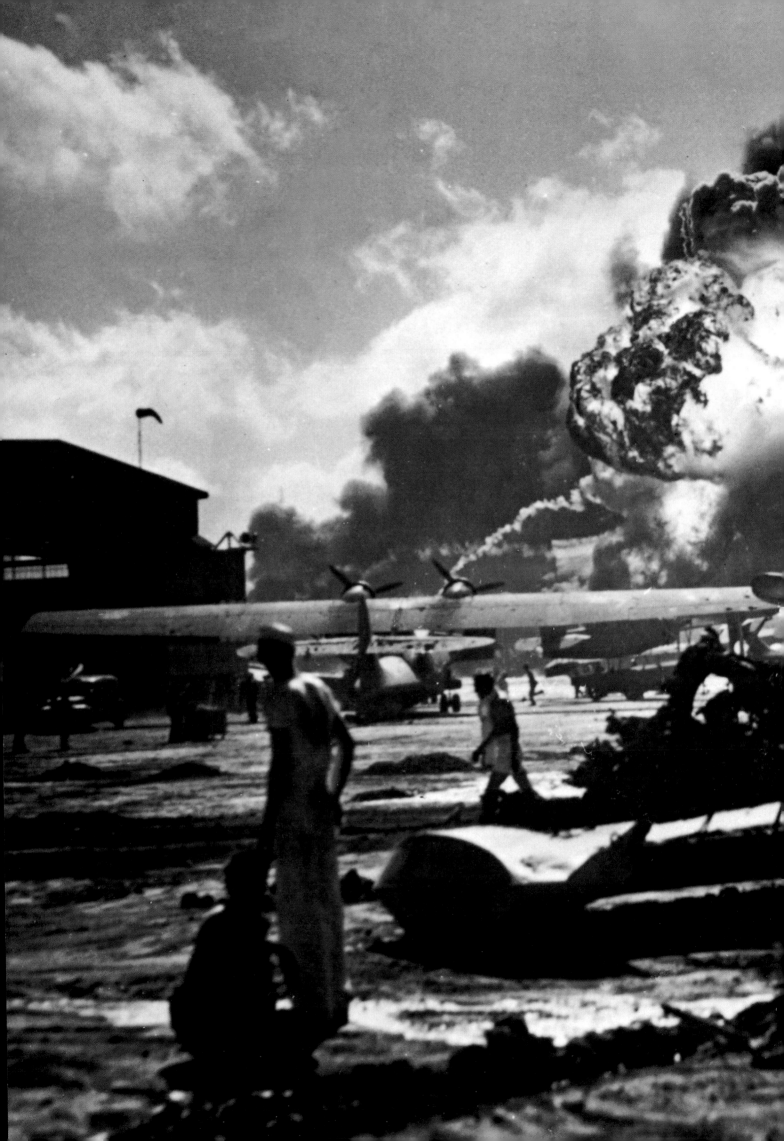

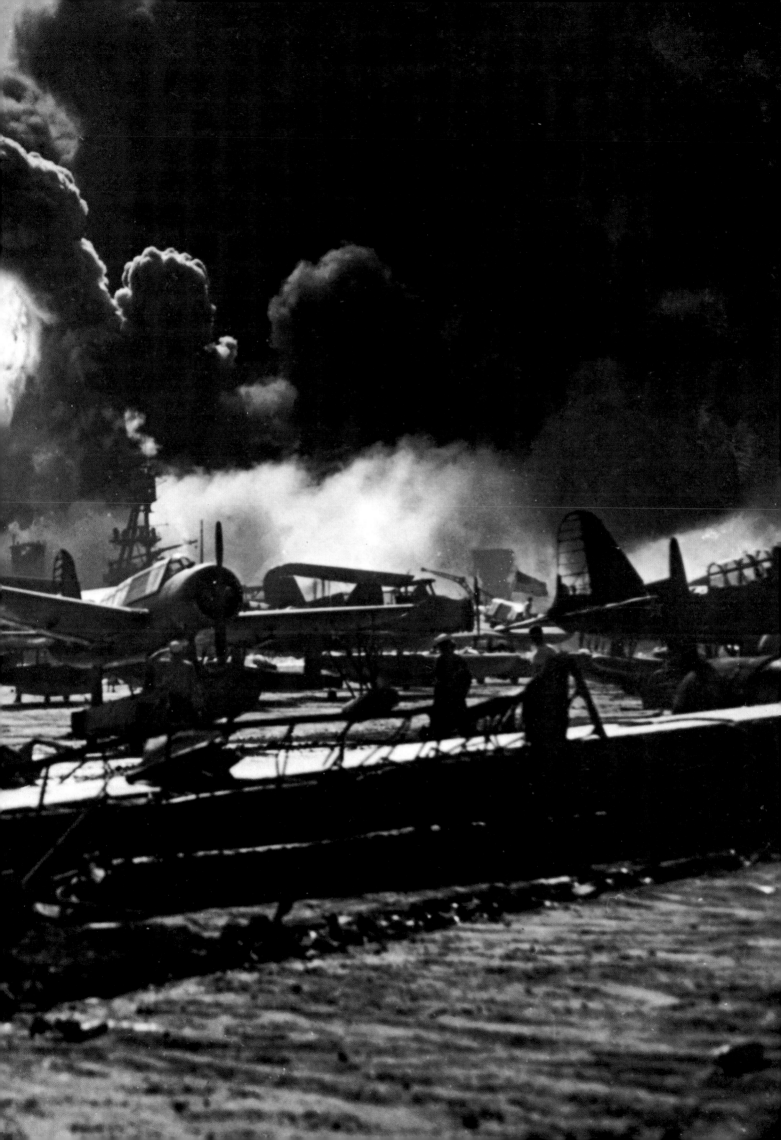

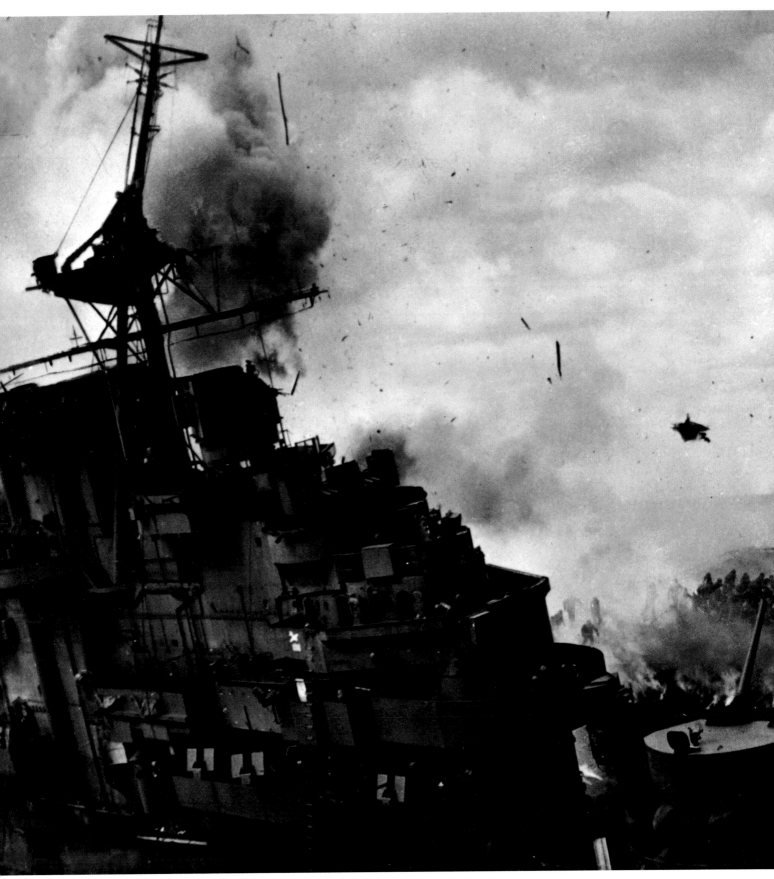

American Losses

(Previous page) The Navy air station, Pearl Harbor, during a ground attack raid on the morning of 7 December 1941. (1) The Essex-class fleet carrier USS *Franklin* is hit by a Japanese dive-bomber, 19 March 1945: a bomb explodes inside the ship. (2) In the attack more than 1000 of the crew are killed or injured, and she seems doomed. (3) After receiving a tow from the cruiser USS *Santa Fe*, the carrier manages to make the 12,000-mile journey to her home port of New York under her own steam.

Amerikanische Verluste

(Vorige Doppelseite) Das Flugfeld der Marine in Pearl Harbour während eines Bodenangriffs am Morgen des 7. Dezember 1941.

(1) Ein Flugzeugträger der Essex-Klasse, die USS *Franklin*, ist bei einem japanischen Sturzfliegerangriff getroffen worden, 19. März 1945. Eine Bombe explodiert im Inneren des Schiffs. (2) Bei dem Angriff wurden mehr als 1000 Besatzungsmitglieder getötet oder verletzt, und das Schicksal des Schiffes schien besiegelt. (3) Vom Kreuzer USS *Santa Fe* ins Schlepptau genommen,

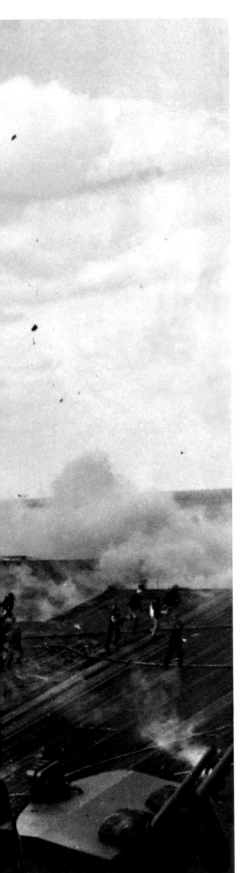

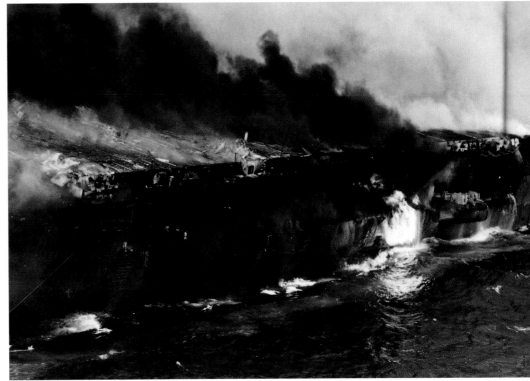

2

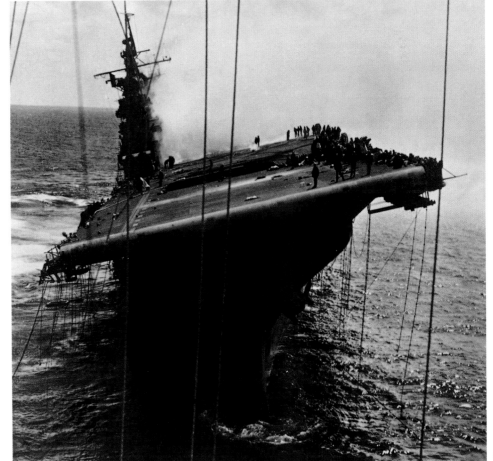

3

konnte der Flugzeugträger unter eigenem Dampf die 12 000 Seemeilen bis zu seinem Heimathafen New York zurücklegen.

Les pertes américaines
(Page précédente) Pearl Harbour, base de la flotte aérienne, lors d'une attaque à terre le 7 décembre 1941 au matin. (1) 19 mars 1945, le porte-avions USS *Franklin* est touché par un bombardier japonais : une bombe explose à l'intérieur du bâtiment. (2) Plus de 1000 membres de l'équipage sont tués ou blessés durant l'attaque et le bâtiment semble perdu. (3) Après avoir été remorqué par le croiseur USS *Santa Fe,* le porte-avions réussit à parcourir près de 20 000 kilomètres pour regagner, par ses propres moyens, son port d'attache à New York.

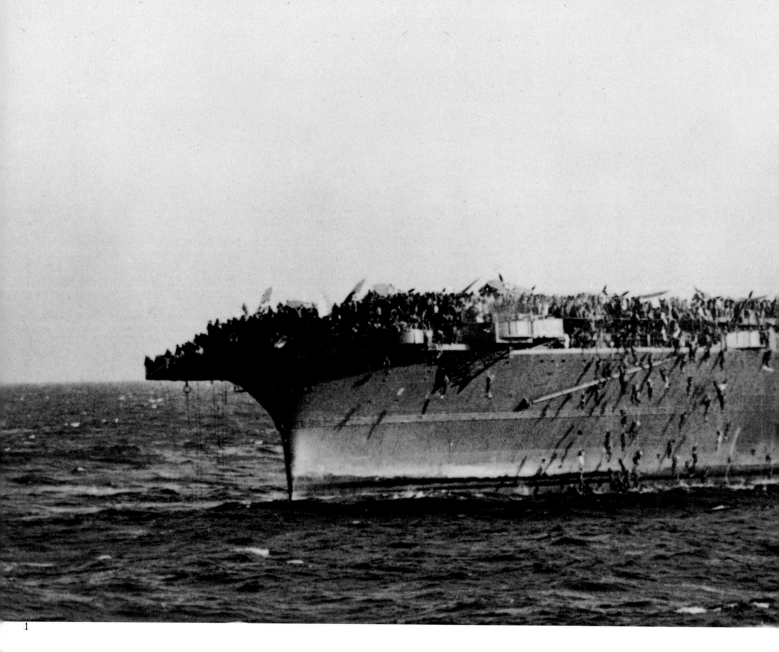

1

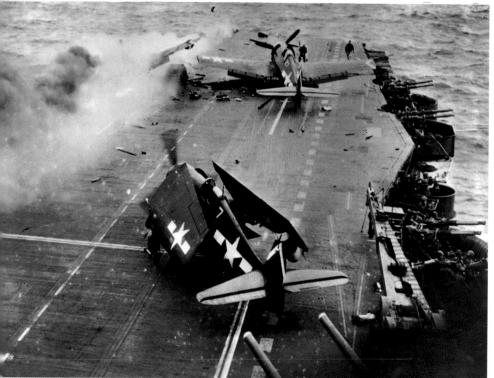

2

Carrier Battles

As the Japanese moved to take Port Moresby in New
Guinea their carriers came up against the USS
Lexington and the USS *Yorktown*. In the battle of
7 and 8 May 1942, 69 American and 51 Japanese
dive-bombers and torpedo-bombers flew repeated
sorties. The Japanese were forced to withdraw but
not before they had sunk the *Lexington* – here (1) the
dramatic moment after the captain had ordered
'abandon ship' – and crippled the *Yorktown*. (2) The
fleet carrier USS *Saratoga* is hit seven times off Iwo
Jima, February 1945, but continues operations. (3) A
Japanese 'Jill' torpedo-bomber levelling for the attack
off Truk, in the Carolinas, February 1945.

Der Kampf der Flugzeugträger

Auf dem Weg nach Port Moresby auf Neuguinea
stellten sich den japanischen Flugzeugträgern die
USS *Lexington* und die USS *Yorktown* entgegen. In
den Gefechten vom 7. und 8. Mai 1942 flogen 69
amerikanische und 51 japanische Sturzkampfflieger
und Torpedo-Bomber mehrere Angriffe auf die
Schiffe des Gegners. Die Japaner wurden zum
Rückzug gezwungen, fügten aber der *Yorktown* große

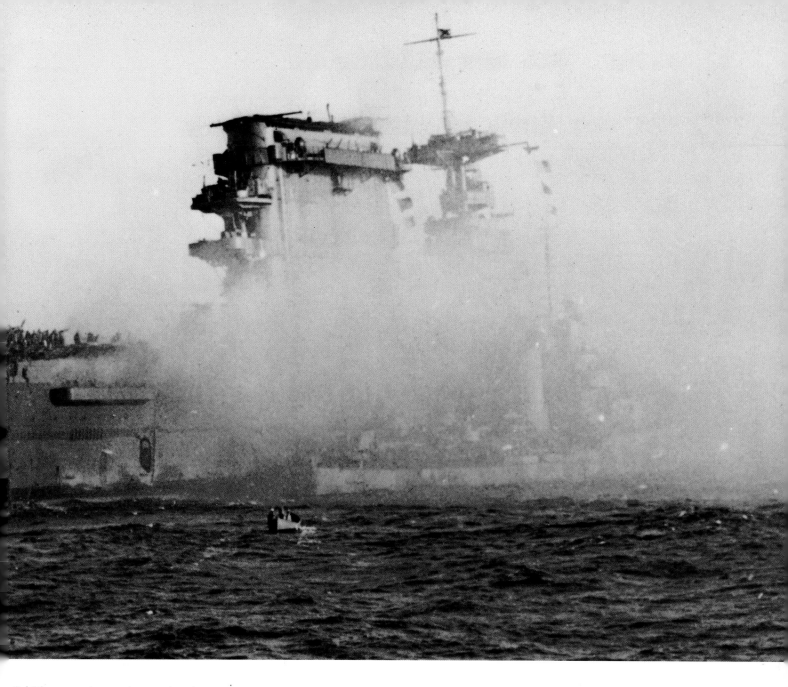

Schäden zu und versenkten vorher die *Lexington* –
hier (1) der dramatische Augenblick, nachdem der
Kapitän »Alle Mann von Bord« beordert hat. (2) Der
Flugzeugträger USS *Saratoga* wurde vor Iwo Jima
sieben Mal getroffen, setzt aber seine Angriffe fort,
Februar 1945. (3) Ein japanischer »Jill« Torpedo-
Bomber bringt sich für den Angriff vor der Karoli-
neninsel Truk in Gefechtsposition, Februar 1945.

Les batailles des porte-avions

Sur la route de Moresby, Nouvelle-Guinée, les
porte-avions japonais sont interceptés par le
Lexington et le *Yorktown*. Durant l'offensive des 7 et 8
mai 1942, 69 porte-avions et bombardiers-torpilleurs
américains, contre 51 pour les Japonais, feront des
sorties répétées. Les Japonais sont contraints de se
retirer, après avoir coulé le *Lexington* – (1) scène
dramatique après l'annonce de « l'abandon du navire »
– et endommagé le *Yorktown*. (2) Février 1945, le
porte-avions USS *Saratoga* est touché à sept reprises
au large de Iwo-Jima mais poursuit les opérations.
(3) Février 1945, un bombardier japonais « Jill » à
destination de Truk, Iles Carolines.

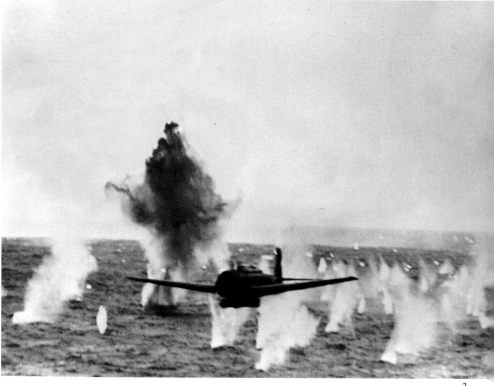

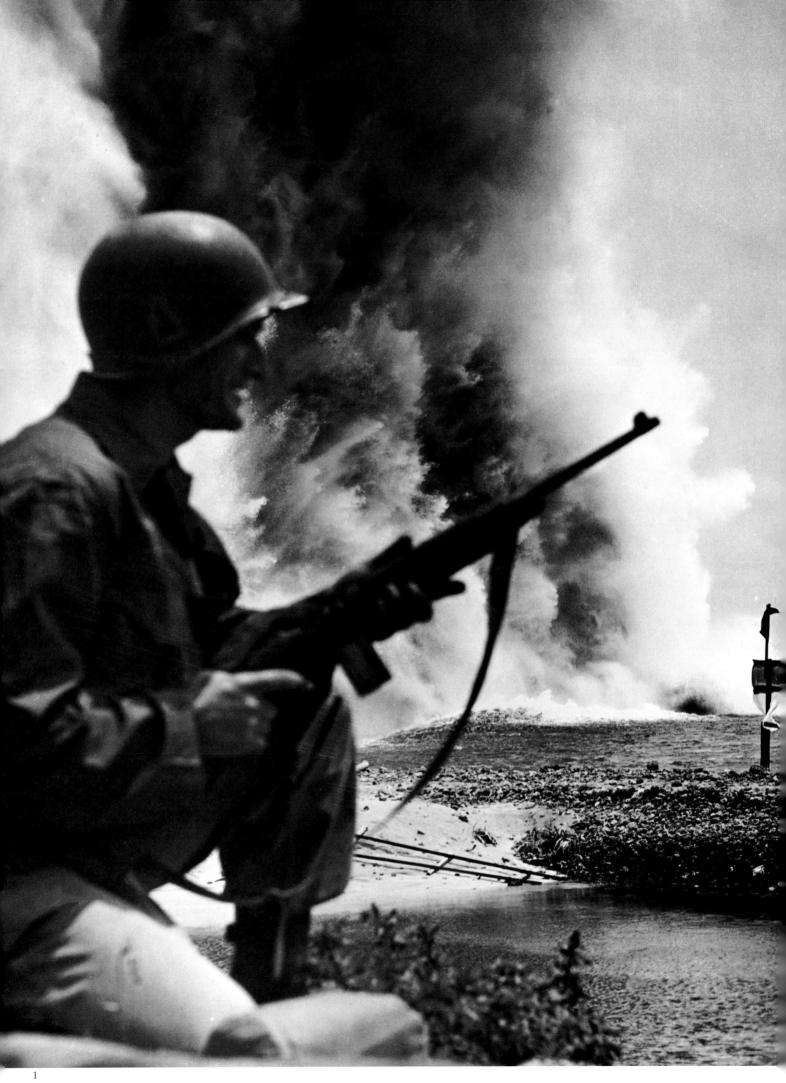

Beach and Jungle

(1) An American GI stands on guard as a coral atoll is blasted during the battle of Okinawa, April to June 1945. (2) American infantry preparing for a jungle patrol on the island of Bougainville, where 5000 Japanese died as they tried to break the American lines in March 1944. (3) The Chindits, special jungle forces, under the charismatic British Major-General Orde Wingate, carried out raids deep behind Japanese lines to ease the advance of Slim's 14th Army in Burma.

Strand und Dschungel

(1) Ein amerikanischer GI steht Wache, während ein Korallenriff bei der Schlacht um Okinawa in die Luft fliegt, April bis Juni 1945. (2) Amerikanische Infanterie bereitet sich auf eine Dschungelpatrouille auf der Insel Bougainville vor. Hier starben im März 1944 5000 Japaner bei dem Versuch, die amerikanischen Linien zu durchbrechen. (3) Die Chindits, spezielle Dschungeleinheiten unter dem charismatischen Generalmajor Orde Wingate, führten Angriffe weit hinter den japanischen Linien durch, um den Vormarsch von Slims 14. Armee in Burma zu erleichtern.

La plage et la jungle

(1) Un GI monte la garde pendant un raid sur un atoll, bataille d'Okinawa, juin-avril 1945. (2) L'infanterie américaine se prépare à patrouiller dans la jungle de l'île de Bougainville. Mars 1944, 5000 Japonais meurent en tentant de percer les lignes américaines. (3) Les Chindits, forces de jungle spéciales, sous l'ordre du charismatique général de division britannique, Orde Wingate. Il lancera des raids très à l'arrière des lignes japonaises pour faciliter l'avance de la 14ᵉ armée de Slim en Birmanie.

3

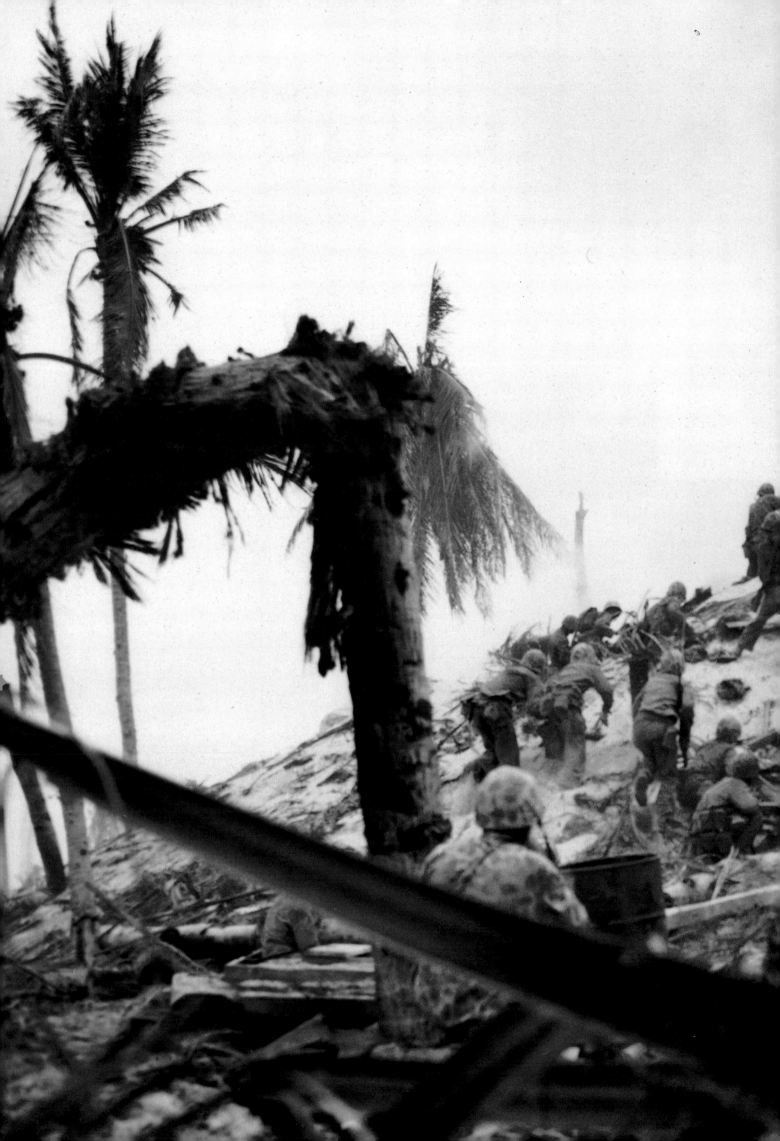

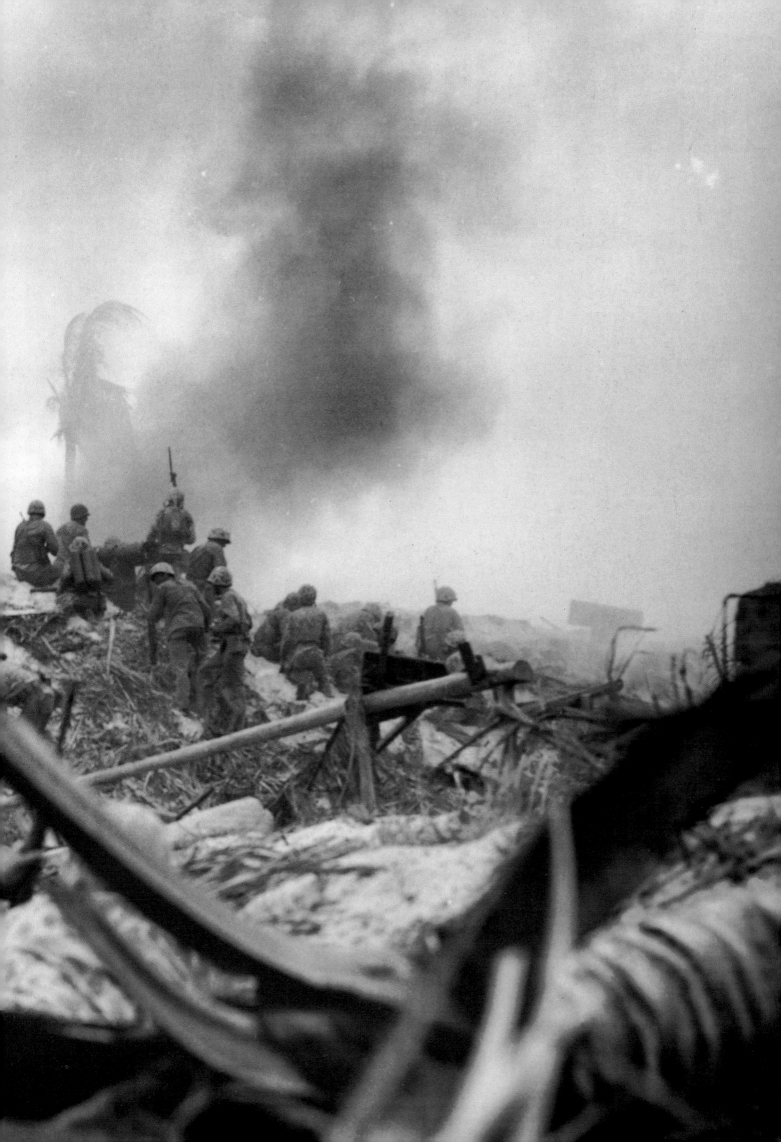

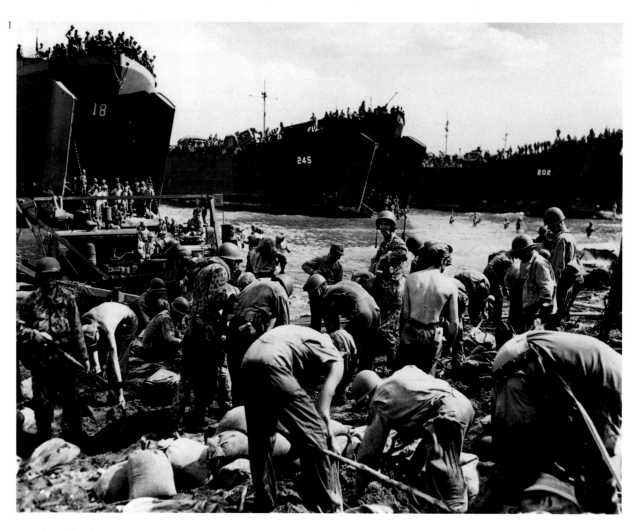

Death and Glory

(Previous page) US Marines storm the island of Tarawa, Gilbert Islands, on 20 November 1943. (1) American troops pour ashore from their landing ships at Leyte during the recapture of the Philippines, October 1944. (2) A landing in April 1944 in the Marshall Islands. (3) Three American soldiers lie dead on the beach at Buna, New Guinea, after a battle in January 1943. They had been ambushed by Japanese concealed in the wreck in the background. These pictures were among the first from the Pacific to show close-ups of American dead.

Tod und Ehre

(Vorige Doppelseite) US Marines stürmen die Insel Tarawa, Teil der Gilbert-Inseln, am 20. November 1943. (1) Amerikanische Truppen strömen während der Wiedereroberung der Philippinen von ihren Landungsschiffen bei Leyte an Land, Oktober 1944. (2) Landung auf den Marshall-Inseln im April 1944. (3) Drei amerikanische Soldaten liegen nach der Schlacht tot am Strand von Buna, Neuguinea, Januar 1943. Sie wurden von Japanern überfallen, die sich in dem Wrack im Hintergrund versteckt hatten. Diese Fotos gehörten zu den ersten aus dem Pazifik, die Nahaufnahmen von amerikanischen Toten zeigten.

La mort et la gloire

(Page précédente) 20 novembre 1943, des marines US prennent d'assaut Tarawa, une des îles Gilbert. (1) Octobre 1944, des troupes américaines débarquent à Leyte lors de la reconquête des Philippines. (2) Avril 1944, débarquement sur les Iles Marshall. (3) Janvier 1943, après une attaque, les corps de trois soldats américains tués sur la plage de Buna, Nouvelle-Guinée. Ils sont tombés dans une embuscade dressée par des Japonais cachés dans le bateau naufragé. C'est une des premières photos à montrer des victimes américaines en gros plan.

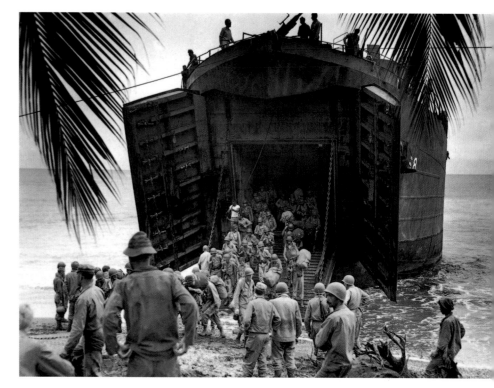

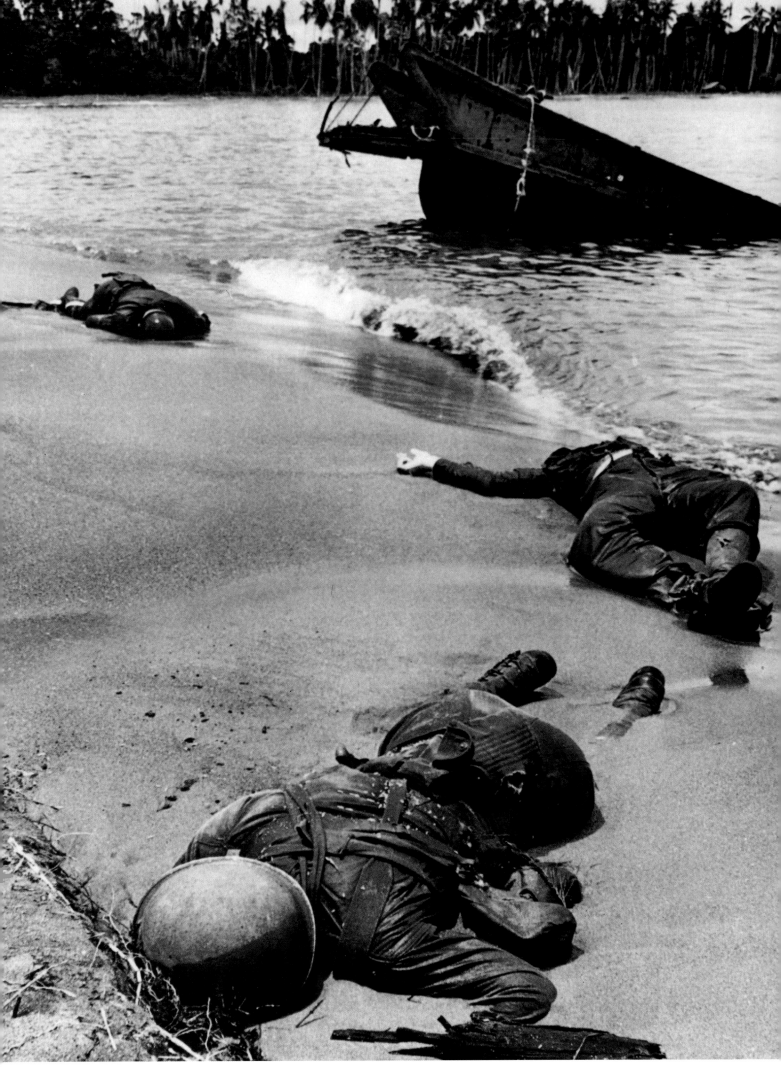

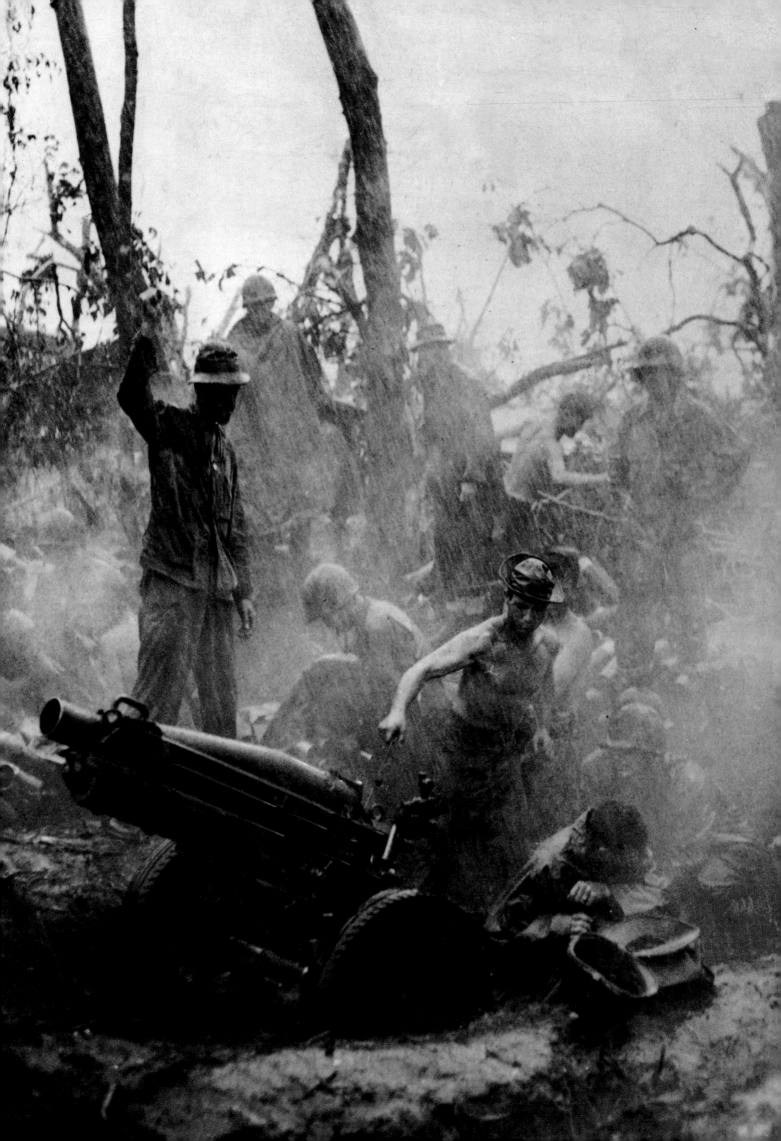

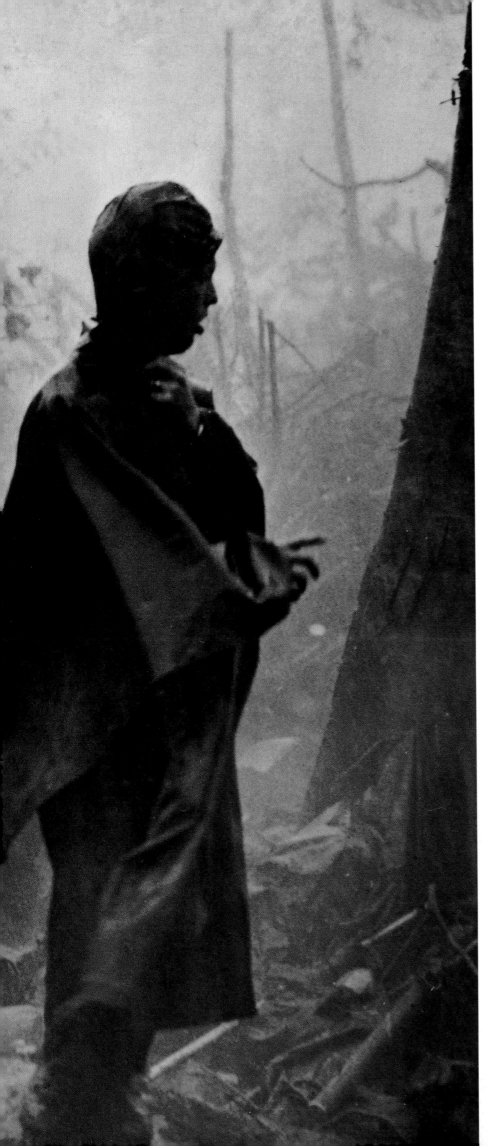

Last Gasp

American artillery firing in a tropical downpour in the battle for Cape Gloucester, New Britain. The 75-mm howitzer is embedded in the mud and swamp, rendering it difficult to register accurately. It appears to be being used in a close support role at a range of a few thousand metres at most. The gun captain raises his arm for the signal to fire, apparently oblivious to the storm, and the gunlayer is stripped to the waist. Disease was to account for a high proportion of American casualties in such conditions. (Overleaf) Hiroshima: the scene of devastation, September 1945, a month after the first atom bomb had levelled the centre of the city.

In den letzten Zügen

Amerikanische Artillerie feuert in einem tropischen Regen beim Kampf um Cape Gloucester, New Britain. Die 75-mm-Haubitze ist im Sumpf und Schlamm eingegraben, was ein genaues Zielen erschwert. Diese Haubitzen wurden meist in einer Entfernung von wenigen tausend Metern zur Unterstützung der Frontkämpfer eingesetzt. Der Artillerieoffizier hebt seinen Arm zum Feuersignal, anscheinend unbeeindruckt vom Sturm, während der Kanonier bis zur Hüfte nackt ist. Unter solchen Umständen führten Seuchen zu einem Großteil der amerikanischen Verluste. (Folgende Doppelseite) Hiroshima: Der Ort der Zerstörung, September 1945 – einen Monat, nachdem die erste Atombombe das Stadtzentrum dem Erdboden gleichgemacht hat.

Le dernier souffle

Artillerie américaine ouvrant le feu sous une pluie tropicale pendant la bataille de Cape Gloucester, Nouvelle Bretagne. L'obusier de 75 mm est tellement embourbé qu'il est difficile de viser avec précision. Il semble être utilisé comme une arme d'appoint pour atteindre des cibles de proximité, à un ou deux kilomètres au plus. L'officier lève son bras pour donner le signal du tir, oubliant apparemment la pluie torrentielle. Le canonnier est dénudé jusqu'à la poitrine. Les conditions climatiques et les maladies entraîneront de lourdes pertes dans l'armée américaine. (Page suivante) Septembre 1945, scène de désolation à Hiroshima, un mois après la première bombe atomique qui a rasé tout le centre de la ville.

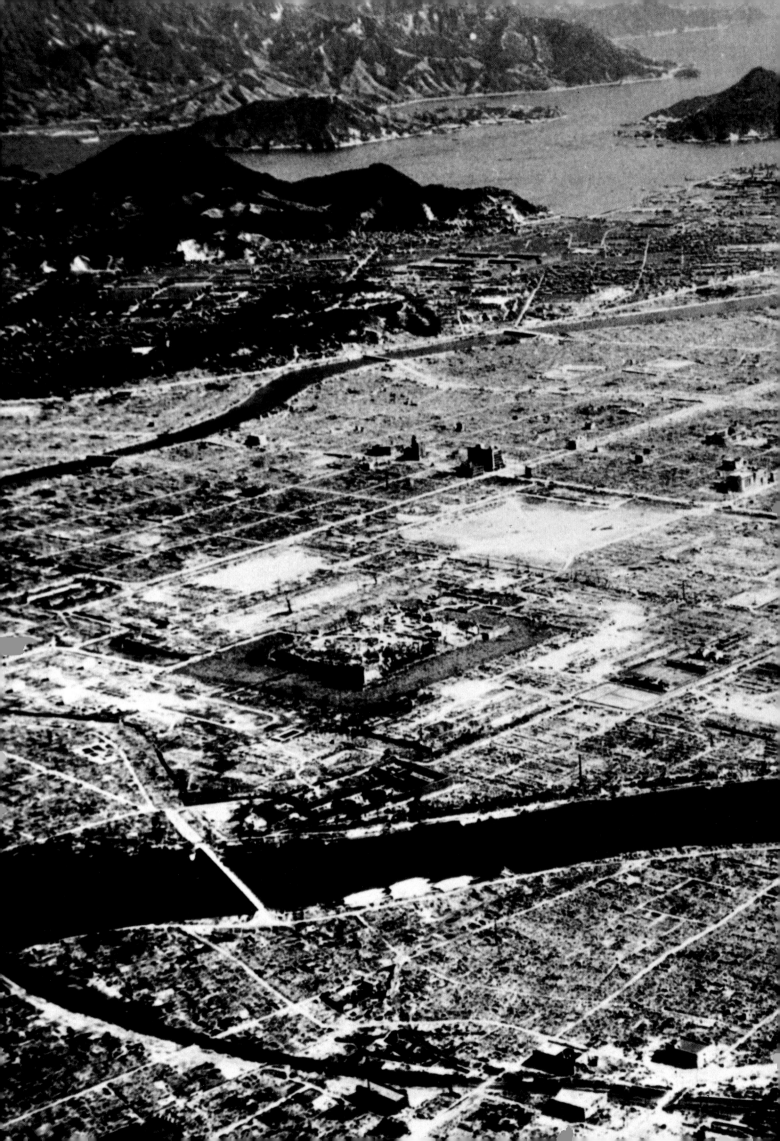

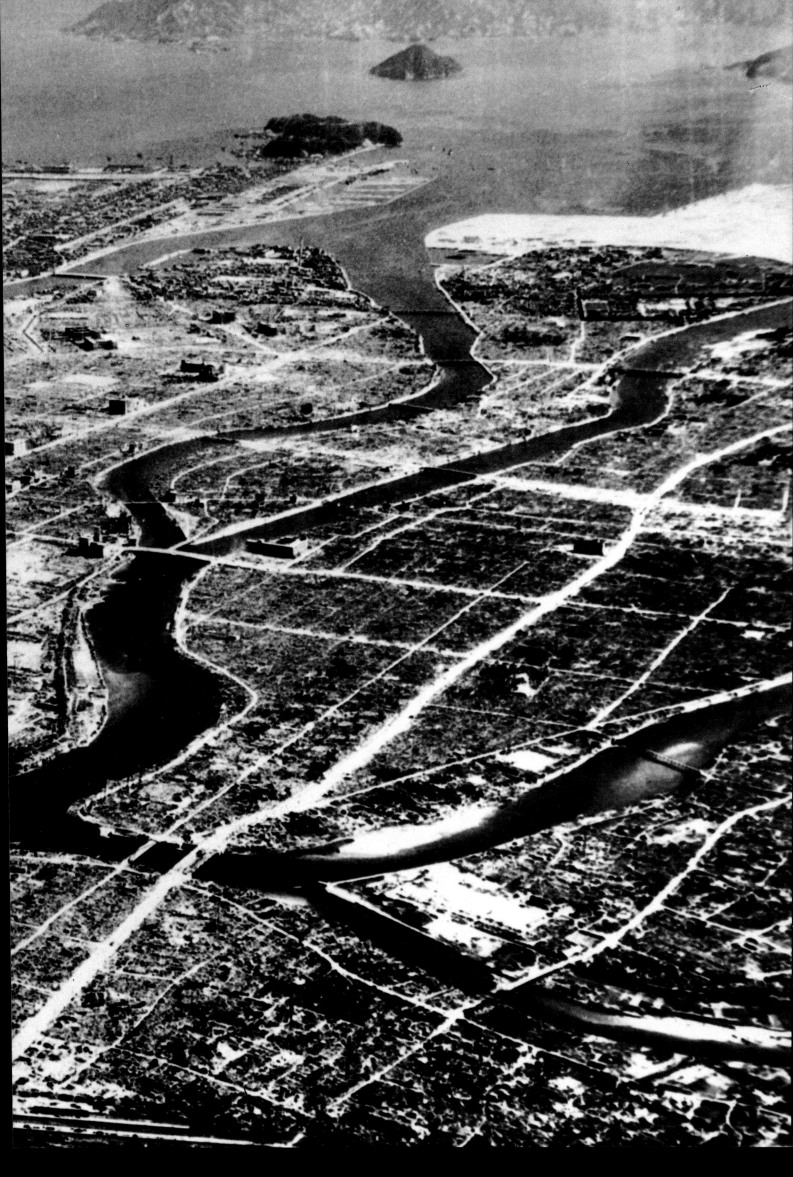

In 1946 the Iron Curtain descended over Europe. For 40 years the balancing forces of Nato Alliance and Warsaw Pact ensured an uneasy peace, though they supported local wars in other parts of the world. Several times they teetered to the brink of nuclear war. The fall of the Berlin Wall in 1989 symbolised the end of the Cold War, and the collapse of Communism in eastern Europe. Two of the outstanding Cold War leaders, Vice-President Richard Nixon and Nikita Khrushchev of the Soviet Union, here in an angry confrontation in America in 1960.

1946 fiel der Eiserne Vorhang über Europa. 40 Jahre lang ermöglichten die um ein Gleichgewicht der Kräfte bemühten Truppen der Nato und des Warschauer Pakts einen unbehaglichen Frieden, unterstützten aber in anderen Teilen der Welt lokale Kriege. Mehrere Male balancierten sie am Abgrund eines nuklearen Krieges. Der Fall der Berliner Mauer 1989 symbolisierte das Ende des Kalten Krieges und den Zusammenbruch des Kommunismus in Osteuropa. Zwei der prominentesten Führer des Kalten Krieges, der amerikanische Vizepräsident Richard Nixon und der russische Parteichef Nikita S. Chruschtschow, hier 1960 in den Vereinigten Staaten während einer wütenden Auseinandersetzung.

En 1946, le «rideau de fer» s'abat sur l'Europe. Pendant près de 40 ans, les puissances respectives de l'OTAN et du pacte de Varsovie maintiendront la paix tant bien que mal, tout en soutenant des conflits dans d'autres régions du monde. A plusieurs reprises, elles seront au bord de la guerre nucléaire. La chute du mur de Berlin en 1989 symbolise la fin de la guerre froide et du communisme en Europe de l'Est. Les deux grands leaders de la guerre froide, le vice-président américain Richard Nixon et le Russe Nikita Khrouchtchev, lors d'une rencontre houleuse aux Etats-Unis en 1960.

The Iron Curtain

As peace came to Europe, the wartime allies America and Russia began to eye each other with increasing suspicion and hostility. Co-operation in 1945 had become confrontation by the middle of 1946. The Western allies rapidly demobilized their armies in Europe, while the Soviet Red Army did not. Stalin, the Russian dictator, was concerned about America's possession of nuclear weapons, and the acquisition of a nuclear arsenal became a Soviet priority.

'From Stettin in the Baltic to Trieste in the Adriatic an Iron Curtain has descended across the Continent,' Winston Churchill, now in opposition in Britain, told an audience of students at Fulton, Missouri, on 5 March 1946. 'The dark ages may return on the gleaming wings of science. Beware, I say. Time may be short.'

By the middle of 1946 the Russians had established a physical barbed-wire-and-concrete barrier through the middle of Germany – the Inner German Border – though previously they had pledged to keep Germany as one country. This marked the beginning of the Cold War, which was to bring the most extravagant arms race in history, when both sides acquired a nuclear arsenal capable of destroying the planet many times over.

In 1949, 12 Western allies formed the North Atlantic Treaty Organisation. When Germany joined Nato in 1955, the Soviet Union formed the rival Warsaw Pact of seven east European countries; all except Albania were Soviet satellites. Tito's Yugoslavia, though Communist, successfully thumbed its nose at Moscow and stayed neutral.

In the early stages the Cold War threatened to go 'hot' as the rivals tested each other's nerves. In June 1947 Stalin closed land routes from the west into Berlin. The British and Americans responded with the Berlin airlift, which was to supply the city with more than 172,000 tons of food and material until January 1949, an air supply operation only surpassed by the air bridge into Sarajevo from 1992 to 1995.

In the Balkans, Soviet Russia backed the Communist insurgents in Greece's murderous civil war (1946-49). In 1947 President Truman pledged America's support for countries threatened by armed Communist minorities (the Truman doctrine). The use of American aircraft was decisive in the royalist victory in Greece.

America began reviving the shattered economies of western Europe through the Recovery Programme devised by the Secretary of State, George Marshall. Marshall saw his plan as a means of saving Europe from Communism. Stalin saw it as a threat. When it was suggested that Czechoslovakia might get Marshall aid, the Communists organized a coup and the country became a Soviet satellite.

The police regimes of eastern Europe were to have a profound effect on the culture and society of that region. It was the era of official lying and spying, to the most banal degree. Secret police forces like the Stasi of Germany and the Securitate of Romania actually kept sheds full of files on their fellow citizens. 'To every question why, there was a because whether it was true or not,' said a Croat, remembering school under Tito.

Many tried to resist, and suffered loss of identity, citizenship, torture and worse. In 1953 a workers' uprising in east Berlin was quickly crushed. In October 1956 the Communist regime in Budapest was overthrown for ten brief, heady days. But the Russians sent in their tanks, and the West was pre-occupied with the Suez crisis and war in the Middle East.

The two power blocs did confront each other on the battlefield through their clients and proxies in wars across the globe, from Africa to Latin America and the Middle East. In

(1) Nikita Khrushchev raises his finger to denounce a speech by the British Prime Minister Harold Macmillan during the UN General Assembly session on 29 September 1960. The chairman of the 15th session was to accuse the European Communist bloc of trying to wreck the assembly, which he adjourned. (2) The moment of truth: Russian soldiers marking the frontier of the Soviet Union as their armies roll westward in Europe, March 1944.

(1) Nikita Chruschtschow hebt den Finger, um eine Rede des britischen Premierministers Harold Macmillan während der Sitzung der UN-Vollversammlung am 29. September 1960 zu verurteilen. Der Vorsitzende der 15. Sitzung warf dem Block der Europäischen Kommunisten vor, die Versammlung durch Verzögerungen zum Scheitern zu bringen. (2) Der Augenblick der Wahrheit: Russische Soldaten markieren die Grenze der Sowjetunion, während ihre Armeen weiter westwärts nach Europa rollen, März 1944.

(1) 29 septembre 1960, Nikita Khrouchtchev lève le doigt pour dénoncer le discours du Premier ministre britannique Harold Macmillan tenu devant l'Assemblée générale de l'ONU. Le président de cette 15ᵉ séance accuse le bloc communiste européen de vouloir saboter l'assemblée et l'ajourne. (2) Mars 1944, moment de vérité: des soldats russes marquent la frontière de l'Union soviétique alors que leurs armées avancent sur l'Europe de l'Ouest.

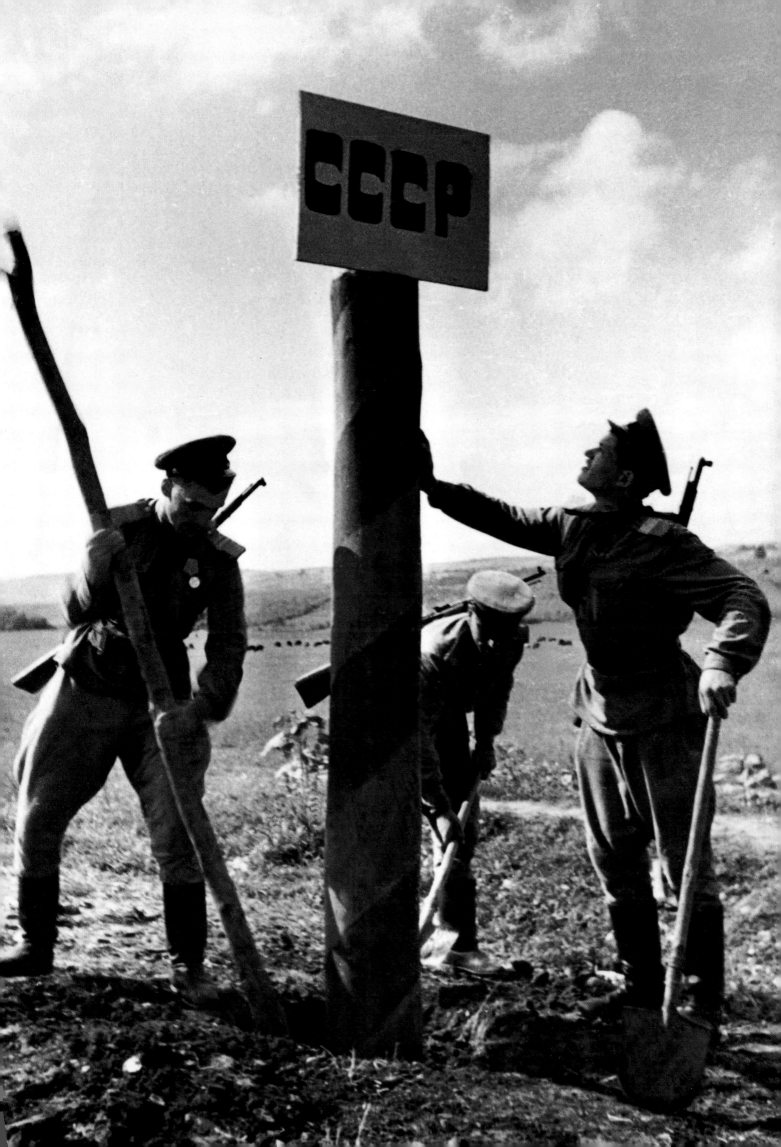

1962, however, the threat of war came to America's doorstep when the Soviet leader Khrushchev decided to base rockets with nuclear warheads on the island of Cuba, which had been under Fidel Castro's Communists since 1959.

Once American intelligence got wind of the plan, President John F. Kennedy put a blockade round Cuba, threatened nuclear retaliation on Russia, and the invasion of Cuba itself if the missiles were not removed. With much public bad temper, Khrushchev backed down. The military pattern of the rest of the Cold War was set: under military threat, America would raise the stakes.

On 13 August 1961 Berliners woke to find a huge wall being built down their divided city to stop the increasing flow of escapers and refugees to the West. The wall was to be the supreme symbol of the Europe divided by the Cold War.

In 1968 Czechs voted with their feet, and with flowers, 'to give Communism a human face', in the gentle uprising of the Prague Spring. By August the Russians had their tanks on the streets – though the dissidents of Prague kept up a powerful intellectual and cultural resistance.

By the 1970s both alliances realized they were dangerously overarmed and tried to reduce ballistic nuclear weapons through Strategic Arms Limitation Talks (SALT). A deal was struck on intermediate weapons, with the Russians agreeing to stand down SS-20 missiles in eastern Europe, if the Western allies withdrew Cruise and Pershing II rockets just installed in Germany, Italy and Britain. In 1983 President Ronald Reagan inaugurated the Strategic Defence Initiative (SDI), an anti-missile defence in space. To compete, the Soviets would have to break the bank.

Meanwhile Russia's military involvement in Afghanistan, to which she had sent massive forces in 1980, was proving as difficult as the American experience in Vietnam from 1964 to 1975.

In October 1978, the Roman college of cardinals meeting in conclave chose Karol Wojtyla, Archbishop of Cracow, as the next Pope, the first from Poland. As Pope John Paul II he became the inspiration of the free trade-union movement 'Solidarity' and the focus of spiritual resistance in eastern Europe.

By the end of the 1980s it was clear that the West had won the battle of wills, and the Soviet Union and its satellites were politically, materially and spiritually exhausted, as the new Soviet leader Mikhail Gorbachev recognized. After a mass movement of refugees in eastern Europe in the late summer of 1989, the east German regime gave up. On a joyous night in November the first slabs of steel-reinforced concrete were torn out of the Berlin Wall. The Cold War was over. In the next year and a half the Communists would lose power, or change their name, in every regime of eastern Europe, and the Soviet empire broke up like melting pack-ice.

Though the lives of many had been destroyed, and the aspirations of generations blighted, Europe had undergone a major change of direction without the massive slaughter of another war.

Als in Europa endlich Frieden herrschte, begannen die Kriegsalliierten Amerika und Rußland, sich mit wachsendem Mißtrauen und Feindseligkeit zu beäugen. Die Kooperation noch im Jahre 1945 schlug ab Mitte 1946 in Konfrontation um. Die westlichen Alliierten demobilisierten ihre Armeen in Europa relativ zügig, ganz im Gegensatz zur sowjetischen Roten Armee. Stalin, der russische Diktator, war über Amerikas Besitz von Nuklearwaffen beunruhigt. Der Erwerb eines nuklearen Arsenals wurde zum obersten Ziel sowjetischer Politik.

»Von Stettin im Baltikum nach Triest an der Adria ist ein eiserner Vorhang über Europa gefallen«, erklärte Winston Churchill am 5. März 1946, jetzt als Oppositionsführer in Großbritannien, einem Auditorium von Studenten in Fulton, Missouri. »Die dunkle Zeit wird vielleicht auf den schimmernden Schwingen der Wissenschaft zurückkehren. Seid wachsam, sage ich. Die Zeit kann knapp werden.«

Bis Mitte 1946 hatten die Russen eine Grenze aus Stacheldraht und Beton mitten durch Deutschland gezogen, obwohl sie ursprünglich für ein ungeteiltes Deutschland gestimmt hatten. Dies bedeutete den Beginn des Kalten Krieges, in dessen Verlauf beide Seiten versuchten, ein nukleares Potential aufzubauen, mit dem die Erde mehrfach zerstört werden konnte.

1949 gründeten zwölf westliche Verbündete den Nordatlantikpakt Nato. Nach dem Beitritt der Bundesrepublik Deutschland 1955 rief die Sowjetunion als Gegenorganisation den Warschauer Pakt ins Leben, der aus sieben osteuropäischen Mitgliedstaaten bestand; alle Staaten außer Albanien zählten zu den sowjetischen Satelliten. Titos Jugoslawien, obwohl kommunistisch, widersetzte sich erfolgreich Moskaus Vorschlägen und blieb neutral.

In der Anfangsphase drohte der Kalte Krieg durch das gegenseitige Provozieren der Rivalen in einen »heißen« Krieg umzuschlagen. Im Juni 1947 sperrte Stalin die Landwege von Westen nach Berlin. Die Briten und die Amerikaner antworteten mit der Berliner Luftbrücke, die die Stadt bis zum Januar 1949 mit über 172 000 Tonnen Lebensmitteln und anderen Gütern versorgte. Das Ausmaß dieser Luftversorgungsoperation wurde später nur noch durch die Luftbrücke nach Sarajewo zwischen 1992 und 1995 übertroffen.

Auf dem Balkan unterstützte die Sowjetunion kommunistische Rebellen in Griechenlands mörderischem Bürgerkrieg (1946-49). 1947 versprach Präsident Truman amerikanische Hilfe für Länder, die von bewaffneten kommunistischen Minderheiten bedroht wurden (die sogenannte »Truman-Doktrin«). Der Einsatz der amerikanischen Luftwaffe war entscheidend für den Sieg der Royalisten in Griechenland.

Nach den Vorschlägen von Außenminister George Marshall startete Amerika ein Wiederaufbauprogramm zur Belebung der zusammengebrochenen Wirtschaft in Westeuropa. Marshall verstand seinen Plan als Mittel zur Rettung Europas vor dem Kommunismus; Stalin sah ihn als Bedrohung. Als vorgeschlagen wurde, die Tschechoslowakei mit Marschallplanhilfe zu unterstützen, organisierten die

Kommunisten einen Staatsstreich und machten das Land zu einem Ableger der Sowjetunion.

Die Polizeistaaten in Osteuropa hatten eine durchgreifende Wirkung auf die Kultur und Gesellschaft dieser Region. Ein Zeitalter der offiziellen Lügen und Bespitzelungen brach an. Geheimpolizei wie die Stasi in Deutschland und die Securitate in Rumänien sammelten schrankeweise Akten über ihre Mitbürger. »Auf jedes ›Warum‹ gab es ein ›Weil‹, egal ob die Antwort wahr oder falsch war«, kommentiert ein Kroate die Erinnerung an seine Schulzeit unter Tito.

Wer Widerstand zu leisten versuchte, wurde seiner Identität und Bürgerrechte beraubt oder erlitt Folter oder Schlimmeres. 1953 wurde ein Arbeiteraufstand in Berlin niedergeschlagen, im Oktober 1956 setzte man das kommunistische Regime in Budapest für zehn Tage ab, die wie ein Rausch empfunden wurden. Aber die Russen schickten ihre Panzer, während der Westen mit der Suez-Krise und dem Krieg im Nahen Osten beschäftigt war.

Die beiden Machtblöcke standen einander in Stellvertreterkriegen überall auf der Welt gegenüber – in Afrika, Lateinamerika und im Nahen Osten. 1962 gelangte die Kriegsdrohung bis vor Amerikas Haustür, nachdem der sowjetische Präsident Chruschtschow die Stationierung von Raketen mit Nuklearsprengköpfen auf der seit 1959 von Fidel Castros Kommunisten regierten Insel Kuba anordnete.

Als der amerikanische Geheimdienst Wind von der Sache bekam, ordnete Präsident John F. Kennedy eine Blockade Kubas an und drohte Rußland mit einem nuklearen Vergeltungsschlag und der Invasion Kubas, wenn die Raketen nicht zurückgezogen würden. Unter vielen öffentlichen Mißmutsäußerungen gab Chruschtschow nach. Damit war die militärische Strategie für den Rest des Kalten Krieges festgelegt: Im Falle militärischer Bedrohung würde Amerika die Herausforderung annehmen.

Am Morgen des 13. August 1961 waren die Berliner mit einer großen Mauer mitten durch ihre geteilte Stadt konfrontiert, die den wachsenden Strom der Flüchtlinge in den Westen aufhalten sollte. Die Mauer war das deutlichste Symbol für das durch den Kalten Krieg geteilte Europa.

Während des gewaltlosen Aufstandes im Prager Frühling 1968 wählten die Tschechen mit den Füßen und mit Blumen, »um dem Kommunismus ein menschliches Antlitz zu verleihen«. Im August rollten russische Panzer durch die Straßen – obwohl die Prager Dissidenten eine starke intellektuelle und kulturelle Widerstandsbewegung aufrecht erhielten.

In den 70er Jahren wurde beiden Seiten klar, daß sie sich gefährlich überbewaffnet hatten. Durch die sogenannten SALT-Verhandlungen zur Begrenzung strategischer Waffen wollte man die ballistischen Nuklearwaffen reduzieren. Man erzielte eine Übereinkunft über Mittelstreckenwaffen, und die Russen stimmten dem Abbau der SS-20 Raketen in Osteuropa zu – unter der Bedingung, daß die westlichen Verbündeten ihre kurz zuvor in Deutschland, Italien und Großbritannien stationierten Cruise-Missile- und Pershing-Raketen zurückzogen. 1983 rief Ronald Reagan die SDI-Initiative ins Leben, ein Raketen-Verteidigungssystem im Weltraum. Ein solches Programm konnten sich die Russen nicht leisten.

In der Zwischenzeit erwies sich die russische Militärintervention in Afghanistan, wohin man seit 1980 Streitkräfte in großem Umfang geschickt hatte, als ebenso problematisch wie der amerikanische Einsatz in Vietnam von 1964 bis 1975.

Im Oktober 1978 wählte das römische Kardinalskollegium mit Karol Wojtyla, dem Erzbischof von Krakau, den ersten Polen zum nächsten Papst. Als Papst Johannes Paul II. wurde er richtungsweisend für die freie Gewerkschaftsbewegung »Solidarität« und zum Zentrum des geistlichen Widerstandes in Osteuropa.

Gegen Ende der 80er Jahre wurde deutlich, daß der Westen den Machtkampf gewonnen hatte und daß die Sowjetunion und die von ihr kontrollierten Länder politisch, materiell und geistig erschöpft waren, wie auch der neue sowjetische Führer Michail Gorbatschow erkannte. Nach einer Massenflucht in Osteuropa im Spätsommer 1989 gab das DDR-Regime auf. Am 9. November wurden die ersten Stücke aus dem mit Stahl verstärkten Beton der Berliner Mauer herausgeschlagen. Der Kalte Krieg war zu Ende. In den nächsten eineinhalb Jahren verloren die Kommunisten in jeder osteuropäischen Regierung an Macht oder änderten ihren Namen. Das sowjetische Imperium brach zusammen wie schmelzendes Packeis.

Obwohl das Leben vieler Menschen zerstört und die Hoffnungen von Generationen im Keim erstickt worden waren, hatte Europa eine markante Richtungsänderung ohne das Blutvergießen eines neuen Krieges erlebt.

La paix règne sur l'Europe mais les Etats-Unis et la Russie, alliés pendant la guerre, s'observent avec une méfiance et une hostilité grandissantes. La coopération de 1945 fait place à la confrontation vers le milieu de 1946. En Europe, les Alliés occidentaux démobilisent rapidement leurs armées, au contraire de l'Armée rouge. Staline, le dictateur russe, s'inquiète du potentiel nucléaire américain et l'acquisition d'un arsenal nucléaire devient une priorité pour les Soviétiques.

Le 5 mars 1946, Winston Churchill, devenu membre de l'opposition en Grande-Bretagne, met en garde les étudiants de l'université de Fulton, Missouri: «Un rideau de fer est tombé sur l'Europe, de Stettin sur la mer Baltique à Trieste sur la mer Adriatique. L'âge des ténèbres peut revenir sur les ailes rayonnantes de la science. Attention. Avant qu'il ne soit trop tard.»

Vers le milieu de 1946, les Russes ont dressé une barrière de fils barbelés et de murs à travers l'Allemagne – la frontière allemande intérieure – alors qu'ils s'étaient prononcés en faveur d'une Allemagne unie. Ce geste marque le début de la guerre froide, qui entraînera la plus grande et la plus folle course aux armements de l'histoire. De part et d'autre, l'arsenal nucléaire ainsi acquis pourrait détruire plusieurs fois la planète.

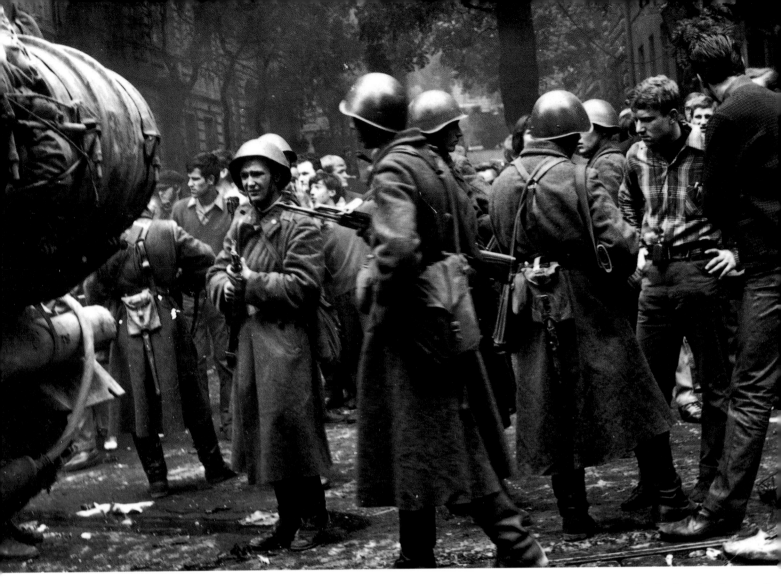

En 1949, douze Alliés occidentaux créent l'Organisation du Traité de l'Atlantique Nord. Lorsque l'Allemagne rejoint l'OTAN en 1955, l'Union soviétique réagit en créant le pacte de Varsovie réunissant sept pays d'Europe de l'Est qui sont tous, à l'exception de l'Albanie, des pays satellites. La Yougoslavie de Tito, bien que communiste, fait un pied de nez à Moscou et conserve sa neutralité.

Au début, la guerre froide menace d'être «chaude» alors que les pays rivaux se testent. En juin 1947, Staline ferme les routes d'accès de l'Ouest sur Berlin. Les Britanniques et les Américains répliquent par un pont aérien sur la ville qui permettra d'acheminer plus de 172 000 tonnes de nourriture et de matériel jusqu'en janvier 1949. Cette opération d'approvisionnement aérien ne sera égalé que par le pont aérien de Sarajevo de 1992 à 1995.

Dans les Balkans, la Russie soviétique soutient les insurgés communistes grecs après la guerre civile meurtrière de 1946 à 1949. En 1947, le président Truman s'engage à soutenir les pays menacés par les minorités communistes armées (la doctrine Truman). Le recours à l'aviation américaine sera déterminante dans la victoire des royalistes en Grèce.

L'Amérique met en place le plan Marshall, établi par le secrétaire d'Etat George Marshall, pour relancer les économies ruinées de l'Europe occidentale. Pour Marshall, ce plan de reconstruction est le moyen de sauver l'Europe du communisme. Staline le perçoit comme une menace. Quand il est question pour la Tchécoslovaquie de recevoir l'aide du plan Marshall, les communistes organisent un coup d'état et le pays tombe sous la coupe soviétique.

Les régimes policiers de l'Europe de l'Est auront un effet durable sur la culture et la société de cette partie du monde, qui incarneront l'ère du mensonge et de l'espionnage à tous les niveaux. Les polices secrètes, comme la Stasi en Allemagne et la Securitate en Roumanie, rempliront des abris entiers de dossiers sur leurs compatriotes. «Quand on demandait ‹pourquoi›, on nous répondait toujours ‹parce que›, que ce soit vrai ou pas», se souvient un Croate en évoquant l'école du temps de Tito.

Beaucoup tenteront de résister. Ils perdront leur identité, leur citoyenneté et souffriront de la torture et des pires atrocités. En 1953, une révolte de travailleurs à Berlin-Est est rapidement réprimée. En octobre 1956, le régime communiste à Budapest est renversé pendant 10 courtes mais tragiques journées. Les Russes réagissent et envoient leurs chars tandis que l'Ouest se préoccupe de la crise de Suez et de la guerre au Moyen-Orient.

Les deux grandes puissances s'affrontent par procuration dans des guerres livrées sur toute la planète, de l'Afrique à l'Amérique latine et au Moyen-Orient. En 1962, cependant, la menace de guerre frappe à la porte des Etats-Unis lorsque Khrouchtchev décide d'installer des fusées à tête nucléaire à Cuba qui, depuis 1959, vit sous le régime communiste de Fidel Castro.

（頭）

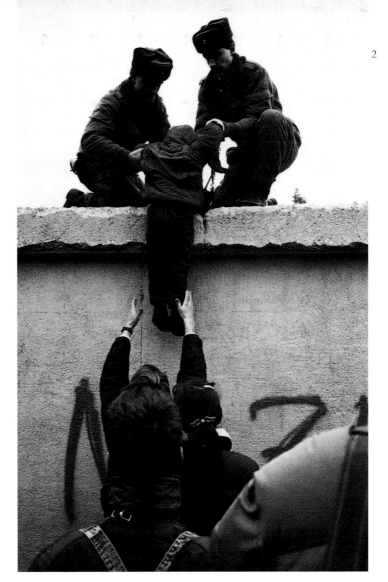

) On 24 August 1968 several hundred thousand Soviet troops with
nks and armoured carriers took over Czechoslovakia to crush the
olicy of 'Socialism with a Human Face'. This was the last popular
prising in eastern Europe that the Soviets were to suppress with
omplete success. (2) Border guards help an East German child up on
) the Berlin Wall for a view of the West, 31 December 1989.

) Am 24. August 1968 marschierten mehrere hunderttausend
owjetische Soldaten mit Panzern und Panzerfahrzeugen in der
schechoslowakei ein und zerstörten die Politik des »Sozialismus mit
nenschlichem Antlitz«. Es war der letzte öffentliche Aufstand in Ost-
uropa, den die Sowjets mit vollem Erfolg unterdrückten. (2) Grenz-
chützer helfen einem ostdeutschen Kind auf die Berliner Mauer,
amit es einen Blick in den Westen werfen kann, 31. Dezember 1989.

) Le 24 août 1968, plusieurs centaines de milliers de troupes
oviétiques, avec chars et blindés, envahissent la Tchécoslovaquie pour
sprimer la politique du «socialisme au visage humain». C'est le
ernier soulèvement populaire en Europe de l'Est que les Soviétiques
éussiront à écraser. (2) 31 décembre 1989, des garde-frontières aident
n petit Allemand de l'Est à monter sur le mur de Berlin pour qu'il
uisse voir l'Ouest.

Les services secrets américains ont connaissance de ce plan
t le président John F. Kennedy établit un blocus autour de
Cuba. Il menace la Russie de représailles nucléaires et d'enva-
ir Cuba si les missiles ne sont pas retirés. Khrouchtchev plie,
on sans avoir fait preuve de beaucoup de mauvaise humeur
n public. Le plan militaire pour le restant de la guerre froide
rend forme: sous la menace militaire, les Américains font
nonter les enchères.

Le 13 août 1961 au matin, les Berlinois découvrent qu'un
mmense mur est élevé à travers la ville divisée pour mettre fin
u flot grandissant de gens qui fuient à l'Ouest. Ce mur est le
lus grand symbole d'une Europe divisée par la guerre froide.

En 1968, les Tchèques manifestent avec des fleurs en faveur
l'un «communisme à visage humain». C'est la révolution
ranquille du printemps de Prague. En août, les Russes
nvoient leurs chars dans les rues, mais les dissidents de
'rague sauront maintenir une résistance intellectuelle et
ulturelle.

Dans les années 70, les deux alliances admettent qu'elles
ont surarmées et tentent de réduire leur arsenal nucléaire
négociations S.A.L.T.). Un marché est conclu à propos des
rmes de moyenne portée. Les Russes acceptent de retirer
eurs missiles SS-20 de l'Europe de l'Est si les Alliés occi-
lentaux retirent leurs fusées Cruise et Pershing, installées
lepuis peu en Allemagne, en Italie et en Grande-Bretagne. En
983, le président Ronald Reagan inaugure l'Initiative de
Défense Stratégique (S.D.I.), une défense anti-missiles dans
'espace. Pour leur faire concurrence, les Soviétiques devraient
asser leur tirelire.

Pendant ce temps, l'engagement militaire de la Russie en
Afghanistan, où elle a envoyé en 1980 un nombre impression-
iant de troupes, se révèle aussi difficile que celui des Etats-
Jnis au Vietnam de 1964 à 1975.

En octobre 1978, le collège des cardinaux de Rome se
éunit en conclave et nomme pape Karol Wojtyla, l'Arche-

vêque de Cracovie. Jean Paul II inspire le mouvement du
syndicat libre «Solidarité» et incarne la résistance spirituelle en
Europe de l'Est.

A la fin des années 80, il ne fait plus de doute que l'Ouest a
gagné la guerre d'usure. L'Union Soviétique et ses pays
satellites sont à bout politiquement, matériellement et spiri-
tuellement, comme le reconnaît le nouveau leader soviétique,
Mikhail Gorbatchev. A la fin de l'été 1989, après un flux massif
de réfugiés venus de l'Est, le régime est-allemand abandonne
le pouvoir. Les premiers pans du mur de Berlin tombent par
une joyeuse nuit de novembre. C'est la fin de la guerre froide.
Dans l'année qui suit, les communistes perdent le pouvoir ou
changent de nom dans chaque pays d'Europe de l'Est.
L'empire soviétique fond comme neige au soleil.

Beaucoup de vies ont été détruites et les aspirations de
plusieurs générations gâchées mais l'Europe traverse ce grand
bouleversement sans pour autant être ravagée par une nouvelle
guerre.

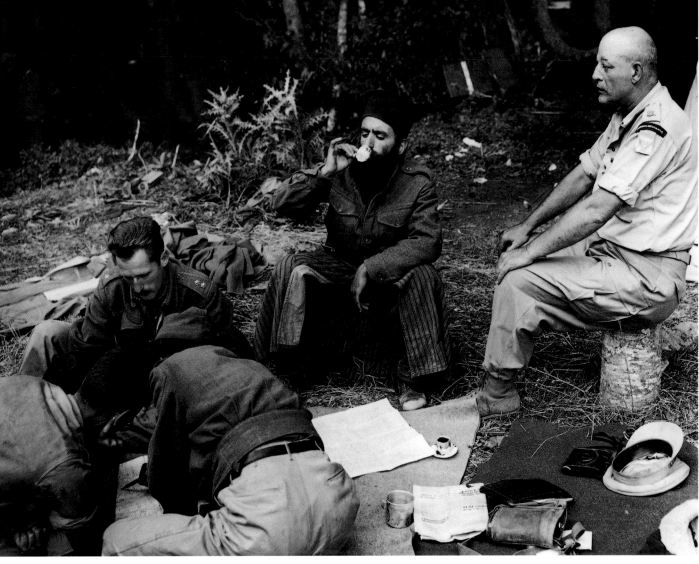

The Greek Civil War

Some of the bitterest fighting was along the mountain border with Albania. (1) A government observation post with machine gun at Karpensi, 1948. Note the British style of uniforms. (2) A priest sips his coffee as officers plan the assault on Mount Kiapha – priests travelled with most government formations. (3) A mule train hauling ammunition in Macedonia in 1948, scene of a bitter ethnic war between Slavs and Greeks.

Der griechische Bürgerkrieg

Einige der erbittertsten Gefechte des Krieges wurden entlang der bergigen Grenze zu Albanien ausgetragen. (1) Ein Beobachtungsposten der Regierung mit Maschinengewehr bei Karpensi, 1948. Auffällig ist der britische Stil der Uniformen. (2) Ein Priester trinkt seinen Kaffee, während Offiziere einen Angriff auf den Berg Kiapha planen – Priester begleiteten die meisten Regierungseinheiten. (3) Ein Maultiertreck bringt 1948 Waffen nach Makedonien, wo ein bitterer ethnischer Krieg zwischen Slawen und Griechen ausgefochten wurde.

La guerre civile grecque

Les plus durs combats ont lieu le long de la frontière montagneuse de l'Albanie. (1) En 1948 à Karpensi, un poste d'observation gouvernemental avec mitrailleuse. A noter le style britannique des uniformes. (2) Un prêtre orthodoxe déguste son café pendant que des officiers préparent l'assaut du mont Kiapha. Les prêtres accompagnent la plupart des formations gouvernementales. (3) 1948, un convoi de mules transportant des munitions en Macédoine, scène d'une guerre ethnique acharnée entre Slaves et Grecs.

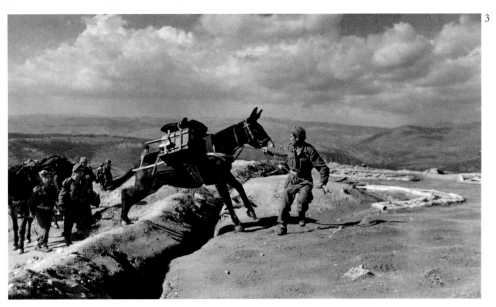

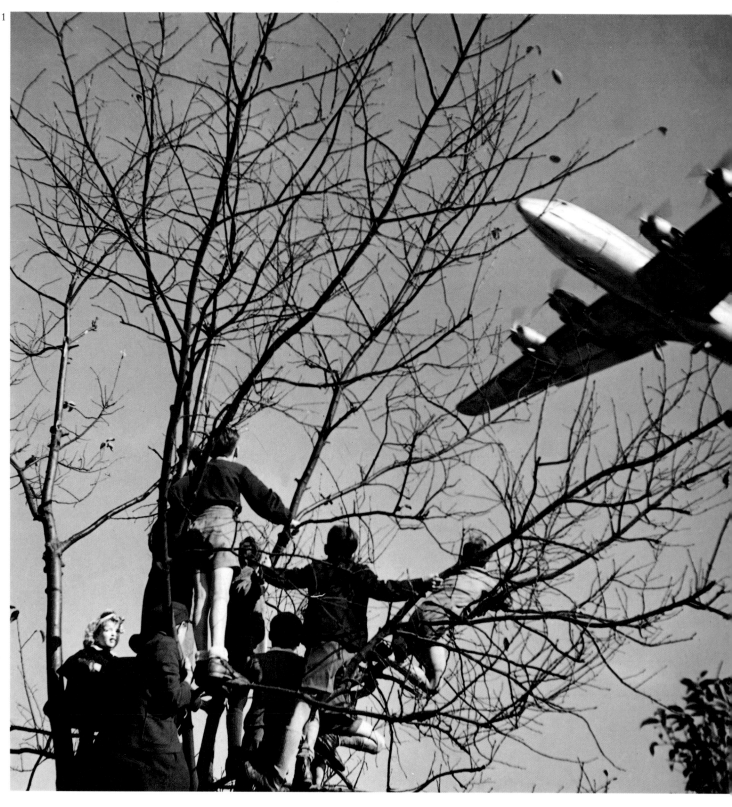

The Berlin Airlift

In June 1947 Stalin tried to choke the free sectors of Berlin by blockade. The Americans and British brought in more than 172,000 tons of supplies by air to the city in just under two years. (1) Children watch an American four-engined cargo plane skim the trees near the Brandenburg Gate. (2) Loading planes at Wunstorf airport; a plane had to leave every three minutes. (3) The British load up a train for their sector in the city. (4) A German airlift worker's wife feeds children on a makeshift bed – their lunch is one slice of dark bread and margarine. Note the Red Cross box on the table.

Die Berliner Luftbrücke

Im Juni 1947 versuchte Stalin mit einer Blockade, den freien Sektoren Berlins die Luft abzuschnüren. In weniger als zwei Jahren brachten die Amerikaner und die Briten per Flugzeug mehr als 172 000 Tonnen Nachschub in die Stadt. (1) Kinder beobachten ein viermotoriges Lastflugzeug dicht über den Bäumen in der Nähe des Brandenburger Tores. (2) Beladung der Flugzeuge auf dem Flughafen Wunstorf; alle drei Minuten mußte eine Maschine starten. (3) Die Briten beladen einen Zug für ihren Sektor der Stadt. (4) Die Frau eines deutschen Luftbrückenhelfers füttert Kinder auf einem provisorischen Bett – ihr Mittagessen besteht aus einer Scheibe Graubrot und Margarine. Bemerkenswert: das Paket des Roten Kreuzes auf dem Tisch.

Le pont aérien de Berlin

En juin 1947, Staline tente d'étrangler les trois secteurs libres de Berlin par un blocus. Pendant deux ans, Américains et Britanniques achemineront par les airs plus de 172 000 tonnes de vivres sur Berlin.

(1) Des enfants regardent un cargo américain à quatre moteurs passer au-dessus des arbres près de la porte de Brandenbourg. (2) Chargement d'un avion à l'aéroport de Wunstorf. Un avion doit décoller toutes les trois minutes. (3) Les Britanniques chargent un train pour leur secteur à Berlin. (4) La femme d'un ouvrier allemand, affecté au pont aérien, nourrit ses enfants assis sur un lit de fortune. Pour tout repas, une tranche de pain noir, tartinée de margarine. Sur la table, une boîte de la Croix-Rouge.

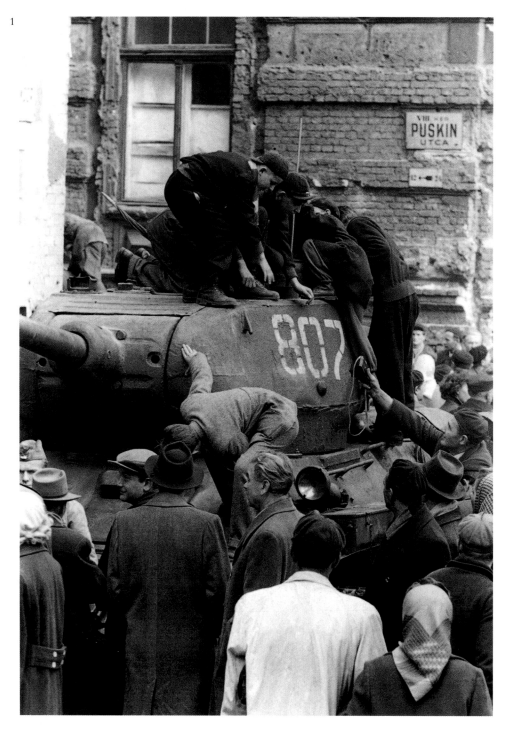

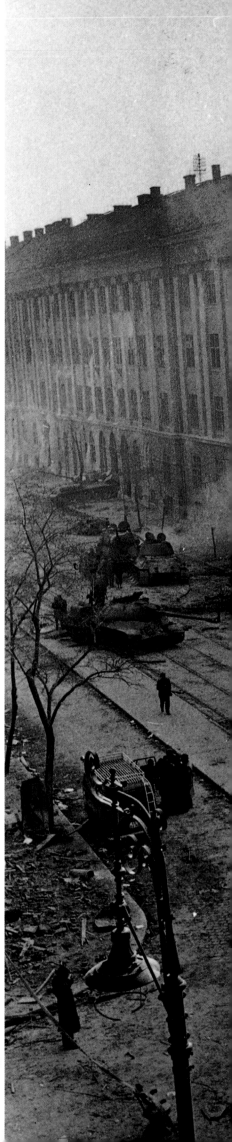

The Hungarian Uprising

In late October 1956 the Hungarians attempted to overthrow the Communist regime, installing Imre Nagy as their leader. More than 3000 died in the uprising. The *Picture Post* photographer Jack Esten and writer Trevor Philpott recorded the brief days of freedom in Budapest. (1) Citizens swarm on a 'liberated' Russian tank. (2) The Kilian barracks, site of one of the worst battles.

Der Ungarnaufstand

Ende Oktober 1956 versuchten die Ungarn, das kommunistische Regime zu stürzen und Imre Nagy zu ihrem Regierungschef zu machen. Mehr als 3000 Menschen kamen bei diesem Aufstand ums Leben. Der Fotograf der *Picture Post,* Jack Esten, und der Schriftsteller Trevor Philpott dokumentierten die kurzen Tage der Freiheit in Budapest. (1) Bürger klettern auf einen »befreiten« Panzer. (2) Die Kiliankaserne, Schauplatz eines des schlimmsten Gefechte.

Le soulèvement hongrois

Fin octobre 1956, les Hongrois tentent de renverser le régime communiste et installent Imre Nagy au pouvoir. Plus de 3000 personnes mouront durant le soulèvement. Le photographe du *Picture Post,* Jack Esten, et l'écrivain Trevor Philpott ont saisi les quelques jours de liberté à Budapest. (1) Des citoyens s'attroupent autour d'un char russe « libéré ». (2) Le quartier de Kilian, lieu des combats les plus acharnés.

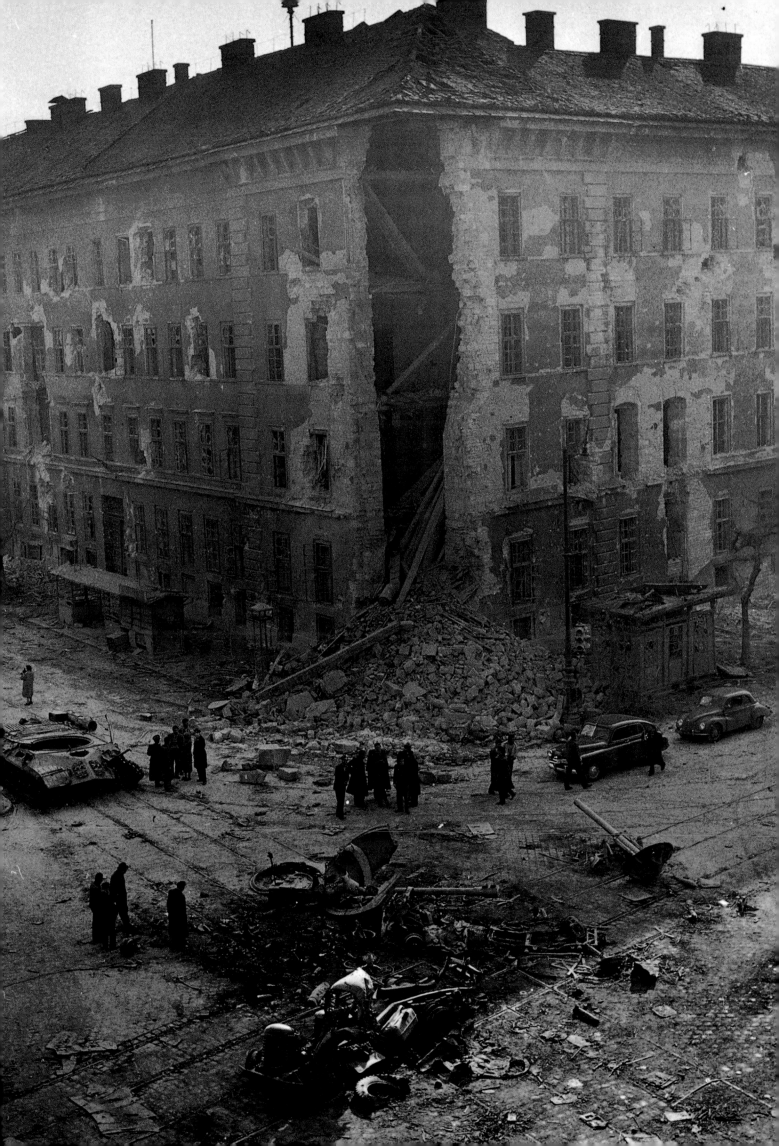

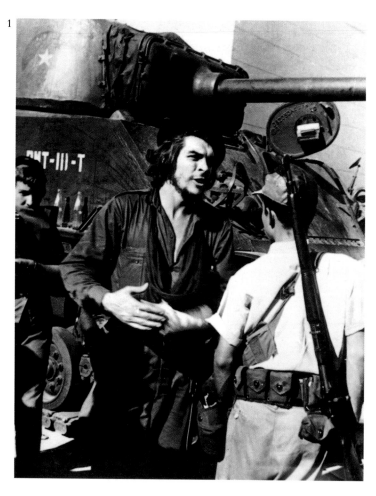

stopping them as they landed in the Bay of Pigs – the biggest foreign policy disaster of the early Kennedy presidency. (2) The motley band of prisoners on the beach in the Bay of Pigs. (3) A group of Castro's men.

Befreiung und Kampf
(1) Ernesto »Che« Guevara war in den 60er Jahren die Leitfigur der marxistischen nationalen Befreiungsbewegungen in Lateinamerika. Er schloß sich Castros Revolution an und starb 1967 im bolivianischen Dschungel. Eine Gruppe kubanischer Freischärler, von den USA unterstützt, versuchte 1961, Castro zu stürzen. Seine Streitkräfte hatten wenig Schwierigkeiten, sie bei der Landung in der Schweinebucht aufzuhalten – der größte außenpolitische Mißerfolg der frühen Präsidentschaft Kennedys. (2) Der bunte Haufen der Gefangenen am Strand der Schweinebucht. (3) Eine Gruppe von Castros Männern.

La libération et la confrontation
(1) En Amérique latine, dans les années 60, Ernesto «Che» Guevara est le symbole des mouvements communistes de libération nationale. Il s'engage dans la révolution de Castro et meurt dans la jungle bolivienne en 1967. Une bande de pirates cubains, soutenus par les Américains, tentent en 1961 de renverser Castro. Mais l'armée cubaine n'a aucune difficulté à les arrêter au moment de leur débarquement dans la baie des Cochons. C'est le plus retentissant désastre en politique étrangère de Kennedy au début de sa présidence. (2) Un groupe hétéroclite de prisonniers sur la plage de la baie des Cochons. (3) Un groupe de partisans castristes.

Liberation and Confrontation
(1) Ernesto 'Che' Guevara was the icon of Marxist national liberation movements in Latin America in the 1960s. He joined Castro's revolution and died in the Bolivian jungle in 1967. A gang of freebooting US-backed Cubans attempted in 1961 to oust Castro, whose forces had little difficulty in

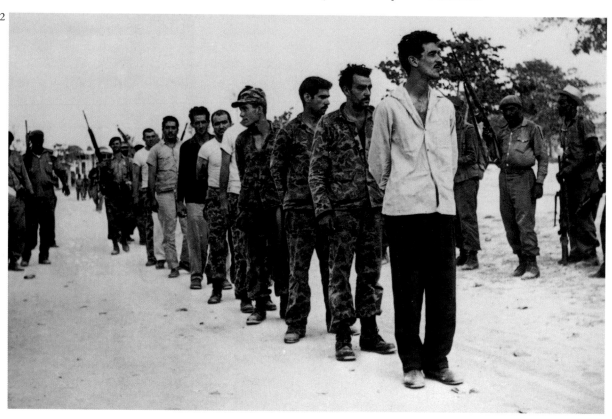

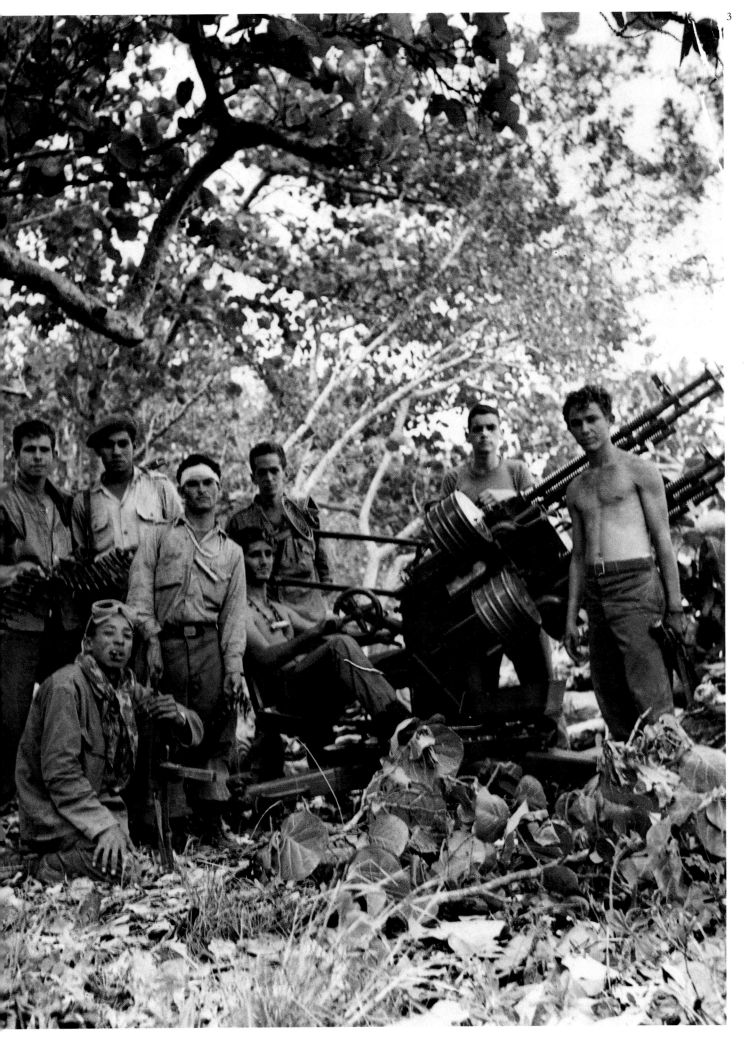

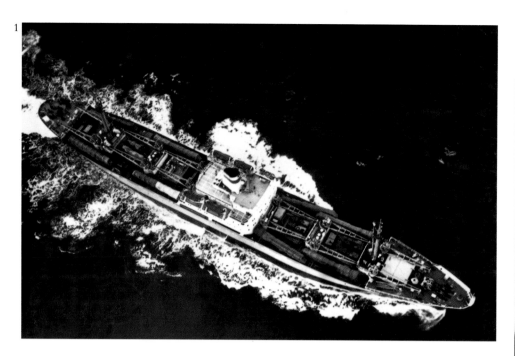

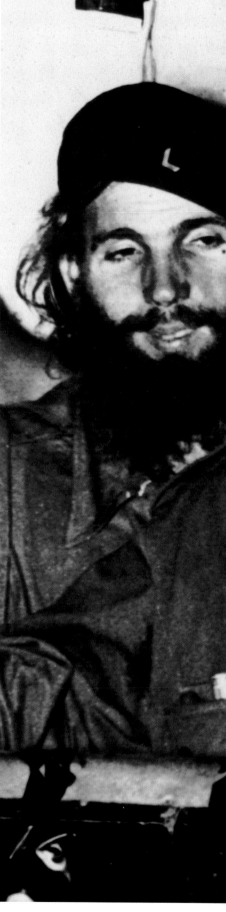

The Cuban Missile Crisis

The decision by Khrushchev to deploy Soviet missiles to Cuba in 1962 brought the most serious confrontation between the two superpowers. (1) The evidence for President Kennedy, the cargo ship with the missiles and their launchers lashed on deck. (2) The sites on Cuba being prepared for the missiles, photographed by a spy plane. (3) The ebullient Castro in his hour of triumph, after his enemy President Batista has fled, 1 January 1959.

Die Kubakrise

Die Entscheidung Chruschtschows, 1962 sowjetische Raketen auf Kuba zu stationieren, führte zu einer der gefährlichsten Konfrontationen der beiden Supermächte. (1) Der Beweis für Präsident Kennedy: Das Frachtschiff mit den an Deck gebrachten Raketen und ihren Abschußvorrichtungen. (2) Die für die Raketen vorbereiteten Stationen auf Kuba, fotografiert von einem Spionageflugzeug. (3) Der überschwengliche Castro in der Stunde des Triumphs nach der Flucht seines Feindes Präsident Batista, 1. Januar 1959.

La crise de Cuba

En 1962, la décision de Khrouchtchev de déployer des missiles soviétiques à Cuba déclenche le plus grave face-à-face des deux superpuissances. (1) Ce cargo transportant des missiles et des lance-missiles constitue une preuve pour Kennedy. (2) Les sites cubains prêts à déployer les missiles, photographiés par un avion-espion. (3) Heure de gloire pour l'exubérant Castro après la fuite du président Batista le 1er janvier 1959.

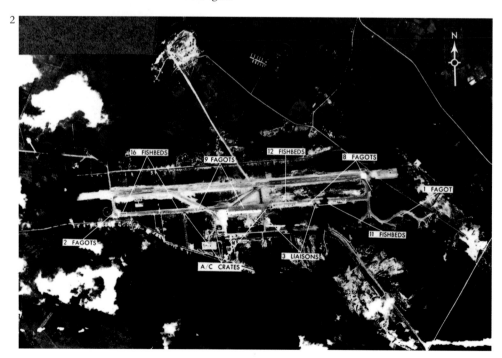

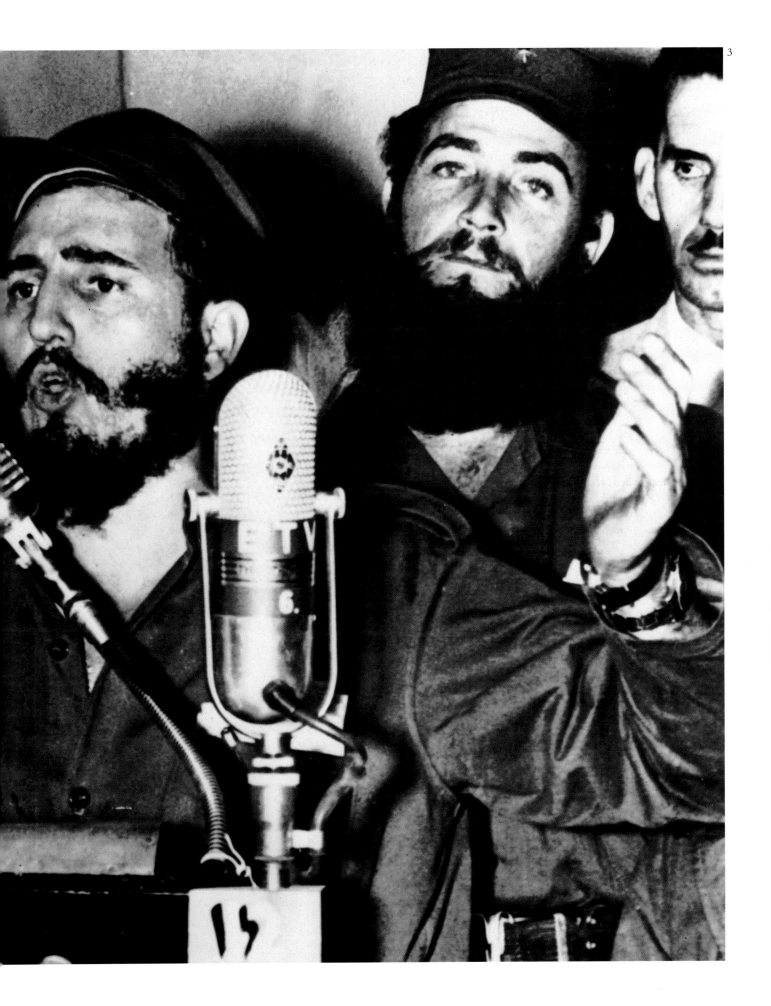

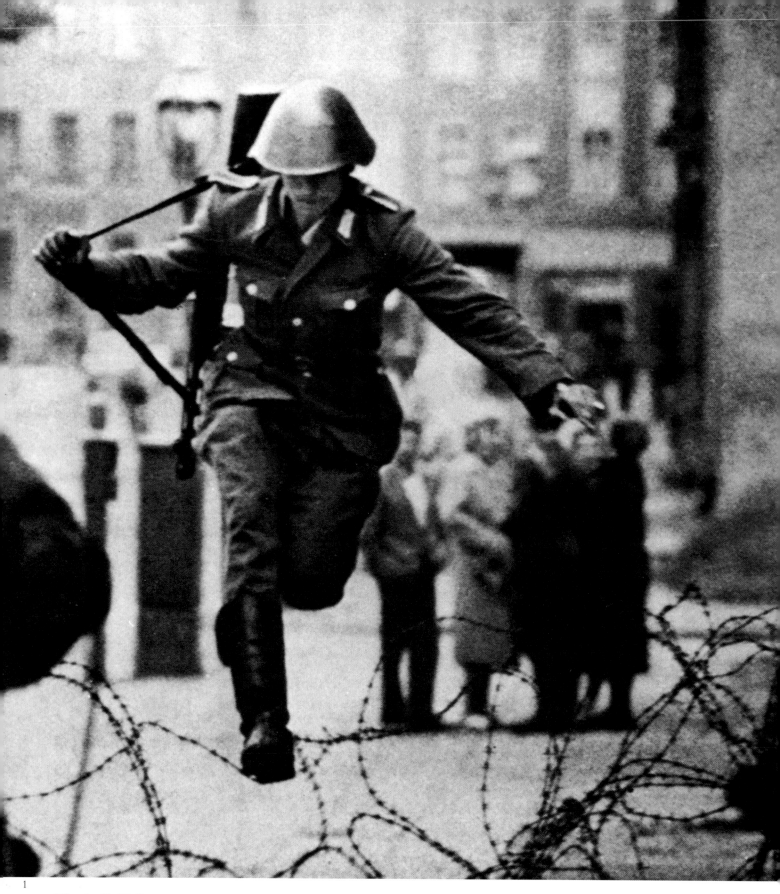

1

The Berlin Wall

In August 1961 the hardline Communist regime built a wall down the middle of Berlin, to stem the flow of refugees to the West. It became the symbol of the Cold War at its chilliest. (1) One of the most eloquent pictures of the time: an East German seizes the moment and leaps to freedom as the wall is being built, captured by photographer Peter Leibing on 12 August 1961.
(2) Families and friends divided by the new barriers. (3) The view across the wall from the west, April 1964.

Die Berliner Mauer

Im August 1961 baute das kommunistische Regime eine Mauer mitten durch die Stadt, um die Flut von Flüchtlingen in den Westen einzudämmen. Sie wurde zum Symbol des Kalten Krieges in seiner kältesten Phase.
(1) Eines der ausdrucksstärksten Bilder der Zeit: Ein ostdeutscher Soldat springt in die Freiheit, während die Mauer gebaut wird; aufgenommen von dem Fotografen Peter Leibing am 12. August 1961. (2) Familien und Freunde werden durch neue Grenzen getrennt. (3) Der Ausblick von Westen über die Mauer, April 1964.

Le mur de Berlin

En août 1961, le régime communiste élève un mur et coupe Berlin en deux pour mettre fin au flot de réfugiés vers l'Ouest. Ce mur

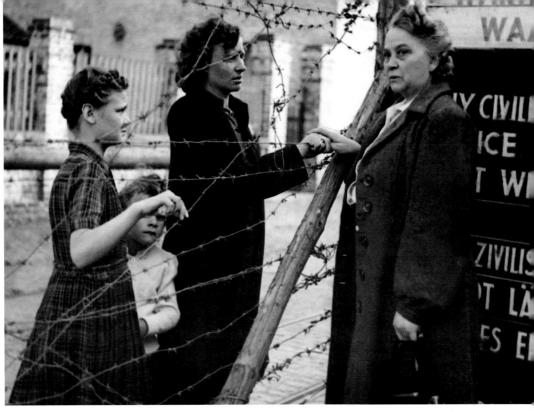

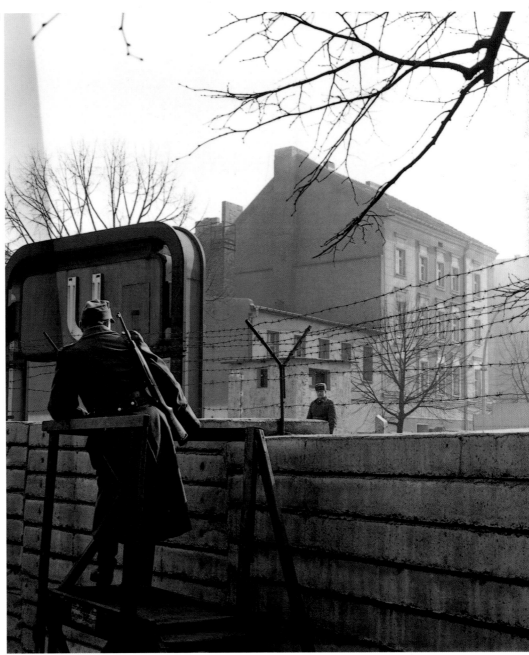

sera le symbole des temps les plus forts de la guerre froide. (1) Pendant la construction du mur: un soldat est-allemand saisit l'occasion et saute du côté de la liberté. C'est une des photos les plus parlantes de cette époque, prise par Peter Leibing le 12 août 1961. (2) Des familles et des amis séparés par les nouvelles barrières. (3) Avril 1964, vue de l'Ouest sur l'autre côté du mur.

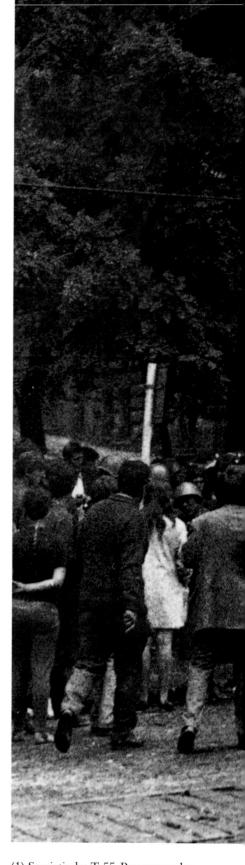

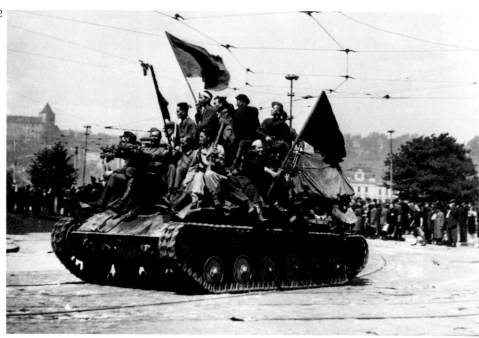

Prague Spring

In 1968 Alexander Dubček endeavoured to give Czechoslovakia 'Socialism with a human face'. The Soviet leadership ordered Warsaw Pact forces 'on manoeuvres' to enter Prague and crush the movement. (1) The Soviet T-55 tanks watched from a café in the centre of town, 29 August 1968. (2) The brief days of political spring, when Soviet tank crews and reformists celebrated together atop a Russian tank. (3) The arrival of the Russians provoked a largely passive resistance campaign, and a lively, intellectual underground led by the playwright Václav Havel, who became president after the 'velvet revolution' of 1989.

Prager Frühling

1968 bemühte sich Alexander Dubček, in der Tschechoslowakei einen »Sozialismus mit menschlichem Gesicht« einzuführen. Die sowjetische Führung befahl den Streitkräften des Warschauer Paktes, die sich gerade »im Manöver« befanden, in Prag einzudringen und die Bewegung zu zerschlagen.

(1) Sowjetische T-55-Panzer werden von einem Café im Stadtzentrum aus beobachtet, 29. August 1968. (2) Die kurzen Tage des politischen Frühlings, in denen sowjetische Panzerbesatzungen und Reformer zusammen auf einem russischen Panzer feierten. (3) Die Ankunft der Russen führte zu einem größtenteils passiven Widerstand und zur Entstehung eines lebendigen intellektuellen Untergrunds unter der Leitung des Dramatikers Václav Havel, der nach der »samtenen Revolution« 1989 Präsident wurde.

Le printemps de Prague
En 1968, Alexandre Dubček tente de donner
«un visage humain au socialisme» tchèque.
Les dirigeants soviétiques ordonnent aux
troupes du pacte de Varsovie d'entrer dans
Prague et de réprimer le mouvement. (1) 29
août 1968, vue d'un café du centre-ville sur
des chars T-55 soviétiques. (2) Durant le bref
printemps politique: l'équipage d'un char
soviétique et les réformistes célèbrent leur
victoire sur un char russe. (3) L'arrivée des
Russes engendre un immense mouvement

de résistance, essentiellement passif, et
l'émergence d'une culture clandestine animée
par le dramaturge Václav Havel qui sera élu
président après la «révolution de velours» de
1989.

The past 50 years have brought a string of local or brushfire wars, civil conflicts and battles for national liberation. Though the old colonial empires faded, the great powers aided and controlled their proxies, and became involved in the fighting themselves. Here an American-equipped South Korean soldier patrols gingerly past the wreckage of the tea room 'Utopia', after the American-led amphibious attack and capture of Inchon, 1950.

In den letzten 50 Jahren haben zahlreiche kleinere, lokale Kriege, Bürger- und Befreiungskriege stattgefunden. Auch wenn die alten Kolonialreiche ihre Macht verloren hatten, standen die Großmächte doch den befreundeten Staaten bei, schützten sie und griffen in die Kämpfe ein. Hier patrouilliert ein südkoreanischer Soldat in US-Ausrüstung bei einem Teehaus namens »Utopia« in der Stadt Inchon, die 1950 unter amerikanischer Leitung von der See her eingenommen wurde.

Les 50 dernières années ont vu apparaître une quantité de conflits régionaux ou localisés, de guerres civiles et de luttes de libération nationale. Au moment même où les empires coloniaux disparaissent, les grandes puissances commencent à aider tout en les contrôlant leurs protégés respectifs et se trouvent elles-mêmes impliquées dans les conflits. Ici, un soldat sud-coréen, portant un équipement américain, patrouille avec appréhension le long du salon de thé « Utopia » après l'attaque amphibie sous commandement américain et la prise d'Inchon en 1950.

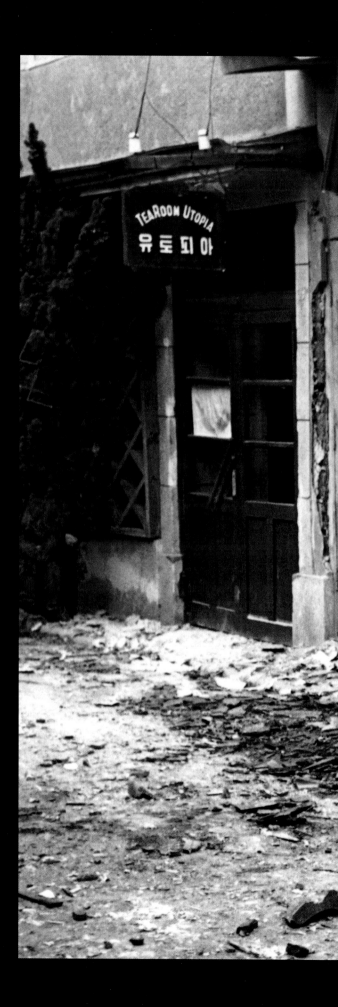

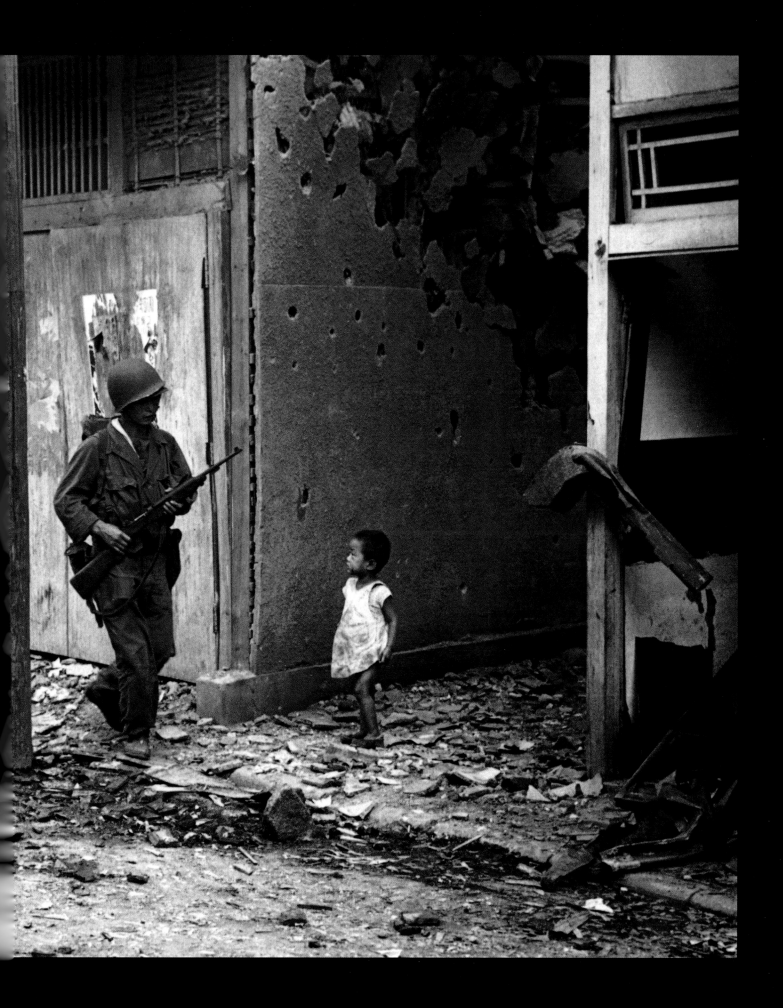

Decolonialization

Client States of the Superpowers

The signs of new local conflicts across the world were evident even as the great armies were preparing to demobilize in Europe in 1945. Beyond Europe the old order of the colonial empires could not be put together again on the old lines. In Asia the new era began with two seismic events, the end of British rule in India in 1947, and the victory of Mao Tse-Tung and Communism in the Chinese Civil War in 1949. The Second World War left plenty of arms for the new armies, and a desire for self-determination.

The first real test for the powers in localized war came with the sudden invasion of South Korea by the forces of the Communist North Korea of Kim Il Sung on 25 June 1950. The two states of divided Korea were clients of the great opponents in the Cold War. North Korea was virtually the creation of the Soviet Union, and inherited quantities of its armaments from the successful Manchurian campaign of 1945. The United States succeeded in winning a UN mandate for an international force to defend the South and repel the attacking armies from the North – the Soviet Union was absent from the Security Council in the crucial vote.

The American-led international army was the only one to take the field for offensive peace-making operations under the UN flag. In the opening months the South and its inter-national allies under the command of General Douglas MacArthur were squeezed into the south-eastern quarter of the Korean peninsula, but successfully held the perimeter round Pusan. MacArthur then executed one of the master counter-strokes of modern warfare. In huge rolling tides – with a swell of more than 32 feet – his international force carried out an amphibious assault and landed under heavy naval gunfire support at Inchon, to the north of the southern capital of Seoul, which was now well inside enemy-held territory. The move cut the Communists' main supply route, and more than 120,000 of their men were captured.

MacArthur continued his pursuit deep into North Korea, but then carried out several successful fighting withdrawals. The Chinese declared that the allies had threatened their se-curity on the Yalu River and entered the war, and the Western allies were to encounter a new, terrifying and thoroughly primitive tactic, the human wave. In some battles, such as the great British fighting withdrawal on the Imjin River in April 1951, hordes of Chinese scrambled on to the British tanks and armoured cars, and neighbouring vehicles had to open fire with their machine guns to scrape them off.

MacArthur wanted President Truman to pursue a more aggressive 'Asia First' policy against the Chinese, but was sacked for his pains. The front eventually stabilized after a successful American-led counter-stroke against the Chinese and North Koreans in the summer of 1951, though talks did not start until July 1953. The Korean war meant that the American government and forces were committed to the mainland of south-east Asia, and would not be isolationist in the affairs of the Pacific. It also underlined the sheer physical power of China and its armed forces.

The war was the last significant conflict in which the war photographer was dominant in news coverage, though the television wars were not far off. *Picture Post*, the most celebrated of British photo journals, was to fall on its own sword, or tripod, in a famous row about the mistreatment and killing of South Korea's prisoners of war.

The retreat from empire was gathering pace in the Pacific. The Dutch gave up their colonies of the East Indies, now Indonesia, after a bloody four-year war of independence, in which more than 7000 Dutch soldiers died. Britain became involved in a long war against Chinese Communist insurgents in Malaya, which was to go on until 1960. The British had made up the 1941 deficit in training in jungle warfare, and the containment of the emergency under Sir Gerald Templar is one of the great successes of counter-insurgency warfare. The British were to use this experience to good effect in helping Borneo and Brunei in their confrontation in the jungle with Indonesia in 1963-65.

By 1965 the new Labour government had decided that Britain would withdraw its forces east of Suez, though it lent a concealed hand in numerous small wars such as the Dhofar conflict in the Arabian Peninsula, 1968-75, an ideal training ground for Special Forces units of the SAS. British training and military culture were prominent in the regional clashes of the Indian and Pakistani armies, which still glare at each other across the wild and disputed lands of Kashmir.

The image of war which stands for this period, for all the terrible and continuing wars in Latin America, Africa and the Maghreb, is Vietnam. The conflict, involving over 30 years the French, the Americans and their allies against the political toughness and military genius of Hanoi, has shaped the whole culture of war reporting today, in print or on screen.

It was a muddled tale from the beginning. The French might have granted the independence of their former colony to Ho Chi Minh by 1950, but their military and the Americans would not have it. The French military campaign against the Communist Vietminh ended in defeat with the siege of Dien Bien Phu in May 1954, in which General Vo Nguyen Giap showed his mastery of jungle tactics and logistics by getting his men to carry more than 200 dismantled field pieces over the mountains to the battle area.

In 1959 the Communist North began plans to take over the South, and by 1964 the Americans had more than 12,000 troops, plus helicopters and strike aircraft, commanded by

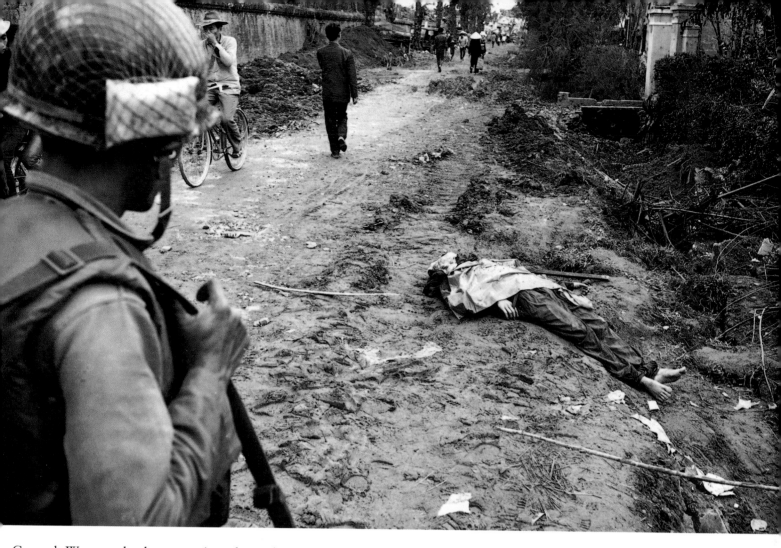

General Westmoreland, supporting the rickety regime of Saigon. The Americans were to build up an army of more than 385,000 by the turning point of the Tet Offensive in 1968, which was a technical defeat for General Giap, the North Vietnam Army and the Vietcong, but at huge cost to American manpower, morale and credibility. The Americans had difficulty in adapting their tactics to a strange mixture of guerrilla and high intensity conventional warfare; they had superior technology, but not the knowledge of the terrain, and at home they had the vociferous opposition of the peace movement. Epic battles like the relief of Khe Sanh in April 1968 did not alleviate the criticism.

Eventually the Americans moved into Cambodia, and attempted to cut the main supply route through the jungle of the Ho Chi Minh trail supporting insurgents in the South. Comprehensive mining and blockade of Haiphong and strategic bombing threatened to take the North Vietnamese economy 'back to the stone age'. In 1973 the North agreed to a cease-fire, and the Nixon administration began withdrawing American forces. The following year Giap's successor General Dung began his advance on the South. In April 1975 Saigon fell without a fight and the remaining Americans made a rapid exit. At the same time Cambodia's capital Phnom Penh fell to Pol Pot's Khmer Rouge, and in the next four years he was to exterminate more than 2.5 million of his fellow countrymen.

Vietnam was the first war that America lost, in which 58,718 servicemen died. The Vietnamese, North and South, suffered about a million dead. Vietnam was the war that

South Vietnamese walk past the dead in the old imperial city of Hue, after B-52 bomber air strikes. In 1968 the North took the city, but held it only briefly.

Südvietnamesen gehen an Opfern eines Luftangriffs vorüber, der mit B-52-Bombern auf die alte Kaiserstadt Hue geflogen wurde. Der Norden hatte 1968 die Stadt erobert, hielt sie jedoch nur kurze Zeit.

Dans l'ancienne cité impériale de Hué, des Vietnamiens du Sud longent les morts après le passage de bombardiers B-52. En 1968, le Nord a brièvement occupé la ville.

came to America's sitting rooms via television. War photographers and journalists became main actors, and some in the military still blame the liberal press and television for undermining popular support. But the American political strategy and military direction on the ground were often confused and poorly executed, usually by an army of reluctant conscripts. New tactics were invented, such as the use of 'air cavalry' troops dropped in by helicopter and protected by helicopter gunships. But the war marked the beginning of the American political obsession with the 'body-bag syndrome'. Increasingly American leaders would only commit troops to ground operations overseas with a minimum risk of casualties, and only then if America's vital domestic interests were at stake.

Vietnam stands out among the local wars, because its cultural and political message, more than its tactical lessons, is still of global importance.

(1) An explicit message on an American position in Cambodia, 1970. Many American conscripts, however, were not convinced about the necessity of their presence in south-east Asia. (2) A young insurgent, Kalashnikov in hand, of the Shahn United Burma Army in 1979.

(1) Diese Botschaft an einer amerikanischen Stellung in Kambodscha, 1970, ist deutlich genug. Viele der zwangsweise eingezogenen Soldaten wußten jedoch weniger gut, was Amerikaner in Südostasien zu suchen hatten. (2) Ein junger Aufständischer der Shahn United Burma Army mit einer Kalaschnikow in der Hand, 1979.

(1) Message explicite, sur une position américaine au Cambodge, 1970. Toutefois, de nombreux conscrits américains n'étaient pas convaincus de la nécessité de leur présence en Asie du sud-est. (2) Un jeune insurgé de l'armée Shahn de l'Union birmane, Kalashnikov en main, 1979.

Noch bevor 1945 in Europa die großen Armeen ihre Soldaten entlassen hatten, waren überall auf der Welt neue lokale Kriege bereits im Entstehen begriffen. Außerhalb Europas standen die Kolonialmächte vor der schwierigen Aufgabe, eine neue Ordnung zu finden. In Asien begann die neue Ära mit zwei entscheidenden Ereignissen, dem Ende der britischen Herrschaft über Indien (1947) und dem Sieg Mao Tse-tungs und der Kommunisten im chinesischen Bürgerkrieg (1949). Aus dem Zweiten Weltkrieg waren mehr als genug Waffen für die neuen Armeen übriggeblieben, und überall strebte man nach Selbstbestimmung.

Die erste Herausforderung an die Großmächte war der Überraschungsschlag, mit dem die Truppen des von Kim Il Sung beherrschten kommunistischen Nordkorea am 25. Juni 1950 in Südkorea einmarschierten. Die beiden Staaten des geteilten Korea waren Satellitenstaaten der beiden großen Antagonisten des Kalten Krieges. Nordkorea war weitgehend durch sowjetischen Einfluß entstanden und hatte nach dem erfolgreichen Mandschureifeldzug von 1945 große Waffenvorräte. Die Vereinigten Staaten setzten ein UN-Mandat für eine internationale Truppe durch, die den Süden verteidigen und den Vormarsch der Nordarmee stoppen sollte – bei der

entscheidenden Abstimmung fehlte die Sowjetunion im Sicherheitsrat.

Die amerikanisch geführte internationale Truppe war die einzige, die je unter der UN-Flagge als offensive Friedenstruppe ins Feld zog. In den ersten Monaten wurden die südkoreanischen Truppen und ihre Verbündeten unter Führung von General Douglas MacArthur bis in den Südosten der Halbinsel zurückgedrängt, hielten jedoch erfolgreich den Brückenkopf Pusan. Dann gelang MacArthur einer der beispielhaftesten Gegenschläge in der Geschichte der modernen Kriegführung. Bei gewaltigem Seegang – die Wellen schlugen zehn Meter hoch – unternahmen seine Truppen einen Angriff von See her und landeten im Feuerschutz der Marine in Inchon, nördlich der in Feindeshand gefallenen südkoreanischen Hauptstadt Seoul. Mit diesem Schachzug war die Hauptnachschublinie der Kommunisten unterbrochen, und über 120000 ihrer Soldaten gerieten in Gefangenschaft.

MacArthur stieß bis weit ins Landesinnere Nordkoreas vor und lieferte anschließend eine Reihe von erfolgreichen Rückzugsgefechten. Die Chinesen, die das Vordringen der Alliierten bis an den Fluß Yalu als Bedrohung ihrer Sicherheit empfanden, starteten Ende 1950 eine Gegenoffensive. Die Westalliierten wurden nun mit einer angsteinflößenden und in ihrem Wesen primitiven Taktik konfrontiert – der »Menschenwelle«. In manchen Kämpfen, etwa in dem erfolgreichen Rückzugsgefecht der Briten am Fluß Imjin im April 1951, kletterten Hunderte von Chinesen auf die gegnerischen Panzer und Panzerwagen und mußten von anderen Fahrzeugen aus mit Maschinengewehren hinuntergeschossen werden.

MacArthur riet Präsident Truman zu einem offensiveren Kurs gegen China, wurde jedoch durch General Matthew Bunker Ridgway abgelöst. Die Front stabilisierte sich schließlich im Sommer 1951 nach einem erfolgreichen amerikanischen Gegenschlag gegen die Chinesen und Nordkoreaner, doch es dauerte noch bis Juli 1953, ehe Friedensverhandlungen begannen. Der Koreakrieg machte deutlich, daß die amerikanische Regierung und ihr Militär auch weiterhin in Südostasien präsent sein würden und in der Pazifikpolitik keinen Isolationskurs einschlugen. Außerdem unterstrich dieser Krieg die »physische« Macht Chinas und der chinesischen Armee.

Der Koreakrieg war der letzte große Krieg, dessen Berichterstattung von Fotojournalisten geprägt war – die Ära der Kriegsberichte im Fernsehen stand bevor. *Picture Post*, die angesehenste britische Illustrierte, wurde nach einer vehement geführten Auseinandersetzung um Bilder von Mißhandlungen in südkoreanischen Kriegsgefangenenlagern eingestellt.

Das Ende der Kolonialzeit kam im Pazifik nun mit Macht. Die Holländer gaben ihre ostindischen Kolonien auf, das heutige Indonesien; in dem blutigen, vier Jahre dauernden Unabhängigkeitskrieg kamen über 7000 holländische Soldaten um. Großbritannien ließ sich auf einen Krieg gegen chinesische Kommunisten auf der Malaiischen Halbinsel ein, der bis 1960 dauerte. Seit 1941 hatten die Briten ihre Lektion

n Dschungelkrieg gelernt, und Sir Gerald Templar hielt mit großem Geschick die Aufständischen in Schach. Die Briten konnten auf diesen Erfahrungen aufbauen, als sie 1963-65 Borneo und Brunei in deren Dschungelkrieg gegen Indonesien zur Seite standen.

1965 hatte die neue Labour-Regierung beschlossen, die Truppen östlich von Suez zurückzuziehen, obwohl Großbritannien indirekt auch danach noch in eine Reihe kleinerer Kriege eingriff, etwa beim Dhofar-Konflikt auf der arabischen Halbinsel, 1968-75. Dieser Konflikt war ein ideales Übungsgebiet für die Spezialeinheiten der Luftlandetruppen SAS. Britische Ausbildung und britische Militärtraditionen waren in den regionalen Auseinandersetzungen indischer und pakistanischer Armeen zu spüren, die sich bis heute beiderseits des umstrittenen Berglands von Kaschmir argwöhnisch belauern.

Neben erbittert geführten Kriegen in Lateinamerika, Afrika und im Maghreb war der Inbegriff des Kriegs in jenen Jahrzehnten der Vietnamkrieg. Dieser Krieg, in dem Franzosen, Amerikaner und ihre Verbündeten über 30 Jahre lang gegen das politisch gewiefte und militärisch ideenreiche Hanoi kämpften, hat unseren heutigen Begriff von Kriegsberichterstattung geprägt, und das in den Print- wie auch den Funkmedien wie Radio und Fernsehen.

Es war von Anfang an keine gute Geschichte, die es zu berichten gab. Die Franzosen hätten 1950 beinahe ihrer ehemaligen Kolonie unter Ho Chi Minh die Unabhängigkeit gewährt, doch ihr eigenes Militär und die Amerikaner verhinderten es. Der Feldzug gegen die kommunistischen Vietminh endete mit einer französischen Niederlage in der Belagerung von Dien Bien Phu im Mai 1954, einer Schlacht, in der General Vo Nguyen Giap seine überlegene Dschungeltaktik und -logistik bewies, als er von seinen Männern mehr als 200 zerlegte Geschütze über die Berge ins Kampfgebiet tragen ließ.

1959 wurden im kommunistischen Norden Pläne laut, sich den Südteil des Landes anzugliedern. Bis 1964 hatten die Amerikaner bereits 12 000 Mann mit Hubschraubern und Kampfflugzeugen im Land, die unter dem Kommando von General William Childs Westmoreland das schwache Regime in Saigon stützten. Bis zum Wendepunkt der Tet-Offensive im Jahr 1968 sollten die Amerikaner eine Vietnam-Armee von 385 000 Mann aufbauen. Militärisch war die Tet-Offensive eine Niederlage für General Giap, die nordvietnamesische Armee und den Vietcong, doch die Verluste an Männern, Moral und Glaubwürdigkeit der Amerikaner waren beträchtlich. Den Amerikanern fiel es nicht leicht, ihre Taktiken der ungewohnten Verbindung aus Guerillakrieg und intensiver konventioneller Kriegführung anzupassen; technisch waren die Amerikaner überlegen, doch ihnen fehlte die Kenntnis des Terrains, und in den USA wuchs der Widerstand der Friedensbewegung. Schwere Schlachten wie etwa der Entsatz von Khe Sanh im April 1968 gaben der Kritik noch weiter Nahrung.

Im Bestreben, den Aufständischen im Süden die Versorgung durch den Dschungel, über den Ho-Chi-Minh-Pfad,

abzuschneiden, marschierten die Amerikaner auch in Kambodscha ein. Die Blockade und Verminung des Hafens Haiphong sowie strategisches Bombardement sollten die nordvietnamesische Wirtschaft »zurück in die Steinzeit« versetzen. 1973 stimmte Nordvietnam einem Waffenstillstand zu, und die Regierung unter Präsident Nixon begann, amerikanische Truppen abzuziehen. Im folgenden Jahr startete Giaps Nachfolger General Dung seinen Vormarsch gegen den Süden. Im April 1975 ergab Saigon sich kampflos, und die letzten Amerikaner verließen Hals über Kopf das Land. Zur gleichen Zeit fiel die kambodschanische Hauptstadt Phnom Penh in die Hände der Roten Khmer, und unter der Herrschaft ihres Anführers Pol Pot kamen in den nächsten vier Jahren über zweieinhalb Millionen seiner Landsleute um.

Der Vietnamkrieg war der erste Krieg, den die Amerikaner verlieren sollten; 58 718 US-Soldaten fielen. Nord- und Südvietnam hatten etwa eine Million Tote zu beklagen. Der Vietnamkrieg war ein Krieg, der vor allem über die Fernsehschirme zu den Amerikanern ins Wohnzimmer kam. Kriegsberichterstatter und Bildreporter wurden zu Hauptakteuren, und manche Kritiker in US-Militärkreisen machen bis heute das Fernsehen und die liberale Presse dafür verantwortlich, daß die Amerikaner den Glauben an diesen Krieg verloren. Doch politisch wie taktisch war das Verhalten der Amerikaner

oft wirr, und es wurde schlecht gekämpft, gerade von den Zwangseingezogenen. Neue Taktiken wurden ersonnen, etwa die der »fliegenden Kavallerie« – Truppen, die mit dem Hubschrauber ins Kampfgebiet geflogen und von Kampfhubschraubern aus verteidigt wurden. Doch dieser Krieg war der Anfang jener chronischen Furcht, Menschenleben aufs Spiel zu setzen, die seither die amerikanische Politik beherrscht hat *(body-bag syndrome)*: Immer mehr setzten die politischen Führer Bodentruppen nur noch dort ein, wo das Risiko minimal war, daß Soldaten fielen. Und selbst dann taten sie es nur, wenn es um wichtige nationale Interessen ging.

Der Vietnamkrieg überragt in seiner Bedeutung alle anderen örtlich begrenzten Kriege; taktisch brachte er nur wenig Neuerungen, doch kulturell und politisch hat dieser Krieg die Welt verändert.

Les signes annonciateurs de nouveaux conflits locaux à travers le monde se manifestent dès 1945, alors que les grandes armées s'apprêtent à démobiliser. Il apparaît clairement que les principes qui régissaient les anciens empires coloniaux européens sont désormais dépassés. En Asie, deux événements de portée sismique annoncent une nouvelle ère: la fin de la domination britannique en Inde en 1947 et la victoire de Mao Tsê-Tung et du communisme à l'issue de la guerre civile chinoise en 1949. La Deuxième Guerre mondiale lègue aux nouvelles armées de grandes quantités d'armes et aux peuples un immense désir d'auto-détermination.

Les grandes puissances s'engagent pour la première fois dans un conflit local à l'occasion de l'invasion de la Corée du Sud par l'armée communiste nord-coréenne de Kim Il Sung le 25 juin 1950. Les deux Etats de la Corée divisée sont respectivement protégés par les deux grands opposants de la guerre froide: la Corée du nord est pratiquement une création de l'Union soviétique et a largement hérité son armement de la campagne de Mandchourie en 1945, tandis que les Etats-Unis obtiennent mandat des Nations unies pour envoyer des forces internationales défendre le Sud contre les offensives du Nord - L'Union soviétique est absente du Conseil de sécurité au moment du vote.

L'armée internationale dirigée par les Américains est la seule à s'engager dans une offensive pour le rétablissement de la paix sous l'égide de l'ONU. Les premiers mois, le Sud et ses alliés internationaux, sous le commandement du général Douglas MacArthur, restent confinés dans le quart sud-est de la péninsule coréenne, mais réussissent à défendre le périmètre de Pusan. MacArthur réalise alors l'un des retours offensifs les plus étonnants de la guerre moderne. Aidée par une houle énorme – presque 10 m de haut – l'armée internationale mène une attaque amphibie et, protégée par une lourde artillerie navale, débarque à Inchon, au nord de Séoul, la capitale sudiste occupée par l'ennemi. Cette opération coupe la principale route d'approvisionnement des communistes et fait plus de 120 000 prisonniers.

MacArthur pénètre plus avant en Corée du Nord mais doit ensuite battre en retraite à plusieurs reprises. Les Chinois affirment que les pays alliés menacent leur sécurité sur le fleuve Yalu, et s'engagent dans la guerre. Les alliés occidentaux doivent alors affronter la technique primitive et terrifiante de la vague humaine. Pendant certaines batailles, comme la grande retraite britannique du fleuve Imjin en avril 1951, des hordes de Chinois grimpent sur les tanks et les voitures blindées britanniques et il faut tirer à la mitraillette depuis les véhicules voisins pour les en arracher.

MacArthur souhaite que le président Truman adopte une politique plus offensive («Asia first») contre les Chinois, mais pour prix de ses efforts il sera renvoyé. Le front finit par se stabiliser au terme d'un retour offensif américain couronné de succès contre les Chinois et les Nord-Coréens pendant l'été 1951. Les pourparlers ne commencent qu'en juillet 1953. La guerre de Corée montre clairement que le gouvernement américain et son armée sont concernés par l'Asie du Sud-Est et refuseront de mener une politique isolationniste dans le Pacifique. Elle met aussi en évidence l'énorme puissance numérique de l'armée chinoise.

Ce sera le dernier conflit important couvert en priorité par les photographes. Les guerres télévisées ne sont plus très loin. Le Picture Post, un célèbre journal de reportages photographiques, se saborde en publiant une série très controversée sur les mauvais traitements et les massacres de prisonniers de guerre par les Sud-Coréens.

Dans le Pacifique, les empires coloniaux disparaissent l'un après l'autre. Les Pays-Bas renoncent à leurs colonies des Indes orientales, l'Indonésie actuelle, au bout de quatre années d'une sanglante guerre d'indépendance où disparaissent plus de 7000 soldats néerlandais. La Grande-Bretagne sera engagée jusqu'en 1960 dans une longue guerre contre l'insurrection communiste chinoise en Malaisie. Depuis 1941, les Britanniques ont comblé leur méconnaissance de la jungle, et la répression de l'insurrection, sous la conduite de Sir Gerald Templar, est l'un des grands succès de la guerre anti-insurrectionnelle. Les Britanniques utiliseront à bon escient cette expérience de la jungle en soutenant Borneo et le Brunei dans la guerre qui les oppose à l'Indonésie en 1963-65.

En 1965, le nouveau gouvernement travailliste de Grande-Bretagne retire toutes ses troupes situées à l'est de Suez, continuant néanmoins à se prêter de manière dissimulée à plusieurs petites guerres, comme le conflit du Dhofar dans la péninsule arabique, en 1968-75, qui fournit aux unités du Special Air Service (SAS) un terrain d'entraînement idéal. L'entraînement et la culture militaire britanniques jouent un rôle essentiel dans les affrontements des armées indienne et pakistanaise, qui continuent à se défier de part et d'autre du territoire disputé du Cachemire.

Mais la guerre emblématique de cette période, celle qui évoque dans son sillage toutes les longs et douloureux conflits de l'Amérique latine, de l'Afrique et du Maghreb, c'est la guerre du Vietnam, où pendant plus de 30 ans, Français, Américains et leurs alliés sont confrontés à la ténacité politique et au génie militaire de Hanoi; cette guerre façonnera toute une culture du reportage de guerre photographique ou filmé.

Dès le début, c'est un sac de nœuds. En 1950, France pourrait accorder à Hô Chi Minh l'indépendance de cette ancienne colonie mais ni l'état-major français, ni les Américains ne sont d'accord. La campagne militaire française contre le parti communiste du Viêt-minh s'achève par une défaite en mai 1954 lors du siège de Diên Biên Phû, où le général Vo Nguyen Giap fait la preuve de sa maîtrise tactique et logistique de la jungle en faisant transporter par ses hommes plus de 200 pièces démontées d'armement lourd à travers la montagne, jusque dans la région des combats.

En 1959, le Nord communiste commence à planifier l'invasion du Sud. En 1964, les Américains ont sur le terrain plus de 12 000 hommes, des hélicoptères et des avions de combat, sous le commandement du général Westmoreland pour aider le régime branlant de Saigon. Le contingent américain comptera 385 000 soldats en 1968, au moment de l'offensive-charnière du Têt, une défaite technique pour Giap, l'armée nord-vietnamienne et le Viêt-cong, mais dont le coût en vies humaines et le poids sur la crédibilité et le moral des Américains seront énormes. Les Américains ont du mal à adapter leur tactique à cette étrange combinaison de guerrilla et de guerre conventionnelle à haute intensité; s'ils possèdent un avantage technologique certain, ils ne connaissent pas le terrain. De plus, ils rencontrent chez eux l'opposition bruyante du mouvement pacifiste, que des épopées comme la libération de Khe Sanh en avril 1968 n'apaisent guère.

Finalement, les Américains pénètrent au Cambodge et tentent de couper la principale route d'approvisionnement de la piste de Hô Chi Minh, qui soutient les insurgés du Vietnam du Sud. Le minage systématique, le blocus de Haiphong, et les bombardements stratégiques menacent de ramener l'économie nord-vietnamienne à l'âge de pierre. En 1973, le Nord accepte un cessez-le-feu et l'administration de Nixon entreprend le retrait des troupes américaines. L'année suivante, le successeur de Giap, le général Dung, commence son avancée sur le Sud. En avril 1975, Saigon tombe sans un combat et les Américains restés sur place font une prompte sortie. Au même moment, la capitale du Cambodge, Phnom Penh, tombe aux mains des Khmers rouges de Pol Pot qui extermineront 2,5 millions de leurs compatriotes au cours des quatre années suivantes.

Le Vietnam est la première guerre perdue par les Etats-Unis, avec 58 718 soldats tués. Les Vietnamiens, Nord et Sud confondus, ont environ un million de morts. C'est aussi la première guerre entrée dans les salons américains par la télévision. Photographes et journalistes de guerre en étaient des protagonistes à part entière et aujourd'hui encore, certains militaires reprochent à la presse et à la télévision de gauche d'avoir entamé le soutien populaire dû à l'armée. Mais la stratégie politique et la direction militaire américaines sur le terrain étaient souvent embrouillées et mal exécutées, par une armée largement composée de conscrits peu convaincus. De nouvelles tactiques ont vu le jour, par exemple la « cavalerie aérienne », des soldats déposés par hélicoptère et couverts par des hélicoptères de combat. Enfin, cette guerre inaugure pour

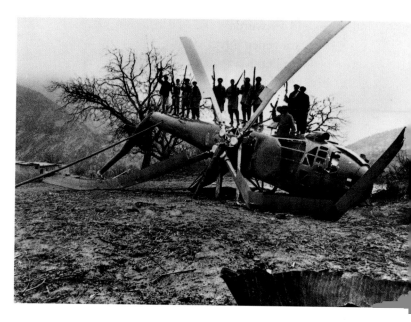

Mujaheddin of Afghanistan celebrating after they have brought down a Russian helicopter. Afghan rebels fought a determined guerrilla campaign against the occupation by the Russians. The effect was more psychological than physical, and the defeated Russians left in 1989.

Afghanische Mujaheddin feiern den Abschuß eines russischen Hubschraubers. Die Rebellen Afghanistans lieferten den russischen Besatzern einen erbitterten Guerillakrieg. Physisch konnten sie nicht viel ausrichten, doch die psychologische Wirkung war so groß, daß die Russen 1989 abzogen.

En Afghanistan, ces mudjahidines viennent d'abattre un hélicoptère russe. Les rebelles afghans ont mené une guerrilla acharnée contre l'occupation soviétique. Défaits plus psychologiquement que physiquement, les Soviétiques quitteront le pays en 1989.

les Etats-Unis le « syndrome du body-bag » (Mil. *body-bag* = sac servant à transporter les cadavres). De plus en plus, les dirigeants américains n'enverront des soldats outre-Atlantique que dans des opération à risques réduits et seulement là où les intérêts vitaux des Etats-Unis sont en jeu.

La guerre du Vietnam se distingue des autres guerres locales, parce que la leçon politique et culturelle qui s'en dégage, plus que ses enseignements tactiques, est toujours d'importance mondiale.

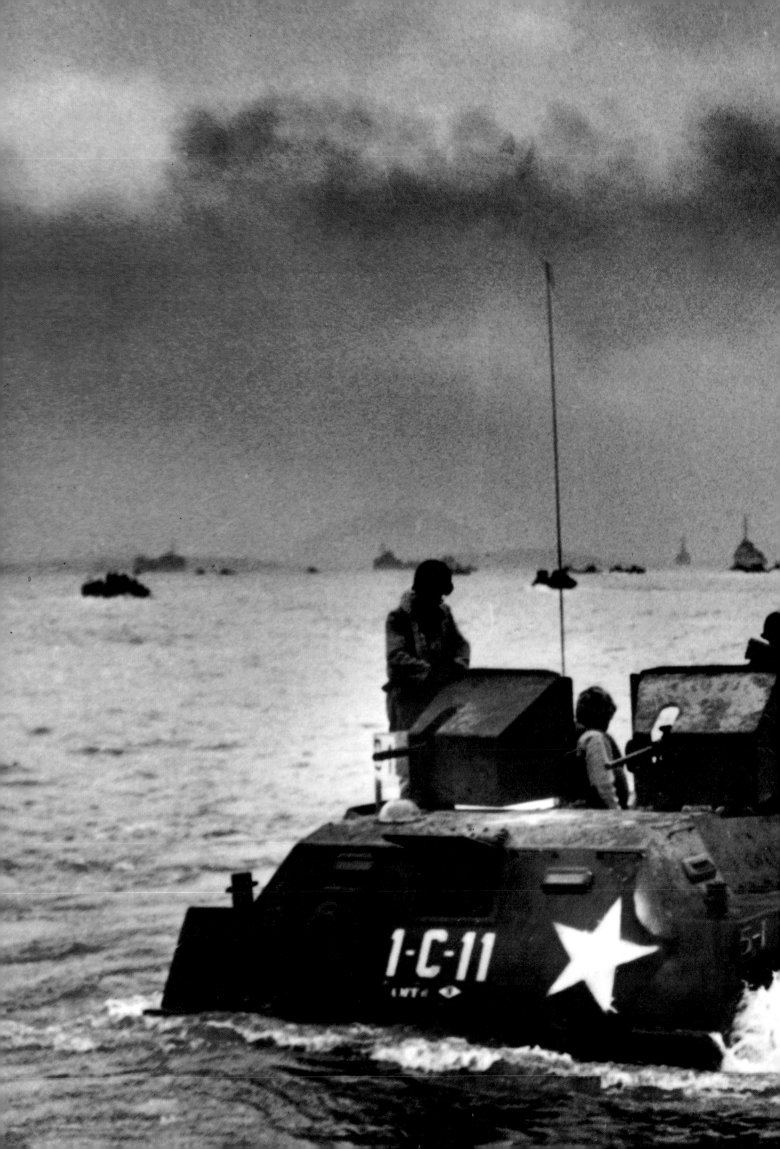

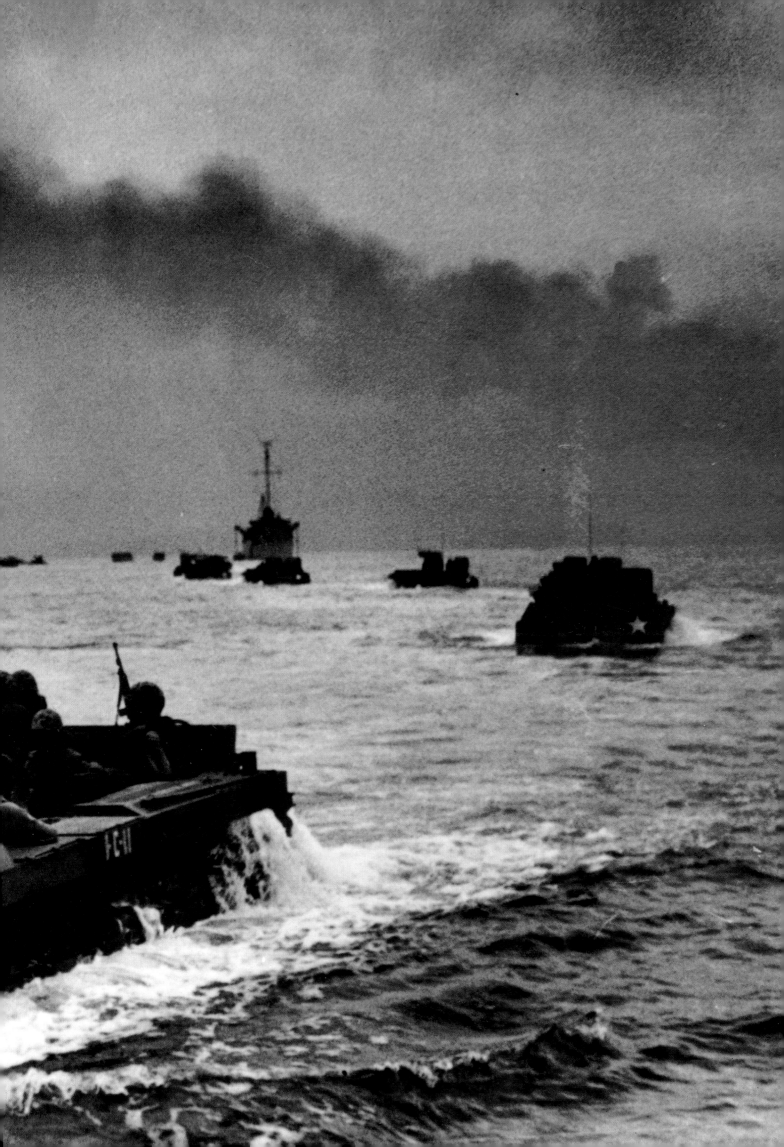

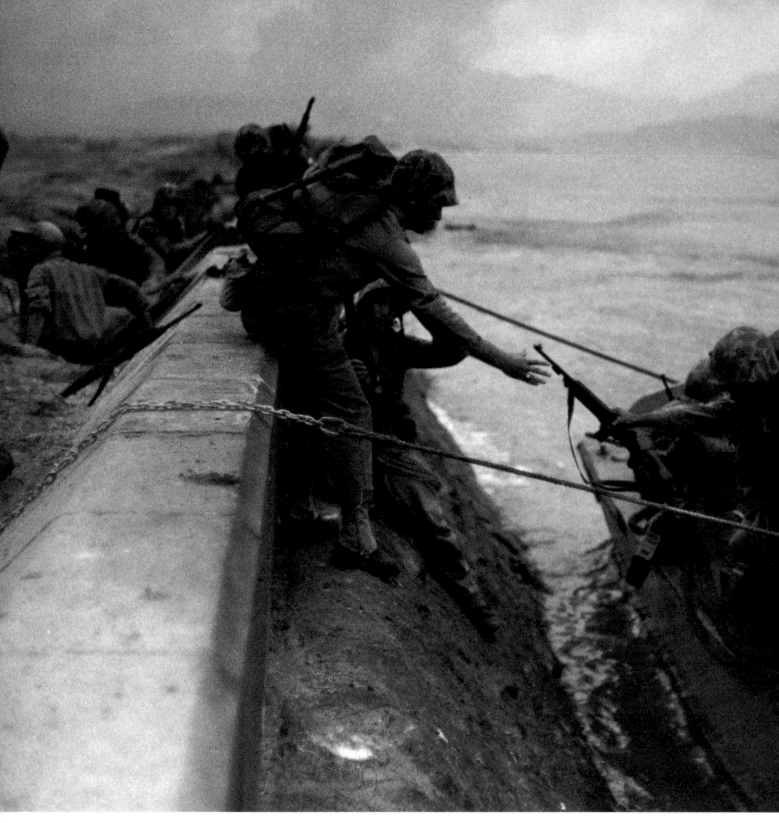

The Korean War

The Americans led the first counter-attack of the war (1950-53) by a daring amphibious assault at Inchon in October 1950. (Previous page) American assault craft heading inshore after a heavy naval bombardment.
(1) American forces scramble over the sea defences – the huge swell was a major obstacle during the landings. (2, 3) American and Commonwealth soldiers scrambling to take up positions, Inchon. These scenes were captured by Bert Hardy of *Picture Post*, who was to take some of the most arresting, and controversial, photographs of the war.

Der Koreakrieg

Die erste Gegenoffensive des Krieges (1950-53) führten die Amerikaner mit einem wagemutigen Landungsangriff im Oktober 1950 bei Inchon. (Vorige Seite) Amerikanische Landungsboote auf ihrem Weg an die Küste, die unter schwerem Beschuß liegt. (1) Amerikanische Truppen überklettern den Deich – starker Seegang war eines der Haupthindernisse beim Landemanöver. (2, 3) US- und Commonwealth-Soldaten beziehen Stellung in Inchon. Diese Aufnahmen wurden von Bert Hardy von der *Picture Post* gemacht, von dem einige der besten, aber auch umstrittensten Bilder des Krieges stammen.

La guerre de Corée

Les Américains lancent la première contre-attaque de la guerre (1950-53) sous la forme d'un audacieux assaut amphibie sur Inchon en octobre 1950. (Page précédente) Char d'assaut américain se dirigeant vers la côte après un lourd bombardement naval. (1) Les soldats américains se pressent sur les barrages de défense; la forte houle rendait les débarquements très difficiles. (2, 3) Inchon: les soldats américains et du Commonwealth courent vers leurs positions. Ces scènes ont été fixées par Bert Hardy, du *Picture Post,* qui publiera certaines des photos les plus saisissantes et les plus controversées de la guerre.

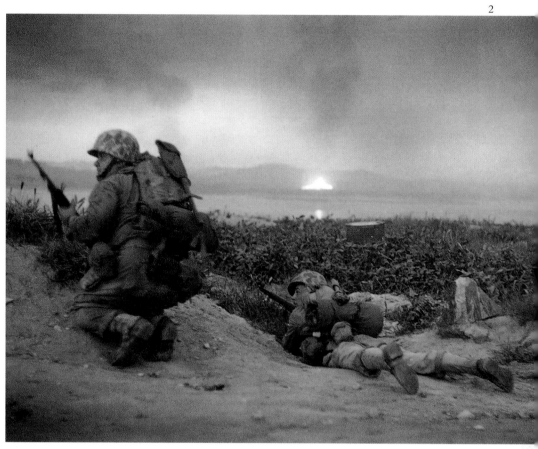

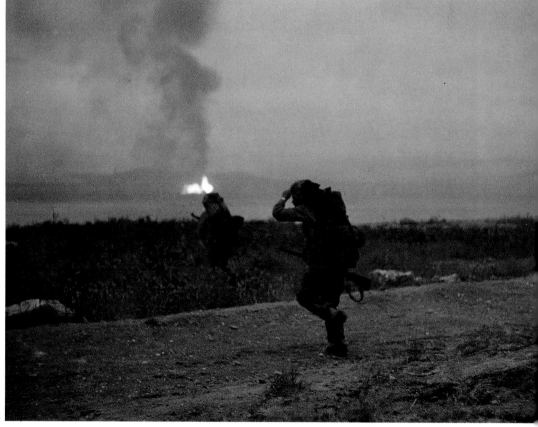

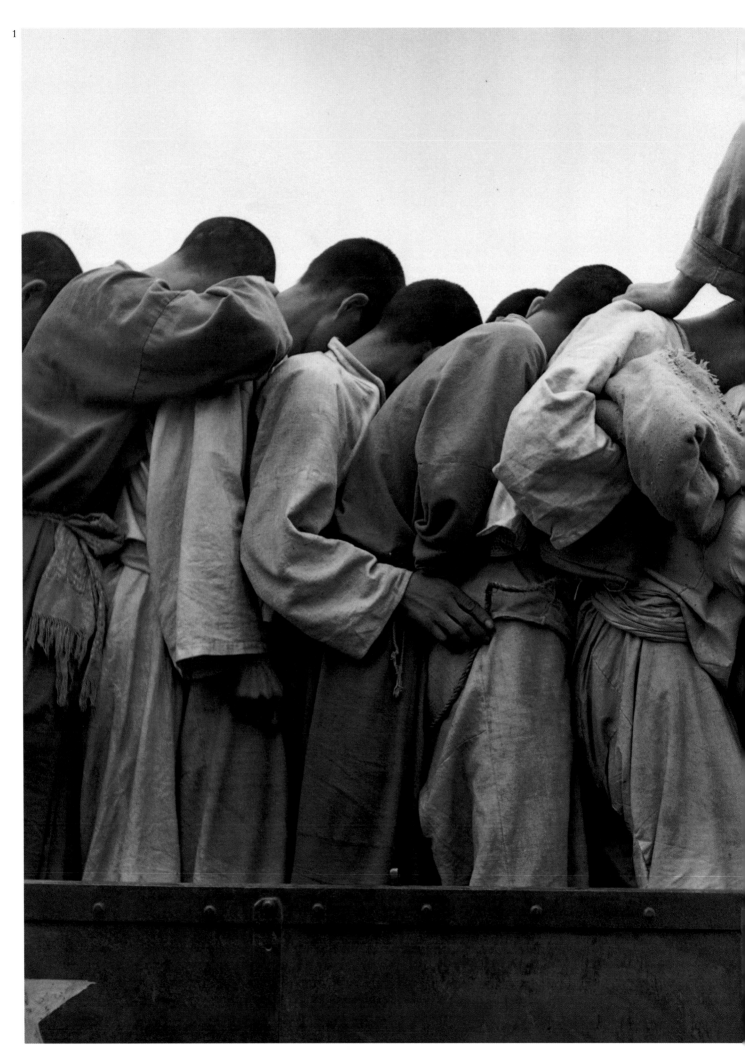

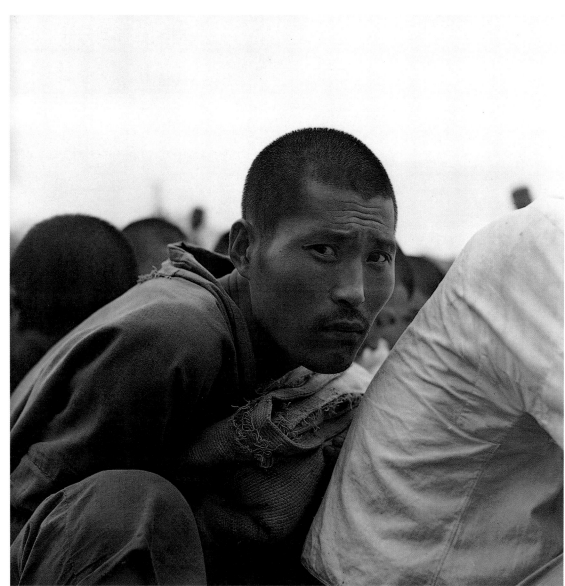

Korean Prisoners, 1

South Korean 'political' prisoners being rounded up at Pusan (1, 2). This subject was hugely sensitive and controversial, on both sides. The human rights issue was to become a major feature of international policy and actions in the local wars of the latter part of the 20th century, though effective action to curb excesses is a rarity.

Koreanische Gefangene, 1

»Politische« Gefangene der Südkoreaner werden in Pusan zusammengetrieben (1, 2). Diese Bilder eines hochsensiblen Themas erregten auf beiden Seiten die Gemüter. In der zweiten Hälfte des 20. Jahrhunderts sollten die Menschenrechte ein Hauptthema internationaler Politik werden und auch bei den Lokalkriegen eine große Rolle spielen. Allerdings gelingt es nur selten, denen, die sie mißachten, beizukommen.

Prisonniers coréens, 1

Rafle de prisonniers «politiques» coréens à Pusan (1, 2). Un problème extrêmement sensible et controversé des deux côtés. Les droits de l'homme deviendront un thème directeur de la politique et des actions internationales dans les guerres locales de la dernière partie du 20ᵉ siècle, bien que les interventions effectives destinées à contenir les excès restent rares.

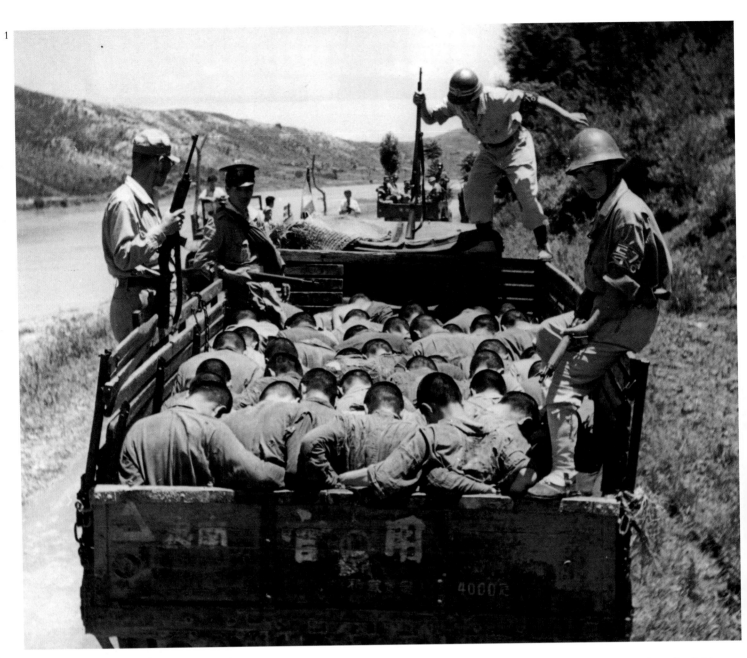

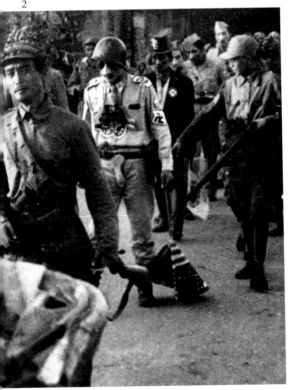

Korean Prisoners, 2

Prisoners were treated badly by all sides; publications such as *Picture Post* were reluctant to publish the most graphic images and reports. (1) South Korean military police take 'political' prisoners to be shot in the Taejon area. (2) American and South Korean prisoners paraded through the streets of Pyongyang. The American officer is made to wear a Hitler moustache and drags an American flag behind him. (3) A North Korean prisoner being registered at the camp at Taegu.

Koreanische Gefangene, 2

Gefangene wurden auf allen Seiten schlecht behandelt; Illustrierte wie die *Picture Post* hatten oft Hemmungen, drastischere Aufnahmen zu zeigen. (1) Südkoreanische Militärpolizisten bringen in der Gegend von Taejon »politische« Gefangene zur Hinrichtung. (2) Amerikanische und südkoreanische Gefangene werden durch die Straßen von Pjöngjang getrieben. Dem US-Offizier hat man ein Hitlerbärtchen aufgemalt; als Demütigung muß er die amerikanische Flagge durch den Dreck ziehen. (3) In einem Lager in Taegu werden die Personalien eines nordkoreanischen Gefangenen aufgenommen.

Prisonniers coréens, 2

Dans tous les camps, les prisonniers ont été maltraités; des publications comme le *Picture Post* hésitaient à montrer les photos et les reportages les plus choquants. (1) La police militaire sud-coréenne emmène les prisonniers «politiques» qui seront fusillés dans la région de Taejon. (2) Prisonniers américains et sud-coréens exhibés dans les rues de Pyongyang. L'officier américain est affublé d'une moustache hitlérienne et traîne un drapeau américain derrière lui. (3) Un prisonnier sud-coréen est enregistré au camp de Taegu.

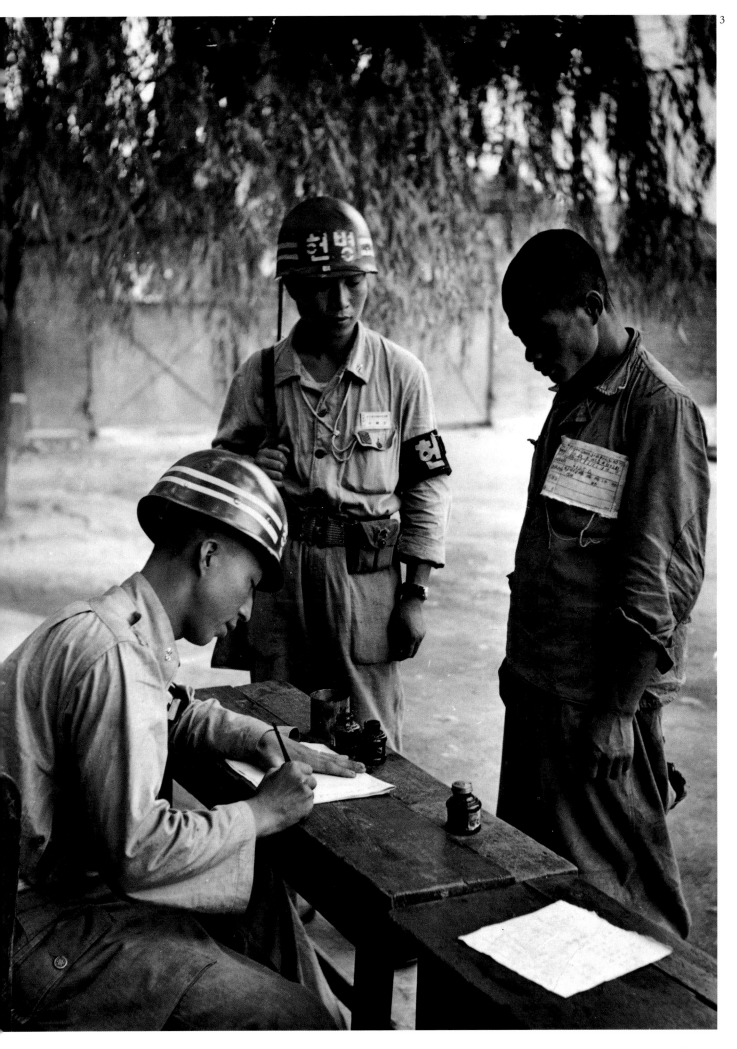

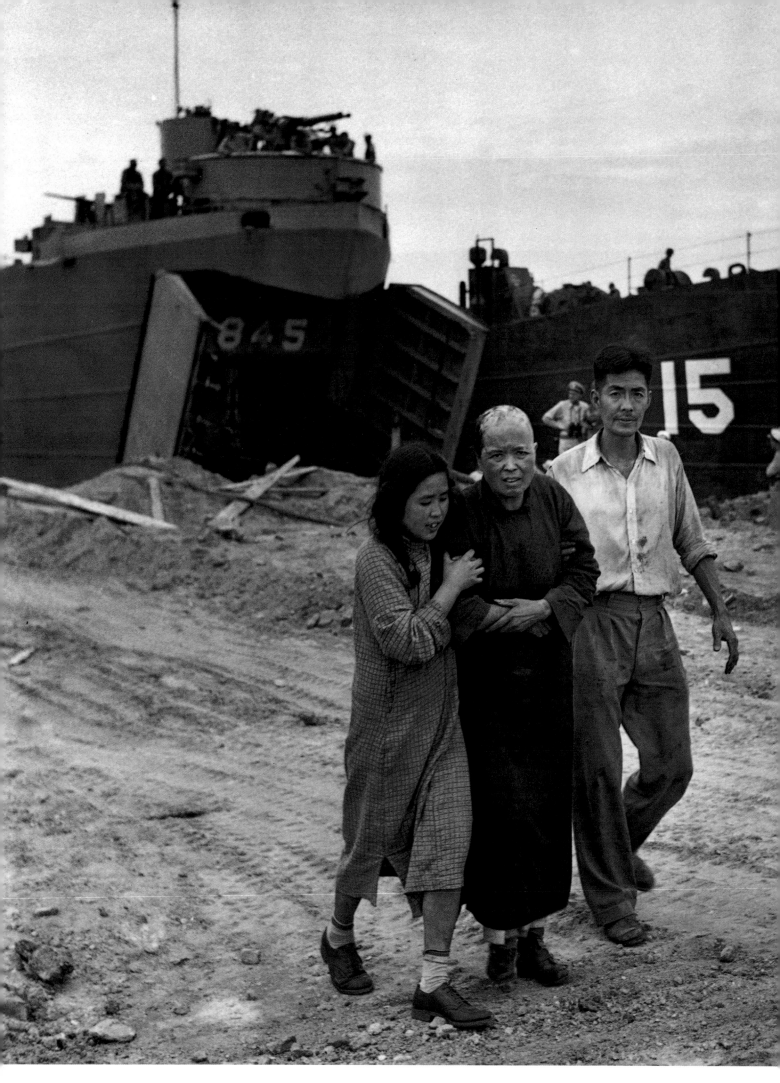

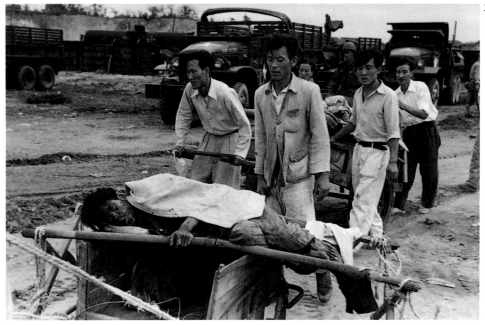

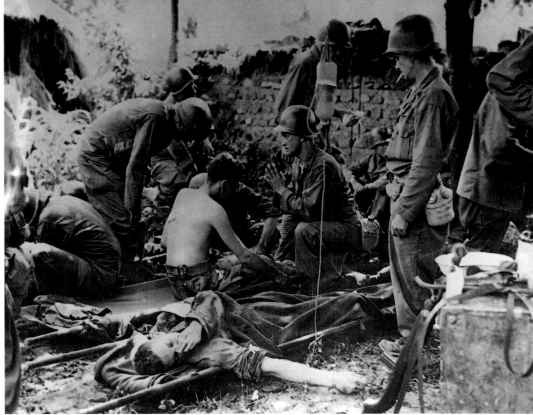

Casualties

(1) Koreans seeking medical attention; American amphibious craft are in the background. (2) A battle casualty dressing station 'somewhere in Korea'. Battlefield medicine had improved enormously over the previous decade, largely due to better drugs including antibiotics. (3) A civilian casualty after the American landing at Inchon, 1950.

Die Opfer

(1) Koreaner suchen medizinische Hilfe; im Hintergrund US-Landungsboote. (2) Ein Feldlazarett »irgendwo in Korea«. Die Kriegsmedizin hatte sich im Laufe des vorangegangenen Jahrzehnts deutlich verbessert, vor allem dank neuer Medikamente und Antibiotika. (3) Ein verwundeter Zivilist nach der Landung der Amerikaner in Inchon, 1950.

Morts et blessés

(1) Coréens en quête de soins médicaux; on voit à l'arrière-plan les chars amphibies américains. (2) Une station de soins aux victimes, « quelque part en Corée ». La médecine de guerre a considérablement progressé au cours de la décennie qui précède, en grande partie grâce à une meilleure pharmacopée, antibiotiques compris. (3) Une victime civile après le débarquement américain à Inchon, 1950.

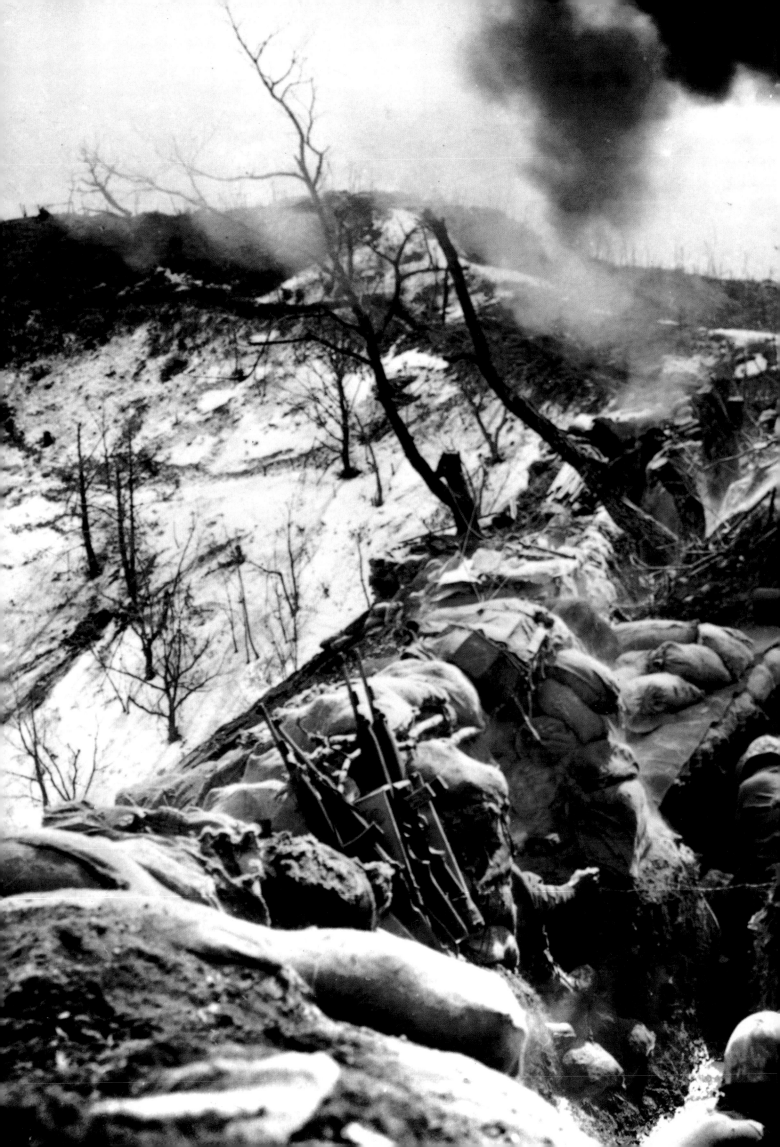

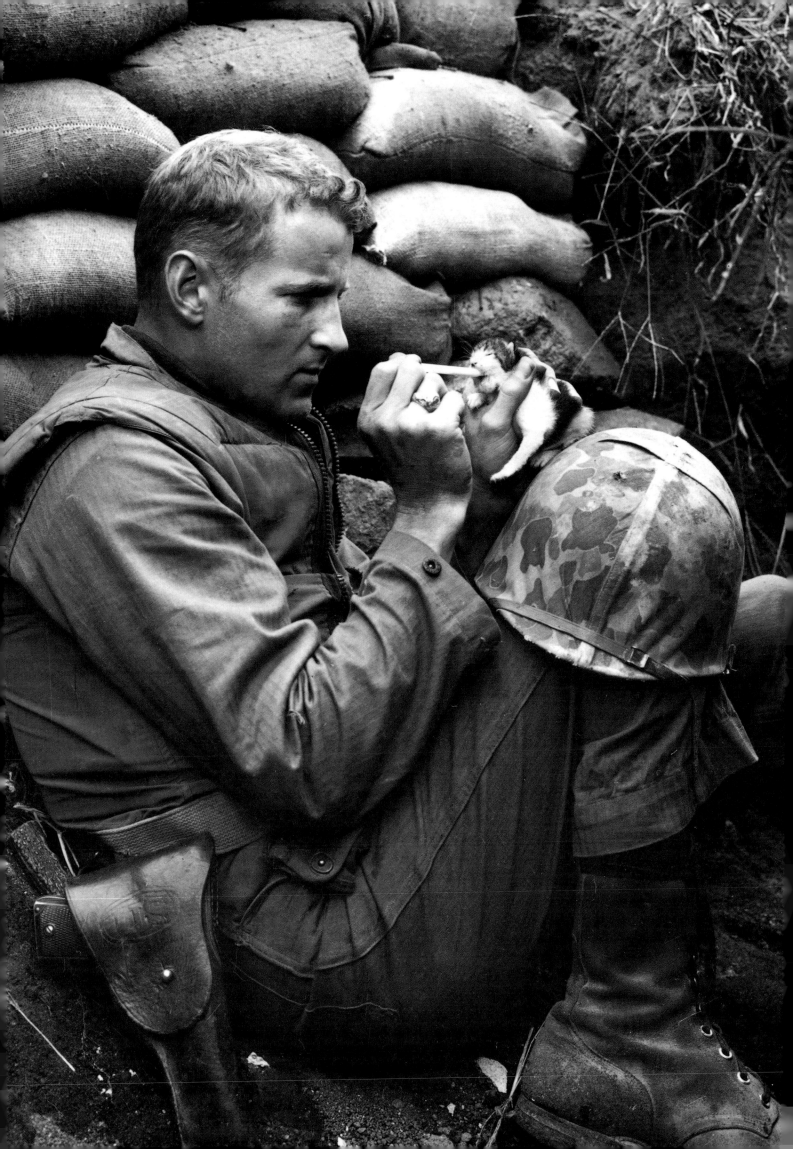

Marines at War

(Previous page) US Marines dig in. The war settled down to static defensive lines by 1953, while the talks went on. (1) A US Marine, Sergeant Frank Praytor of Birmingham, Alabama, feeds an orphan kitten found after a heavy mortar barrage at 'Bunker Hill'. (2) A US Marine using a flame-thrower to burn out positions which could conceal North Korean snipers. This technique foreshadowed the American tactics of clearing the jungle with defoliants in Vietnam.

Die »Marines« im Kampf

(Vorhergehende Seite) US-Marineinfanteristen graben Stellungen. 1953 hatte sich der Krieg zu unbeweglichen Verteidigungslinien verhärtet; die Waffenstillstandsverhandlungen waren im Gange. (1) Ein Marinesoldat, Sergeant Frank Praytor aus Birmingham, Alabama, füttert ein verwaistes Kätzchen, das sich nach schwerem Granatwerferbeschuß am »Bunker Hill« fand. (2) Mit einem Flammenwerfer brennt ein US-Marinesoldat Positionen aus, die nordkoreanische Scharfschützen decken könnten. Diese Technik deutet die amerikanische Taktik im Vietnamkrieg an, den Dschungel mit Entlaubungsmitteln zu lichten.

Marines en guerre

(Page précédente) Les *marines* dans les tranchées. En 1953, le front se stabilise le long des lignes défensives tandis que les négociations se poursuivent. (1) Un *marine* américain, le caporal-chef Frank Praytor de Birmingham, Alabama, nourrit un chaton orphelin découvert après un lourd barrage de mortier sur «Bunker Hill» (la «colline du bunker»). (2) Un *marine* brûle au lance-flammes des positions pouvant dissimuler des tireurs isolés nord-coréens. Cette technique préfigure l'utilisation de défoliants pour dénuder la jungle vietnamienne.

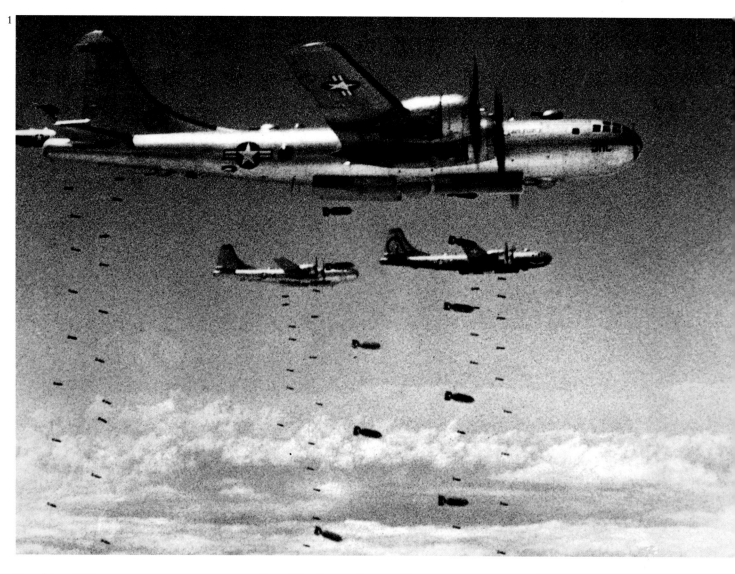

Bombing Raids

(1) B-29 Superfortresses dropping bombs over North Korea. (2) Bombs from B-29s impacting on a magnesium plant. (3) An American F-80 making a low-level attack with a napalm bomb on a storage centre at Suan, 35 miles south-east of Pyongyang, 8 May 1951. Napalm, an exploding petroleum-based jelly or liquid, was used on a wide scale for the first time in the Korean conflict; 12,000 gallons were dropped in this raid alone.

Bombenangriffe

(1) B-29 Superfortress werfen ihre Bomben über Nordkorea ab. (2) Bomben einer B-29 haben ein Magnesiumwerk getroffen. (3) Eine amerikanische F-80 beim Tiefflugangriff mit Napalmbomben auf ein Versorgungslager in Suan, 50 Kilometer südöstlich von Pjöngjang, 8. Mai 1951. Der Koreakrieg war der erste, in dem das aus Petroleum gewonnene, flüssige oder geleeförmige Napalm in größerem Maße zum Einsatz kam; allein bei diesem Einsatz wurden 45 000 Liter abgeworfen.

Bombardements aériens

(1) Superforteresse B-29 lâchant ses bombes sur la Corée du Nord. (2) Impacts de bombes de B-29 sur une usine de magnésium. (3) Attaque de F-80 américain à basse altitude lâchant une bombe au napalm sur un centre de stockage à Suan, à 55 km au sud-est de Pyongyang, le 8 mai 1951. C'est pendant la guerre de Corée que le napalm, une gelée explosive à base d'essence, a été utilisé pour la première fois à une grande échelle. 45 000 litres de napalm ont été lâchés pour ce seul raid.

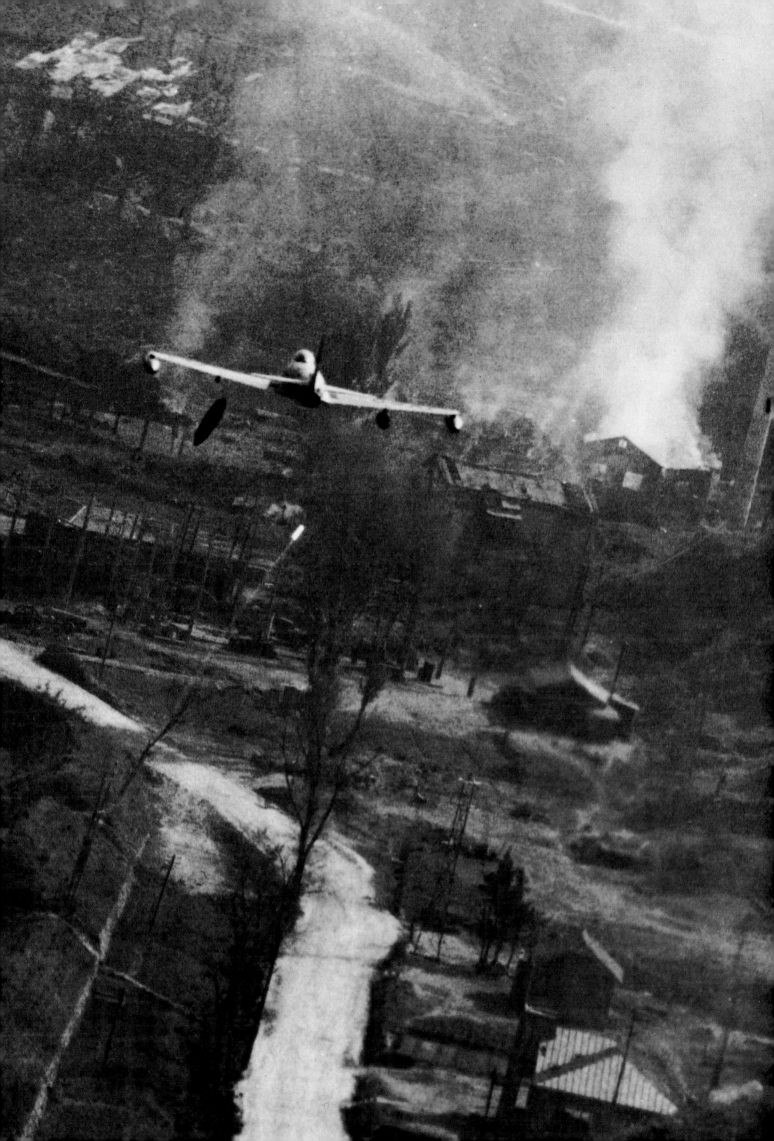

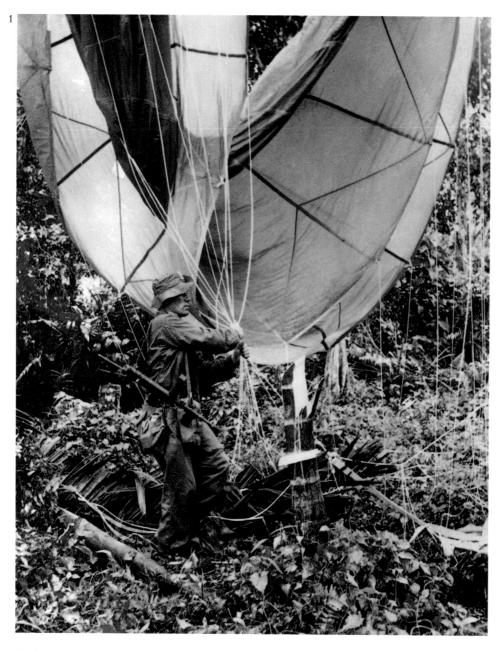

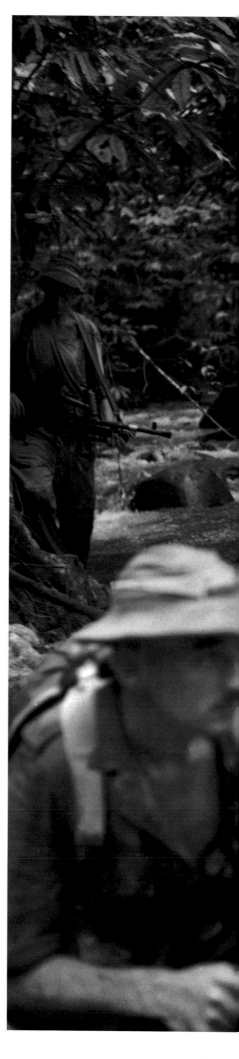

Malaya

The Malayan emergency, 1948-60, saw one of the most successful counter-insurgency operations of modern times. British and local Malay forces used special troops, police and a powerful 'hearts and minds' policy towards the local community. (1) Paratroopers preparing to take a Communist hideout in 1952, guided by SAS troops who had marched for weeks through tropical forests. (2) Men of the Special Air Services with a casualty waiting for helicopter evacuation, photographed by *Picture Post*'s Charles Hewitt, 1953.

Malaya

In der Malayakrise (1948-60) wurden die Aufständischen durch eine meisterhaft geführte Kampagne niedergeworfen. Die britischen und einheimischen Armeen arbeiteten mit Einsatztruppen, Polizei und den Einheimischen zusammen, die sie »mit Herz und Verstand« für sich gewannen. (1) Fallschirmjäger bereiten sich auf die Erstürmung eines kommunistischen Verstecks vor, 1952. Soldaten der SAS-Luftlandeeinheit waren wochenlang durch die tropischen Wälder gestreift, bis sie es ausfindig machten. (2) Männer der SAS warten auf den Hubschrauber, der einen Verwundeten evakuieren soll, fotografiert von Charles Hewitt von der *Picture Post*, 1953.

La Malaisie

Les opérations anti-insurrection les plus réussies de l'époque moderne se sont déroulées au moment de la crise malaisienne (1948-60). Les forces britanniques et malaisiennes disposaient de soldats et de policiers bien préparés, qui mirent en oeuvre une politique «du cœur et de l'esprit» vis-à-vis de la population. (1) Parachutistes se préparant à prendre une cache communiste, conduits par des soldats du Special Air Service (SAS) qui ont marché pendant des semaines à travers les forêts tropicales, 1952. (2) Hommes du SAS avec une victime, attendant l'évacuation par hélicoptère; photo de Charles Hewitt du *Picture Post,* 1953.

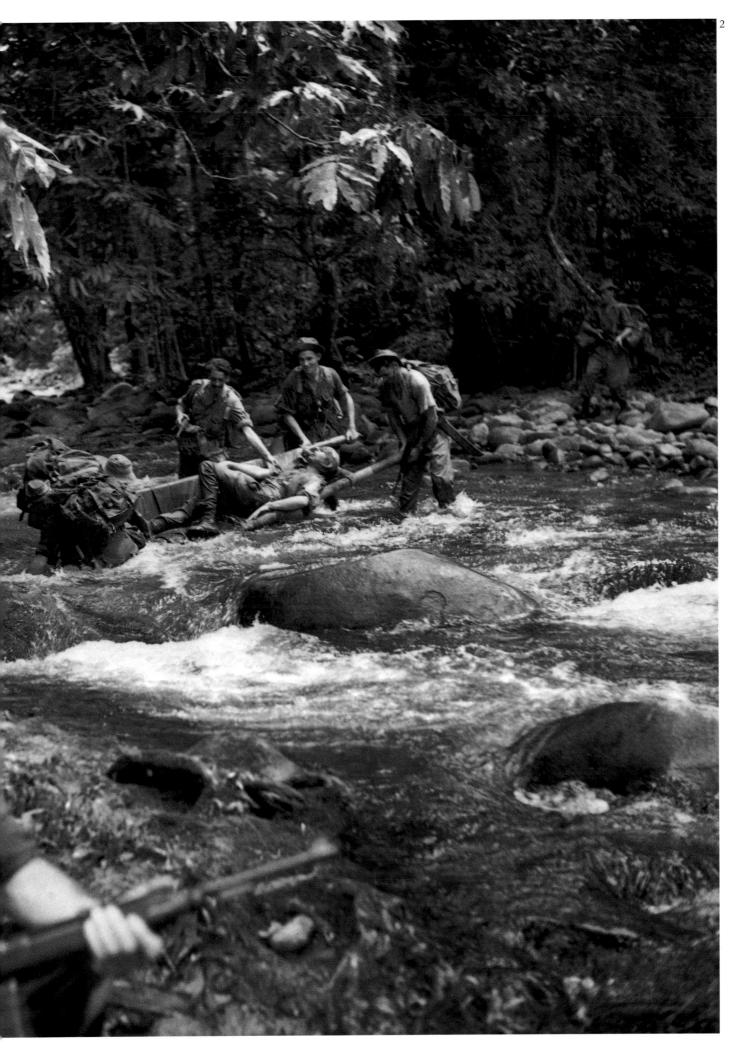

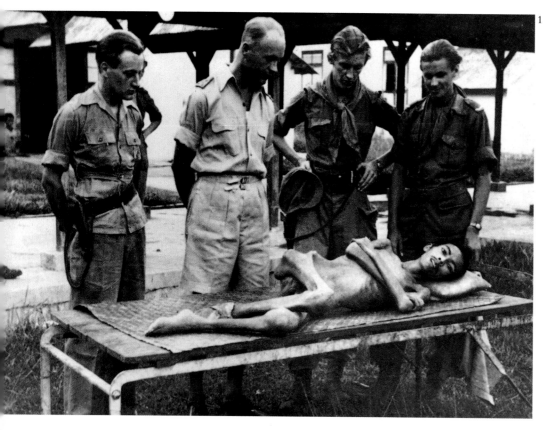

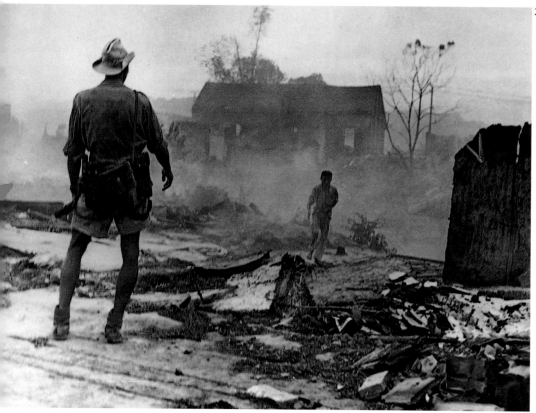

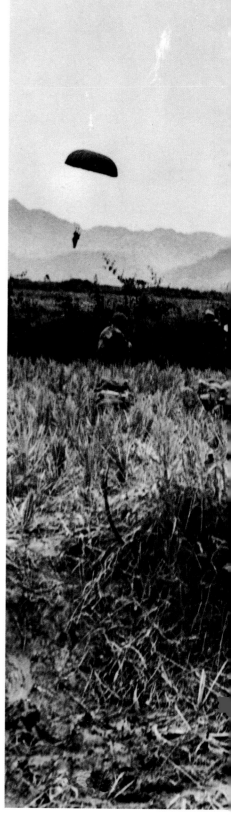

Indonesia and Indo-China

The war for independence in Indonesia was to last four years, and cost more than 7000 Dutch casualties. (1) An emaciated Indonesian soldier in a Dutch military hospital in northern Sumatra, 1949. (2) The French war in Indo-China: a Vietminh insurgent surrenders after his house has been burnt during the battle of Phuly. (3) The initial French parachute drop in 1953 on the forward stronghold of Dien Bien Phu, to attack General Giap's Vietminh in the flank. Giap was able to surround the fortress and force the French to surrender on 7 May 1954, spelling the end to French colonial rule in south-east Asia.

Indonesien und Indochina

Der indonesische Unabhängigkeitskrieg zog sich über vier Jahre hin und kostete über 7000 Holländer das Leben. (1) Ein halbverhungerter indonesischer Soldat in einem holländischen Lazarett, Nord-Sumatra, 1949. (2) Der französische Indochinakrieg: Ein Vietminh ergibt sich in der Schlacht von Phuly, nachdem sein Haus niedergebrannt ist. (3) Die ersten französischen Fallschirmjäger landen auf dem vorgezogenen Stützpunkt Dien Bien Phu, von wo sie General Giaps Vietminh in der Flanke angreifen wollen. Giap gelang es, die Festung zu umzingeln, und am 7. Mai 1954 mußten die Franzosen sich ergeben; das war das Ende der

französischen Kolonialherrschaft in Südostasien.

L'Indonésie et l'Indochine

La guerre d'indépendance en Indonésie a duré quatre ans et causé la mort de plus de 7000 soldats néerlandais. (1) Un soldat indonésien décharné dans un hôpital militaire néerlandais au nord de Sumatra, 1949. (2) La guerre en Indochine: un insurgé viêtminh se rend après l'incendie de sa maison pendant la bataille de Phuly. (3). Premier parachutage français en 1953 sur le bastion avancé de Diên Biên Phû, pour attaquer sur son flanc le Viêt-minh du général Giap. Mais Giap parviendra à encercler Diên Biên Phu et les Français se rendront le 7 mai 1954, mettant fin à la domination coloniale française en Asie du Sud-Est.

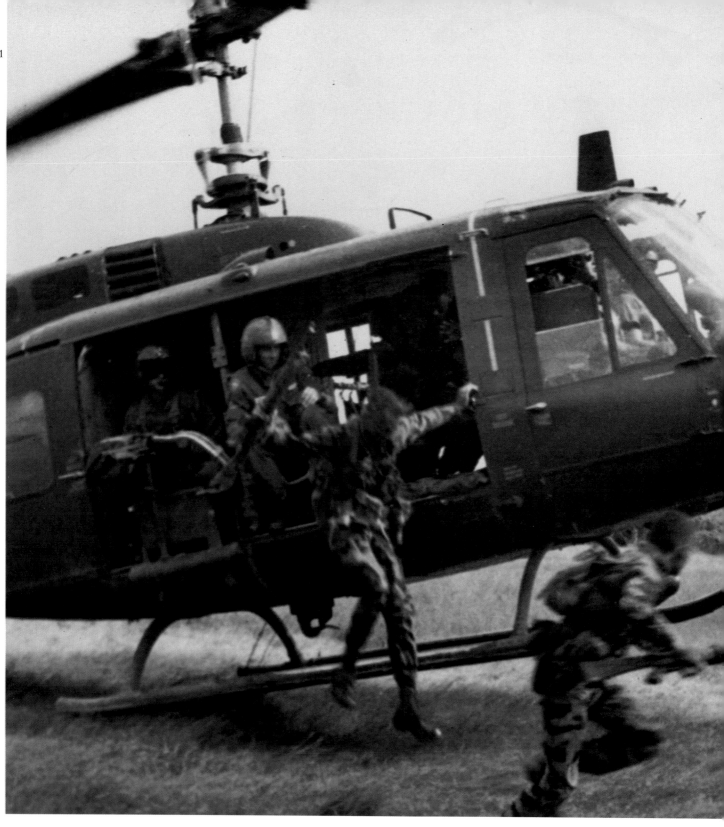

The War in Vietnam

American troops deploy in Vietnam. (1) A forward reconnaissance patrol drops from a helicopter near Cu Chi in 1967. The Americans were to pioneer new tactics of airmobile troops with their concept of the 'air cavalry'. (2) An early joint American-South Vietnamese operation: 840 Vietnamese paratroopers are dropped from C-123s of the US Air Force in Tay Ninh province in 1963; the area had been comprehensively hit by American fire beforehand. (3) A crewman in an American helicopter gunship watches a flight of escorting Huey helicopters in an operation in November 1968.

Der Krieg in Vietnam

Aufmarsch der Amerikaner in Vietnam. (1) Ein Erkundungstrupp springt nahe Cu Chi aus dem Hubschrauber, 1967. Mit dem Konzept der »fliegenden Kavallerie« entwickelten die Amerikaner neue Taktiken für den mobilen Lufteinsatz. (2) Ein frühes Gemeinschaftsunternehmen amerikanischer und südvietnamesischer Truppen: 840 vietnamesische Fallschirmspringer werden 1963 in der Provinz Tay Ninh von C-123-Flugzeugen der US Air Force abgesetzt; zuvor hatten die Amerikaner die Gegend ausgiebig unter Beschuß genommen. (3) Ein Besatzungsmitglied eines US-Kampfhubschrau-

bers blickt beim Einsatz im November 1968 auf die Helikopter des Geleitschutzes.

La guerre au Vietnam

Déploiement de troupes américaines au Vietnam. (1) Une patrouille de reconnaissance déposée par hélicoptère près de Cu Chi en 1967. Les Américains inaugureront une nouvelle tactique de soldats aéroportés, la «cavalerie aérienne». (2) L'une des premières opérations conjointes de soldats américains et sud-vietnamiens: 840 parachutistes vietnamiens sautent des C-123 de l'US Air Force dans la province de Tay Ninh en 1963; auparavant, la région entière a subi des tirs

américains. (3) A bord d'un hélicoptère de combat américain, un homme d'équipage observe un vol d'hélicoptères d'accompagnement Huey au cours d'une opération, novembre 1968.

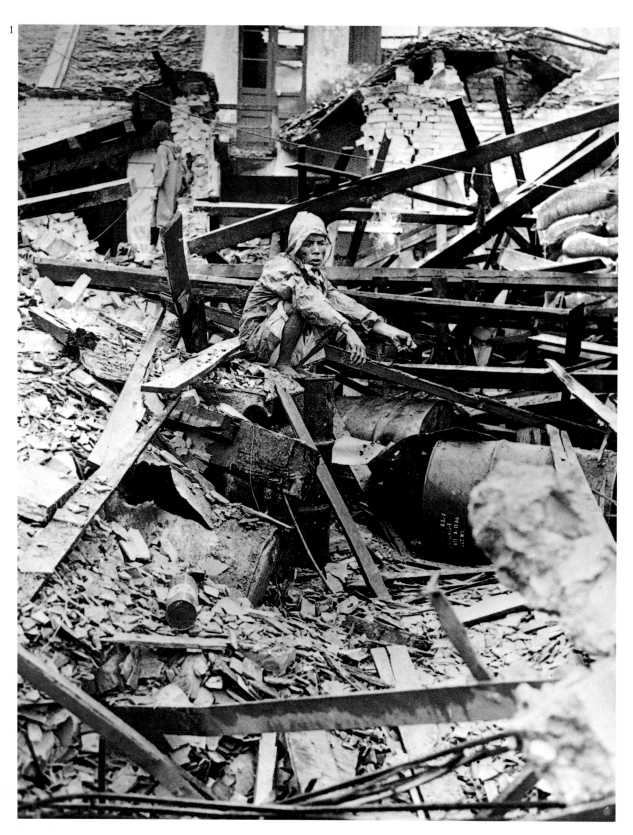

The Tet Offensive

The battle for the ancient imperial capital of Hue was part of the Tet Offensive in 1968, a turning point in the Vietnam war. (1) The Americans eventually drove the Vietcong out after they took the old city, but it was a costly operation. This man surveys the wreckage of his home and shop. (2) A US Marine bundles an old woman away from the battle in her village. (Overleaf) The exodus from Hue, badly damaged by American fire.

Die Tet-Offensive

Die Schlacht um die alte Kaiserstadt Hue war Teil der Tet-Offensive von 1968, einer der Wendepunkte des Vietnamkriegs. (1) Nach der Eroberung der Altstadt konnten die amerikanischen Truppen die Vietcong in die Flucht schlagen, doch es war ein verlustreicher Sieg. Dieser Mann sitzt in den Trümmern seines Ladens und seiner Wohnung. (2) Ein Soldat der US-Marines trägt eine alte Frau aus ihrem umkämpften Dorf. (Folgende Seite) Die Bevölkerung verläßt das von den Amerikanern bombardierte Hue.

L'offensive du Têt

La bataille pour l'ancienne capitale impériale de Hué est incluse dans l'offensive du Têt, en 1968, une charnière dans la guerre du Vietnam. (1) Les Américains finissent par chasser les viêt-cong de Hué, mais le prix de l'opération sera lourd. Cet homme contemple sa maison et sa boutique en ruines. (2) Un *marine* US emporte une vieille femme loin des combats de son village. (Page suivante) L'exode de Hué, très abîmée par les tirs américains.

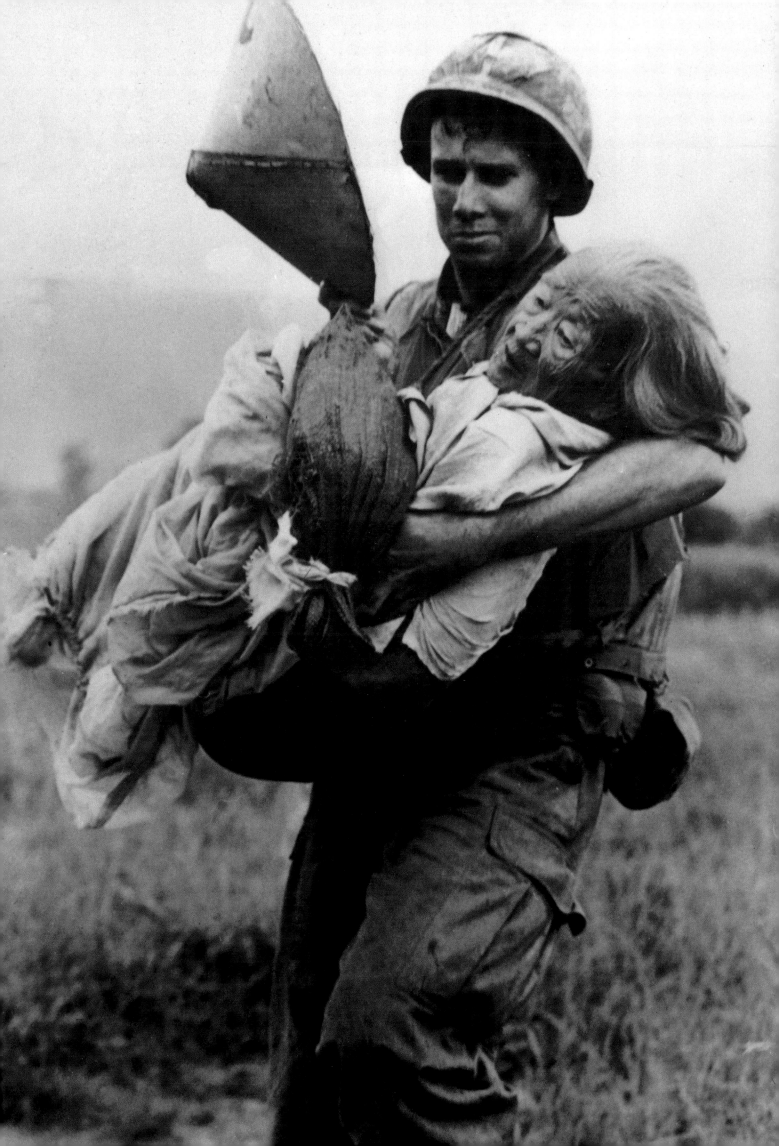

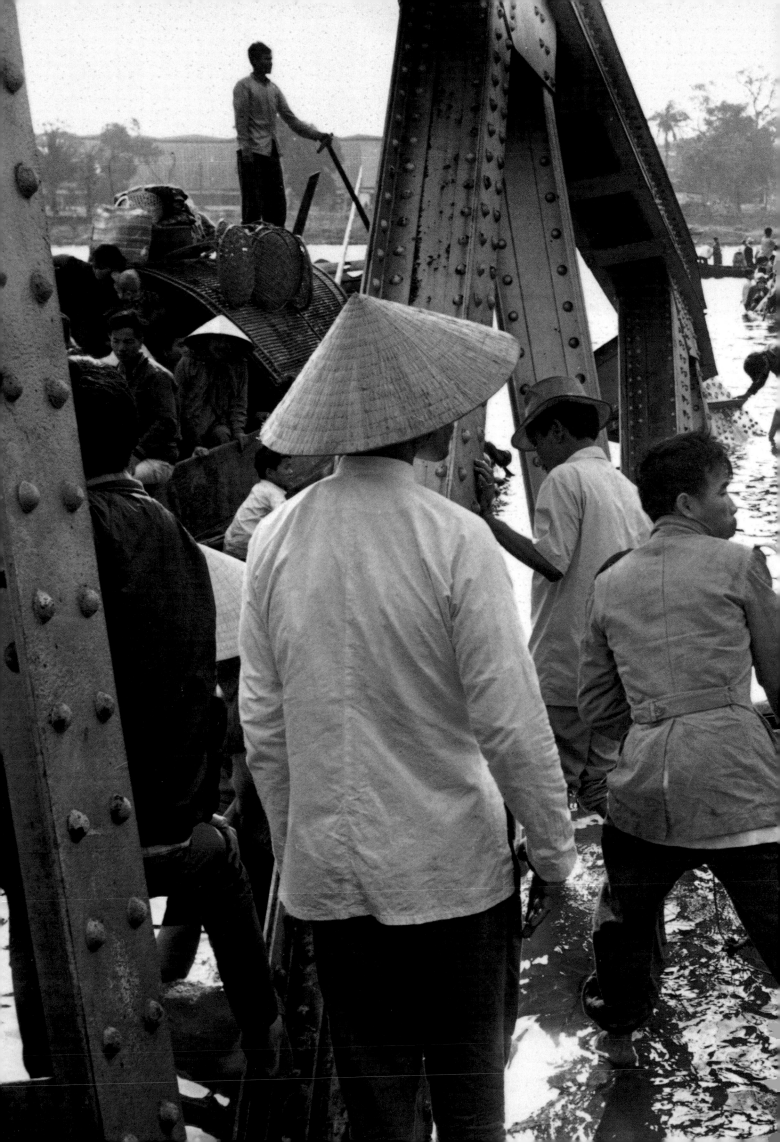

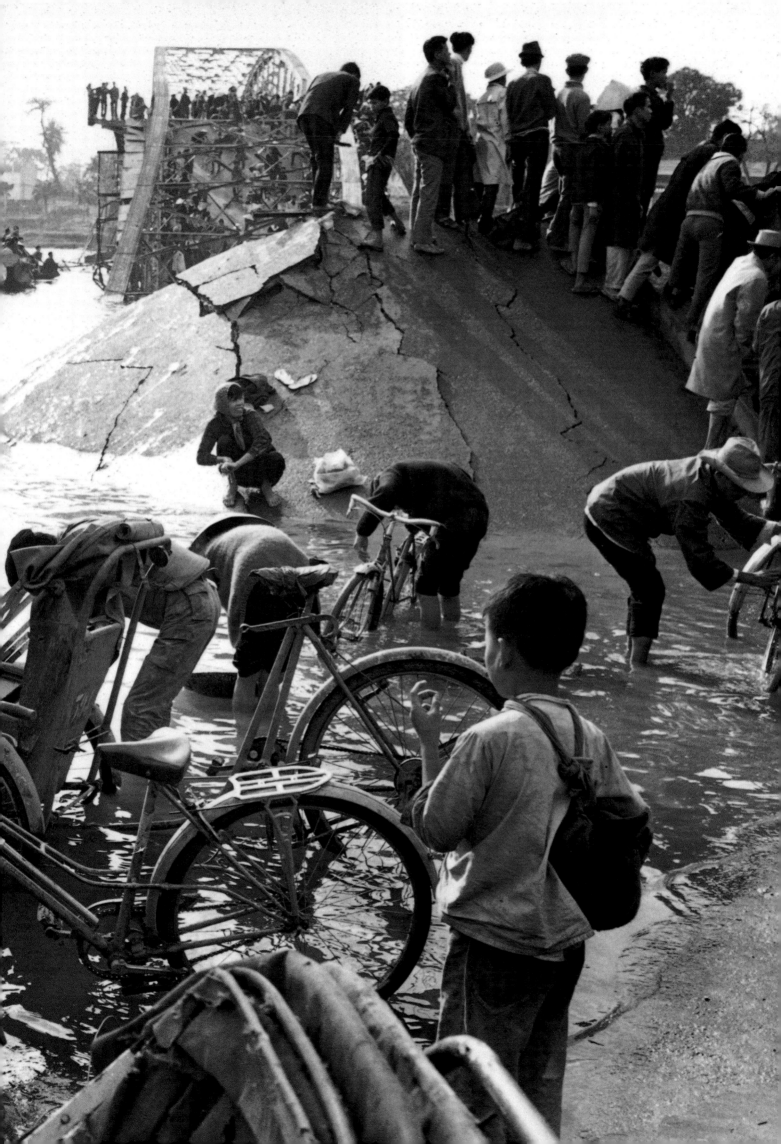

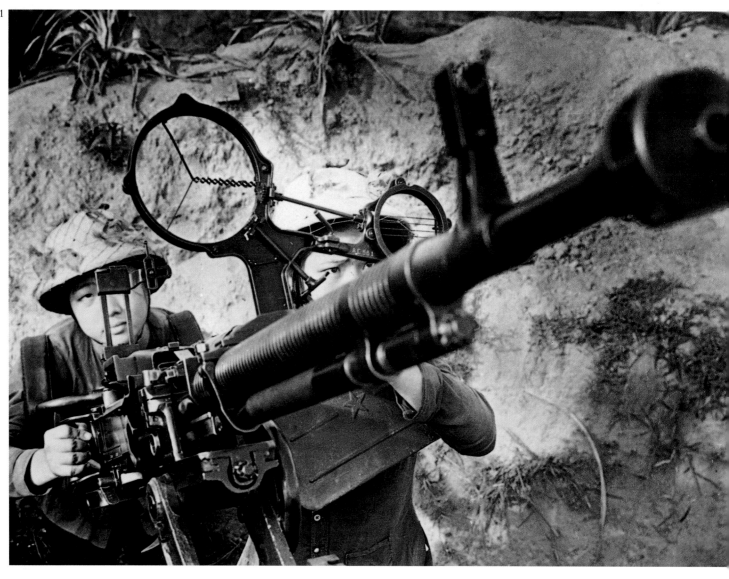

Armies of the North

(1) Girls of the North Vietnamese Army pose for a propaganda picture – they had brought down three American aircraft. (2) An action shot released by Hanoi of North Vietnamese troops during the assault on a South Vietnamese base, March 1971. (3) Vietcong fighting in Quang Tri in 1969. Note the ubiquitous AK-47 assault rifle. The expression on the soldier's face is eloquent; he appears about to throw a primitive grenade.

Armeen des Nordens

(1) Mädchen der Ersten Frauenbatterie der nordvietnamesischen Armee posieren mit ihrem schweren Flugabwehr-Maschinenge-wehr für ein Propagandabild – sie hatten drei amerikanische Flugzeuge abgeschossen.
(2) Eine von Hanoi veröffentlichte Kampf-aufnahme zeigt nordvietnamesische Soldaten beim erfolgreichen Angriff auf eine Basis der Südvietnamesen im März 1971. (3) Vietcong-Kämpfer in Quang Tri, 1969, mit dem allge-genwärtigen AK-47-Kampfgewehr (mit einklappbarem Bajonett). Der Gesichtsaus-druck des Mannes (rechts) sagt alles; offenbar ist er im Begriff, eine primitive Handgranate zu werfen.

Armées du Nord

(1) Des soldates de l'armée nord-vietnamienne posant pour une photo de propagande après avoir abattu trois avions américains. (2) Un groupe de soldats nord-vietnamiens lors de l'attaque d'une base du Sud en mars 1971. (3) Soldats viêtcong à Quang Tri en 1969. Noter le fusil d'assaut AK-47, omniprésent. Le visage du soldat de droite est éloquent: il est sur le point de lancer une grenade primitive.

2

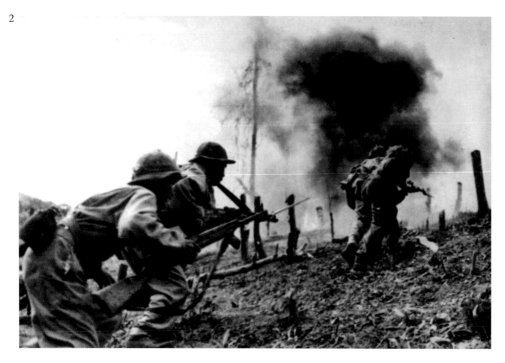

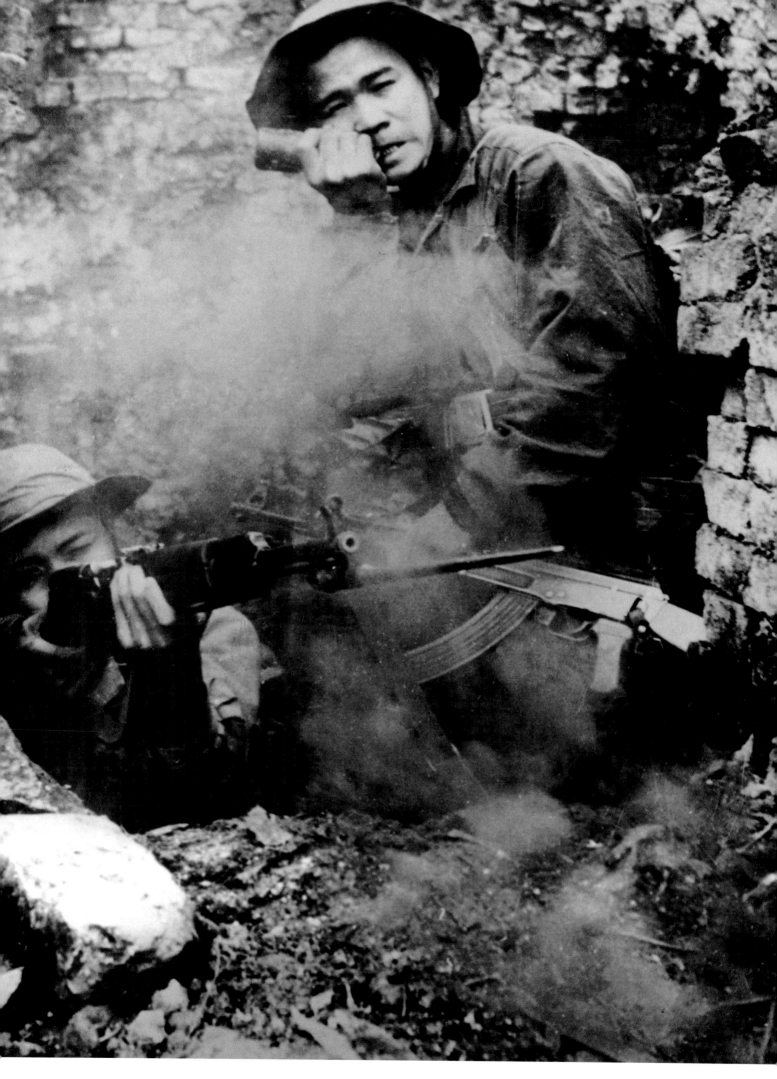

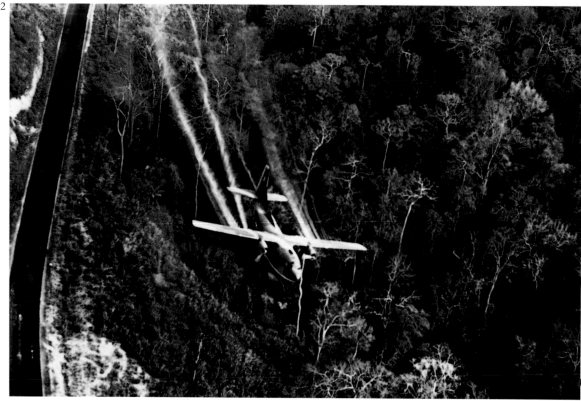

Air Attack

(1) A Northrop A-5 fighter-bomber dropping iron bombs over the jungle. This aircraft could reach speeds of more than 1000 mph (1600 kph) and carried air-to-air missiles and cannon for ground attack. (2) An aircraft spraying defoliant to expose Vietcong positions in the Ho Chi Minh Trail through the jungle. The propaganda caption to this photograph of May 1966 says this spray is 'harmless to humans, animals, soil and water'. The revelation that Agent Orange was a variant of Dioxin was to be the source of a major ecological scandal. (3) Soldiers of the National Liberation Front (Vietcong) firing their heavy machine gun at attacking American aircraft, April 1969.

Luftangriff

(1) Ein Kampfbomber vom Typ Northrop A-5 beim Bombenabwurf über dem Dschungel. Diese Maschinen erreichten Geschwindig-keiten von über 1600 Stundenkilometern und waren mit Raketen zum Abschuß feind-licher Flugzeuge ebenso wie mit Geschützen für Bodenattacken ausgerüstet. (2) Ein Flug-zeug sprüht Entlaubungsmittel, um Vietcong-Positionen entlang des Ho-Chi-Minh-Pfades zu enttarnen. Die offizielle Bildunterschrift zu dieser Aufnahme vom Mai 1966 besagte, daß das Mittel »ungefährlich für Mensch, Tier, Boden und Wasser« sei. Als bekannt wurde, daß Agent Orange eine Abart von Dioxin war, provozierte dies einen ökologi-schen Skandal. (3) Soldaten der Nationalen Befreiungsfront (Vietcong) feuern mit ihrem schweren Maschinengewehr auf angreifende amerikanische Flugzeuge, April 1969.

Attaques aériennes

(1) Un bombardier de combat Northrop A-5 lâchant des bombes à ferraille sur la jungle. Cet avion volait à plus de 1600 km/h, trans-portant des missiles air-air et des canons d'attaque de terrain. (2) Cet avion répand un défoliant sur la piste de Ho Chi Minh dans la jungle, pour mettre à nu les positions du Viêt-cong. En mai 1966, la légende de cette photo affirme que ce produit est « inoffensif pour les humains, les animaux, le sol et l'eau ». Les révélations portant sur l'Agent Orange, un dérivé de la dioxine, provoqueront un énorme scandale. (3) Des soldats du Front de libération nationale (Viêt-cong) tirant à la mitrailleuse lourde sur un avion attaquant américain, avril 1969.

3

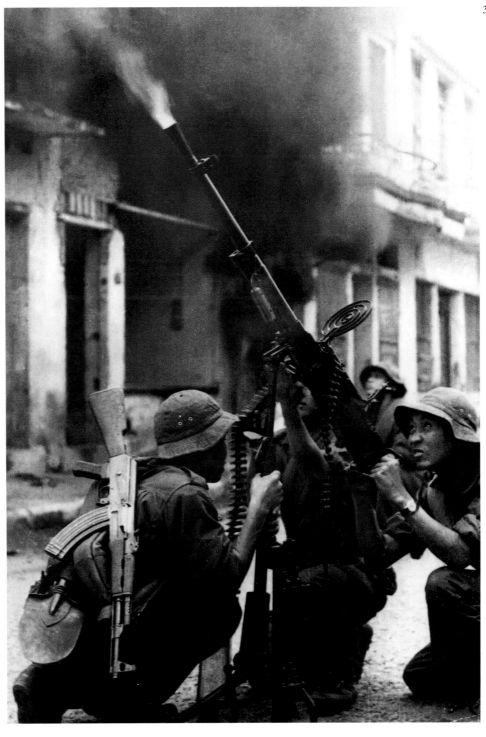

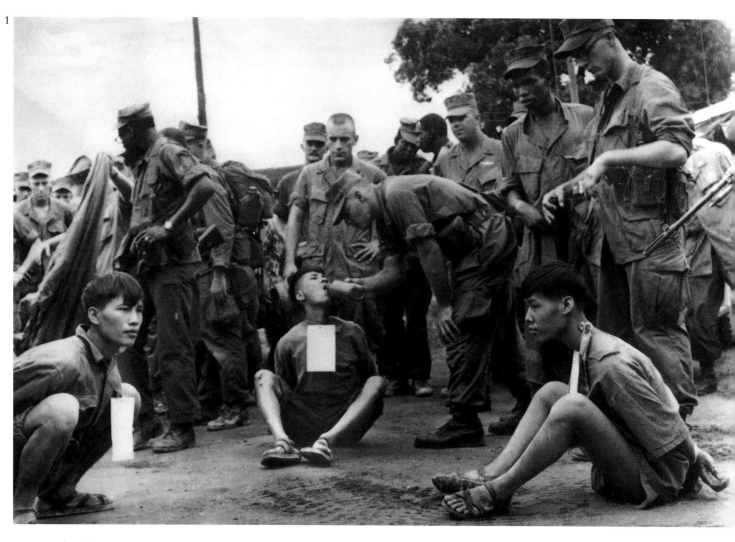

Captured and Wounded

(1) Three North Vietnamese Army soldiers seized by an American reconnaissance patrol. Their hands are tied while a Marine gives them water: the labels state time and place of capture. (2) Vietcong captives being marched through the rice fields. (3) A badly wounded South Vietnamese soldier, caught in fighting near Saigon in January 1973 – the fighting went on even though both sides at this time were in full peace negotiations.

Gefangene und Verwundete

(1) Ein amerikanischer Erkundungstrupp hat drei Soldaten der nordvietnamesischen Armee gefangengenommen. Ihre Hände sind auf dem Rücken gefesselt, ein Marineinfanterist gibt ihnen zu trinken; auf den Schildern um ihrem Hals stehen Zeit und Ort der Gefangennahme. (2) Gefangene Vietcong werden durch die Reisfelder getrieben. (3) Ein schwer verwundeter südvietnamesischer Soldat, aufgenommen nahe Saigon im Januar 1973. Die Kämpfe hielten an, auch wenn zu dieser Zeit die Friedensverhandlungen in vollem Gange waren.

Prisonniers et blessés

(1) Trois soldats nord-vietnamiens capturés par une patrouille de reconnaissance américaine. Ils ont les mains liées et un *marine* leur donne de l'eau; ils portent des pancartes indiquant la date et le lieu de leur capture. (2) Prisonniers viêtcong conduits à travers les rizières. (3) Ce soldat sud-vietnamien gravement blessé a été fait prisonnier près de Saigon en janvier 1973. Les combats se poursuivaient alors même que les deux parties étaient déjà en pleines négociations de paix.

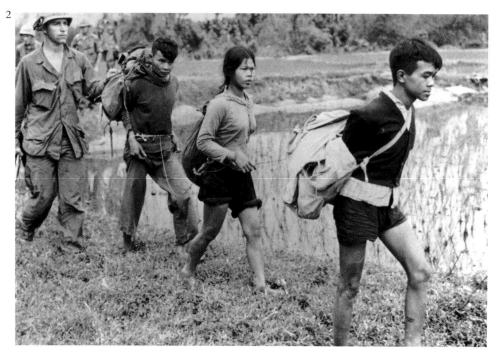

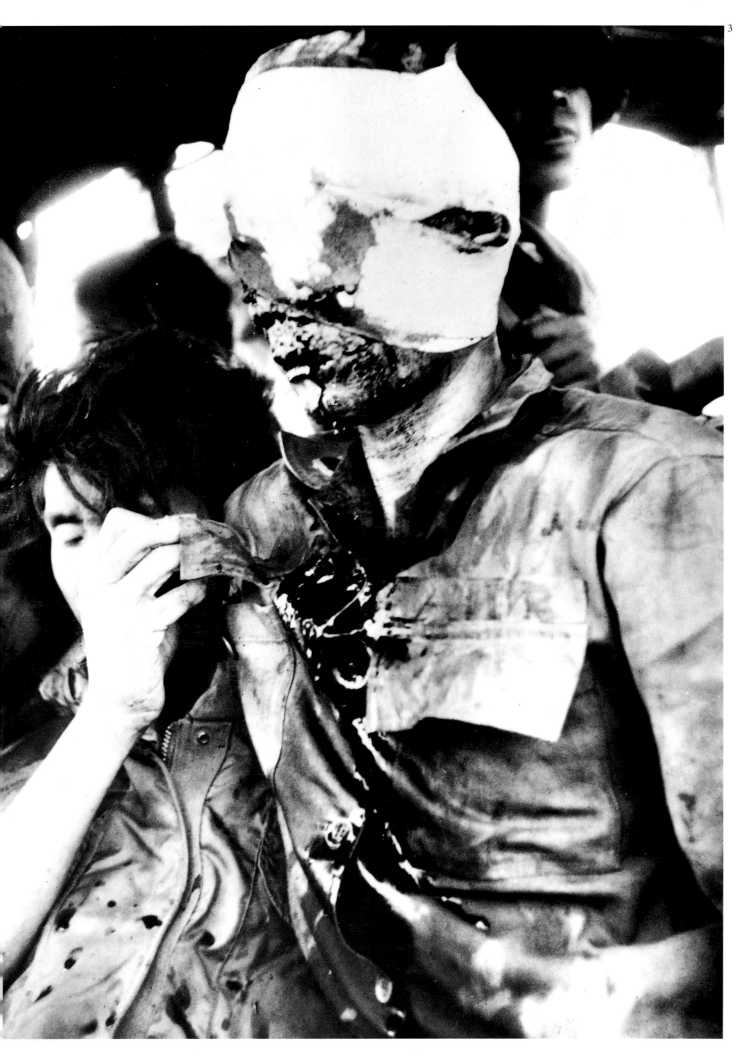

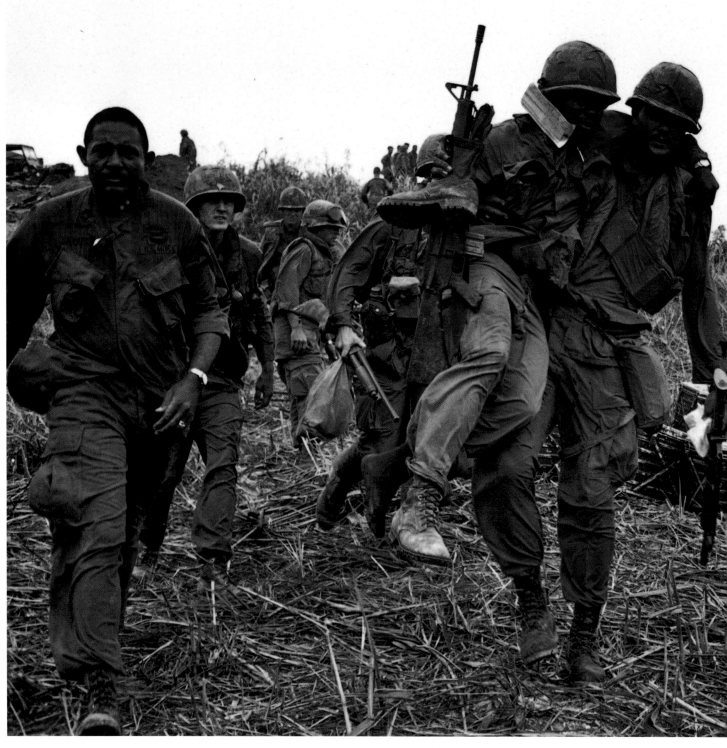

US Setbacks

(1) An American soldier carries a wounded buddy down Hill Timothy, April 1968. This is from a famous set of pictures taken by Terry Fincher and Larry Burrows, who was later killed flying over Cambodia. (2) Soldiers take cover in the trenches round Hill Timothy. (3) A US aircraft destroyed on the runway at the fortress of Khe Sanh, March 1968.

Rückschläge für die Amerikaner

(1) Ein US-Soldat trägt einen verwundeten Kameraden den Hill Timothy hinunter, April 1968. Dieses Bild stammt aus einer Reihe berühmter Aufnahmen von Terry Fincher und Larry Burrows; Burrows wurde später über Kambodscha abgeschossen. (2) Männer in Deckung in den Schützengräben des Hill Timothy. (3) Das Wrack eines amerikanischen Flugzeugs auf der Rollbahn der Festung Khe Sanh, März 1968.

Revers américains

(1) Un soldat américain descend Hill Timothy en transportant un camarade blessé, avril 1968. Photo extraite d'une série célèbre de Terry Fincher et Larry Burrows, lequel sera tué plus tard au cours d'un vol au-dessus du Cambodge. (2) Soldats s'abritant dans les tranchées qui entourent Hill Timothy. (3) Un avion US détruit sur la piste d'atterrissage de la forteresse de Khe Sanh, mars 1968.

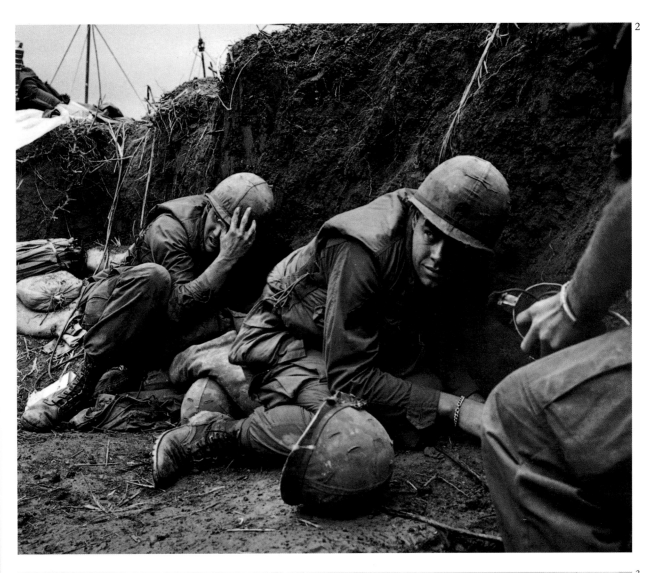

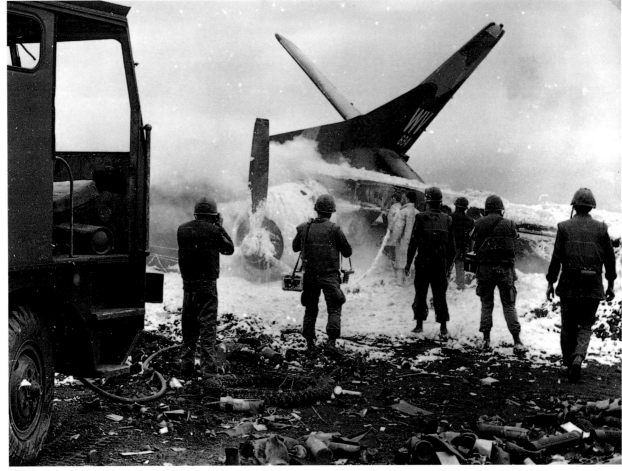

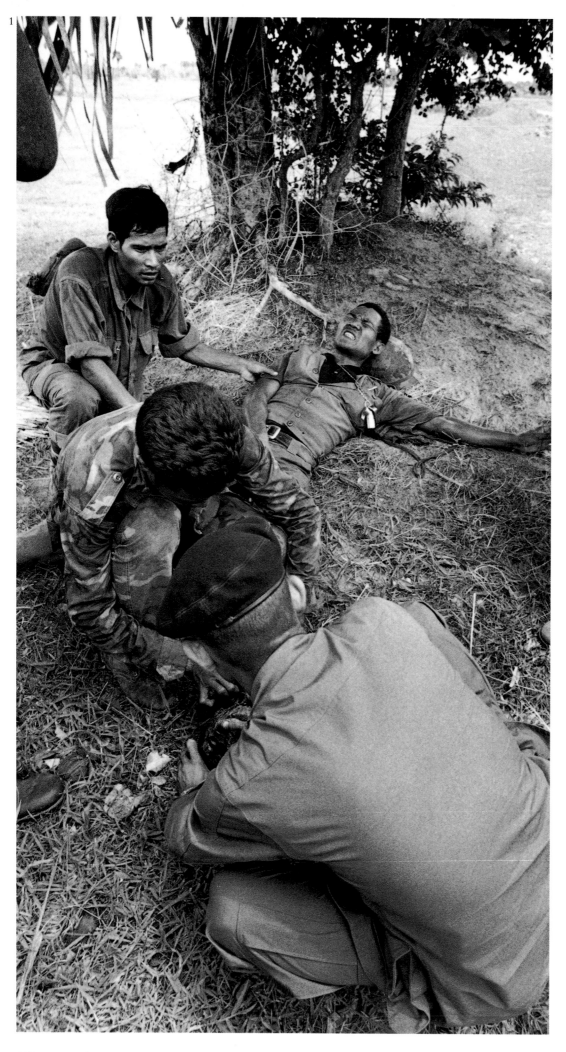

Cambodia

(1) Wounded soldiers from a village near Phnan Baset off Highway 5, July 1983. (2) A Khmer Rouge refugee, 1979, after the worst atrocities of Pol Pot's regime had been committed. (Overleaf) About one million Khmers were killed, according to most estimates, in one of the worst extermination programmes of modern times. These skulls are heaped in the compound at the Tuoi Sleng camp.

Kambodscha

(1) Verwundete Soldaten aus einem Dorf nahe Phnan Baset an der Hauptstraße 5, Juli 1983. (2) Auf der Flucht vor den Roten Khmer, 1979, als die schlimmsten Greueltaten des Pol-Pot-Regimes bereits geschehen waren. (Folgende Seite) Den meisten Schätzungen zufolge wurden etwa eine Million Kambodschaner getötet – eines der schwersten Pogrome unserer Zeit. Diese Ansammlung von Totenschädeln fand sich im Konzentrationslager Tuoi Sleng.

Le Cambodge

Soldats blessés d'un village près de Phnan Baset, non loin de l'autoroute n° 5, en juillet 1983. (2) Réfugiée khmère fuyant les atrocités du régime de Pol Pot, 1979. (Page suivante) On estime généralement à un million le nombre de Khmers tués dans l'un des pires programmes d'extermination des temps modernes. Ces crânes sont entassés dans l'enceinte du camp de Tuoi Sleng.

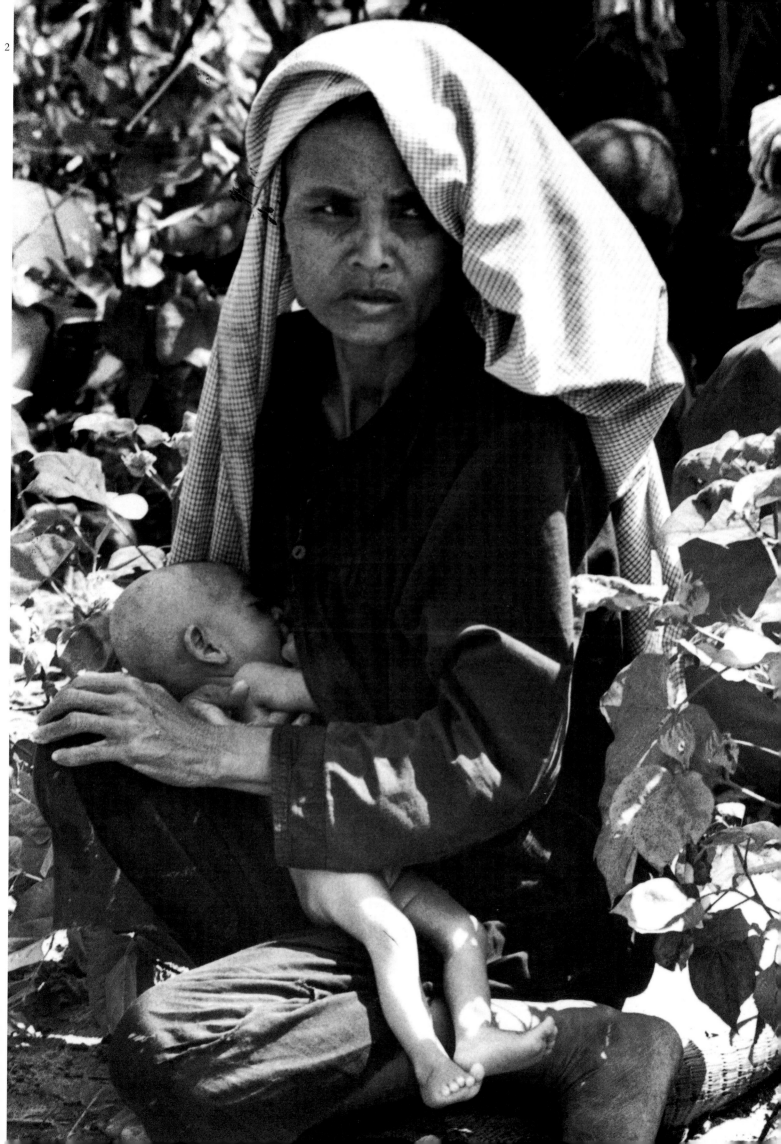

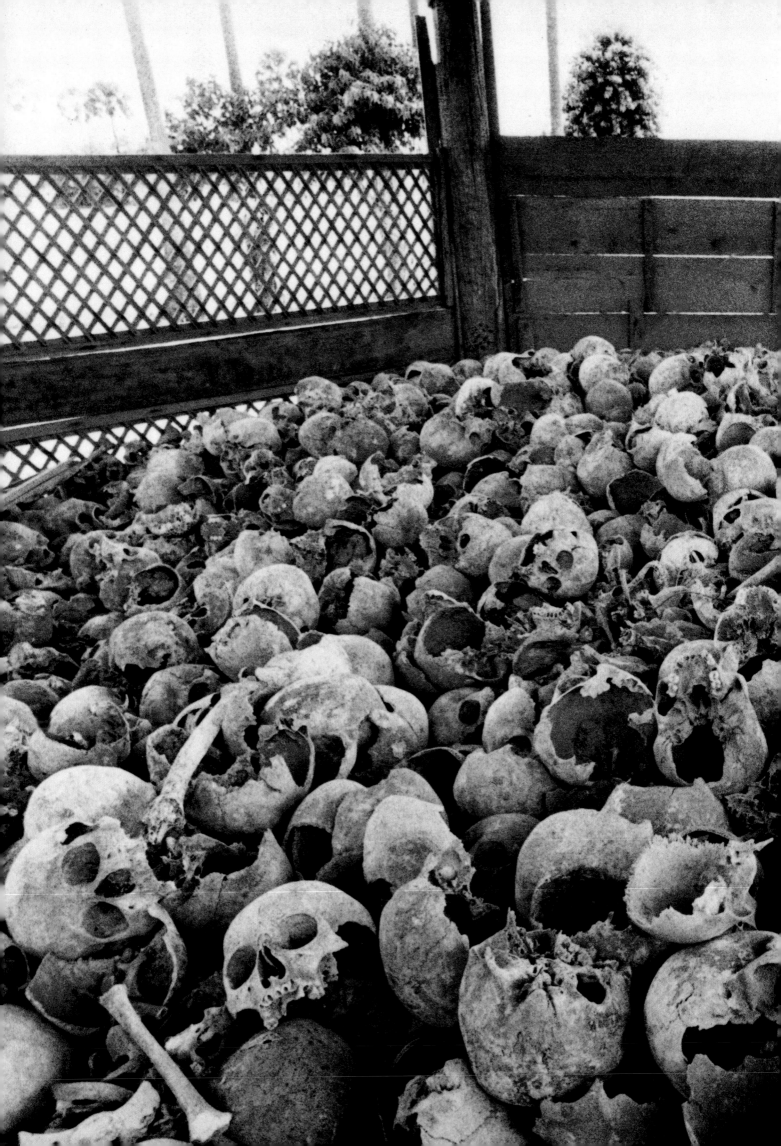

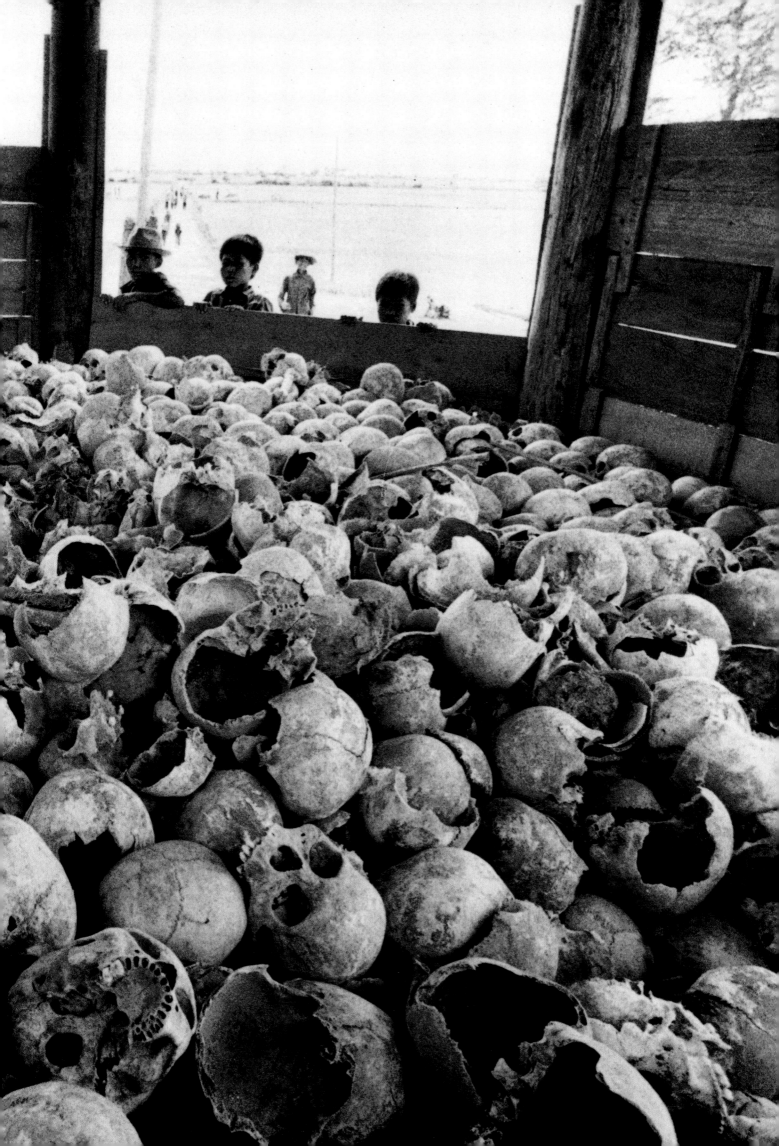

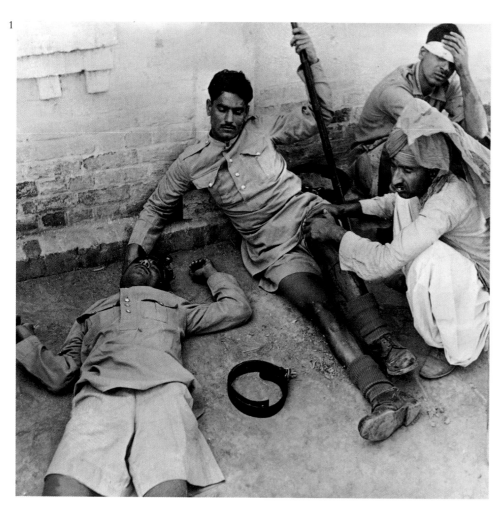

Indian Independence and Partition

Partition on the eve of independence, which created a separate Pakistan as well as India, triggered a ferocious bout of communal butchery between Hindus and Muslims. (1) Dead and wounded after the 'Direct Action Day' which developed into pitched battles between Hindus and Muslims in Calcutta in August 1946, the year before independence. (2) Dead and wounded in Lahore in March 1947, after disturbances in which 15 people died and 114 were injured. (3) Pakistani troops, equipped and trained on strict British lines, patrol near the Kashmir border in the Indo-Pakistan conflict of 1965.

Unabhängigkeit und Teilung Indiens

Im Vorfeld der Teilung des Subkontinents in die beiden unabhängigen Staaten Indien und Pakistan kam es zu entsetzlichen Gemetzeln zwischen Hindus und Moslems. (1) Tote und Verwundete nach dem »Direct Action Day« im August 1946, ein Jahr vor der Unabhängigkeit, als sich Hindus und Moslems in Kalkutta erbitterte Gefechte lieferten. (2) Tote und Verwundete in Lahore im März 1947; die

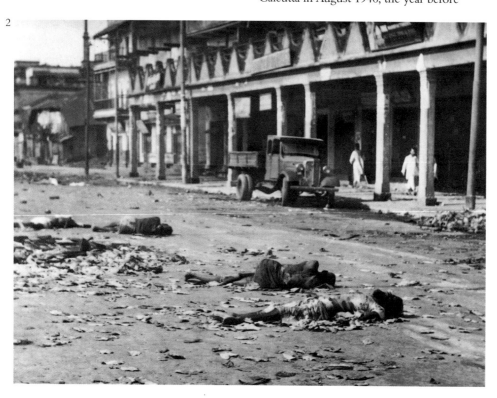

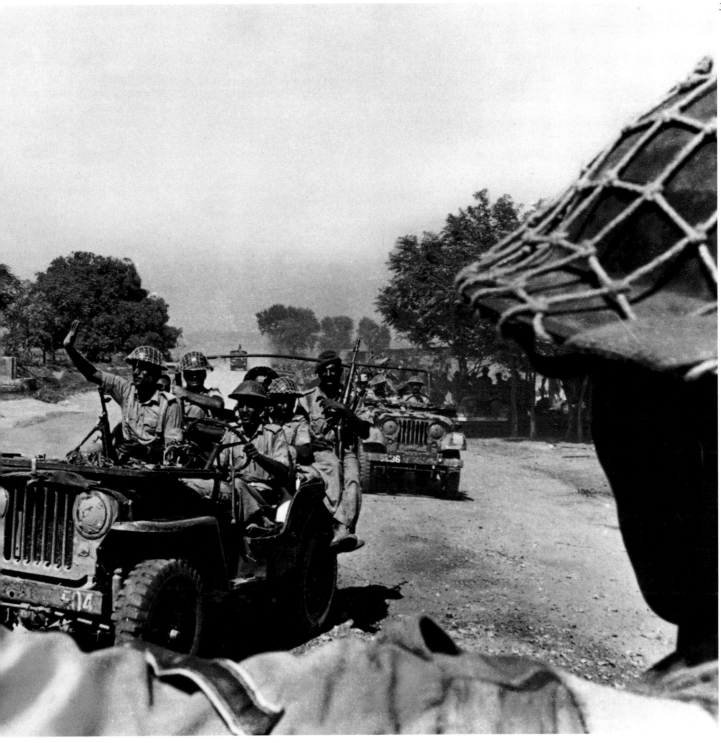

Unruhen hatten 15 Tote und 114 Verwunde-te gefordert. (3) Pakistanische Truppen, strikt nach britischem Vorbild gerüstet und ausge-bildet, patrouillieren im Indisch-Pakistani-schen Krieg 1965 nahe der Grenze von Kaschmir.

L'indépendance et la partition de l'Inde
A la veille de l'indépendance, la scission de l'Inde et du Pakistan déclenche des massacres réciproques entre hindous et musulmans. (1) Victimes du «Jour d'action directe» qui portera à leur comble les combats entre hindous et musulmans à Calcutta en août 1946, l'année d'avant l'indépendance. (2) Morts et blessés à Lahore en mars 1947, suite à des émeutes qui firent 15 morts et 114 blessés. (3) Soldats pakistanais équipés et entraînés sur le modèle britannique, patrouillant le long de la frontière du Cachemire pendant la guerre indo-pakistanaise de 1965.

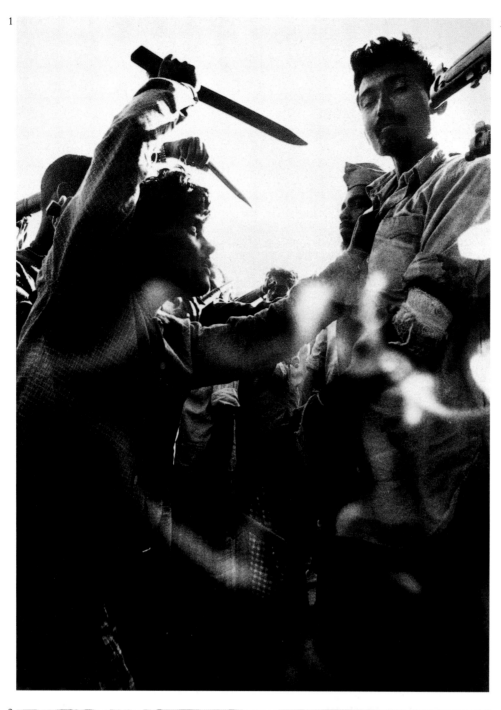

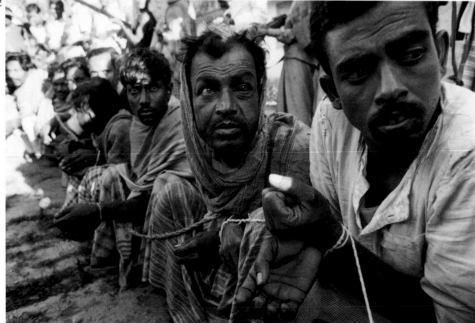

Bangladesh

The India-Pakistan war of 1971 led to the creation of Bangladesh, formerly East Pakistan. The new state was born in another round of communal savagery, this time the guerrillas of the Mukhti Bahini turning on 'collaborators' with the Pakistan regime.

(1) A guerrilla bayonets one of his victims.
(2) Bengalis roped together, about to be shot after the fall of Dacca, December 1971.
(3) A Pakistani patrol fans out in a field along the border near Agartala, July 1971.

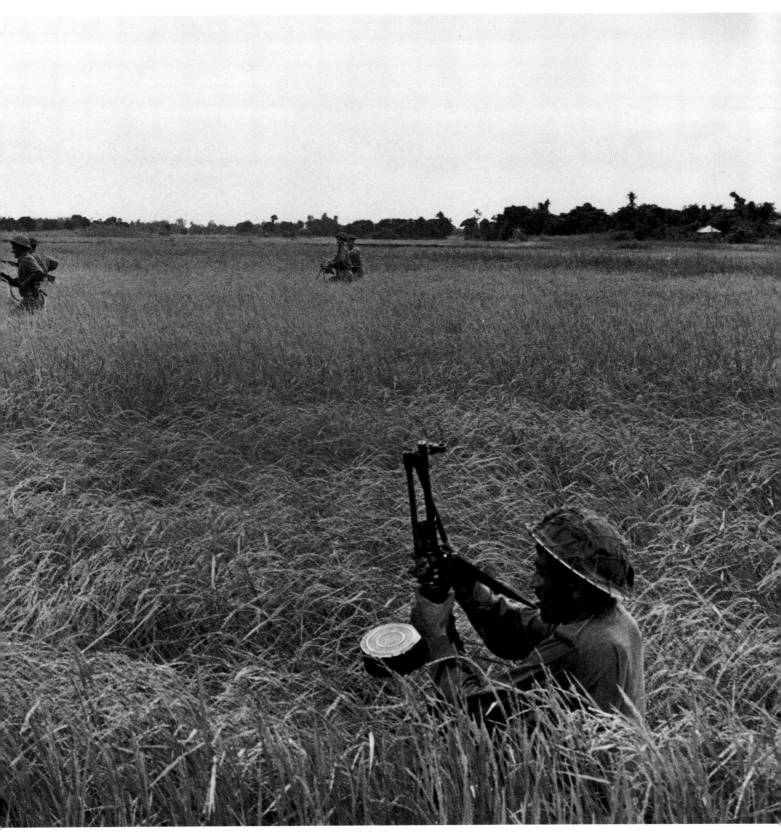

Bangladesch

Im Indisch-Pakistanischen Krieg von 1971 entstand aus dem ehemaligen Ostpakistan der unabhängige Staat Bangladesch. Auch diesmal ging es nicht ohne Bürgerkrieg ab; die Mukhti-Bahini-Guerillas richteten ein Blutbad unter den »Kollaborateuren« der pakistanischen Regierung an. (1) Guerillas gehen mit dem Bajonett auf ein Opfer los. (2) Mit Stricken aneinandergebundene Bengalis, die nach dem Fall von Dacca auf ihre Erschießung warten, Dezember 1971.

(3) Eine pakistanische Patrouille durchkämmt ein Feld an der Grenze bei Agartala, Juli 1971.

Bangladesh

La guerre indo-pakistanaise de 1971 conduit à la création du Bangladesh, ancien Pakistan oriental. Le nouvel Etat naît au milieu d'une nouvelle vague de massacres entre communautés religieuses; cette fois, les guérilleros du Mukhti Bahini « collaborent » avec le régime pakistanais. (1) Un guérillero poignarde sa victime. (2) Bengalis liés ensemble avant d'être tués après la chute de Dacca, décembre 1971. (3) Une patrouille pakistanaise se déploie en éventail le long de la frontière près d'Agartala, juillet 1971.

1

Sri Lanka

The war in Sri Lanka is a bitter ethnic conflict, with the Tamils, spearheaded by their Tiger guerrilla forces in the north round the Jafna Peninsula, seeking independence from the Sinhalese government in the south. (1) Sri Lankan Army T-55 tanks provide a fire-base for infantry in June 1992. (2) Wounded being recovered from the same battle. (3) Young Tiger recruits being kitted and drilled in June 1992. They display the two basic tools of post-modern guerrilla warfare, the Kalashnikov assault rifle, and the rocket-propelled grenade launcher.

Sri Lanka

In Sri Lanka tobt ein erbitterter Bürgerkrieg, bei dem die Tamilen des Nordens rund um die Halbinsel Jaffna – an ihrer Spitze die Guerillatruppen der »Tamilischen Tiger« – die Unabhängigkeit von der singhalesischen Regierung im Süden erringen wollen. (1) Im Juni 1992 greifen Soldaten der Armee von Sri Lanka im Schutz von T-55-Panzern an. (2) Verwundete desselben Gefechts werden vom Schlachtfeld getragen. (3) Junge Rekruten der »Tiger« erhalten Waffen und Ausrüstung. Sie zeigen die beiden wichtigsten Waffen des Guerillakriegs unserer Tage, das Kalaschnikow-Kampfgewehr und den Raketengranatwerfer.

Sri Lanka

La guerre du Sri Lanka est un douloureux conflit ethnique. Au nord, autour de la Péninsule de Jaffna, les Tamouls et leur armée de Tigres luttent pour l'indépendance contre le gouvernement cinghalais au sud. (1) Les tanks T-55 de l'armée srilankaise fournissent à l'infanterie une base de tir, juin1992. (2) Au cours des mêmes combats, on emporte les blessés. (3) Jeunes recrues des Tigres recevant équipement et entraînement en juin 1992. Elles portent les attributs caractéristiques de la guérilla post-moderne: fusil d'assaut Kalashnikov et lance-grenades à autopropulsion.

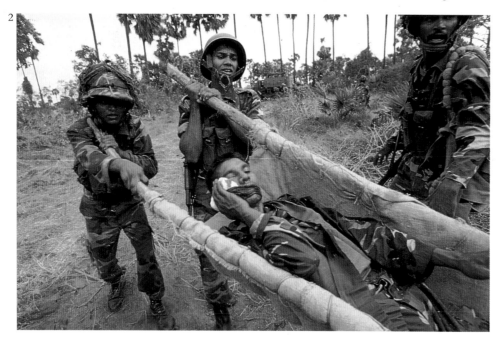

2

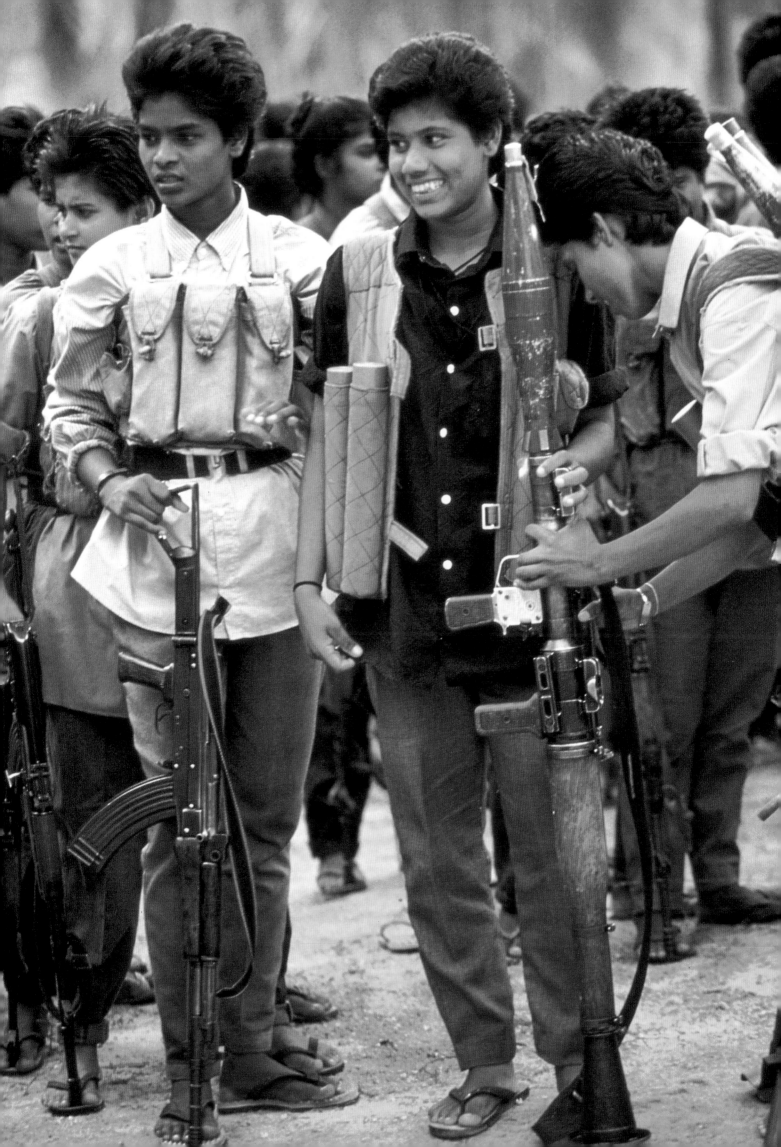

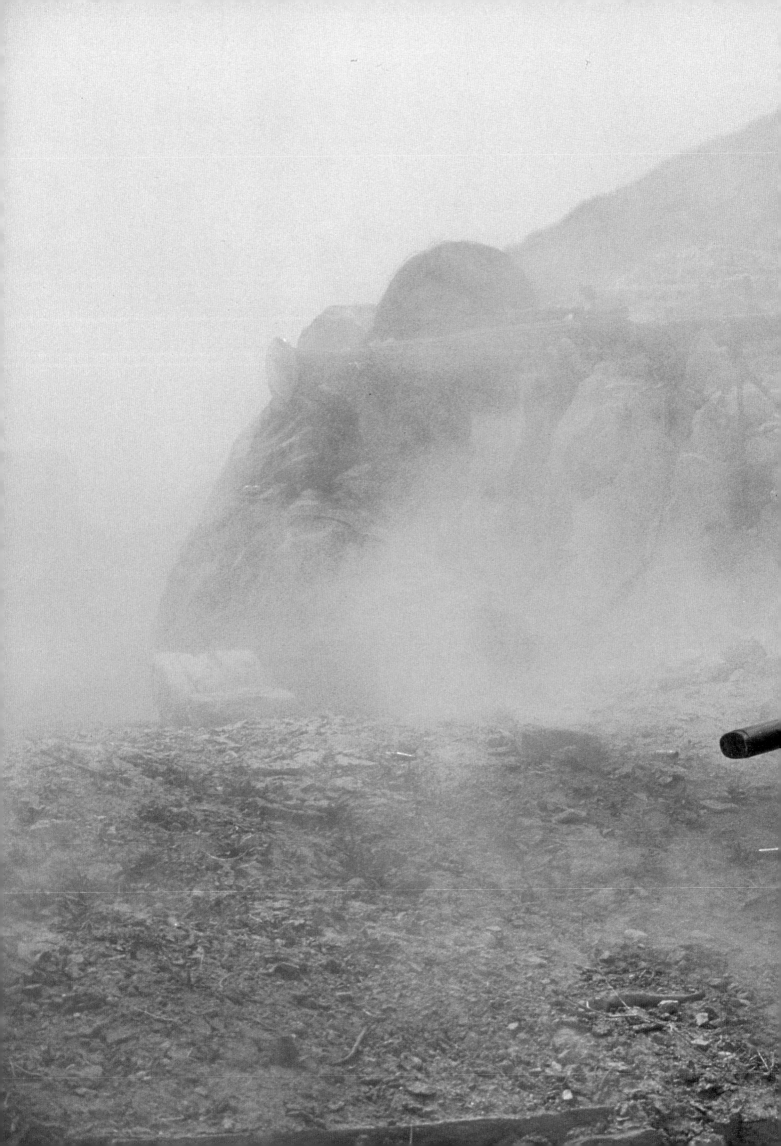

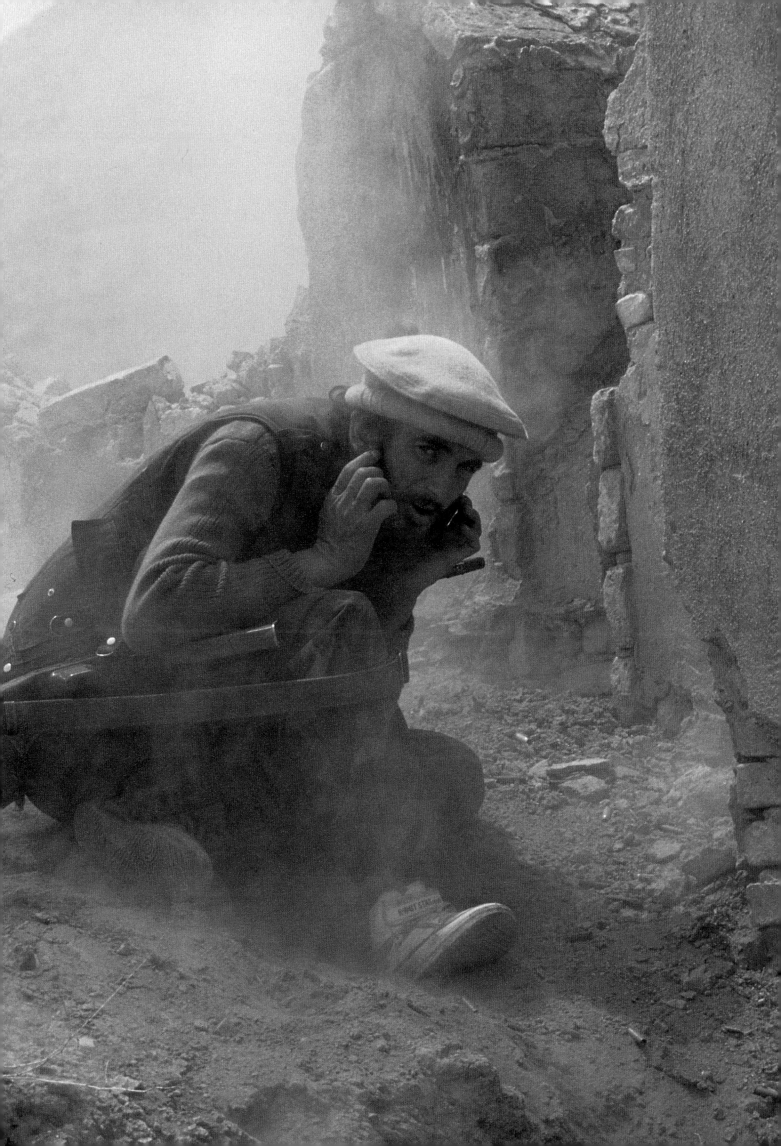

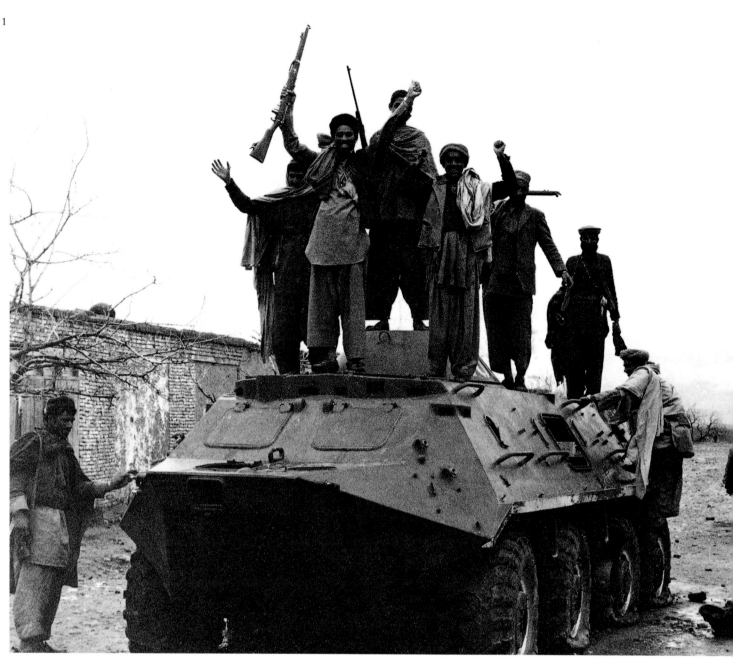

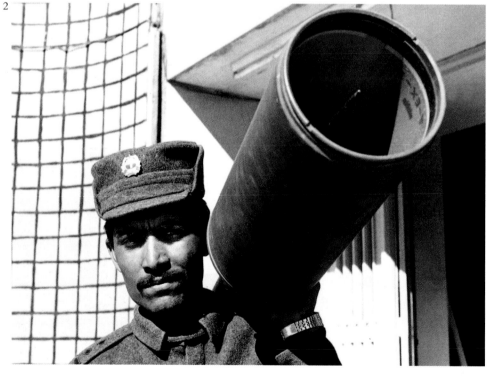

Afghanistan

The conflict in Afghanistan turned into a vicious religious and tribal war long after the Russians ended their military occupation in 1989. (Previous page) A Mujaheddin crouches away from a blast, 1992. (1) Jubilant guerrillas on a captured Russian armoured carrier, April 1980. (2) A government soldier displays a captured British Blowpipe anti-aircraft missile launcher. (3) The last Russian columns disappear north up the Salang Highway, February 1989. (4) Guerrillas with their prisoners in Kabul, 1992.

Afghanistan

Der erbitterte Glaubens- und Stammeskrieg hielt in Afghanistan noch lange nach Abzug der sowjetischen Besatzungstruppen im Jahre 1989 an. (Vorhergehende Seite) Ein Muja-heddin duckt sich vor einem Treffer, 1992. (1) Triumphierende Guerillas auf einem erbeuteten russischen Panzerwagen, April 1980. (2) Ein Regierungssoldat führt einen

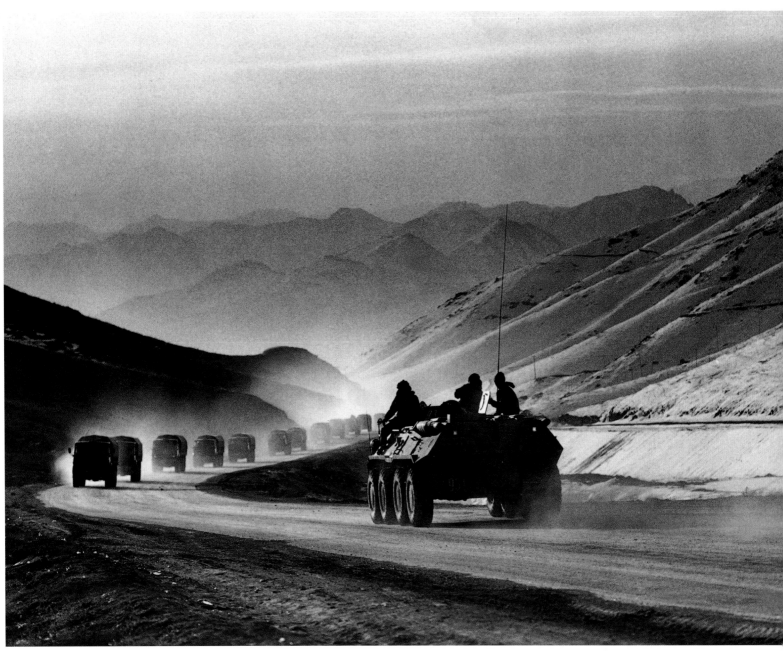

erbeuteten Blowpipe-Flugabwehrraketenwer-
fer aus britischer Produktion vor. (3) Die
letzten russischen Konvois auf dem Weg nach
Norden, Salang, Februar 1989. (4) Guerilla-
kämpfer mit Gefangenen in Kabul, 1992.

Afghanistan

Le conflit afghan a tourné à une violente
guerre religieuse et tribale bien après la fin de
l'occupation militaire soviétique en 1989.
(Page précédente) Un mudjahidine se
protège d'une explosion, 1992. (1) Résistants
afghans après la prise d'un char blindé
soviétique, avril 1980. (2) Un soldat du
gouvernement exhibe une prise de guerre: un
lance-missiles anti-aérien britannique
Sarbacane. (3) Les dernières colonnes
soviétiques disparaissent au nord de l'auto-
route de Salang, février 1989. (4) Résistants
afghans avec leurs prisonniers, Kaboul, 1992.

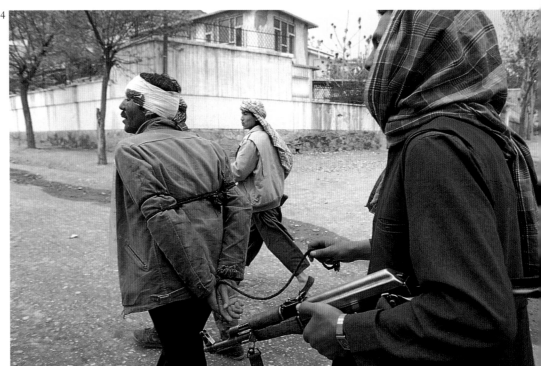

The Middle East

Israel and Palestine

The existence of the state of Israel, born in 1948, and the aspirations of Palestinians seeking their own statehood have led to five wars in the Middle East, and some of the bitterest terrorist campaigns of the modern world.

In 1917 with the Balfour Declaration the British promised the Zionist Jews, led by Chaim Weizmann, their own state in their biblical homeland of Palestine. Under their mandate to rule Palestine after the First World War, the British failed to reconcile the Jews' desire for a home with growing Arab nationalism. After the Second World War, with hundreds of thousands of Jews demanding to come to Palestine from Europe, the British were subjected to a terrorist campaign by three armed Jewish groups, the Stern Gang, Irgun and the Haganah, the defence organisation of Jewish settlements. In 1946 they blew up the King David Hotel in Jerusalem, the residence of British officers, and killed 91 people. The British decided to hand the Palestinian question to the United Nations, who in 1947 recommended that Palestine should be partitioned into separate Jewish and Arab states. The Arab League, founded in 1945, put together an army of 30,000 to oppose the Jews.

On the British departure in May 1948 there was a cease-fire. Then with the help of volunteers and weapons from Europe and America the Israelis, many of whom had fought with the British in the Second World War, managed to repel the Arabs, who were poorly commanded and trained, and advanced into the Negev.

In the next three wars the Israelis, who had by now organized an effective army, were to prove masters of manoeuvre warfare, especially with tanks and artillery. With superior tactics and better battlefield communication than their foes, they could rely on surprise rather than superior numbers. A flood of Palestinian refugees led the Arabs to demand redress and plot revenge, while the Israelis sought more secure boundaries.

Their chance came in 1956 when the British and French prepared to respond with force to the threat to nationalise the Suez Canal by the new Egyptian leader, Colonel Gamal Abdel Nasser. On 29 October, Israeli tanks raced across the Sinai desert and in days were within striking distance of the Canal. On 5 November the British and French began an airborne and amphibious operation to occupy Port Said. But the Americans and Russians insisted on a UN-brokered cease-fire and Anglo-French withdrawal. The dominant British role in the Middle East was at an end and Nasser became the Arab hero.

In 1967 he tried to squeeze Israel by denying access to the mouth of the Gulf of Aqaba. With complete surprise the Israelis carried out one of the most devastating pre-emptive strikes of modern warfare, destroying the Egyptian air force on

the ground on 5 June; within days they had reached the Suez Canal, and seized the whole of Jerusalem and the west bank of the Jordan from Jordanian forces. The final act of the Six-Day War was the seizure of the Golan heights from the Syrians in the north-east.

In October 1973 the Egyptians sought revenge with a surprise attack across the Suez Canal, which caught the Israelis unaware on the Jewish festival of Yom Kippur. In a series of bloody counter-attacks they recovered their position both in Sinai and on the Golan, from which they had been pushed in the opening battles.

Meanwhile they were facing another kind of war. In 1964 the Palestinian Liberation Organisation was formed, pledged to destroy Israel. Their chosen tactic was aircraft hijacking, and in 1970 they seized no fewer than three airliners and blew them up at Dawson's Field in Jordan. The Palestinian liberation movement was to fragment into ever more extreme movements, such as Black September which kidnapped and murdered ten Israeli athletes at the Munich Olympics in 1972.

The Palestinians were one of the triggers to the civil war which raged in Lebanon from 1975 to 1990. In 1982 the Israelis drove into Lebanon as far as Beirut in the 'Peace for

An Israeli soldier studies a refinery ablaze in Port Suez after shelling by Israeli forces. The Israeli Army had made a lightning advance across Sinai in the Six-Day War of June 1967.

Ein israelischer Soldat beobachtet nach einem Artillerieangriff eine brennende Raffinerie in Port Suez. Die Israelis hatten im Sechstagekrieg (Juni 1967) die Sinai-Halbinsel in einem Blitzangriff genommen.

Un soldat israélien observe une raffinerie en flammes à Port Suez, après un tir d'obus de l'armée israélienne qui a effectué une traversée éclair du Sinaï pendant la guerre des Six jours, juin 1967.

Galilee' operation to clear the Palestinians from their positions n southern Lebanon. Yassir Arafat's PLO left Lebanon but the errorist threat continues from the hardline Hamas, Islamic Jihad and the Iranian-inspired Hezbollah.

Elsewhere in the region a major war, which cost more than a million casualties, broke out between the fanatically nationalist Saddam Hussein of Iraq and the new revolutionary Islamic Republic of Iran in 1980. It was to last for eight years, with a form of static warfare reminiscent of the Western Front. Ostensibly it was over a border dispute, but Saddam's megalomania was to shift the focus of international concern in the Middle East from the Arab-Israeli confrontation.

Die Existenz des 1948 entstandenen Staates Israel und die Bestrebungen der Palästinenser, für sich einen eigenen Staat zu schaffen, haben bisher zu fünf Nahostkriegen und zu einigen der erbittertsten Terroristenkampagnen unserer Zeit geführt.

Mit der Balfour-Deklaration von 1917 versprachen die Briten den zionistischen Juden unter ihrem Anführer Chaim Weizmann einen eigenen Staat in ihrer biblischen Heimat Palästina. Doch während der Jahre ihres Palästinamandats nach dem Ersten Weltkrieg gelang es den Briten nicht, einen Kompromiß zwischen den jüdischen Forderungen und dem zunehmenden arabischen Nationalismus zu finden. Nach dem Zweiten Weltkrieg, als Hunderttausende europäischer Juden nach Palästina drängten, sahen sich die Engländer dem Terror dreier bewaffneter Gruppen ausgesetzt, der Stern-Gruppe, der Irgun und der Haganah, der stärksten militärischen Organisation der Juden. 1946 kamen bei einem Bombenanschlag auf das King David Hotel in Jerusalem, wo die britischen Offiziere residierten, 91 Menschen ums Leben. Die Engländer legten die Palästinafrage in die Hände der UNO, die 1947 empfahl, Palästina in einen jüdischen und einen arabischen Staat aufzuteilen. Die 1945 gegründete Arabische Liga stellte gegen die Juden eine Armee von 30 000 Mann auf.

Als die Engländer im Mai 1948 abzogen, wurde ein Waffenstillstand vereinbart. Doch dann schlugen die europäisch und amerikanisch bewaffneten israelischen Freiwilligen, von denen viele im Zweiten Weltkrieg auf britischer Seite gekämpft hatten, die schlecht ausgebildeten und schlecht geführten arabischen Truppen zurück und drangen bis in die Negev-Wüste vor.

1

In den drei folgenden israelisch-arabischen Kriegen erwiesen sich die Isrealis, die inzwischen eine schlagkräftige Armee aufgebaut hatten, als Meister der taktischen Kriegführung, insbesondere des Panzer- und Artilleriekrieges. In Taktik und Kommunikation waren sie ihren Gegnern überlegen und konnten vor allem auf Überraschungsangriffe bauen. Ein palästinensischer Flüchtlingsstrom ergoß sich in die arabischen Staaten, die daraufhin Wiedergutmachung forderten und Rachepläne schmiedeten; gleichzeitig strebten die Israelis danach, sichere Grenzen zu schaffen.

Ihre Chance kam 1956, als der neue ägyptische Präsident Gamal Abd el Nasser die Verstaatlichung des Suezkanals proklamierte und Großbritannien und Frankreich sich auf eine militärische Intervention vorbereiteten. Am 29. Oktober fielen israelische Panzer in die Wüste Sinai ein und waren in wenigen Tagen in Schußweite des Kanals. Am 5. November begannen Briten und Franzosen ihren Luft- und Seeangriff zur Eroberung Port Saids. Doch Amerikaner und Sowjets bestanden auf einem von der UNO ausgehandelten Waffenstillstand und dem Rückzug der anglo-französischen Verbände. Damit war die Zeit der britischen Vorherrschaft im Nahen Osten zu Ende gegangen, und Nasser war der neue Held der arabischen Welt.

1967 versuchte er Israel mit einer Blockade des Golfs von Akaba unter Druck zu setzen. Völlig überraschend holten die Israelis zu einem der vernichtendsten Präventivschläge der neueren Kriegsgeschichte aus; am 5. Juni zerstörten sie die ägyptische Luftwaffe am Boden, wenig später standen sie am Suezkanal und hatten bis zum 10. Juni Jerusalem und das Westjordanland besetzt. Zum Abschluß dieses Sechstagekriegs rangen sie im Nordosten den Syrern die Golanhöhen ab.

Im Oktober 1973 nahmen die Ägypter Rache und starteten einen Überraschungsangriff über den Suezkanal; er traf die Israelis unvorbereitet während des jüdischen Jom-Kippur-Fests. In blutigen Gegenschlägen eroberten sie die Positionen auf dem Sinai und den Golanhöhen zurück, die sie in den ersten Tagen des »Jom-Kippur-Krieges« hatten räumen müssen.

Mittlerweile mußte Israel sich auch mit einer anderen Art Krieg auseinandersetzen. 1964 hatte sich die Palästinensische Befreiungsorganisation (PLO) formiert, deren erklärtes Ziel die Zerstörung des Staates Israel war. Eine bevorzugte Taktik der Palästinenser war die Flugzeugentführung. So sprengten sie 1970 gleich drei entführte Linienmaschinen auf dem jordanischen Dawson-Flugfeld. Im Laufe der Jahre spaltete sich die Befreiungsbewegung in immer extremistischere Gruppierungen, darunter die Gruppe Schwarzer September, die 1972 bei den Olympischen Spielen in München zehn israelische Sportler entführte und später tötete.

Palästinenser waren auch mitverantwortlich für den Bürgerkrieg, der zwischen 1975 und 1990 im Libanon tobte. 1982 drangen die Israelis unter der Parole »Frieden für Galiläa« bis nach Beirut vor, um die Palästinenser aus ihren Stellungen im Südlibanon zu vertreiben. Jassir Arafats PLO verließ den Libanon, doch Terror droht nach wie vor durch die extremistischen Hamas, die islamische Dschihad-Bewegung und die iranisch inspirierten Hisbollah.

An anderer Stelle derselben Region brach zwischen dem vom fanatischen Nationalisten Saddam Hussein geführten Irak und der nach der fundamentalistischen Revolution entstandenen Islamischen Republik Iran 1980 ein größerer Krieg aus, der über eine Million Opfer forderte. Die Kämpfe, die über acht Jahre lang andauerten, nahmen bald die Form eines Grabenkriegs an, wie er an der Westfront des Ersten Weltkriegs geführt wurde. Anlaß war eine Grenzstreitigkeit, doch in Wahrheit ging es Saddam Hussein darum, die weltweite Aufmerksamkeit im Nahostkonflikt von den israelisch-arabischen Auseinandersetzungen auf den Irak zu verlagern.

La naissance de l'Etat d'Israël en 1948 et l'aspiration des Palestiniens à un Etat ont été la cause de cinq guerres au Moyen-Orient, et des campagnes de terrorisme parmi les plus violentes de notre époque.

Avec la déclaration Balfour signée en 1917, les Britanniques ont promis aux juifs sionistes dirigés par Chaïm Weizmann un foyer national en Palestine. Mais pendant toute la durée de son mandat sur la Palestine, commencé après la Première Guerre mondiale, la Grande-Bretagne échoue à concilier l'aspiration juive à un Etat et le nationalisme arabe grandissant. Après la Deuxième Guerre mondiale, des centaines de milliers de juifs veulent émigrer d'Europe en Palestine et les Britanniques sont confrontés aux opérations terroristes de trois organisations juives armées: le groupe Stern, l'Irgoun et la Haganah, qui défend les colonies juives. En 1946, une bombe explose et fait 91 morts à l'hôtel King David de Jérusalem où résident les officiers britanniques. Les Britanniques décident de soumettre la question palestinienne aux Nations unies qui recommandent en 1947 le partage de la Palestine en deux Etats, un juif et un arabe. Fondée en 1945, la Ligue arabe rassemble une armée de 30 000 soldats pour s'opposer aux juifs.

Un cessez-le-feu est instauré au départ des Britanniques en mai 1948. Aidés par des volontaires et des armes d'Europe et des Etats-Unis, les Israéliens, dont beaucoup ont combattu avec les Britanniques pendant la Deuxième Guerre mondiale,

parviennent à repousser les Arabes, mal dirigés et mal entraînés, et à avancer dans le désert du Négev.

Les Israéliens possèdent désormais une armée efficace et, lors des trois guerres suivantes, montreront une grande maîtrise dans les manœuvres, particulièrement avec leurs chars et leur artillerie. Meilleurs tacticiens et dotés d'un meilleur système de communication sur le terrain que leurs adversaires, ils misent davantage sur l'effet de surprise que sur la supériorité numérique. Alors que les Israéliens aspirent à des frontières plus sûres, le flux de réfugiés palestiniens conduit les Arabes à exiger réparation et à préparer leur revanche.

La chance leur sourit en 1956. La Grande-Bretagne et la France s'apprêtent à répondre par la force à la menace du nouveau leader égyptien, Gamal Abdel Nasser, de nationaliser le canal de Suez. Le 29 octobre, les chars israéliens traversent le désert du Sinaï à toute allure et, en quelques jours, sont à portée de tir du canal. Le 5 novembre, Britanniques et Français tentent une opération aéroportée et amphibie pour occuper Port-Saïd. Mais les Etats-Unis et l'URSS exigent un cessez-le-feu médiatisé par les Nations unies et le retrait anglo-français. La prépondérance britannique au Moyen-Orient est finie et Nasser devient le héros du monde arabe.

En 1967, il veut paralyser Israël en lui interdisant l'accès au golfe d'Aqaba. Par effet de surprise, les Israéliens réalisent l'une des opérations préventives les plus dévastatrices des temps modernes: le 5 juin, ils détruisent l'aviation égyptienne au sol; ils rejoignent en quelques jours le canal de Suez, enfin ils occupent Jérusalem-Est et la Cisjordanie, précédemment sous contrôle jordanien. Le dernier acte de la guerre des Six jours est la prise du Golan, au nord-est, aux Syriens.

Les Egyptiens veulent une revanche et lancent une attaque-surprise par le canal de Suez en octobre 1973, le jour de la fête juive de Yom Kippour. Dans une série de contre-attaques sanglantes, les Israéliens reprennent les positions perdues lors des premiers combats dans le Sinaï et sur le Golan.

Entre-temps ils doivent faire face à une guerre d'un autre genre. En 1964 naît l'Organisation de Libération de la Palestine qui s'engage à détruire l'Etat d'Israël. La technique employée est le détournement d'avions. En 1970, trois appareils sont détournés et explosent à Dawson's Field en Jordanie. Le mouvement palestinien se divisera, avec des groupes de plus en plus extrémistes, comme Septembre Noir qui enlèvera et assassinera dix athlètes israéliens aux Jeux olympiques de Munich en 1972.

La présence des Palestiniens a été l'une des causes de la guerre civile qui a ravagé le Liban de 1975 à 1990. En 1982, les Israéliens pénètrent jusqu'à Beyrouth lors de l'opération «paix en Galilée» destinée à évacuer les Palestiniens de leurs positions au Sud-Liban. L'OLP de Yasser Arafat quitte le pays, mais la menace terroriste continue sous la forme d'organisations plus dures: Hamas, Jihad islamique et le Hezbollah, d'inspiration iranienne.

Dans une autre partie du Moyen-Orient éclate en 1980 une guerre, qui fera plus d'un million de morts, entre l'Irakien Saddam Hussein, nationaliste fanatique, et la nouvelle Répu-

2

(1) One of three airliners hijacked by the PLO and blown up at Dawson's Field, an old British base in Jordan, September 1970.
(2) Refugees scramble across the Allenby Bridge over the Jordan as Jordanian forces are driven out of the West Bank by the Israeli offensive of the Six-Day War, June 1967.

(1) Eines der drei Flugzeuge, die im September 1970 von der PLO gekapert und auf dem Flugfeld von Dawson, einer alten britischen Militärbasis in Jordanien, gesprengt wurden. (2) Flüchtlinge überqueren auf der zerstörten Allenby-Brücke den Jordan, da die israelische Offensive des Sechstagekrieges (Juni 1967) die jordanischen Truppen aus dem Westjordanland vertreibt.

(1) L'un des trois avions de ligne détournés et détruits par l'OLP à Dawson's Field, une ancienne base britannique en Jordanie, septembre 1970. (2) Des réfugiés se bousculent pour traverser le pont Allenby sur le Jourdain, les forces jordaniennes ayant été repoussées de Cisjordanie par l'offensive israélienne en juin 1967.

blique islamique d'Iran. La guerre durera 8 ans, et prendra une tournure de guerre de positions qui rappelle celle du front occidental de la Première Guerre mondiale. L'enjeu apparent est un conflit de frontières, mais la mégalomanie de Saddam Hussein sera la cause d'un déplacement du foyer des préoccupations internationales au Moyen-Orient, du conflit israélo-arabe à la guerre Iran-Irak.

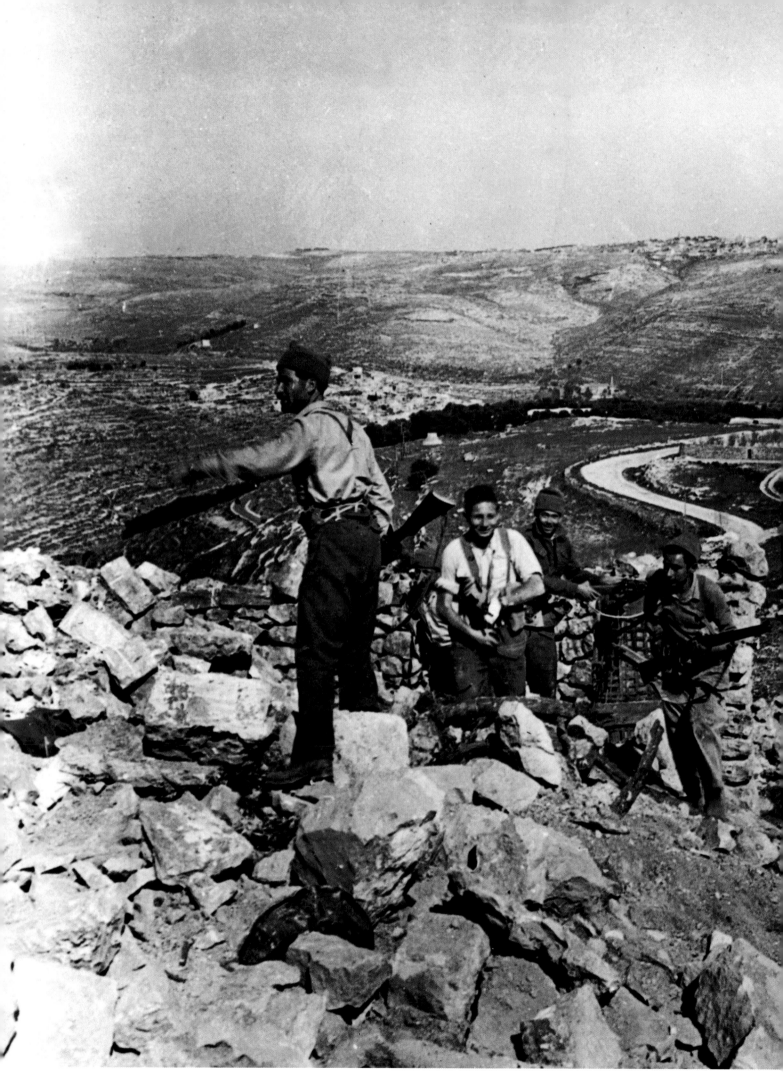

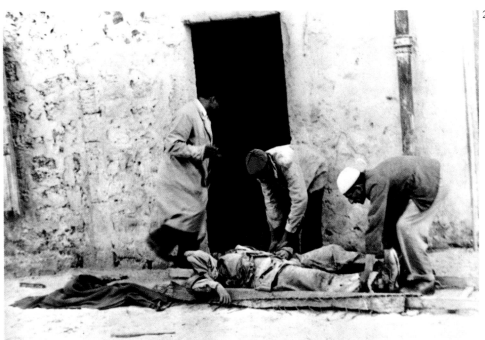

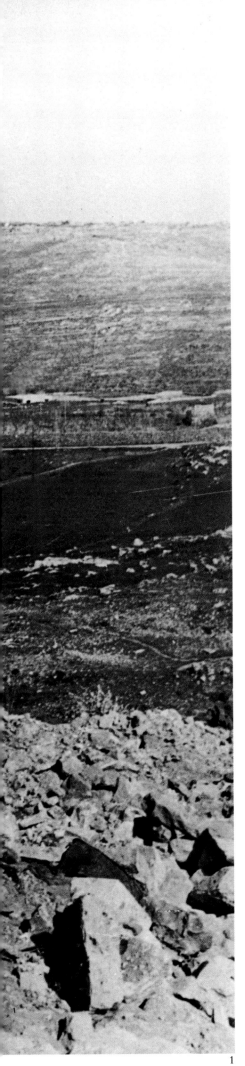

The Birth of Israel

(1) Fighters of the Haganah on the heights of Castel, April 1948. The Arabs here put up one of their most stubborn defences, led by Abdul-Khader al-Husseini, father of Faisal Al-Husseini, now the leading PLO figure in east Jerusalem. (2) Palestinians recover their dead in Jaffa before the exodus of thousands of Arabs from the new Israel, May 1948. (3) Israeli infantry in a full assault against the Egyptians in the Negev, October 1948.

Die Geburt Israels

(1) Kämpfer der Haganah auf den Castel-Höhen, April 1948. Die Araber leisten hier erbitterten Widerstand; Anführer ist Abdul-Khader al-Husseini, der Vater von Faisal Al-Husseini, heute der wichtigste Mann der PLO in Ostjerusalem. (2) Palästinenser bergen ihre Gefallenen in Jaffa; als im Mai 1948 der neue Staat Israel ausgerufen wurde, flohen die Araber zu Tausenden. (3) Israelische Truppen im Sturm auf die Ägypter, Negev-Wüste, Oktober 1948.

Naissance de l'Etat d'Israël

(1) Combattants de la Haganah sur les hauteurs de Castel, avril 1948. Ici, les Arabes ont mené une résistance acharnée sous la conduite d'Abdul-Khader Al-Husseini, père de Faisal Al-Husseini, aujourd'hui l'un des dirigeants de l'OLP à Jérusalem-Est. (2) Mai 1948: des Palestiniens ramassent leurs morts à Jaffa avant de quitter par milliers le nouvel Etat d'Israël. (3) L'infanterie israélienne en plein assaut contre les Egyptiens dans le Négev, octobre 1948.

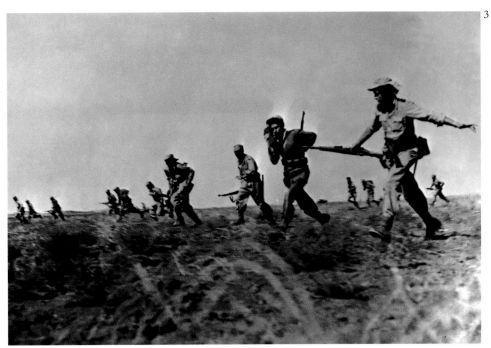

1

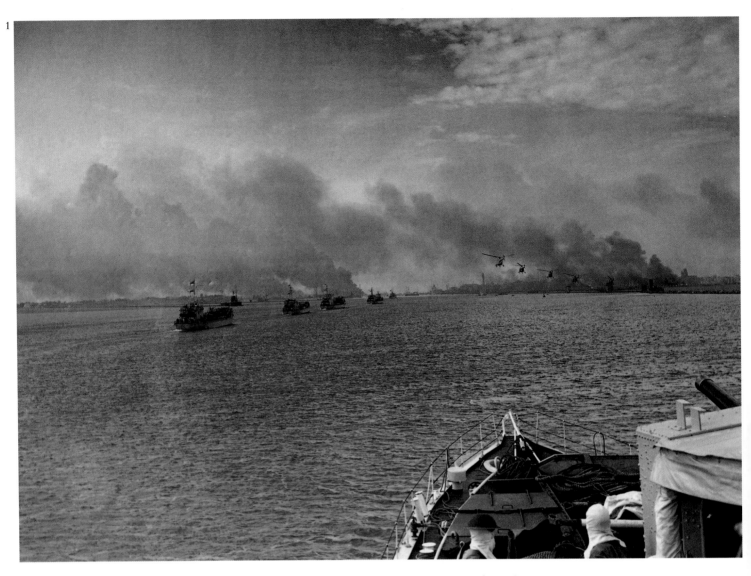

Suez

The Suez crisis of 1956 spelt the end of British and French dominance in the affairs of Egypt and the Levant. (1) British helicopters flying over landing craft approaching Port Said, November 1956 – the same means were to be used by the British to retake the Falklands 25 years later. (2) British troops move inland from Port Said where (3) a woman bewails the British bombing of her home in the port, 8 November.

Suez

Mit der Suezkrise von 1956 ging die Ära des britischen und französischen Einflusses in Ägypten und der Levante zu Ende. (1) Britische Landungsboote mit Geleitschutz von Hubschraubern nähern sich im November 1956 Port-Said – mit derselben Taktik eroberten die Briten 25 Jahre später die Falklandinseln zurück. (2) Britische Truppen auf dem Marsch von Port-Said ins Inland. (3) Eine Frau in der Hafenstadt beklagt die Zerstörung ihres Hauses, 8. November.

Suez

La crise de Suez, en 1956, met un terme à l'hégémonie franco-britannique sur l'Egypte et le Moyen-Orient. (1) Hélicoptères britanniques survolant les navires de débarquement qui approchent Port-Saïd, novembre 1956; les mêmes moyens serviront 25 ans plus tard aux Britanniques pour récupérer les îles Malouines. (2) Les soldats britanniques pénètrent dans les terres, quittant Port Saïd où (3) une femme déplore le bombardement de sa maison, 8 novembre.

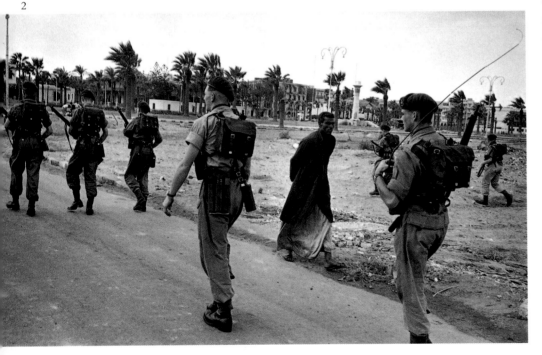

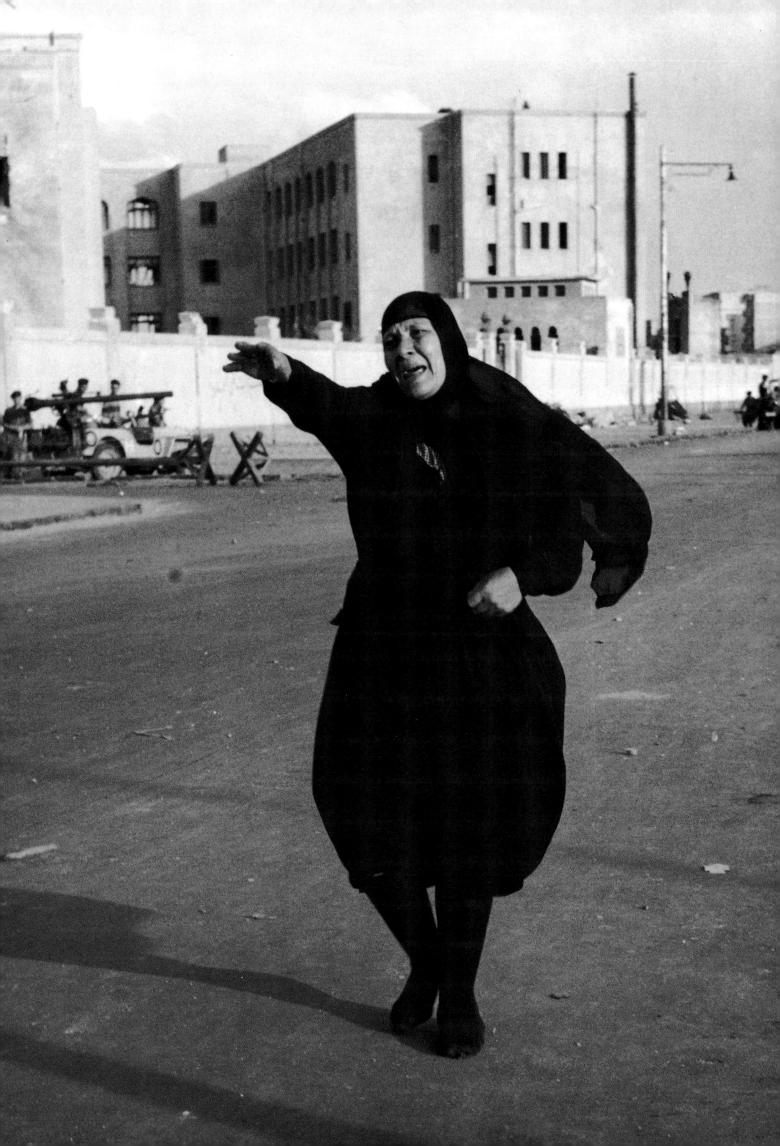

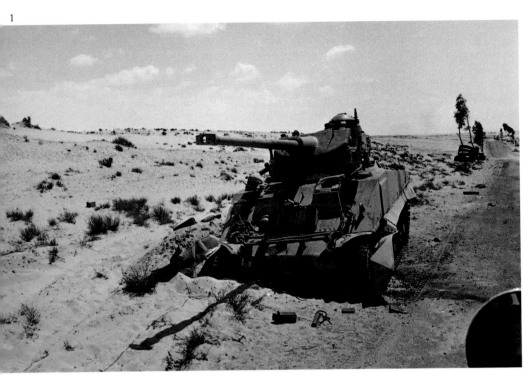

Der Sechstagekrieg

Mit großer Energie gingen die Israelis am 5. Juni 1967 mit einer Reihe von Präventivschlägen gegen ägyptische Truppen vor und errangen einen überwältigenden Sieg. (1) Ein zerschossener ägyptischer Panzer in der Sinai-Wüste. (2) Der größte Teil der ägyptischen Luftwaffe wurde – hier auf dem Flugfeld El-Arish, Sinai – am Boden zerstört. Dies ist auch in der Aufnahme von einem israelischen Aufklärungsflugzeug aus (3) zu erkennen. (Folgende Seite) Eine Kolonne der israelischen gepanzerten Infanterie auf dem Weg nach Suez, 9. Juni 1967; in der Gegenrichtung ein Lastwagen mit bis auf die Unterwäsche entkleideten ägyptischen Kriegsgefangenen.

La guerre des Six jours

5 juin 1967: les Israéliens ne cessent de gagner du terrain au moyen d'attaques préventives et remportent une écrasante victoire contre l'armée égyptienne. (1) Un char égyptien éliminé dans le désert du Sinaï. (2) Pour une large part, l'aviation égyptienne a été frappée au sol, comme cet avion de la base d'El-Arish dans le Sinaï, ou comme le montre (3) cette photo de reconnaissance israélienne. (Page suivante) Une colonne israélienne d'infanterie motorisée avance vers le front de Suez le 9 juin 1967 et croise un camion transportant des prisonniers de guerre égyptiens en sous-vêtements.

The Six-Day War

The Israelis achieved unstoppable momentum with a series of pre-emptive attacks on Egyptian forces on 5 June 1967, winning an overwhelming victory. (1) An Egyptian tank knocked out in the Sinai desert. (2) Most of Egypt's air force, like this plane at the El-Arish base in Sinai, were caught on the ground, as this Israeli reconnaissance photograph (3) shows. (Overleaf) A column of Israeli mechanized infantry moves up to the Suez front on 9 June 1967 as a truck carrying Egyptian POWs in their underwear heads the other way.

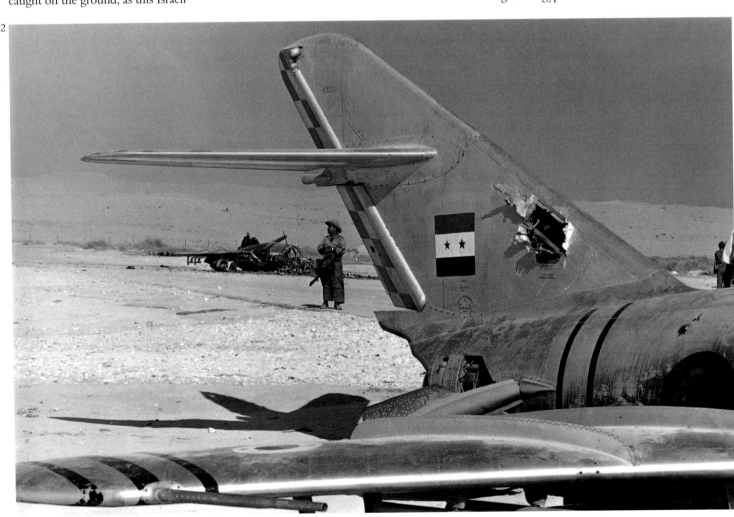

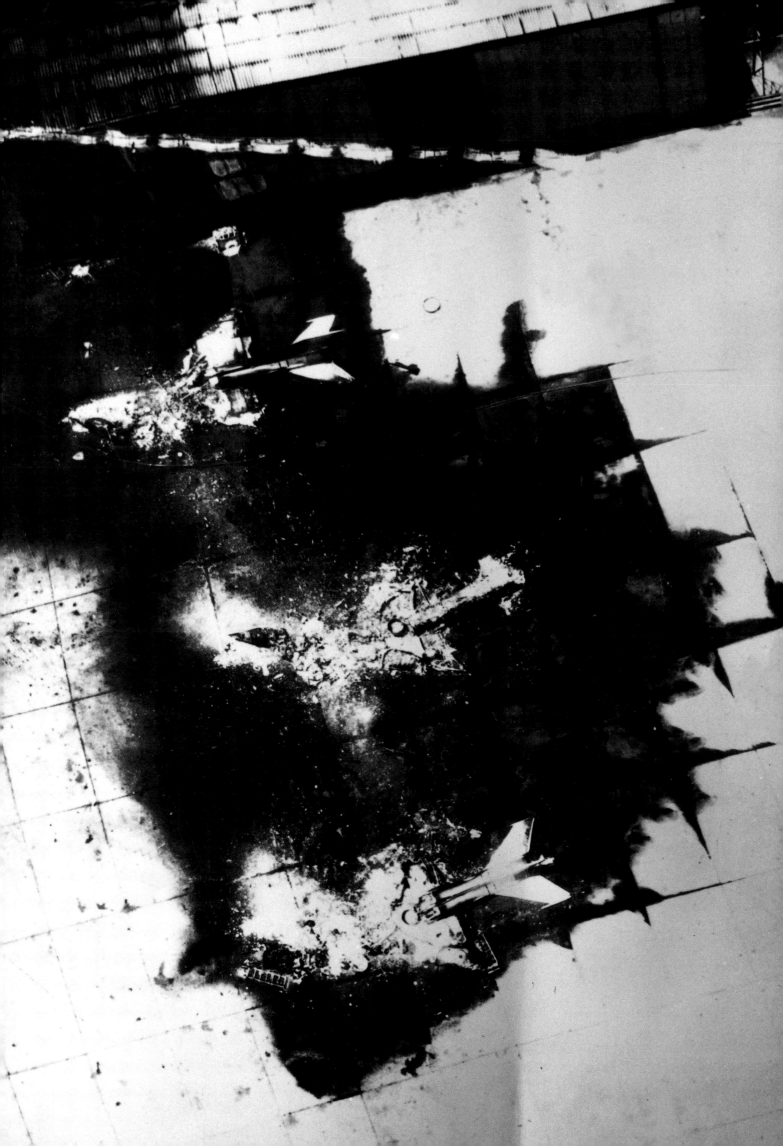

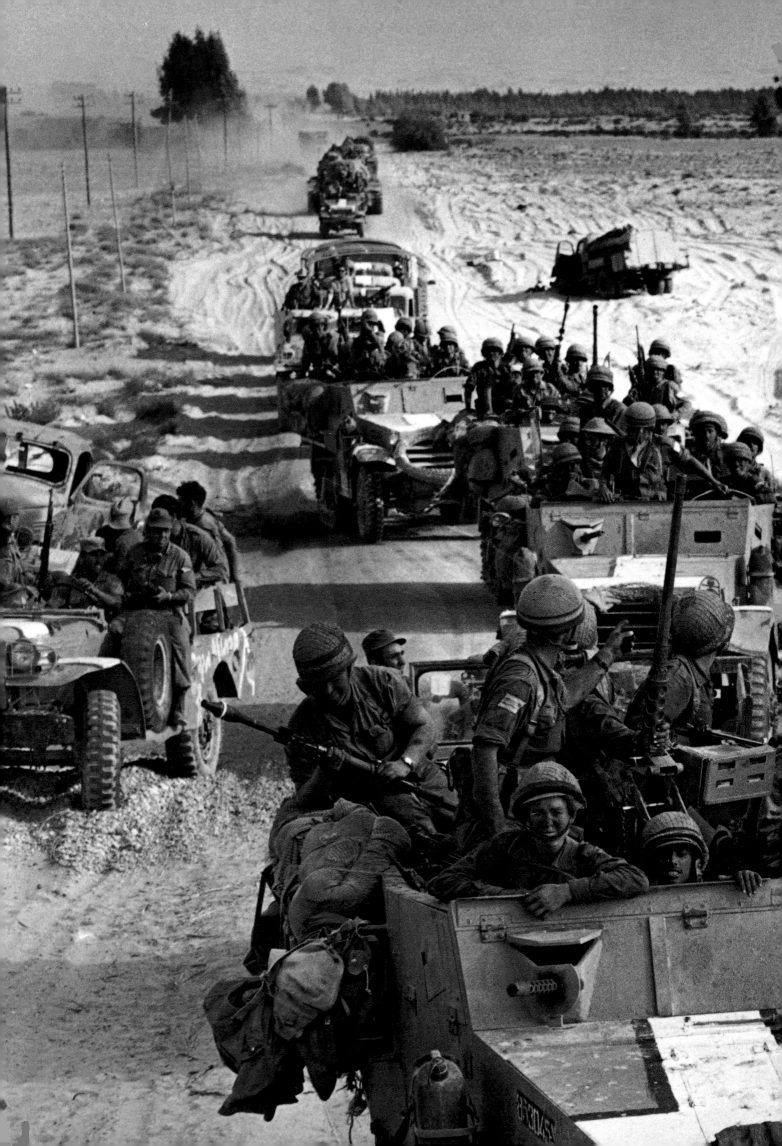

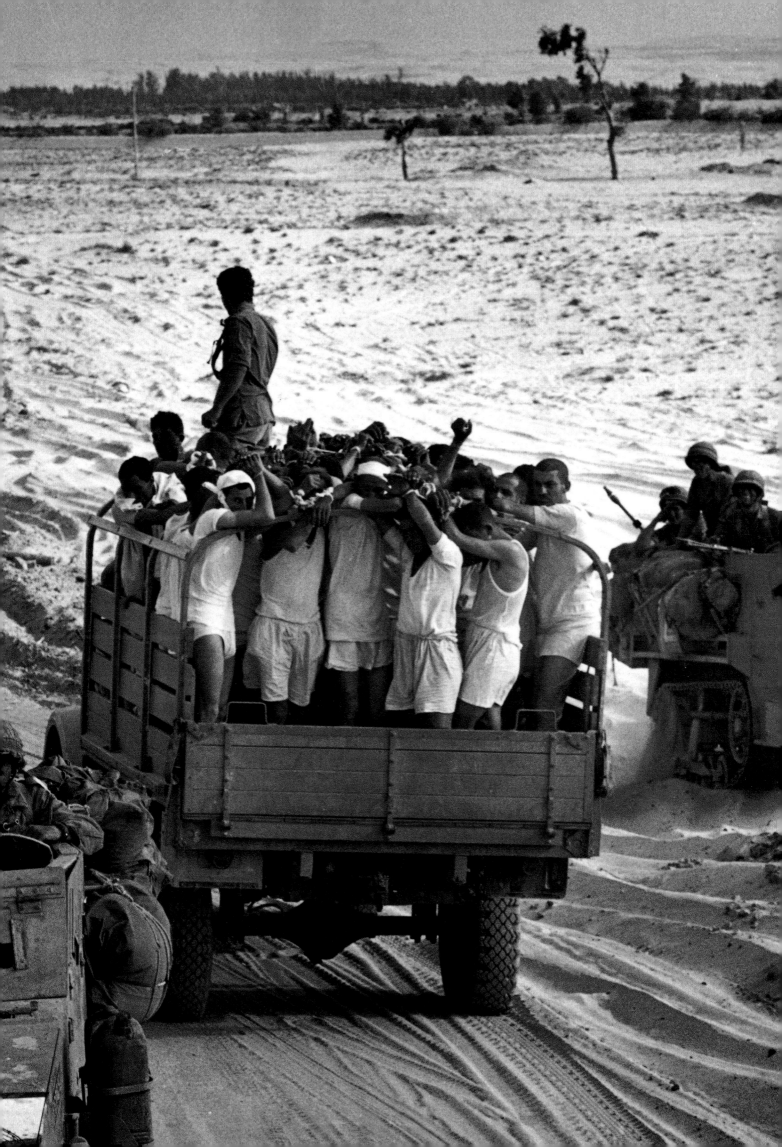

1

The Yom Kippur War, 1

The Arab-Israeli war of October 1973 was a much harder-fought affair; the Israelis had stood down many of their reserves for the Jewish feast of Yom Kippur and were taken by surprise. (1) A wounded Israeli crewman is taken from his tank on the Golan front, where the Syrians made a dramatic punch through Israeli lines, but could not maintain their momentum. (2) Egyptian prisoners from the Israeli counter-attack on the Suez front. (3) A dead soldier on the line of the Israeli counter-offensive which seized back the Golan Heights.

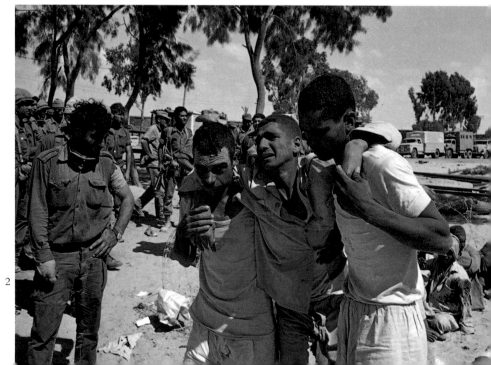

2

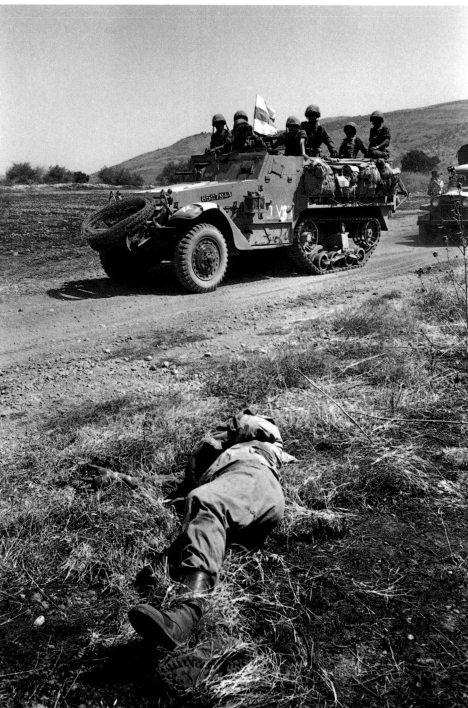

Jom-Kippur-Krieg, 1

Im arabisch-israelischen Krieg vom Oktober 1973 wurde weitaus schwerer gekämpft als im Sechstagekrieg. Da die Israelis einem Großteil der Reservetruppen Urlaub für das Jom-Kippur-Fest gegeben hatten, waren sie auf den überraschenden Angriff nicht ausreichend vorbereitet. (1) Ein verwundetes Besatzungsmitglied wird aus einem israelischen Panzer geborgen; an der Golanfront war den Syrern ein dramatischer Durchbruch durch die israelischen Linien gelungen, doch fehlte ihnen die Kraft zum weiteren Vormarsch. (2) Ägyptische Kriegsgefangene des israelischen Gegenangriffs an der Suezfront. (3) Ein Gefallener an der Front der Gegenoffensive, mit der die Israelis die Golanhöhen zurückeroberten.

La guerre du Kippour I

La guerre israélo-arabe d'octobre 1973 sera beaucoup plus difficile. De nombreux réservistes israéliens sont en permission pour la fête religieuse de Yom Kippour et le pays est attaqué par surprise. (1) Un soldat israélien blessé est extrait de son char, sur le front du Golan où les Syriens ont percé les lignes israéliennes de manière spectaculaire; mais ils ne réussiront pas à conserver leur avance. (2) Prisonniers égyptiens lors de la contre-attaque israélienne sur le front de Suez. (3) Un soldat mort le front de la contre-offensive israélienne qui permettra de reprendre le Golan.

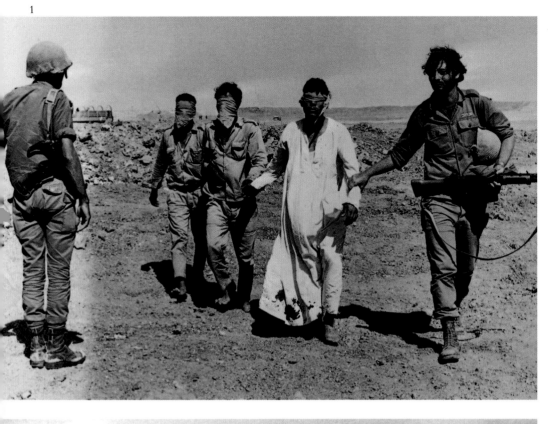

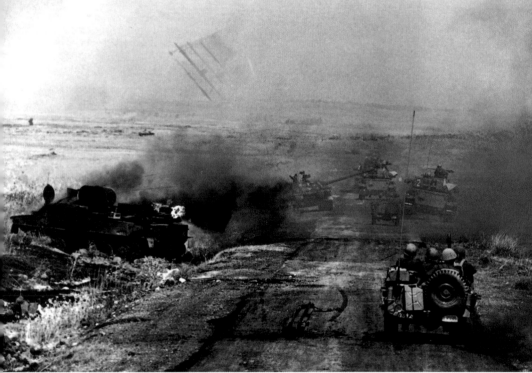

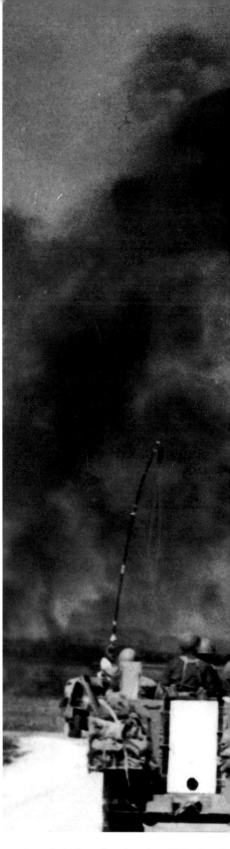

The Yom Kippur War, 2

(1) Egyptian prisoners, one a civilian in his dishdash, being led blindfold by Israeli soldiers, Suez front, 1973. Note the dishevelled state of the Israelis as well as the Egyptians – they had been hit hard by the Egyptian infantry assault across the Suez Canal. The Egyptian infantry equipped with Sagger rockets initially proved highly effective against Israeli tank forces. (2) The hard-fought battle for the Golan Heights, with Syrian tanks burning by the road – the open country afforded little cover to either side, and the Israelis had to rely on their artillery as much as their famed tank units. (3) In the air they proved decisive: a Skyhawk levels for a ground attack to aid an Israeli infantry column.

Jom-Kippur-Krieg, 2

(1) Gefangene Ägypter, darunter ein Zivilist im Burnus, werden mit verbundenen Augen abgeführt, Suezfront 1973. Auffällig ist, daß die israelischen Soldaten ebenso abgekämpft wirken wie die Ägypter – der ägyptische Infanterieangriff über den Suezkanal machte ihnen schwer zu schaffen, und die Raketen vom Typ Sagger waren zunächst sehr wir-

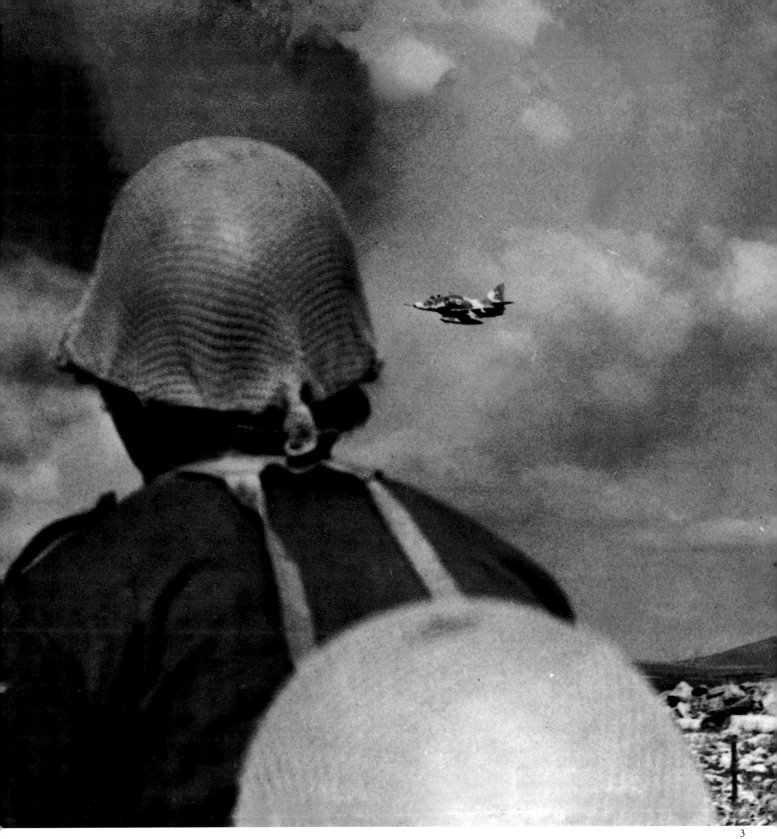

ungsvoll gegen die israelischen Panzerver-
bände. (2) Die schwer umkämpften Golan-
höhen, mit brennenden syrischen Panzern
im Straßenrand. Das offene Gelände bot
keiner Seite Deckung, und die Israelis brauch-
en Artillerie zur Unterstützung ihrer
berühmten Panzertruppen. (3) Zu Luft
waren die Israelis eindeutig überlegen; hier
schützt ein Skyhawk im Tiefflug die angrei-
ende Infanterie.

La guerre du Kippour II

(1) Front de Suez, 1973: des prisonniers
égyptiens, dont un civil en djellabah, sont
conduits les yeux bandés par des soldats
israéliens. Noter l'aspect échevelé des
Israéliens aussi bien que des Egyptiens: ils
ont durement souffert de l'assaut de
l'infanterie égyptienne par le canal de Suez.
Celle-ci, équipée de roquettes Sagger, s'est
d'abord montrée supérieure aux chars
israéliens. (2) L'âpre bataille du Golan, avec
les chars syriens en flammes au bord de la
route. Le terrain découvert offre peu de
protection et les Israéliens ne peuvent se fier

qu'à leur artillerie et à leurs célèbres unités de
chars. (3) Leur aviation sera l'élément décisif.
Un Skyhawk prend ses marques pour une
offensive terrestre de soutien aux colonnes de
l'infanterie israélienne.

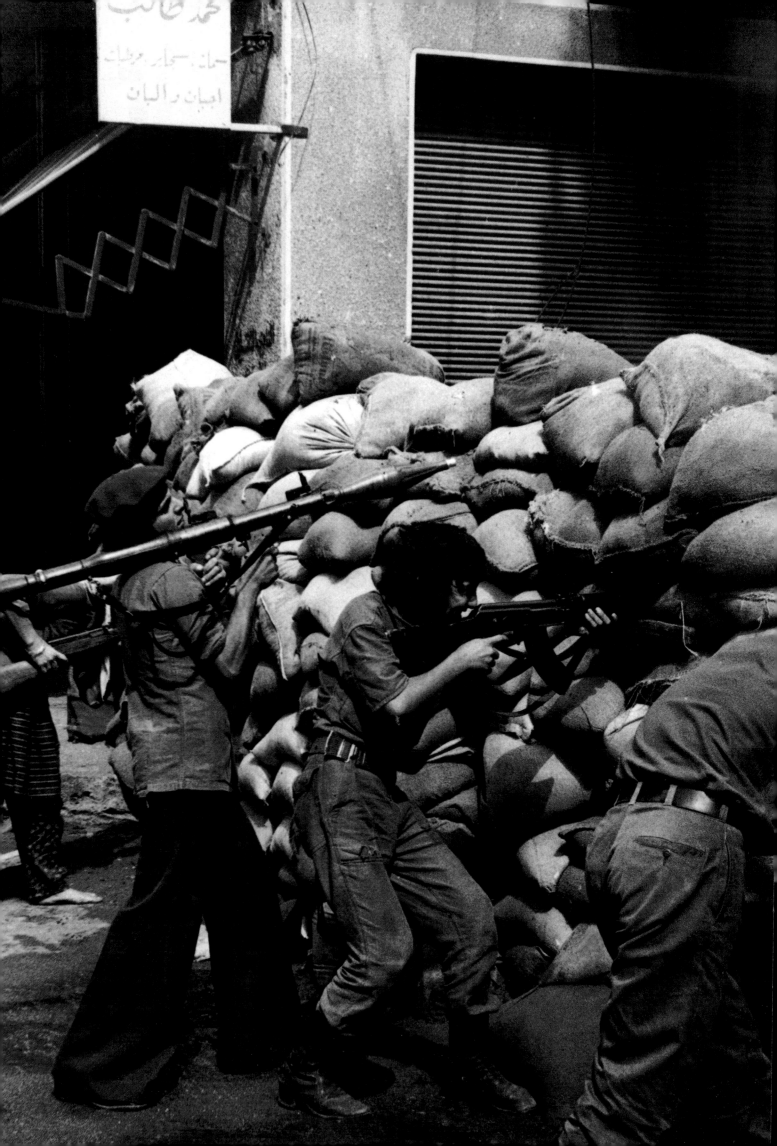

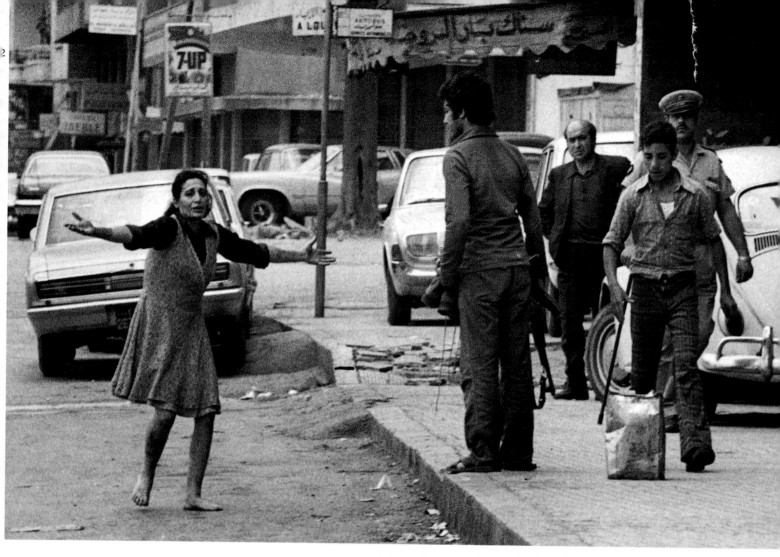

Civil War in Lebanon

The civil war erupted in 1975 and dragged on for 15 years; to some it still is not ended. (1) Militiamen at a barricade in the Chyal area of Beirut, breaching the 22nd cease-fire agreement in three months, December 1975. (2) A woman pleads for assistance for her wounded husband in the Dekwan district in the same round of street battles. (3) A Lebanese Mozabitoun fighter and a victim in a Beirut residential area, December 1975.

Bürgerkrieg im Libanon

Der Bürgerkrieg, der 1975 ausbrach, dauerte 15 Jahre – manche sagen, er hält bis heute an. (1) Milizionäre an einer Barrikade im Beiruter Stadtviertel Chyal brechen im Dezember 1975 den 22. Waffenstill-stand innerhalb eines Vierteljahres. (2) Eine Frau bittet während derselben Straßenkämpfe im Dekwan-Viertel um Hilfe für ihren verwundeten Mann. (3) Zwei Straßenkämpfer und ein Opfer in einem Wohnviertel Beiruts, Dezember 1975.

La guerre civile du Liban

La guerre civile éclate en 1975 et durera 15 ans; aux yeux de certains elle n'est pas encore finie. (1) Des hommes de la milice derrière une barricade du quartier de Chyal à Beyrouth, rompant le 22ᵉ accord de cessez-le-feu en 3 mois, décembre 1975. (2) Une femme demande du secours pour son mari blessé dans le district de Dekwan, au cours de la même série de combats de rues. (3) Un combattant libanais mozabite et une victime dans un quartier résidentiel de Beyrouth, décembre 1975.

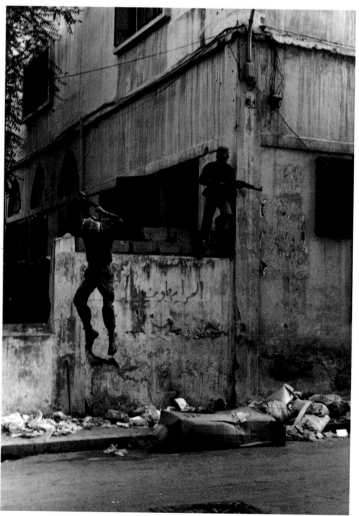

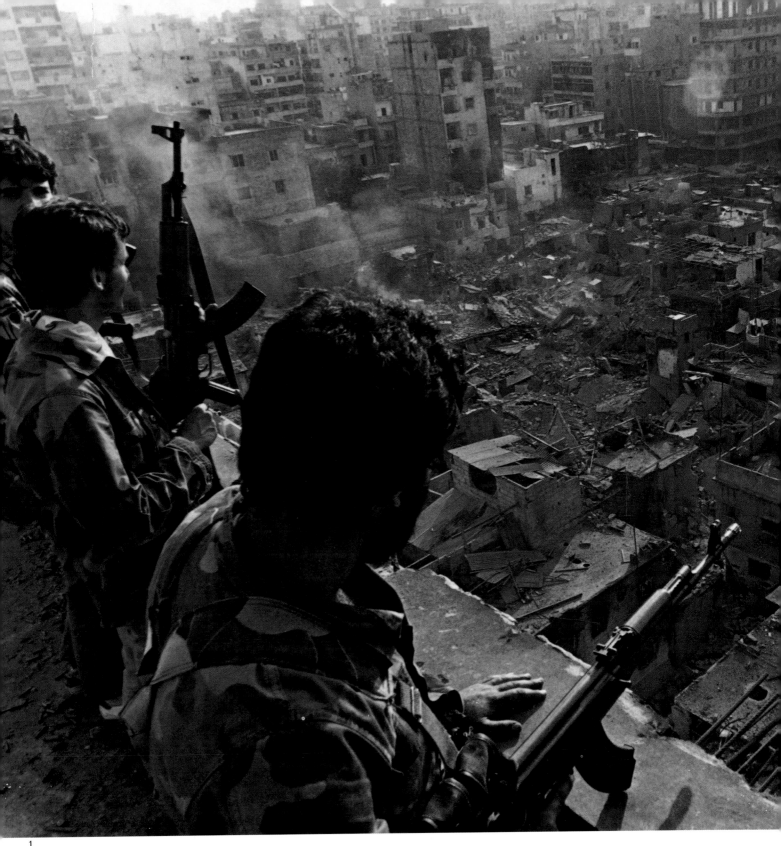

1

Southern Lebanon

(1) Fighters of the Shi'ite Amal militia look down on the ruins of the Palestinian refugee camp of Sabra, 1985. Palestinian refugees were masssacred here by Christian militias in 1982 after the assassination of the Maronite Christian President-elect Bashir Gemayel. (2) The ruins of the UN refugee camp in southern Lebanon after it had been hit by Israeli artillery, killing at least 60 initially and wounding more than a hundred refugees in April 1996. (3) Israeli soldiers in a training exercise prior to the drive against Hezbollah guerrillas in southern Lebanon, spring 1996.

Südlibanon

(1) Kämpfer der schiitischen Amal-Miliz blicken hinab auf die Ruinen des palästinensischen Flüchtlingslagers Sabra, 1985. Hier wurden 1982 nach der Ermordung des christlichen Siegers der Präsidentschaftswahlen, Bashir Gemayel, die Palästinenser von christlichen Milizen niedergemetzelt. (2) Die Überreste des südlibanesischen UN-Flüchtlingslagers nach israelischem Artilleriebeschuß im April 1996; mindestens 60 Flüchtlinge wurden getötet, über 100 verwundet. (3) Israelische Soldaten bei einer Waffenübung vor dem Schlag gegen die Hisbollah-Guerillas im Südlibanon, Frühjahr 1996.

Le Sud-Liban

(1) 1985: des combattant de la milice chiite Amal contemplent les ruines du camp de réfugiés palestiniens de Sabra. Ici, en 1982, les réfugiés palestiniens ont été massacrés par les milices chrétiennes après l'assassinat du président élu, le chrétien maronite Bechir Gemayel. (2) Les ruines d'un camp de réfugiés des Nations unies au Sud-Liban après un bombardement par l'artillerie israélienne, qui a fait au moins 60 morts et

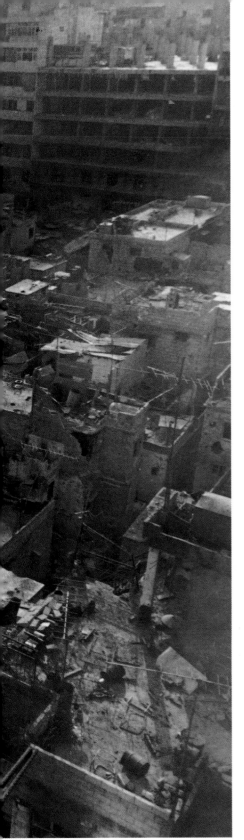

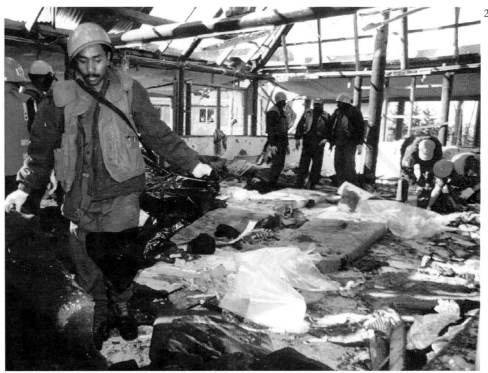

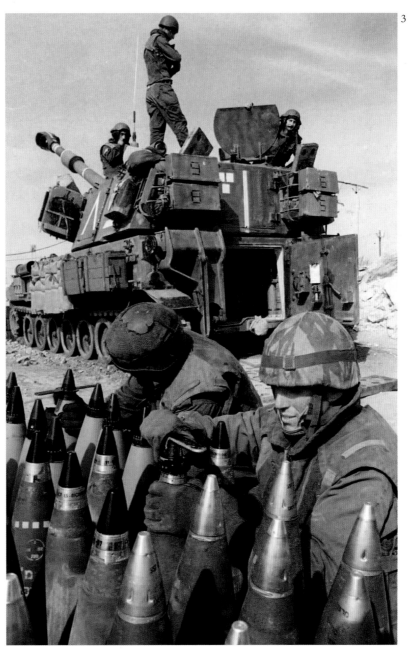

plus de cent blessés en avril 1996. (3) Soldats israéliens pendant un exercice, avant de partir pour une opération anti-Hezbollah, printemps 1996.

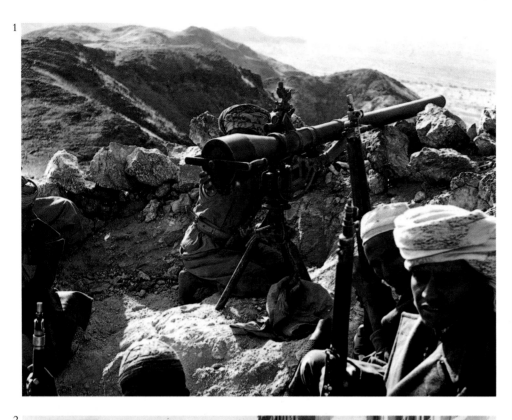

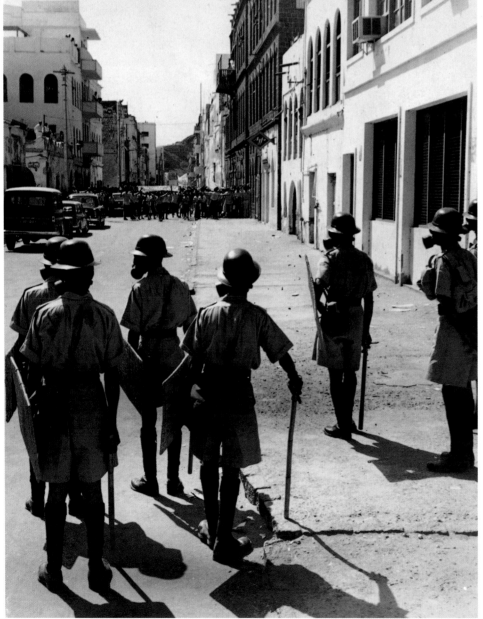

Aden and the Yemen

Civil war erupted between republicans and royalists in Yemen in 1962, and fighting was to go on sporadically for the next 30 years. President Nasser of Egypt backed the anti-British republicans. (1) Royalist forces man a well-prepared position with a recoilless gun on the crest of Algenat Alout. (2) British-trained Aden police, in gas masks, prepare to face rioters in September 1962. (3) A British soldier manhandles a local resident during disturbances in the Crater district of Aden, where 17 British soldiers were to be seized and tortured to death by insurgents.

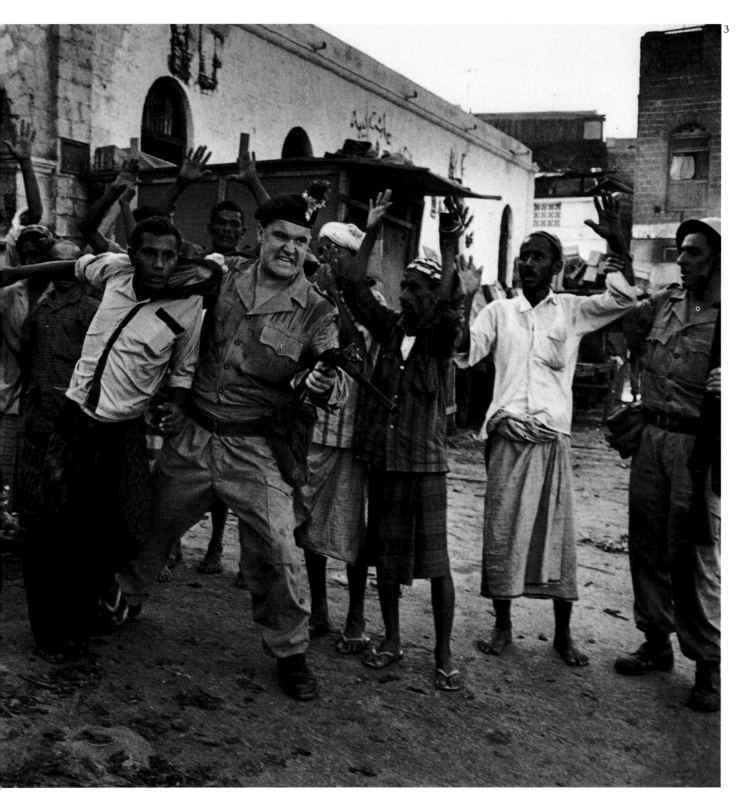

Aden und Jemen

Zwischen Republikanern und Royalisten kam es 1962 im Jemen zum Bürgerkrieg; die Kämpfe flammten in den nächsten 30 Jahren immer wieder auf. Der ägyptische Präsident Nasser unterstützte die antibritischen Republikaner. (1) Royalistische Truppen in einer gut befestigten Stellung auf dem Hügelkamm des Algenat Alout, mit rückstoßfreiem Geschütz. (2) Die britisch ausgebildete Polizei von Aden stellt sich den Aufständischen in Gasmasken, September 1962. (3) Ein britischer Soldat packt brutal einen Einheimischen während der Unruhen im Crater-Viertel von Aden, bei denen 17 britische Soldaten von den Aufständischen zu Tode gefoltert wurden.

Aden et le Yémen

Au Yémen, la guerre civile éclate entre républicains et royalistes en 1962 et les combats continueront sporadiquement pendant 30 ans. Le président égyptien Nasser soutient les républicains anti-britanniques. (1) Sur la crête d'Algenat Alout, sur une position bien défendue, des soldats royalistes servent un canon sans recul. (2) La police d'Aden, entraînée par les Britanniques et équipée de masques à gaz, s'apprêtant à affronter des émeutiers en septembre 1962.

(3) Un soldat britannique malmène un habitant lors des troubles du quartier de Crater à Aden, où 17 soldats britanniques seront capturés et torturés à mort par des insurgés.

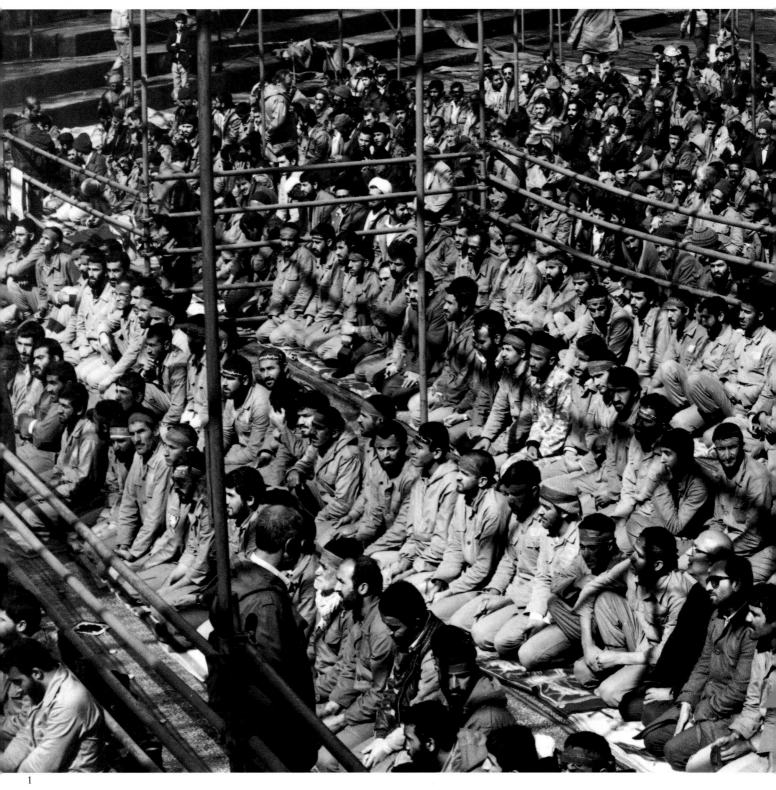

1

Iran v. Iraq, 1
The Iran-Iraq War of 1979-88 was to see
fighting as primitive as anything in the trench
warfare of the First World War. Officers on
both sides had received training at military
academies in America, France and Britain;
some Iraqis had trained in Russia. (1) A
group of Iraqi prisoners being indoctrinated
in Iran's Islamic revolution. (2) A fighter
weeps for his dead friend – he may well be a
Kurd fighting against Saddam's army.
(3) Tactical skills with armour and artillery
were highly developed, but the essence of the
war was static defence, with huge earthworks
and trenches battered by artillery and tanks

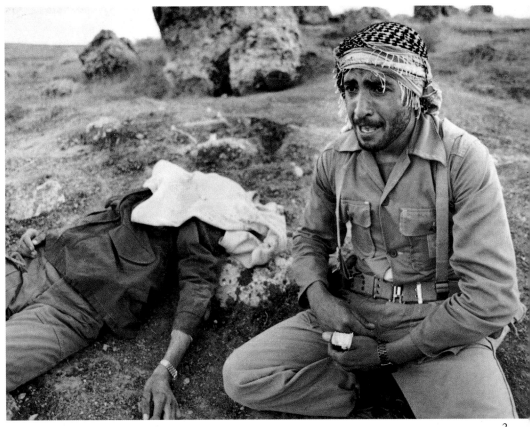

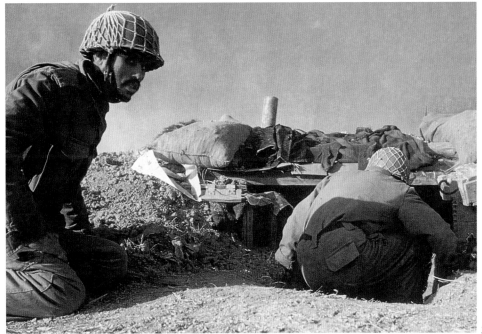

and then assaulted by huge waves. In the case of Iran many fighters were as young as 12.

Iran gegen Irak, 1

Der Iranisch-Irakische Krieg 1979-88 (Erster Golfkrieg) sah Kämpfe, die taktisch so rückständig waren wie der Grabenkrieg des Ersten Weltkriegs. Die Offiziere auf beiden Seiten hatten ihre Ausbildung in Amerika, Frankreich und England erfahren, einige Iraker auch in der Sowjetunion. (1) Irakischen Gefangenen werden im Iran die Grundsätze der Islamischen Revolution beigebracht. (2) Ein Kämpfer weint um seinen toten Freund – vielleicht ein Kurde, der gegen Saddams Truppen kämpft. (3) Auch wenn der taktische Einsatz von bewaffneten Fahrzeugen und Artillerie hochentwickelt war, gilt dieser Krieg doch im wesentlichen als statisch: Gräben und gewaltige Erdwälle wurden mit Artillerie und Tanks beschossen und dann in großen Angriffswellen gestürmt. Der Iran schickte sogar zwölfjährige Kinder in den Kampf.

La guerre Iran-Irak, 1

La guerre de 1979-88 a donné lieu à des combats comparables en brutalité à ceux de la Première Guerre mondiale. Des deux côtés, les officiers avaient été formés dans les académies militaires américaines, françaises et britanniques; quelques Irakiens avaient été entraînés en URSS. (1) Un groupe de prisonniers irakiens reçoit l'endoctrinement de la révolution islamique iranienne. (2) Un combattant pleure son ami mort: peut-être un Kurde résistant contre l'armée de Saddam Hussein. (3) L'utilisation tactique des blindés et de l'artillerie était très développée, mais l'essentiel de la guerre s'est déroulé en défense statique, avec d'énormes ouvrages de terre et des tranchées martelées par l'artillerie et les chars puis assaillies par vagues énormes. En Iran, les combattants n'avaient parfois pas plus de 12 ans.

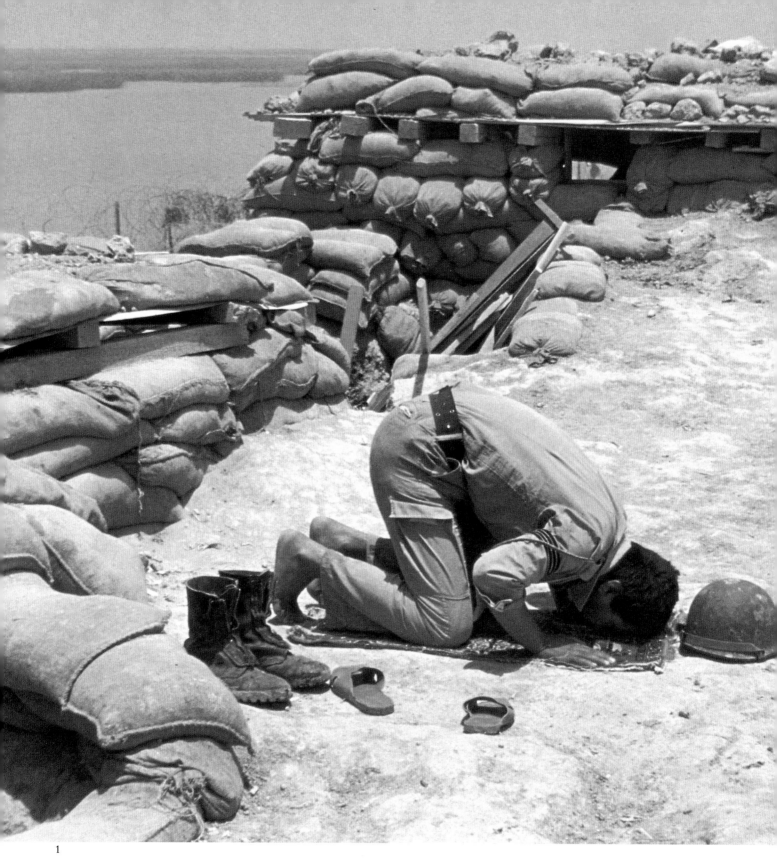

Iran v. Iraq, 2

Religion was not the monopoly of any one side in the murderous war. (1) An Iraqi soldier steps outside his dug-out to pray during Ramadan, 1984, on the southern front near Majnoon island. (2) A procession of Revolutionary Guards march on the Iranian parliament in a demonstration in Tehran in April 1986 before leaving for the front. The man with headband and shroud bearing Koranic texts is carrying a Russian state-of-the-art Dragonov sniper rifle slung across his chest. (3) Iraqi troops celebrating on a pontoon bridge in the Karoun river, 1980. Iranian positions have been set ablaze by Iraqi bombardment in the distance.

Iran gegen Irak, 2

Gläubigkeit war nicht bloß auf eine Seite beschränkt. (1) An der Südfront bei der Insel Majnoon ist ein irakischer Soldat aus seiner Stellung gekommen, um das Ramadan-Gebet zu sprechen, 1984. (2) Vertreter der Revolutionären Garde bei einer Parade vor dem iranischen Parlament in Teheran, April 1986, bevor sie ins Feld zogen. Der Mann mit

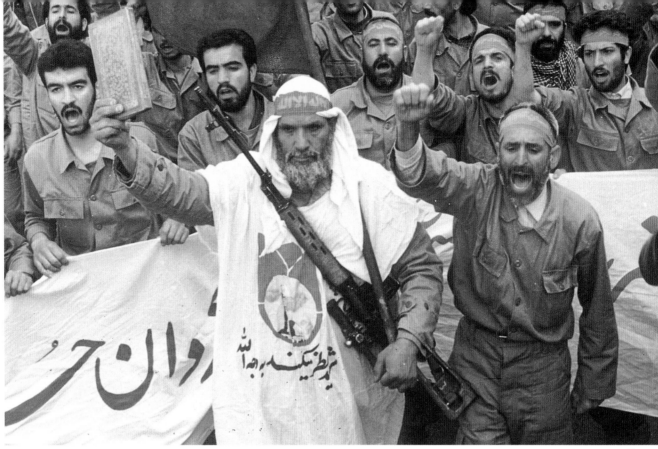

2

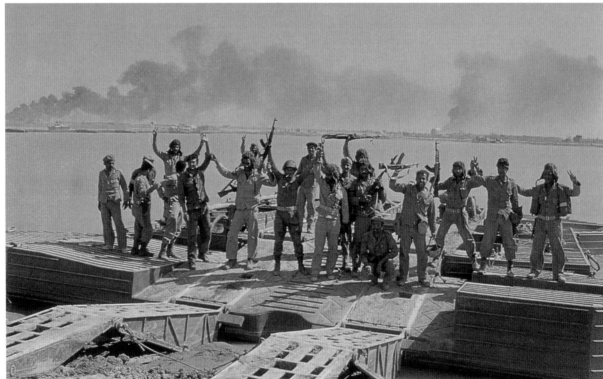

3

Stirnband und Umhang (auf denen Koran-texte stehen) besitzt ein modernes russisches Dragonow-Gewehr mit Zielfernrohr.
(3) Triumphierende irakische Truppen auf einer Pontonbrücke über dem Fluß Karun, 1980. Am Horizont sind die Positionen der Iraner sichtbar, die nach irakischem Bombardement in Flammen stehen.

La guerre Iran-Irak, 2

Dans cette guerre meurtrière, la religion n'a été le monopole d'aucune des parties.
(1) 1984: sur le front Sud, près de l'île de Madjnoun, un soldat irakien sort de sa tranchée-abri pour prier pendant le Ramadan.
(2) Une marche des Gardes révolutionnaires sur le parlement iranien pendant une manifestation à Téhéran en avril 1986, avant le départ au front. L'homme au bandeau et au foulard portant des inscriptions coraniques est armé d'un fusil soviétique Dragonov dernier cri. (3) Soldats irakiens en fête sur un ponton du fleuve Karoun, 1980. Les positions iraniennes bombardées à distance par les Irakiens.

Winds of Change
Oppression and Liberation

When the British Prime Minister Harold Macmillan told the South African Parliament in February 1960 'The wind of change is blowing through this continent', he was acknowledging the obvious. Most of colonial Africa and Asia was in an advanced state of decolonization. In 1945 at the end of the wars with Japan and Germany, only two African countries enjoyed full independence, Ethiopia and Liberia. Fifty years on nearly all parts of the continent were free – but at huge cost.

The local wars were often very long, and very violent towards their civilian populations. Wars of liberation from colonial rule would often be pretexts for deeper, and longer, civil and tribal wars. India and Pakistan were to fight three wars following India's independence from the British in 1947, the third in 1971 leading to the creation of the new state of Bangladesh.

Faced with sustained guerrilla and terrorist action, the colonial authorities had neither the means nor the will for long local wars. In 1952 Kenyan nationalists began the Mau Mau uprising, with attacks on white settlers. Britain brought in thousands of extra troops and used ruthless counter-insurgency tactics against the leadership of the Kikuyu tribe, but Kenya became independent in 1963. Meanwhile, in the Belgian colony of the Congo, civil war followed hard upon the battle for independence which was granted in June 1960.

Independence in Nigeria, the richest of Britain's African colonies, was soon followed by a series of military coups leading to full-blown civil war. In 1967 the Ibo tribe under Lt-Colonel Odumegwu Ojukwu rejected a reorganization of the federal structure of Nigeria, and declared independence in their homeland of Biafra; the federal forces soon put Biafra under blockade. By the time the war ended in 1970, nearly a million Biafrans had died, mostly from starvation and disease.

Two African possessions of Portugal, Angola and Mozambique, were to be the settings of long civil wars in which the super-powers of the Cold War backed opposing sides as their proxies. In Angola the fighting has spanned at least two generations. Mozambique since 1975 has seen its economy ruined by fighting and the huge use of land mines, with more than four million of its people displaced and around a million killed.

The same cycle of upheaval, civil war and starvation has engulfed Ethiopia for the closing decades of the 20th century, abetted by the natural disaster of drought. Emperor Haile Selassie was removed by the Marxist coup of 1974, which led to the military dictatorship of Lt-Colonel Mengistu Haile Mariam. One of the worst-hit drought regions was the setting for the war of secession in Eritrea, which in 1993 gained full independence. Despite the copious arming of the Mengistu regime by Russia and China, the Eritreans eventually forced Mengistu to flee. Both sides used international aid supplies to their starving people to fuel their war effort.

One of the last campaigns Britain fought on the long retreat from her empire in Africa and India was in Cyprus, which she had held as a forward base since 1878. In the mid-1950s Greek nationalists of the Eoka movement began waging a sustained guerrilla and terrorist campaign. Eoka was wedded to a notion of *enosis* – union with Greece – aimed at the Turks as much as the British. Independence led to outbreaks of communal butchery between Greeks and Turks in the island in 1963. A repetition in 1974 brought a full-scale invasion by Turkey's armed forces and the island was partitioned. For the first time two Nato allies fought an all-arms air-land battle in what became an almost private war, with no international press as witness.

Another long war of liberation against colonial rule – at least in the eyes of some protagonists – was fought in Latin Central America. Marxist insurgents, and some liberals, feared that their countries were ensnared in the economic colonialism of the United States. Washington intervened directly in Grenada in 1983, Panama in 1990 and Haiti in 1994. In El Salvador and Nicaragua it chose to support clients and proxies to put up a fight against the import of Castro's Marxist revolution to mainland central America. In both cases the clients proved unsatisfactory: abuses of human rights included the use of death squads and torture.

Latin American waters were to provide the setting for the last British colonial war, in 1982. After the Argentine military junta seized the Falkland Islands, a British colony since the 1830s, Mrs Thatcher despatched a naval task-force 8000 miles to recapture them. It was soon over, with the loss of some 255 British lives, and more than 750 Argentines. To astonished bystanders the fight for the boggy, rocky archipelago was like 'two bald men fighting over a comb'. It did, however, lead to the collapse of the military dictatorship in Argentina; and other similar regimes in the area fell soon after.

Als der britische Premierminister Harold Macmillan im Februar 1960 in einer Rede vor dem südafrikanischen Parlament verkündete: »Ein frischer Wind weht durch diesen Kontinent«, da hatte der Kontinent diesen Wind längst zu spüren bekommen. Überall in Asien und Afrika war die Auflösung der Kolonien in vollem Gange. 1945, am Ende des Zweiten Weltkriegs, hatte es nur zwei wirklich unabhängige Staaten in Afrika gegeben: Äthiopien und Liberia. 50 Jahre später war fast der gesamte Kontinent befreit – doch die Kosten waren gewaltig.

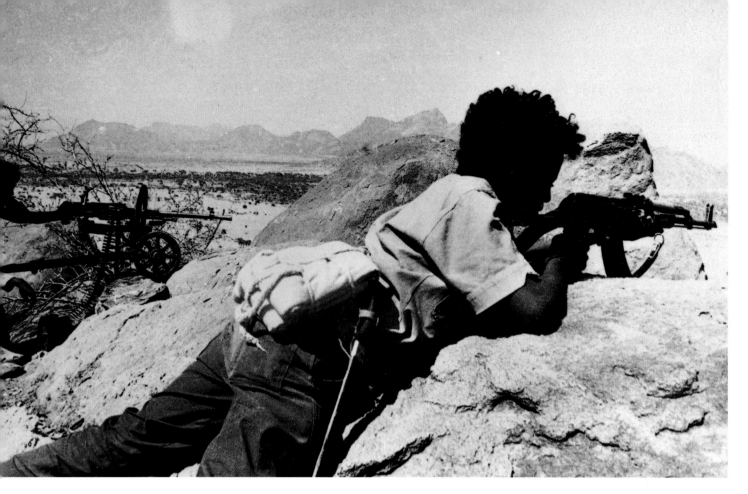

Die lokalen Kriege zogen sich oft lange hin, und die Zivilbevölkerung hatte schwer zu leiden. Die Befreiung vom kolonialen Joch war oft nur ein Vorwand für tiefergehende und langwierigere Bürger- und Stammeskriege. Indien und Pakistan sollten sich, nachdem sie 1947 die Unabhängigkeit von den Briten erlangten, drei Kriege liefern, deren dritter 1971 zur Schaffung des unabhängigen Staates Bangladesch führte.

Die Kolonialbehörden, die zunehmend Guerilla- und Terrorunternehmungen ausgesetzt waren, hatten weder die Mittel noch die Energie, lange Lokalkriege auszufechten. 1952 begannen Nationalisten in Kenia den Mau-Mau-Aufstand, wobei sie auch weiße Siedler angriffen. Großbritannien brachte Tausende zusätzlicher Soldaten ins Land und ging unerbittlich gegen den anführenden Kikuyu-Stamm vor, doch bis 1963 hatte Kenia seine Unabhängigkeit errungen. Der belgische Kongo war im Juni 1960 unabhängig geworden, doch folgte auf den Unabhängigkeitskrieg sogleich der Bürgerkrieg.

Auf die Unabhängigkeit Nigerias, der reichsten britischen Afrikakolonie, folgte rasch eine Reihe von Militärputschen, die in den Bürgerkrieg mündeten. 1967 weigerte sich der Ibo-Stamm unter Führung von General Odumegwu Ojukwu, eine Neuorganisation der bundesstaatlichen Struktur Nigerias anzuerkennen, und proklamierte das Stammesgebiet als unabhängigen Staat Biafra; die Bundestruppen schnitten daraufhin Biafra von der Außenwelt ab. Nach Ende des Krieges, 1970, war fast eine Million Biafrer umgekommen, die meisten davon durch Hunger und Krankheit.

Zwei afrikanische Besitzungen Portugals, Angola und Mozambique, sollten Schauplatz blutiger Bürgerkriege werden, die von den beiden Großmächten des Kalten Krieges, die je-

An Eritrean guerrilla takes up a sniping position in the rocks above Asmara, which was to become the capital of the new independent Eritrea. A comrade aims a machine gun, with no assistant to feed the ammunition chain.

Ein eritreischer Guerillero sucht sich in den Felsen oberhalb von Asmara eine Stellung als Heckenschütze; Asmara sollte die Hauptstadt des neuen unabhängigen Eritrea werden. Ein Kamerad bringt ein Maschinengewehr in Stellung; er muß ohne Helfer auskommen und seinen Munitionsgurt selber nachladen.

Un combattant érythréen sur une position de tir isolé, dans les rochers surplombant Asmara, future capitale de l'Erythrée indépendant. Son camarade manœuvre une mitrailleuse sans assistance pour le chargement de la chaîne de munitions.

weils eine Seite der Kontrahenten unterstützten, als Stellvertreterkriege geführt wurden. In Angola dauern die Kämpfe seit mindestens zwei Generationen an. Der Krieg in Mozambique hat durch fortdauernde Kämpfe und den massierten Einsatz von Landminen seit 1975 die Wirtschaft des Landes ruiniert; über vier Millionen Menschen sind heimatlos geworden, etwa eine Million kam um.

Derselbe Kreislauf von Aufstand, Bürgerkrieg und Hungersnot hat auch Äthiopien in den letzten Jahrzehnten des 20. Jahrhunderts heimgesucht, wobei in diesem Land eine katastrophale Dürre die Leiden noch verschlimmerte. Ein marxistischer Putsch stieß 1974 Kaiser Haile Selassie vom Thron, und eine Militärdiktatur unter Oberstleutnant Mengistu Haile Mariam entstand. Zu den am schlimmsten von der Dürre heimgesuchten Provinzen zählt Eritrea, das 1993 den Unabhängigkeitskrieg für sich entscheiden konnte. Trotz der schweren russischen und chinesischen Bewaffnung des Men-

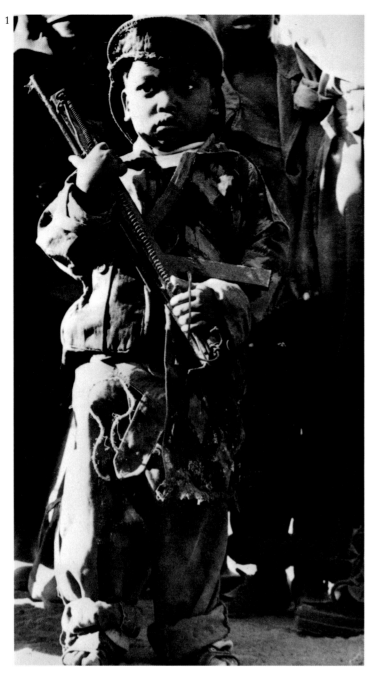

(1) A soldier of the Marxist MPLA in the early stages of his indoctrination in Angola. (2) Jubilant Greek insurgents with their trophy, a Turkish flag, after seizing the strategic heights of St Hilarion castle above Kyrenia in the Cyprus troubles of 1963-64.

(1) Ein Soldat der marxistischen MPLA in Angola bei der Grundausbildung. (2) Triumphierende griechische Aufständische der Zypern-Unruhen von 1963/64 mit einer bei der Eroberung der strategischen Höhen der Festungsruine St. Hilarion oberhalb Kyrenia erbeuteten türkischen Fahne.

(1) Un soldat du MPLA marxiste dans les premières étapes de son endoctrinement, en Angola. (2) Insurgés grecs brandissant joyeusement leur trophée, un drapeau turc, après la prise du château de St-Hilarion, au-dessus de Kyrenia, lors des troubles de 1963-64 à Chypre.

Ein weiterer langer Befreiungskrieg gegen die Kolonialherren – jedenfalls empfanden einige der Kontrahenten es so – wurde in Mittelamerika gefochten. Marxistische Aufständische und auch manche Liberalen sahen ihre Länder als Opfer des Wirtschaftsimperialismus der Vereinigten Staaten. Zu militärischen Interventionen Washingtons kam es 1983 in Grenada, 1990 in Panama und 1994 in Haiti. In El Salvador und Nicaragua unterstützten die Vereinigten Staaten statt dessen bestimmte Gruppen, die für sie gegen die Ausbreitung von Castros marxistischer Revolution im kontinentalen Mittelamerika kämpften. Doch in beiden Fällen erwiesen sich die Stellvertreter als unzuverlässig: Sie mißachteten Menschenrechte, folterten und setzten Todesschwadrone ein.

Südamerikanische Gewässer gaben 1982 den Schauplatz für den letzten Kolonialkrieg Großbritanniens ab. Als das argentinische Militärregime die Falklandinseln annektierte – eine britische Kolonie seit den 1830er Jahren –, schickte Margaret Thatcher eine Marine-Einsatztruppe 12 000 Kilometer weit, um sie zurückzuerobern. Der Krieg war schnell vorbei; er kostete etwa 255 Briten und über 750 Argentinier das Leben. Für die ungläubigen Zuschauer hatte der Kampf um die felsige, moorige Inselgruppe etwas von »zwei Glatzköpfigen, die sich um einen Kamm streiten«. Allerdings trug der Falklandkrieg zum Zusammenbruch der argentinischen Militärdiktatur bei, und andere, ähnliche Regimes dieses Erdteils fielen kurze Zeit später.

Quand le Premier ministre britannique Harold Macmillan déclare devant l'assemblée sud-africaine, en février 1960: «Le vent du changement souffle sur ce continent», il ne fait que reconnaître l'évidence. La plus grande partie de l'Afrique et de l'Asie coloniales sont dans un processus avancé de décolonisation. En 1945, deux Etats africains seulement jouissaient d'une indépendance pleine et entière: l'Ethiopie et le Libéria. Cinquante ans plus tard, presque tout le continent est libéré, mais le prix payé est énorme.

Si les guerres locales sont parfois longues et très violentes envers les populations civiles, les guerres de libération sont souvent à l'origine de conflits civils ou tribaux, plus profonds et plus durables. L'Inde et le Pakistan s'affrontent dans

gistu-Regimes schlugen die Eritreer am Ende Mengistu in die Flucht. Beide Seiten benutzten internationale Hilfsgelder, die der hungernden Bevölkerung zugedacht waren, zu weiterer Aufrüstung.

Eine der letzten Schlachten in der langwierigen Auflösung des Britischen Empire in Afrika und Asien fochten die Engländer auf Zypern, das ihnen seit 1878 als Militärbasis gedient hatte. Mitte der 50er Jahre begannen die griechischen Nationalisten der Eoka-Bewegung mit ihrer Guerilla- und Terrorkampagne. Das Schlagwort der Eoka war *enosis* – Anschluß an den griechischen Staat – und richtete sich damit ebenso gegen die türkischen Bewohner der Insel wie gegen die Briten. Die Unabhängigkeit mündete 1963 in einen Bürgerkrieg zwischen griechischen und türkischen Zyprioten. Eine zweite Kriegswelle führte 1974 zur türkischen Invasion und zur Teilung der Insel. Zum ersten Mal fochten zwei Verbündete der NATO in einem regelrechten Land- und Luftkrieg gegeneinander, doch blieb dies ein beinahe privater Krieg – internationale Journalisten waren nicht zugegen.

trois guerres, suite à l'indépendance indienne de 1947; la dernière aura pour résultat la création d'un nouvel Etat, le Bangladesh.

Face aux luttes de libération et au terrorisme incessants, les autorités coloniales n'ont ni les moyens ni la volonté de mener de longues guerres locales. En 1952, les nationalistes kenyans lancent la révolte des Mau-Mau avec des attaques contre les colons blancs. La Grande-Bretagne envoie des milliers de soldats et exerce une répression impitoyable contre le leadership insurrectionnel de la tribu des Kikuyus. Pourtant, le Kenya deviendra indépendant en 1963. Dans le même temps, au Congo belge, la lutte pour l'indépendance, obtenue en 1960, est suivie par une terrible guerre civile.

Après l'indépendance du Nigeria, la plus riche des colonies britanniques en Afrique, une série de coups d'Etat militaires conduisent à une véritable guerre civile. En 1967, la tribu des Ibo, sous le commandement du lieutenant-colonel Odumeg-wu Ojukwu, rejette la réorganisation de la structure fédérale du Nigeria et, de son territoire du Biafra, fait sécession. L'armée fédérale instaure un blocus sur le Biafra. A la fin de la guerre, en 1970, près d'un million de Biafrais sont morts, généralement de faim et de maladie.

Deux possessions portugaises en Afrique, l'Angola et le Mozambique, vont être le théâtre d'interminables guerres civiles entre parties soutenues respectivement par les deux superpuissances de la guerre froide. En Angola, les combats s'étendront sur au moins deux générations. Quant au Mozambique, depuis 1975 il a vu son économie ruinée par la guerre et le minage des terres, plus de 4 millions de personnes déplacées et environ un million de morts.

Le même cycle de soulèvements, de guerres civiles et de famines, à quoi s'est ajoutée la sécheresse, s'est abattu sur l'Ethiopie dans les dernières décennies du 20e siècle. L'empereur Hailé Sélassié est déposé en 1974 par un coup d'état qui inaugure la dictature militaire du lieutenant-colonel Mengistu Hailé-Mariam. L'Erythrée, une des régions les plus durement frappées par la sécheresse, mène une longue guerre de sécession et obtiendra la pleine indépendance en 1993. Les Erythréens ont fini par chasser Mengistu, pourtant abondamment armé par la Russie et la Chine. D'un côté comme de l'autre, l'aide internationale destinée aux populations affamées est détournée sur l'effort de guerre.

L'une des dernières campagnes menées par la Grande-Bretagne au cours de la lente disparition de son empire en Afrique et en Inde a été celle de Chypre, sa base avancée en Méditerranée depuis 1878. Au milieu des années 1950, les nationalistes grecs du mouvement Eoka commencent à entretenir une guérilla incessante et une campagne de terrorisme. A Eoka s'associe la notion d'*enosis* - union avec la Grèce - dirigée tant contre les Turcs que contre les Britanniques. L'indépendance déclenche des massacres entre communautés grecque et turque dans l'île en 1963. Une deuxième vague de massacre provoque l'entrée des forces armées turques et la partition de l'île. Pour la première fois, deux pays membres de l'OTAN se font une guerre qui engage tous les

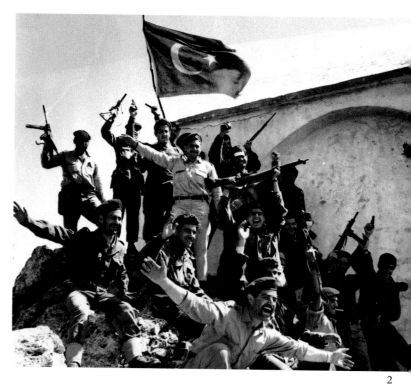

2

corps d'armée, et pourtant presque privée, d'où sont absents les témoins de la presse internationale.

Une autre longue guerre de libération contre la domination coloniale - du moins aux yeux de certains de ses acteurs - a lieu en Amérique centrale. Des insurgés marxistes, et quelques libéraux, craignent le piège d'un colonialisme économique américain. Washington intervient directement à Grenade en 1983, à Panama en 1990 et en Haïti en 1994. Au Salvador et au Nicaragua, les Etats-Unis choisissent d'entretenir des gouvernements qui leur sont acquis, afin d'empêcher l'importation de la révolution castriste en Amérique centrale. Chaque fois, ces gouvernements déçoivent: violations des droits de l'homme, escadrons de la mort, tortures.

Les eaux latino-américaines ont fourni en 1982 le décor de la dernière guerre coloniale britannique. Quand la junte militaire argentine s'empare des îles Falkland, britanniques depuis les années 1830, Mme Thatcher envoie un corps expéditionnaire naval à 12 000 km de l'Angleterre pour les reprendre. L'opération est rapide et fera 255 morts britanniques et plus de 750 argentins. Pour les observateurs, cette guerre, dont l'enjeu est un archipel rocheux et marécageux, évoque «deux chauves se disputant un peigne». Elle provoquera néanmoins la chute de la dictature militaire argentine. Dans la région, d'autres régimes similaires tomberont peu après.

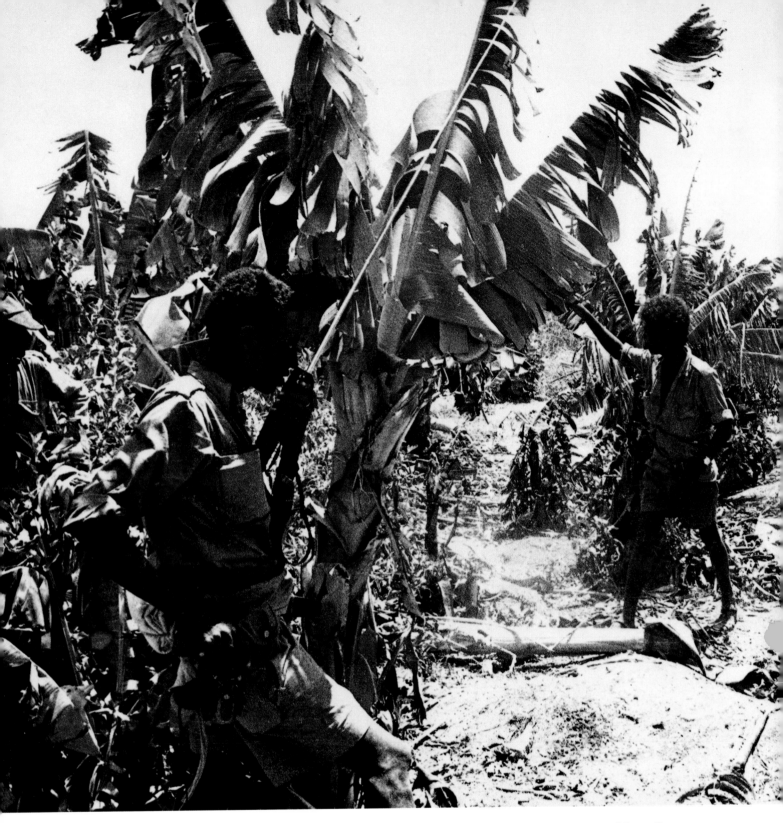

Ethiopia and Somalia

In the ebb and flow of fighting in Ethiopia in the 1970s and 80s, Somali guerrillas seized slices of the northern territory as deep bases for operations over the border. (1) Here they set up positions for heavy 120-mm mortars. The fire control officer, left, speaks to forward observers through a two-way radio. (2) With the the help of Russian and Cuban support in *matériel* and advisers, the Marxist Ethiopian forces recovered territory and rebel weaponry in several counter-offensives. Here soldiers with a Russian T-54 tank guard quantities of rifles captured in the previous fighting season, Ethiopia, February 1978.

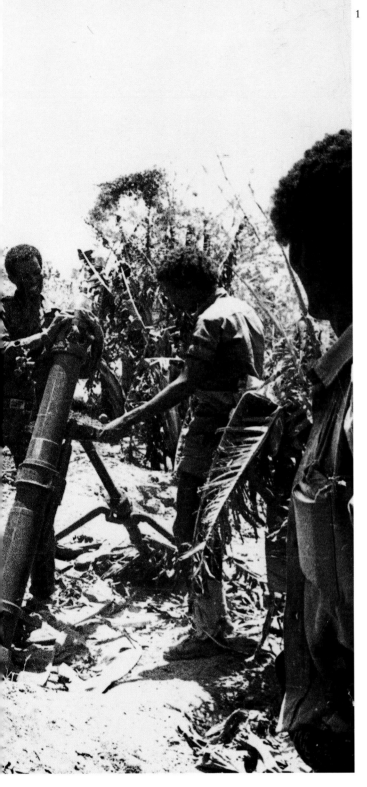

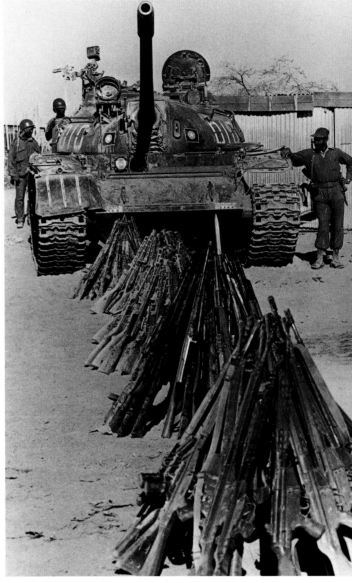

Äthiopien und Somalia

In den 70er und 80er Jahren brachten in den Wirren der Kämpfe somalische Guerillas Territorien im nördlichen Äthiopien an sich, die sie als Stützpunkte für Operationen jenseits der Grenze nutzten. (1) Hier bereiten sie Stellungen für schwere 120-mm-Granatwerfer vor. Der Schütze (links) ist über Sprechfunk mit Beobachtern verbunden, die am Zielgebiet stationiert sind. (2) Mit der Unterstützung von Russen und Kubanern, die Kriegsmaterial und Berater schickten, eroberte die marxistische äthiopische Regierungsarmee in einer Reihe von Gegenoffensiven Territorien zurück und erbeutete Waffen der Rebellen. Hier (Äthiopien, Februar 1978) bewachen Soldaten mit einem russischen T-54-Panzer ein Lager von Gewehren, die beim vorangegangenen Waffengang erbeutet wurden.

L'Ethiopie et la Somalie

Dans la tourmente éthiopienne des années 1970 et 80, les combattants somaliens s'emparent de morceaux du territoire du nord, d'où ils peuvent opérer par-delà la frontière. (1) Ici, préparant des positions pour des mortiers lourds de 120 mm. A gauche, l'officier de contrôle des tirs s'adresse à des observateurs d'avant-poste au moyen d'un émetteur-récepteur. (2) Aidés par du matériel et des conseillers soviétiques et cubains, les forces armées éthiopiennes marxistes reprennent aux rebelles des territoires et des armes en plusieurs contre-offensives. Près de ce char soviétique T-54, des soldats gardent un lot de fusils saisis lors d'une précédente série de combats. Ethiopie, février 1978.

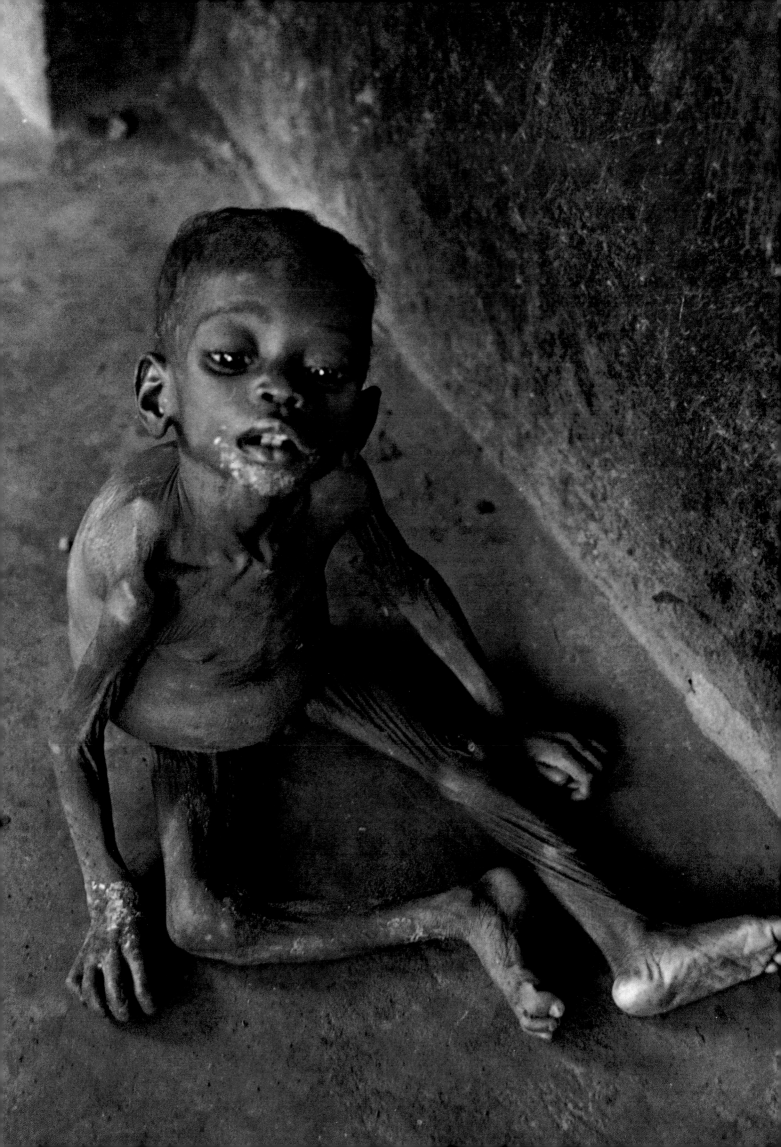

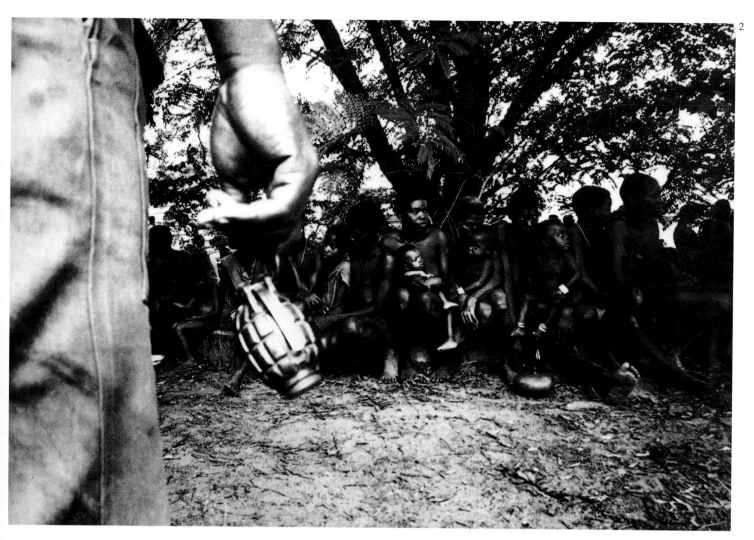

Biafra

(1) Innocent casualty of the Biafran War, an Ibo child in 1970. After two and a half years of civil war, almost a million civilians had died of starvation. (2) A federal soldier swinging a hand grenade guards Ibo women prisoners with their children in 1968. (3) Biafran rebels prepare for an attack on Afam power station.

Biafra

(1) Dieses Ibo-Kind ist ein unschuldiges Opfer des Biafrakrieges, 1970. Nach zwei-einhalb Jahren Bürgerkrieg war fast eine Million Zivilisten verhungert. (2) Ein Wach-posten der Bundestruppen hält mit einer Handgranate gefangene Frauen und Kinder der Ibo in Schach, 1968. (3) Biafrische Rebel-len bei der Vorbereitung eines Anschlags auf das Kraftwerk Afam.

Le Biafra

(1) Un enfant ibo en 1970, victime innocente de la guerre du Biafra. En deux ans et demi de guerre civile, près d'un million de civils sont morts de faim. (2) 1968: un soldat fédéral garde des prisonnières ibo avec leurs enfants, tout en agitant une grenade. (3) Des rebelles biafrais préparent une attaque sur la centrale électrique d'Afam.

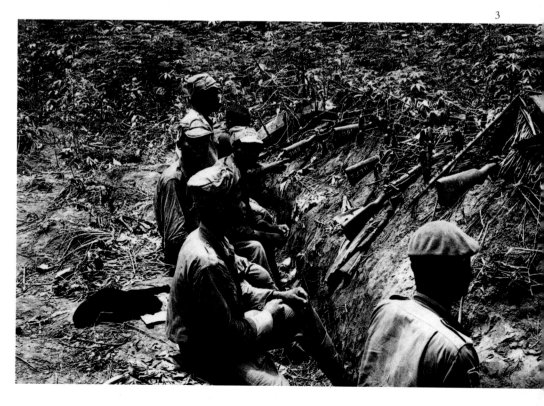

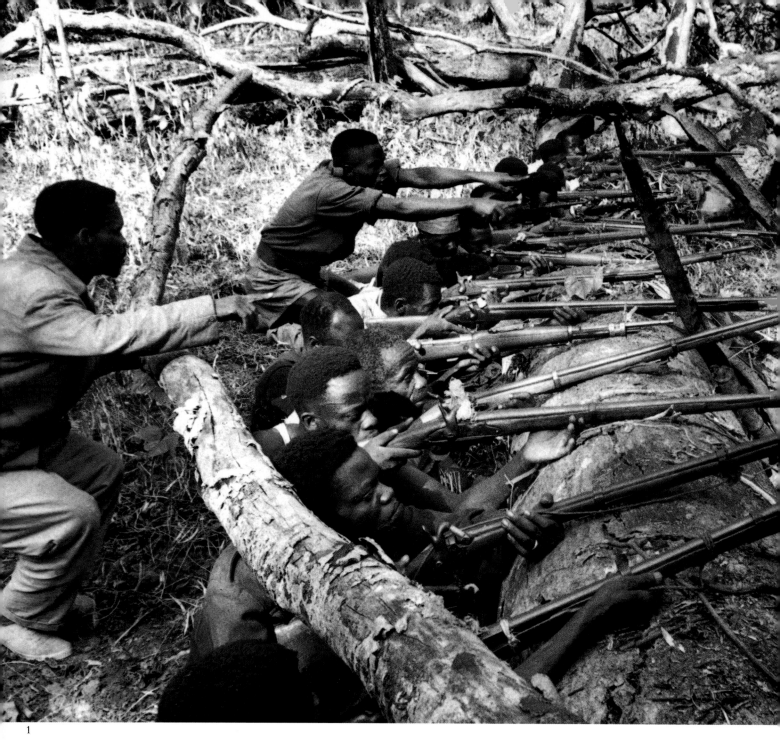

1

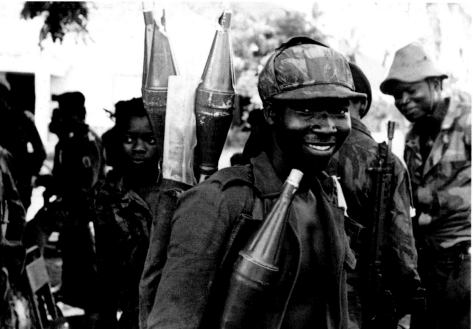

2

Angola

(1) UNITA soldiers train their recruits in the use of Chinese weapons, of a distinctly primitive design, at a camp along the Zambian border, 1961. (2) The Marxist MPLA is better equipped with shoulder rocket launchers and Soviet assault rifles. These soldiers have just completed a successful offensive in the north and west of the country. (3) Veterans of the UNITA pro-Western forces cradle a local variant of the AK-47 Kalashnikov.

Angola

(1) Rekruten der UNITA lernen in einem Lager an der Grenze zu Sambia den Umgang mit altertümlichen chinesischen Waffen, 1961. (2) Die marxistische MPLA ist mit ihren tragbaren Raketenwerfern und sowjetischen Kampfgewehren besser bewaffnet. Diese Soldaten kehren von einer erfolg-

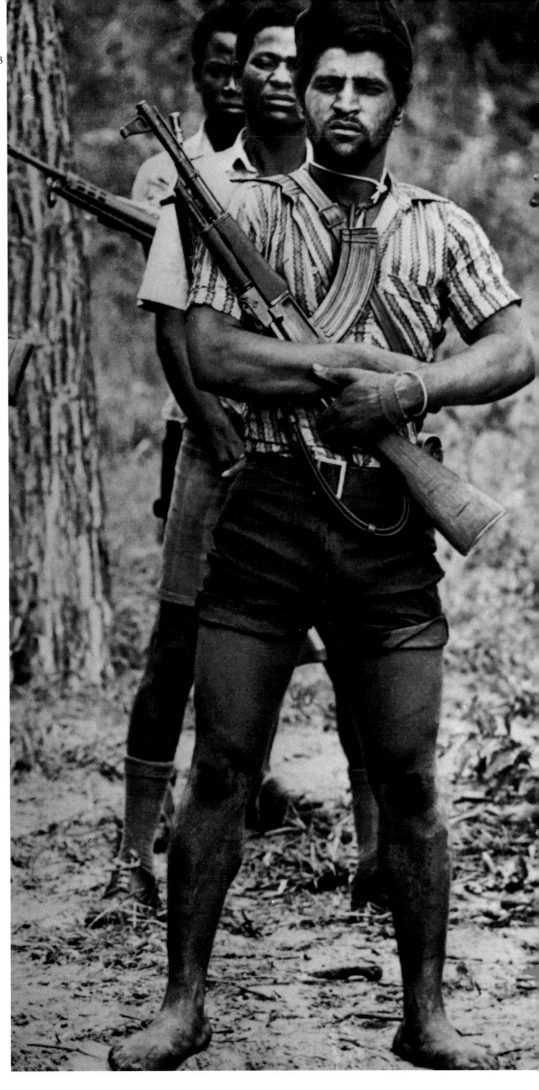

reichen Offensive im Norden und Westen des Landes zurück. (3) Erfahrene Kämpfer der prowestlichen UNITA mit einer lokalen Variante der Kalaschnikow AK-47 im Arm.

L'Angola

(1) Des soldats de l'UNITA entraînent leurs recrues au maniement d'armes chinoises, de fabrication assez primitive, dans un camp près de la frontière zambienne, en 1961.
(2) Le MPLA marxiste est mieux équipé, lance-roquettes à l'épaule et fusils d'assaut soviétiques. Ces soldats viennent de remporter une offensive dans le nord et l'ouest du pays. (3) Vétérans des forces pro-occidentales de l'UNITA, avec une variante locale de la Kalashnikov AK-47.

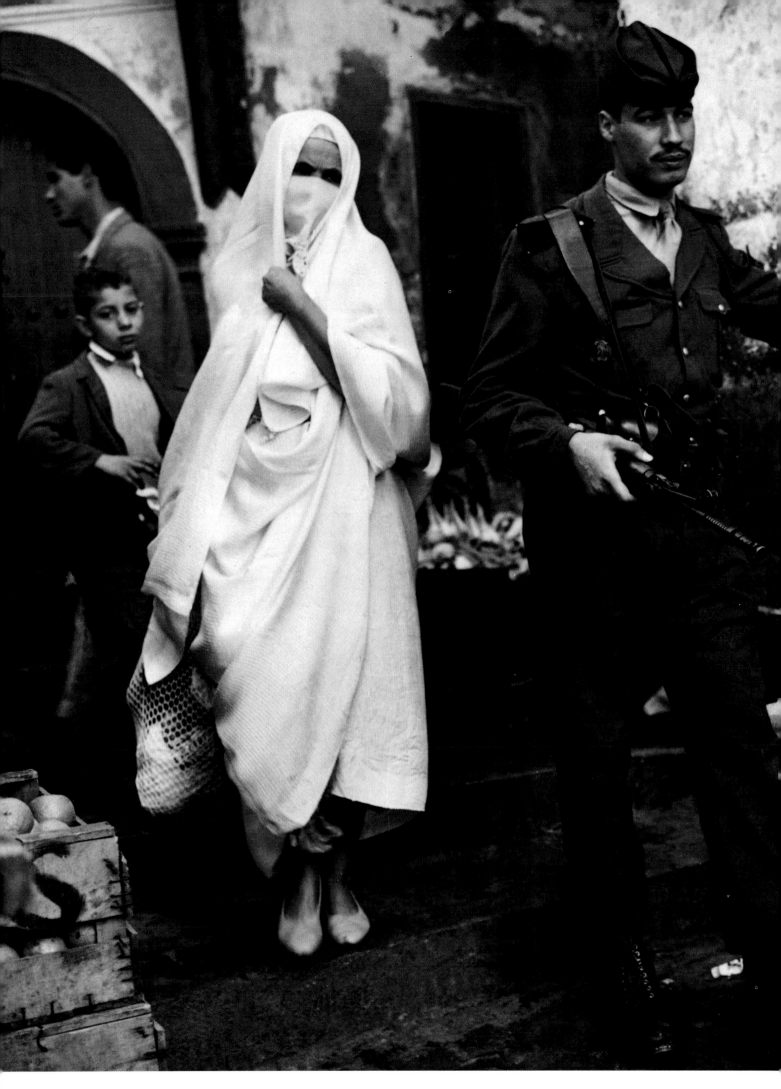

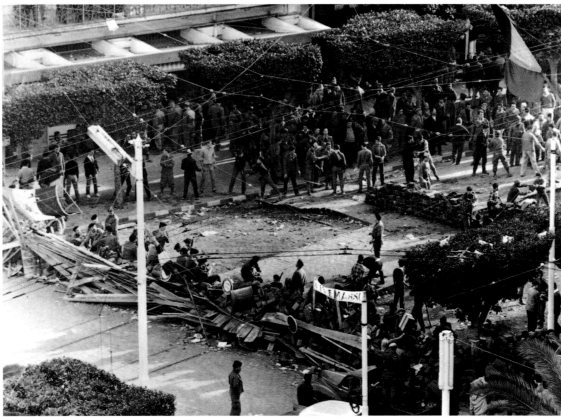

Algeria

More than a million died in the war of Algerian independence, 1954-62. (1) A French soldier on patrol in the Casbah, Algiers, 1962, the year De Gaulle conceded independence to Algeria. (2) A scene of devastation after a bombing by FLN guerrillas, who would conceal their explosives in ice cream or the frames of bicycles. (3) General Raoul Salan, in the képi, and General Massu, in the beret, Algiers, May 1958. The two, who led the revolt of French settlers and officers, were founder members of the OAS (Secret Army Organisation), for which they were to be imprisoned.

Algerien

Mehr als eine Million Menschen kam im algerischen Unabhängigkeitskrieg um, 1954-62. (1) Ein französischer Soldat patrouilliert in der Kasbah von Algier, aufgenommen 1962. Im selben Jahr gewährte Charles de Gaulle den Algeriern die Unabhängigkeit.
(2) Verwüstungen nach einem Bombenanschlag der FLN-Guerillas, die ihre Sprengstoffe in Eiscreme oder Fahrradrahmen versteckten. (3) General Raoul Salan, mit Képi, und General Massu, mit Barett, Algier, Mai 1958. Die beiden führten den Aufstand der französischen Siedler und Offiziere gegen die Unabhängigkeitsbestrebungen und waren Gründungsmitglieder der Untergrundarmee OAS; später sollten sie dafür ins Gefängnis kommen.

L'Algérie

De 1954 à 1962, la guerre d'indépendance en Algérie fait plus d'un million de morts. (1) Un soldat français patrouillant dans la Casbah, à Alger, en 1962, l'année où De Gaulle accorde l'indépendance à l'Algérie.
(2) Scène de dévastation après l'explosion d'une bombe posée par des combattants du FLN qui cachaient leurs explosifs dans les glaces des marchands ou dans les cadres de vélos. (3) Le général Raoul Salan, en képi, et le général Massu, en béret, Alger, mai 1958; ils dirigeront la révolte des colons et dès officiers français contre l'indépendance et seront membres fondateurs de l'OAS (Organisation armée secrète), ce qui leur vaudra la prison.

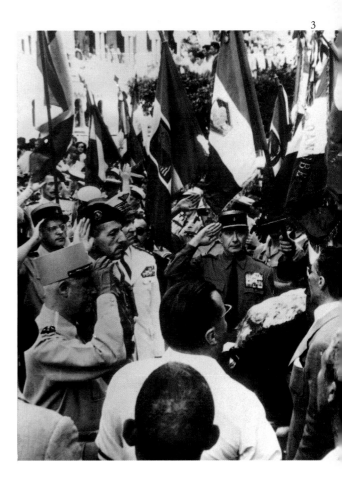

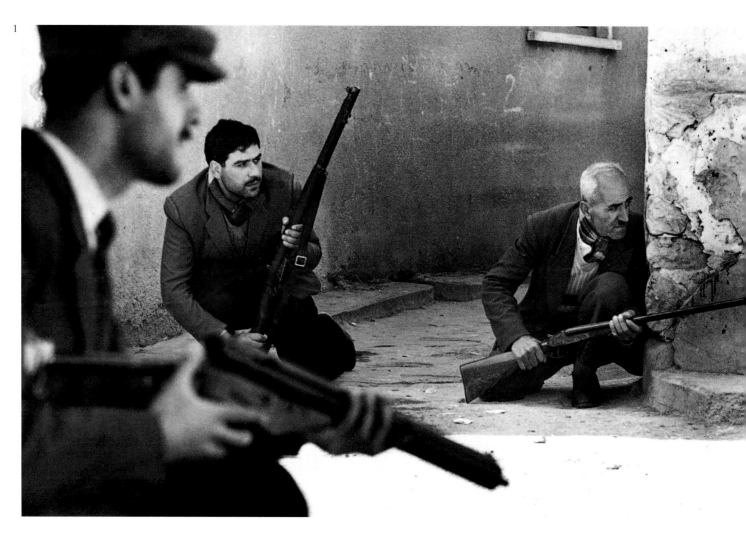

Union with Greece

(1) Greek Cypriots armed with shotguns and primitive British Sten sub-machine guns fight for their corner in Nicosia in 1964.
(2) A Greek Orthodox priest shoulders his shotgun in the service of the Greek 'Home Guard' in Nicosia, March 1964. (3) In an earlier phase of the Eoka campaign, British Royal Marines carry out an early morning arms search in a suspected Eoka hideout in the mountain village of Akantmou. The marines had to abseil down steep cliffs to maintain the element of surprise.

Anschluß an Griechenland

(1) Griechische Zyprioten, mit Flinten und altertümlichen britischen Sten-Maschinen-pistolen bewaffnet, verteidigen ihre Straßen-ecke in Nikosia, 1964. (2) Ein griechisch-orthodoxer Priester hat seine Flinte zum Dienst in der griechischen »Heimatgarde« geschultert, Nikosia, März 1964. (3) In einer früheren Phase des Eoka-Feldzugs durch-suchen britische Marineinfanteristen in einem frühmorgendlichen Überraschungs-angriff das Bergdorf Akantmou, in dem sie ein Versteck der Eoka vermuten. Damit die Überraschung gelang, hatten sie sich an einer steilen Klippe abseilen müssen.

Union avec la Grèce

(1) Chypriotes grecs armés de fusils de chasse et de mitraillettes britanniques Sten, défendant leur territoire à Nicosie en 1964. (2) Un prêtre grec orthodoxe armé d'un fusil de chasse, au service de la «Défense du territoire» grecque à Nicosie, mars 1964. (3) Au début de la campagne de l'Eoka, les soldats de la Marine royale britannique effectuent une descente matinale dans une possible cachette de l'Eoka à Akantmou, un village montagnard. Les marines ont dû descendre en rappel des rochers escarpés pour bénéficier de l'élément de surprise.

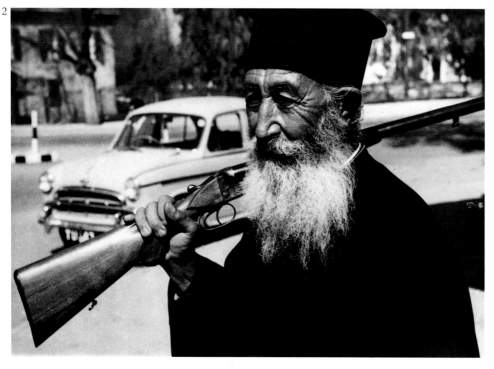

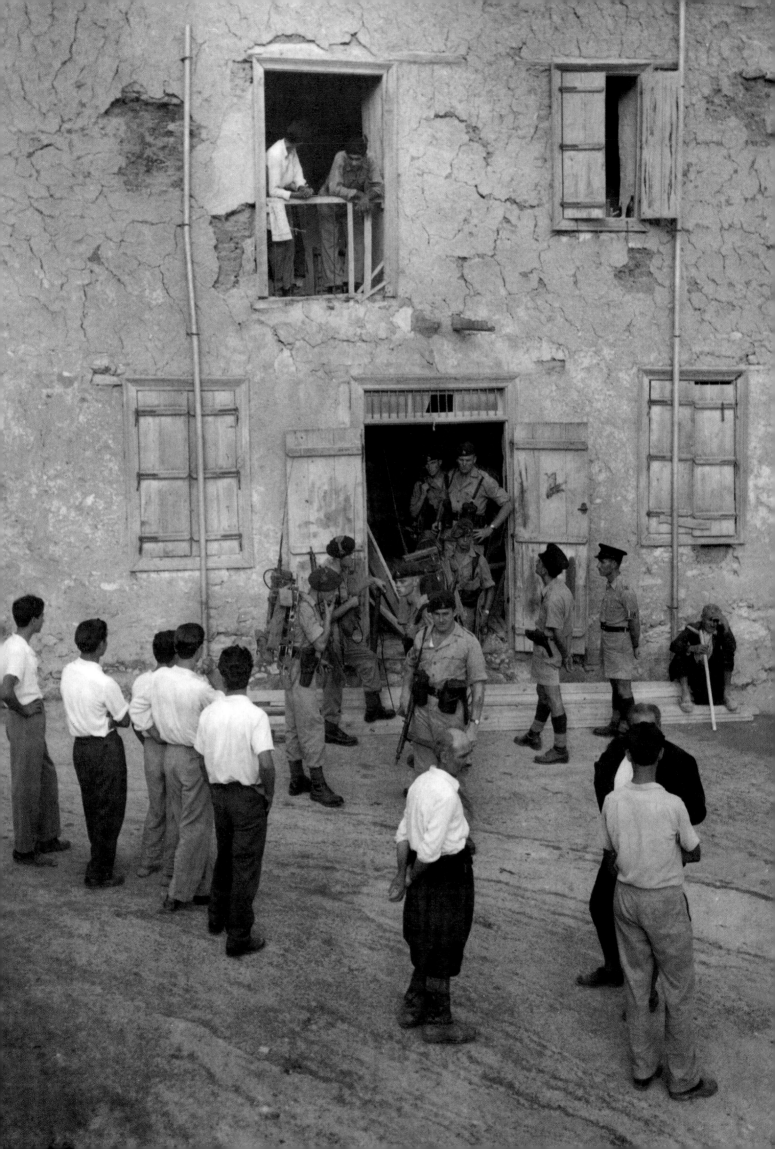

1

Greek v. Turk
(1) A Greek Cypriot National Guardsman runs for cover from the heavy machine-gun position on the roof of the Ledra Palace Hotel in Nicosia, during the confrontation with Turkish forces when they seized the northern portion of the island in July 1974. (2) A victim of the violence that led to the Turkish attack. (3) Eoka supporters of the gunman and journalist Nikos Samson – he

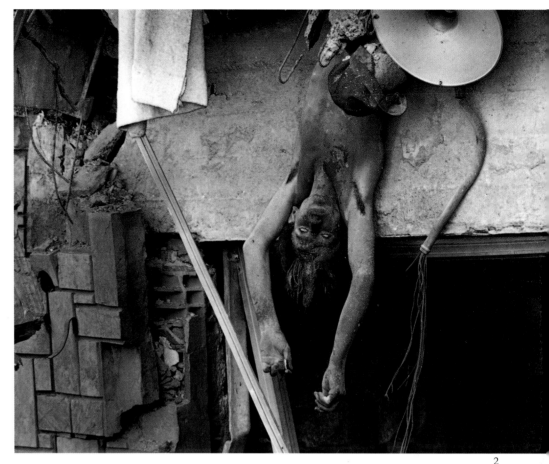

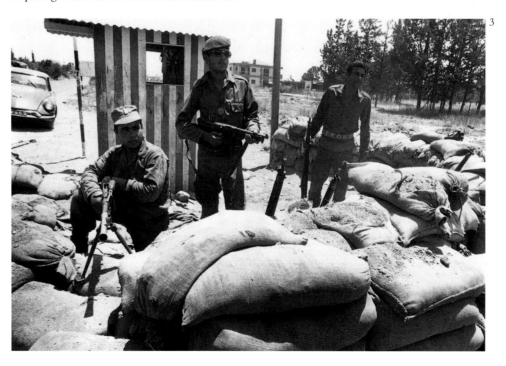

hatten türkische Truppen den Nordteil der Insel erobert. (2) Ein Opfer der Ausschreitungen, die den türkischen Angriff provozierten. (3) Eoka-Anhänger des Journalisten Nikos Samson, der sich im Staatsstreich vom Juli 1974 zum Präsidenten erklärte – was zum türkischen Einmarsch, der Teilung des Landes und zum Sturz der Militärregierung in Griechenland führte.

La guerre gréco-turque
(1) Un Garde national chypriote grec court se protéger des tirs de mitrailleuse lourde du toit du Ledra Palace Hotel de Nicosie, lors des confrontations avec les forces armées turques, qui s'emparent du nord de l'île en juillet 1974. (2) Une victime des violences qui déclencheront l'intervention turque. (3) Partisans de l'Eoka de Nikos Samson, journaliste et terroriste, qui s'autoproclame président en 1974, ce qui déclenche l'intervention turque, divise l'île et conduit à l'effondrement de la dictature militaire grecque.

declared himself president in the coup in July 1974 which was to bring in the Turks, divide the island, and lead to the collapse of the military dictatorship in Greece itself.

Griechen kontra Türken
(1) Ein griechisch-zypriotischer Nationalgardist geht vor schwerem türkischen Maschinengewehrfeuer vom Dach des Ledra-Palace-Hotels in Nikosia in Deckung; im Juli 1974

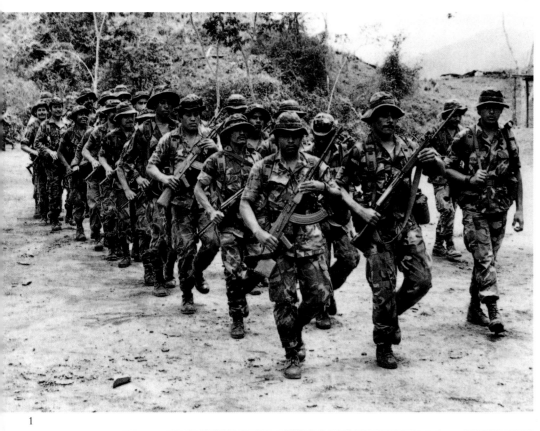

1

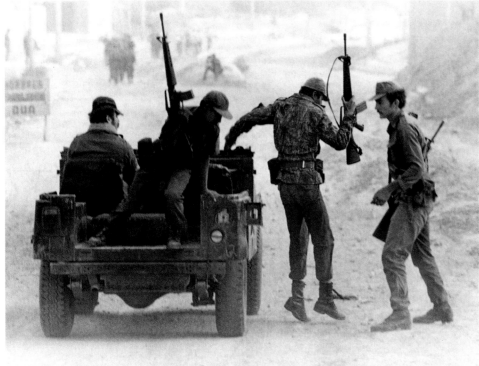

2

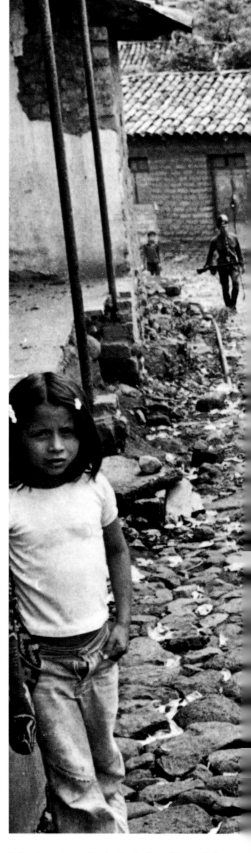

Nicaragua and El Salvador

(1) A band of Contra right-wing guerrillas in training in the jungle of Nicaragua. They were covertly equipped with arms and aid on the initiative of President Reagan in a complicated deal involving funds from Iran, though Congress had vetoed direct military aid to the fighters. (2) Salvadorean government troops come under guerrilla sniper fire on the main road into San Salvador. (3) Government militia patrol a village in northern El Salvador, in a war which saw excessive activity by death squads.

Nicaragua und El Salvador

(1) Ein Trupp der rechtsgerichteten Contra-Rebellen bei der Ausbildung im Dschungel Nicaraguas. In einem komplizierten Geschäft, an dem auch Finanzen aus dem Iran beteiligt waren, unterstützte US-Präsident Reagan sie mit Waffen und Mitteln, obwohl der Kongreß gegen direkte Militärhilfe sein Veto eingelegt hatte. (2) Regierungstruppen El Salvadors geraten auf der Hauptstraße nach San Salvador in das Feuer von Guerilla-Heckenschützen. (3) Regierungstruppen patrouillieren in einem Dorf im Norden El

Salvadors; im salvadorianischen Bürgerkrieg verübten Todesschwadrone zahllose Greuel-taten.

Le Nicaragua et le Salvador

(1) Une bande de contras d'extrême-droite à l'entraînement dans la jungle du Nicaragua. Ils sont secrètement armés et soutenus par les USA à l'initiative du président Reagan, selon un accord compliqué engageant des fonds iraniens, malgré le veto du Congrès à toute aide militaire directe aux combattants. (2) Des soldats du gouvernement salvadorien

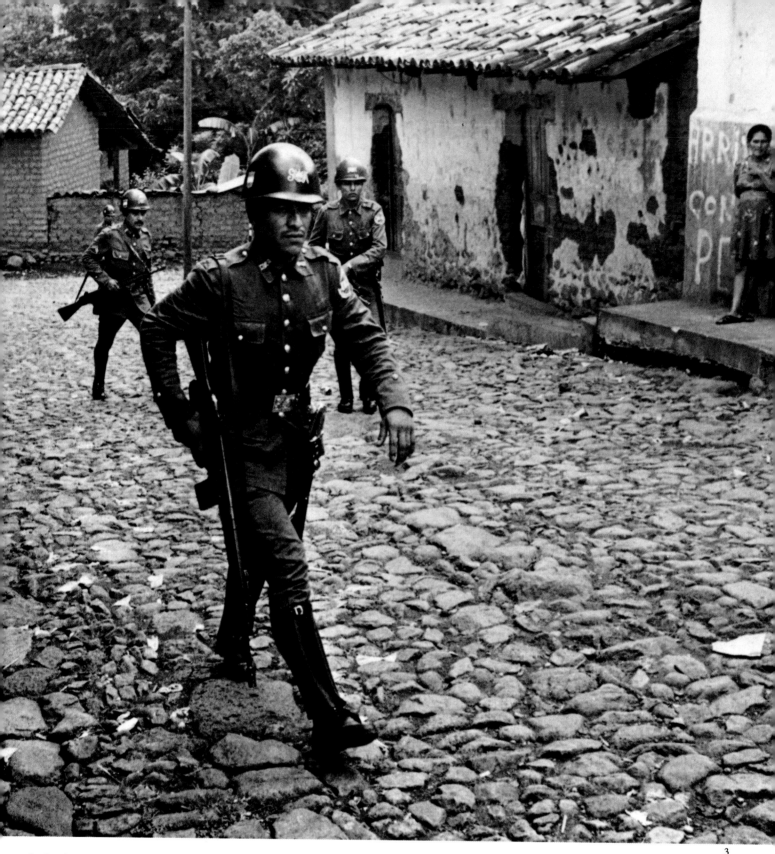

sous le feu de tireurs isolés sur la route
principale conduisant à San Salvador.
(3) Miliciens du gouvernement patrouillant
dans un village au nord du Salvador, dans
une guerre marquée par les excès des
escadrons de la mort.

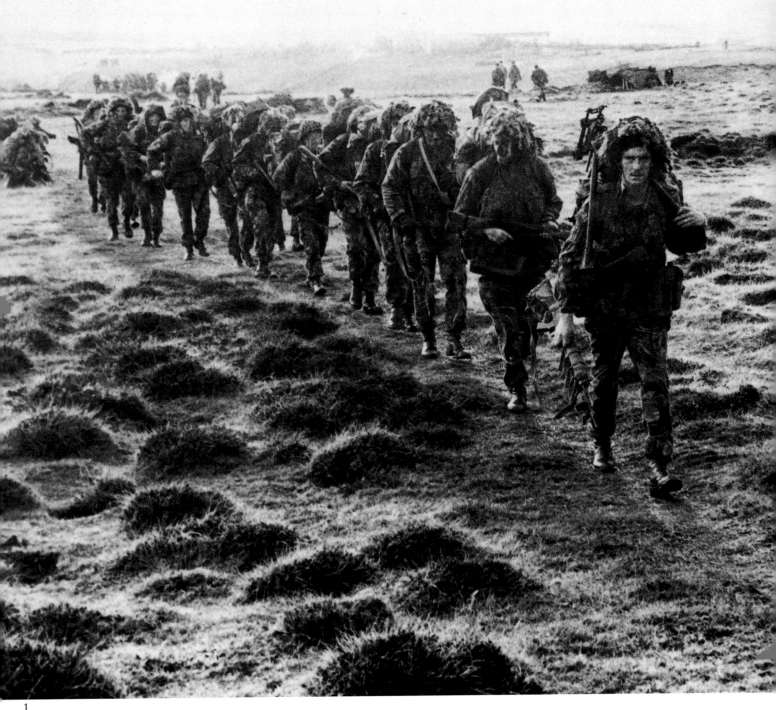

1

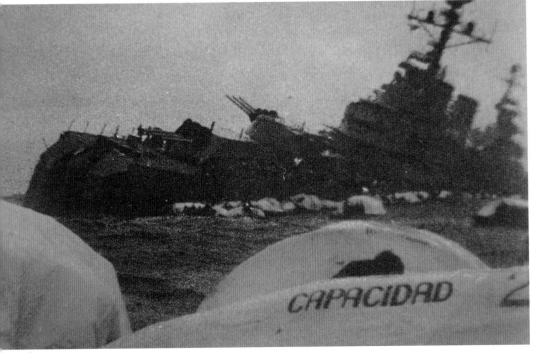

2

The Falklands War

(1) British troops march across the main island for the final attack on the tiny capital, Stanley. (2) In late April 1982 the battle-cruiser *General Belgrano* was sunk on the edge of the exclusion zone with the loss of over 300 lives – as the USS *Phoenix* she had survived Pearl Harbor in 1941. (3) British wounded after the destroyer HMS *Sheffield* was sunk by an Exocet missile. (4) The frigate HMS *Antelope* explodes after a bomb 'cooks' amidships.

Der Falklandkrieg

(1) Britische Truppen bei ihrem Marsch über die Hauptinsel zum letzten Angriff auf die winzige Hauptstadt Stanley. (2) Ende April 1982 wurde der argentinische Schlachtkreuzer *General Belgrano* am Rande der Sperrzone versenkt; über 300 Mann kamen um. Als USS *Phoenix* hatte das Schiff 1941 den Angriff auf Pearl Harbor überstanden.

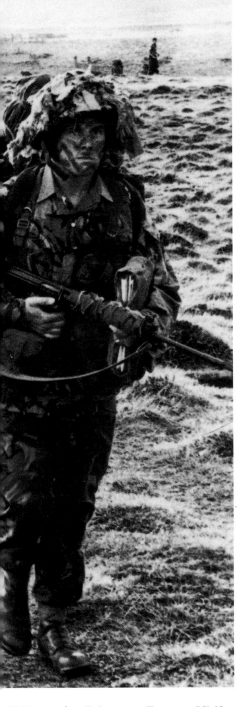

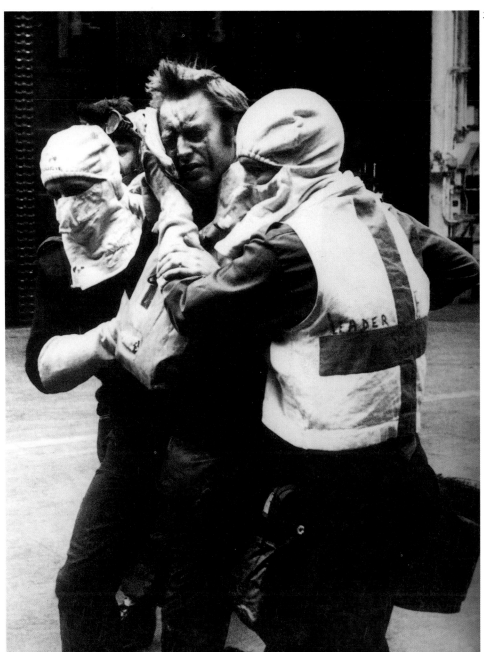

(3) Verwundete Briten vom Zerstörer HMS *Sheffield,* den der Treffer einer Exocet-Rakete versenkte. (4) Die Fregatte HMS *Antelope* explodiert, nachdem an Bord eine Bombe gezündet hat.

La guerre des Falkland

(1) Soldats britanniques en marche dans l'île principale pour l'attaque finale sur la petite capitale, Stanley. (2) Fin avril 1982, le croiseur cuirassé *General Belgrano* est coulé au bord de la zone d'exclusion, faisant plus de 300 morts. Comme le *Phoenix,* il avait survécu à Pearl Harbor, en 1941. (3) Soldats britanniques blessés après que le destroyer *Sheffield* ait été coulé par un missile Exocet. (4) Explosion de la frégate *Antelope* par une bombe située au milieu du navire.

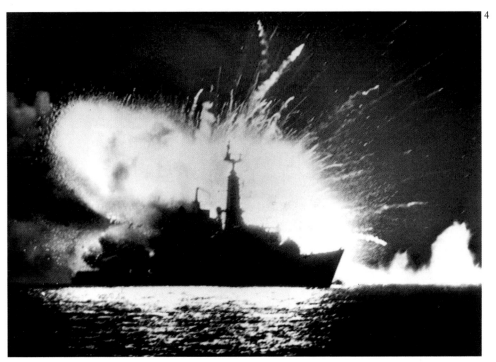

Retreat and Chaos: the well-heads of the Kuwaiti oil fields set ablaze by the retreating Iraqis at the end of the Gulf War, February 1991. The fires caused huge damage, and were extinguished only after months of work by fire teams from all over the world. Though he was to lose quantities of armour and more than 100,000 casualties Saddam continued in power, if anything tightening his grip over dissidents.

Rückzug und Chaos: die Brunnen der kuwaitischen Ölfelder, die von den Irakern auf ihrem Rückzug gegen Ende des Golf-kriegs in Brand gesetzt wurden, Februar 1991. Die Feuer verursachten große Schäden und konnten erst nach monatelangem Einsatz von Feuerwehrteams aus der ganzen Welt gelöscht werden. Obwohl Saddam Hussein große Materialverluste und mehr als 100 000 Tote hinnehmen mußte, blieb der Diktator an der Macht und unterdrückte politische Dissidenten danach stärker als zuvor.

Retrait et chaos: les Irakiens mettent le feu aux puits de pétrole koweitiens lors de leur retrait de l'émirat en février 1991. Les incendies ont causé d'immenses dégâts et ont été éteints des mois après par des équipes venues du monde entier. Bien qu'ayant subi d'énormes pertes en blindés et en hommes (plus de 100 000), Saddam est resté au pouvoir, accentuant même sa pression sur les opposants.

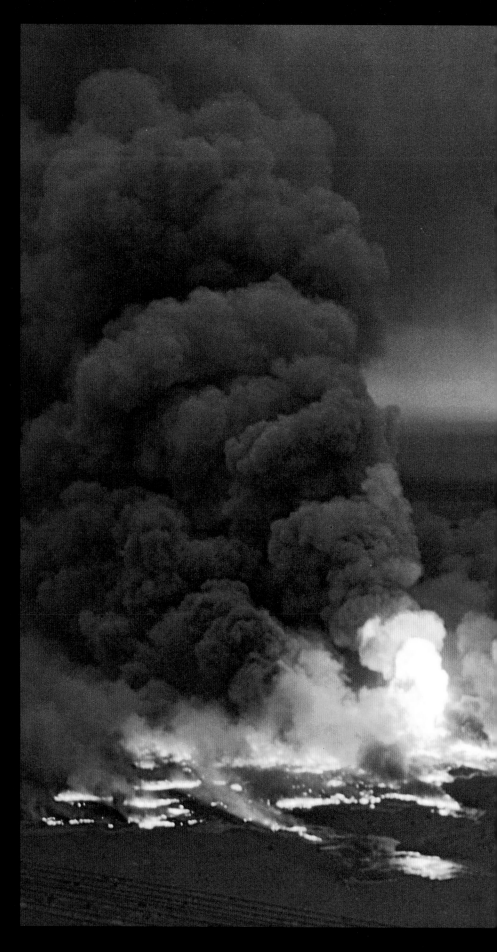

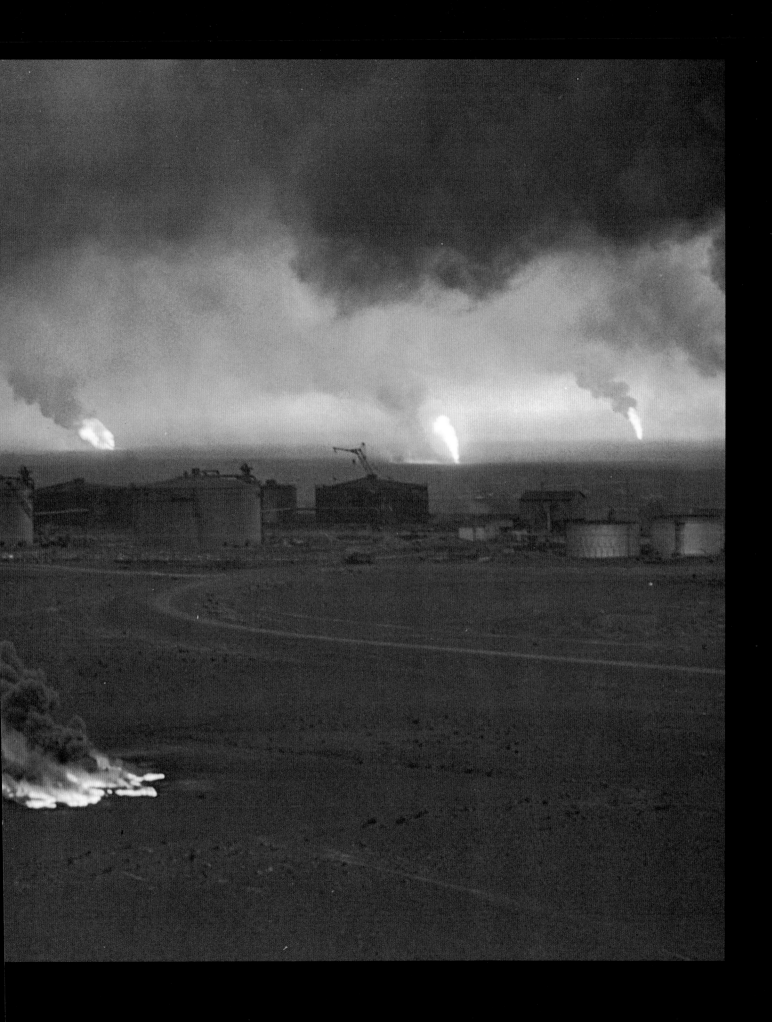

Cursed Are the Peacemakers

Less than a month after the cranes and bulldozers pulled asunder the reinforced concrete of the Berlin Wall, the American Secretary of State, James Baker, visited the city to proclaim 'a new world order'. He said that nuclear confrontation on the scale of that between Nato and the Warsaw Pact should be a thing of the past, and that alliances should be based on economic cooperation and the recognition of human rights.

Events of the next five years were to prove otherwise; the Nato allies and the UN were to become more active in trying to maintain order in an increasingly unruly world. Regional wars in Sri Lanka, Afghanistan, the Horn of Africa and Angola flared with increased intensity. Massacre and genocide became looming spectres in three continents. By 1995 the UN was involved in more than 40 military peace missions across the world – straining budget, administration and credibility to breaking point. In 1995 Nato deployed a ground force on active service for the first time in a peace mission in Bosnia, which was to test to the limit its validity in the post-modern world. For the nations who had confronted each other and fought proxy wars in the Cold War, and were now contributing troops to peacekeeping missions by the dozen, the notion of a 'a new world order' and the 'peace dividend' proclaimed in 1989 carried a bitter message: cursed are the peacemakers.

New wars were coming with an old face; instead of the armies being loyal first to their nation and state, they were the warriors of the people, the race, the tribe and the community. Faced with this, the advanced armies of Nato and the developed world, whether wearing the blue helmets of the UN peacekeeper or the Nato combat soldier, struggled to meet the new challenge of the bloody tactics of tribal warfare.

The first big challenge came when on 2 August 1990 the armour of Saddam Hussein's Republican Guard rolled into Kuwait city and grabbed the emirate, which has been described as the largest oil well in the world. The Americans and their allies, including those from the Arab nations, could not allow the notoriously unpredictable and bloodthirsty dictator Saddam to corner nearly a third of the world's oil production. They should, however, have seen this threat coming – like the Falklands, and the Bosnia conflict, the war against Saddam was marked by a spectacular failure of intelligence-gathering or analysis. For eight years Saddam had fought a bloody and largely static war against Iran, which killed and wounded more than a million civilians and soldiers. In 1988 he had used mustard gas to destroy Kurd villages in the Mosul area. He had a formidable arsenal of chemical and biological weapons, and was prepared to use them.

Where aggression was concerned Saddam was a repeat offender, and so when he began to warn Kuwait about stealing Iraqi oil reserves by cross-border drilling, and causing a drop in world oil prices by overproduction, the outside world should have been on alert. It was not. Saddam's tactics, in the event, relied heavily on bluff – but it was an expensive bluff for America and her allies.

In the end it took 350,000 heavily armed American and allied troops in 17 divisions to dislodge the 450,000 Iraqi troops from Kuwait. The campaign which opened on the night of 17 January 1991 was to be a test of the American 'air/land 2000' tactics, the refinement of both *Blitzkrieg* and Russian shock attack. It was the last of the old tactical wars and the first of the new hi-tech electronic era. On 17 January the new American F-117 Stealth fighters went into action for the first time, bombing communications installations round Baghdad. Tomahawk Cruise missiles were aimed with such accuracy that reporters in the Iraqi capital saw one negotiating the main boulevard with the precision of a police car.

At the end of February a third of a million allied troops drove into southern Iraq and within 100 hours the war was over. The ground battle was never more than a pursuit, a hunt for fleeing Iraqis who had been abandoned by their commanders. The television images of the devastation of a fleeing column of Iraqi soldiers and civilians helped persuade President George Bush to call off the campaign with the accomplishment of only its minimum aim, the liberation of Kuwait itself. The whole episode of Operation Desert Storm was to leave more questions than answers.

The reporting of the war was as spectacular as the technology of its weaponry. Satellite television showed the bombing of Baghdad as it happened, the firing of multi-launch rockets, and the advance of the tanks. But the media missed the crucial battle, which was portrayed as a small raid by Iraqi armour on the Saudi fishing port of Khafji at the end of January. In reality this started as a pre-emptive strike with a big division, but the advance tanks got caught in their own minefield and were pulverized from the air by American strike planes. The world media reported this only as a skirmish with the few troops that got to Khafji. But at the beginning the Iraqi divisional commander requested permission to release chemical weapons: this was refused and, when the action failed, he was recalled to Baghdad and shot. Equally the world media did not report the initial mission of the allied ground forces – to destroy the elite Republican Guard and cut the Euphrates lines. Indecision by the allies allowed Saddam to reassert his power against Shi'ites rebelling in the south and Kurds in the north.

A mere three months after the end of the war with Saddam and 'operation provide comfort' for the Kurds, the Nato allies were watching war unfolding in Europe. At the end of June

1991 Slovenia, one of the republics of the Yugoslav Federation, announced its full independence, giving Croatia little option but to follow. The Serb-dominated Yugoslav Federal Army attempted to seal Yugoslavia's international borders, then turning to protect the Serb minority in Croatia. By the autumn all-out war had developed with tanks and artillery, and murderous guerrilla irregulars. The international community, whether through the European Community or the UN, seemed incapable of anticipating events or devising a policy to halt the growing turmoil in southern Europe. They did impose an arms embargo; this favoured the Serbs with their predominant support from the officer corps of the old Federal Army, which became increasingly the Serb army. By the end of 1991 the Croats had lost nearly a third of their territory. The town of Vukovar on the Danube had been reduced to a ruin by three months of siege, at the end of which the Serbs shot at least 1400 of their captives and buried them in mass graves.

In Bosnia trouble flared in the spring of 1992. Once Croatia was recognised internationally at the end of 1991, the Bosnians knew they were faced with their own war of independence, which was an even more one-sided affair than that in Croatia. The Bosnians said at the time, 'We had a war before we had an army, and an army before we had a state.' Leading politicians in the West breathed the rhetoric of 1930s appeasement. The British Foreign Secretary Douglas Hurd refused to consider lifting the arms embargo on the Bosnians as it would create 'a level killing field'. Earlier he had told the Croats in 1991 that the international community would do anything to resolve the crisis in Yugoslavia 'short of the use of force'.

Yet in the end international force had to be used, after the Serbs had occupied nearly 70 per cent of the country – though they had a third of the population – and the Croats and Muslims had fought each other as well as their common Serb foe. In 1992 the UN despatched 16,000 troops to help aid convoys and displaced refugees, but by the end of the following year more than 60 per cent of the entire population had been forced out of their homes. More than 150 peacekeepers were to die, often carrying out missions the UN Security Council and its ineffectual Secretary-General Boutros Ghali would not give them the means to fulfil, such as the protection of four Muslim enclaves inside Serb territory in northern and eastern Bosnia. It was when one of these, at Srebrenica, fell in July 1995 with the accompanying cold-blooded massacre of at least 3000 unarmed Muslim men and boys that the Americans and Nato decided to act. American airpower effectively bombed the Serbs to the negotiating table. Judicious use of French and British artillery brought an end to the three-and-a-half-year siege of Sarajevo, the longest in modern European warfare.

For the photographers and reporters, the war in Bosnia marked the beginning of armoured journalism. They began to wear bullet-proof vests and helmets, and travelled routinely in armour-protected vehicles for the first time. The same happened in the fighting and massacres in Somalia in 1993 and

Soldiers of the UNIFIL force standing guard in southern Lebanon: one of the most thankless of UN peacekeeping missions, with fire coming from both the Israelis and local militias.

Soldaten der UNIFIL-Streitkräfte halten im Südlibanon Wache – eine der undankbarsten UN-Friedensmissionen, mit Angriffen sowohl von israelischer als auch von libanesischer Seite.

Des soldats de l'UNIFIL en faction au Sud-Liban, une des plus ingrates missions de maintien de la paix des Nations unies car les Casques bleus se trouvent pris entre le feu israélien et celui des milices locales.

Rwanda in 1994, where more than half a million died in tribal butchery and many more fled to neighbouring Zaire. More reporters and photographers were killed in these three conflicts in three years than in Vietnam. Not only were they on the front line in the new warfare – they were part of it, often providing information where soldiers and diplomats were in the dark. Their pictures and words showed the hesitancy in taking decisive action displayed by modern diplomats and leaders of the Western democracies as the aftermath of the Cold War headed towards new world disorder.

Czech decontaminators had to go into action when the allies seized dumps of chemical and biological weapons in the 1990-91 Gulf War. The British armed forces called up more than 2000 doctors and auxiliaries for service in Britain and the Gulf for such a contingency.

Nachdem die Alliierten im Golfkrieg 1990-91 Depots mit chemischen und biologischen Waffen eingenommen hatten, mußten tschechische Entgiftungsexperten eingesetzt werden. Die britischen Streitkräfte hielten mehr als 2000 Ärzte und Helfer in Großbritannien und am Golf für den Ernstfall bereit.

Des décontaminateurs tchèques sont utilisés par les forces alliées lorsqu'elles saisissent des dépôts d'armes chimiques et biologiques pendant la guerre du Golfe, 1990-91. L'armée britannique a mobilisé 2000 médecins et auxiliaires pour servir en Grande-Bretagne et dans le Golfe en cas d'attaque chimique ou biologique.

Knapp einen Monat, nachdem Krane und Bulldozer die Stahlbetonplatten der Berliner Mauer auseinandergebrochen hatten, besuchte der amerikanische Außenminister James Baker die Stadt und proklamierte eine »Neue Weltordnung«. Er erklärte das Ausmaß der nuklearen Konfrontation, wie sie zwischen NATO und Warschauer Pakt geherrscht hatte, zu einem Relikt der Vergangenheit. Bündnisse sollten nun auf ökonomischer Zusammenarbeit und der Anerkennung der Menschenrechte beruhen.

Die Ereignisse der nächsten fünf Jahre wiesen jedoch in eine andere Richtung: Die NATO-Partner und die UN mußten sich aktiv für den Erhalt der Ordnung in einer ständig unruhiger werdenden Welt einsetzen. Regionale Kriege in Sri Lanka, Afghanistan, am Horn von Afrika und in Angola flackerten mit wachsender Intensität auf. Massaker und Völkermord entwickelten sich mit erschreckenden Auswirkungen auf drei Kontinenten. Bis 1995 war die UN mit mehr als 40 militärischen Friedensmissionen auf der ganzen Welt im Einsatz, die ihr Budget, ihren Verwaltungsapparat und ihre Glaubwürdigkeit bis an die Grenzen der Belastbarkeit forderten. 1995 sandte die NATO erstmals Bodentruppen zum aktiven Friedenseinsatz nach Bosnien – eine Mission, die die Rechtsgültigkeit der UN in einer postmodernen Welt auf

ihre bisher schwerste Probe stellen sollte. Für diejenigen Nationen, die sich im Kalten Krieg feindlich gegenübergestanden und Stellvertreterkriege ausgefochten hatten und jetzt mit ihren Streitkräften Dutzende von Friedensmissionen unterstützten, beinhaltete die Idee einer »Neuen Weltordnung« und einer »Friedensdividende«, wie sie 1989 verkündet worden war, eine bittere Botschaft: Verflucht sind die Friedensstifter.

Neue Kriege entstanden in alten Gewändern: An die Stelle von Armeen, die in erster Linie ihrer Nation und ihrem Staat treu waren, traten nun die Kämpfer für das Volk, die Rasse, den Stamm und die Gemeinschaft. Konfrontiert mit dieser Art von Krieg, hatten die modernen Armeen der NATO und der westlichen Welt – ob Blauhelme der UN-Friedenstruppe oder NATO-Kampfeinheiten – Schwierigkeiten, sich mit der neuen, blutigen Taktik des Stammeskrieges zurechtzufinden.

Die erste große Herausforderung kam am 2. August 1990, als Saddam Husseins Republikanische Garde in Kuwait City einmarschierte und das Emirat, das als der größte Ölbrunnen der Welt galt, annektierte. Die Amerikaner und ihre Verbündeten, einschließlich einiger arabischer Nationen, waren nicht bereit zuzulassen, daß der als unberechenbar und blutrünstig bekannte Diktator Saddam fast ein Drittel der Ölförderung der Welt in seine Hand brachte. Auch wenn dieser Schlag vorhersehbar war, ist der Krieg gegen Saddam – ebenso wie der Falklandkrieg und der Bosnienkonflikt – durch ein spektakuläres Versagen bei der Sammlung und Auswertung von Geheimdienstinformationen gekennzeichnet. Acht Jahre lang hatte Saddam einen blutigen und größtenteils statischen Krieg gegen den Iran geführt, bei dem mehr als eine Million Zivilisten und Soldaten getötet oder verwundet wurden. 1988 hatte er Senfgas zur Zerstörung kurdischer Dörfer in der Mosul-Gegend eingesetzt. Ihm stand ein bemerkenswertes Arsenal an chemischen und biologischen Waffen zur Verfügung, und er war bereit, davon Gebrauch zu machen.

Was aggressive Politik anging, so hatte Saddam sich dessen bereits mehrfach schuldig gemacht. Als er damit begann, Kuwait vor dem Diebstahl irakischer Ölreserven durch Bohrungen jenseits der Grenze und vor einem Fall der Ölpreise wegen Überproduktion zu warnen, hätte die übrige Welt hellhörig werden müssen. Aber nichts geschah. In diesem Fall beruhte Saddams Taktik größtenteils auf Bluff – ein Bluff, der Amerika und seine Verbündeten teuer zu stehen kam.

Letztendlich benötigte man 350 000 schwerbewaffnete amerikanische und verbündete Truppen in 17 Divisionen, um die 450 000 irakischen Soldaten aus Kuwait zu vertreiben. Der Feldzug, der in der Nacht zum 17. Januar 1991 begann, wurde zum Test der amerikanischen »Luft/Land 2000«-Strategie, einer Verfeinerung des deutschen »Blitzkriegs« und des russischen Überraschungsangriffs. Er war der letzte der alten taktischen Kriege und der erste des elektronischen Hi-Tech-Zeitalters. Am 17. Januar kamen die neuen amerikanischen Kampfflugzeuge vom Typ F-117 »Stealth Fighter« bei der Bombardierung Bagdads erstmals zum Einsatz. Tomahawk-Cruise-Missiles wurden mit einer solchen Genauigkeit auf ihr

Ziel angesetzt, daß Reporter in der irakischen Hauptstadt einen dieser Marschflugkörper mit der Präzision eines Polizeiwagens verglichen, der über eine Hauptstraße fuhr.

Ende Februar drangen mehr als 300 000 alliierte Soldaten in den Südirak ein, und nur 100 Stunden später war der Krieg beendet. Die Schlachten am Boden waren nicht mehr als Verfolgungsgefechte – eine Jagd auf fliehende Iraker, die von ihren Kommandanten im Stich gelassen worden waren. Die Fernsehbilder von der heillosen Flucht aufgeriebener irakischer Verbände und von Zivilisten am Mutla Ridge außerhalb von Kuwait City trugen dazu bei, Präsident Bush zur Beendigung des Feldzugs zu überreden, nachdem das erste Ziel – die Befreiung Kuwaits – erreicht worden war. Die »Operation Desert Storm« hinterließ jedoch mehr offene Fragen als Antworten.

Ebenso spektakulär wie die Technologie der eingesetzten Waffen war auch die Berichterstattung über diesen Krieg. Satellitenbilder zeigten die Bombardierung Bagdads, den Abschuß von Mehrfach-Raketen und den Vormarsch der Panzer unmittelbar während des Geschehens. Aber die Medien verpaßten das entscheidende Gefecht, das als kleiner Überfall irakischer Panzerfahrzeuge auf den saudi-arabischen Fischerhafen Khafji Ende Januar dargestellt wurde. In Wirklichkeit handelte es sich um einen Präventivschlag einer starken Division. Die vorstoßenden Panzer wurden allerdings in ihrem eigenen Minenfeld gefangen und durch amerikanische Kampfflieger aus der Luft zerstört. Die Medien der Weltöffentlichkeit berichteten von diesem Gefecht lediglich als Scharmützel zwischen den wenigen Truppen, die bis nach Khafji vorgedrungen waren. Zu Beginn der Aktion bat der irakische Divisonskommandeur um die Erlaubnis, chemische Waffen einsetzen zu dürfen. Aber seine Bitte wurde abgelehnt, und als die Aktion scheiterte, befahl man den Mann nach Bagdad und stellte ihn vor ein Erschießungskommando. Die Weltmedien berichteten ebenfalls nicht von der ursprünglichen Mission der alliierten Landstreitkräfte: Zerstörung der Eliteeinheit der Republikanischen Garden und Durchbruch durch die Euphratlinien. Die Unentschlossenheit der Alliierten ermöglichte es Hussein, seine Kräfte erneut zu sammeln und sie gegen schiitische Rebellen im Süden sowie gegen Kurden im Norden einzusetzen.

Nur drei Monate nach dem Ende des Krieges gegen Saddam Hussein und der »Operation humanitäre Hilfe« für die Kurden erlebte die NATO den Beginn eines Krieges in Europa. Ende Juni 1991 erklärte sich Slowenien, eine Teilrepublik der Jugoslawischen Föderation, für unabhängig – ein politischer Schachzug, der Kroatien wenig Alternativen ließ, außer es Slowenien gleichzutun. Die von Serben dominierte jugoslawische Bundesarmee versuchte, Jugoslawiens innere Grenzen abzuriegeln und übernahm dann den Schutz der serbischen Minderheit in Kroatien. Bis zum Herbst hatte sich ein vollständiger Krieg mit Panzern, Artillerie und mörderischen Guerillatruppen entwickelt. Die internationale Gemeinschaft schien weder mit Hilfe der EG noch durch die UN in der Lage, die Ereignisse vorauszuberechnen oder eine

Politik zu führen, die der wachsenden Unruhe in Südeuropa Einhalt gebieten konnte. Man verhängte ein Waffenembargo, was den Serben zugute kam. Diese wurden von den Offizieren der alten Bundesarmee unterstützt, die sich immer stärker in eine rein serbische Armee verwandelte. Bis Ende 1991 hatten die Kroaten fast ein Drittel ihres Territoriums verloren. Die Stadt Vukovar an der Donau wurde nach einer dreimonatigen Belagerung, an deren Ende die Serben mindestens 1400 ihrer Gefangenen erschossen und in Massengräbern begruben, dem Erdboden gleichgemacht.

Im Frühjahr 1992 flackerten auch in Bosnien die ersten Unruhen auf. Nachdem Kroatien Ende 1991 international anerkannt worden war, wußten die Bosnier, daß nun ihr eigener Unabhängigkeitskrieg bevorstand – eine noch einseitigere Angelegenheit als in Kroatien. Zu dieser Zeit sagten die Bosnier: »Wir hatten einen Krieg, bevor wir eine Armee hatten, und wir hatten eine Armee, bevor wir einen Staat hatten.« Führende Politiker der westlichen Welt griffen wieder auf die Rhetorik der Appeasement-Politik der 30er Jahre zurück. Der britische Außenminister Douglas Hurd lehnte die Aufhebung des Waffenembargos gegen Bosnien ab, weil damit ein »Kopf-an-Kopf-Schlachtfeld« geschaffen würde. 1991 hatte er bereits den Kroaten versichert, daß die internationale Gemeinschaft alles »bis an die Grenzen des Kampfeinsatzes Mögliche« tun werde, um die Krise in Jugoslawien zu beenden.

Am Ende mußten jedoch internationale Streitkräfte eingesetzt werden, nachdem die Serben – obwohl sie nur ein Drittel der Bevölkerung ausmachten – fast 70 Prozent des Landes eingenommen hatten und die Kroaten und Moslems sowohl gegeneinander als auch gegen den gemeinsamen serbischen Feind kämpften. 1992 sandte die UN 16 000 Soldaten zur Sicherung der Hilfslieferungen und zum Schutz von Flüchtlingen in die Krisengebiete. Trotzdem wurden bis zum Ende des folgenden Jahres mehr als 60 Prozent der Gesamtbevölkerung aus ihrer Heimat vertrieben. Über 150 Friedenssoldaten starben – viele von ihnen bei dem Versuch, eine Mission zu erfüllen, wofür ihnen vom UN-Sicherheitsrat und seinem wirkungslosen Generalsekretär Boutros Ghali nicht die nötigen Mittel zur Verfügung gestellt worden waren. Dies galt beispielsweise für die Sicherung von vier Moslem-Enklaven auf serbisch besetztem Gebiet in Nord- und Ostbosnien. Als im Juli 1995 eine dieser Enklaven, Srebrenica, genommen wurde und die Serben in einem blutigen Massaker mindestens 3000 unbewaffnete moslemische Männer und Jungen ermordet hatten, entschlossen sich die Amerikaner und die NATO zum Eingreifen. Die amerikanische Luftwaffe bombte die Serben erfolgreich an den Verhandlungstisch, und der kluge Einsatz von französischer und britischer Artillerie machte der dreieinhalbjährigen Belagerung von Sarajevo, der längsten Belagerung in der modernen Kriegsgeschichte, ein Ende.

Für die Fotografen und Reporter bedeutete der Bosnienkrieg den Beginn des bewaffneten Journalismus. Man trug kugelsichere Westen und Helme und reiste durchweg in

gepanzerten Wagen. Dasselbe geschah bei den Kämpfen und Massakern in Somalia 1993 und in Ruanda 1994, bei denen mehr als eine halbe Million Menschen in Stammeskriegen umkamen und weitaus mehr Flüchtlinge ins benachbarte Zaire drängten. Innerhalb von drei Jahren wurden in diesen drei Konfliktherden mehr Reporter und Fotografen getötet als im Vietnamkrieg. Sie standen nicht nur an der Frontlinie der neuen Kriege – sie waren ein Teil dessen und lieferten häufig dort Informationen, wo Soldaten und Diplomaten im Dunklen tappten. Ihre Bilder und Reportagen dokumentierten das Zögern der modernen Diplomaten und Führer der westlichen Demokratien beim Versuch, entscheidende Schritte zu unternehmen, während die Welt sich vom Kalten Krieg einer »Neuen Weltunordnung« zuwandte.

M oins d'un mois après la démolition du Mur de Berlin par les bulldozers et les grues, le secrétaire d'Etat américain James Baker vient en visite dans la capitale allemande. Il y annonce un «nouvel ordre mondial» car, affirme-t-il, la confrontation nucléaire entre l'OTAN et le pacte de Varsovie est du passé, et les alliances doivent dorénavant reposer sur la coopération économique et la reconnaissance des droits de l'homme.

Les événements des cinq années à venir démentiront cette déclaration américaine: les membres de l'OTAN et de l'ONU auront plus encore à faire pour maintenir l'ordre dans un monde en proie à une anarchie croissante. Au Sri Lanka, en Afghanistan, dans la corne de l'Afrique ou en Angola, les conflits s'intensifient. Sur trois continents, on voit resurgir le spectre du massacre ou du génocide. En 1995, l'ONU envoie une quarantaine de missions militaires de paix dans le monde, grevant ses ressources, son administration et sa crédibilité jusqu'à la limite. Pour la première fois, en 1995, l'OTAN déploie des forces terrestres en service actif dans le cadre d'une mission de paix en Bosnie, dont le but est de tester sa force dans le monde post-moderne. Pour les nations qui se sont affrontées tout au long de la guerre froide, souvent par nations interposées, et qui participent depuis à de nombreuses missions du maintien de la paix, la notion de «nouvel ordre mondial» et de «dividende de la paix» proclamée en 1989 recèle un message empoisonné: maudits soient les pacificateurs.

Les nouveaux conflits prennent une physionomie ancienne. Les armées ne font plus acte de loyauté à la nation et l'Etat mais avant tout à leur peuple, leur race, leur tribu ou leur communauté. Les armées du monde développé, Casques bleus ou forces de l'OTAN, ont bien du mal à faire face au nouveau défi que représentent les luttes tribales et leurs sanglantes tactiques.

Le premier grand défi est lancé par Saddam Hussein le 2 août 1990 lorsque les blindés de sa garde républicaine envahissent l'émirat du Koweït, considéré comme le plus riche puits de pétrole de la planète. Les Américains et leurs alliés, dont certains pays arabes, ne peuvent laisser l'imprévisible et sanguinaire dictateur de l'Irak mettre la main sur le tiers de la production pétrolière mondiale. Mais ils auraient pu prévoir le

danger. Comme aux Malouines ou en Bosnie, la guerre contre Saddam consacre l'éclatant échec des services de renseignements ou d'analyse. Huit ans auparavant, Saddam a mené une guerre meurtrière, et largement de positions contre l'Iran, avec à la clé un million de morts et de blessés parmi les civils et les soldats. En 1988, il a détruit les villages kurdes de la province de Mossoul au gaz moutarde. Il dispose alors d'un immense arsenal d'armes chimiques et biologiques et est prêt à s'en servir.

En matière d'agression, Saddam Hussein est un récidiviste notoire, aussi le reste du monde aurait-il dû être alerté lorsqu'il commence à accuser le Koweït de voler les réserves de pétrole de l'Irak en forant dans son sous-sol et de surproduire pour faire effondrer les prix mondiaux. Aucune réaction dans le monde. La tactique de Saddam repose, en l'occurrence, sur le bluff, mais un bluff qui va coûter très cher à l'Amérique et à ses alliés.

Il faut envoyer en effet 350 000 soldats américains et alliés lourdement armés – 17 divisions en tout – pour déloger du Koweït 450 000 Irakiens. L'opération lancée dans la nuit du 17 janvier 1991 va être un test pour la tactique «air-sol 2000» américaine, version perfectionnée du blitzkrieg allemand et de l'attaque de choc russe. Elle sonnera le glas des anciennes guerres de tactique et inaugurera la guerre électronique du futur. Les tout nouveaux F-117, les avions furtifs, entrent pour la première fois en action le 17 janvier, bombardant les centres de communication tout autour de Bagdad. La frappe des missiles Tomahawk est si infaillible que des reporters se trouvant dans la capitale irakienne peuvent en voir un négocier le boulevard principal avec la précision d'une voiture de police.

A la fin de février, plus de 300 000 hommes de l'armée alliée marchent dans le sud de l'Irak. En 100 heures, la guerre est finie. La bataille terrestre n'a jamais été qu'une chasse aux soldats irakiens, abandonnés par leurs commandants. Les pays alliés étaient divisés sur le dernier objectif à remplir. Les images, à la télévision, de la destruction d'une colonne de soldats et de civils irakiens en fuite convainquent le président américain George Bush de mettre fin à la campagne, l'objectif minimum ayant été rempli: la libération du Koweït. L'opération «tempête du désert» s'achève par plus de questions que de réponses.

La couverture de la guerre est aussi spectaculaire que l'armement Hi-tech. La télévision par satellite montre le bombardement de Bagdad, le tir des lance-roquettes multiples MLRS et l'avance des chars. Mais les médias ne perçoivent pas l'importance d'une bataille livrée fin janvier et présentée comme un petit raid de forces blindées irakiennes sur Khafji, port de pêche saoudien. C'est en réalité une attaque préventive lancée par une division blindée irakienne, mais les chars se fourvoient dans leur propre champ de mines où ils sont finalement pulvérisés par l'aviation américaine. Les médias internationaux en rendent compte comme d'une simple escarmouche de quelques troupes à Khafji. Pourtant, dès le début, le commandant de la division irakienne a demandé la permission d'utiliser des armes chimiques: on la lui a refusée

t, l'opération ayant échoué, il est rappelé à Bagdad et fusillé. Les médias n'évoquent pas plus la mission initiale de l'armée de terre alliée: celle de détruire la garde républicaine de Saddam et de percer les lignes de l'Euphrate. L'indécision des alliés permet à Saddam de briser la rébellion des Chiites dans le sud et des Kurdes dans le nord. Ceux-ci fuient par centaines de milliers dans les montagnes aux frontières de la Turquie et de l'Iran, une tragédie qui oblige par la suite le déploiement de forces internationales pour une longue mission humanitaire.

Trois mois à peine après la guerre du Golfe et l'opération d'assistance aux Kurdes, une guerre éclate sur le sol européen. À la fin de 1991, la Slovénie, une des républiques de la Fédération yougoslave, proclame son indépendance, obligeant ainsi la Croatie à suivre son exemple. L'armée fédérale yougoslave dominée par les Serbes essaie de fermer les frontières de la Yougoslavie, puis de protéger la minorité serbe de Croatie. A la fin de l'automne, la guerre est totale et la région livrée aux blindés et à l'artillerie ainsi qu'aux milices impitoyables. La communauté internationale, Communauté européenne ou ONU, paraît incapable d'anticiper les événements ou de trouver un moyen pour mettre fin au conflit. L'embargo sur les armes favorise les Serbes, ceux-ci bénéficiant du soutien massif de l'ancienne armée fédérale qui s'affirme de plus en plus comme une armée serbe. Fin 1991, les Croates ont perdu près du tiers de leur territoire. La ville de Vucovar sur le Danube est réduite en cendres au bout de trois mois de siège. Les Serbes, vainqueurs, exécutent 1400 prisonniers – beaucoup parmi eux sont des blessés graves ou des malades – et les mettent dans des fosses communes.

Le conflit se propage en Bosnie au printemps 1992. Une fois l'indépendance de la Croatie reconnue par la communauté internationale (fin 1991), les Bosniaques sont conscients de devoir mener leur propre guerre d'indépendance qui sera plus inégale encore qu'en Croatie. Ils disent à ce moment-là: « Nous avons eu une guerre avant d'avoir une armée, et une armée avant d'avoir un Etat». Les dirigeants occidentaux recourent à la politique d'apaisement des années 30. Le secrétaire du Foreign Office, Douglas Hurd, s'oppose à la levée de l'embargo sur les armes pour la Bosnie sous prétexte que cela créerait un «champ de la mort assuré». Quelque temps auparavant, il avait déclaré aux Croates que la communauté internationale ferait tout pour résoudre la crise en Yougoslavie «sauf recourir à la force».

Mais il faut se résoudre à faire usage de la force car les Serbes finissent par occuper 70% du territoire alors qu'ils représentent à peine un quart de la population yougoslave; les Croates et les Bosniaques, de leur côté, se battent aussi bien entre eux qu'avec leur ennemi commun, les Serbes. En 1992, le Conseil de sécurité des Nations unies envoie 16 000 Casques bleus pour protéger les convois humanitaires et les réfugiés, mais vers la fin de l'année suivante, plus de 60% des civils ont dû abandonner leurs maisons. Plus de 150 Casques bleus sont tués, souvent lors de missions que le Conseil de sécurité et son inefficace secrétaire général Boutros Ghali ne leur ont pas donné le moyen de remplir, telle la protection des

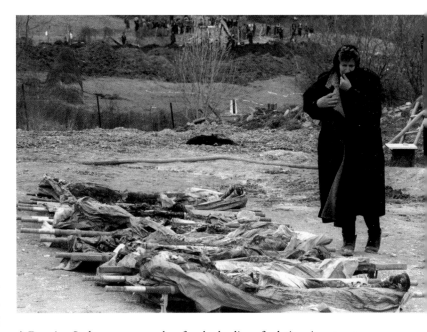

A Bosnian Serb woman searches for the bodies of relatives in a mass grave near Mrkonjic Grad, overrun in the Croat advance through western Bosnia in late 1995.

Eine bosnische Serbin sucht nach den Leichen von Verwandten in einem Massengrab nahe Mrkonjic Grad, das bei einem Vorstoß der Kroaten durch Westbosnien Ende 1995 überrannt wurde.

Une Serbe de Bosnie cherche les corps de parents dans une fosse commune près de Mrkonjic Grad, ville occupée par les Croates pendant leur campagne de Bosnie fin 1995.

enclaves musulmanes du nord et de l'est de la Bosnie, situées en territoire serbe. Ce n'est que lorsque dans l'une de ces enclaves, Srebrenica, tombée en juillet 1995, les Serbes massacrent au moins 3000 Musulmans, jeunes et vieux, que les Américains et l'OTAN se décident à agir. La puissance des bombardements américains pousse finalement les Serbes vers la table de négociation. Une utilisation judicieuse de l'artillerie française et britannique met fin à trois ans et demi de siège à Sarajevo, le plus long siège de la guerre moderne en Europe.

Pour les photographes et les reporters, la guerre en Bosnie ouvre l'ère du journalisme «en armure»: pour la première fois, ils sont forcés de se déplacer en véhicules blindés et de porter vestes et casques pare-balles. Même chose pendant la guerre de Somalie en 1993 et au Rwanda en 1994 où seront massacrées plus de 500 000 personnes, et où un plus grand nombre encore devra s'enfuir au Zaïre. Ces trois conflits font plus de victimes parmi les reporters et les photographes que toute la guerre du Vietnam. Ceux-ci non seulement se trouvent sur le front mais en sont partie intégrante, renseignant même soldats et diplomates dans l'ignorance. Leurs reportages montrent combien est grande l'incapacité des dirigeants et des diplomates occidentaux à prendre des mesures concrètes tandis qu'un nouveau désordre mondial naît des cendres de la guerre froide.

Saddam's Revenge

The Gulf War against Saddam Hussein ended with a headlong charge by allied troops into southern Iraq and Kuwait in February 1991. (1) An American Aegis-class cruiser patrols inshore against a backdrop of the burning well-heads and installations set alight by Iraqi troops. The Aegis radar system could target more than half the Gulf area by itself: the Iraqis had no chance against such sophisticated technology, and their air force was grounded after the first few days of Operation Desert Storm. (2) Tankers had been prime targets in both Gulf Wars: between Iran and Iraq (1979-88) and over Kuwait (1990-91). The Cypriot tanker *Pivot* after an Iranian attack, December 1987. (Overleaf) Troops of the crack 1st US Cavalry Division march back to their billets in the eastern desert after hearing a speech from James Baker, Secretary of State, November 1990.

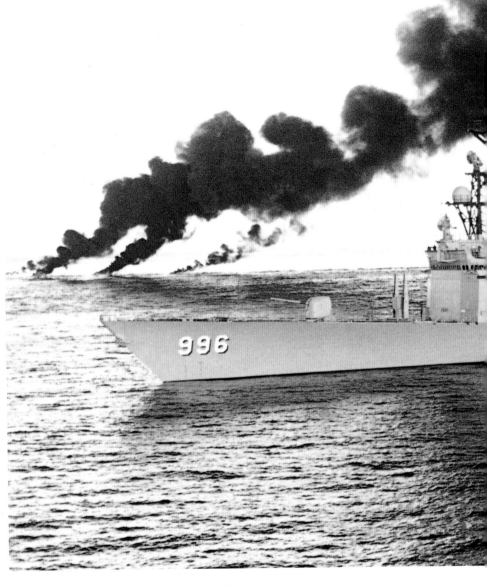

2

Saddams Rache

Der Golfkrieg gegen Saddam Hussein endete mit dem überstürzten Einfall alliierter Truppen in den Südirak und nach Kuwait im Februar 1991. (1) Ein amerikanischer Aegis-Kreuzer patrouilliert vor der Küste; im Hintergrund sind brennende Ölquellen und von irakischen Truppen in Brand gesetzte Bohranlagen zu erkennen. Das Radarsystem Aegis konnte mehr als die Hälfte des Golfgebiets überwachen. Gegen diese ausgefeilte Technologie hatten die Iraker keine Chance: Ihre Luftwaffe wurde bereits in den ersten Tagen der »Operation Desert Storm« vom Himmel geholt. (2) Tanker waren wichtige Ziele in beiden Golfkriegen – im Krieg zwischen dem Iran und dem Irak (1979-88) und im Krieg

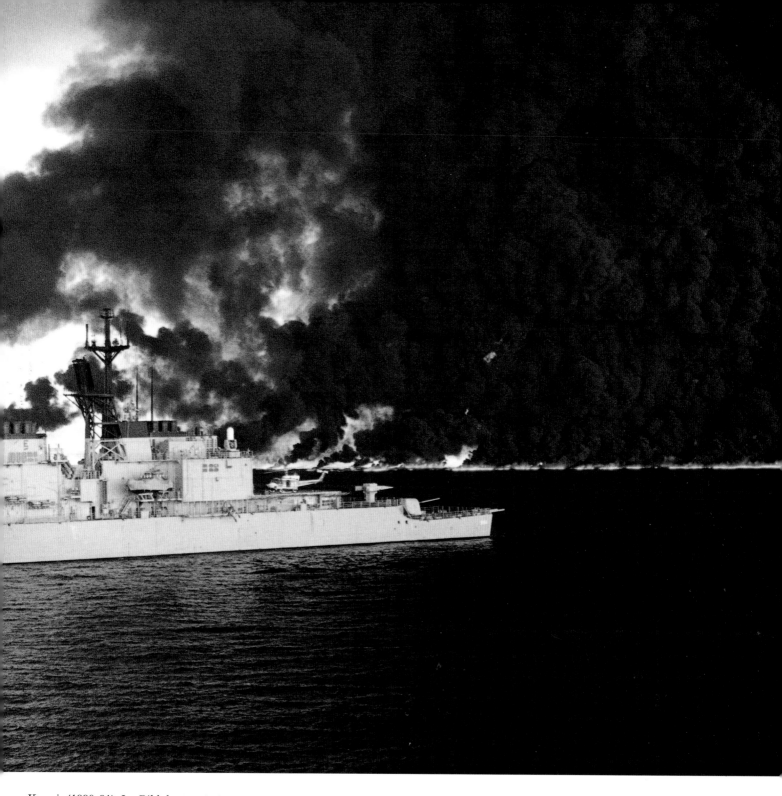

um Kuwait (1990-91). Im Bild der zypriotische Tanker *Pivot* nach einer iranischen Attacke, Dezember 1987. (Folgende Doppelseite) Truppen der berühmten 1st US Cavalry Division marschieren zurück in ihre Quartiere, nachdem sie einer Rede von Außenminister James Baker beigewohnt haben, November 1990.

La revanche de Saddam

La guerre du Golfe se termine par une charge éclair des forces alliées dans le sud de l'Irak et le Koweït en février 1991. (1) Un croiseur américain de type Aegis patrouille près de la côte; à l'arrière-plan, installations pétrolières incendiées par les troupes irakiennes. Le système radar Aegis peut contrôler plus de la moitié de la région du Golfe: les Irakiens n'ont aucune chance contre une telle technologie et leur aviation se retrouve clouée au sol dès les premiers jours de l'opération «tempête du désert». (2) Les tankers ont été des cibles privilégiées pendant les deux guerres du Golfe: entre l'Iran et l'Irak (1979-88) et au Koweït (1990-91). Décembre 1987, le tanker chypriote *Pivot* après une attaque iranienne. (Verso) Hommes de la fameuse 1ère division de cavalerie américaine revenant à leur cantonnement dans l'est du désert, après avoir écouté un discours de James Baker, secrétaire d'Etat, en novembre 1990.

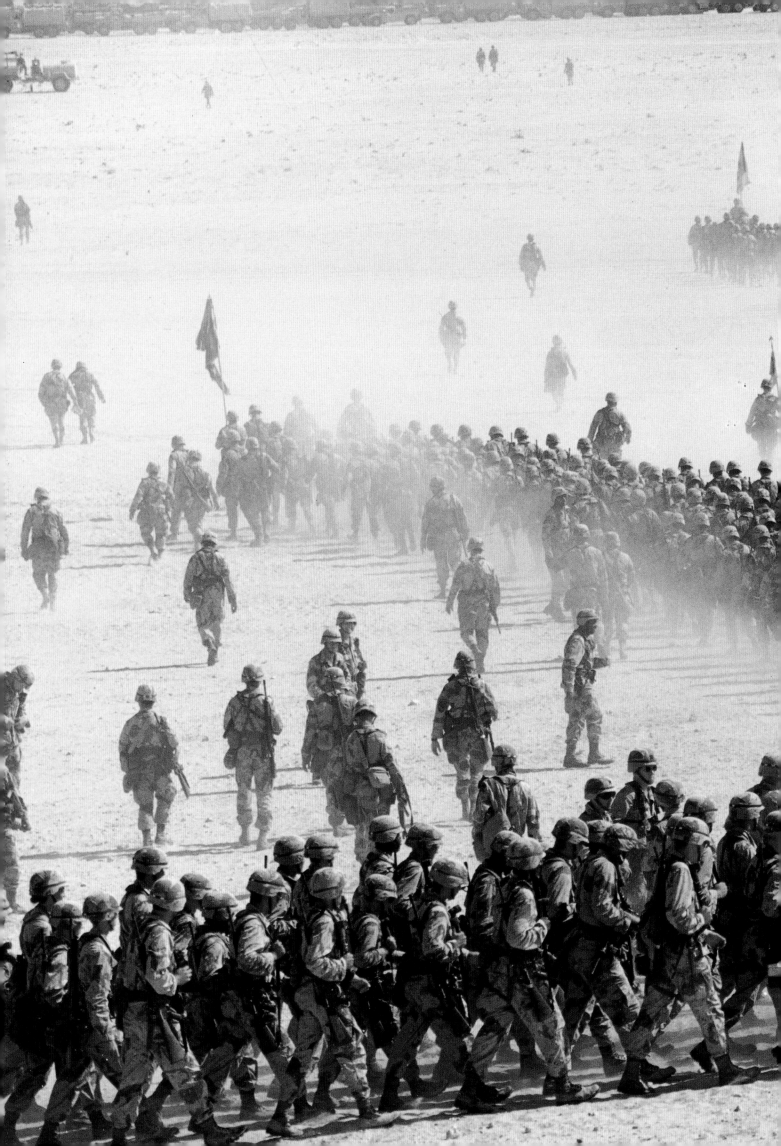

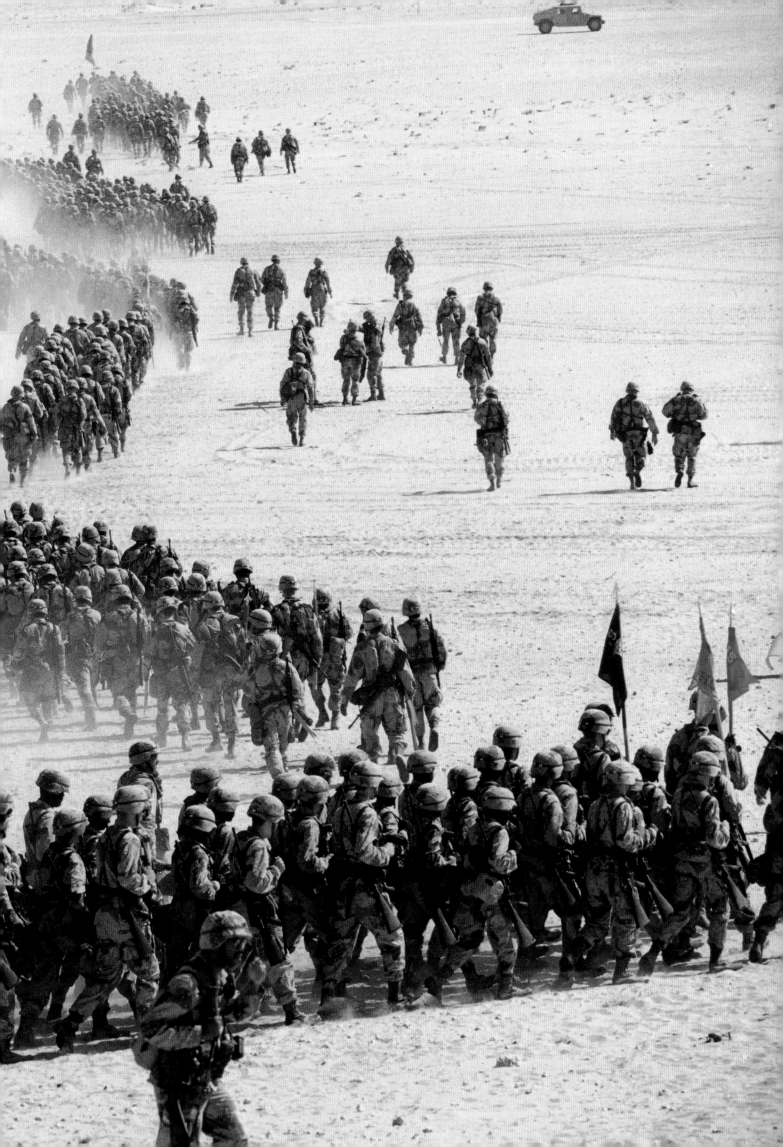

Fire Power

(1) A missile being fired during the allied ground advance 'Operation Desert Sabre', 100 hours into Kuwait. The American multi-launch rocket system proved superior to almost any other form of artillery, and in one salvo could destroy infantry positions over a third of a square kilometre; each rocket contained 264 fragmentation bomblets.
(2) The bombing of Baghdad as the offensive opened on 18 January 1991. Stealth fighters attacked communication centres and Tomahawk cruise missiles were launched from the US fleet in the Gulf and the Red Sea. These scenes were witnessed almost as they happened on satellite television by audiences across the world, including Baghdad itself. (3) An abandoned Iraqi T-72 tank, with an oil well burning in the background.

Feuerkraft

(1) Während des alliierten Landangriffs »Operation Desert Sabre« wird eine Rakete abgeschossen, etwa 100 Stunden nach Beginn der Operation. Die amerikanischen Mehr-fach-Raketensysteme erwiesen sich gegen-über fast allen anderen Formen von Artillerie als überlegen. Mit einer Salve konnten sie Infanteriepositionen im Umkreis von einem Quadratkilometer zerstören; jede dieser Raketen enthielt 264 Splitterbomben.
(2) Die Bombardierung Bagdads zu Beginn der Offensive am 18. Januar 1991. »Stealth Fighter« griffen Nachrichtenzentren an, während von der US-Flotte im Persischen Golf und im Roten Meer Tomahawk-Cruise-Missiles abgeschossen wurden. Diese Szenen konnten über Satellitenfernsehen fast zeit-gleich im Moment des Geschehens von Zuschauern auf der ganzen Welt gesehen werden – auch in Bagdad selbst. (3) Ein verlassener irakischer T-72-Panzer; im Hintergrund brennt eine Ölquelle.

Puissance de feu

(1) Un missile lancé par l'armée de terre alliée pendant l'opération « Sabre du désert » ou 100 heures au Koweït. Le système de lance-roquettes multiple MLRS, où chaque projectile contient 264 sous-munitions à fragmentation, s'avère supérieur à presque toute autre forme d'artillerie: une seule salve peut détruire des positions d'infanterie sur un tiers de kilomètre carré. (2) Le bombarde-ment de Bagdad commence le 18 janvier 1991. Les avions furtifs attaquent les centres de communication de la ville et la flotte américaine lance des missiles de croisière Tomahawk depuis le Golfe et la mer Rouge. Le monde entier, Bagdad compris, peut assister à ce bombardement grâce à la télévision par satellite. (3) Un char T-72 abandonné par l'armée irakienne avec, à l'arrière-plan, un puits de pétrole en feu.

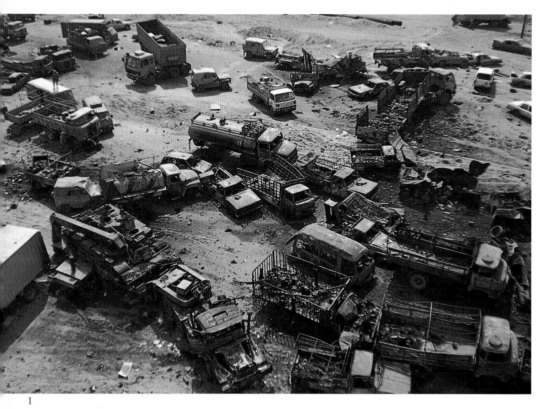

1

Highway of Death

(1) The scene that helped stop the war: the Mutla Ridge, Kuwait, 1 March 1991. American forces caught a column of Iraqi troops and civilians as they beat a retreat north in cars laden with booty. The column was blocked by tanks and pounded from the air by ground-attack aircraft and helicopters. This was the scene on television that persuaded the American administration to call a cease-fire. (2) The joy of liberation: some of the first troops, from Arab countries in American vehicles, arrive in the newly freed Kuwait City. (3) More than 90,000 prisoners were taken in a day and a half on the advance into Kuwait. Many were reluctant to go home; the exact number of Iraqi dead will never be known, though it could be as high as 100,000 on the southern battlefront alone.

Straße des Todes

(1) Die Szene, die dazu beitrug, den Krieg zu beenden: Mutla Ridge, Kuwait, 1. März 1991. Amerikanische Streitkräfte stellen eine Kolonne irakischer Truppen und Zivilisten auf dem Rückzug nach Norden mit Fahrzeugen voller Beutegut. Die Kolonne wurde durch Panzer gestoppt und aus der Luft von Kampfflugzeugen und Hubschraubern unter Beschuß genommen. Diese auch im Fernsehen übertragenen Szenen bewogen die amerikanische Regierung, einen Waffenstillstand auszurufen. (2) Die Freude der Befreiung: Die ersten arabischen Truppen fahren in amerikanischen Wagen in das gerade befreite Kuwait City ein. (3) Während der Einnahme Kuwaits wurden in eineinhalb Tagen über 90 000 Gefangene gemacht; viele von ihnen zögerten, nach Hause zurückzukehren. Die genaue Zahl der irakischen Toten wird nie bekannt werden – allerdings sprechen Schätzungen allein auf dem südlichen Kriegsschauplatz von bis zu 100 000 Mann.

La route de la mort

(1) Cette scène de désolation va mettre fin à la guerre: la crête de Mutla au Koweït, 1ᵉʳ mars 1991. Les forces américaines ont pris pour cible une colonne de soldats et de civils irakiens fuyant vers le nord dans des voitures chargées de butin. La colonne est stoppée par des blindés et pilonnée par l'aviation et les hélicoptères de l'armée américaine. Après cette tragédie, les Etats-Unis reconnaissent la nécessité d'un cessez-le-feu. (2) Les joies de la libération: les premiers soldats arabes arrivent dans des véhicules américains dans le Koweït libéré. (3) En une journée et demie, plus de 90 000 Irakiens sont faits prisonniers sur la route du Koweït. Beaucoup seront peu disposés à rentrer en Irak. On ne connaîtra jamais le nombre exact de morts du côté irakien, même si on l'évalue à 100 000 pour le seul front du Sud.

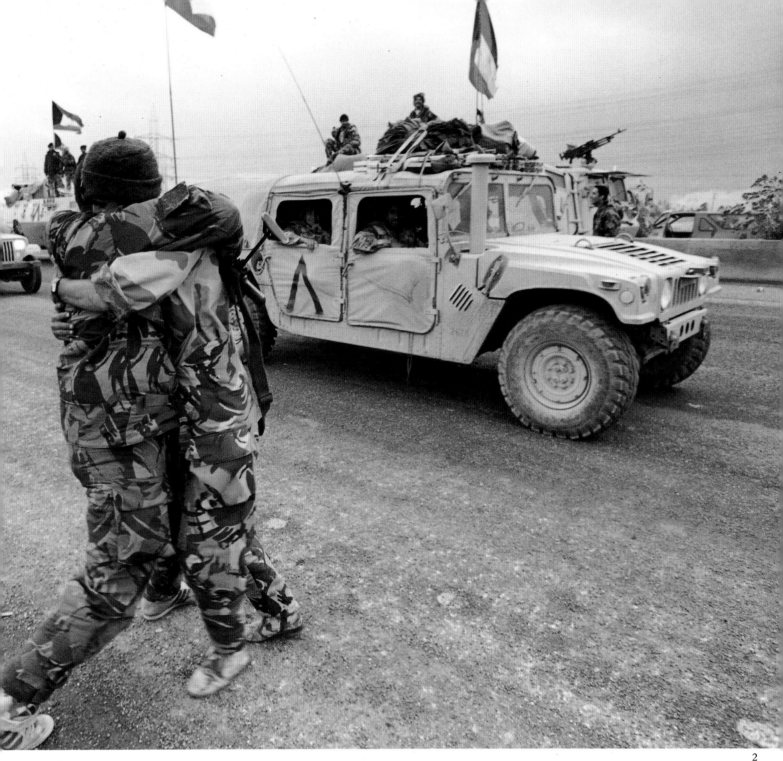

2

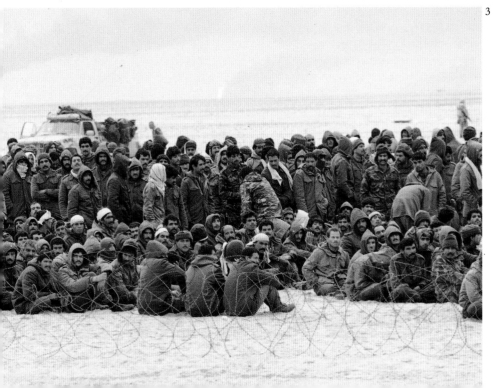

3

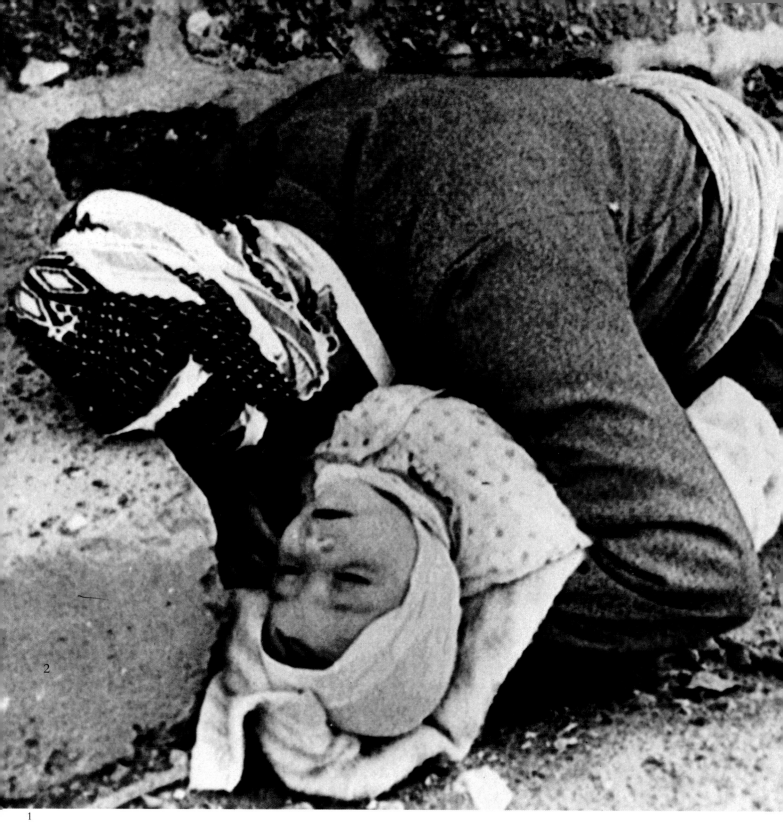

2

1

The Kurds

After the defeat of Saddam's army in the desert the Kurds rose in the north of Iraq and the Shi'ites in the south round Basra. Saddam's forces used gas to quell the Kurds and drive them from their homes – repeating tactics used in 1988. (1) A Kurd embracing his dead child, killed in the mustard-gas attack on Halabja, mid-March 1988.
(2) Fleeing Kurds break through a Turkish military road block to get to food on the Turkish-Iraqi border, April 1991.
(3) Kurdestan has been in perpetual conflict for 100 years. Here a fighter examines the remains of an Iraqi bomb, Kurdestan, 1971.

Die Kurden

Nach der Niederlage von Saddam Husseins Armee in der Wüste rebellierten die Kurden im Norden des Irak und die Schiiten im Süden um Basra. Husseins Streitkräfte setzen Gas ein, um den Aufstand zu unterdrücken und die Kurden aus ihrer Heimat zu vertreiben – eine Strategie, die bereits 1988 angewandt worden war. (1) Ein Kurde hält sein totes Kind im Arm, das bei einem Senfgas-Angriff auf Halabja Mitte März 1988 ums Leben gekommen ist. (2) Fliehende Kurden durchbrechen eine türkische Militär-Straßensperre, um Lebensmittel an der türkisch-iranischen Grenze zu bekommen, April 1991.

(3) Seit Ende des 19. Jahrhunderts war Kurdistan ein ständiger Konfliktherd. Hier inspiziert ein Kämpfer die Überreste einer irakischen Bombe, Kurdistan 1971.

Les Kurdes

Après la défaite de l'armée irakienne dans le désert, les Kurdes se soulèvent dans le nord de l'Irak et les Chiites dans la région de Basra au sud. L'armée de Saddam utilise des gaz pour venir à bout des Kurdes et vider la région, une tactique éprouvée dès 1988.
(1) Mars 1988, un Kurde étreint son enfant tué lors d'une attaque au gaz moutarde sur Halabja. (2) Avril 1991, des Kurdes en fuite

franchissent un barrage routier de l'armée turque pour chercher de la nourriture à la frontière turco-irakienne. (3) Le Kurdistan n'a pas connu la paix depuis un siècle. Un combattant examine les débris d'une bombe irakienne, Kurdistan, 1971.

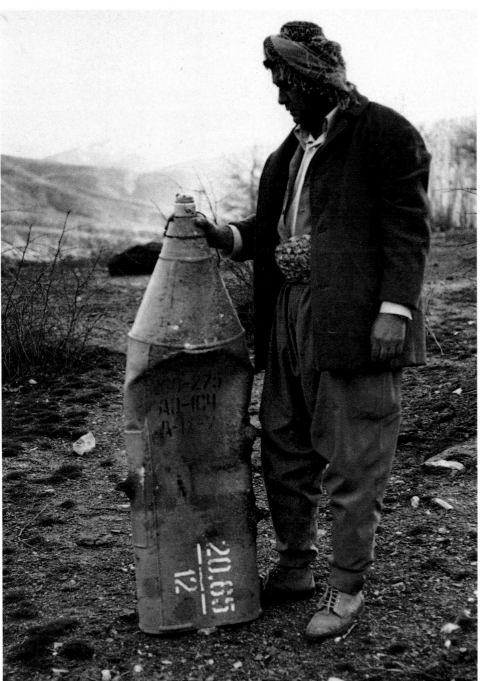

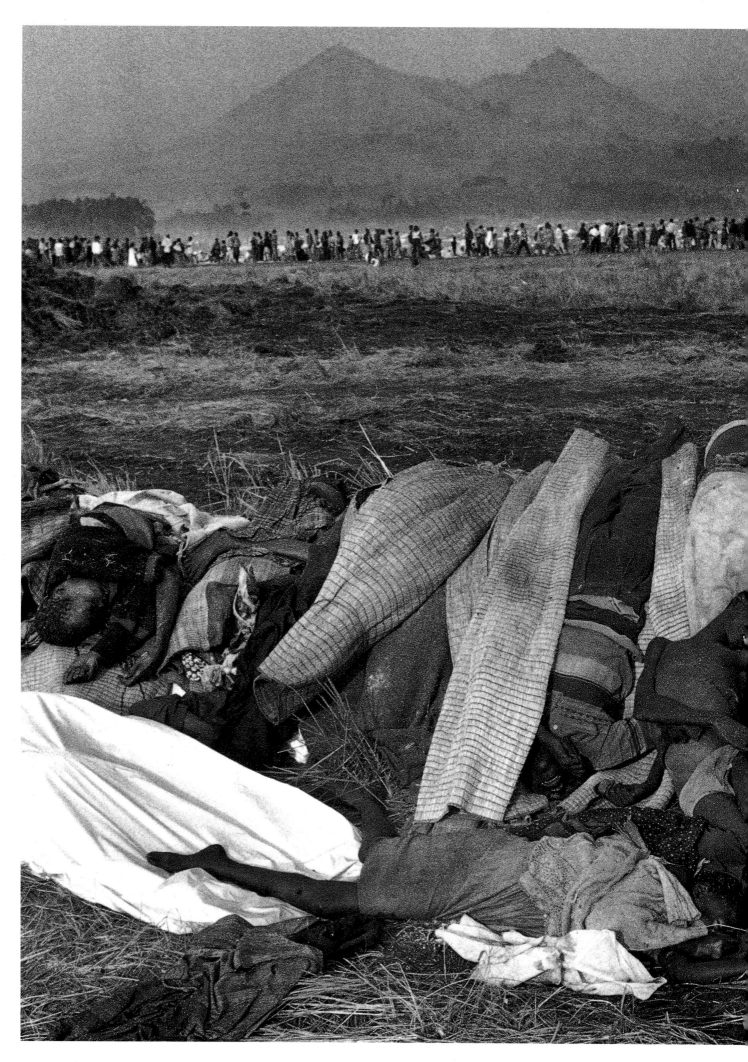

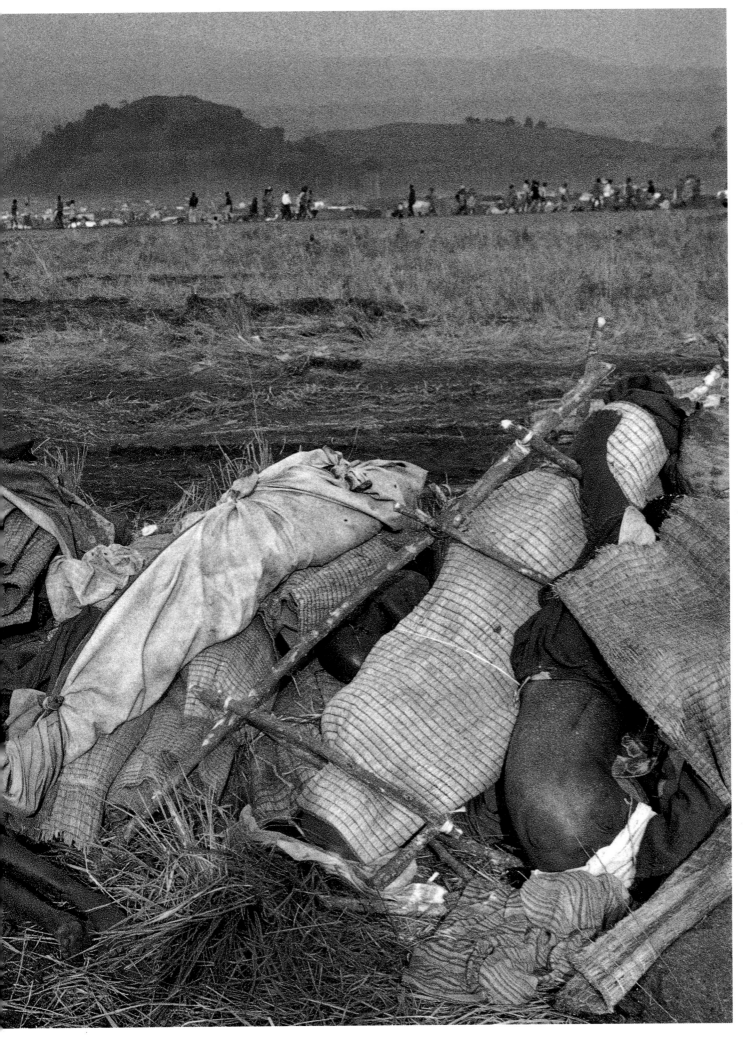

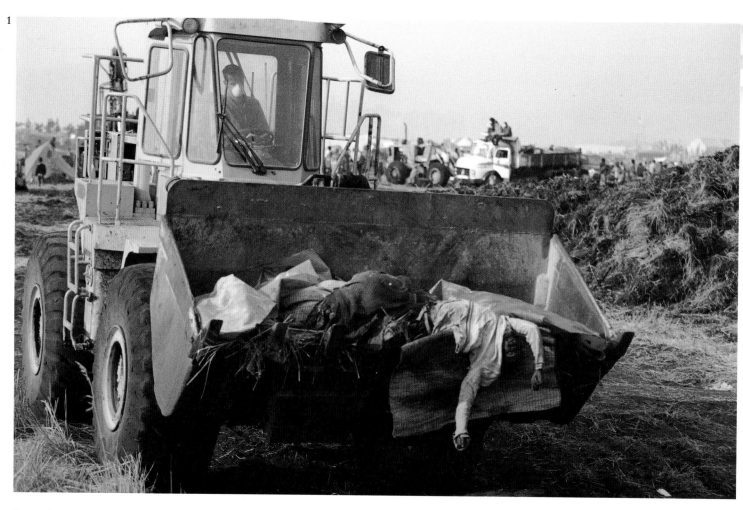

Rwanda

A whirlwind of tribal violence erupted in the central African republic after its President Habyarimana died in an air crash in 1994 – believed shot down. The Patriotic Front of the minority Tutsi tribe took on the majority Hutu. More than 500,000 were killed in six weeks; three times as many fled, most into Zaire. (Previous page) Bodies in the refugee camp, Goma, Zaire. (1) Bodies being taken for mass burial, Goma. (2) Queues for water in the Goma camps. (3) Up to 500,000 Hutu had fled to this area alone. Conditions became so violent in the camps that aid workers could operate only in daylight, usually under armed escort.

Ruanda

Nachdem Präsident Habyarimana 1994 bei einem Flugzeugabsturz ums Leben kam – man vermutet einen Anschlag –, brach in dieser zentralafrikanischen Republik ein Sturm von Stammeskriegen los. Die Patriotische Front des kleineren Tutsi-Stammes stellte sich gegen die Mehrheit der Hutus. In nur sechs Wochen starben über 500 000 Menschen; dreimal soviel flohen, die meisten nach Zaire. (Vorhergehende Doppelseite) Leichen im Flüchtlingslager Goma, Zaire. (1) Leichen werden für ein Massenbegräbnis gesammelt, Goma. (2) Schlangestehen für Wasser im Lager Goma. (3) Bis zu 500 000 Hutus waren allein hierher geflohen. Die Atmosphäre in den Lagern wurde so gewalttätig, daß Helfer nur am Tag und in der Regel mit bewaffneten Eskorten arbeiten konnten.

Rwanda

Une explosion de violence tribale souffle sur le pays en 1994, après le décès du président Habyarimana dans un accident d'avion, provoqué aux dires de certains. Le Front patriotique de la minorité Tutsi s'en prend alors à la tribu des Hutus, majoritaire. Plus de 500 000 Hutus sont massacrés en six semaines; trois fois plus s'enfuient, pour la plupart au Zaïre. (Page précédente) Le camp de réfugiés de Goma au Zaïre. (1) Goma, corps transportés pour être enterrés dans des fosses communes. (2) Queues pour l'eau dans les camps de Goma. (3) 500 000 Hutus ont fui vers cette région. La situation devient si explosive dans les camps que le personnel des organisations humanitaires ne peut plus travailler qu'en plein jour, de préférence sous escorte armée.

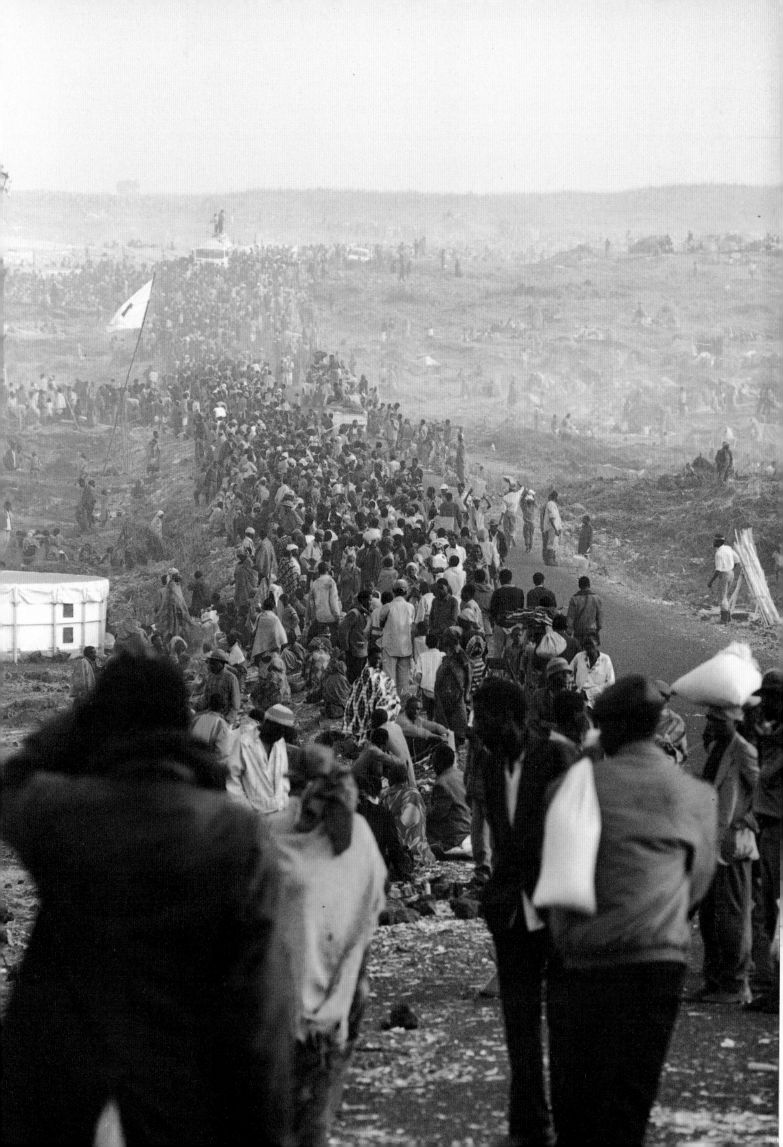

1

Somalia

The Americans attempted in December 1992 to halt the anarchy: the civil war had already claimed at least 100,000 lives. But as the internal truce crumbled, the US took on the main leader, Mohammed Farah Aidid.
(1) Aid arrives by Sikorski helicopter.
(2) Troops fan out in the south. (3) A soldier 'winning hearts and minds' in Mogadishu – an increasingly rare event as US and UN troops, journalists and aid workers were attacked. The Americans withdrew in 1994.

Somalia

Im Dezember 1992 versuchten die Amerikaner dem Chaos Einhalt zu gebieten: Der Bürgerkrieg hatte bereits mindestens 100 000 Leben gefordert. Als der interne Waffenstillstand zusammenbrach, stellten sich die Amerikaner gegen den Hauptanführer, Mohammed Farah Aidid. (1) Amerikanischer Nachschub wird mit Sikorski-Hubschraubern eingeflogen. (2) Truppen schwärmen nach Süden aus. (3) Ein Soldat »erobert Herz und Verstand« in Mogadischu – ein seltenes

Ereignis, da amerikanische und UN-Truppen, Journalisten und Helfer permanent bedrängt und angegriffen wurden. Die Amerikaner zogen sich 1994 zurück.

Somalie

Les Américains tentent en décembre 1992 de mettre fin à l'anarchie: la guerre civile a déjà coûté la vie à 100 000 personnes au moins. Mais lorsque les factions rivales ne respectent plus la trêve négociée, les Américains attaquent le principal seigneur de la guerre,

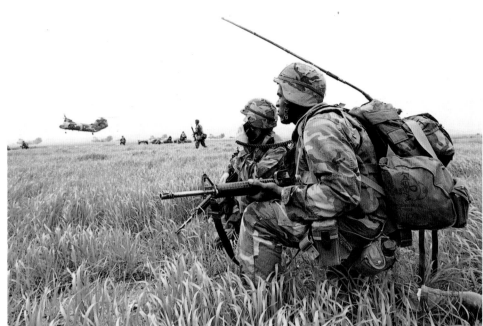

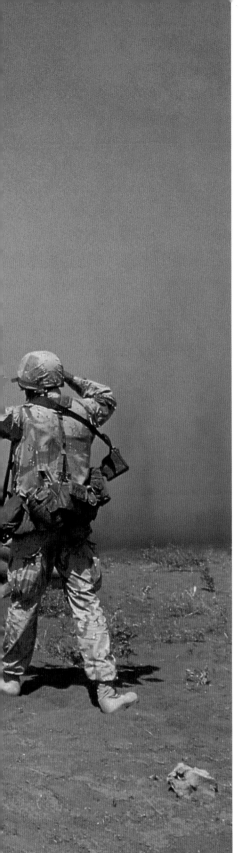

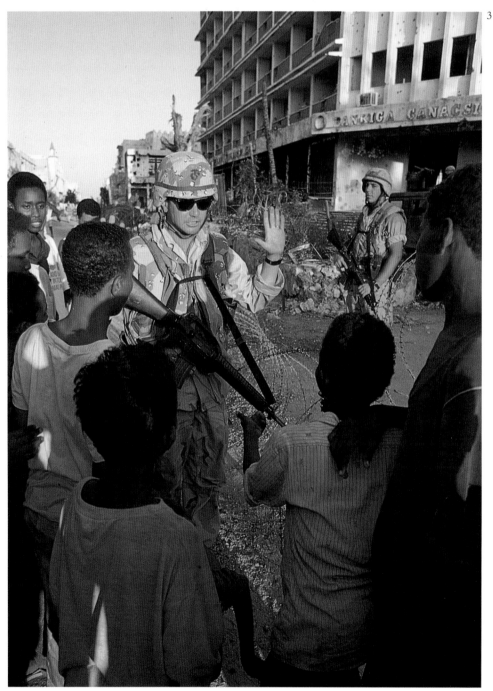

Mohammed Farah Aidid. (1) Les renforts de l'armée américaine arrivent par hélicoptères Sikorski. (2) Troupes se déployant dans le sud du pays. (3) Mogadiscio, soldat et Somaliens fraternisant, un fait de plus en plus rare car les troupes américaines et onusiennes ainsi que les journalistes et le personnel des organisations humanitaires se font attaquer. Les Américains se retireront de la région en 1994.

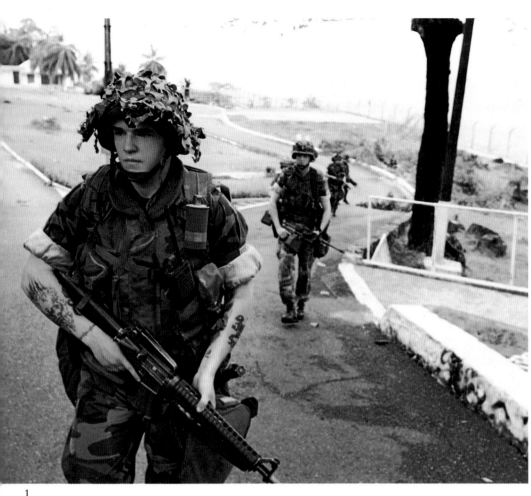

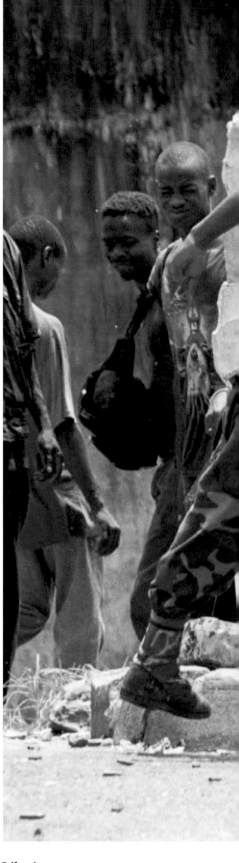

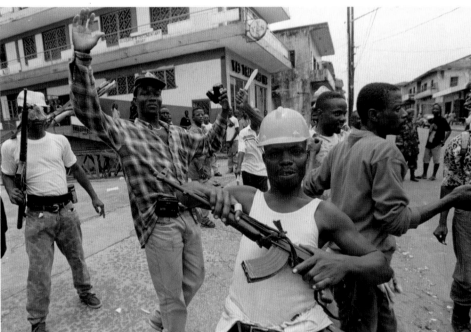

Liberia

The country descended into a deepening spiral of anarchy and violence as factions vied for control of the capital, Monrovia. The conflict is the essence of the long communal war of the late 20th century, where fighting often appears to be an end in itself. In the spring of 1994 Krahn tribesmen loyal to a former army commander, Roosevelt Johnson, fought militias loyal to Charles Taylor. Foreigners were driven to seek shelter in the US embassy compound, and a US Marine rescue team was sent in. (1) Marines put out their first patrols, 20 April 1996. (2) Krahn militiamen celebrate after a day's fighting outside a shelter for thousands of refugees, 17 April 1996. (3) The merciless vendetta: a militiaman of Charles Taylor's National Patriotic Front shoots an unarmed prisoner, who has begged for his life.

Liberia

Durch Parteikämpfe um die Kontrolle der Hauptstadt Monrovia verfiel das Land in eine sich immer schneller drehende Spirale von Anarchie und Gewalt. Dieser Konflikt ist typisch für die langen Volkskriege des späten 20. Jahrhunderts, bei dem oft der Kampf um seiner selbst Willen geführt wurde. Im Frühjahr 1994 kämpften Angehörige des Krahn-Stammes, die dem ehemaligen Armeekommandeur Roosevelt Johnson anhingen, gegen die Milizen von Charles Taylor. Ausländer

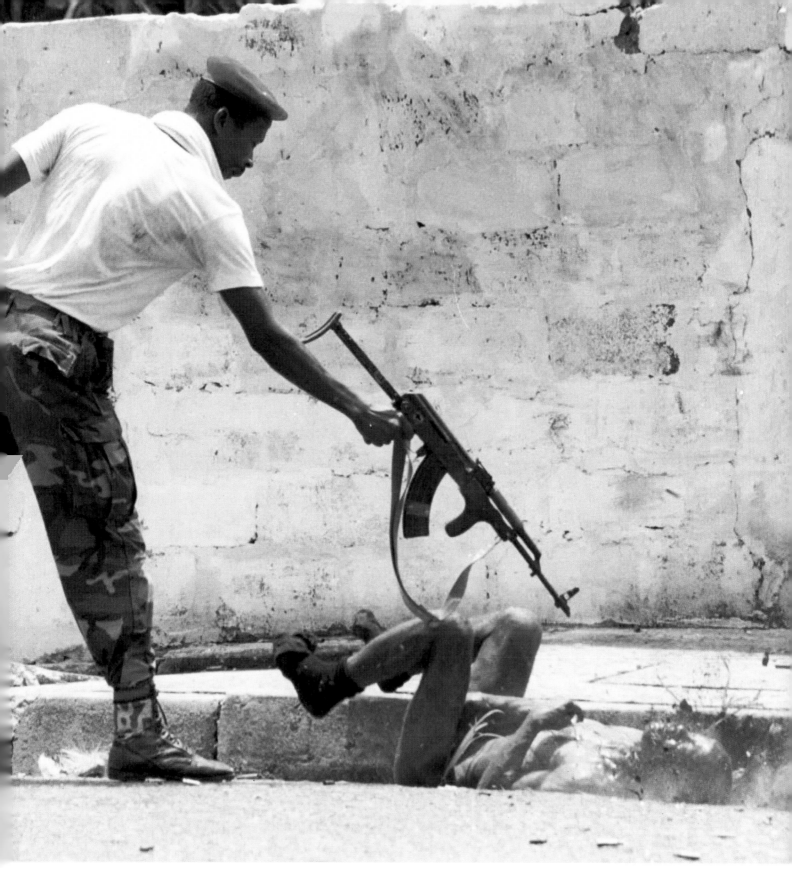

mußten auf dem Gelände der amerikanischen Botschaft Schutz suchen. Ein Rettungsteam der US-Marines wurde zum Schutz dorthin geschickt. (1) Marines schicken ihre ersten Patrouillen aus, 20. April 1996. (2) Milizen des Krahn-Stammes feiern nach einem Kampf außerhalb eines Lagers, in dem Tausende von Flüchtlingen Schutz gefunden haben, 17. April 1996. (3) Gnadenlose Rache: Ein Milizionär von Charles Taylors National Patriotic Front erschießt einen unbewaffneten Gefangenen.

Liberia

Le pays est pris dans la spirale de la violence et de l'anarchie quand les factions rivales veulent prendre le contrôle de la capitale, Monrovia. C'est le type même de la longue guerre interethnique de la fin du 20e siècle, où se battre semble devenu une fin en soi. Au printemps 1994, les Krahn, tribu loyale à Roosevelt Johnson, un ancien commandant de l'armée, battent les milices dirigées par Charles Taylor. Les étrangers trouvent refuge dans l'enceinte de l'ambassade des Etats-Unis

grâce à une équipe de sauvetage de la marine américaine dépêchée sur place pour les sauver. (1) 20 avril 1996, les Marines effectuent leur premières patrouilles. (2) Les miliciens Krahn se réjouissent après une journée de combat devant des bâtiments où se sont réfugiées des milliers de personnes, 17 avril 1996. (3) Vengeance sans merci: un homme du National Patriotic Front of Liberia exécute un prisonnier non armé qui lui a demandé grâce.

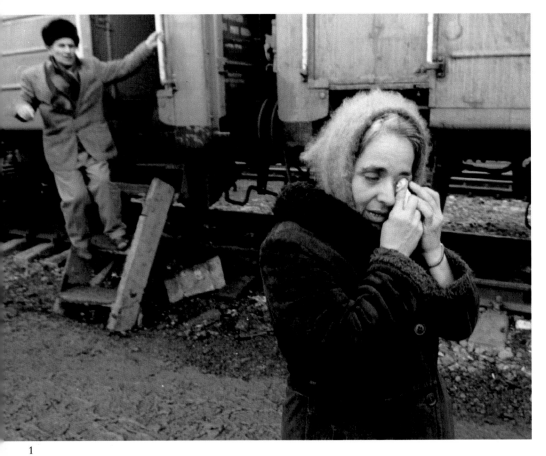

1

The War in Chechenya, 1

In December 1994 Russia sent troops to
quell the separatists in the southern republic
of Chechenya, which was demanding
independence under its charismatic President
Zhokar Dudayev, a former air force colonel, a
devout Muslim and fierce Chechen
nationalist. The Russians attacked Grozny,
the capital. (1) The city, capital of an oil-rich
region, was reduced in large part to rubble –
its citizens like this woman forced to flee for
the second time in 50 years. (2) Russian
armour and carriers were trapped in the
streets and incinerated by Chechen fighters
using hand-held weapons. (3) A shaky
Russian army had difficulty in fighting the
rebels even after Dudayev was killed in April
1996. Here a Russian tank crewman throws
down his anti-tank rocket launcher in a
sniper battle in Argun, February 1995.

2

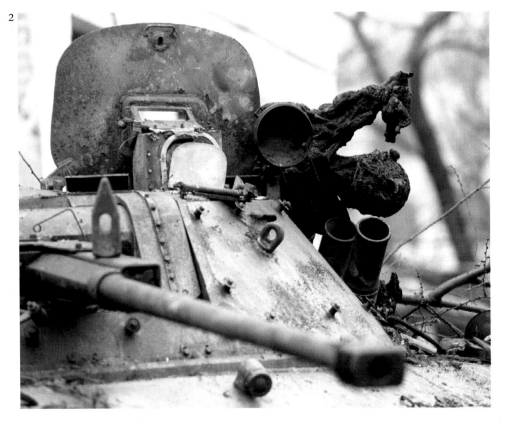

Der Krieg in Tschetschenien, 1

Im Dezember 1994 schickte Rußland
Truppen zur Niederschlagung eines Separa-
tistenaufstands in die südliche Republik
Tschetschenien. Unter Führung des charis-
matischen Präsidenten Zhokar Dudajew –
eines ehemaligen Luftwaffenobersts,
überzeugten Moslems und strikten tsche-
tschenischen Nationalisten – forderte die
Republik die nationale Unabhängigkeit.
Daraufhin griff die russische Armee die
Hauptstadt Grosny an. (1) Die Stadt, Haupt-
stadt einer ölreichen Region, wurde in weiten

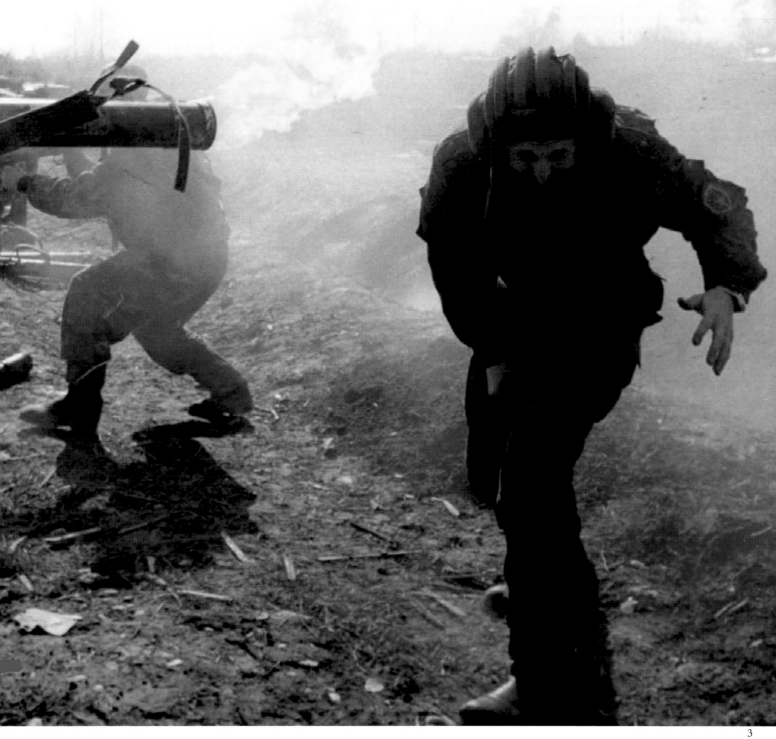

Teilen in Trümmer gelegt – und ihre Bewoh-
ner, wie diese Frau, mußten zum zweiten
Mal innerhalb von 50 Jahren ihre Heimat
verlassen. (2) Russische Panzerfahrzeuge
und Transporter wurden in den Straßen ein-
geschlossen und von tschetschenischen
Kämpfern mit tragbaren Waffen in Brand
geschossen. (3) Die unsicher wirkende
russische Armee hatte bei der Bekämpfung
der Rebellen auch nach der Ermordung
Dudajews in April 1996 große Schwierigkei-
ten. Hier wirft ein Mitglied einer russischen
Panzerbesatzung während eines Hecken-

schützengefechts in Argun seinen Raketen-
werfer weg, Februar 1995.

La guerre en Tchétchénie, 1
En décembre 1992, la Russie envoie des
troupes pour venir à bout des séparatistes
tchétchènes qui réclament l'indépendance de
leur pays sous la houlette de Djokhar
Doudaev, leur président charismatique, un
ancien colonel de l'armée de l'air soviétique,
pieux musulman et farouche Tchétchène. Les
Russes attaquent Grosny, capitale de la
Tchétchénie. (1) La ville, située dans une

région riche en pétrole, a été en grande partie
détruite; ses habitants, comme cette femme,
sont obligés de fuir pour la seconde fois en
50 ans. (2) Les guerriers tchétchènes
bloquent les blindés russes dans les rues et les
incendient avec leurs armes portatives.
(3) Une armée russe affaiblie a du mal à
combattre les rebelles, même après la mort de
Doudaev en avril 1996. Février 1995, un
soldat russe jette son lance-roquettes antichar
dans un tir d'embuscade à Argun.

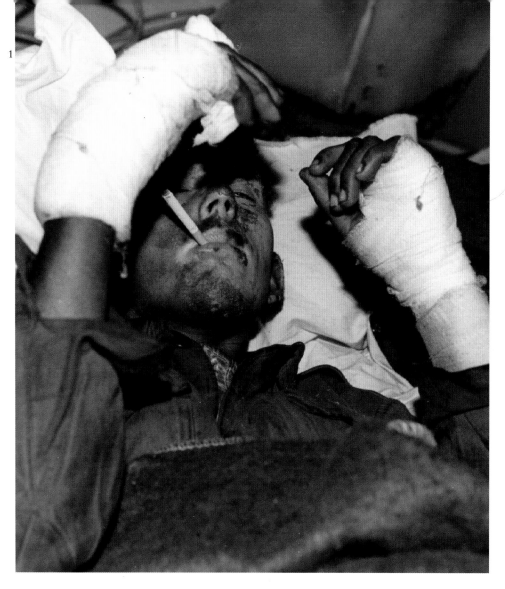

The War in Chechenya, 2
(1) A wounded Russian soldier in the dressing station in the basement of the presidential palace, Grozny, January 1995. The Russians hit the city with tank, artillery, rocket and air attacks but lost large numbers of tanks and armoured personnel carriers – which are always at a disadvantage against a well motivated and prepared guerrilla enemy such

as the Chechens. Another failure was the weakness in Russian military staff planning – which had been the great strength at the end of the Patriotic War. For weeks the generals stood outside Grozny trying to plan the next move. (2) A woman in a village near Gudermes shouts at the Russians to go away. (3) Nor were the Chechens bereft of weaponry. Here they fire a heavy-calibre howitzer in the battles round Grozny, September 1995.

Der Krieg in Tschetschenien, 2
(1) Ein verwundeter russischer Soldat in der Sanitätsstation im Keller des Präsidenten-palastes, Grosny, Januar 1995. Die Russen griffen die Stadt mit Panzern, Artillerie, Raketen und aus der Luft an, verloren aber große Mengen an Panzern und gepanzerten Mannschaftswagen – die gegenüber hoch-

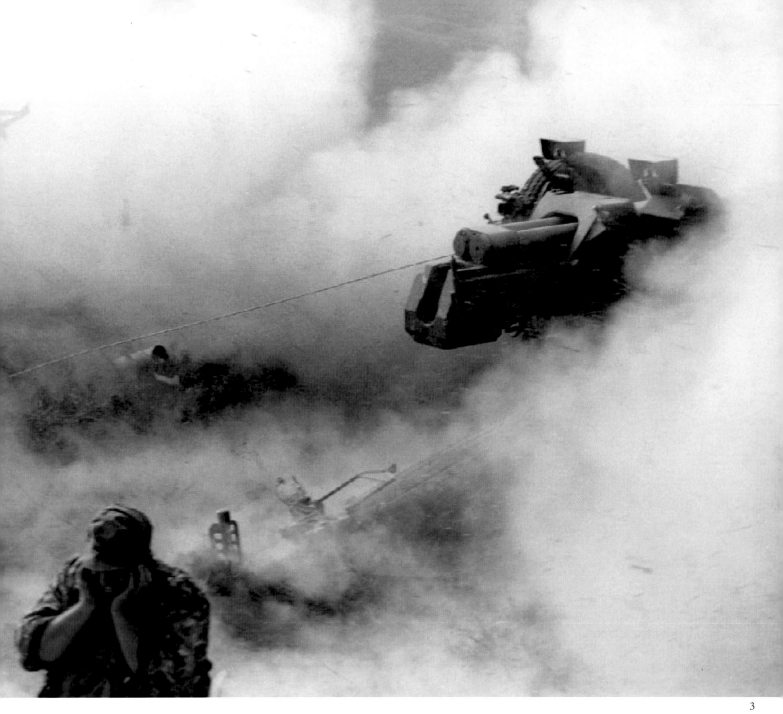

motivierten und gut vorbereiteten Guerillas, wie den Tschetschenen, immer im Nachteil sind. Hinzu kam die Schwäche der russischen Militärplanung, die gegen Ende des Vaterländischen Krieges noch zu Rußlands großen Stärken gezählt hatte. Wochenlang standen die Generäle vor Grosny und diskutierten ihre nächsten Schritte. (2) Eine Frau in einem Dorf in der Nähe von Gudermes schreit die Soldaten an, sie sollen verschwinden. (3) Die Tschetschenen waren gut mit Waffen ausgestattet. Hier feuern sie bei Gefechten um Grosny eine großkalibrige Haubitze ab, September 1995.

La guerre en Tchétchénie, 2
(1) Grosny, janvier 1995, un blessé de l'armée russe au poste de secours installé au rez-de-chaussée du palais présidentiel. Les Russes ont attaqué la ville au blindé, à l'artillerie, à la roquette et au raid aérien, mais ils ont perdu beaucoup de chars et de transporteurs blindés, ce qui est toujours un inconvénient face à des ennemis très motivés et formés à la guérilla tels que les Tchétchènes. La faiblesse organisatrice de l'état-major constitue un autre inconvénient, alors qu'elle a été la force de l'armée à la fin de la grande guerre patriotique. Pendant des semaines, les généraux campent devant Grosny, essayant d'organiser le prochain mouvement. (2) Une villageoise de la région de Goudermes crie aux Russes de rentrer chez eux. (3) Les Tchétchènes ne manquent pas d'armes. Septembre 1995, dans les batailles autour de Grosny, ils tirent avec des obusiers de gros calibre.

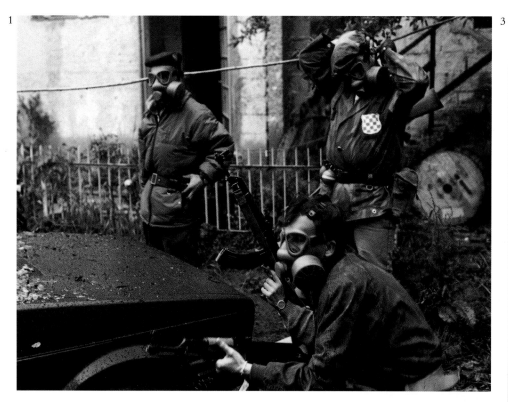

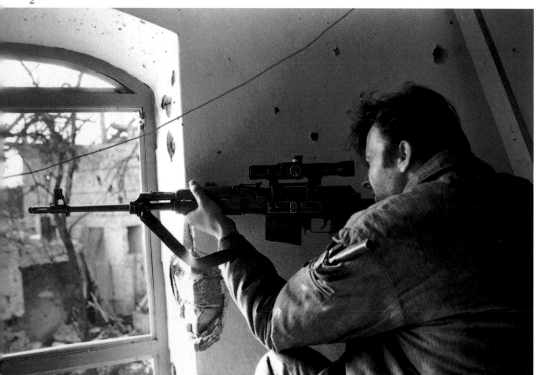

Yugoslavia Breaks Up

The war which broke out in Bosnia in April 1992 had been anticipated for several months, but few expected the ferocity of attacks on civilians of all sides. The Bosnian Serbs carried out a systematic programme of ethnic cleansing, using selective terrorism, torture and rape to drive more than 750,000 non-Serbs from their homes and expel Muslims from the boundary zone along the River Drina. The Muslims were largely unarmed and initially made common cause with the Croats. (1) Here they take up positions, wearing gas masks, near the airport at Sarajevo, June 1992. (2) Eventually the Muslims did get supplies of new arms. A Muslim sniper lines up his weapon at Brcko, one of the most contested areas in the whole of Bosnia, on the River Sava. (3) Croats and Muslims fought a bitter turf war in central Bosnia and round Mostar, 1993-94. These are Muslim prisoners, held by Croats in the Dretelj camp.

Jugoslawien bricht auseinander

Der Krieg, der im April 1992 in Bosnien ausbrach, war Monate zuvor bereits vorauszusehen; aber nur wenige hatten die Grausamkeiten gegenüber Zivilisten auf allen Seiten erwartet. Die bosnischen Serben führten ein systematisches Programm zur »ethnischen Säuberung« durch. Mit Hilfe von Terrorakten, Folter und Vergewaltigungen wurden über 750 000 Nicht-Serben aus ihrer Heimat und Moslems aus dem Grenzgebiet entlang der Drina vertrieben. Diese Moslems waren größtenteils unbewaffnet und hatten ursprünglich gemeinsame Sache mit den Kroaten gemacht. (1) Hier beziehen sie,

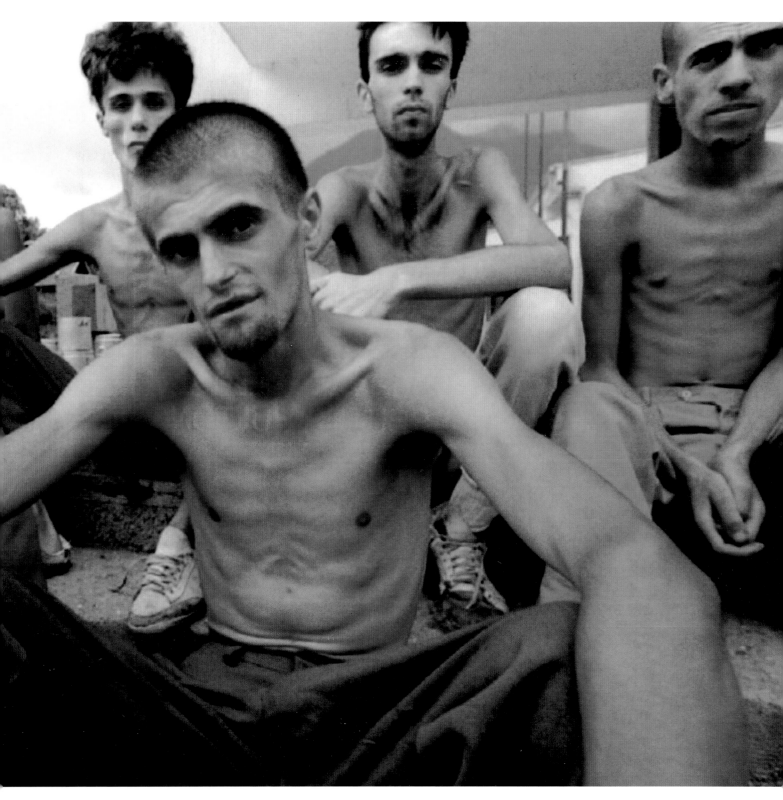

ausgestattet mit Gasmasken, Stellungen in der Nähe des Flughafens von Sarajevo, Juni 1992. (2) Schließlich bekamen die Moslems Nachschub an neuen Waffen. In Brcko am Sava-Fluß, einem der am heftigsten umkämpften Gebiete in ganz Bosnien, bringt ein moslemischer Heckenschütze seine Waffe in Stellung. (3) Kroaten und Moslems kämpften einen bitteren Landkrieg in Zentralbosnien und um Mostar, 1993-94. Das Bild zeigt moslemische Gefangene im kroatischen Lager Dretelj.

L'éclatement de la Yougoslavie

La guerre qui embrase la Bosnie en avril 1992 est prévisible depuis plusieurs mois mais personne n'aurait pu imaginer la férocité des attaques contre les civils de tous bords. Les Serbes bosniaques lancent une campagne de purification ethnique, terrorisant, torturant et violant systématiquement pour faire partir de chez eux plus de 750 000 non-Serbes et chasser les Musulmans de la zone frontière longeant la Drina. Les Musulmans qui n'ont pas d'armement font cause commune, au début, avec les Croates. (1) Equipés de masques à gaz, ils se mettent en position près de l'aéroport de Sarajevo,

juin 1992. (2) Les Musulmans peuvent finalement s'approvisionner en armes malgré l'embargo. Un franc-tireur bosniaque en position de tir à Brcko, l'une des zones les plus attaquées de Bosnie, sur la rivière Sava. (3) Croates et Musulmans se livrent une guerre impitoyable dans le centre de la Bosnie et autour de Mostar, 1993-94. Prisonniers musulmans internés par les Croates au camp de Dretelj .

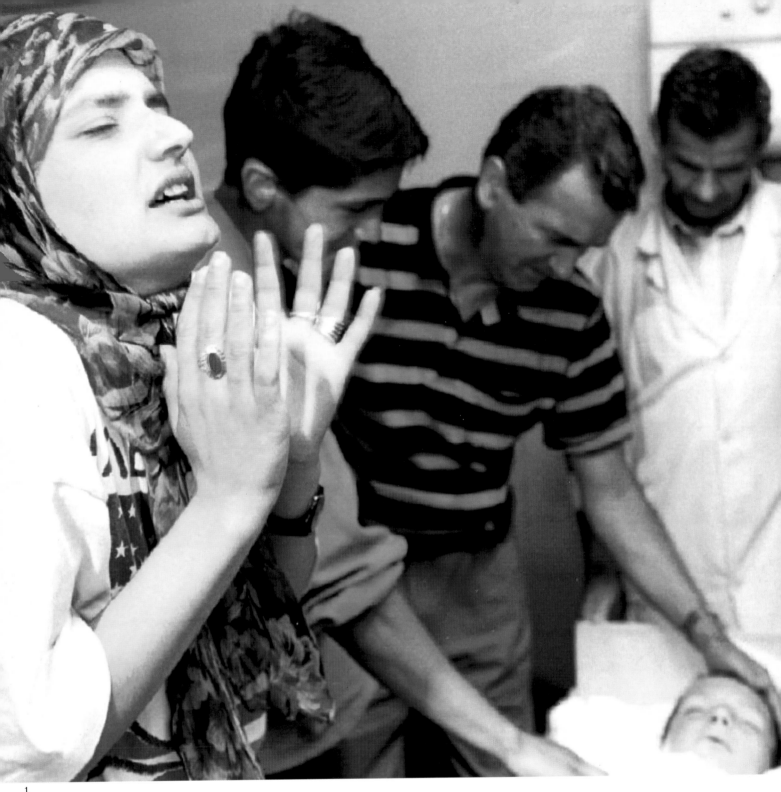

1

The Siege of Sarajevo

The city was under siege from May 1992 to December 1995, longer than the siege of Leningrad. The international authorities were reluctant to recognize that the citizens could not move anywhere without risking attack from sniper, mortar or artillery fire. (1) Arna Hadzic weeps over the body of her brother Adnan, 13, killed by a mortar attack on 20 July 1995. (2) A woman and her son walk past one of the gutted apartment blocks, 1 April 1996. An estimated 10,000 Sarajevans died in the vindictive guerrilla battle, in which communities savaged each other. (Overleaf) Hundreds had to be buried in the Zetra stadium below the Kosevo Hospital, an area reasonably safe from sniper ambush.

Die Belagerung Sarajevos

Die Belagerung der Stadt dauerte von Mai 1992 bis Dezember 1995, länger als die Belagerung von Leningrad. Die internationalen Behörden zögerten lange, bevor sie begriffen, daß die Einwohner nirgendwohin fliehen konnten, ohne Angriffen von Heckenschützen, Granatwerfern und Artilleriefeuer ausgesetzt zu sein. (1) Arna Hadzic weint über dem Leichnam ihres 13jährigen Bruders Adnan, der bei einem Granatwerferangriff am 20. Juli 1995 ums Leben gekommen ist. (2) Eine Frau und ihr Sohn gehen an einem der ausgebrannten Wohnblocks vorbei, 1. April 1996. Schätzungsweise 10 000 Einwohner von Sarajevo starben in rachsüchtigen Guerillakämpfen, in denen friedliche

Gemeinden zu erbitterten Feinden wurden. (Folgende Doppelseite) Hunderte von Menschen mußten im Zetra-Stadion unterhalb des Kosevo-Hospitals begraben werden – einem Ort, der vor Heckenschützenüberfällen relativ sicher war.

Le siège de Sarajevo

La ville est assiégée de mai 1992 à décembre 1995, un siège plus long encore que celui de Léningrad. Les autorités internationales sont longues à reconnaître que les habitants ne peuvent se déplacer sans risquer d'être touchés par une balle de franc-tireur, un mortier ou un tir d'artillerie. (1) Arna Hadzic pleure la mort de son frère Adnan, 13 ans, tué lors d'une attaque au mortier le 20 juillet

1995. Le 28 août, une attaque similaire tue 27
personnes sur le vieux marché de Sarajevo.
Elle déclenchera enfin une riposte aérienne
de l'OTAN et des Américains et un bombar-
dement commun français, britannique et
hollandais, obligeant les Serbes à négocier.
(2) 1er avril 1996, une mère et son fils passent
devant un immeuble en ruines. On estime à
10 000 le nombre d'habitants de Sarajevo
morts durant ce conflit opposant des
nationalités décidées à en découdre. (Page
suivante) Des centaines de personnes ont été
enterrées dans le stade de Zetra situé en
dessous de l'hôpital de Kosevo, une zone
relativement à l'abri des tireurs embusqués.

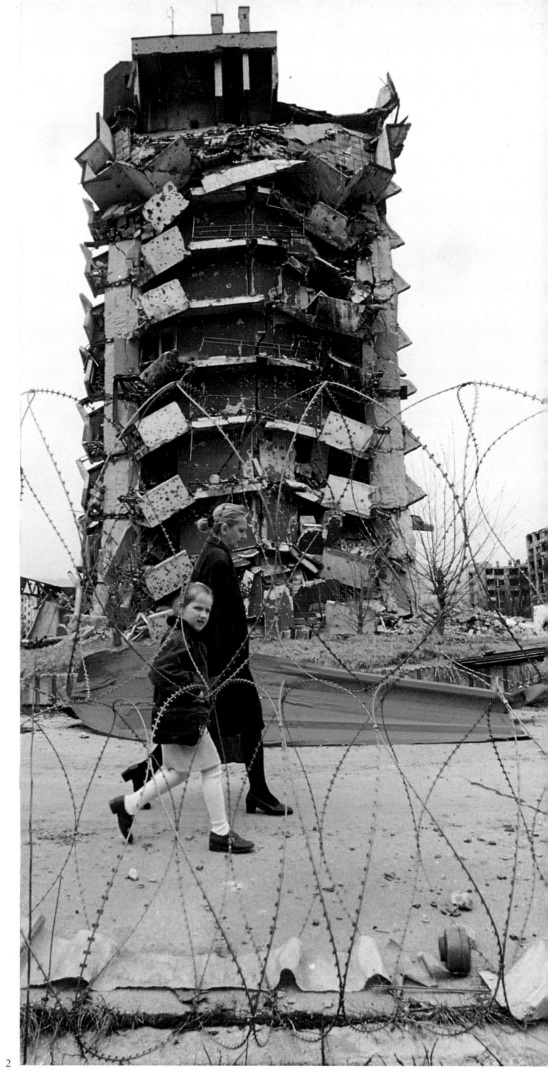

2

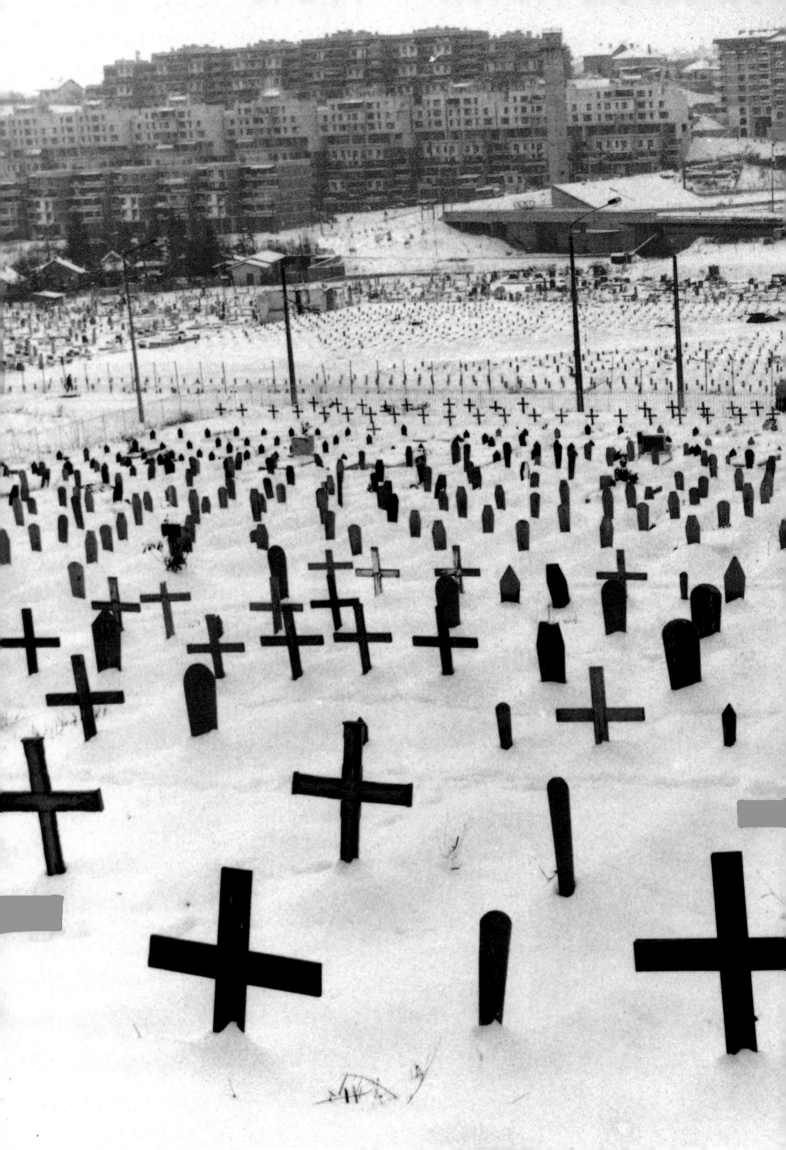

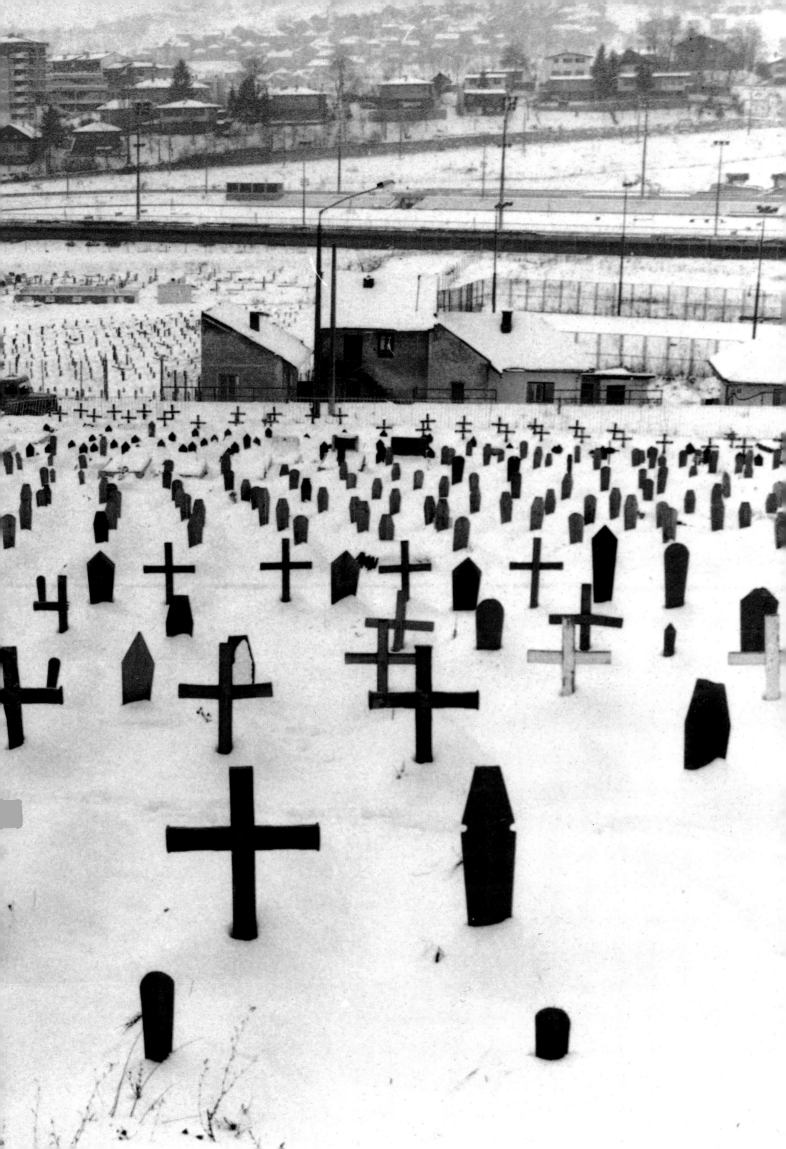

The UN Peacekeepers

(1) UN troops had the thankless task of defending UN-designated safe areas: in Gorazde they were shot at by both Muslims and Serbs. (2) Members of a French UN anti-sniper team clearing 'sniper alley', Sarajevo. (3) In July 1995 the Srebrenica enclave was overrun by General Mladic's Bosnian Army. Here a woman refugee remonstrates as she is forced to flee from Potocari UN camp. (4) A Dutch soldier, held hostage during the fall of Srebrenica, weeps on his return to Holland.

Die UN-Friedenstruppen

(1) UN-Truppen hatten die undankbare Aufgabe, die UN-Schutzzonen zu verteidigen: In Gorazde wurden sie sowohl von den Moslems als auch von den Serben beschossen. (2) Mitglieder eines französischen Anti-Heckenschützen-Teams der UN sichern »Sniper Alley«, die »Heckenschützenallee« in Sarajevo. (3) Im Juli 1995 wurde die Enklave Srebrenica von der bosnischen Armee unter General Mladic überrannt. Hier protestiert eine Flüchtlingsfrau dagegen, daß sie gezwungen wird, das UN-Lager Potocari zu

verlassen. Beachtenswert: die niederländischen UN-Truppen und die serbischen Soldaten in der Menge. (4) Ein niederländischer Soldat, der während des Falls von Srebrenica als Geisel gehalten wurde, weint bei seiner Rückkehr nach Holland.

Les soldats de la paix

(1) Les Casques bleus ont l'ingrate tâche de défendre les zones de sécurité protégées par l'ONU: à Gorazde, ils sont la cible des Musulmans et des Serbes. (2) Casques bleus français dégageant «l'allée des francs-tireurs» à

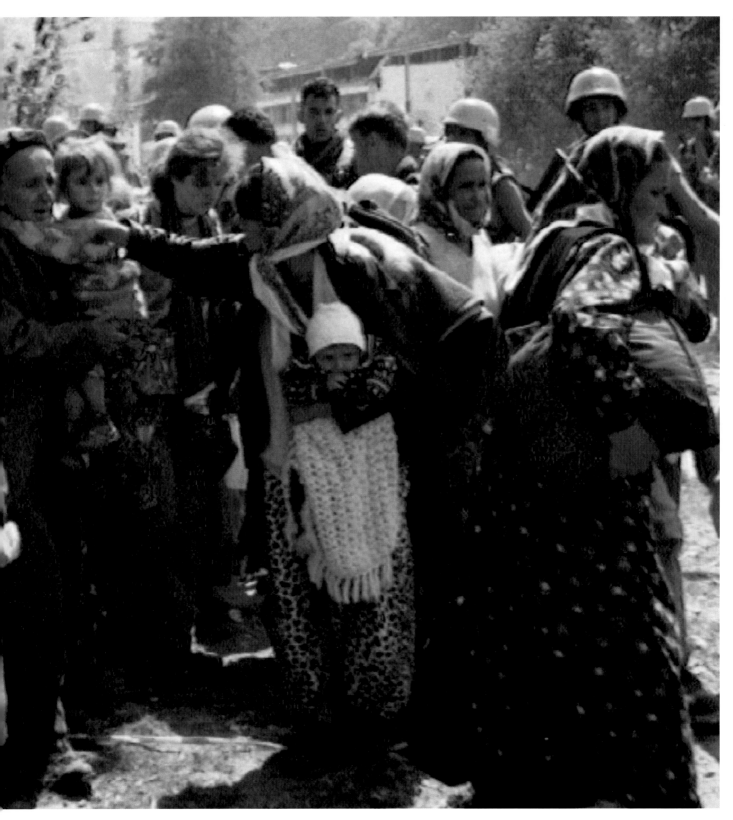

Sarajevo. (3) L'armée serbo-bosniaque du
général Mladic investit l'enclave de
Srebrenica en juillet 1995. Une réfugiée
proteste énergiquement lorsqu'elle doit
quitter le camp de l'ONU de Potocari.
(4) Un soldat hollandais retenu en otage
pendant la prise de Srebrenica pleure en
rentrant dans son pays.

4

Back to the Future

Wars Present and to Come, and how we will record them

In 1989 the Cold War ended and once more Europe began to disarm. The collapse of the Warsaw Pact and the disengagement of the Nato force marked the end of the mobilization of great armies in Europe – for them at least the era of mass, industrialized warfare was at an end. Elsewhere in the world conflicts continued, spread, and took on patterns that the technically advanced nations and their armies and agencies like the UN found increasingly difficult to control.

'Well boys, you may go home now,' said the old Royalist Sir Jacob Astley, after the defeat of his army in the English Civil War at Stow-in-the-Wold (1646), 'unless you will fall out among yourselves.' As the endless wrangles in the United Nations Security Council were to prove, the powers were to fall out repeatedly over how to manage demands for peace-keeping and humanitarian operations in at least 40 places at any one time in the world. They were faced with a restive public and electorate at home, and an ever more critical and polemical press. Highly sophisticated armies like the American-led armoured and heli-borne forces which liberated Kuwait in early 1991 could have stayed in the field and maintained a peak fighting capability for only a few months at most.

When in the same war the small British 1st Armoured Division was dispatched to form the hinge element of the US 7th Armoured Corps in the desert, its commander Major-General Rupert Smith remarked, 'I have been given the whole train set, with full support of a corps' assets of artillery – but it is the only train set, I can't afford to lose it, because there isn't one to replace it.' The sophisticated powers could now only afford to fight short wars, and deploy for only spasmodic and limited peacekeeping operations.

In the era of industrial wars, the end of a conflict was usually clearly defined by victory and defeat, or a truce based on mutual interest. Combatants would wear each other down by attrition, invasion or conquest. The Falklands conflict of 1982 ended with a quick victory in the field in which the British achieved their mission of ejecting the Argentine forces. In the Gulf War over Kuwait of 1990-91, the primary mission of freeing Kuwait was achieved, but the broader, secondary aim of destroying Saddam's main armoured forces to bring tranquillity and stability to the region was barely touched upon. Saddam could continue his reign by terror tactics, bringing misery to most of his civilian subjects, and murder and mayhem to the Kurdish and Shi'ite minorities. The political leadership of the Western allies of the Kuwait-Gulf conflict had neither the will nor, they felt, the support of their public to finish the task they had set themselves.

Attitudes to warfare in the West had changed radically in the decades after 1945. Defence and security became taboo subjects in most public debate, and it was felt armies should only fight in cases of direct threat to national interest and survival. The era of the 'mammista' armies was at hand, in which the 'mammas' of the nation's soldiers would protest about their sons and daughters being 'placed in harm's way' in missions remote from hearth and home. The great irony of the aftermath of the Cold War was that it left the one remaining superpower, the USA, with an army it was decreasingly able to use in any operation likely to involve combat and casualties.

The Americans continue to be chased by the shadows of Vietnam, an ever unpopular adventure that cost nearly 60,000 lives and a major political defeat. The sense of misgiving about the deployment of American troops overseas was deepened by experiences with a multinational peace force in Lebanon in 1983, when 241 US Marines (and separately, 58 French paratroopers in their base) were blown up in their compound in Beirut. Ten years later the American television-viewing public was to be horrified by the sight of the bodies of US soldiers dragged through the streets of Mogadishu by whooping militiamen during the peace mission to Somalia.

When some 20,000 American troops were despatched to lead Nato's first operational mission, the Peace Implementation Force (IFOR) in Bosnia at the end of 1995, as much attention was given to their own protection as to carrying out their wider tasks. Reluctance to tackle looting, burning and ethnic cleansing and to apprehend war criminals was to undermine the credibility of the mission.

The leadership of America's allies – Britain, France, and above all Germany – shared the mood of reluctance, but on the ground British and French commanders showed more resilience and began quietly rewriting the principles of peacekeeping. They argued that there was no use in trying to keep peace where there was no peace to keep, as during the UN deployment in Bosnia, 1992-95, and that international troops must be prepared to fight to fulfil their mission, however humane its intention. Moreover, British officers believed that the Cold War notion of 'rules of engagement' being laid down by politicians beforehand deprived soldiers and their commanders on the ground of the necessary flexibility over when to use force against unpredictable opponents.

The British Army, though much diminished in size and beset by muddled direction from the politicians, remained highly effective – and was paid the ultimate backhanded compliment from President Chirac of France when he said the French Army should reform on British lines. By mid-1996 nearly 60 per cent of the entire British strength of just 100,000 was on active service – unprecedented since 1945. The

Americans conceded a reform of Nato so that the European allies, meaning principally Britain and France, should be able to mount and command their own separate Nato operations.

But such expeditions would be of limited duration, unlike the new, ragged, open-ended wars pursued in many parts of the world and round the fringes of Europe in Algeria, the Caucasus and Bosnia. In parts of Africa such as Liberia and Angola, in Afghanistan and Sri Lanka, war became a continuous pattern, an end in itself, where the traffic in arms, booty, contraband and drugs would sustain warlords. Liberia had lurched through phases of war and peace since 1946. Fifty years on the lords of the gun had taken over Monrovia, and the state was only a part-time actor.

In the Middle East, the Israelis tried to fight the old industrial kind of modern war, with tanks, artillery and helicopter gunships to secure their borders. But the more extreme Islamic opponents were prepared for the long terrorist war which could span generations.

In Bosnia, too, disgruntled Muslim nationalists show signs of opting for the long informal campaign, where conflict will become a way of life and survival. These conflicts have been summed up by the Israeli academic Martin van Creveld as 'Future War', where armies are no longer formal trained organisations, but something between a guerrilla band and a mafia militia. They are part of the community, and have little to do with the state as such. They use modern weaponry in a way unimagined by their designers – 'below the threshold of sophistication', in the jargon phrase. Thus a field howitzer like a 122-mm artillery piece, designed to fire in concert with the rest of the battery, regiment or brigade, is used as a terror weapon firing randomly and without warning on civilians. The little town of Olovo, hardly a household name in the news despatches from Bosnia, was pounded almost every day throughout the war – nearly 90 per cent of its housing was damaged or wrecked, and yet people still lived on there.

The emerging military powers in the conventional sense are those that can put large conventional forces in the field and be capable of replacing them if they suffer casualties and reverses. The dominant powers in Asia and the Pacific are likely to be India, China and emergent players like Indonesia. In the Levant, South-West Asia and the Gulf, Turkey, Iran and Pakistan are likely to dominate. Turkey has the largest Nato army apart from that of the United States, and it is governed by formidable discipline. On the other hand, as the traumas of Chechenya show, the Russian Army is in a process of decay. In 1996 it had 75 per cent of the strength of the old Soviet Army, with under a fifth of the budget of 1989. The military vacuum left by Russia in northern central Asia is likely to be one of the most pressing strategic issues of the new century.

Such change makes it more difficult for the photographer to record conflict and its consequences, the pity and terror and reality of it. Journalism of all kinds, in electronic reproduction, on paper, television and radio, has followed the politicians and the directors of the 'mammista armies'. War and its consequences are part of the information-entertainment, 'infotainment' industry: titillation by sound-bite and a brief snatch of action photography or film, then the audience can move on to the next thing. The sustained work of Bert Hardy and James Cameron at Inchon, the best action photographers of the Second World War and Vietnam, is unlikely to be surpassed – the time, money and interest are not afforded to many of their like by the modern media world.

But as the images and words from Bosnia, Chechenya, Rwanda and Somalia have proved, they remain the vital witnesses in a sceptical world. The reporter or the photographer has to be the man at the front – not a part-time moral sage, political prophet or crackpot historiographer, which many of the trade have become. These men and women have to train as much as the corporal in the armoured carrier and the medic at the first-aid station. These are the people who have made the record of this book – and, as every general worth his salt knows, an army depends on its corporals.

In April 1944 after he had succeeded in kidnapping the German Commander on Crete, General Karl Kreipe, Patrick Leigh Fermor heard of a remark from one of the more relaxed members of the General Staff in Berlin: 'Kreipe – Kreipe. They've taken Kreipe. Well, thank God they didn't take someone really vital like Corporal Schmidt!'

Zurück in die Zukunft

Heutige und zukünftige Kriege und wie wir davon berichten werden

1989 ging das Zeitalter des Kalten Krieges zu Ende, und wieder einmal begann in Europa die Abrüstung. Nach dem Zusammenbruch des Warschauer Pakts und dem Abzug der NATO-Truppen gab es in Europa keine großen stehenden Heere mehr – zumindest dort war die Ära des industrialisierten Massenkriegs vorbei. In anderen Weltteilen hielten die Konflikte an, breiteten sich aus und nahmen Formen an, die von den technisch fortgeschritteneren Nationen, von deren Armeen und Vertretern wie den Vereinten Nationen immer schwerer unter Kontrolle zu halten waren.

»Also, Jungs, ihr könnt jetzt nach Hause gehen«, sagte der alte Royalist Sir Jacob Astley, als im Englischen Bürgerkrieg seine Truppen in Stow-on-the-Wold geschlagen waren (1646), »es sei denn, ihr fallt übereinander her.« Wie die endlosen Auseinandersetzungen im UN-Sicherheitsrat zeigen sollten, waren die dort vertretenen Mächte sich vielfach uneins bei der Frage, wie man die gut 40 Kriege, die auf der Welt ständig im Gange sind, befrieden und den Opfern humanitäre Hilfe leisten soll. Die Delegierten müssen an die unruhige Bevölkerung in ihren Heimatländern und an die nächste Wahl denken, zudem wird die Presse täglich kritischer und polemischer. Hochentwickelte Truppen wie die gepanzerten Helikoptereinheiten, die Anfang 1991 unter amerikanischer Führung Kuwait befreiten, hätten höchstens ein paar Monate aktiv sein können und ihre volle Kampfbereitschaft behalten.

Als im selben Krieg die kleine britische Truppe der 1. Panzerdivision ausgeschickt wurde, um an strategischer Stelle in der Wüste das 7. US-Panzerkorps zu unterstützen, meinte der Kommandant Generalmajor Rupert Smith: »Sie haben mir die ganze Spielzeugeisenbahn überlassen, und dazu den vollen Artilleriebestand eines Korps – aber es ist die einzige Spielzeugeisenbahn, die wir haben, ich darf nichts davon kaputtmachen, weil es alles unersetzliche Stücke sind.« Die hochentwickelten Mächte können sich inzwischen nur noch kleine Kriege leisten und ihre Truppen nur noch für sporadische, kurze Friedensmissionen mobilisieren.

Zu Zeiten des industrialisierten Krieges war das Ende eines Konflikts in der Regel eindeutig durch Sieg oder Niederlage bestimmt oder durch einen Waffenstillstand, der für beide Seiten vorteilhaft war. Die Kontrahenten zermürbten sich gegenseitig durch Stellungskrieg, oder sie führten einen Eroberungskrieg. Der Falklandkrieg von 1982 endete mit einem raschen Sieg auf dem Felde, und die Briten erreichten ihr gesetztes Ziel, die argentinischen Truppen zu vertreiben. Im Golfkrieg von 1990/91 wurde das Primärziel, die Befreiung Kuwaits, schnell erreicht. Das sekundäre, weiter gesteckte Ziel – Saddams Panzertruppen zu vernichten und dadurch der ganzen Region mehr Ruhe und Stabilität zu geben – wurde jedoch nicht in Angriff genommen. Saddam konnte seine

Terrorherrschaft ungehindert fortsetzen, die seitdem fast die gesamte Zivilbevölkerung seines Landes ins Unglück stürzt. Die politischen Führer der Westalliierten im Golfkrieg hatten weder den Kampfgeist noch – so sahen sie es zumindest – die Zustimmung ihrer Bevölkerung, um die Aufgabe zu Ende zu bringen, die sie sich gestellt hatten.

Die Einstellung des Westens zum Krieg hat sich in den Jahrzehnten seit 1945 radikal verändert. Eine Diskussion über Verteidigung und Sicherheit ist in den meisten Fällen in der Öffentlichkeit tabu. Der allgemeine Konsens besagt darüber hinaus, daß Armeen nur dann kämpfen sollten, wenn nationale Interessen und der Bestand des Staates unmittelbar gefährdet sind. Im Zeitalter der »Armeen von Muttersöhnen« legen die »Mütter« der Soldaten einer Nation ihren Protest ein, wenn den Söhnen und Töchtern Gefahr droht, vor allem fern von Heim und Herd. Die größte Ironie der Zeit nach dem Kalten Krieg war, daß die USA (die eine Großmacht, die übriggeblieben war) mit einer Armee ausgestattet war, die immer weniger für Einsätze geeignet war, bei denen es zum Kampf kommen konnte und mögliche Verluste drohten.

Bis heute sitzt den Amerikanern die Erinnerung an den Vietnamkrieg in den Knochen, ein durch und durch unpopuläres Abenteuer, das fast 60 000 Amerikaner das Leben kostete und als eine gewaltige politische Niederlage gilt. Der Unwillen, amerikanische Truppen ins Ausland zu schicken, wurde 1983 noch durch die Erfahrungen mit einer multinationalen Friedenstruppe im Libanon verstärkt, wo 241 US-Marineinfanteristen (und an anderer Stelle 58 französische Fallschirmjäger in ihrem Lager) mit ihrem Quartier in Beirut in die Luft gesprengt wurden. Zehn Jahre später verfolgten die Amerikaner mit Entsetzen an den Fernsehschirmen, wie johlende Milizionäre die Leichen von US-Soldaten, die auf Friedensmission in Somalia waren, durch die Straßen von Mogadischu schleiften.

Als Ende 1995 im Rahmen des ersten NATO-Ernstfalleinsatzes nahezu 20 000 Amerikaner an der Spitze der Friedenstruppe nach Bosnien kamen, betrieben sie ihre eigene Sicherheit mit ebensoviel Aufwand wie die eigentlichen Aufgaben. Daß keiner der Soldaten bereit war, Plünderung, Brandstiftung und ethnische Greueltaten zu verhindern und Kriegsverbrecher gefangenzunehmen, untergrub am Ende die Glaubwürdigkeit der Mission.

Die Führungen der amerikanischen Verbündeten – Großbritannien, Frankreich und allen voran Deutschland – waren nicht weniger zaghaft, doch die britischen und französischen Kommandanten vor Ort sorgten in aller Stille dafür, daß ihre Friedensmission anders ausgelegt wurde. Nach ihrer Auffassung konnte man keinen Frieden halten, wo es keinen Frieden gab – so wie es von 1992 bis 1995 die UN-Friedens-

truppen in Bosnien gehandhabt hatten. Man forderte, daß internationale Truppen auch bereit sein müssen zu kämpfen, um ihren Auftrag zu erfüllen, so friedlich dieser Auftrag auch sei. Britische Offiziere waren darüber hinaus der Überzeugung, daß ein vorheriges Festlegen von Verhaltensregeln durch die Politiker – ein Überbleibsel aus der Zeit des Kalten Krieges – den Soldaten und ihren Kommandierenden vor Ort die notwendige Flexibilität nahm. Sie forderten, selbst entscheiden zu können, wann sie gegenüber unberechenbaren Gegnern zur Waffe griffen.

Die britische Armee, wenn auch zahlenmäßig sehr geschrumpft und durch die Unentschlossenheit der Politiker behindert, blieb ausgesprochen effektiv. Indirekt machte ihr der französische Präsident Chirac ein großes Kompliment, als er vorschlug, die französische Armee nach britischem Vorbild zu reformieren. Mitte 1996 war die britische Armee nur noch 100 000 Mann stark, wovon fast 60 Prozent im aktiven Dienst standen – mehr als zu jeder anderen Zeit seit 1945. Die Amerikaner stimmten einer NATO-Reform zu, nach der die europäischen Verbündeten, das heißt vor allem Großbritannien und Frankreich, nun auch ihre eigenen NATO-Operationen organisieren und kommandieren können.

Solche Einsätze wären jedoch stets von begrenzter Dauer, anders als die neue, offene und regellose Form des Krieges, die heute in vielen Erdteilen und an den Rändern Europas geführt wird: in Algerien, dem Kaukasus und in Bosnien. In manchen Teilen Afrikas wie etwa in Liberia und Angola, in Afghanistan und Sri Lanka, ist der Krieg zum Dauerzustand geworden, zum Selbstzweck, bei dem der Handel mit Waffen, Beute, Schmuggelgut und Drogen die Kriegsgewinnler reich macht. In Liberia hatten sich seit 1946 Kriegs- und Friedenszeiten abgewechselt. Nach 50 Jahren ist Monrovia heute in den Händen der bewaffneten Banden, und der Staat spielt nur noch eine unbedeutende Statistenrolle.

Im Nahen Osten versuchten die Israelis lange, in konventionellen Kriegen unter Einsatz von Panzern, Artillerie und Kampfhubschraubern ihre Grenzen zu sichern. Doch die extremistischeren islamischen Gegner sind für einen Terrorkrieg gerüstet, der noch Generationen dauern könnte.

Auch in Bosnien scheinen die unzufriedenen moslemischen Nationalisten sich für den langen, formlosen Krieg zu entscheiden, wo Auseinandersetzungen mit der Waffe Lebens- und Überlebensform sein werden. Solche Konflikte hat der israelische Akademiker Martin van Creveld als »Krieg der Zukunft« beschrieben, in dem es keine nach bestimmten Regeln ausgebildeten organisierten Armeen mehr gibt, sondern ein Mittelding im Bereich zwischen Guerillagruppe und Mafiamiliz. Diese Armeen sind Teil der Gesellschaft und weitgehend vom eigentlichen Staat unabhängig. Sie gehen derart mit modernen Waffen um, daß deren Erfinder den Kopf schütteln würden – »unterhalb der Kulturschwelle«, wie es im Jargon heißt. So kann zum Beispiel eine Feldhaubitze als Terrorinstrument gebraucht werden, wenn man damit willkürlich und ohne Vorwarnung auf die Zivilbevölkerung schießt. Das Städtchen Olovo, von dem in Presseberichten aus Bosnien nur selten die Rede war, wurde während des gesamten Krieges fast täglich beschossen – fast 90 Prozent der Häuser sind ganz oder teilweise zerstört, und trotzdem leben noch immer Menschen dort.

Die aufstrebenden Militärmächte im konventionellen Sinne sind diejenigen, die große Armeen alten Stils aufstellen können und über Reserven verfügen, um ihre Verluste auszugleichen. In Asien und im Pazifik werden in der nächsten Zeit Indien und China die dominierenden Kräfte sein, dazu neue Mächte wie etwa Indonesien. In der Levante, in Südwestasien und am Golf werden die Türkei, Iran und Pakistan die herrschenden Mächte sein. Die Türkei verfügt über die größte NATO-Armee nach den Vereinigten Staaten, und sie wird mit eiserner Disziplin geführt. Die russische Armee hingegen ist, wie die traumatischen Ereignisse in Tschetschenien zeigen, im Niedergang begriffen. 1996 hatte sie nur noch 75 Prozent der Stärke der alten Sowjetarmee und noch nicht einmal ein Fünftel der Geldmittel von 1989 zur Verfügung. Das militärische Vakuum, das Rußland im nördlichen Zentralasien hinterläßt, dürfte eine der brennendsten strategischen Fragen des 21. Jahrhunderts werden.

In solchen Zeiten wird es für Fotografen schwieriger denn je, Kriege und ihre Folgen, das Elend und den Terror im Bild festzuhalten. Der Journalismus ist in all seinen Formen – ob in den elektronischen Medien, in den Printmedien, im Fernsehen oder im Radio – den Tendenzen der Politiker und der Anführer der »Muttersöhnchen-Armeen« gefolgt. Krieg und dessen Folgen sind Teil der Unterhaltungsindustrie geworden; sie geben Material für »Infotainment« ab: ein paar oberflächliche Worte, ein Bild oder ein Filmclip mit »Action«, dann wird übergeleitet zum nächsten Thema. Die Qualität der Arbeiten von Bert Hardy und James Cameron aus Inchon, der besten Kriegsfotografen des Zweiten Weltkriegs und des Vietnamkriegs, wird es wohl nie wieder geben – die Medienwelt unserer Tage hat anderes zu tun, als dafür Zeit, Geld und Interesse aufzubringen.

Und doch beweisen uns die Bilder und Berichte aus Bosnien, Tschetschenien, Ruanda und Somalia, daß sie zu den wichtigsten Zeugen in einer skeptischen Welt gehören. Der Reporter oder Fotograf muß der Mann an der Front sein – kein Hobbyphilosoph, kein politischer Prophet oder weltfremder Historiker. Diese Männer und Frauen müssen dasselbe Training durchmachen wie der Unteroffizier im Panzerwagen und der Sanitäter im Feldlazarett. Von solchen Menschen stammen auch die Dokumente, die in diesem Buch zu sehen sind. Wie jeder General, der etwas wert ist, weiß, sind es die Unteroffiziere, auf die es in einer Armee ankommt.

Im April 1944 war es Patrick Leigh Fermor gelungen, den deutschen Kommandeur auf Kreta, General Karl Kreipe, zu entführen; zufällig hörte er eine Bemerkung von einem der nicht ganz so verbissenen Mitglieder des Generalstabs in Berlin: »So, so, sie haben Kreipe. Na Gott sei Dank, daß sie nicht jemand wirklich Wichtigen geschnappt haben. Stellen Sie sich vor, sie hätten Unteroffizier Schmidt erwischt!«

Retour au futur

Des guerres d'aujourd'hui et de demain et de la manière d'en rendre compte

La guerre froide prend fin en 1989, et les Européens commencent une nouvelle fois à désarmer. L'effondrement du pacte de Varsovie et le désengagement de l'OTAN marquent la fin de la mobilisation des grandes armées en Europe. Pour elles du moins, l'ère de la guerre industrielle et de masse arrive à sa conclusion. Mais les conflits continuent dans d'autres régions du monde, s'étendent et prennent des formes que les nations technologiquement avancées ainsi que leurs armées et leurs agences telles que l'ONU ont de plus en plus de mal à contrôler.

« Bon, maintenant, vous pouvez rentrer chez vous », déclara le royaliste Sir Jacob Astley à ses soldats, après leur défaite à Stow-in-the-Wold (1646), pendant la guerre civile anglaise, « à moins que vous ne vous fâchiez entre vous ». Comme le prouvent les interminables discussions au sein du Conseil de sécurité des Nations unies, les puissances occidentales se sont souvent querellées sur les moyens de gérer les opérations de maintien de la paix et les missions humanitaires dans quelque 40 régions de la planète à la fois. Il leur faut tenir compte d'une opinion publique et d'un électorat indociles, et d'une presse encore plus critique et prompte à la polémique. Une armée hautement sophistiquée, comme les forces blindées et aéroportées qui, sous commandement américain, libèrent le Koweït au début de l'année 1991, ne pourrait rester en campagne en gardant une capacité de combat maximum que quelques mois au plus.

Lorsque, dans cette même guerre, la 1ère division blindée britannique, de taille modeste, est expédiée dans le désert pour constituer l'élément pivot du 7e corps US, son commandant, le général Rupert Smith déclare : « On m'a donné le grand jeu avec la batterie complète d'une artillerie de corps d'armée mais c'est le seul jeu que je ne puisse pas me permettre de perdre car il n'y en a pas d'autre pour le remplacer ». Les pays développés et technicisés ne peuvent mener que des guerres de courte durée ainsi que de brèves et sporadiques opérations de maintien de la paix.

A l'époque des guerres industrielles, la fin d'un conflit se définissait simplement par une victoire et une défaite, ou une trêve basée sur un intérêt commun. Une armée pouvait prendre le dessus par une guerre d'usure, une invasion ou une conquête. En 1982, la guerre des Malouines s'est achevée par une victoire rapide sur le terrain et l'expulsion de l'armée argentine du pays, premier objectif des Britanniques. Si, pendant la guerre du Golfe, le Koweït a été libéré, la seconde mission, et la plus vaste, celle de détruire le potentiel militaire de Saddam afin de rétablir le calme et la stabilité dans la région, est loin d'avoir été remplie par les coalisés. Saddam a pu continuer à gouverner par la terreur, appauvrissant la population, assassinant et mettant à mal les minorités kurde et chiite. Les pouvoirs occidentaux en place n'ont ni la velléité ni le soutien de leur opinion publique pour mener à bien la tâche qu'ils se sont eux-mêmes fixée.

Après 1945, la guerre commence à être considérée sous un nouveau jour dans les pays occidentaux. Les questions de défense et de sécurité deviennent des sujets tabous. L'idée clé est que si vraiment les armées doivent se battre, cela aura uniquement lieu en cas de menace directe de l'intérêt national ou de la population. L'époque des armées « mammas » a débuté : les mères pourront protester contre l'engagement, loin de chez eux et pour des missions dangereuses, des soldats de la nation, en l'occurrence leurs fils et leurs filles. Ironie de l'histoire : la fin de la guerre froide laisse la seule superpuissance, les Etats-Unis, à la tête d'une armée de moins en moins capable de supporter une action militaire impliquant combats et pertes.

Les Américains restent hantés par la guerre du Vietnam, une aventure des plus impopulaires qui coûtera à l'Amérique près de 60 000 soldats et une grave défaite politique. Les doutes de la population quant à l'intervention de soldats à l'étranger se nourrissent de diverses expériences malheureuses : en 1983, à Beyrouth, 241 Marines meurent dans un attentat (58 parachutistes français sont tués également dans leur cantonnement). Dix ans plus tard, les téléspectateurs américains seront horrifiés à la vue des corps de certains de leurs soldats envoyés en Somalie pour y rétablir la paix, traînés dans les rues de Mogadiscio par des miliciens en joie.

Quand, fin 95, 20 000 soldats américains sont expédiés en Bosnie pour y diriger la première mission opérationnelle de l'OTAN, l'IFOR, leur protection est considérée comme une priorité, au même titre que le travail à accomplir. Cette mission perdra en crédibilité par leur indécision à réagir contre les pillages, les incendies, la purification ethnique, et à arrêter les criminels de guerre.

Les Etats alliés – Grande-Bretagne, France et Allemagne – sont incapables de prendre des mesures concrètes, mais sur le terrain, les commandements français et britannique font preuve de plus de résolution en redéfinissant la notion du maintien de la paix. Selon eux, il ne sert à rien d'essayer de préserver la paix là où il n'y a pas de paix à préserver, comme le prouvera d'ailleurs le déploiement des Casques bleus en Bosnie de 1992 à 1995. Les troupes internationales doivent donc être prêtes à se battre pour remplir leur mission, si humanitaire soit-elle. De plus, pour les officiers britanniques, la notion de « règles d'engagement » datant de la guerre froide et inventée par des hommes politiques, prive d'avance les hommes de terrain, soldats et commandants, de la souplesse nécessaire pour répondre par la force à des adversaires imprévisibles.

L'armée britannique, bien qu'ayant diminué en taille et affaiblie par une direction quelque peu confuse de la part des hommes politiques, n'a rien perdu de son efficacité. C'est le président Jacques Chirac qui lui rend le plus bel hommage en disant que la refonte de l'armée française devra se faire sur le modèle britannique. Vers le milieu de 1996, près de 60 % de ses effectifs, 100 000 en tout, sont en service actif, un fait sans précédent dans l'histoire de cette armée depuis 1945. Les Américains ont accordé une réforme de l'OTAN qui consiste à laisser les membres européens, la Grande-Bretagne et la France principalement, mener des opérations militaires pour leur propre compte.

Mais ces actions seraient brèves, contrairement aux guerres interminables ayant éclaté dans de nombreuses régions du monde et aux frontières de l'Europe – en Algérie, dans le Caucase et en Bosnie. Au Liberia et en Angola, en Afghanistan, au Sri Lanka, la guerre est devenue un scénario continu, une fin en soi que des seigneurs de la guerre peuvent poursuivre grâce à la contrebande, au butin, au trafic d'armes et de drogues. Le Liberia est passé alternativement par des phases de guerre et de paix depuis 1946. Pendant cinquante ans, les seigneurs de la guerre ont eu la haute main sur Monrovia, reléguant souvent l'Etat à un rôle de second plan.

Au Proche-Orient, les Israéliens essaient de garantir leurs frontières en menant une guerre de type industriel avec des blindés, de l'artillerie et des hélicoptères de combat. Mais ils ont en face d'eux des adversaires islamiques formés à la guerre terroriste qui pourrait durer des générations.

En Bosnie également, les nationalistes musulmans semblent avoir opté pour une longue action militaire menée par des troupes irrégulières, faisant de cette guerre une manière de vivre et de survivre. L'Israélien Martin van Creveld appelle ce type de conflit la «guerre du futur»: l'armée ne sera plus une unité de combat organisée et entraînée mais quelque chose d'intermédiaire entre la guérilla et la milice mafieuse. En Bosnie, les soldats font partie intégrante de la communauté mais n'ont rien à voir avec l'Etat en tant que tel. Ils se servent de leur armement moderne d'une manière que n'ont pas prévue ses inventeurs: «en dessous du seuil de sophistication», comme il est dit dans le jargon du métier. Ainsi un obusier de campagne de 122 mm destiné à tirer de concert avec le reste de la batterie, régiment ou brigade, sème la terreur parmi les civils, fermiers et villageois des montagnes de Bosnie, en tirant au hasard, sans avertissement. Le petit bourg d'Olovo, à peine mentionné sur les dépêches en provenance de Bosnie, a été pilonné presque chaque jour de la guerre. La quasi totalité des maisons a été endommagée ou détruite, et pourtant, les gens continuent d'y vivre.

A l'avenir, les vraies puissances militaires dans le sens conventionnel du terme seront capables de placer sur le terrain de nombreuses forces conventionnelles et de les remplacer en cas de pertes et de revers. En Asie et dans le Pacifique, les nouvelles puissances seront certainement l'Inde, la Chine et des nouveaux venus comme l'Indonésie. De leur côté, la Turquie, l'Iran et le Pakistan domineront très probablement la région du Moyen-Orient et du Golfe. La Turquie a la plus grande armée de l'Alliance atlantique en dehors des Etats-Unis, et elle est parfaitement disciplinée. Quant à l'armée russe, ainsi que le montrent ses déboires en Tchétchénie, elle est en déclin. En 1996, elle n'affiche plus que 75 % des effectifs de l'ancienne armée soviétique et un budget qui représente le cinquième de celui de 1989. Son équipement conventionnel sera devenu obsolète dans sa majeure partie vers 2005. Le vide militaire laissé par la Russie dans le nord de l'Asie centrale sera l'un des problèmes stratégiques majeurs à l'aube du second millénaire.

De tels changements rendront plus difficile encore le travail des photographes rendre compte du conflit jusque dans ses conséquences et sa réalité, avec toute la terreur et la pitié qu'il engendre. Le journalisme sous toutes ses formes – reproduction électronique, journal, télévision et radio – a suivi les hommes politiques et les chefs des armées «mammas». La guerre avec ses conséquences relève maintenant de l'information-spectacle, de l'industrie du «produit info»: débitée en phrases toutes faites qui titillent, avec des bribes de photographie ou de film d'action … vite, le public peut passer à autre chose. Le grand travail de Bert Hardy et de James Cameron à Inchon, les meilleurs photographes de la Seconde Guerre mondiale et du Vietnam, ne sera probablement jamais surpassé – l'argent, le temps et l'intérêt profond ne sont pas les choses les mieux partagées dans le monde des médias.

Mais, les images et les mots en provenance de Bosnie, de Tchétchénie, du Rwanda et de Somalie en sont la preuve: ils restent des témoins irremplaçables dans un monde professant le scepticisme. Il faut souhaiter que le reporter ou le photographe demeure un homme du front, et ne se transforme pas en un moraliste à la petite semaine, en un prophète politique ou un historiographe farfelu, ce que beaucoup sont devenus dans ce métier. Ces hommes et ces femmes doivent s'exercer autant que le caporal dans son blindé ou le médecin-major dans son poste de secours. Ce sont eux qui ont fait ce livre, grâce à leurs photographies, et tout général digne de ce nom vous le dira, une armée dépend de ses caporaux.

En avril 1944, Patrick Leigh Fermor qui venait de capturer le général Karl Kreipe, commandant de l'armée allemande en Crète, entendit cette remarque faite par un membre, très détendu, de l'état-major allemand à Berlin: «Kreipe – Kreipe. Ils ont pris Kreipe. Dieu merci, ils n'ont pas pris quelqu'un de vraiment important comme le caporal Schmidt! »

Index

Where the entry is not translated, page numbers separated by a slash refer to English/German/French text respectively.

Bei Einträgen ohne Übersetzung sind die Seitenzahlen wenn erforderlich in der Reihenfolge Englisch/Deutsch/Französisch durch einen Schrägstrich getrennt.

Pour les entrées sans traduction les numéros de pages se référant au texte anglais/allemand/français sont séparés par une barre oblique, si différent.

Abessinien 128, 151ff
Abyssinia 126, 151ff
Abyssinie 131, 151ff
Aden 346/347/347
Adrianopel 54, 64
Adrianople 54, 64
Aegis 380/380/381
Afghanistan, 42ff/42ff/43f
 Russian involvement 252, 277, 324
 russische Intervention 253, 277, 324
 engagement de la Russie 255, 277, 325
Africa
 decolonisation 352
Afrika
 Entkolonisierung 352ff
Afrikaaners 58, 62
Afrikaners 58, 62
Afrique
 décolonisation 354f
Agent Orange 307
Ägypten
 Protektorat 48
Aidid, Mohammed Farah 394/394/395
Air/land 2000 tactics 374
Aircraft
 American 118
 fighters and bombers 114
 photography 10f
 reconnaissance 70, 114
Akaba /110/111, /328/329
Al-Husseini, Abdul-Khader 331
Albania 50
Albanian partisans 212
Albanie 55
Albanien 53
Albanische Partisanen 212
Algeria, war of independence 363
Algérie, guerre d'indépendence 363
Algerien, Unabhängigkeitskrieg 363
Allenby, General Sir Edmund 112/112/113
American Civil War 8f, 20, 22, 31
Amerikanischer Bürgerkrieg 12f, 20, 23, 31
Amiens 71/76/79
Andric, Ivo 52/54/55
Angola 354, 360/360/361

Anschluss 164
Antelope, HMS 370/371/371
Antietam 9/13/17
Anse de l'Anzac 80
ANZAC 73/77/80
Anzac-Bucht 77
Anzac Cove 73
Aqaba 110, 326
Arafat, Jassir 328
Arafat, Yasser 329
Arafat, Yassir 327
Armee des Königreichs Serbien 104
Armée Rouge 217
Armée serbe 104
Armées «mammas» 414
Armee von Muttersöhnen 412
Armes biologiques 378
Armes chimiques 81, 376, 378
Armes V 207
Armoured Fighting Vehicle 68
Artillerie 32, 88
Artillerie fédéral 32
Artillery 32, 88
Astley, Sir Jacob 410/412/414
Atatürk (Mustafa Kemal) 126/127/131, 137
Äthiopien 357
Atlantic, battle in the 182
Atlantik, Schlacht im 182
Atlantique, bataille de 182
Aubervilles, fort d' 39
Aubervilles, Fort of 38
Aubervilles, Fort von 38
Audacious, HMS 118
Auschwitz 196/197/197
Austria 164
Austro-hongrois, Empire 55, 81
Austro-Hungarian Empire 50, 73
Autriche 164
Avions
 américaines 118
 chasseurs et bombardiers 114
 furtifs 378
 photographie 18f
 reconnaissance 79, 114

Baedeker raids 204
Baedeker-Angriffe 204
Bagdad
 Bombardierung -s 384
 bombardement de 384
Baghdad, bombing of 384
Baie de Cossack 28
Baker, James 374/376/378, 380/381/381
Bala Bagh 44
Bala Bug 44
Balaclava 26
Balaklava 27
Balaklawa 26
Balkan League 50
Balkan Wars 50, 64
Balkanbund 53
Balkanique
 entente 55
 guerres 55, 64
Balkankriege 53, 64
Baltic Fleet 50
Baltique, flotte de 55
Bangladesch 319
Bangladesh 318//319
Bataille d'Angleterre 203
Battle of Britain 202

Bazooka 192
BBC 198/200/201
Beato, Felice 8/13/17
Beaumont, Schlacht von 13
Beaumont Hamel, battle of 10
Beaumont-Hammel, bataille de 18
Beatty, Admiral 120
Beatty, Amiral 121
Berlin 10/13/18, 215
Berlin Airlift 258
Berlin, mur de 255, 266
Berlin, pont aérien de 258
Berlin Wall 252, 266
Berliner Kongreß 54
Berliner Luftbrücke 258
Berliner Mauer 253, 266
Béthune 92
Beveridge, Sir William 198/200/201
Bevin, Ernest 198/199/200
Bey, Enver 110
Biafra, guerre du 359
Biafrakrieg 359
Biafran War 359
Biological weapons 374
Biologische Waffen 376
Birmanie 231
Blitzkrieg 10/15/19, 174, 204/204/204
Bloemfontein 50/52/55
Blücher 120/120/121
Boer War 50f, 58ff
 treatment of prisoners and civilians 62
Boers, guerre des 51, 55, 58ff
 traitement des prisonniers et civils 62
Bolcheviks 81, 132, 134
Bolschewiki 78, 132, 134
Bolsheviks 73, 132, 134
Bonhoeffer, Dietrich 198/200/201
Bosnia 11, 375, 379, 411
Bosnie 19, 379, 415
Bosnien 15, 377, 379, 413
Bougainville 239
Bourrasque 178
Brady, Mathew B. 8ff/12ff/16ff
Brême, constructions navales de 208
Bremen dockyards 208
Bremer Werften 208
Brest-Litovsk 73//81
Brest-Litowsk 78
Brigade de Sassari 80
Brigade montée polonaise 180
Britische Expeditionsarmee 178
Britisches Weltreich 48
British Empire 48
British Expeditionary Force 178
British South Africa Company 52
Bromhead, Lt. Gonville 52
Broz, Josip (Tito) 198/200/201
Brussilov, General Alexei 73//80
Brussilow, General Alexej 77
Buchenwald 196/197/197
Bulgaria 50, 73
Bulgarie 55, 80
Bulgarien 53, 76
Bull Run 9/13/17
Buna 242
Buren 58, 62
Burenkrieg 51f, 58ff
 Behandlung von Soldaten und Zivilisten 62

Burma 228/230/
Burrows, Larry 10/15/19, 16
Bush, George 374/377/378

Cachemire 276, 317
Cadorna, General 73/78/80
Cambodge 277, 312
Cambodia 273, 312
Cambrai 70/75/79, 88
Cameron, James 11/15/19, 14
Canal de Suez 329, 332, 341
Capa, Robert 10/15/19, 188/188/189, 190
Cape Gloucester 245
Caporetto 10/15/19
Casques bleus 375, 378f, 408, 414
Castro, Fidel 252/253/254, 264
Catalogne 131
Catalonia 126
Cavaliers cosaques 180
Chapei 146
Char d'assaut 68
 Mark IV 91
 Mark V 79
 chars russes 218
Chard, Lt. John 52
Charge de la brigade légère 16, 23f
Charge of the Light Brigade 8/12/, 22/23/
Chariots 39
Chechenya 18, 398ff
Chemical weapons 74, 374, 376
Chemische Waffen 78, 376, 377
Chemin de fer de Hejaz 111
Chiang Kai-Shek, General 126//131, 140, 149
Chiites 388
Chilas Fort 67
China
 Bürgerkrieg 128, 140
 civil war 126, 140
 Guerila 149
 guerrillas 149
 Langer Marsch 129, 145
 long march 126, 145
Chindits 239
Chine
 guerre civile 131, 140
 guérilla 149
 longue marche 131, 145
Chinesisch-Japanischer Krieg 142ff
Chruschtschow, Nikita 248
Chu Wen-hai 149
Churchill, Winston 68, 73/77/80, 250/252/253
Chypre 364, 367
CNN 11/15/19
Cold War 248ff
Colenso 50/52/55
Cologne 194, 208
Commune 25, 40
Communication 94
Condor Legion 126
Conduct of the Defensive Battle 70
Conduite de la guerre défensive 79
Congrès de Berlin 55
Congress of Berlin 50
Constantinople 50//55
Contra guerrillas 368
Contra-Rebellen 368
Contras 368
Coral Sea, battle of 10
Corée, guerre de 19, 270, 276, 280ff

Corps expéditionnaire britannique 178
Cossack Bay 28
Cossack cavalry 180
Coventry 204
Crete, German invasion of 188
Crète, invasion allemande de la 189
Crimean War 8f, 22ff
Cruise missiles 384
Cruise-Missiles 384
Cuba 252//254, 262
 crise de 264
 Missile Crisis 264
Cyprus 364, 366f
Czechoslovakia 162ff, 255

D-Day 10/13/18, 186
Dardanellen 77, 108
Dardanelles 73//80, 108//109
Dawson-Flugfeld 328f
Dawson's Field 326//329
Decolonialization 272ff
Décolonisation 276ff
Derviches 55
Dervishes 50
Derwische 52
Deutsch-Französischer Krieg 24f, 36ff
Deutsche 8. Armee 76
Deuxième Guerre Mondiale 168ff
 attaque amphibie 186
 attaque japonaise 229ff
 bataille de l'Atlantique 182
 bataille du Sahara 185
 bombardement 200ff
 civils 200f
 développement de tactique 81
 évacuation 201
 femmes au travail 211
 fin 231
 fin de partie 194
 opération Barbarossa 216
 opération Typhon 216
 partisans 212
 rations de nourriture 201
 résistance 212
 troupes allemandes en Russie 216f
Dhofar conflict 272
Dhofar, conflit du 276
Dhofar-Konflikt 275
Diaz, General Armando 73/78/80
Dictateur, canon de la guerre 32
Dictator gun 32
Dieppe 186
Diktator, Kriegsgeschütz 32
Dimbleby, Richard 10/15/19
Dix, Otto 10/13/18
Dorian Front 104
Dorjan, Front bei 104
Doudaev, Djokhar 399
Dresde 208
Dresden 208
Dubček, Alexander 268
Dubček, Alexandre 269
Dudajew, Zhokar 398
Dudayev, Zhokar 398
Dunkerque 178, 201
Dünkirchen 178, 199
Dunkirk 178, 198

Egypt
 protectorate 48

Egypte
 protectorat 48
Eiserner Vorhang 248, 252f
El-Alamein 184, 185
El Salvador 368
Empire de la France 48
Empire de la Grande-Bretagne 48
England-Krieg 204
Enola Gay 228/230/231
Entkolonisierung 274ff
Eoka 364, 366/367/367
Erster anglo-afghanischer Krieg 42
Erster Weltkrieg 12, 74ff
 Gefangene und Verwundete 102
 Krieg auf dem Balkan 104
 Krieg in der Türkei 108
 Kriegserklärung 54
 Opfer 68
 Ostfront 76ff, 98ff
 Seeschlacht 120ff
 Wasser- und Luftangriffe 114, 118
 Westfront 71, 74f
Et-Tell el-Kebir 48, 52
Etat providence 201
Ethiopia 356
Ethiopie 357
Exocet missile 370
Exocet-Rakete 370

Falkenhayn, Erich von 70/74/79
Falklandkrieg 13, 370, 412
Falklands War 8, 370, 410
Fallschirmspringer-Truppen 188ff
Fenton, Roger 8/13/16
Fernsehen 15
Fincher, Terry 10/15/19, 16
First Afghan War 42
First World War 8, 70ff
 air and sea battle 114, 118
 Balkan Front 104
 casualties of 68
 dead and wounded 102
 declaration of 52
 Eastern Front 71ff
 Russian Front 98
 sea battle 120ff
 war in Turkey 108
 Western Front 70f
FLN 363
Flotte américaine 230
Flugzeuge
 amerikanische 118
 Aufklärung 75, 114
 Fotografie 14f
 Jäger und Bomber 114
Forces françaises de l'interieur 212
Fort Douaumont 70/74/79
Fort Totten 20
Franco, General Francisco 126/129/131, 129, 154/154/155, 158
Franco-Prussian War 22f, 25, 36ff
François-Ferdinand, archiduc 55, 64
Franklin, USS 234/234/235
Franz Ferdinand, Archduke 50, 64
Franz Ferdinand, Erzherzog 54, 64
Französische Partisanenarmee 212
Französische Weltmacht 48
French Empire 48
French Forces of the Interior 212
Front dorien 104

Gallipoli 71, 73/77/80, 108/108/109
Gambetta, Léon Michel 40/40/41
Gas warfare 73f, 92, 151
Gaskrieg 78, 92, 151
Gatling gun 22, 67
Gatling-Maschinengewehr 24, 67
Gatling, mitrailleuse automatique 25, 67
Gaz au phosgène 92
Gaz lacrymogène, le 81
Gaz moutarde, gaz à l'ypérite 81, 92
Geheimdienst 253
General Belgrano 370/370/371
German Army Group North 214
German 8th Army 72
Gettysburg 31
Gigli, Lessona Cobolli 151
Golfkrieg 15, 372ff, 412
Goma 392
Gorbachev, Mikhail 252
Gorbatchev, Mikhail 255
Gorbatschow, Michail 253
Grabenkrieg 82
Grande-Bretagne, bataille en 204
Grant, Ulysses S. 22/24/25
Grèce, guerre civile 254, 257
Greek civil war 250, 257
Griechenland, Bürgerkrieg 252, 257
Groupement nord de l'armée allemande 216
Guadalcanal 228/230/231
Guernica 126/129/131
Guerre civile espagnole 19, 131, 155ff
Guerre civile yougoslavien 379, 403ff
Guerre de gazage 81, 92, 151
Guerre de la Crimée 9, 16, 23ff
Guerre de l'opium 17
Guerre de Sécession 16f, 20, 25, 31
Guerre des Falkland 355, 371
Guerre des Malouines 16, 378, 414
Guerre des six jours 329, 334
Guerre de tranchées 82
Guerre de transmission 94
Guerre du Golfe 19, 372ff , 414
Guerre du Kippour 339ff
Guerre du Vietnam 16, 19, 276f
Guerre en Pacifique 18, 230f
Guerre franco-allemande 25, 36ff
Guerre froide 248, 253ff
Guerre hispano-américaine 55, 57
Guerre irano-irakienne 81, 349ff
Guerre russo-japonaise 55
Guerre sino-japonaise 142ff
Guerres zouloues 55
Guevara, Ernesto 'Che' 262
Gulf War 11, 372ff, 410

Habyarimana 392
Hailé Sélassié, empereur 131, 151
Haile Selassie, Emperor 126, 151
Haile Selassie, Kaiser 128, 151
Halabja 74/78/81
Hanrahan, Brian 8/13/16
Hardy, Bert 11/15/19, 14
Harper's Ferry 31
Havel, Václav 268/268/269
Heeresgruppe Nord 215
Hejaz railway 110
Heydrich, Reinhard 214/215/217
Hidjasbahn 110

Hill Timothy 10/15/19, 16, 310
Hindenburg, General Paul von 72/76/80
Hipper, Admiral 120/120/121
Hiroshima 228/230/231, 245
Hitler, Adolf 124, 127, 126/127f/131
Hitlerjugend 124
Holocaust 196/197/197
Home Guard 198/199/201
Hôpital de Wijnberg 62
Horsa Glider 190
Horsa-Lastensegler 190
Hsuchon 131
8ᵉ Armée Allemande 80
Hulton, Edward 10f/13ff/18f
Hungarian uprising 250, 260
Hurd, Douglas 375/377/379
Hussein, Saddam 74/78/81, 327/328/329, 372, 374/376f/378f, 381/381/382

Iles Marshall 242
Inchon 14
Inde 317
India 316
Indien 316
Indonesia 272, 296
Indonésie 276, 297
Indonesien 275, 296
Irak
 révoltes tribales 139
 Volksaufstände 139
Iran-Iraq War 74, 348ff
Iranisch-Irakischer Krieg 78, 349ff
Iraq, tribal rebellion 139
Iron Curtain 248ff
Isonzo 73/78/80
Israel 331
Iwo Jima 228/230/231

Jackson, Stonewall Th. 22/24/25, 31
Jaffa Gate, Jerusalem 160
Jaffa-Tor, Jerusalem 161
Jameson, Dr. 52
Jean Paul II 255
Jemen 347
Jerusalem 160
Jérusalem 161
Joe Chamberlain, canon 51
Joe Chamberlain, Geschütz 51
Joe Chamberlain gun 51
Joffre, Joseph 70/74/79
Johannes Paul II 253
John Paul II 252
Johnson, Roosevelt 396/396/397
Jom-Kippur-Krieg 328, 339ff
Jugoslawien, Bürgerkrieg 376f, 402ff

Kaboul 43f, 325
Kabul 42/42f/, 44, 324/325/
Kalter Krieg 248, 252f
Kambodscha 275, 312
Kampftaktik 78
Kandinsky, Vassily 10/13/18
Kaschmir 275, 317
Kashmir 272, 316
Katalonien 129
Kosakenbucht 28
Kosakenkavallerie 180
Kemal, General Mustafa (Atatürk) 73/77/80, 108/108/109, 126, 137
Kennedy, John F. 252/253/255
Khrouchtchev, Nikita 248
Khrushchev, Nikita 248

Killing zone 84, 86
Kimberley 50/52/55
Kitchener, General Sir Herbert 8/13/16, 50/52/54
Koffie Spuit 60
Köln 194, 208
Konstantinopel 53
Korallenmeer, Schlacht vom 15
Koreakrieg 15, 270, 274, 280ff
Korean War 11, 270, 272, 280ff
Kosakenbucht 28
Kovess, General 104
Koweit 372, 378f
Kreipe, General Karl 411/413/415
Krieg im Pazifik 13, 229f
Kriegsfotografie 12
Krimkrieg 9, 12f, 23f
Kuba 253, 262
 Kubakrise 264
Kurdestan 388
Kurdistan /388/389
Kuwait 372, 374/376f/

Lacs Mazures 80, 99
Ladysmith 50/53/55
Lawrence, T. E. 10/15/19, 110/110/111
League of Nations 126, 142
Lebanon, civil war 343f, 375, 410
Lee, Robert E. 22/24/25, 32
Legion Condor 129
Légion Condor 131
Leibing, Peter 11/15/19, 266/266/267
Lenin, Vladimir Ilyich 73
Lenin, Wladimir Iljitsch 78
Lénine, Vladimir Ilitch 81
Lewis, Cecil 10/14/18
Lexington, USS 10/15/19, 236/236/237
Leyte, Golfe de 231, 242
Leyte, Golf von 230, 242
Leyte Gulf 228, 242
Liban, guerre civile 343ff, 375, 414
Libanon, Bürgerkrieg 343ff, 375, 412
Liberia 396/396/397
Lincoln, Abraham 22/24/25
Long Range Desert Group 184/185/185
Ludendorff, Erich von 70ff/74ff/79f
Luft/Land 2000-Strategie 376
Lule Burgas 50/53/55

MacArthur, Douglas 272/274/276
Macédoine 55
Macedonia 50
Machine gun 67, 149
Mackensen, General August von 73/76/80, 104
Macmillan, Harold 250
Mafeking 50/52/55, 58
Magersfontein 50f/51f/55
Mahdi 50/52/54
Maine, USS 50/53/55
Makale 153
Malaisie 276, 294
Malaya 272/274/, 294
'Mammista' armies 410
Manchuria 12, 50, 126, 142, 228
Mandchourie 12, 55, 131, 142, 231
Mandschurei 12, 53, 128, 142, 230
Mao Tse-Tung 126/128/131, 145,

272/274/276
Marne 70/74/79
Marshall-Inseln 242
Marshall Islands 242
Marshall Plan 250
Marshall-Plan 252
Maschinengewehr 67, 149
Massu, General 363
Masurian Lakes 72, 98
Masurische Seen 76, 99
Matabele rebellion 52
Matabele-Aufstand 52
Matabélé, rébellion des 52
Maxim gun 50, 67
Maxim-Maschinengewehr 52, 67
Mazedonien 53
McCullin, Don 10/15/19
Mechanised Transport Training Corps 211
Megiddo offensive 112
Megiddo-Offensive 112
Menen, Straße nach 102
Menin Road 102
Menin, route de 102
Mer de Corail 19
Messines 88
Miar 160/161/161
Michael Offensive 71
Middle East 326f
 mandates 126
Midway 228/230/230
Minage menée, opération de 114
Mine-laying 114
Minen, deutsche Operation 114
Missile Exocet 371
Missiles de croisière 384
Mitrailleuse 67, 149
Mitrailleuse Maxim 55, 67
Mitrailleuse Vickers 67
Moltke, General Helmuth von 22/24/25
Montgomery, General Bernard 184/185/185
Mossoul, révolte kurde 81
Mosul, Kurdenaufstand 78
Mosul, Kurdish revolt 74
Mouvement hitlérien 124
Mouvement sioniste 131
Moyen-Orient 328f
 mandats au 131
Mukden 126/128/131, 142
Mulberry Harbour 186
Murrow, Ed 10/15/19
Mussolini, Benito 74/78/81, 124, 126/128/131, 127, 129, 198/200/201
Mustard gas 74, 92
Mutla Ridge 386/386/386

Nadar, Gaspard-Félix 40
Nagasaki 228/230/231
Nah-Ost-Mandate 127f
Naher Osten 327f
Nankin 146
Nanking 146
Napalm 292
Napoléon III 22/24/25
Nash, Paul 10/13/18
Nasser, Gamal Abd el 326/328/329
Nationalsozialisten 128
Nato 248, 250/252/
 forces 374f
 -Streitkräfte 376f
Nazi Party 126

Nazis 131
Neufundland-Regiment 13
Newfoundland Regiment 10
Nicaragua 368
Nicholas II, Czar 73
Nicolas II, Tsar 80
Nightingale, Florence 22/23/24
Nikolaus II, Zar 76
Nixon, Richard 248
Normandie 194
Normandy 194
Northrop A-5 307
Norvège, attaque allemande à 173
Norway, German attack on 170
Norwegen, deutscher Angriff auf 172
Nuremberg Rally 127
Nuremberg, rassemblement nazi à 127
Nürnberger Reichsparteitag 127

OAS 363
October Revolution 10
Offensive décisive à Megiddo 113
Offensive du Têt 300
Offensive Michael 79
Okinawa 228/230/231, 239
Oktoberrevolution 15
OLP 329
Omdurman 50/52/
Omdourman 54
ONU 379, 408
Operation Barbarossa 214/214/216
Operation Desert Sabre 384
Operation Desert Storm 374/377/, 380
Operation Michael 76
Operation Overlord 170/172/173, 186
Opération sabre du désert 384
Opération tempête du désert 378, 381
Opium Wars 9
Opiumkriege 13
Osmanische Türkei 53
Österreich 164
Österreich-Ungarn 53, 78
Ostseeflotte 53
OTAN 248, 253f
 forces de 378
Ottoman Turkey 50
Owen, Wilfred 10/13/18

Pacific War 10, 228
Pacte de Varsovie 248
Pakistan 316/316f/317
Palästina 160
Palestine 160//161
Panzerfahrzeug 68
 Mark IV 91
 Mark V 76
 russisches 218
Panzerfaust 217
Parachute forces 188ff
Parachutistes 189f
Paris 40
Paris Commune 40
Pariser Kommune 40
Partisans albanais 212
Partito d'Azione 212
Pascha, Enver 110
Passchendæle 71/75/79, 86/86/87
Pearl Harbor 228f/229f/230f
Pershing, General John 71/76/79,

118
Petacci, Clara 198/200/201
Pétain, General Philippe 70/74/79
Pferdewagen 38
Phoenix, USS 370/370/371
Philippinen 231
Philippines 231
Phosgen-Gas 92
Phosgene gas 92
Photographie de la guerre 16
Picture Post 10f/13ff/18f
Plan Marshall 254
PLO 326/328/, 329
Poland
 cavalry battle in 180
 invasion of 170, 176
Polen
 Kavallerie-Schlacht 180
 Überfall auf 171, 176
Polices secrètes 254
Polish Mounted Brigade 180
Polnische Berittene Brigade 180
Pologne
 bataille montée 180
 conquête 172, 177
Portail Jaffa, Jérusalem 161
Port Arthur 50/53/55
Port Moresby 228/230/230, 236/236/237
Prager Frühling 253, 268
Prague Spring 252, 268
Praytor, Sergeant Frank 291
Première guerre afghane 43
Première Guerre mondiale 16, 79ff
 blessés et prisonniers 102
 déclaration 55
 front balkanique 104
 front oriental 71, 79f
 front occidental 80f, 99ff
 guerre en Turquie 109
 guerre sur mer 121ff
 morts et blessés 68
 opérations dans les airs et sur mer 114, 118
Pretoria 50/52/55
Princip, Gavrilo 50/54/55
Printemps de Prague 255, 269
Pusan 11/15/19, 14

Raids Baedeker 204
Raketensysteme 192
Reagan, Ronald 252/253/255, 368
Red Army 214
Régiment Royal Canadien 60
Rennenkampf, General Pavel 72f/76/80
Révolution d'Octobre 18
Rhein, Absprung über dem 188
Rheinland 164
Rhénanie 164
Rhin, traversée du 189f
Rhine crossing 188
Rhineland 164
Rhodes, Cecil 52
Rhodesia 52
Rhodésie 52
Rhodesien 52
Rideau de fer 248, 254f
Roberts, General Sir Frederick 42/43/43, 44, 50/52/55
Rocket systems 192
Rommel, Erwin 184/185/185
Roosevelt, Theodore 56/57/57
Rorke's Drift 50/52/55, 52

Roschdestwenskij, Admiral 53
Rosenthal, Joe 10/15/19
Rosselli, Carlo 127/129/131
Rote Armee 215
Rough Riders 56/57/57
Royal Air Force 139
Royal Canadian Regiment 60
Royal Serb Army 104
Rozhdestvenski, amiral 55
Rozhdestvensky, admiral 50
Ruanda 392
Russell, William Howard
 8ff/13ff/16ff, 9, 22/23/24
Russia
 civil war in 134
 revolution 10, 132
 1st Army 72
Russie
 guerre civile 134
 révolution 18, 132
 première armée 80
Russisch-Japanischer Krieg 53
Rußland
 Bürgerkrieg 134
 1. Armee 76
 Revolution 15, 132
Russo-Japanese War 50
Rwanda 392

Saint-Cloud 38/38/39
Saint-Mihiel-Bogen 76
Saint-Mihiel, saillant de 79
Saint-Mihiel salient 71
Salan, General Raoul 363
SALT 252/253/255
Salvador 368
Samson, Nikos 366/367/367
Samsonow, General Alexander 76
Samsounov, général Alexandre 80
Samsunov, General Alexander 72
Sanders, General Otto Liman von
 73/77/80
Santa Fe, USS 234/234/235
Sarajevo 50/53/55
 Belagerung von 404
 siège de 404
 siege of 404
Saratoga, USS 236/237/237
Sargent, John Singer 10/14/18
SAS 184/185/185, 272/275/276, 294
Sassari Brigade 73
Sassari-Brigade 78
Schanghai 146
Schiiten 388
Schilinski, General Jakow 76
Schlieffen, General Alfred von
 70/74/79
Schukow, Marschall Georgij 215
SDI 252/253/255
Sébastopol 28
Sechstagekrieg 334
Second Afghan War 42ff
Second Balkan War 50ff
Second Opium War 22, 34
Second World War 168ff
 amphibious assaults 186
 battle in the Atlantic 182
 bombing 198ff
 development of tactics 74
 end of 228
 end-game 194
 evacuation 198
 German forces in Russia 214ff
 involvement of civilians 198

 Japanese expansion 228ff
 Operation Barbarossa 214
 Operation Typhoon 214
 partisan forces 212
 rationing 198
 resistance groups 212
 Western Desert 184
 work of women 211
Seconde guerre afghane 43f
Seconde guerre balkanique 54f
Seconde guerre de l'opium 24, 35
Secret police 250
Sedan 22/24/25, 36
Senfgas 78, 92
Serbia 50, 375
Serbie 55, 379
Serbien 53, 377
Sevastopol 28
Sewastopol 28
Shanghai 146
Sheffield, HMS 370/371/371
Shi'ites 388
Signal 10/13/18
Sino-Japanese War 142ff
Sirdars 44
Six-Day War 326, 334
Skopje 50/54/55
Slim, Sir William 228/230/231
Slovenia 375
Slovénie 379
Slowenien 377
Smith, Rupert 410/412/414
Smyrna 137
Smyrne 137
Société des Nations 129, 142
Somalia 356/357/, 375/378/, 394
Somalie 357, 379, 394
Somme 10/13/18, 70/75/79,
 86/86/87
Soulèvement hongrois 254, 260
South Wales Borderers 52
Spanisch-Amerikanischer Krieg 53,
 57
Spanischer Bürgerkrieg 15, 129,
 154ff
Spanish-American War 50, 56
Spanish Civil War 10, 126, 154ff
Speer, Albert 198/199/201
Sphinx de Gizeh 48
Sphinx of Giza 48
Sphinx von Giseh 48
Spion Kop 50/52/55, 60
Sri Lanka 320
Stalin, Josef 129, 215, 252
Stalin, Joseph 129, 214, 250
Staline, Joseph 129, 217, 253
Stealth fighters 374/376/
Stellungskrieg 75
Sterling, David 184/185/185
Stormberg 50/52/55
Suez Canal 326, 332, 340
Suezkanal 328, 332, 340
Sun Yat-Sen 140
Sunnyside farm 60
Système radar Aegis 381
Systèmes des roquettes 192
Szabo, Violette 198/200/201

Tactics 74
Tactique 81
Tactique air-sol 2000 378
T'ien-Tsin 24, 35
Tientsin 22/23/, 34/35/
Tanks 68

Mark IV 90
Mark V 71
 Russian 218
Tannenberg 72/76/80
Tarawa 242
Taylor, Charles 396/396f/397
Tchécoslovaquie 163f, 255
Tchétchénie 18, 399ff
Tear gas 73
Tel el Kébir 48, 54
Tel-el-Kebir 48, 50
Television 11
Télévision 19
Temin, Victor 12
Templar, Sir Gerald 272/275/276
Terre-Neuve, régiment de 18
Tet Offensive 300
Tet-Offensive 300
Thrace 50//55
Thrakien 53
Todesritt von Balaklawa 12, 23
Todeszone 85ff
Togo, Admiral 50/53/55
Torgau 194
Tourgau 194
Tränengas 78
Transvaal 52
Trench warfare 82
Tschapei 146
Tschechoslowakei 162ff, 255
Tschetschenien 18, 398ff
Tschiang Kai-schek, General 129,
 140, 149
Tschu Wen-hai 149
Türkei 108ff
 Unabhängigkeit 137
Turkey 108ff
 independence 137
Turquie 109ff
 indépendence 137
 ottomane 55

UN peacekeepers 375, 408
UN-Friedenstruppen 376, 408
Ungarnaufstand 253, 260
UNIFIL 375
UNITA 360/360/361
US-Artillerie 32
US Federal Artillery 32
US-Flotte 230
US Marine Corps 228

V-bombs 206
V-Waffen 206
Varsovie 164, 177
Vaughan, Thomas Wynford
 10/15/19
Verdun 70/74/79
Versailles 126/127/129f
Vickers machine gun 67
Vickers-Maschinengewehr 67
Vickers Vernon, bombardier 139
Vickers Vernon bomber 139
Vickers Vernon-Bomber 139
Vietnam War 11, 16, 272ff
Vietnamkrieg 15, 16, 274ff
Vimy 88
Vittorio Veneto 73/78/81
Völkerbund 127, 142

Waggon trains 38
War photography 8ff
Warsaw 164, 176

Warsaw Pact 248
Warschau 164, 176
Warschauer Pakt 248
Wavell, Archibald 126/127/129
Wehrmacht 180
Weizmann, Chaim 326/327/328
Welfare State 198//201
Wesel 188/188/189
Western Desert 184
Wijnberg Hospital 62
Wijnberg-Krankenhaus 62
Wingate, Orde 239
Wireless communication 50, 94
Wohlfahrtsstaat 200
Woo, General 140

Yamamoto, Admiral 228/229/230
Yates, Elsie 211
Yemen 346
Yémen 347
Yom Kippur War 338ff
Yorktown, USS 236/236/237
Ypern 102
Ypres 102
Yugoslavian civil war 374f, 402ff

Zhilinsky, général Yakov 80
Zhilinsky, General Yakov 73
Zhoukov, Maréchal Georgi 217
Zhukov, Marshal Georgi 214
Zionist Jewish movement 126
Zionistisch-jüdische Bewegung
 128
Zone de la mort 85, 87
Zulu Wars 50
Zulu-Kriege 52
Zweiter anglo-afghanischer Krieg
 42ff
Zweiter Balkankrieg 52ff
Zweiter Opiumkrieg 23, 35
Zweiter Weltkrieg 168ff
 Amphibischer Angriff 186
 Bombardement 198ff
 Deutsche Truppen in Rußland
 214ff
 Ende 230
 Endspiel 194
 Evakuierung 199
 Frauen 211
 japanische Expansion 229f
 Lebensmittelrationierung 200f
 Nordafrika 184
 Operation Barbarossa 214
 Operation Taifun 215
 Partisanen 212
 Schlacht im Atlantik 182
 Strategische Neuerungen 78
 Widerstand 212
 Zivilisten 198ff
Zypern 364, 367

Photo Credits
Fotonachweis
Crédits photographiques

Agence France-Presse 372-373
Anderson (ERA/Agence France-Presse) 405.2
Andrews, Peter/Reuters 398.1, 408.1
Associated Press 351.2, 351.3, 384.1

Balugh, Laslo/Reuters 404.1
Beato, Felice 34.1. 35.3
Behrakis, Yannis/Reuters 18, 398.2, 400.1,
 403.3
Borea, Roberto (The Associated Press) 385.3
Bourke-White, Margaret (Life Pool) 197.2
Bosshard, Walter 148.1, 149.2, 149.3
British Official Photo 86.1, 87, 91.3, 100-
 101, 102.1, 103.3, 185.3, 187.3
Brooke, John Warwick
 (British Official photo) 72
Brooks, Ernest (British Official photo) 70
Burke, Capt. James 42-43, 44.1, 44.2, 45.3,
 46-47

Capa, Robert (Life Pool) 189.2, 189.3, 190.1,
 190.2
Chase, Harry 110.1
Cukovic, Ranko/Reuters 379

Dempster, Stuart (for *Daily Express*) 358.1,
 367.2
Dufka, Corinne/Reuters 396.2, 397.3

Eades, Brian (for *The Observer*) 275, 313, 314-
 315
Eason, Steve (Hulton Getty) 255
English, Greg (Link) 320.1, 320.2, 321.3,
 322-323, 325.4, 376, 380, 381, 382-383,
 387.2, 387.3, 394.1, 395.2, 395.3
Erwitt, Elliott (donated to
 U.S. Library of Congress) 248-249
Esten, Jack (for *Picture Post*) 260.1, 261.2

Fenton, Roger 8, 22, 23, 26-27, 28.1, 28.2,
 29.3, 29.4
Fincher, Terry (for *Daily Express*) 16, 299.3,
 310.1, 311.2, 329, 334.1, 334.2, 336-337,
 338.2, 339.3, 347.3 (for Keystone) 333.3
Florea, John (Life Pool) 225.2

Garanin, A. (Slava Katamidze Collection)
 219.2
Gardner, Alexander 4, 31.3, 33.3
Gianini, John (for *The Observer*) 312

Hardy, Bert (for *Picture Post*) 256.1, 257.3,
 259.2, 270-271, 278-279, 280.1, 281.2,
 281.3, 282, 283, 284.1, 286.1
Hewitt, Charles (for *Picture Post*) 295
Heydinger, Stuart (for *The Observer*) 317.3,
 362.1

IRNA/Agence France-Presse 388.1
Ishmael, Lamaa (Agence France-Presse)
 344.1

Jackson (INP Pool) 194.1
Jacobs, Fenno 258.1
Jahjah, Najla Abon/Reuters 345.2

Koratayev, Viktor/Reuters 399.3
Kuznets, Dmitry/Reuters 400.2

Lampen, Jerry/Reuters 409.4
Lancaster, Chris (for *Daily Express*) 268.1
Leibing, Peter (The Associated Press) 266.1
Liebert, Alphonse 38.2
Lovelace, William (for *Daily Express*) 274

McGrath, Tony (for *The Observer*) 318.1,
 318.2, 338.1, 366.1, 367.3
McCullin, Donald (for *The Observer*) 364.1
McKeown, Joseph (for *Picture Post*) 332.2
Magee, Haywood/Reiss, Francis
 (for *Picture Post*) 206.1
Mather, Ian (for *The Observer*) 348.1
Mell, Don (The Associated Press) 350.1
Mesinis, Dimitri (Agence France-Presse)
 389.2
Mikami, Sadayuki (The Associated Press)
 386.1
Mollard, Dominique (The Associated Press)
 384.2

Observer, The 277
O'Driscoll, Paul (for *The Observer*) 324.1,
 325.3, 375
O'Sullivan, Timothy 32.1

Patellani, Federico 257.2
Petrusov, Georgi
 (Slava Katamidze Collection) 128
Popov, Oleg/Reuters 408.2
Prime, Tony (for *The Observer*) 368.2

Ramage, Frederick 193.3, 194.2, 195.3, 224.1
Reuters 409.3
Rider-Rider, William
 (Canadian Official photo) 86.2
Rimmer, Cleland (for *Daily Express*) 267.3
Robinson, David (for *The Observer*) 359.3

Sébah, Pascal 48-49
Seigman (Acme Pool) 206.2
Shagin, Ivan (Slava Katamidze Collection)
 217
Shaiket, Arkady
 (Slava Katamidze Collection) 200
Silverman, David/Reuters 345.3
Simon, Christophe (Agence France-Presse)
 396.1
Slava Katamidze Collection 96-97, 134.1,
 134.2, 135.3, 218.1
Stathatos, John 389.3
Strock, George (Life Pool) 243.3

Tambulov, Grigory/Reuters 401.3
Temin, Victor (Slava Katamidze Collection)
 12, 215, 220-221, 251
Tereschuk, David (for *The Observer*) 319.3
Thiele, Reinhold 51, 60.1, 61.3, 62.1, 62.2
Trench, Richard (for *The Observer*) 353, 356

U.S. Air Force 188.1, 209, 264.2, 293.3,
 306.1, 306.2
U.S. Army 197.3, 239.2, 240-241, 242.1,
 298.1
U.S. Army Signal Corps 71, 88-89, 191.4
U.S. Coast Guard 186.1
U.S. Library of Congress 30.1, 32.2, 57, 68-
 69
U.S. Marine Corps 290
U.S. National Archives 228
U.S. Navy 187.2, 229, 236.1
U.S. Official Photo 191.3, 192.1, 192.2, 234.1,
 235.2, 235.3

Van Hoepen 58.1, 58.2

Weaver, Kevin (Hulton Getty) 390-391,
 392.1, 392.2, 393.3, 402.1, 402.2, 406-407

Young, Gavin (for *The Observer*) 360.2